D1061714

CENTRAL EUROPEAN AVANT-GARDES

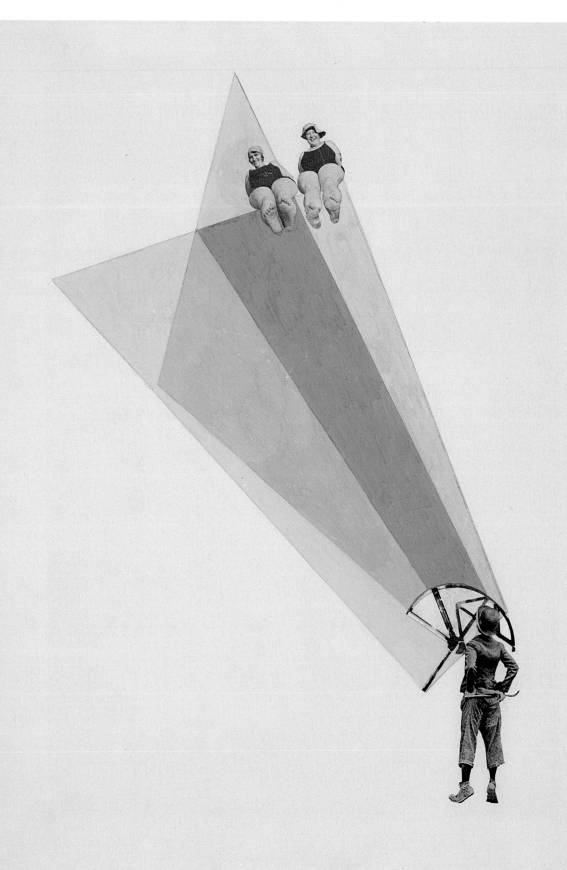

Timothy O. Benson

With curatorial assistance by Monika Król

Preface by Péter Nádas

Essays by Timothy O. Benson
Éva Forgács
Michael Henry Heim
Monika Król
Esther Levinger
Christina Lodder
S. A. Mansbach
Krisztina Passuth
Piotr Piotrowski
Derek Sayer
Anthony D. Smith
Karel Srp
Andrzej Turowski

central european avant-gardes:

exchange and transformation, 1910–1930

Los Angeles County Museum of Art

The MIT Press
Cambridge, Massachusetts and London, England

Published by Los Angeles County Museum of Art,
5905 Wilshire Boulevard, Los Angeles, California
90036, and The MIT Press, Cambridge,
Massachusetts 02142.

Library of Congress
Cataloging-in-Publication Data

Central European avant-gardes : exchange and
transformation, 1910–1930 / edited by Timothy O.
Benson with a foreword by Péter Nádas and essays
by Timothy O. Benson ... [et al.]
 p. cm.
Includes bibliographical references and index.
ISBN 0-262-02522-1 (hc. : alk. paper)
1. Art, European—Europe, Central—20th century—
Exhibitions. 2. Avant-garde (Aesthetics)—Europe,
Central—History—20th century—Exhibitions. I.
Benson, Timothy O., 1950–
N6758 .C45 2002
709'.43'09041—dc21

 2001054618

Exhibition itinerary:

Los Angeles County Museum of Art: March 3–
June 2, 2002
Haus der Kunst, Munich: July 7–October 6, 2002
Martin-Gropius-Bau, Berlin: November 2002–
February 2003

Managing editor: Stephanie Emerson
Editor: Thomas Frick
Editorial assistants: Sara Cody, Elizabeth Durst,
Suzanne Kotz
Design: Scott Taylor with Katherine Go
Production coordinator: Karen Knapp
Production assistant: Theresa Velázquez
Supervising photographer: Peter Brenner
Rights and reproductions coordinator:
Cheryle T. Robertson

Printed and bound by Snoeck-Ducaju & Zoon NV,
Ghent, Belgium

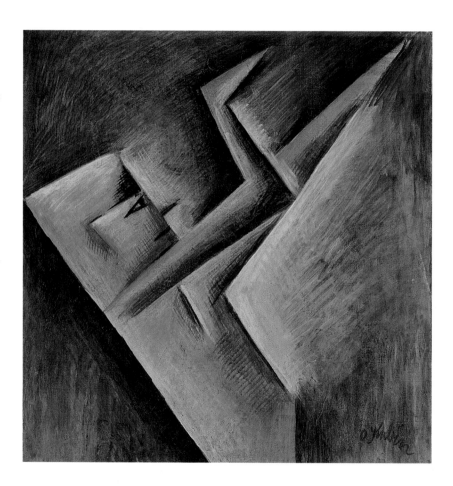

Eureka, the text type in this book, was drawn by
Peter Bilak, a Slovakian designer working in the
Netherlands. The proportions of Eureka were
specifically developed to accommodate the numer-
ous diacritics of Central and East European lan-
guages. DIN, the sans serif type used herein, is an
adaptation of DIN-Mittelschrift. The name refers to
Deutsche Industrie-Norm, the German industrial
standard, and the original typeface was adopted
for road signs and license plates in the former West
Germany.

Frontispiece:
■ László Moholy-Nagy, *The City Lights*, 1926 [?],
photocollage and tempera on cardboard

Above:
■ Otakar Kubín, *The Sun Worshiper*, c. 1913, oil on
canvas

Page 9:
Henryk Stażewski, *Composition*, 1930, oil on canvas,
seen in the a.r. installation at the Muzeum Sztuki in
Łódź, 1932

EXHIBITION CREDITS

This book was published in conjunction with the exhibition *Central European Avant-Gardes: Exchange and Transformation, 1910–1930*, which was organized by the Los Angeles County Museum of Art. The exhibition was supported in part by the Art Museum Council; the National Endowment for the Arts; and the National Endowment for the Humanities, dedicated to expanding American understanding of history and culture. Additional support was provided by the Trust for Mutual Understanding; the Austrian Federal Ministry for Foreign Affairs; an International Partnership among Museums Award presented by the American Association of Museums with funding from the Bureau of Educational and Cultural Affairs of the United States Information Agency and the Samuel H. Kress Foundation; and H. Kirk Brown III and Jill Wiltse.

In-kind support for the exhibition is provided by KLON 88.1 FM.

This publication was made possible in part by Mary and Roy Cullen.

CONTENTS

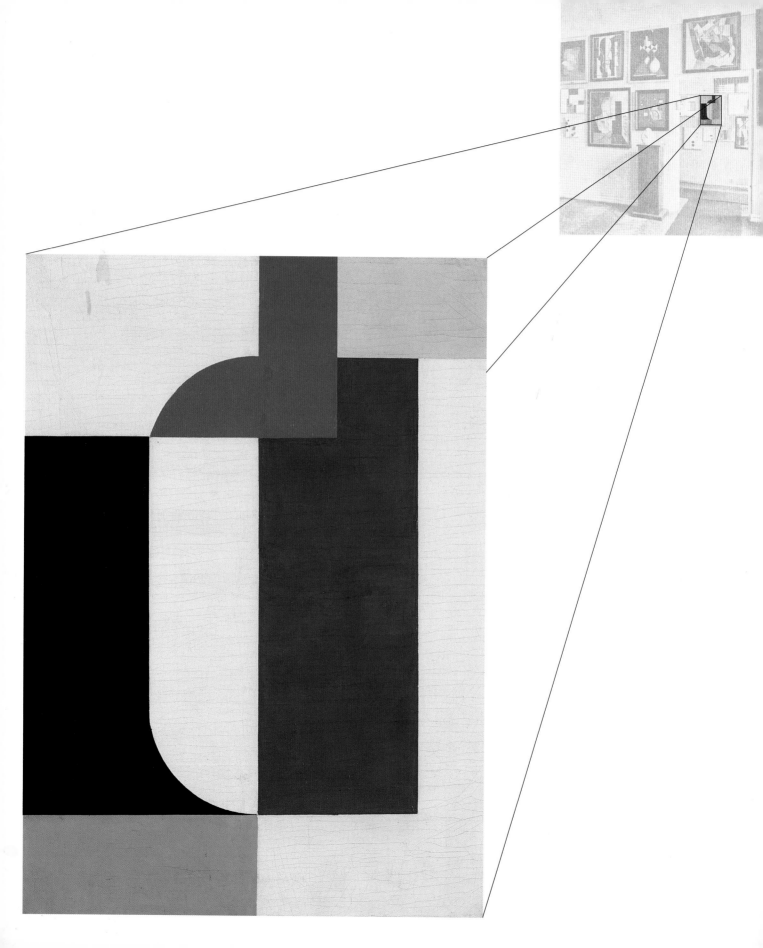

FOREWORD

Central European Avant-Gardes: Exchange and Transformation, 1910–1930 offers a new view of the evolution of modern art by examining a remarkable body of work from an era and region long obscured by subsequent historical events. The complex interaction among artists of diverse ethnicities—at the moment when the nation-states of Austria, Czechoslovakia, Germany, Hungary, Poland, Romania, and Yugoslavia were being born—forged entirely new relationships between regional traditions and the cosmopolitan utopianism of the international avant-garde. This exhibition explores painting, sculpture, the graphic arts, photography, and the decorative arts to follow the artists' ennobling search for a common language for all of humanity.

In acknowledging the crucial importance of the relationships among artists from different regions to the transformation of modern art and culture, *Central European Avant-Gardes* considers not only the artworks themselves, but also the situations where their meanings were articulated, most notably the international exhibitions that took place in Berlin, Budapest, Prague, Warsaw, and many other cities throughout the region. Each gallery in the exhibition features one such "situation of exchange," its richness conveyed by a selection of marvelous objects, many seen in this country for the first time.

The complex and ambiguous sense of identity that emerged as Central Europe entered the modern age remains instructive today as we seek to understand the phenomenon of globalization that was in some ways presaged by this earlier period of cultural exchange. The exhibition's attention to the social context in which art is produced and appreciated continues a venerable tradition of innovative exhibitions at LACMA.

An exhibition of this breadth would not be possible without the support of many organizations and individuals. We are grateful to the Trust for Mutual Understanding, the Alexander von Humboldt Foundation, and the Samuel H. Kress Foundation for their support of the planning of this complex project. This support enabled Timothy O. Benson, the exhibition's organizer and curator of the museum's Rifkind Center for German Expressionist Studies, to assemble an initial team of advisors including Krisztina Passuth, Piotr Piotrowski, and Karel Srp. We are grateful to them, to curatorial assistant Monika Król, and to the many others listed in our acknowledgments for their roles in all phases of realizing the project.

LACMA would like to thank in particular the Art Museum Council, the National Endowment for the Arts, and the National Endowment for the Humanities for their generous sponsorship of *Central European Avant-Gardes*. We are grateful for additional support provided by the Austrian Federal Ministry for Foreign Affairs, H. Kirk Brown III and Jill Wiltse, and Mary and Roy Cullen. In-kind support was provided by KLON 88.1 FM. We owe our special gratitude to the many lenders (listed on page 428), whose willingness to part temporarily with the works of art in this exhibition was essential to its realization.

Andrea L. Rich
President and Director

Central Europe circa 1910

Moscow

Russia

Berlin
Poznań
Warsaw

Germany
Dessau
Łódź

Weimar

Paris

Prague
Cracow

Vienna

Budapest

Austria-Hungary

Ljubljana
Zagreb

Belgrade
Bucharest
Romania

Serbia

Central Europe circa 1930

Estonia

Latvia

Moscow

Lithuania

Germany

Soviet Union

Berlin
Poznań
Warsaw

Germany
Dessau
Łódź

Poland

Weimar

Paris

Prague
Cracow

Czechoslovakia

Vienna

Austria

Budapest

Hungary

Ljubljana
Zagreb
Romania

Belgrade
Bucharest

Yugoslavia

CENTRAL EUROPEAN AVANT-GARDES

Note
Full captions for illustrated
checklist items (■) can be found in
the complete checklist, beginning
on page 374.

INTRODUCTION

Timothy O. Benson

It is ironic that a region long at the heart of European culture should now seem to us obscure, even exotic. Ranging without fixed boundaries along the shores of the Danube and Oder Rivers and across the backbone of the European continent from the Balkans to the Baltic, having existed between the great Latin and Greek traditions, it remains a rich cauldron of ethnic conflict and melding, where modern Slavic, Germanic, and Gaelic cultures have profoundly influenced the world beyond.[1] *Central European Avant-Gardes: Exchange and Transformation, 1910–1930* attempts to regain a perspective on this diverse region through the works of its foremost artists, whose participation was often crucial to the unfolding of modernism throughout Europe.

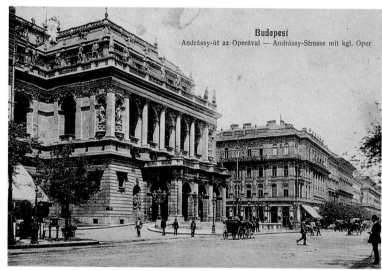

Opera house on Andrássy Avenue, Budapest, 1910s

For those of us encountering Central Europe from the West, its temporal mapping appears as ambiguous as its shifting geographic boundaries. When much of Western Europe was emerging from the industrial revolution with modern states born of the Enlightenment, Central Europe remained a vestigial feudal society at the twilight of the Romanov, Hohenzollern, Habsburg, and Ottoman Empires. And yet a strength of these great empires was the rich cultural and ethnic diversity sustained within them. Now obscured by decades of neglect imposed in part by subsequent absolutist regimes, the Central European avant-garde of the early decades of the century was integrally related to its now better-known, well-documented counterparts in Paris and Moscow. Artists and writers coalesced in metropolitan centers such as Berlin, Warsaw, Munich, Vienna, Prague, and Budapest, each a cultural capital in its own right with a long heritage of both "official" culture and artistic innovation. Yearning for the cutting edge, they traveled between cities, and sojourned to Paris and Moscow with an increasing frequency made possible by the rail network created during the late nineteenth century through the influx of Western capital. In turn, they brought a rich variety of artistic approaches to the social

network of artists and writers that made up the Western European avant-garde.

Where was?—when was?—the avant-garde of Central Europe? Where was its creative center, its soul, so to say? In Budapest around 1912 at the Japan Café, where artists and architects gathered, the Café Central patronized by artists and historians, or any number of other cafés along the nearby Andrássy Avenue frequented by the intelligentsia? The coffee-houses of Budapest, where "the waiter…put the recent *Le Figaro* in your hands" as chronicled by the great Hungarian writer Gyula Krúdy,[2] were a century older than those of Paris or Vienna. Conversation during the autumn and winter of 1912–13 might have focused on such exhibitions at the Nemzeti Szalon as Nyolcak's [The Eight's] November exhibition (where writer Endre Ady is said to have met composer Béla Bartók) or the January exhibition of Italian Futurists and German Expressionists created by socialist writer and critic Alexander Mercereau.[3] Or was the creative center of Central Europe in 1912 to be found in Prague, where in November at the Municipal House on the Náměstí Republiky (an opulent *fin-de-siècle* homage to Charles Garnier designed by Antonín Balšánek and Osvald Polívka) some of the exhibition halls were transformed by Josef Gočár's crystalline vaults and angled walls for an exhibition of the Czech Cubist Skupina výtvarných umělců [Visual Artists' Group], (while in nearby rooms an exhibition by the Czech Symbolist group Sursum

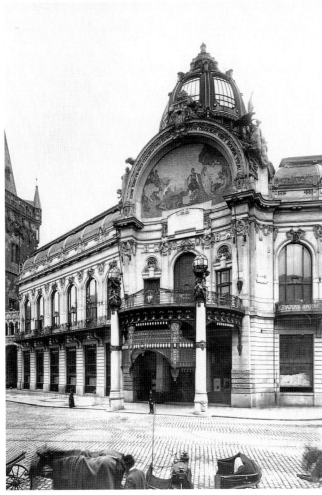

Antonín Balšánek, Osvald Polívka, Municipal House on the Náměstí Republiky, 1903–12

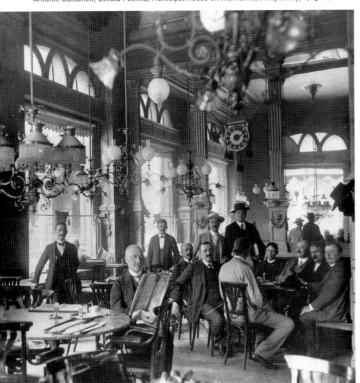

Café Central, Budapest, c. 1910

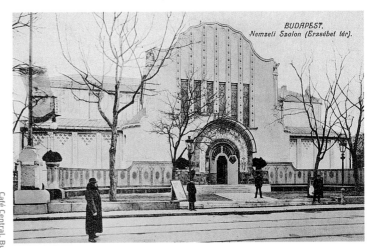

Nemzeti Szalon, Budapest, 1907

Furniture by Josef Gočár in second Skupina exhibition, Prague, September–November 1912

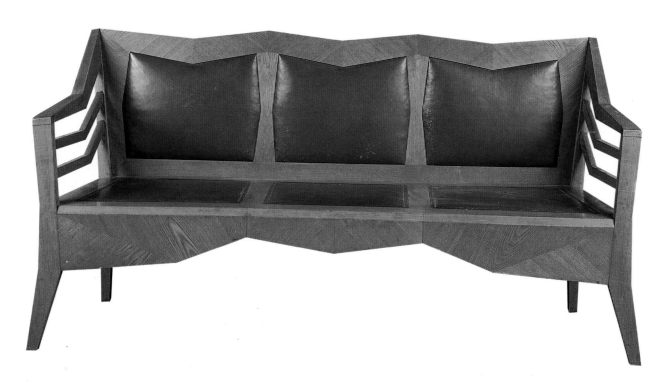

■ Josef Gočár, Settee, 1915, ash and leather

Vincenc Kramář, Prague, 1931

showed the lingering influence of the Munch exhibition that had traveled to Prague in 1905)? How should we describe the faceted forms found throughout the paintings, sculpture, furniture, and ceramics of Skupina members Vincenc Beneš, Emil Filla, and Bohumil Kubišta? Since they were inspired by study in Paris as well as by the Braques and Picassos that Prague collector and art historian Vincenc Kramář had obtained, should we call these works Cubist? Or were they closer to the tradition of the Bohemian Baroque, still vividly present in the innumerable undulating façades around Prague's Old Town Square and throughout the city? Or does the true meaning of Czech Cubism lie beyond stylistic similarities, perhaps closer to the works by Ernst Ludwig Kirchner, Karl Schmidt-Rottluff, and other German Expressionists displayed prominently in the exhibition at the invitation of Skupina? That German interest in Czech artists was equally keen is demonstrated not only by a Skupina exhibition in Berlin at Herwarth Walden's galleries the following autumn, but also by the prominence of Czech artists in Walden's huge Erste Deutsche Herbstsalon [First German Autumn Salon] of 1913, hitherto the broadest international survey of modernism in Germany.[4]

Indeed Berlin, with its cosmopolitan cafés, galleries, and ateliers, cannot be overlooked in any survey of the centers of the Central European avant-garde. Long a *Weltstadt*, Berlin would become by 1920 one of Europe's most diverse metropolises, with some four million inhabitants, a city where in the aftermath of war and revolution over 100,000 Russian émigrés would find their home,[5] many residing around the Nolendorfplatz in the company of Hungarians forced out of their homeland by the rightist Horthy Regime. In 1922 a gathering in artist Gert Caden's Berlin studio included Germans Hans Richter and Mies van der Rohe, Russians El Lissitzky and Naum Gabo, Hungarians László Moholy-Nagy and László Péri, Ernő Kállai and Alfred Kemeny, and Dutch De Stijl founder Theo van Doesburg.[6]

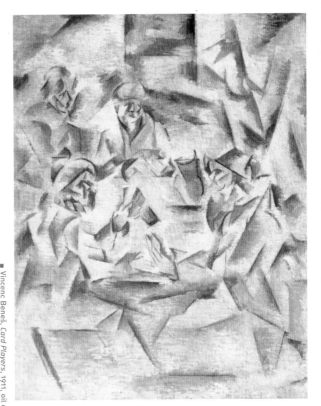

Vincenc Beneš, *Card Players*, 1911, oil on canvas

■ Václav Špála, *Brick Factory*, 1912, oil on canvas

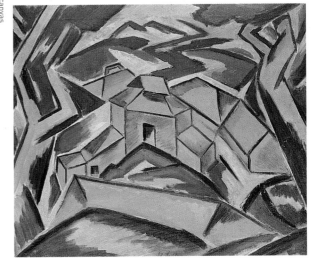

If Berlin had become the place where the East meets the West then, as Russian émigrés El Lissitzky and Ilya Ehrenburg said of the scene they found there during the early 1920s, "Art is today international, though retaining all its local symptoms and particularities."[7] From the perspective of its participants the avant-garde was becoming pluralistic, not centered in one place but constantly shifting among various sites of exchange, where multiple views and approaches were debated and absorbed. The avant-garde was itself becoming migratory, as artists' mobility increased. For example, many of those who met in Caden's Berlin studio would be in Düsseldorf within a few days to attend the Congress of International Progressive Artists. Here groups from Darmstadt, Berlin, and Dresden exhibited with individuals from France, Holland, Hungary, Italy, Poland, and Russia in this first "International Exhibition." Not one avant-garde, then, but many avant-gardes, interacting with one another yet each retaining its unique characteristics.

Central European Avant-Gardes: Exchange and Transformation, 1910–1930 considers the locations where artists and writers worked to be "exchange sites," venues of varying degrees of isolation and cosmopolitanism where artistic idioms, styles, ideologies, and languages were debated, embraced, dismissed, and modified. Just as Central European history itself has long been as much one of disruption, discontinuity, and intentional rewriting as one of coherent evolution—a region that "was *always* a 'post-modern' polyphony," as Derek Sayer has said of the Czech-speaking lands,[8]— we approach the cultural production of the avant-garde as irreducibly multiple: varied in its states of completion and extraordinarily diverse in its intentions. While this approach pushes to the forefront the phenomena of reciprocal influence, and meaning as determined by immediate social and cultural setting (phenomena that have long mystified

historians and theoreticians of culture), it opens us to a recognition that artists of the era had themselves arrived at: the avant-garde had become at once regionally diverse and irretrievably international. This insight was expressed as a necessity by the Union of Progressive International Artists in Düsseldorf: "Art must become international or it will perish."[9] The ambition among the members of the avant-garde for universality in a world of nation-states is the focus of the present exhibition and the selection of essays that follows. It marked a turning point in the history of modernism, one scarcely yet accounted for and one bringing into question our concepts of national, regional, and individual identity as well as our notions of artistic influence and intended meaning.

In this volume scholars familiar with the fourteen locales featured in the exhibition convey what distinguished each of them as they contributed to the broader discourse of exchange and transformation that defined the avant-garde across Europe. Lenka Bydžovská informs us about Prague as a venue of encounters with Cubist and Purist art, Russian structuralist linguistics, American film and jazz, and the unique responses produced in the Skupina and Devětsil groups. Lee Congdon brings to life the rich social texture of Budapest as it was experienced by Lajos Kassák, Endre Ady, Béla Balázs, and others who shaped vanguard culture as the Hungarian Commune rose and was then defeated by the counterrevolutionary forces of Miklós Horthy. The creative activity that immediately followed, as the Hungarian activists emigrated to Vienna, is considered in Pál Deréky's account of this city, so long a host, as the Habsburg capital, to a polyglot of ethnicities and now home not only to Arnold Schoenberg and Robert Müller but also to Lajos Kassák, Béla Uitz, and Lajos Tihanyi.

Yet perhaps the principal destination in the 1920s, not only for Hungarians but for Austrians, Romanians, Russians,

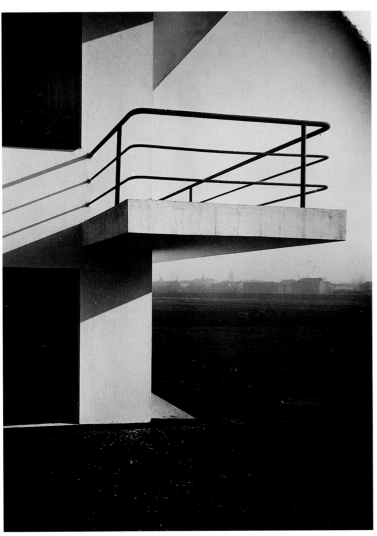

■ Lucia Moholy, *Balcony of the Studio Building*, from the Bauhaus series, Dessau, 1926

Serbians, and other émigrés from the East, was Berlin, discussed by Krisztina Passuth, a city with an astonishing variety of meeting places, fostering encounters among virtually all the contemporary modernist movements in Europe. In Weimar, and later Dessau, the Bauhaus, with its stellar faculty, attracted students from throughout Central Europe, gradually taking over Berlin's role as the focus of International Constructivism, as well as furthering a host of art forms not widely taught in schools, including photography, stage design, and typography; this development is explored in a pair of essays by Éva Bajkay.

During the early and mid-1920s the increasingly international activities of the avant-garde produced correspondingly cosmopolitan exhibitions occurring as far afield as Bucharest (in the 1924 Contimporanul group show, described by Ioana Vlasiu) and Belgrade, a city where progressive and regressive tendencies flourished simultaneously (in a complex mixture deciphered by Miško Šuvaković). The Zenitist movement, which mounted an international exhibition in 1924 in Belgrade's Stanović music school, had its origins in Zagreb, whose cultural milieu is charted by Želimir Koščević. The International Constructivist tendencies that were becoming a bond of commonality among various vanguard centers were brought to Ljubljana by August Černigoj (who had been a student at the Bauhaus) and Ferdo Delak, founders of the periodical *Tank*, as discussed by Lev Kreft.

Further north, Expressionism had evolved in Poznań, a Polish city (until 1918 under German domination) with close ties to Berlin. Jerzy Malinowski's essay shows how the Poznań Bunt group had contacts not only with artists in Warsaw and Lwów, but also with Berlin's *Die Aktion* gallery (where they exhibited in 1918), Łódź's Jung Idysz group, and Cracow's Formisci, where Expressionism was evolving simultaneously. Cracow, until 1918 under Austrian rule, had a venerable tradition as a university town. As Tomasz Gryglewicz details in his essay, painter Leon Chwistek's Ph.D. in philosophy from the university (where he later served as an assistant professor) equipped him for intellectual debates with the brilliant writer, photographer, and painter Stanisław Ignacy Witkiewicz, who added a knowledge of Russian Constructivism to the Formisci's familiarity with Expressionism, Futurism, and Cubism.

The transition in Poland to International Constructivism in *Blok* and its successor group Praesens took place in Warsaw, a city described as a crossroads by Dorota Folga-Januszewska. *Blok* cofounder Henrik Berlewi was frequently in Paris and Berlin, where he exhibited in the Sturm galleries along with

fellow cofounders Mieczysław Szczuka and Teresa Żarnower. Prominent Polish Constructivists Władysław Strzemiński and his wife Katarzyna Kobro brought influences from Moscow's Inkhuk [Institute of Artistic Culture], where the term "Constructivism" originated. Jaromir Jedliński recounts how after playing a leading role in Blok and Praesens, Kobro and Strzemiński participated in a.r., the successor group to Praesens, which had moved from Warsaw to the textile mill city of Łódź; there it created in 1931 the first artist-founded museum of the avant-garde, with artworks donated from throughout Europe.

Central European culture has long been a highly contested arena, unstable and diverse. There has been little agreement on how it should be interpreted or even what the boundaries of the field of inquiry should be. Rather than proposing a resolution of such issues, the longer essays in this volume are intended to attune the reader to the intricacies of the vexed discourse on modernism in Central Europe.

Far more pertinent than attempting to fix precise boundaries to the regions of Central Europe is gaining an understanding of the sui generis character of the characteristics of locale

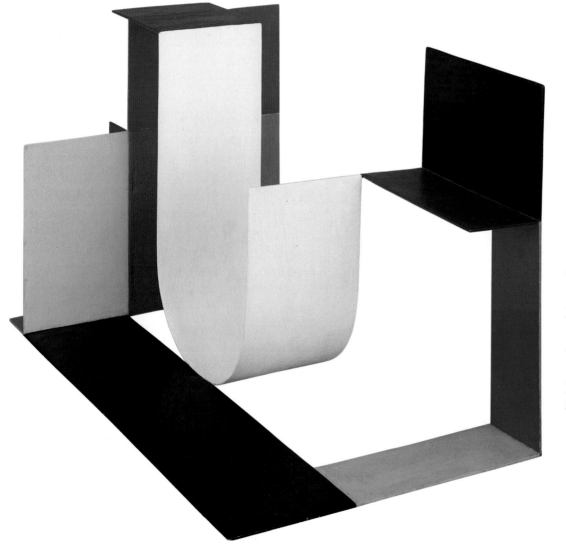

Katarzyna Kobro, *Space Composition 4*, 1929, painted steel

18

that set the region apart. To comprehend a world of locales without center or peripheries we might begin by asking, with Péter Nádas, what it was like to experience a specific location not as a potential periphery but as one's sole reality. Nádas shows how the collective consciousness prevailing in this premodern condition deepened commonality yet precluded open discourse, cultivated durable and flexible *relationships* of exchange yet altered qualitatively every *instance* of exchange in a way foreign to the quantifying forces of the urban-based capitalist economy to which we have become accustomed. If, as Benedict Anderson suggests, "all communities larger than primordial villages of face-to-face contact (and perhaps even these) are imagined,"[10] how did the projection of a wider community change as modern nation-states were born and the very meaning of the local was being dissipated by progress? How did the avant-garde respond as it found itself confronted with an array of increasingly ephemeral events and situations of exchange, sites that might come and go even while the forces of nationalism unleashed by the fall of the great empires during the 1910s redefined the meaning of the regional and the local?

How are we to understand nations and nationalism? Is the nation, as Rogers Brubaker has suggested, a form of practice that is used "to structure perception, to inform thought and experience, to organize discourse and political action"?[11] Or is there something *essential* revealed in the myths, symbols, traditions, and language that define a people? Clearly, the avant-garde existed (often precariously) between the forces of nationalism and modernism, a nexus to which Anthony D. Smith devotes his essay. Smith leads us through the intricacies of the terminology, concepts, and modes of explanation of nationalism and modernism, showing just how intertwined these concepts are while demonstrating the importance of the prenational "ethno-symbolic heritage"— the ethnic motifs and symbols that form the common bonds

of myth and memory—that modernism is thought to have left behind.

Indeed the very project of modernism, at once utopian and totalizing, seeking commonality and universal structures— seen in the linguistics of the Prague structuralists, the elementalist aesthetics of Hans Richter and László Moholy-Nagy, the Productivism espoused in Russian Constructivism, and the "socialist cathedral" upon which Bauhaus ideology was initiated—could not overcome the disjunctions of a reality made up of overlapping traditions and juxtaposed social and artistic agendas to which Derek Sayer draws our attention in his essay on the artists of Prague. The collages of Karel Teige, Jindřich Štyrský, and Toyen (Marie Čerminová) capture the ambiguity underlying conceptions of time and space, to which modernism was seeking to bring its assumptions of causality and order. If, as Sayer suggests elsewhere, these discontinuities were at least as endemic to the Czech Lands as to any other setting, International Constructivism was precisely such a modernist project, intended as a universally valid means of overcoming the diversity of locale that was needed to rescue the avant-garde. I discuss this in my exploration of the assertions made by the participants in the Congress of International Progressive Artists in Düsseldorf in May 1922.

In making such proclamations, these spokesmen of the avant-garde found themselves confronted with the very plurality that their myth of the avant-garde (based on faith in progress and continuity) had long sought to obscure. Yet throughout Europe visual culture was becoming increasingly uniform through the sheer power of both mass popular culture and the standardized industrial production of high capitalism. As Karel Srp points out in his probing of the Devětsil group and Czech Poetism, artists' responses in periodicals ranging from the Polish *Blok* to the Czech *ReD* used the imagery of cinema (above all the emblem of Charlie Chaplin), advertising, and

generic machine products to develop the grammar of a new mode of communication that would lead to a new collective consciousness, as prevalent as the ageless one described by Péter Nádas.

Yet between the extremes of the universal culture and the local are forged the deep linguistic bonds of the "ethnie" (as Anthony D. Smith terms an ethnic community based in shared myths, memories, lived rituals, and experiences), which contributes to the diversity of the spoken languages of Central Europe. The avant-garde of each such group, as Michael Henry Heim reminds us, played a liberating role, rescuing its linguistic heritage just as the modern nations emerged from the residue of the collapsing monarchical empires, which had for so long enforced a German-language hegemony in Central Europe. Neither nationalist nor fully internationalist, Czech Poetism, in Heim's view, attained uniqueness through its playful celebration of life and refusal to be absorbed into either mass culture or the Western "isms" that it encountered. Poetism (in the spirit of Dada) meant to be an end of "isms," a critique of Constructivism and of the other codified movements it found itself surrounded by. Indeed no "ism" arriving from beyond was entirely recognizable after entering Central Europe.

The extent of this transformation is nowhere more apparent than in Constructivism, whose migration from Russia to Germany, primarily through the agency of El Lissitzky, is carefully charted by Christina Lodder. The severely utilitarian ideology that gave birth to Constructivism in Moscow was replaced in Berlin by a more broadly utopian ethos, and the Constructivist visual language was transformed as it was put to new purposes by artists in that cosmopolis, most notably those from Holland and Hungary. As did their Polish and Czech counterparts, the Hungarian artists of Ma had their own direct contacts with Russia. As Éva Forgács emphasizes in her essay on the Hungarian contribution, much of the meaning of International Constructivism may be found in the *difference* wrought by each group's transformation of Constructivism's purported international idiom. Focusing on artist Lajos Kassák and critic Ernő Kállai, Forgács shows how Hungarian Constructivism adapted itself to the ambiguous space of emigration.

If, generally speaking, an increasingly migratory and ephemeral avant-garde now emerged in events rather than locales, the premier event had become the exhibition, a manifestation wherein artists played the role of entrepreneurs, and critics, collectors, and cultural entrepreneurs played the role of artists. The exhibition thus gained the possibility of becoming a work of art in itself, as is argued by Krisztina Passuth in her discussion of exhibitions in the 1920s. The most significant of these exhibitions diverged from normal practice, critiquing the status quo and situating the artists involved vis-à-vis other groups of artists, hence evolving a kind of communal enterprise aimed at creating an unprecedented aesthetic experience. Often bolstered by little magazines (which could serve as catalogues), exhibitions in the early 1920s became increasingly internationalist in their intentions, conjoining the regional "microenvironments" of their origins with the international network of avant-gardes that was increasingly articulated in the various groups' periodicals.

Inevitably such enterprises were propelled forward by strong, sometimes domineering personalities: Lajos Kassák for the Vienna Ma; Karel Teige in the case of Devětsil; Ion Vinea, M. H. Maxy, and Marcel Janco for Contimporanul; Mieczysław Szczuka, Katarzyna Kobro, and Władysław Strzemiński for Blok and Praesens. In some instances, explored by Monika Król, artistic partnerships born of the relationships of couples were a creative and motivating force. The collaborative production of the married couples Margarete Kubicka and Stanisław Kubicki of the Bunt group, and Kobro and Strzemiński as well as Szczuka and Teresa Żarnower of the Blok group, helped define each group's identity through exhibitions and periodicals. Yet in other instances the dominant personality—the most eccentric case of all being Ljubomir Micić, leader of Zenit in Zagreb and Belgrade—could entirely transform the meanings we associate with the modernist project. As Esther Levinger makes clear in her analysis of Micić's Zenit activities, his ambitions had little to do with embracing the West, despite his sophisticated knowledge of modernism. Micić's hopes of Balkanizing Europe led to a privileging of the regional and local above the universal and international. In the eyes of many (including Constructivist collaborators Hans Richter and El Lissitzky) such attitudes were reactionary and nationalist. Yet as S. A. Mansbach reminds us, it is precisely in the often contradictory and complex blending of the regional and local with the universalist idioms so extolled by the Western avant-gardes that we find the unique qualities of Central European modernism.

Piotr Piotrowski shows how Poland, until 1918 partitioned for over a century by three empires, experienced an awakening of national sentiment at once subversive of the status quo and revealing of a deep crisis in national identity. When the empires disappeared, the heritage so deeply embodied in

Jacek Malczewski's 1894 painting *Melancholy* lingered on to influence Polish Cubism and Expressionism, the forms of expression of the Jewish minority (especially the Jung Idysz group), and the Rytm group's "nationalized modernism," seen at the 1925 Exposition Internationale des Arts Décoratifs et Industrielle in Paris. Yet the complexity of the Central European identity—ambiguous, diffuse, fragmentary, contradictory—and its artistic manifestations should cause us to rethink our approach to a culture all too often conceived as the Other, as Andrzej Turowski argues in his essay. Focusing on our assumptions about biography, geography, and historical and artistic processes, he makes a plea whose fulfillment we hope this exhibition will encourage: "To go beyond the canonical text of modernist or avant-garde geography and history, to side-spaces abandoned, shamefully concealed, or treated as reservations for 'otherness.'"

Central European Avant-Gardes: Exchange and Transformation, 1910–1930 might be called a heuristic enterprise, for it seeks access to precisely such "side-spaces" in order to perceive unobstructed the visual and intellectual qualities of the remarkable works of art that have begun to emerge from their ironically modernist obscurity.

1 On the consequences of the historical confrontation of the great Orthodox and Occidental traditions for modern art, see Andrzej Turowski, *Existe-t-il un art de l'Europe de l'Est?: Utopie & idéologie* (Paris: Editions de la Villete, 1986), 13–18.

2 Krúdy, quoted in John Lukacs, *Budapest 1900* (New York: Grove Press, 1988), 23; see also 148–52.

3 See chronology in *The Hungarian Avant-Garde: The Eight and the Activists* (London: Hayward, 1980) and, for a listing of works in the exhibition, Donald Gordon, *Modern Art Exhibitions: 1910–1916* (Munich: Prestel, 1974), vol. 2, 652–54. A cofounder of the group of artists and writers l'Abbaye à Crétel, Mercereau was also instrumental in presenting French art in Moscow, and in Prague at a 1914 exhibition at the galleries of the Mánes group.

4 Skupina also exhibited in Hans Goltz's gallery Neue Kunst in Munich in April 1913 (where Filla and Beneš had exhibited the previous October with Kandinsky and others). Filla, Beneš, Kubišta, and Procházka had exhibited the previous summer (1912) at the Sonderbund exhibition in Cologne.

5 The population of Berlin in 1920 was around 3,858,000 and by 1925 had reached 4 million; from *Berlin, Berlin: Die Ausstellung der Geschichte der Stadt* (Berlin: Nicolai, 1987), 45. Russian population figure from Hammer and Lodder, *Constructing Modernity: The Art and Career of Naum Gabo* (New Haven: Yale University Press, 2000), 101.

6 Accounts of the gathering are based on a letter from Caden to Harald Obrich dated May 11, 1976 (in the Caden estate at the Sächsische Landesbibliothek in Dresden). For interpretation see Winfried Nerdinger, *Rudolf Belling und die Kunstströmungen in Berlin 1918–1923* (Berlin: Deutscher Verlag für Kunstwissenschaft, 1981), 117; Bernd Finkeldey, "Hans Richter and the Constructivist International," in *Prophet of Modernism: Hans Richter, 1911–1941*, ed. Stephen C. Foster (Cambridge: MIT Press, 1998), 99; Kai-Uwe Hemken, "'Muss die neue Kunst den Massen dienen?': Zur Utopie und Wirklichkeit der Konstruktivistischen Internationale," Bernd Finkeldy, et. al., eds., *Konstruktivistische Internationale Schöpferische Arbeitsgemeinschaft 1922–1927* (Stuttgart: G. Hatje, 1992), 58. Hammer and Lodder, *Constructing Modernity*, 107, and 479–80, n. 43, show that Pevsner could not have been in attendance.

7 El Lissitzky and Ilya Ehrenburg, "The Blockade of Russia Is Coming to an End," (1922) in *The Tradition of Constructivism*, ed. Stephen Bann (New York: Viking, 1974), 55.

8 Derek Sayer, *The Coasts of Bohemia: A Czech History* (Princeton: Princeton University Press, 1998), 17.

9 "Founding Proclamation of the Union of Progressive International Artists," in *De Stijl* 5, no. 4 (1922), trans. Nicholas Bullock, in Bann, 59.

10 Benedict Anderson, *Imagined Communities: Reflections on the Origin and Spread of Nationalism*, rev. ed. (New York: Verso, 1991), 6.

11 Rogers Brubaker, *Nationalism Reframed: Nationhood and the National Question in the New Europe* (Cambridge: Cambridge University Press, 1996), 7.

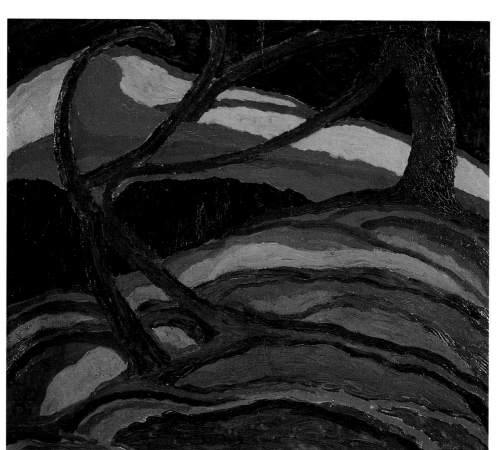

János Máttis-Teutsch, *Dark Landscape with Trees*, 1918, oil on cardboard

A CAREFUL DEFINITION OF THE LOCALE:
WALKING AROUND AND AROUND A SOLITARY WILD PEAR TREE

Péter Nádas

Ever since I've been living in the proximity of this giant wild pear tree I do not need to move to see far ahead or look back in time.

The leaves of the wild pear tree are small and globular, growing densely on the branches. The small leaves are shiny, and tough like cowhide, the leaf-covered branches bend all the way to the ground, while the main branches raise a well-shaped spherical crown against the sky, absorbing the heat, filtering the light and, with the use of the ingeniously twirling little leaves, able to deflect and scatter all precipitation around itself.

Such solitary wild pear trees also live on the ridges of Göcsej, on the southeastern slopes of the long hills, and elsewhere in the area. From late August to early October they generously let fall their tart fruit, thickly covering the lean earth. From the fallen fruit, the locals make brandy and vinegar, both of excellent quality.

Fecundity is the wild pear's doom.

After the summer cloudbursts, when plants and trees can no longer absorb any more moisture, the main branches sometimes collapse under the weight of the fruit and break off. In these summer accidents, the leafy crowns loosen up and become vulnerable to further injuries, yet even in their torn and battered state they last for centuries. Our giant wild pear tree has retained its full crown; an *Arbores excelsae* by its scientific name, it is an extraordinary specimen of its kind. Once, on a sleepy summer afternoon, an enormous crackling broke the silence and at the same time the earth under my feet gave a thumping and grievous sound. I ran to see what had happened; by the time I got there, a huge side-branch had broken off and was lying on the ground. At first glance I could not appreciate the extent of the tragedy. It was as if an arm had been ripped out at its base. I put my saw to use, and during the following autumn the branch turned into heat in our tile stove. The absence of the branch has not stopped

aching in me. I try to look at the tree without seeing its wound, even though over the last ten years, helped by the increased leaf production of other branches, the gap in the crown has been greatly reduced. What I think I am saying is that our wild pear tree knows what to do, and when to do it. Slowly it is rebuilding its own perfection, or at least the appearance of its perfection.

Twice I've written "our" wild pear tree, even though I've never considered it to be my property. On the contrary; I feel privileged that I have been able to live near it for the last two decades, and that when looking up from my work I am allowed to see it: standing in its flowery bloom, with its crown full, or for long months showing nothing but bare trunk and branches.

The eldest of the local inhabitants tell me that in their youth, during summer nights when the heat would not let up, the village used to gather under the wild pear tree. This means that even eighty years ago the tree must have been quite large. Before we put up a fence, the older men used to bring their beers at sundown to sit at our white garden table under the tree, and they would stay, talking quietly, well into the night. Under such a large wild pear tree it is always cooler, even in the most intense summer heat. None of these older men is alive any more.

I must explain that when the locals say "village," they don't simply mean a geographical location with a name. There is a kind of universal meaning to it, much like when the French say *tout le monde*. The village is identical with "everybody." And whoever lives outside the circle does not, of course, belong with "everybody." In this the locals are a bit like the Spartans used to be, or the inhabitants of Lesbos or Athens, and all the other Greeks who considered all non-Greeks to be barbarians, or at least beastly creatures who did not honor the Greek gods, and were incapable of using the Greek language decently; in short, they were not human. Or perhaps

this attitude resembles that of the medieval army, recruited from German, Polish, Hungarian, Czech, and Italian mercenaries, whose objective it was—and not very far from our village—to take on the terrible Turks. The night before the decisive battle the warriors of various nationalities got so mad at one another that they resorted to the use of their weapons. No group could tolerate that the others, instead of speaking, made animal sounds, and understood nothing of normal human language. They put to flight or butchered one another, their combined efforts opening the way for the dreaded enemy, who then proceeded to destroy nearly everything around here for long centuries to come.

With us, the folks of nearby villages belong to the existing world, to everything and everybody; folks of distant villages do not.

This is probably so because after long and complicated, covert and overt maneuvers and adjustments, all at once everybody in the village must act the same way, while in other villages, most likely, other people must do other things, at different times and in a different way; and that's what makes the difference. When the village sees that it's time to plant potatoes or husk the corn, there is no doubt that *everybody* should be planting potatoes or husking corn, and then the village is indeed busy planting potatoes or husking corn. For a long time I was rather averse to these orchestrated and weather-driven activities, but I always wound up on the wrong side with my individual decisions. If I don't do what the village does, and don't do it when and how the village does it, I make my life, in the physical sense of the word, much harder. Regarding the connection between the earth, the sky, soil, and weather, the village can do no better than consider probabilities. However, no individual perception stops the village from submitting to these probabilities. This is a compulsion so profound and comprehensive—encompassing all phenomena of life—that a conscience used to individual decisions can barely absorb it.

Whenever the village does something or notices something, neither the action nor the observation is performed by a subject—there is no person behind it; or rather, the collective consciousness ritually swallows up the persons involved in the action or observation, and summons their experiences to stand firmly behind the appellation which designates the village. Today the village is planting potatoes. Of course there are always influential people who probably have more say in the decisions that have been prepared in a long, complicated, and mysterious way; but once a decision is made, and accepted by all without any resistance, these personages no longer have

any meaning—whether their calculations were right or wrong, good or bad. Regarding communal decision making, in twenty years I have never heard a single subsequent reproach. At most, it is recorded that this year something has happened a certain way, which, in another year, happened a different way. No villager connects the responsibility for the action to anyone's name, not even to his own, not even in the case of severe negligence. Things in the universe are arranged precisely the way they occur.

It took me about ten years before I could accept that during reaping, no matter how hot it is, I should wear long pants and a long-sleeved shirt, and that the shirt should be buttoned to the very top. Anyone who is dressed otherwise while reaping cannot regulate his body temperature, his sweat cools on him, and horse-flies might sting him to death.

The concept of the village, however, has an even wider and more abstract meaning. The village does not merely mean everybody who belongs to it and their combined observations and actions, all those who are closely tied by blood, and everything they do or avoid doing, but it also means the totality of the collective consciousness, which is simultaneously owned by everyone. Outside the knowledge of the village, there is no knowledge.

I will tell you a story that will throw a brighter light on the way the village uses language, and on the irrevocable and impervious perception of the world that stands behind this "usage."

During World War Two, the front moved several times across the area. Once, when the Russians happened to beat back the Germans, six German soldiers ran away from their unit and hid in the attic of the winery in a nearby vineyard. They didn't want to surrender to the enemy, but they had had enough of the war. The village respected their wish and hid them for six years. That didn't mean they couldn't leave the attic for six years; on the contrary, they lived and worked in the field like everyone else. During the first spring one of the soldiers hurt his foot while plowing, the wound got infected, followed by high fever, and the soldier died within days. The village knew, everyone knew the soldier was dying, but no one called the doctor. The doctor, living in a distant village, did not belong to the village's "everybody." And neither did the priest; the soldier was therefore buried without a priest.

The impenetrable and impervious perception of the world, which failed to save one of the German soldiers, made the lives of the remaining five so free and inviolable that later they worked not only for local farmers but also took on jobs

as day-laborers in the neighboring villages as well. There was
no problem with this, since the people of these villages also
belonged to "everybody," and whatever is known to everybody
is not worth talking about, and no one else can know about
it. This is the reason I say that I live in a region where people
think in premodern concepts.

In the darkest years of the Cold War, when the incredible
network of stool pigeons and secret agents pervaded all of
Hungarian society, the five German men not only enjoyed
full protection but, when they could no longer contain their
homesickness, the locals took them across the nearby Austrian
border—across barbed-wire fences, across minefields, across
the feared Iron Curtain.

One has the feeling that life here consists not of personal
experiences, historical memories, or forgetfulness, but rather
of profound silence.

Which is understandable, of course, because, blessed with
individual consciousness, people always tend to say more
than what they know; in a premodern environment, how-
ever, people usually say a lot less than what everybody
knows.

In the quiet countryside, spotted with woods, along whose
western boundary the highway runs, following the path of
the ancient Romans—and where, besides the more recent
designations, the old Latin names of the province's cities have
been preserved like the nicknames of close acquaintances—
the ground is very uneven. The first asphalt roads were paved
by British and American oil companies in the early thirties
of the twentieth century, when geologists discovered that the
nicely undulating earth contained large deposits of oil. The
new roads followed the former wagon trails, which climbed
the hills, crisscrossed by tiny brooks and runnels, to carefully
descend on the far side into another valley, where the same
kinds of reeds, bulrushes, cowslips, and water lilies live in
the thicket among willows and hornbeams, and where other,
nameless rivulets are trickling. Hills and dales run expan-
sively and majestically from northwest to southeast. At dusk
they fill up with an ever-thickening mist, which lasts into
the morning. A somber landscape shaped not by movements
of the earth, and not even by an ancient sea, it was carved
out and chiseled at the end of the Ice Age by snow and chunks
of ice sliding down from the Alps. Standing on one of the
heights and looking in the direction of the gentle Adriatic
and the Istrian peninsula, one can still hear something of
the enormous grating and booming of the moraine that has
lasted for several thousands of years. Or at least the land-
scape's physical attributes may intimate the sounds and

The village does not merely mean everybody who belongs to it and their combined observations and actions, all those who are closely tied by blood, and everything they do or avoid doing, but it also means the totality of the collective consciousness, which is simultaneously owned by everyone. Outside the knowledge of the village, there is no knowledge.

scale of nature's destruction and rebuilding in the most distant past.

The tiny localities on the ridges lie so close to one another that one village can not only hear the bells of another—from which it knows that somebody has died, knows who is being buried, knows that there is a wedding, a new birth, or a christening taking place in church, or simply that it is noon, or morning, or evening, that life is moving along its even and uneventful path—but on a clear day the houses partly hidden near the edge of plum and apple orchards can be seen in the distance.

Not only knowledge, but hearing and seeing also move on the level of collective impersonality. People see and hear together. It surprises me anew each time that wearing something hitherto unseen is enough to make a person unrecognizable by fellow villagers. This makes understandable how, in the ages before individuality was emphasized, appearing in disguise must indeed have had a confusing effect. What is more, when a stranger arrives, the villagers cannot judge the newcomer's age. They have no eyes for age because, most likely, it is not external appearance they pay attention to but rather behavior and character. In some cases of external appearance, the villagers' reaction may be very contrary. They are very distrustful of all strangers, painfully so, yet they would, without a second thought, allow into their house anyone who wears a suit and tie and shows them some paper. Petty burglars, therefore, pretend to be tax collectors or surveyors. The trick works as many times as it is performed. When hearing strange words or expressions, the villagers try to find meaning for them by sound, and thus to adopt them, making them part of their language. Thus mayonnaise becomes "majomméz" (monkey honey), and agronomist turns into "ugrómókus" (jumping squirrel), and this is so in spite of the fact that Hungarian's Latin borrowings are preserved here better than anywhere else in the country. They distinguish only between primary colors: yellow, red, and blue; they call brown the color that elsewhere is designated as purple, ochre, or beige. Even in the textile store of the nearby town, dark brown, dark gray, and dark blue are all called black. Anyone who doubts that the way of seeing different colors is not a natural human trait but rather a matter of agreement, even the result of a local agreement, may rest at ease.

Knowledge of these deep-seated premodern peculiarities takes us closer to understanding why this region gave in and, in certain instances, continues to give in to the fatal temptations of European history: nationalism, fascism,

and Bolshevism. Suddenly someone comes along and begins to talk, driven by personal intentions, but in the name of the collective consciousness. For the premodern consciousness the *personal* intention behind the declaration is not recognizable.

If smoke rises somewhere, the village knows who has built a fire; the village feels what it is someone is burning. The world is visible, conceivable; an eye can be kept on "everybody." And the village cannot imagine an "everybody" that would include additional persons besides those on whom an eye can be kept.

In the spring of 1990, when every citizen of the freshly declared republic could vote freely for the first time, the village chief asked me if I could tell him who the village should vote for. He came as a delegate of the village. Indeed the village sent him because the meaning or content of political freedom was not clear to anyone; and not just in the village, but in all the region, past the borders, as far as the eye could see; maybe these concepts were known to some people in the distant large cities of Prague, Warsaw, Berlin, or Budapest, but even there their number must have been very small. And let us also note that in 1989 the Communist regime, which we call the dictatorship, collapsed not because the peoples of Eastern and Central Europe had suddenly become convinced that the world order of liberal democracy and free-market economy was better than the world order of socialism—more or less realized—or that of Communism, which was never realized, for the reason that democracy and the free market provided a larger of chunk of happiness to the individual. It would have been nice had that been the case. However, the truth is that the peoples of Eastern and Central Europe, obeying their beastly selfishness and their survival instinct, insisted on keeping a minimum of their private properties and self-government; they insisted on regaining or gaining what they felt they had coming to them. For this purpose, they jointly undermined the regimes that attempted to lend a fabulous form to the ancient instincts of the human collective and to the equally ancient desire for every man and woman to be equal to every other man and woman, by using the means of dictatorship, terror, mass murder, and the severe restriction of the freedom of speech, of the press, and of assembly. In this sizable region of the world, political freedom had and still has a very different meaning than in other parts.

Had I told the local chief who the village should vote for, the village would probably have cast its vote for the same party or the same candidate that I did; but I didn't tell him. And

the reason I didn't is because I am aware of the responsibility that goes with the spoken word. I didn't tell him because in the first moments of democracy I did not wish to deny my own perception of political freedom and democracy. Rather, I briefly related to him, as my own personal view, what positions the various candidates represented and, as a result, what advantages and disadvantages the village might have to consider regarding each of the aspirants. I took great care to show not the slightest bias toward any party or candidate. I could see in the official's eyes that he considered my behavior shunning, and because of his disappointment he grasped only a small portion of what I was telling him. He left disheartened and empty-handed, with more uncertainties than he had come with. I preferred this to pretending to be a shaman who, exploiting my listener's magical and mythical consciousness, would tell him things that no one else could foresee. He has died since then, and to this day I am gratified that, although I caused him some disappointment, regarding the basic, individualistic nature of democracy I did not lead him astray.

At any rate, since that time, political views have become rather diversified within the village, too. The village had to go through the realization that for the first time in its history it can no longer be impervious to the events of the outside world. Everyone is responsible for his or her personal opinion, which of course makes opinions very fragile, and personal lives most dangerous.

During those hot summer nights, as related by the oldest villagers, people sang quietly under the wild pear tree. Each storyteller emphasizes that they did it quietly.

The village sang quietly.

Most likely the village did not wish unduly to disturb the night.

To this day the mentality of the locals alludes to ingredients of consciousness that are strongly magical and mythical—while the world around them is off in different directions. They are aware of this discrepancy and they are also capable of switching mechanically between levels of consciousness, even though this has no particular effect on the inner life of the village, since the switch is dictated by their instinct for life and, lacking the culture of individual reflection, they cannot analyze it. I will relate the simplest examples so that we may gain some insight into this peculiar split consciousness.

The villagers know, because they also work outside the village, that people greet one another when they meet. Still, the custom of greeting within the village is unknown. They don't greet people from the neighboring villages, either. Nor do they say good-bye. Whenever neighbors, relatives, or acquaintances notice one another on the street or in vehicles, instead of saying hello they begin to talk immediately, and they continue to talk until the person addressed moves out of hearing range. This, and only this, is the courteous way to act. They do not inquire of the other's health. This sort of inquiry rather startles and even frightens everyone, because they have no abstract reactions to the daily state of their bodies or their souls, although they like to give detailed reports of their most serious illnesses, and readily uncover their bodies to show off their injuries, proudly pulling up a skirt, or pulling down a pair of pants to demonstrate that, despite the injury, they have prevailed. While in conversation, they do not listen to each other, they are not familiar with the genre of dialogue. They have no opinion of this or that subject; they are continually describing occurrences, they are relating a single great story. If there are several of them at the same location, they speak in parallel fashion, overlapping one another, three or four of them at the same time, as if to record their impersonal monologues on the same audio tape. Although this results in a great cacophony, they absorb precisely and, from the viewpoint of the collective consciousness, analyze and evaluate, and later fit into the proper place within the great chronicle of the village's history, all the statements and declarations made by all the participants.

Statements and declarations cannot be corrected because of hindsight, or because their earlier analysis may have been faulty. This is something they would not do, nor would they allow it to be done. The act of correction is unknown, and therefore not only can misunderstandings not be straightened out, but unfamiliar concepts cannot be introduced, nor can erroneously accepted concepts be rectified. This is probably so because of the difference between the villagers' experience of time and the way of keeping track of chronological time. For anything to change in the collective consciousness, there is need for more experience than is represented by the personal contrary opinion of a single person. The peculiarity of the time experience can also be seen in that the great chronicle of the village's narrative may mention days, and it may include accruing events but, just as with the ancient writers of history, there are no years, no annual designations in it. "Toosdey, comin' outta the house, 'cause I said to m'self gotta check if my son come with the three o'clock bus, the summer y'member, them wires broke off the poles, in the big storm, I thought lightnin' was gonna hit us, by then you was livin'

here, too, hail the size o' my fist, ice poundin' hard on the roofs, anyhow, I wanted to see, I said to m'self, an' here come that man with him, you know him, damn' if can r'member who else come on the three o'clock bus, but I ain't the only one who saw that man, the rent collector, that's who, hell, I can't tell you his name, he never come every month, he'd show up ever other month, regular like," and on and on like this, in an exact associative order. Neither Freud nor Proust would have had any professional objection.

There are always a lot of villagers who work together. They work together in the largest possible groups; the whole family works with members of other families with whom, for some reason, they have come into some economic relationship, or with those they have had no choice but to become economic partners of. While working they all talk incessantly, at times keeping up a protracted level of shouting because out in the open words must cover large distances. Volume always overcomes individual requirements—which to the ear of an outsider may sound like a curious work song, which every one of them sings to himself in a raised voice, conforming to the collective rhythm. It is as if everyone has to convince himself every minute of the sensibility of communal labor.

The value of money is absolutely clear to everyone; the relationship between money and labor, theoretically, is also clear. Still, in the inner life of the village money is not the means of payment, and therefore the value of the labor performed here is not expressible in terms of money. An outsider doing work in the village is paid in cash; within the boundaries of the village, to this day, no one does any job for money. An outside observer, of course, would hardly ever have a chance to see this kind of arrangement, which predates the money economy. The exchange of material, agricultural produce, and labor is ongoing, but the transactions' value is determined not by the outside market, but by prevailing conditions of the village's interior market with its centuries-long past. And these conditions have nothing to do with money or the money-market, not even if, curiously, we are talking about merchandise purchased with money. In this category one may find roof-tiles, bricks, concrete well-cylinders or concrete beams, which within the internal commerce of the village may be redeemed with labor, produce, or with some other material—but not by just anybody.

Not only do the villagers keep track for decades of who has given what to whom, and what he has received in return— or what he still may owe—but these acts of bartering determine the relationships among families and individuals more

The village had to go through the realization that for the first time in its history it can no longer be impervious to the events of the outside world. Everyone is responsible for his or her personal opinion, which of course makes opinions very fragile, and personal lives most dangerous.

28

profoundly than anything else. This system of trading interests, unknown and confusing for the outsider, was formed sometime in the ancient past and is headed toward the unforeseeable future; and since the value of personal relationships is substantially greater than that of any traded item, and since the commercial value of such an item cannot be reckoned in, or converted into money, within the village's borders there are no credits and debits, assets and liabilities in the classical sense. If I receive something, it is obvious that some sort of giving on my part is unavoidable, but this transaction, based on mutual trust and never recorded on paper, may be put on ice for any length of time until my partner will need something that I can provide for him. Neither partner would hasten with, or even initiate, the collecting or eliminating of virtual debts; in fact no one wants to get back anything for just the equal value of his services rendered or material provided. Experience with these transactions seems to teach that the more debtors one has, and the larger the debts, the more likely it is that in an emergency situation one would be helped by one's fellow villagers.

Naturally, cheating, stealing, violence, and sexual deviance are not unknown phenomena in the village. There are sanctions against them, and the sanctions have various degrees, but neither the criminal procedure nor the punishment remind one of the legal procedures and punishments in effect in other societies or even in the cities closest to the village. One reason for this is that no crook, thief, madman, or violent person may be removed from the village. It would be possible only with the help of the authorities, but it hasn't happened in the last twenty years and, if one is to believe the stories told by the villagers, not even before that. During the last twenty years I've also had the impression that there is no village without a few idiots, and a village must have at least one thief. Thieving is a reminder that one is nothing but a parasite on nature's body and, with secret deviations, quite a burden to society. There are madmen, thieves, and perverts in the village, all members of families that have blood ties with other families, who in turn have strong commercial ties with everyone.

Theoretically, therefore, there is nothing to be done, yet the village must do something about the offenders, for the sake of order and peace.

If the village is shaken by an extraordinary event, the very first thing that happens is a speedy process of verification and conciliation. In the necessity of this procedure one may understand, in retrospect, why it is imperative that everyone knows everything about everything in the village, all the time; who was where, who saw what, what happened where and when. Everybody must be ready to answer these questions in the difficult and ominous hours. And a picture will quickly emerge from the answers even if no one has seen anything, because everybody knows everybody else's habits, and the process of elimination kicks in. The suspected person is rapidly found, and it is usually a recidivist, which reinforces the village's conviction that crime is one of the inevitable calamities of nature, and the only thing man can control is the extent of the damage. The person in question is identified by allusions, so that his or her name should not be pronounced. The closest they get to it is when they say, "I do know, but I won't tell you who I'm thinking about. But you know that yourself, don't you?"

And indeed, this is so, because, as a result of the process of elimination, and of identification, the village does know it, but it knows it as if it had known it from the very first. Everybody knows who it is, even though no one has pronounced the person's name.

With the sentencing they wait until quite a few of them gather in one place, along with the suspect. In the suspect's presence they put forward the case or story, and they listen and observe. Dreadful glances. This is the mildest form of punishment. There is also beating, regular beating, and there is setting the barn on fire, or the house, and there is also killing. Like someone falling into the well, by accident. When I first visited the village forty years ago, I could still see the charred roof of a house that had been burnt down.

Of the more serious crimes they do not speak even among themselves. These crimes remain as heavy silences, black lacunae in the great narrative of the village.

I couldn't say the village is dead; it is alive, though over the last few years the conditions of life have changed fundamentally, part of the population has been replaced, and the village's isolation has lessened considerably. For quite some time there have been no serious crimes or violations for which the village would have had to reach back to its deeply concealed and suppressed means of justice. But I myself have witnessed the carrying out of verbal punishment.

During the long years of totalitarianism—prior to the current money economy—there was another system of economy, built on the familiar network of connections and riddled with heavy sanctions. It was this so-called second economy, otherwise known as the shadow economy, that made it possible for the societies of Eastern and Central Europe not only to circumvent, but actually to exploit the socialist economy based on the communal ownership of the means of production. This

was the same attitude with which these societies for several decades had protected their belief in the necessity and sanctity of private ownership, but paradoxically they had also managed to deepen the collectivist character of their thinking. In the collective consciousness cheating and stealing, even if out of necessity, were elevated, by consensus, to the level of accepted natural phenomena. The collective consciousness no longer considered cheating or stealing from the main institutions of collectivity—the cooperatives (farms and factories) and the government—to be a crime. On the contrary, the collective consciousness gave permission, indeed it encouraged people, to do just that. If I stole from the shared economy, it meant that I acted like a brave and free man, because I extracted, in the name of everyone, some moral compensation for all the wrongs that had been done to me in the name of material and social collectivity—or that I took back something of what could have been mine or what in fact was mine. General ethical barriers set up to protect common property simply dissolved in the collective consciousness. In the twentieth year of the dictatorship no one asked any more whether there was at least a nominal reason for taking something; everybody took whatever could be taken, and it all got noted in the collective consciousness as an ethically accepted and politically desirable deed. The turn toward democracy caused no change in the basic structure of social consciousness. Privatization and re-privatization were accomplished within a few years, but this could not satisfy the sense of collectivism, which had been based on the spirit of equality and which had deepened during the years of the dictatorship. Neither could it prevent the structures of economy and consciousness, settled and strengthened during the previous regime, from continuing in the form of corruption pervading all strata of society—making impossible, or at least seriously threatening, the functioning of democracy.

One reason the village's narrative, when viewed from under the wild pear tree, is so comprehensible is that in it, after great events, following earthshaking changes, history falls silent for long centuries.

As if Giuseppe Tomasi di Lampedusa had personally written above each gate and portal: "A lot of things must change for everything to remain the same."

The first real nocturnal noise I ever heard here was the sound of airplanes on their way to the war in Kosovo; giant flying machines carrying cargo and troops above our heads. With the peace in Kosovo, silence has returned.

In the old days, so the story is told, people played soft music under the wild pear tree to accompany their singing, which they did softly. That is how—with a cautiousness against the night—preserved from ancient times, they probably signaled to their gods that theirs was no careless revelry, and they had no intention of breaking the silence that had been part of the history of the Earth. Back in those days there was only one musical instrument worthy of the name in the whole village, a cello that somebody had brought back from the Italian front after the end of World War One. No one can recall what instrument had been used for accompaniment before the cello.

One can imagine the deep voice of the cello, the soft singing of the many single-tongued mouths, the motionless summer night alive with the hooting of owls and the chirring of crickets.

Only the moon and the stars cast any light on the earth. Fences were unknown in this region until recently. At most, people would put something around vegetable patches to save them from roaming animals. Houses were built of wooden beams, walls were rendered with mud.

The last witch was burned alive here at the end of the eighteenth century.

Houses had no chimneys until the end of the nineteenth century; smoke from ovens would escape through an opening above the kitchen door.

Electricity was installed in the village only in the middle of the 1960s.

When, as a young man, I first visited in these parts, the day ended with sundown in the village; in the kitchens the only light came from the flames in the oven; there was no gas, not even oil lamps. Even today, some old folks—the thrifty or the stingy among them—still turn in as soon as it begins to grow dark. This landscape is not crossed by trains that would make some noise or create the superfluous illusion that anybody might reach other worlds from here. At the end of the nineteenth century, when the rail network of the Austro-Hungarian Empire was reaching its final form, in accordance with various economic interests, it was the Catholic Church, citing the need to preserve moral order, that insisted on having no trains in this region. The situation hasn't changed since then. Only the forests owned by the Eszterházy princes were hooked up, with a small narrow-gauge train, to the distant main rail line. To this day, like a toy out of a fairy tale, it can be seen and heard puffing as it carries cordwood along the quiet fringes of the forest.

No one can doubt that during those hot summer nights spent under the giant wild pear tree, the village sank into ritual cogitation, validating, as it were, the contents of its collective

consciousness. Anyone who can imagine this peculiarity may also be able to see something of the times prior to one thousand years of Christianity in Hungary—which in this region has been only eight hundred years. After the Conquest of Hungary, in the ninth century, the Magyar (Hungarian) tribesmen who settled in this region could not be cajoled or forced, not even by the most brutal measures, to bow to the institutions of a Christian kingdom. In this western border region of the Hungarian kingdom, which was protected by a marchland of piles and earthworks, and where kings in the early Middle Ages would free their most loyal serfs and make them noblemen, the Magyars kept their old customs and served their old gods for another two hundred years. The shadows of these times still come back to visit and are closer to the souls of the local inhabitants than they would like to admit to themselves.

This is not without precedent in the history of European Christianity. Areas far larger than our region would remain pagan for long periods, and traces of centuries-long landslides on the spiritual map of the continent, as a gauge of different levels of development, can be seen to this day.

Up in the far north, for instance, in the huge wooded area between the North Sea and the still-untouched Masurian Lakes, and between the rivers Vistula and Memel where the Pruzzi, or as they are known today the Prussians, once lived, something very similar happened. The Prussians were converted to Christianity by the same Bishop Adalbert of Prague who had a major role in the conversion of the Hungarians. The story of Adalbert's life is worth telling, because in it one may find many of the connections and interrelationships that in earlier times had defined the inner life of that large geographic unit which contemporary political parlance is very fond of calling Central Europe, or Eastern Europe, or sometimes both, but whose borders, despite all compulsion for an ultimate definition, it cannot or dare not delineate.

Should anyone undertake the difficult job of definition, it would be necessary, first of all, to declare where the center of the continent is, and what, in relation to this center, would be considered peripheral. To do that, however, it would be necessary to lift the concept of Europe out of the net of nationalistic and colonial mythology of each of the national histories so that, as the result of the mutual influence of these histories, and as part of the complex and many-sided process of acculturation, the history of the continent could be described. But then it would become clear that neither European history nor European culture could be described within the framework of geographical concepts. The religious history of Russia, for example, differs greatly from that of countries that were not part of Byzantine Christianity; but this is not so with Russia in relation to the history of its art, philosophy, and mentality because, geographically, the European continent does come to an end at the Ural Mountains, but European history does not. In 1841 Prince Metternich, with an arbitrariness more amusing than geographical concepts, did define the borders of Europe. At the Congress of Vienna, where delegates of European monarchies, using brand-new techniques of negotiation, determined the fate of the continent for centuries, Metternich opined that "Europa endet bei der Wiener Landstraße." Which was to say that Europe ended behind the great Market Square of Vienna, just one street over from the place Metternich was speaking, beyond which, he implied, it was the beginning of the Balkans where, as everyone knew, the inhabitants were not humans. It is on the same old Market Square that Vienna's central bus station is located today, where regularly scheduled long-distance buses arrive from every country of the Balkans.

Be that as it may, the outstanding personage with the name Adalbert came into the world as the Count of Libice, in the year 955. He was barely thirty when he agreed to become the bishop of Prague on condition that he would be given sufficient power to take extreme measures to rectify moral backsliding; within a few years he had to admit that his measures had proved completely ineffective. The story makes immediately clear what Adalbert had understood by "moral backsliding." Not that a lady from a very distinguished family deceived her husband, and that she did this with a priest who happened also to be her confessor. Adalbert could not be bothered with such banal affairs. What had raised his ire was that, in keeping with pagan customs, the husband was preparing to execute his wife, an act approved not only by both families but by the entire city of Prague.

Adalbert considered the collective pagan regression to be immoral. Just as, looked at from the viewpoint of democracy, premodern regression is not an advantageous state of affairs, for it greatly reduces the effectiveness of democratic institutions.

Adalbert had his servants abduct the lady and shut her up in a nunnery. He did not reckon with the fact that pagan customs and rituals had followers even among the devotees of Christ, thus the distinguished family had no difficulty discovering the lady's whereabouts. The servants of the family

reabducted the sinful wench and, to everyone's great satisfaction, the husband killed her with his own hands. Fearing the wrath of the people, Adalbert left his post as bishop and along with his entourage sought refuge among the Hungarians, where he hoped for more success. From his envoys he learned that Gejza, the prince of the Hungarian clans, had shown a certain willingness to join Christianity. Adalbert arrived at the seat of the Hungarian prince in 994 and managed to convert several members of the leading Hungarian families. We don't know how long Adalbert stayed, but we do know that he left behind his court priest, Astric, who became the first Hungarian Royal Court Advisor in matters of conversion and who, in the spring of 1001, set out for Rome at the head of a delegation assembled to render homage to Pope Sylvester II.

By then Adalbert was no longer alive.

We know that he had spent some time in the court of Prince Boleslav, and presumably he yielded to the Polish prince's invitation not only to have a chance at converting at last the pagan Prussians, but also because in the court of Prague they would not hear of his returning as the bishop of the Czechs.

Ever since the most impressive structure of the Cold War, the Berlin Wall, was torn down, and the countries that had been stuck between the strong European democracies and the Soviet dictatorship, and lived their isolated lives until then, are once again open to visitors, hordes of astonished tourists and excited entrepreneurs have been discovering the Polish landscape, untouched by civilization, full of dark forests and crystal-clear lakes, where the pagan Prussians murdered Bishop Adalbert and his entire entourage. Only against a heavy ransom did Prince Boleslav manage to retrieve Adalbert's body so that he could bury it in accordance with the rituals of his newly acquired religion. Another two hundred years had to go by before Polish princes dared to think of forcefully converting their Prussian neighbors. In the end it was Prince Conrad who, in 1226, came to an agreement about the matter with the Grand Master of the Teutonic Knights, residing in the Holy Land at the time. The Grand Master sought assurances from both the Holy Roman Emperor and the Pope that in return for his missionary and colonizing efforts he would definitely receive the land of the Kulms and that of the Prussians, just as the Polish prince had promised him. The sanguinary war, fought in the name of Christian charity, lasted half a century. Not even the silence of our giant wild pear tree reaches back to days so long past.

However, not far from our wild pear tree stands a very ancient Spanish chestnut tree, judged by our foresters to be eight hundred years old. Several times each year I make my pilgrimage to it. It stands on a hilltop, at the quiet edge of the woods.

It must have matured into a full-grown tree when the conversion of the local inhabitants was finally successful—which has left very few objective traces in this region, and it is difficult to find any vestiges of it today in local customs or locution. People here do not call on Jesus Christ or the Virgin Mary to save them, they don't pray to them; the most they do is mention God a few times when they get into trouble. Some of the settlements on the hilltops still have no churches of their own—and not necessarily for reasons of poverty. At the same time, mass has been celebrated throughout the centuries in the three small churches whose foundations were laid by missionaries of the early Middle Ages. One needs to go great distances to find a chapel or a roadside crucifix. Christianity must not have had much time for immersing the ancient settlers of this region in its tenets; and the methods used for spreading the belief in love and charity must not have been overly effective either. At most, it is tombstones and wooden belfries that remind one that the people who live here are Christians.

When the first freely elected Hungarian parliament finally sorted out the relationship between church and state—by enacting appropriate laws—ordering them neither below nor above one another but, for the first time in our history, placing them side by side, I wanted to share my joy and satisfaction with one of my neighbors, an elderly man with whom I was riding on the bus. After a long silence he responded, rather anxiously, that he wouldn't like his grandson to be taken to church on Sunday by a gendarme, as had been done to him when he was a child.

The names of the villages consist of two parts; each name is always the combination of a family name and the common noun describing the mode of settlement. This common noun, in ancient Hungarian, meant a deforested area, or seat, or residence. Each village is the residence of a noble family. The people who live in these villages are the descendants of those court serfs whose job it was to guard the borders and who, after several centuries of loyal service, and after their conversion to Christianity, were freed and elevated to the rank of nobility in 1178 by King Béla III and, a few decades later, by King András II. The names of these noble families allude not only to Hungarian but also to Turkish, Cuman, Slavic, and even Walloon origins. It is also known that people do not

live exactly in the same places their ancestors had settled. Originally the villages were not built on the ridges but in the wide valleys, on the low, gentle slopes near streams and brooks. Material uncovered during rescue excavations and topographical reevaluations at the end of the nineteenth century suggest that these old settlements date from much earlier times. Tools made of stone and shards of ceramics testify that the most ancient of original inhabitants found this a favorable place to live as early as the Neolithic age. In the area of the village closest to ours, significant relics from a late Bronze Age culture were unearthed, among them a portion of a heavily decorated, standing female figure, and a gold coin that had been part of an earthenware pot. The settlements remained populated throughout the early and late Bronze Age as well as in the Iron Age; later it was the Celts who lived here for a long time and left behind proofs of their stay. The Celtic settlements were still here when the Roman conquerors arrived; and we also have traces of fireplaces built by settlers of Italian origin. These settlers were followed by waves of immigrant settlers that included the Avars, Germans, Moravians, Franks, and finally the Slavs. I myself have found some Roman potsherds; they usually pop out of the ground as a result of plowing or hoeing, or get washed out by the rain. This area, inhabited for thousands of years along the banks of brooks, and stretching over mild elevations, can be easily defined, without any need for archae-ological expertise. It has remained empty and unusually flat; plants grow differently around it.

The continuity harking back to the beginning of historic times was interrupted by the Turkish conquest. The inhabitants of the area's noble villages had no choice—they left the brooks and streams and moved up to the safer hilltops which, at the time, were covered with thick forests. In the early Middle Ages roads followed the paths of streams and brooks, and these tracks can still be seen in the spring or fall when the vegetation has not grown in yet or has already wilted. The marauding Turks used these roads to raid the villages, herd away the stolen animals. They also emptied all the storage vessels, and carried off the children to be turned into slaves. Even if they had not set fire to the thatched roofs of the small shacklike houses, for the survivors these raids meant almost certain death by starvation in the bitter winter. The century and a half of Turkish occupation was difficult to pull through even for the villages on the hilltops. When the Austrian Imperial Army at the end of the seventeenth century managed to force the Turks back to the Balkans, there were seventeen people in this village. These seventeen souls preserved and

transmitted something of that millennium-old knowledge under the large trees. Of that knowledge I have also had a chance to acquire a small portion.

I know that during hot summer nights the village used to gather and sing softly under the giant wild pear tree that stands in the middle of my yard. There, I have just passed on this bit of knowledge; however, today there are no longer chosen trees, and the village no longer sings.

Translated by Imre Goldstein

El Lissitzky

Franz Wilhelm Seiwert

Hannah Höch

Otto Freundlich

Ruggero Vasari

Unidentified figure

Nelly van Doesburg

Hans Richter

Theo van Doesburg

Raoul Hausmann

Werner Graeff

Stanisław Kubicki

Cornelis van Eesteren

Participants at the Congress of International Progressive Artists, Düsseldorf, May 1922

Zur Fachausstellung
für Städtereinigung
— u. Fuhrwesen —
28. Mai – 11. Juni

EXCHANGE AND TRANSFORMATION:
THE INTERNATIONALIZATION OF THE AVANT-GARDE[S] IN CENTRAL EUROPE

Timothy O. Benson

The long dreary spiritual isolation must now end. Art needs the unification of those who create. Forgetting questions of nationality without political bias or self-seeking intention our slogan must now be: "Artists of all nationalities must unite." Art must become international or it will perish.[1]

With unprecedented urgency, this statement from the Founding Proclamation of the Union of Progressive Artists staked the future of art on a vision of commonality that would prove profoundly difficult to achieve. It intended to rally together the artists of several countries who came to Düsseldorf in May 1922 to attend the Congress of International Progressive Artists and to participate in the First International Exhibition, organized by the Young Rhineland group. Why was an international art suddenly at the fore? What does this ominous declaration convey about the avant-garde at the apex of its "heroic" phase? Was this exhibition truly an embodiment of the internationalist ambitions asserted in its title? Whose criteria would we accept in making such a judgment?

The following essay will explore what the avant-garde was revealing about itself at this moment of internationalist aspirations, what bearing this ambition had on the works of art it produced, and how the international avant-garde functioned as the social context in which the ideas and artifacts of culture were created and conveyed.

EVENTS AND SITUATIONS

Despite the optimistic declarations of some of its participants, the Congress of International Progressive Artists was anything but unified and the tendencies on display in the exhibition far from consistent. To be sure, many of the signatories of the Union statement were based in Expressionism (Theodor Däubler, Else Lasker-Schüler, Oskar Kokoschka, Christian Rohlfs), and the exhibition itself also included an emphasis on German Expressionists (including Ernst Barlach, Erich Heckel, Ernst Ludwig Kirchner, Gabriele Münter, and Emil

Nolde). Some of the non-German signatories could also be considered Expressionists, including the Polish artists Stanisław Kubicki and Jankiel Adler (who exhibited *My Parents* [1921]), and the Russian émigré Wassily Kandinsky (who exhibited *Multicolored Circle* [1921]). But overall the exhibition was vast and diverse, with its foreign section nearly as large as the German section (353 of the 812 total works), and with contributions from some nineteen countries as far flung as America, Egypt, and Japan.[2] Among the trends dutifully surveyed were Fauvism (Matisse, Vlaminck), Cubism (Archipenko, Braque, Gleizes, Gris, Picasso), Futurism (Boccioni, Prampolini), Purism (Léger), Dada (Golyscheff, Grosz, Schwitters), and "a whole range of variants on these movements," as Polish Constructivist Henryk Berlewi remarked in his review of the exhibition.[3]

In the midst of this diversity the most "radical group," in Berlewi's words, was the Constructivists, whose works were conceived as avowedly international. Hungarian László Péri's *Space Construction 16* (1922–23) and *Two Rooms* (1920–21) were on the cutting edge of abstract art, using a shaped ground to embody a spatial abstraction that had only been illusionistically represented in the innovative *Water between Houses* (1920), probably shown just three months earlier at the Sturm gallery in Berlin.[4] László Moholy-Nagy, who had also exhibited in the Sturm exhibition, now presented his *Large Wheel* (1920–21)— which brought into painting the letters and numbers that had appeared prominently in the collages of the German, French, and American Dadaists—and *Nickel Sculpture* (1921), which evoked Russian Vladimir Tatlin's emphasis on material qualities in abstract constructions. Russian artist El Lissitzky's *Proun 17N* presented a vocabulary of universal

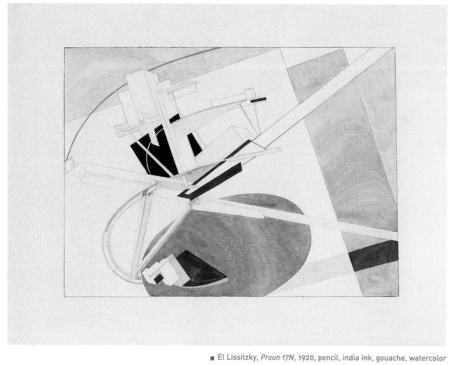

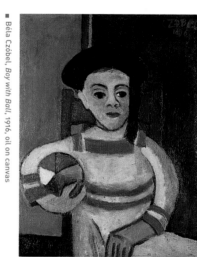

■ El Lissitzky, *Proun 17N*, 1920, pencil, india ink, gouache, watercolor

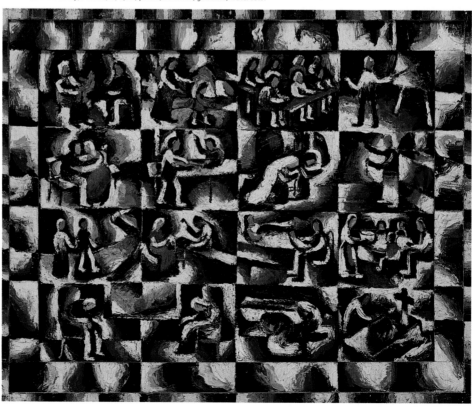

architectonic forms. The Dutch De Stijl movement was represented with works by Theo van Doesburg, Gerrit Rietveld, and Jan Wils. Participants in the De Stijl course that van Doesburg had recently established in Weimar, as an alternative to the Bauhaus, included Karl Peter Röhl and Max Burchartz, although the latter had yet to make the advances of *Geometrische Komposition* (1923).[5] Unaffiliated artists were also presented, including Hungarian Béla Czóbel (who showed *Boy with Ball* [1916]), Romanian János Máttis-Teutsch (who showed one of his *Sensation* series),[6] and the Berlin artist of Romanian-Jewish extraction Arthur Segal (whose newly discovered method of structuring the composition into rectilinear units was seen in *Human Life* [1921]).

Yet despite this international polyphony of styles, the possibility of an international art could scarcely have seemed more remote in the forum of the congress. The proceedings included protests by the Dadaists Raoul Hausmann and Werner Graeff[7]; Graeff quipped, "I have reached the conclusion that you are neither international, nor progressive, nor artists. There is therefore nothing more for me to do here."[8] The most progressive artists attending the event, including van Doesburg, Lissitzky, and Hans Richter, refused to sign the founding proclamation and led an opposing "International Faction of Constructivists." They disputed the Unionists' conservative claim that art was a personal matter, and insisted upon a "universally comprehensible" art.[9] Inspired by the new tendencies that Lissitzky had just brought from Soviet Russia in late 1921, the group rallied around "Constructivism."[10]

In his notes a few months later Berlewi, whose work had also just been transformed by the influence of Lissitzky, considered this breakup and the Constructivists' declaration[11]—along with Hausmann's dance at the reception—to be among the highlights of all the events he had witnessed in Berlin and Düsseldorf during 1922–23.[12] The congress had been

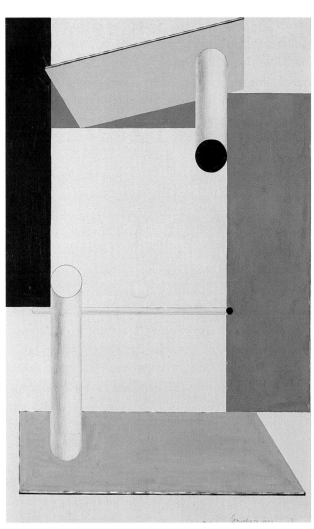

Max Burchartz, *Geometric Composition*, 1923, pencil, ink, and gouache on yellow board

contentious from the beginning, with some participants—those in the Berlin Commune (Hausmann, Kubicki, and Freundlich)—noisily refusing to participate.[13] After the conference the debate continued in the pages of *De Stijl* and *Ma*, with statements by artist groups from Holland, Russia, Romania, Switzerland, Scandinavia, and Germany,[14] as well as the Hungarians in exile in Vienna.[15] The following summer the Constructivist faction, along with Hausmann, Tristan Tzara, Hans Arp, and others, held a "Congress of Constructivists and Dadaists" in Weimar. Preceded by a small "Constructivist Exhibition" in the Weimar atelier of the architect Josef Zachmann, this congress provided a forum for the declaration of an elemental art and pleas such as this by van Doesburg: "The international *must* come into existence, because the reaction [against it] is becoming continually larger and stronger."[16]

Was the focused presentation on Constructivism at Weimar a more successful international art? Were the formal explorations of Dutch De Stijl artist Theo van Doesburg or leading Hungarian Constructivist Sándor Bortnyik, both of whom had studios in Weimar at this time, in some way analagous? Or was there something uniquely Hungarian in the abstract works of Alfréd Forbát, Lajos Kassák, László Moholy-Nagy, and László Péri? In the first broadly international survey of Constructivism, written in 1924 by leading progressive critic Ernő Kállai, tendencies from Russia, Holland, Germany, and Hungary were presented in terms of national traditions. According to Kállai, "Constructivism is as incapable of separating itself from the extant fundamental differences of race and intellectual traditions as any other artistic movement."[17] Yet he saw each nationality, "with its socio-historically fortified subjectivity," as contributing a different sensibility to the Constructivist movement. Writing the following year on the progressive artists in his homeland, Kállai tied the handling of the formal elements of art more closely and

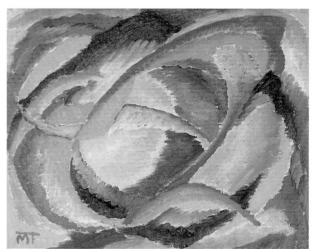

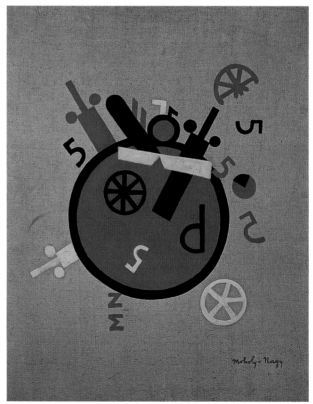

■ János Máttis-Teutsch, *Sensation*, 1919, oil on paper

László Moholy-Nagy, *The Large Wheel*, 1920, oil on canvas

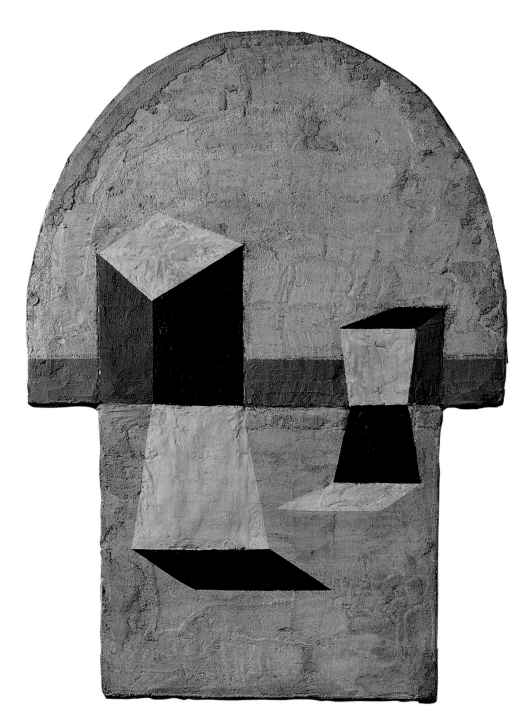

■ László Péri, *Water between Houses (Space Construction II)*, 1920 (recast 1930s), painted cement

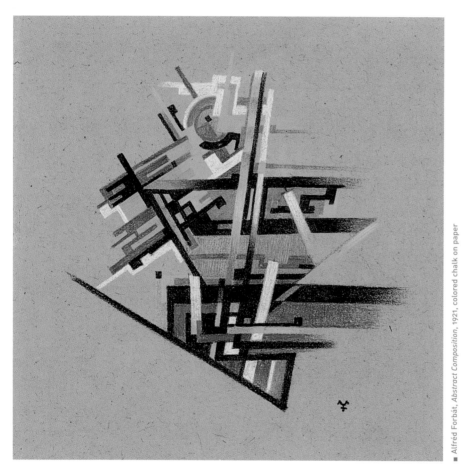

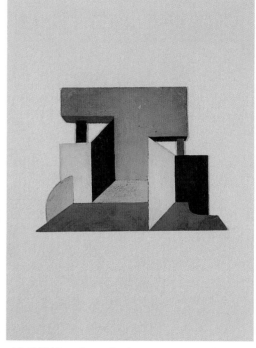

László Péri, *Space Construction 16*, 1922–23, tempera on shaped board

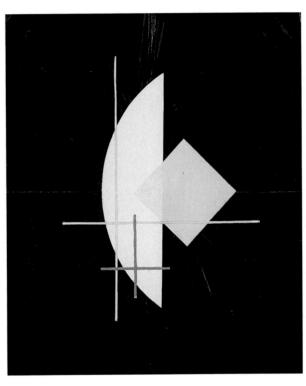

exclusively to national "temperament." The planar color forms of the De Stijl artists had brought strict order and clarity to the picture plane, but their thoroughness had reduced their formal means and rendered their art flat and merely decorative. Kállai saw within Constructivism yet another understanding of form. As Lissitzky and Ilya Ehrenburg insisted in their Berlin-based periodical named for the essence of the matter, *Veshch/Gegenstand/Object*: "The object will intercede for constructive art, whose task it is not to decorate life but to organize it."[18] According to the Russian authors, "with this our urge toward realism, toward weight, toward bulk surrendered to the earth." Kállai found a strand of sensibility that was compatible with this requirement of the real and concrete in the Hungarian Constructivists Sándor Bortnyik (*Geometric Forms in Space*, c. 1925), Alfréd Forbát (*Abstract Composition*, 1921), László Moholy-Nagy (*Composition with Blue Circle Segment, Red Cross, and Yellow Square*, 1922–23), and László Péri (*Space Construction 16*, 1922–23).[19] For Kállai, Péri "treats the pictorial surfaces not as a passive show-place for games with formal forces, but as independent activity," which instead of being contained within the recti-linear scheme of the picture plane "thrust out into the open field of their surroundings."[20] More important than abstraction for Kállai was "the probing of material qualities"—an art that "meshes into the total rush of life."[21] Writing in his *New Painting in Hungary* (1925), he suggests that the "dynamism of the Hungarian temperament presses towards free spatial unfolding" and instinctively "retreats from the prescriptions of the Stijl-Aesthetic."[22]

Kállai exemplifies how each faction—often defined in part by nation or region—staked a claim on Constructivism. The issue is not the validity of any one claim (indeed, they may all be equally valid), but that Constructivism was so hotly contested. The Düsseldorf congress and its aftermath show how the European avant-garde around 1922, as much as any

hitherto, consciously envisioned its future as being "international," yet could not agree on what this meant. Far from sustaining a pan-European modernism, the avant-garde found itself diverse, disunited, and nomadic. Its attention shifted from one event to another in a broad array of exhibitions, publications, performances, and congresses—sites of a continual exchange of viewpoints and artistic practices. Often on the move, the participants were well aware of one another; at such occasions they were often compelled to situate themselves with respect to other artists' groups, affiliations, or positions. Resisting all future attempts at a linear history, the avant-garde consisted at any moment in an array of "events" and "situations," each potent with a vision of what the future might bring.

CENTERS AND PERIPHERIES

The avant-garde had become pluralistic, with a number of often ephemeral centers of development, each blending sophisticated tendencies from abroad with regional traditions and priorities. Even prior to World War I, modernism had already begun to evolve in cosmopolitan centers other than Paris which, with its diverse multinational contingent of artists, had long been at the forefront of innovation. Not only had Italian Futurism, Russian Cubo-Futurism, and Austrian and German Expressionism begun to sway the direction of European modernism, but internationalism had become part of the ideology of the modernist utopia, at least theoretically, as exemplified in the *Blaue Reiter Almanach* (1912), which surveyed and tried to assimilate cultural artifacts from tribal and folk traditions, Far Eastern cultures, and premodern and contemporary West European societies. A blending of international trends was also evident in the 1912 Berlin *Neue Sezession* exhibition (which included the Czech Skupina artists), the 1912 *International Sonderbund* exhibition in Cologne (which included Austria, Czechoslovakia, Hungary, France,

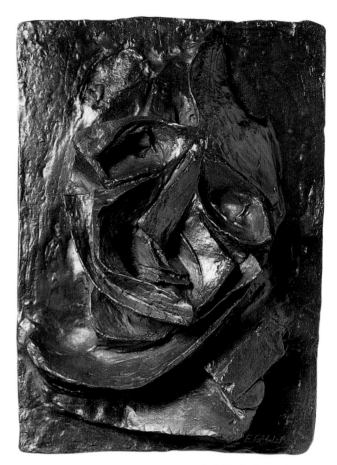

■ Emil Filla, *Head*, c. 1912, bronze

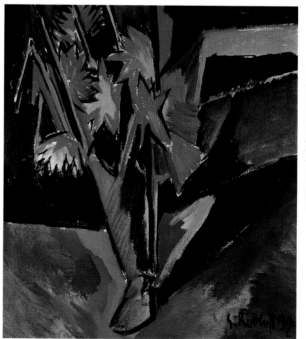

Karl Schmidt-Rottluff, *Dahlias in Vase*, 1912, oil on canvas

Works by Braque and Picasso at the third Skupina exhibition, Prague, May–June 1913

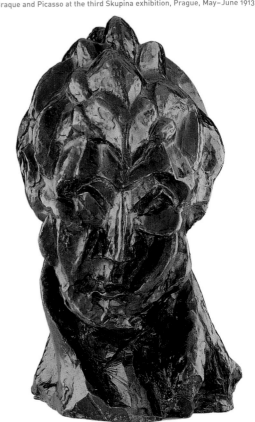

Switzerland, and Norway), and the 1914 *Werkbund* exhibition in Cologne (which included Czech designers). Herwarth Walden's Sturm gallery in Berlin, founded in 1910, steadily propagated international tendencies over the next two decades through its periodical and its exhibition program. If previously in the applied arts such tendencies as French Art Nouveau had attained international currency through its affinities with German Jugendstil and Austrian Secessionism, styles in the fine arts, most notably Impressionism, had been decried in Germany, Hungary, Romania, and throughout Central Europe as "foreign."[23] Nonetheless, French movements from Impressionism through Cubism were regularly exhibited at the Ernst Museum, Nemzeti Szalon, and other venues in Budapest, and in Prague at the galleries of the S. V. U. Mánes, during the prewar years.[24] Walden was even more current with exhibitions devoted to Italian Futurism and French modernism (Fauvism, Cubism, and Orphism)—exhibitions which then toured throughout Europe, even during the war years.[25] His groundbreaking *Erster Deutscher Herbstsalon* [First German Autumn Salon] of 1913 surveyed these tendencies together with recent Russian art (especially in a vein close to Expressionism as seen in Archipenko, David and Wladimir Burljuk, Chagall, Goncharova, and Larionov) and the Czech Cubists of the Prague Skupina group.[26]

For its part, Skupina included German Expressionism and French Cubism in its own exhibitions.[27] As exhibited at the second Skupina exhibition in Prague in 1912, Emil Filla's Czech "Cubist" *Head* (1912), if indebted to Picasso and Braque, nonetheless showed affinities in its broad fractured forms with Expressionist works on view including Karl Schmidt-Rottluff's *Dahlias in Vase* (1912).[28] Living in a city that had produced Rainer Maria Rilke, Franz Werfel, and Franz Kafka, many artists in Prague felt a close affinity with the metaphysical themes of Expressionism and its visionary iconography.[29] For example, the cult of the crystal, which

■ Pavel Janák, *Coffee Set* (partial), 1911, earthenware with black-and-white glaze

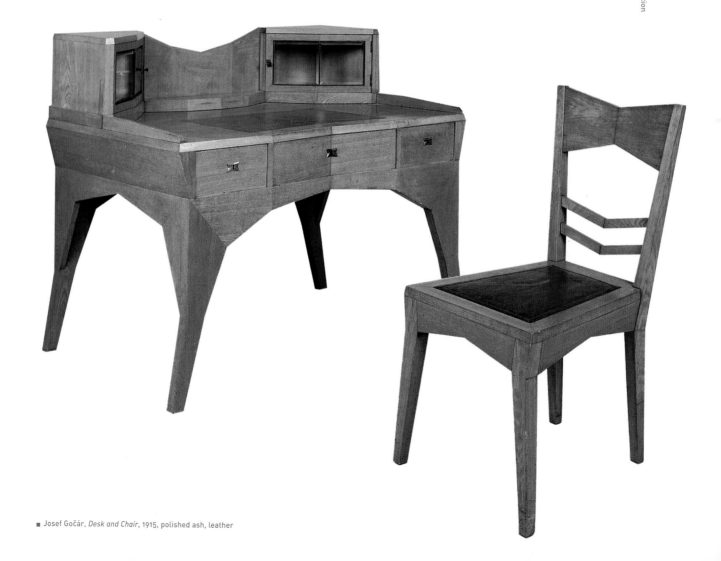

■ Josef Gočár, *Desk and Chair*, 1915, polished ash, leather

had made its potent appearance in Friedrich Nietzsche's *Zarathustra*, Paul Scheerbart's *Glasarchitectur*,[30] and visionary architect Bruno Taut's early utopian schemes, also predominated in the fantasy architectural sketches not only of Taut's Czech-born colleague, Wenzel Hablik,[31] but also of Skupina members Antonín Procházka, Vlastislav Hofman, and Pavel Janák.[32] Janák sought a new architecture based on "prism-shaped building units" derived from natural forces, the most beautiful being the crystallization process.[33] Crystalline forms are clearly manifested in his covered boxes and his exhibition space designed for the first Skupina exhibition. Vlastislav Hofman deployed such forms in various media, as seen in his *Coffee Set* (1913–14) and the architectural fantasies he published as woodcuts in the Berlin periodical *Der Sturm*. Josef Gočár brought similar forms derived from Cubism into his furniture designed at this time.

While their colleagues in the applied arts had trained in Vienna or Munich,[34] the painters and sculptors of the Czech Osma [The Eight] and Skupina groups had been drawn to Paris. Otto Gutfreund had studied there with Antoine Bourdelle in 1909–10 (a time when Bohumil Kubišta was also in Paris and had encountered the work of Braque and Picasso). Josef Čapek had studied in Paris in 1910–11, and Otakar Kubín had taken up residence there in 1912, although he began showing frequently at the Berlin Sturm galleries the following year. Yet Skupina artists had earlier been much inspired by Edvard Munch (through a large exhibition held in Prague in 1905), Paul Cézanne, and Auguste Rodin (often exhibited at the Mánes Society and discussed in the pages of Czech periodicals such as *Volné Směry* [Free Directions] and *Umělecký měsíčník* [Art Monthly].[35] Daumier (on whom Filla wrote an article),[36] El Greco, and Czech traditions including the Bohemian Baroque are essential to understanding the troubled visage and churning drapery of Gutfreund's *Anxiety* (1911), exhibited at the first Skupina exhibition in Prague in January 1912.[37] The Czech Cubists' embrace of their Bohemian Baroque heritage is demonstrated in Antonin Pfeifer's 1912 Cubistic enframement of František Ignaz Platzer's St. John of Nepomuk, a Baroque funerary monument adjacent to the Cubistic portal of the Diamant apartment building by Emil Králíček and Matěj Blecha (1912–13).

While absorbing a Cubist vocabulary, the Czech Cubists often relied on the writings of Wilhelm Worringer (whose theories were central to Expressionism) and Austrian art historian Alois Riegl. These views were conveyed in part through the art historian Václav Velém Štech, who was among the

Vlastislav Hofman, *Design for a Cemetery Entrance, Prag–Dáblice*, 1912, illustration in *Der Sturm* (vol. 5, no. 3), 1914

funerary monument to St. John of Nepomuk

Antonin Pfeifer's 1912 Cubistic enframement of Platzer's

cofounders of Skupina, and art historian and collector Vincenc Kramář, who had studied with Riegl and whose contacts with Daniel-Henry Kahnweiler and Picasso in Paris led to the magnificent collection he amassed of French Cubism, which the group often exhibited with their own works.[38] Thus Gutfreund's expressive figures and Kubišta's melancholic faces, suffused with existential anxiety, are achieved by facial forms that attain the symbolic. Kubišta had studied not only Cubism, Expressionism, and Futurism, but also African tribal cultures and Far Eastern art, all lending an iconic quality to his *Epileptic Woman* (1911). Given the complexity of these influences, the application of such terms as Cubist, Expressionist, or Futurist had already become somewhat arbitrary in describing the increasingly international idioms of Czech art.

In Poland artists had also gained familiarity with events in Berlin, Munich, and Paris before the war, but the avant-garde was only able to coalesce around international vanguard developments toward the war's end, when Expressionism came to the fore.[39] In Poznań, still part of the German Empire until 1918, Jerzy Hulewicz, Stanisław Kubicki, Stefan Szmaj, August Zamoyski, and others founded Bunt [Revolt] in 1917.

They maintained close contacts with Berlin, in part through Kubicki's wife, the German artist Margarete Kubicka, and through Stanisław Przybyszewski, editor of their periodical *Zdrój* [Source], who had close contacts in Germany.[40] Bunt held its second exhibition in Berlin in September 1918 at the galleries maintained by *Die Aktion*, a radical periodical which featured Bunt in two issues that year. Expressionism also prevailed among members of the Jung Idysz group in Łódź (founded in 1918), which included Jankiel Adler, Henryk Barciński, Vincent Brauner, Paula Linderfeld, and Marek Szwarc. They exhibited widely in Poznań, Berlin, Vienna, and New York.[41]

In Cracow, under Austrian domination until 1918, Tytus Czyżewski, Leon Chwistek, and Stanisław Ignacy Witkiewicz had been to Paris and had experienced Cubism firsthand.[42] Yet together with Zbigniew and Andrzej Pronaszko, Jacek Mierzejewski, Konrad Winkler, August Zamoyski, and others they exhibited first as "Expressionists" (then emerging as a blanket term for new art throughout Europe, including Germany) and only in 1919 as Formiści [Formists]. Yet the styles they exhibited were diverse, ranging from the dynamic quasi-Futurist composition of Chwistek's *Fencing* (c. 1919) to Witkiewicz's nearly hallucinatory *General Confusion* (1920). As was the case for Skupina, there were disputes in the Cracow group, especially between Witkiewicz and Chwistek,[43] the former challenging the latter's realist approach with a metaphysical art more open to "pure form." Beyond such artistic issues, and beyond the conflicting demands of aesthetic and Productivist approaches, there were also extra-aesthetic issues at hand that prevented the easy synthesis of an international art. Indeed it cannot be assumed that this was an ambition desired by all.

Perhaps the most extreme counterexample to a pan-European modernist culture was Ljubomir Micić, founder of the Zenitist movement based in Zagreb and later Belgrade. He was fluent

Timothy O. Benson

■ Otakar Kubín, *Still Life with Box*, 1912–13, oil on canvas

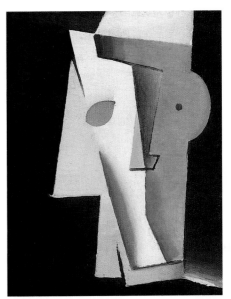

■ Josef Čapek, *Head*, 1914–15, oil on canvas

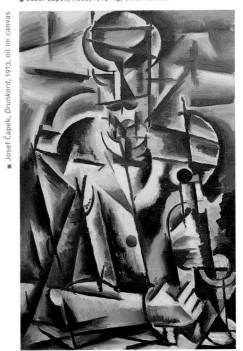

■ Josef Čapek, *Drunkard*, 1913, oil on canvas

"The rotten fruits of European pseudo-culture and civilized progress must be destroyed."

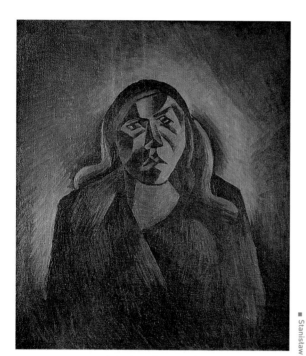

■ Bohumil Kubišta, *Epileptic Woman*, 1911, oil on canvas

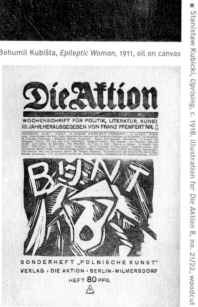

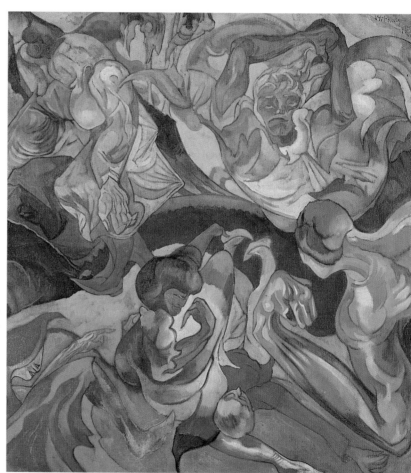

■ Stanisław Kubicki, *Uprising*, c. 1918, illustration for *Die Aktion* 8, no. 21/22, woodcut

■ Stanisław Ignacy Witkiewicz, *General Confusion*, 1920, oil on canvas

48

in the latest international styles—especially Expressionism, Cubism, Constructivism, and Futurist *mots en liberté*—and deployed them to valorize the Serbian "Barbarogenius" and promulgate a "Balkanization" of Europe. He turned such major tenets of an internationalizing of the avant-garde as rationalism, Productivism, and machine ideology on their head: "The rotten fruits of European pseudo-culture and civilized progress must be destroyed. EUROPE'S BARBARIANS are doing so already."[44]

If an "International Style"—the epitome of a unified modernity so deeply desired by artists and architects throughout Europe during the 1920s (and retrospectively applied in the terminology of Henry-Russell Hitchcock and Philip Johnson in a 1932 exhibition at the Museum of Modern Art in New York)—remained unrealized, it persisted as a strong motivation within the myth of the avant-garde.[45] We might regard the avant-garde at this important turn as an "intentional community." Most (though not all) of its members were engaged in a difficult struggle to preserve its credibility and authority by asserting the problematic proposal of an international art, one that could be universally understandable in its formal qualities. Such a proposal—like the parallel search for universals then being proposed in the burgeoning field of linguistics by Ferdinand de Saussure or Roman Jakobson and the Prague Linguistic Circle—might conflate the universal and regional, the center and peripheries.

THE SHIFTING SANDS OF NATIONALISM

As artists sought commonality through their internationalist ambitions, there were often local conditions on the political scene that could inflect the meaning of their artistic production—foremost among them being nationalism. Indeed (as has already been seen in the extreme case of Micić) nationalism sometimes vied with the missionary zeal of the avant-garde, in part because nationalism evolved somewhat

differently in the East than in Western Europe. Whereas in Western Europe the *state* (the political-administrative unit controlling a given geographic area) and *nation* (generally a broader political term that can encompass more than one ethnic group) had evolved gradually from feudal alliances into the ethnically relatively consistent nation-states born in the Enlightenment,[46] Eastern Europe had remained largely feudal (agrarian and only gradually industrialized), with its local political entities controlled by the nobility and national affairs governed by the Habsburg and Romanov dynasties, which managed huge multinational empires of immense cultural diversity. Nationalism, like other "isms" born in the era of revolution and the Napoleonic Wars, was based on an allegiance to a social group that seemed to embody a more equitable social order. In the West this was directed toward the formation of nation-states with relatively consistent ethnic and cultural consistency, based on common languages and shared political, religious, and cultural beliefs. In the East, by contrast, loyalties were formed in an arena of far less consistent boundaries between ethnic and linguistic groups, cultural heritage, or religious and political identification.[47] Similarly, as the region began to modernize, many alliances tended to form across geographic borders. German-speaking Catholics in Northern Europe might feel themselves closer to Catholic Southern Europe—the Czech Lands, Hungary, Croatia, and Italy—than to the Prussian Protestants of their linguistic group. Intellectuals in Budapest might feel more sympathy with their counterparts in cafés in Vienna, Berlin, and Paris—with whom they shared interests in philosophical tendencies or literary and artistic works—than to their countrymen.

In nineteenth-century Poland—which had ceased to exist as a political state since the third partition of 1795 divided its territories between Russia, Prussia, and Austria—the Romantic movement of national "awakening" took place

largely in culture and the arts, and was more concerned with conditions of the past and a possible future than those of the present. This was the general tendency of East European nationalisms, because the social, economic, and political realities fostered by Western nationalist movements had not yet arrived.[48] Hence the very belief in progress upon which the Western avant-garde was based—the utopian expectation that its provocative acts in the present might lead directly to more perfect conditions for humanity in the future—could not be fully formulated in Central Europe. Indeed, Tomasz Gryglewicz has suggested that it was a *disbelief* in "absolute progress" in art that most distinguished the Central European avant-garde from its West European counterparts,[49] a skepticism that may account for the melancholy ambivalence so often ascribed to Central European intellectuals. As Jan Cavanaugh has suggested, late-nineteenth-century Polish artists derived their content less from the latest international styles they were absorbing from Paris than from patriotic themes.[50] The inherent contradictions became apparent when contemporary trends from abroad were imbued with the avant-garde's rebellion toward the past during the Polish *modernizm* period (1890–1918), with two mainstreams evolving to evoke nationalist and internationalist renewals.[51] As Piotr Piotrowski suggests elsewhere in this volume, Jacek Malczewski's 1894 *Melancholy* can be considered as embodying an allegory of an independent Polish state. Yet, as Piotrowski also points out, such a fictive projection may come at a cost: Malczewski renders himself in multiple identities, inside and beyond the painting, and hence embeds within the Symbolist melancholic moment his loss of a unified self and analogously the absence of a Polish state. And yet Malczewski may also be expressing the futility of a national art,[52] thus conveying a deep identity crisis. Such multiple allegiances, felt by the artist as he looked at culture while attempting to exist within it, were typical for Malczewski's generation. The resulting relativism, endemic to the modern condition, was captured in Nietzsche's rhetorical question and answer, "What is truth? A mobile array of metaphors, metonymies, and anthropomorphisms."[53] By the generation of Stanisław Ignacy Witkiewicz, who produced intensely subjective photographic portraits, such cultural relativism had been fully absorbed into the modern psyche, producing a crisis of identity wherein the self was by necessity conceived as fictional.[54] All subsequent generations of artists would have to endure this decentralized identity, described by Andrzej Turowski as a "disintegrated biography."[55]

■ Stanisław Ignacy Witkiewicz, *Jadwiga Janczewska*, c. 1913, photograph

The very belief in progress upon which the Western avant-garde was based could not be fully formulated in Central Europe.

Perhaps no generation was more affected than the "genera-
tion of 1914," which experienced the Great War and subsequent
collapse of the great dynastic empires into the first incarna-
tion of the modern states of Austria, Czechoslovakia, Hungary,
Poland, Romania, and Yugoslavia.[56] In Poland (despite a flurry
of smaller wars over several years subsequent to its founding
in 1918), statehood became again a reality, and Polish nation-
alism was no longer subversive to outside political dominance.
Like artists across Europe, many Polish artists now saw
greater promise in a social transformation, along the lines of
the Russian Revolution, that would presumably take place
beyond all borders. Some, such as Moscow-born Katarzyna
Kobro, were familiar with the revolutionary trends in art that
had been absorbed into the Russian Revolution in its early
years. Kobro had contacts with the Moscow group Obmokhu
[The Union of Young Artists] and had been a member of
Unovis [The Affirmation of New Art]. She had already made
a stunning breakthrough in bold spatial compositions such as
Suspended Construction 2 (1921–22) and *ToS 75-Structure* (c. 1920).
Similarly, a departure from Cubism, a critique of Malevich,
and an embrace of principles learned during study in Moscow
at Vkhutemas [The Higher Artistic and Technical Workshops]
and Inkhuk [Institute of Artistic Culture] are conveyed in
the work of Kobro's husband and collaborator, Władysław
Strzemiński. His *Cubism—Tensions of the Material Structure* (1919)
and *Flat Construction (Breakup of the Black Rectangle)* (1923)[57] were
part of a rebellion against the naturalism of the immediate
past manifest at the public premiere of Polish Constructivism
in May 1923 at the New Art Exhibition in Vilnius, Lithuania.
Yet Strzemiński and Kobro had just departed Soviet Russia.
Fearing its growing political centrism and feeling uncomfort-
able with the ascendancy of the Russian Productivists over
those still seeking an autonomous art, they sought greater
individual creativity in the recently established states of
Poland and (less directly) Latvia, where Kobro's relatives had

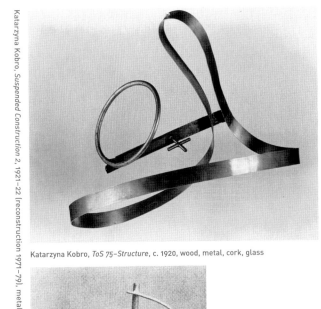

Katarzyna Kobro, *Suspended Construction 2*, 1921–22 (reconstruction 1971–79), metal

Katarzyna Kobro, *ToS 75-Structure*, c. 1920, wood, metal, cork, glass

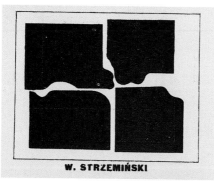

W. STRZEMIŃSKI

repatriated themselves into a dormant family business after years of poverty in Moscow.[58] Strzemiński and Kobro were soon at the forefront of Polish Constructivism, exhibiting their unprecedented works with the Warsaw Blok group in 1924.[59]

The Blok group's most prominent members—Henryk Berlewi, Henryk Stażewski, Mieczysław Szczuka, and Teresa Żarnower—had all been born in Warsaw, and all but Berlewi had also exhibited in Vilnius. While they shared an interest in Russian Productivism, the Blok artists were also committed to the formal abstraction of Malevich, and a Suprematist vocabulary was used in Vytautas Kairiúkštis's cover for the Vilnius catalogue while influencing also the layout of the periodical *Blok*. Szczuka and Żarnower incorporated allusions to technology in the *Blok* layouts and in the photocollages they posed as an alternative to the conventions of easel painting. Blok's version of Constructivism was seen also in Berlin in 1923, when Szczuka and Żarnower exhibited in the Sturm Galleries.

Berlewi, who had trained in Warsaw, Antwerp, and the École des Beaux-Arts in Paris, was living in Berlin from 1922 to 1923. With the chiliastic fires of Expressionism having largely died out—"the ideology of Der Sturm goes bankrupt," he wrote to himself in his notes[60]—his encounter with Constructivism, and especially El Lissitzky, resulted in such works such as *Mechanofaktur* (1924).[61] Now his origins in Cubist collage and Purism were translated into severely reduced planar forms, in homage to the mechanized forms of mass production. To emphasize this association, he exhibited these works in 1924 in the Austro-Daimler showroom in Warsaw. The direction taken by Szczuka and Żarnower diverged from the more Puristic tendencies of Stażewski and the "Unism" developed by Kobro and Strzemiński.[62] Yet Blok Constructivism had taken a particular turn seen only in Poland, if with

Timothy O. Benson

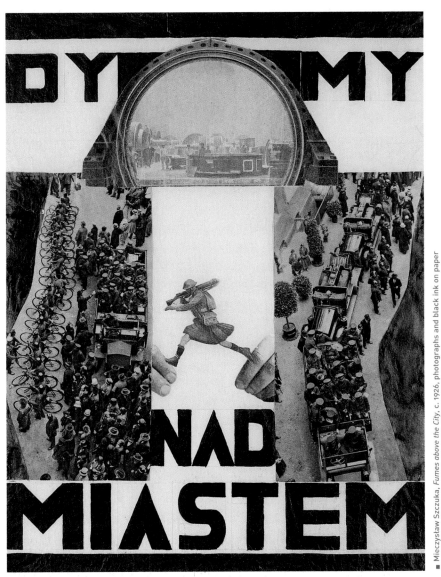

Mieczysław Szczuka, *Fumes above the City*, c. 1926, photographs and black ink on paper

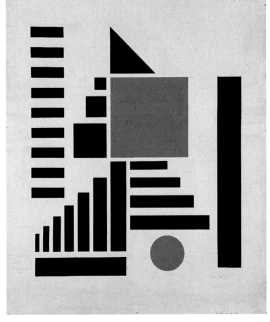

Henryk Berlewi, *Mechanofaktur*, 1924, gouache on paper

■ Sándor Bortnyik, cover design for *Ma*, 1918 (vol. 3, no. 7), linocut

characteristics and conflicts shared by other artists of the emerging International Constructivism.

THE COMMUNIST INTERNATIONAL

The early success of the October 1917 revolution in Russia and rise in Communist and socialist political activity during the instability following the war also had repercussions for the avant-garde in Budapest, where a Hungarian Soviet Republic existed briefly from March to August 1919. As was the case also for the Munich Soviet, conditions never attained the stability of the Russian model. But artists and intellectuals (such as Robert Berény and György Lukács) did find themselves in official positions of power in a Communist government with close ties to the Comintern and its ambitions for an international movement. The Activists around Lajos Kassák had already contributed to the revolutionary fervor. Sándor Bortnyik had used the semiabstract forms of the Expressionist woodcut aesthetic for the covers of Kassák's Activist periodicals *A Tett* and *Ma*—periodicals inspired by Franz Pfemfert's socialist Berlin journal *Die Aktion*. With the revolution, artists who had absorbed Cézanne's influence along with Expressionism and Futurism as members of Nyolcak [The Eight]—and as contributors to *A Tett* and *Ma*—now sought to elicit the social engagement of the populace.[63] Bortnyik's *Red Locomotive* (1918) deployed Cubist faceting and the interpenetrating forms of Futurism in a proto-Constructivist celebration of the machine as part of revolutionary change. Béla Uitz, who in paintings such as *Woman in White Dress* (1918) had rendered contemplative figures using massive forms derived from Cézanne, now energized his figures in rhythmic composi-tions of Expressionistically rendered lines, as exemplified in the determined march forward in his poster *Red Soldiers Forward!* (1919).

However, as the Hungarian Commune became increasingly nationalistic in a desperate attempt to win a broader base, Kassák, at the forefront of the *Ma* group, became more adamant in his assertion of artistic autonomy against any expectations of political or national allegiance. In 1915 Kassák had insisted that "the new literature cannot serve racial or national ends!" but rather has as its subject "the entirety of the cosmos!"[64] He now called for just as much political independence—"We proclaim that art cannot tie itself down to any one party or social class!"[65]—and soon alienated the regime's leader, Béla Kun, with a direct attack in the pages of *Ma* that got the periodical banned.[66] The context swiftly changed once again when the Commune fell

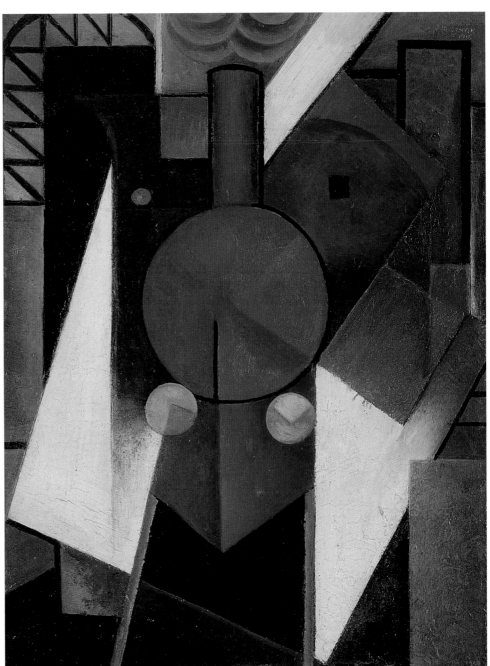

Sándor Bortnyik, *Red Locomotive*, 1918, oil on paper

and was replaced by the rightist Horthy regime, a situation forcing the *Ma* circle into immediate exile in Vienna.

FROM EVENT TO DISCOURSE

One sees in the examples above how greatly the shifting sands of political and social conditions altered the local circumstances in which avant-garde production attained its meaning. Prior to regaining statehood in 1918, Poland existed solely in culture—in essence, Poland *was* subversive art. Nationhood was to a lesser degree suppressed for other peoples living in the great empires. But after 1918 vanguard artists looked more

and more toward the international arena for social change. In Hungary (as in Russia) the "outsiders" of radical art suddenly became the "insiders" of a politically progressive government. Kassák, though remaining outside by choice, asserted the autonomy of the artists and now appeared to the regime as recalcitrant, while seeming conservative to the politically engaged. When a rightist regime took power, Kassák was again perceived as a dangerous radical. Ironically, as an exile in Vienna his art might seem to some as essentially Hungarian, no matter how much he sought to make it universal in its appeal.

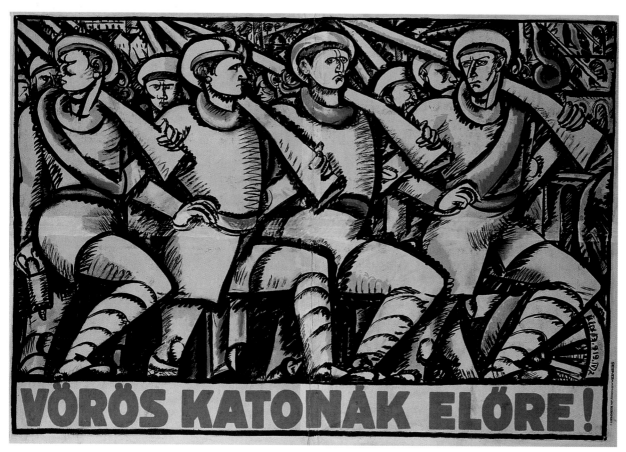

Béla Uitz, *Red Soldiers Forward!*, 1919, lithograph

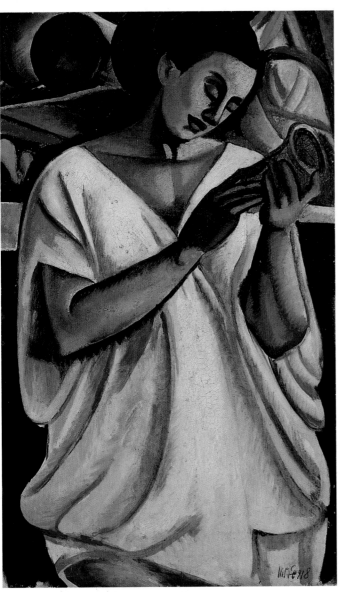

Béla Uitz, *Woman in White Dress*, 1918, oil on cardboard

Neither "avant-garde" nor "nation" is a static, essentialist concept. Rather they are signifiers that constantly shift through the dislocations of historical change. Nor can art exist as "completion" or "totality" in a region where meaning is inherently fragmentary and contradictory, due to the conditions under which culture functions. During the 1910s and 1920s in Central Europe, the meaning of art was highly dependent upon the standpoint or local situation in which it was fashioned. As a twenty-four-year-old Devětsil member recently installed in Prague from Moscow, linguistic theorist Roman Jakobson recognized that a world in which each region has its own version of the whole—even if it seeks to embrace the whole as a totality—resembles an Einsteinian scientific paradigm: When every respectable man had his own *chez soi*, there suddenly appears the science of relativity. For yesterday's physicist, if not our earth, then at least our space and our time were the only possible ones and imposed themselves on all worlds; now they are proclaimed to merely particular instances.[67]

As our emphasis shifts to issues of frameworks and framing, the world we are examining changes from constancy to a multiplicity of events whose interpretation depends on our discourses and perceptions. Such an event-based approach is little different from the way we might look at twentieth-century Central Europe, in the broadest terms, as a multinational culture swiftly changing politically from empires to successor states, back to the empires of the Cold War, and ultimately to the political entities we know today. In *Nationalism Reframed*, Rogers Brubaker draws upon the new institutionalist sociology of Pierre Bourdieu to focus on "nation" as a category of practice—rather than of analysis—which structures perception, informs thought, and organizes discourse and political action. Nation becomes an institutionalized form, practical category, and contingent event—that is, nationness is not something that develops through

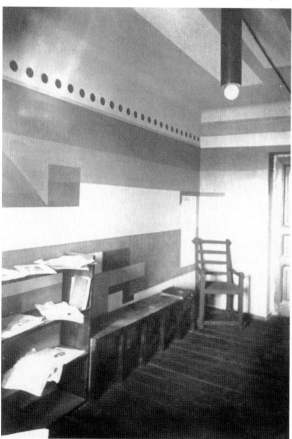

Contimporanul offices, Bucharest (lamp, wall painting, table, and chair by Marcel Janco), c. 1923

essential forces, but something that *happens*. At the same time, the event as such had become recognized as a major strategy of twentieth-century activism, both as an instrument of provocation and as a means for getting beyond the conventional limitations of culture to gain access to a larger political arena. In Stephen Foster's words, "Events are no less made than history... It is from our invention of historical realities that we perceive something as an event."[68] The avant-garde, which exists through such events as the exhibitions it organizes, began to recognize that these events could convey intentional meaning. We can consider the avant-garde of Central Europe as a field of events—exhibitions, actions, performances—each inscribed with the implicit content of its makers while also deriving its content from a multiplicity of discourses, perceptions, and ongoing artistic practices.

To understand Central European avant-gardes we must consider both the actual events they staged (whether concerts, literary evenings, or exhibitions) and the structured frameworks in which they expected events to happen: artistic associations, publication enterprises, and so on. Ma, as a group of Hungarian exile artists living in Vienna, was able to reestablish its contacts and position itself vis-à-vis artists in Moscow, Weimar, and Berlin through its periodical, and to a lesser degree through the small exhibitions it mounted. Contimporanul in Bucharest established its internationalist credentials through both its periodical and the 1924 Contimporanul exhibition. It even created a modernist physical ambience in its editorial offices, with furniture and wall paintings by Marcel Janco, to embody the internationalist arena it sought to address. Such intentionally structured frameworks might be called "situations," to reflect the attempts of avant-garde groups to position themselves in relation to other groups and other sequences or clusters of events around them.

Recognition of this entrepreneurial potential to shape the immediate context in which meaning might be projected was an ever more prevalent factor in the often provocative events that had long been staged by the avant-garde since Gustave Courbet created his Pavilion of Realism in Paris in 1855. But by 1920, the entire avant-garde as a social community—or social subgroup of artists, dealers, and publicists—had become the target of subversive attacks from within. In one such event, the Berlin Dadaists in 1920 staged the First International Dada Fair, an anti-exhibition in the guise of a trade show. Advertising "products" rather than art, the Dadaists exhibited photocollages, assemblages, and posters—all alluding to a more relevant world of mass media and machine production beyond the art galleries and little magazines of the aesthete. Possibly inspired by this Dadaist juxtaposition of art with non-art genres, the Czech Devĕtsil group staged a Bazaar of Modern Art in Prague and Brno in 1923–24.[69] In addition to paintings, they exhibited architectural drawings, stage designs, collages, and photographs, including Man Ray's portfolio of photograms *Les champs délicieux* (1922). As a provocation they exhibited, along with works by Josef Šíma, Jindřich Štyrský, Toyen, Karel Teige, and others, generic objects of the machine age (ball bearings), fashion (wigmaker's dummy), and travel (life preserver), along with a subversive gesture against the portrait genre (mirror).[70] As Teige claimed in his contemporaneous proclamation, "Painting and Poetry,"

The old type of exhibition is all but extinct, resembling too much a gallery-mausoleum. The modern exhibition must be a bazaar (a fair, a world expo) of modern production, a manifestation of the electric century of the machine. Mechanical reproduction and print will eventually make originals redundant; don't we throw even manuscripts into the waste paper basket once they are in print?[71]

Dada Fair, Berlin, 1920

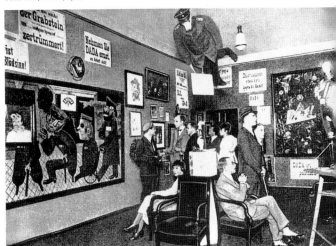

In Teige's concept, the entire setting for the enjoyment of art was broadened beyond the exhibition into the world of media imagery (including book illustration, photography, and photomontage), music, film, and performance: "A picture is...a poster, a public art like cinema, sport, and tourism—and its place is in the street... A traditional framed picture is suddenly being abandoned and loses its factual functionality."[72] Existing art categories are "liquidated," as Teige's new aesthetic of "Poetism" merges with life.[73] With this the era of "isms" is at an end. Constructivism had already transcended all previous isms, for it embodied "the method of all productive work." Similarly, for Teige, "Poetism is not an -ism."[74] Rather it is "the necessary complement of Constructivism"—a superstructure resting upon the Constructivist base of "technical materialism," in the avowedly Marxist terminology Teige deploys.[75]

The avant-garde, having survived for so long in its predicament between progressive politics and the progressive aesthetics of the liberal bourgeois economic order, was now overshadowed by the increasing omnipresence of industrialized mass culture with its heterogeneous array of references

and powerful imagery. It responded by embracing, and often reinventing, this imagery. No image was more pervasive than the visage of Charlie Chaplin, and it was rapidly absorbed in the visual vocabulary of the international avant-garde. It appeared, for example, in the pages of the Czech magazine *ReD* and in the collages of Slovenian artist Avgust Černigoj of the Tank group. Photocollage, with its incorporation of mass-media imagery and purported origins among the Berlin Dadaists, soon became the coin of the realm among avant-garde groups ranging from the Polish Blok to the Czech Poetism of Teige and Štyrský.

As the avant-garde became more practically engaged in the burgeoning industry of mass media throughout Europe, the appearance of the printed page was revolutionized in magazines and commercial enterprises via the innovative typography of leading artists. Just how visually potent this revolution was is demonstrated by the magnificent collaboration *Abeceda*, an alphabet book created by Teige (as typographer), Karel Paspa (as photographer), Vítězslav Nezval (as poet), and Milča Mayerová (as choreographer and dancer). Each letter is explored as a phonetic and visual sign as well as a celebration of life and movement. With this project a new arena was opened in which the avant-garde text—whether poem, photomontage, or topographic layout—might be performed. Meaning could be enacted in the immediate situation of the text rather than being a distant, metaphysical referent.[76] The avant-garde had found a new entry point into the broader cultural discourse of the mass-media publication.

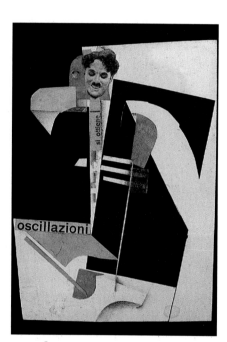

■ Avgust Černigoj, *Charlie Chaplin*, 1926, collage

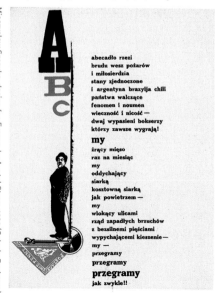

EXCHANGE AND TRANSFORMATION

As did artists throughout the avant-garde, Teige countered the opposition of instrumentalist and aesthetic priorities so pervasive throughout the avant-garde with a unique approach arising from the intellectual and social ambience of his own avant-garde affiliation. His direction came from within the Devětsil group, especially from the poet Nezval and the linguist Roman Jakobson. Going somewhat beyond Jakobson's structuralist approach, which allowed for the Poetist word that could attain nonobjective status,[77] Teige drew a distinction between communicative language (a fixed vocabulary oriented toward the object) and poetic language (oriented toward expression itself) in his typographic poems and picture poems.[78] In *What Is Most Beautiful in a Café* Teige's typographic arrangement of Nezval's poem celebrating the sensual pleasure of coffee is superimposed upon a Constructivist grid-like structure. This overlay would be used throughout Teige's work and is a critique of Russian Constructivism and the

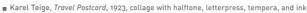

■ Karel Teige, *Travel Postcard*, 1923, collage with halftone, letterpress, tempera, and ink

Karel Teige and Vítězslav Nezval, *What Is Most Beautiful in a Café*, picture poem, 1924

■ Karel Teige, *The Departure for Cythera*, 1923–24, collage

instrumentalism of its Productivist vein. Jakobson believed that Nezval's poetry attained an essential "poeticity" occurring "when words and their composition, their meaning, their external and inner form, acquired a weight and value of their own instead of referring indifferently to reality."[79] For Jakobson, "language was only one of a number of possible sign systems" that make up culture.[80] Teige presented optical speech signs from the broader culture of popular media in such picture-poems as *Travel Postcard* (1923) and *Departure for Cythera* (1923–24), where he adds shading and a small railing to the armature of overlapping planes to create stairways. As in Jindřich Štyrský's *White Star Line* (1923), words and images complement one another to evoke the theme of travel, favored by the Devětsil poets and artists. Having found Hans Richter's abstract films of pulsating forms intriguing but lacking in contact with living experience,[81] Teige envisioned *Departure for Cythera* in motion, as "one moment of a lyrical film," where boats disappear into the distance, and the crane turns.[82] *Travel Postcard* presents the words "greetings from a journey" across a map juxtaposed with a photograph of stellar constellations. An actual envelope and a postcard addressed to his colleague, the poet Jaroslav Seifert, photographs of a coastal city and of binoculars, as well as a gouache rendering of a flag make up a composition evoking displacement across time and space. Juxtaposed maps and photographs embody the themes of travel and adventure in Jindřich Štyrský's *Souvenir* (1924) and *Pantomima* (1924), as well as in the works of Jiři Jelínek and the now-lost collages of actor, and eventual leader of the Liberated Theater, Jiři Voskovec.[83]

Originating in a country without a coastline, the Devětsil works can be seen as celebrations of life and modernity that look with excitement to the world beyond. Like Teige's typographic poems, which he thought to be "a sort of international hieroglyph,"[84] they can be viewed as part of a greater exchange among avant-garde circles of artifacts inscribed with the utopian theme of "internationalism." As such we can consider each of them—in terms of the potlatch system—as a sort of cultural token given and received among the various exchange sites of the avant-garde: Berlin, Brno, Bucharest, Ljubljana, Prague, Vienna, Vilnius, Warsaw, Weimar, and Zagreb, all of which held exhibitions intended as "international" around 1923–25.

Taken together, these events conveyed the yearning for a world beyond, so perfectly embodied in the works of Teige and Štyrský: an assertion of belonging, no longer just to the local scene of café, atelier, and literary circle, nor even just

Meaning could be enacted in the immediate situation of the text rather than being a distant, metaphysical referent.

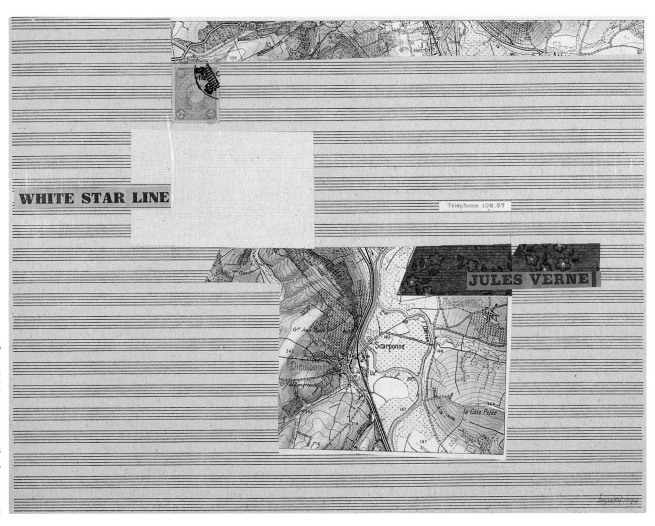

In the avant-garde's emphasis on communication it risked its own deconstruction.

to like-minded artists and intellectuals in other localities, but to human destiny. As Berlewi stated in his review of the First International Exhibition in Düsseldorf:

The notion of progress in art was up to now very relative and usually subject to local conditions. This kind of particularism in art could have no rationale. Recently, in some countries, artists are showing the will to break down dividing walls, to have mutual moral material support, to have a universal exchange of values, and to engage in common action. The internationalization of art—art belonging to the whole of humanity—turned out to be an unavoidable necessity.[85]

If what constituted the avant-garde is to be found precisely in the connections groups maintained with one another, then its primary forum, the site where its contradictions could be overcome and its commonalities could be fused, had become the discourse conveyed in the vast array of periodicals that might be regarded as the glue joining together the international avant-garde like a giant collage. As Berlewi remarked in the same review:

A great network of periodicals has spread around the world, arguing for and propagating new ideas and new forms: the organization of co-operatives on economic and ideological grounds; the generally international character of the whole movement—all these substantiate the claim that we are going through a period of transformation of traditional notions about art.[86]

Yet in the avant-garde's emphasis on communication—as it sought to cultivate both an internationalist social milieu and an elemental visual vocabulary that could transcend national boundaries—it risked its own deconstruction by the very recognition of the multiplicity of its transactions, the fracturing of its totality, and the dispersal of its assumed center. The avant-garde was becoming the avant-gardes. This pluralizing (and decentering) held deep philosophical consequences and posed a challenge to its shared vision of a better future, universal in appeal. As avant-garde(s) it existed uneasily, aware of its potential decomposition, and yet striving toward the unity of its mission by becoming international and multicultural. A subversion of the historical flow (or dialectic), which the avant-garde—above all in the West— had embraced in its sustaining myth, was (as Derek Sayer has demonstrated in his examination of the Czech-speaking lands) endemic to the history of Central Europe.[87] If this region has long lent itself as much to accounts of repeated disruptions and discontinuity as to linear consistency, perhaps the Central European sensibility was suited to the avant-garde in the 1920s, on the verge of its own potential deconstruction. The picture-poems of Teige and Štyrský refer as much to memory as to history. The abstractions of Kassák and Bortnyik are solemn and iconic, in essence timeless, in their existential soul searching. Poised between its own pluralization and absorption into the world of mass culture on one hand, and the potential loss of its sense of unity and deeply felt historical mission on the other, the stakes for the avant-garde had never been higher.

1 "Gründungsaufruf der Union internationaler fortschrittlicher Künstler" ("Founding Proclamation of the Union of Progressive International Artists") in *De Stijl* 5, no. 4, (1922): 49–52. Translation by Nicholas Bullock in *The Tradition of Constructivism*, edited by Stephen Bann (New York: Viking, 1974), 59.

2 The vast majority of artists were European. For an account of the exhibition based on a contemporary newspaper exhibition, see Bernd Finkeldey, "Die '1. Internationale Kunstausstellung' in Düsseldorf 28. Mai bis 3. Juli 1922" in Finkeldey, et al., eds. *Konstruktivistische Internationale Schöpferische Arbeitsgemeinschaft 1922–1927: Utopien für eine europäische Kultur* (Stuttgart: G. Hatje, 1992), 23–30.

3 Henryk Berlewi, "Miedzynarodowa Wystawa w Düsseldorfie" [International Exhibition in Düsseldorf], *Nasz Kurier* (August 2, 1922). Trans. in Timothy O. Benson and Éva Forgács, eds., *Between Worlds: A Sourcebook of Central European Avant-Gardes, 1910–1930* (Cambridge: MIT Press, forthcoming).

4 See Wulf Herzogenrath "Bildfläche—Wandbild—Bildraum: Anmerkungen zu Raumgestaltungen von Lázló Péri, Il Lissitzky und 'De Stijl'-Künstlern" in *Kunstruktivistische Internationale*, 134.

5 See the roster of participants in the Weimar "De Stijl" course in *Konstruktivistische Internationale*, 308–11. Buchartz exhibited a portrait and a landscape in the Düsseldorf exhibition (I. Internationale Kunstaustellung Düsseldorf 1922).

6 Máttis-Teutsch exhibited two oils: *Empfindung 16* and *Komposition 15*.

7 The proceedings were recounted in the Dutch periodical *De Stijl* 5,

no. 4 (1922), trans. by Nicholas Bullock in Bann, 58–62. Hausmann probably read his "Zweite Praesentistische Deklaration," trans. in *Between Worlds*.

8 "A Short Review of the Proceedings," *De Stijl* 4, no. 4 (1922), trans. by Nicholas Bullock in Bann, 62.

9 Statement, part 3, trans. in Bann, 68.

10 The word "constructivism" had arisen around the beginning of 1921 in the Moscow Inkhuk [Institute for Artistic Culture]. The group first exhibited at Obmokhu in Moscow on May 22, 1921. In March 1922 an installation photo was reproduced in *Veshch/Gegenstand/Objet* as the "konstriktivistische Raum" [Constructivist room], making the concept known in Germany. The concept was given theoretical explanation in a lecture at Inkhuk by Varvara Stepanova on December 21, 1921. A decisive presentation of Russian tendencies would occur six months after the Düsseldorf exhibition at the Erste Russische Kunstausstellung at the Berlin Galerie Van Diemen (October 15–December 1, 1922).

11 Erklärung der internationalen Fraktion der Konstruktivisten, [Statement by the International Faction of Constructivists] in *De Stijl* 5, no. 4 (1922): 61–64, trans. in Bann, 68–69.

12 Henryk Berlewi, "Plastyka zagranica" [The Arts Abroad] [1922–23], trans. in *Between Worlds*.

13 Stanisław Kubicki, Otto Freundlich, Ludwig Hilbersheimer, and Raoul Hausmann, "Zweites Manifest der Kommune" [Second Manifesto of the Commune], Berlin, May 1922, rpt. in *Die Novembergruppe*, ed. Helga Kliemann (Berlin: Deutsche Gesellschaft für Bildende Kunst e. V. und Mann Verlag, 1969), 66–68 and in *Kunstruktivistische*

Internationale, 25, n. 4, trans. in *Between Worlds*.

14 These statements appeared in *De Stijl* 5, no. 4 (1922) and are translated in Bann, 64–67. Romania, Switzerland, Scandinavia, and Germany all signed one statement.

15 "Stellungnahme der Gruppe MA," *Ma* 8, no. 8 (August 30, 1922). German trans. Texts selected from *De Stijl* 5, no. 8 (1922): 125–28, trans. in *Between Worlds*.

16 Unpublished document quoted in Kai-Uwe-Hemken, "'Muss die neue Kunst den Massen dienen?' zur Utopie und Wirklichkeit der 'Konstruktivistischen Internationale'" in *Konstruktivistische Internationale*, 65, n. 51, my transl. (emphasis in original). Cf. a poster announcing the Zachmann exhibition in *Konstruktivistische Internationale*, 295.

17 "Der Konstruktivismus kann sich eben genau so wenig über die bestehenden fundamentalen Unterschiede der Rasse aund ihrer geistigen Tradition hinwegsetzen, wie sonst eine Kunstrichtung." Ernő Kállai, "Konstruktivismus" in *Jahrbuch der jungen Kunst* (Leipzig, 1924), 374–84, rpt. in Hubertus Gassner, ed., *WechselWirkungen: ungarische Avantgarde in der Weimarer Republik* (Marburg: Jonas, 1986), doc. 43, 164.

18 Quoted in Kállai, "Konstruktivismus," in *WechselWirkungen*, 166.

19 Ernst Kállai, *Neue Malerei in Ungarn 1900–1925*, 1925; plate 77 was the work shown in the Düsseldorf exhibition.

20 Kállai, "Konstruktivismus" in *WechselWirkungen*, 165.

21 Ibid. 167.

22 Kállai, *Neue Malerie in Ungarn*, 108.

23 For recent studies of this issue, see Robert Jensen, *Marketing Modernism in Fin-de-Siècle Europe* (Princeton: Princeton University

Press, 1994) and Peter Paret, "Modernism and the 'Alien Element in German Art'" in *German Encounters with Modernism* (New York: Cambridge University Press, 2001); 60–91. See also S. A. Mansbach, "The Foreignness of Classical Modern Art in Romania," *Art Bulletin* 80, no. 3 (September 1988): 534–54.

24 See Donald E. Gordon, *Modern Art Exhibitions: 1910–1916* (Munich: Prestel, 1974), vol. 2, 902–6.

25 On Walden's connections with the German Foreign Office that enabled him to function internationally during the war, see Kate Winskell, "The Art of Propaganda: Herwarth Walden and 'Der Sturm,' 1914–1919," in *Art History* 18, no. 3 (1995): 321–28.

26 For a listing of Sturm exhibitions and consideration of the first decade of its activities, see Barbara Alms and Wiebke Steinmetz, *Der Sturm im Berlin der zehner Jahre*, exh. cat., Städtische Galerie Delmenhorst, 2000. A separate Skupina exhibition was held simultaneously in the Sturm galleries.

27 This development was due in part to a sojourn made to Mnischek by Ernst Ludwig Kirchner and Maschka and Otto Mueller during the summer of 1911. They visited Bohumil Kubišta, who became a temporary member of Die Brücke.

28 For an installation view showing Filla's relief, see Jiří Svestka, ed. *1909–1925 Kubismus in Prag: Malerei, Skulptur, Kunstgewerbe, Architektur*, exh. cat. (Düsseldorf: Der Kunstverein für die Rheinland und Westfalen; Stuttgart: G. Hatje, 1991), 81.

29 [Hana Rousová] *Deviace Kubismu v Čechách—Deviationen des Kubismus in Böhmen*, exh. cat., (Cheb: Staatsgalerie der bildende Künste, 1995) and Stephan von Wiese, "Metaphysisches Beefsteak? Zur Kubismus-

Rezeption des Expressionismus" in *Kubismus in Prag*, 38–43.

30 Paul Scheerbart, *Glasarchitektur* (Berlin: Verlag Der Sturm, 1914).

31 Timothy O. Benson, et. al., *Expressionist Utopias: Paradise, Metropolis, Architectural Fantasy*, exh. cat., (Berkeley: University of California Press, 2001), 209–12.

32 For Procházka, see illustrations in Rousová, *Deviace* and *Kubismus in Prag*, passim.

33 Pavel Janák, "Hranol a pyrmida," *Umělecký měsíčník*, 1 (1911–12), 162–70, trans. in *Between Worlds*. On these architects' theories see Rostislav Švácha in *Kubismus in Prag*, 202–38. On the importance of crystals and pyramids as metaphors for built architecture, see Rostislav Švácha, *The Architecture of New Prague 1895–1945* (Cambridge: MIT Press, 1995), 100–43.

34 Pavel Janák had studied with Otto Wagner in Vienna in 1906–1907.

35 Mánes was the main artistic association in Prague over several decades.

36 Emil Filla, "Honoré Daumier, Nekolik poznámek k jeho dílu," *Volné Směry*, 14 (1910): 85–89, trans. in *Between Worlds*.

37 On the complex influences of Cubism and other artistic styles on Skupina, see Tomáš Vlček, "Art between Social Crisis and Utopia: The Czech Contribution to the Development of the Avant-Garde Movement in East-Central Europe, 1910–30," in *Art Journal* 49, no. 1 (spring 1990): 28–35; Pavel Lišha, "Kubismus und Stil," in *Kubismus in Prague*, 26–37; and Rousová, *Deviace*.

38 See Pavla Sadílková, "The Beginnings of Kramář's Art History Studies," in *Vincenc Kramář: From Old Masters to Picasso*, exh. cat. (Prague: National Gallery, 2000), 124–29.

39 For a discussion in English of developments in Poland, see S. A.

Mansbach, *Modern Art in Eastern Europe*, 83–140.

40 See the essay on Poznań by Jerzy Malinowski in this volume.

41 Mansbach, *Modern Art in Eastern Europe: From The Baltic to the Balkans, ca. 1890–1939* (Cambridge: Cambridge University Press, 1999), 106–8.

42 See the essay on Cracow by Tomasz Gryglewicz in this volume.

43 See Gryglewicz in this volume and Mansbach, *Modern Art in Eastern Europe*, 100 ff.

44 Ljubomir Micić, "Zweiter Barbarendurchbruch" and "Worte im Raum" [fragment] in *Zenit* 2, no. 7 [Extra-Ausgabe] (Munich, July 14, 1922), trans. in *Between Worlds*. For a full account of Micić, see Esther Levinger's essay in this volume.

45 Henry-Russell Hitchcock, Philip Johnson, and Lewis Mumford, *Modern Architecture: International Exhibition*, exh. cat., (New York, Museum of Modern Art, 1932).

46 Peter F. Sugar, "External and Domestic Roots of Eastern European Nationalism," in Peter F. Sugar and Ivo J. Lederer, ed., *Nationalism in Eastern Europe* (Seattle: University of Washington Press, 1969), 6–7.

47 See the essay by Michael Heim in this volume.

48 Hans Kohn, *Idea of Nationalism* (1961), discussed in Sugar, "External and Domestic Roots of Eastern European Nationalism," 9.

49 Tomasz Gryglewicz, *Malarstwo Europy Srodkowej, 1900–1914: Tendencje modernistyczne i wczesnoawangardowe* [Painting in Middle Europe, 1900–1914: Modern and Early Avant-Garde Tendencies] (Cracow: Nakladem Uniwersytetu Jagiellonskiego, 1992). German summary, 107.

50 Jan Cavanaugh, *Out Looking In: Early Modern Polish Art, 1890–1918* (Berkeley: University of California Press, 2000), 1.

51 Cavanaugh, *Out Looking In*, 8; Cf. Jaromir Jedliński, "Die Konstruktivistische Avantgarde in Polen," *Wille zur Form* (Vienna: 125 Jahre Hochschule für Angewandte Kunst, 1993).

52 Cavanaugh, *Out Looking In*, 194.

53 Nietzsche's "On Truth and Lie in the Extra-Moral Sense," cited in James Clifford, "On Ethnographic Self-Fashioning: Conrad and Malinowski," in *Reconstructing Individualism*, ed. Thomas C. Heller, Morton Sosna, and David Wellberg (Stanford: Stanford University Press, 1986).

54 Clifford, "On Ethnographic Self-Fashioning: Conrad and Malinowski," 82.

55 See the essay by Andrzej Turowski in this volume.

56 Robert Wohl, *The Generation of 1914* (Cambridge: Harvard University Press, 1979).

57 Cf. *Still Life*, 1919 (State Russian Museum) as example of early work. For other works exhibited at Vilnius, see *Władysław Strzemiński: On the 100th Anniversary of his Birth, 1893–1952* (Łodź: Muzeum Sztuki, 1994), no. 1.5 through 1.8, 165–67.

58 Zenobia Karnicka, "Chronology of Kobro's Life and Work," in *Katarzyna Kobro, 1898–1951*, exh. cat. (Leeds: Henry Moore Institute, 1999), 33–34.

59 It is difficult to determine what Strzemiński showed because his next group of known works is dated 1924–27, and he and Kobro broke with Blok very soon after joining in 1924.

60 Henryk Berlewi, "Platyka za granicz" [The Arts Abroad] [1922–23], trans. in *Between Worlds*.

61 Berlewi soon wrote a proclamation (in 1923), published the following year; see Henryk Berlewi, "Mechanofaktura," Warszawa 1924 (also in *Der*

Sturm 15, no. 3, 1924): 155–153. Trans. in *Between Worlds*.

62 See the essay by Monika Król in this volume.

63 For further discussion, see S. A. Mansbach, "Revolutionary Engagements: The Hungarian Avant-Garde" in S. A. Mansbach, ed. *Standing in the Tempest: Painters of the Hungarian Avant-Garde, 1908–1930*, exh. cat. (Santa Barbara: Santa Barbara Museum of Art, 1991), 46–74.

64 Lajos Kassák, "Program," *A Tett* Budapest, no. 10 (1916), trans. in *Between Worlds*.

65 Lajos Kassák, "Proclamation: For Art!" *Ma* November 20, 1918, trans. in *Between Worlds*.

66 Lajos Kassák, "Levél Kun Bélához" [Letter to Béla Kun in the Name of Art] *Ma* 4 (1919): 7, 146f, trans. in *Between Worlds*.

67 Roman Jakobson, "Dada," in *Vestnik taetra* 82 (February 8, 1921), English trans. in *Language in Literature*, ed. by Krystyna Pomorska and Stephen Rudy (Cambridge: Harvard University Press, 1987), 35, reprinted in *Between Worlds*. On Jakobson's Devětsil activities, see Jindřich Toman, *The Magic of a Common Language: Jakobson, Mathesius, Trubetzkoy, and the Prague Linguistic Circle* (Cambridge: MIT Press, 1995).

68 Stephen Foster, "Event Structures and Art Situations," in *"Event" Arts and Art Events* (Ann Arbor: UMI, 1988), 7.

69 The Umělecký svaz Devětsil [Art Union of Devětsil] had been founded in October 1920 by Joseph Šíma, Alois Wachsmann, František Muzika, Adolf Hoffmeister, Toyen, and Jindřich Štyrský, under the leadership of Karel Teige.

70 For further discussion of these exhibited objects, as well as the origins of the ball bearing image in the American magazine *Broom*, see Karel Srp, "Karel Teige in the Twenties: The Moment of Sweet Ejaculation," in *Karel Teige: L'Enfant Terrible of the Czech Modernist Avant-Garde*, edited by Eric Dluhosch and Rostislav Švácha (Cambridge: MIT Press, 1999), 12–45. According to Srp, Teige may have exhibited a typographical poem (precursor to the picture poems), 40, see fig. 24. For discussion of the origin of the mirror portrait in an object exhibited by Philippe Soupault at the Salon Dada exhibition in Paris, see František Šmejkal, "Devětsil: An Introduction" in *Devětsil: Czech Avant-Garde Art, Architecture and Design of the 1920s and 1930s*. London: Design Museum and Oxford: Museum of Modern Art, 1990, 14–15.

71 Karel Teige, "Malírství a poezie" [Painting and Poetry] in *Disk* 1, (December 1923): 19–20, trans. in *Between Worlds*.

72 Karel Teige, "Painting and Poetry," trans. in *Between Worlds*.

73 Karel Teige, "Poetismus," *Host* 3, no. 9–10 (July 1924): 197–204, Eng. trans. "Poetism," in Dluhosch and Švácha, 70.

74 Ibid.

75 Ibid., 67.

76 On the general evolution of the text from the discursive to the performative in the avant-garde, see Timothy O. Benson, "The Text and the Coming of Age of the Avant-Garde in Germany." In "The Avant-Garde and the Text," special exhibition catalog issue, *Visible Language* 21, no. 3/4, (Rochester, 1988).

77 Jakobson, "What Is Poetry," in *Language in Literature*, 372.

78 I am indebted here to the probing analysis of the relationship of Teige's and Jakobson's theories in Esther Levinger, "Czech Avant-Garde Art: Poetry for the Five Senses," in *Art Bulletin* 81, no. 3, (September 1999): 513–32.

79 Jakobson, "What Is Poetry," in *Language in Literature*, 378.

80 Ibid., 377.

81 Teige, "Kinografie," in *Film* (Prague: Václav Petr, 1925) discussed in Levenger, "Czech Avant-Garde Art," 520.

82 Teige, "Final Notes" in *Film*, 125; discussed in Levinger, 521.

83 Voskovec's collages were reproduced in *Disk* 2 (1925). Cf. Levinger 525.

84 Teige, "Slova, Slova, Slova," in *Horizont* 1, no. 1 (January, 1927): 1–3; no. 2 (February 1927): 29–32; no. 3 (March 1927): 44–47; no. 4 (April 1927): 70–73. Trans. in Levinger, 517.

85 Henryk Berlewi, "Miedzynarodowa Wystawa w Düsseldorfie" [International Exhibition in Düsseldorf], *Nasz Kurier* (August 2, 1922). Trans. in *Between Worlds*.

86 Ibid.

87 Derek Sayer, *The Coasts of Bohemia: A Czech History* (Princeton: Princeton University Press, 1998), and his essay in the present volume.

NATIONALISM AND MODERNITY

Anthony D. Smith

Over one hundred fifty years ago Marx and Engels declared that "the intellectual creations of individual nations become common property. National one-sidedness and narrow-mindedness become more and more impossible, and from the numerous national and local literatures there arises a world literature."[1] And, we may add, a world art and a world music. For, from at least the late nineteenth century, many artists and composers have proclaimed their international affiliation and cosmopolitan sympathies through a multitude of styles and creative media that often strain the understanding of their audiences.

But this has not always been the case. Over the last two centuries, nations and national identities provided a secure anchorage and source of inspiration for most artists and intellectuals. In the late eighteenth century, Rousseau and Herder identified urban, cosmopolitan culture with vice and corruption and extolled a pure and wholesome nature, whose human counterpart was the pristine, authentic nation that had preserved its native customs and culture. Since then, artists and intellectuals, drinking from the same ideological well, have frequently sought to represent the spirit and land-scape of their nations; the cosmopolitan manifestos of the avant-garde have not told the full story, not even about their own work. Traditional and religious themes and concerns have remained relevant throughout the nineteenth and far into the twentieth century, for example, in twentieth-century British art; while national themes and aspirations have often been interwoven with the more cosmopolitan ideas and styles of the modern epoch, as in twentieth-century Latin American and Mexican art.[2]

It is these often complex links between nations, nationalism, and modernity that I will explore here. In particular, I shall be concerned with the work of historians and social scientists who have sought to explain the ubiquitous appeal of nations and nationalism in a modern world.

TERMINOLOGY

Few concepts are as difficult to disentangle as those of nationalism and modernity. But, to minimize confusion, it is necessary to clarify these terms.

The concept of "modernity" carries both chronological and qualitative meanings, which are often conflated. The first refers to a period of history, roughly from the time of the American and French Revolutions to the present. The second refers to the rise of novel social, political, and cultural conditions and processes that are generally taken to include industrialism, capitalism, the modern bureaucratic state, mass participation in politics, secular education, and the predominant role of science. Negatively, modernity can also denote the decline of tradition and religion, of the extended family, of localism and rural society, and of a subsistence economy. By arguing that these processes and changes occurred mainly in the last two centuries, the two meanings are brought into close harmony, if not synthesis.[3]

The concepts of "nation" and "nationalism" are equally problematic. We may start by distinguishing the nation from the state and the ethnic community. The nation is a type of community, whereas the state is a set of institutions with a legitimate claim to monopoly of coercion and extraction in a given territory. The ethnic community (or "ethnie") is closer to the nation, but, as a named population with myths of common descent and shared memories, elements of common culture, and a link with a territory, it lacks the nation's political, economic, and ideological dimensions. While nations need not be defined in terms of the ideology of nationalism, there is a close connection between most nations and nationalism (and more problematically with modernity); whereas ethnic communities have existed in all periods of history and are not necessarily linked to the conditions of modernity.

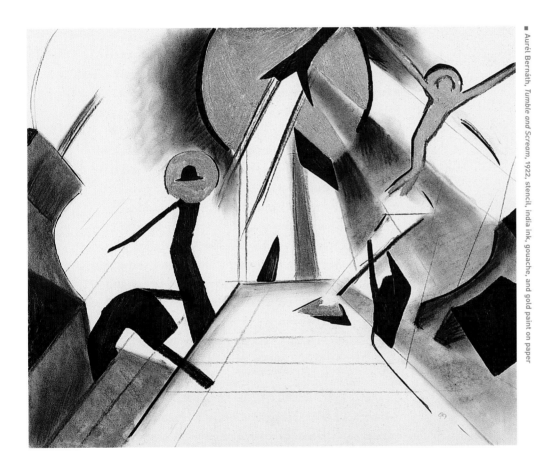

Aurél Bernáth, *Tumble and Scream*, 1922, stencil, india ink, gouache, and gold paint on paper

1 Karl Marx and Friedrich Engels, *Basic Writings on Politics and Philosophy*, ed. Lewis S. Feuer (New York: Anchor Books, 1959), 11.
2 See Dawn Ades, ed., *Art in Latin America* (London: South Bank Centre, 1989).
3 See Anthony Giddens, *The Consequences of Modernity* (Cambridge: Polity Press, 1991).

Nationalism, therefore, can be defined as an ideological movement for attaining and maintaining autonomy, unity, and identity for a group of people deemed by some of its members to constitute an actual or potential nation. We can define a nation, in turn, as a named population that occupies a historic territory and shares common myths and memories, a public culture, a single economy, and equal rights and duties for members. These definitions are, of course, provisional. It cannot be emphasized too strongly that there it is no scholarly agreement regarding the meanings of these concepts.[4]

Paradoxically, nationalism—that is, the aspiration for a particular nation—is also necessarily internationalist. Nationalism recognizes a world of nations, and therefore assumes an internationalist solution to global problems: a world of nation-states and a coming together of national cultures, a world not so far removed from the vision articulated in the passage from the *Communist Manifesto* quoted above. For the ideology of nationalism is founded on the belief in a world of nations; and the key tenets of its core doctrine can be summarized as follows: (1) the world is divided into nations, each with its own character, history, and destiny; (2) everyone must belong to, and owe primary loyalty to, a nation; (3) the nation is the sole source of political power; (4) nations must enjoy maximum self-expression and autonomy; and (5) global peace and justice can only be attained through a world of free nations.

From these propositions, we can infer the types of values and ideals that nationalism enjoins. These include: (1) a quest for national autonomy, free of external constraint; (2) a struggle for national unity, territorial and social; (3) a search for national identity through history and culture; (4) a drive for national authenticity and free self-expression; (5) a rediscovery of nature in the ancestral homeland.

Central to nations and nationalism are a series of myths, memories, symbols, and traditions, which endow each national identity with its unique contents, what Max Weber referred to as its "individuality" and its "irreplaceable culture values." For nationalists, these culture values are not only unique, they constitute the authentic collective self. For they emerged from a long, eventful ethnic past and are embodied in the unique language, customs, rituals, and arts of the people. Only by returning to authentic folk cultures and to our roots in nature and the national landscape can we overcome the modern crisis of alienation and fragmentation.[5]

4 See Walker Connor, *Ethnonationalism: The Quest for Understanding* (Princeton: Princeton University Press, 1994), chap. 2; see Anthony D. Smith, *National Identity* (Harmondsworth: Penguin, 1991), chap. 1, 4.

5 Max Weber, *Max Weber: Essays in Sociology*, ed. Hans Gerth and C. Wright Mills (London: Routledge and Kegan Paul, 1948), 176.

6 See Carlton Hayes, *The Historical Evolution of Modern Nationalism* (New York: Smith, 1931); Hans Kohn, *The Idea of Nationalism* (1944; 2d ed., New York: Collier-Macmillan, 1967).

7 Ernest Gellner, *Thought and Change* (London: Weidenfeld and Nicolson, 1964), 155.

8 Ibid., 160; Ernest Gellner, *Nations and Nationalism* (Oxford: Blackwell, 1983), chap. 2.

9 Gellner, *Thought and Change*, chap. 7; Gellner, *Nations and Nationalism*, chap. 6.

10 Gellner, *Thought and Change*, 168.

11 Gellner, *Nations and Nationalism*, 55. See A. D. Smith, *Nationalism and Modernism* (London and New York: Routledge, 1998), chap. 2.

12 Elie Kedourie, *Nationalism* (London: Hutchinson, 1960), 1.

13 Johann Gottlieb Fichte, *Addresses to the German Nation*, trans. R. F. Jones and G. H. Turnbull (Chicago: Open Court, 1923).

MODERNISM

But is that folk culture authentic? Does a nation have an ancient ethnic past? And, if it has one, does it matter? For Ernest Gellner, it does not matter. Nations have no ethnic pasts. Or rather, what pasts they may have had are of no significance. They are little more than "shreds and patches" of premodern cultures which nationalism uses for its own, peculiarly modern, ends. If Estonian culture existed in the Middle Ages, it is of absolutely no account today. In all that matters, Estonia is a modern nation; it did not exist before the nineteenth century.

Gellner's view of nations and nationalism is the most forthright and sociologically arresting example of what we may term *modernism*. Rejecting the older perennialist belief that nations are immemorial, modernists contend that: (1) nations and nationalism are relatively recent phenomena; (2) nations and nationalism are qualitatively novel; and (3) nations and nationalism are products of modernization and intrinsic to modernity.

This last contention marks out true sociological, as opposed to merely chronological, modernism. Many historians, beginning with Carlton Hayes and Hans Kohn, have demonstrated the chronological modernity of nations and nationalist ideology, but it is only with the works of Gellner and Elie Kedourie that a specific claim for the necessary link among nations, nationalism, and modernity is made. For Gellner, indeed, the connections are deep and pervasive: nations and nationalism are logically contingent but sociologically necessary in the modern world. People do not have to have a nationality as they must have eyes and ears, but in the modern age, and only in the modern age, they must possess a nationality. Whereas the premodern past had no room for nations and nationalism, the modern epoch is intrinsically nationalist, and nations are inherent in the modern condition.[6]

The basic reason for this change, argues Gellner, is that modernization, by which he means industrialization and everything that accompanies it, erodes tradition, destroys local structures, and makes culture the cement of society. In Gellner's formulation, "culture replaces structure."[7] The tide of modernization sweeps out from its Western heartlands and uproots societies, mobilizing the peasants and forcing them into the swollen cities. There, their old folk cultures are of little use. To secure employment, housing, and education, they must learn the "language and culture" of the modern city; the new urban "proletariat" must embrace a "high culture," one that is based on literacy and taught in schools by specialized personnel, because so much of today's work is semantic and based on context-free messages. Newcomers to the city, like everyone else, must be socialized in the new mass education system: a standardized, compulsory, public and academy-supervised system, funded and run by the state. The modern condition is one of literacy as the passport to citizenship—"every man a clerk"—with the intelligentsia as the vanguard of a literate modernity.[8]

There is a darker underside to Gellner's analysis. The process of urban integration of mobilized peasants is prone to conflict. Usually, the peasant newcomers speak the same language, look the same, and share the same religion as the urban old-timers. As a result, we have social conflict over scarce resources. But if the newcomers speak a different language, look different, or have a different scriptural religion, then ethnic conflict is added to class conflict; and the intelligentsia who share their culture, religion, or pigmentation are able to mobilize "their" proletariat against the old-timers on the basis of these differentiating cultural marks. At this point, a national call to secede from the old state is heard, and two new nations are born on either side of the cultural divide. Hence the ubiquity and power of nationalism in the modern world.[9]

For Ernest Gellner nationalism, for all its rhetorical fantasy, is at bottom a serious, practical, objective necessity. Moreover, "nationalism is not the awakening of nations to self-consciousness; it invents nations where they do not exist—but it does need some pre-existing differentiating marks to work on, even if…these are purely negative…"[10] But herein lies the problem. For why, on Gellner's account, should nationalism need any element of preexisting "low" (spontaneous, uncultivated) culture? And is it true that "any old shred or patch" of preexisting cultures can be used by nationalists to invent "their" nations?[11]

The idea that nationalism invents nations is also fundamental to the approach of that other great modernist, Elie Kedourie. In the opening words of his *Nationalism*: "Nationalism is a doctrine invented in Europe at the beginning of the nineteenth century."[12] In this, his first book on the subject, Kedourie implies that the invention of nationalism was as unnecessary as it was undesirable. It was put forward in 1807, in Fichte's *Addresses to the German Nation*[13] and the cognate works of other German Romantics, who sought to apply Kant's ideas on the individual will to collectivities like nations. Nationalism is, primarily, a doctrine of the will; and it seeks to realize its dreams through correct national education, struggle, and terror. True, nationalism was a part

of the modern zeitgeist, and a child of the Enlightenment. But the drive for epistemological certainty and moral certitude that underlay the Enlightenment, beside its destructive legacy for politics, revealed the hubris of modern man in his vain quest for perfectibility in an imperfect world. In fact, Kedourie argues, that quest and its underlying moral pride can be traced back to the medieval Christian millennial movements that wrought such havoc in society, from the heterodox, antinomian Brethren of the Free Spirit to the communist Anabaptists of Münster, who are the true ancestors of the rhapsodic, but subversive, evangelism of enlighteners like Lessing and Herder and their revolutionary nationalist progeny.[14]

But why did nationalism cease to be a spiritual disease of a few intellectuals and become a terrible opiate of the masses? Because basic political traditions and habits, as well as traditional communities like the family and neighborhood, had broken down under the onslaught of the Enlightenment. Early nineteenth-century Germany was full of restless young men, who conspired against authority and tradition because they felt alienated by the impersonal nature of the absolutist state and its bureaucratic regimentation. These educated youths dreamed of a revolution which would usher in a new age of perfect freedom and justice through struggle and terror, for they had imbibed the Revolutionary ideal of virtue through terror. It was a lesson well learned by all those marginal men who arrived in the West from the colonies in Africa and Asia, and whom Kedourie depicts in his second book, *Nationalism in Asia and Africa*, as drinking deep of the Enlightenment quest, and yet, because of their rejection by the West, realizing their messianic fervor by turning the West's weapons against itself.[15] In adopting the West's nationalism, and creating nations out of a medley of tribes and kingdoms in the colonies, these alienated intellectuals adapted the ideology of nationalism to their own ethnic traditions, to the "cult of the dark gods"—as in Bal Gangadhar Tilak's invocation of Kali, goddess of destruction, against the British, or the Mau Mau oaths in the Kenyan forests. Here Kedourie presents us with a penetrating yet deeply pessimistic portrait of nationalism, one that makes it difficult to grasp why so many people all over the world should be attracted to the nationalist vision of the regenerated nation.[16]

NATIONALISM AND THE MODERN STATE

If modernity for Gellner is equated with the impact of industrialization on society, and for Kedourie with that of the Enlightenment on politics, for others it is the professionalist state that acts as the motor of both modernization and nationalism. Anthony Giddens, Michael Mann, and John Breuilly share the view that the rationalized state molds the nation, and that nations and nationalism are therefore recent and novel phenomena. For Giddens, nationalism is essentially a psychological phenomenon, and is really no more than the "cultural sensibility of sovereignty, the concomitant of the co-ordination of administrative power within the bounded nation-state."[17]

Similarly Michael Mann, while defining the nation as "an extensive cross-class community affirming its distinct ethnic identity and history and claiming its own state,"[18] goes on to explain the incidence of nations in political terms: "We cannot predict which few nations successfully emerged on the basis merely of *ethnicity*. The presence or absence of regional administration offers a much better predictor. This suggests a predominantly political explanation."[19]

This view is close to that enunciated recently by Michael Hechter, who argues that nationalism emerges only when indirect rule (in empires) is replaced by direct rule (by modern centralizing states) and when local elites, seeing their power undermined, have to appeal to the local constituents in the name of their common "nationality."[20] But the most explicit political theory of nationalism, which ties it into the dynamics of modernity, is that propounded by John Breuilly. In *Nationalism and the State* Breuilly argues that nationalism is a political movement designed to capture and retain state power, and that it does so by mobilizing, coordinating, and legitimating the interests of various sub-elites.[21]

Nationalism in this reading is really a political argument which asserts that: (a) there exists a nation with an explicit and peculiar character; (b) the interests and values of this nation take priority over all other interests and values; and (c) the nation must be as independent as possible. This usually requires the attainment of at least political sovereignty.[22]

Nationalism emerged and became so successful mainly as a result of the growing gulf between the rational (absolutist) state and civil society in the period of early modernity, which led to a strong sense of alienation among the educated classes. For comfort, the intellectuals fell back on historicist arguments like those of Herder, which promised to reintegrate state and society by defining the authentic cultural nation as the modern political nation. But such sleight-of-hand redefinitions, while addressing a real and serious problem, are necessarily spurious, promising more than they can deliver.

Yet Breuilly's instrumentalist analysis ends on a note of doubt. Though he claims that ideology, and the intellectuals, are secondary to the state and political interests, Breuilly accepts that nationalist ideology has been a powerful force. Its self-referential quality has made it unique, and its focus on "the restoration of a glorious past in a transformed future has a special power which it is difficult for other ideological movements to match."[23] The trouble, he admits, is that people do yearn for communal membership, do have a strong sense of us and them, of territories as homelands, of belonging to culturally defined and bounded worlds which give their lives meaning. Ultimately, much of this is beyond rational analysis and, I believe, the explanatory powers of the historian.[24]

IMAGINED NATIONS AND INVENTED HISTORIES

This crucial passage raises the central issue of myth and symbol in the making of modern nations, a theme addressed by both Eric Hobsbawm and Benedict Anderson. Both scholars share the postmodernist conviction that nations are cultural artifacts of modernity; but while Hobsbawm regards nationalism as a waning force in a global era, Anderson sees in nationalism something more akin to religion and the family than to political ideologies, and as such, destined to persist.

For Hobsbawm and his associates in *The Invention of Tradition*, nations and nationalism can best be grasped through an analysis of new traditions engineered by elites faced with the social disruptions caused by capitalist industrialization, urbanization, and mass democratization.[25] Various traditions, from the Boy Scouts to Labor Day, from statues of the French Republic (Marianne) to choral societies and archery contests, were instituted in the later nineteenth century; but the most effective were those myths, symbols, and traditions which created the image, and illusion, of nations and of their deep historical continuity, be it through forged Scottish poems (Ossian) or Czech manuscripts, or semifictional history (Boadicea, Vercingetorix, Arminius). For Hobsbawm, these invented traditions are "beyond effective historical continuity," and "can never develop or even preserve a living past."[26] And, in reality, "All these (i.e., the nation, nationalism, and national symbols) rest on exercises in social engineering which are often deliberate and always innovative, if only because historical novelty implies innovation."[27]

Some years later, Hobsbawm located these exercises in social engineering in the period 1870–1914 in Europe, when he distinguished the divisive, small-scale, ethnolinguistic

14 Kedourie, *Nationalism*; cf. A. D. Smith, *Nationalism in the Twentieth Century* (Oxford: Martin Robertson, 1979), chap. 2.

15 Elie Kedourie, ed., *Nationalism in Asia and Africa* (London: Weidenfeld and Nicolson, 1971).

16 Kedourie, ed., *Nationalism in Asia and Africa*, intro.

17 Anthony Giddens, *The Nation-State and Violence* (Cambridge: Polity Press, 1985), 219.

18 Michael Mann, *The Sources of Social Power*, vol. 2 (Cambridge: Cambridge University Press, 1993), 215.

19 Michael Mann, "A Political Theory of Nationalism and its Excesses," in Sukumar Periwal, ed., *Notions of Nationalism* (Budapest: Central European University Press, 1995), 50.

20 Michael Hechter, *Containing Nationalism* (Oxford: Oxford University Press, 2000), chap. 2, 3.

21 John Breuilly, *Nationalism and the State*, 2nd ed. (Manchester: Manchester University Press, 1993).

22 Ibid., 2.

23 Ibid., 68.

24 Ibid., 401.

25 Eric Hobsbawm and Terence Ranger, eds. *The Invention of Tradition* (Cambridge: Cambridge University Press, 1983).

26 Ibid., 7, 13–14.

27 Ibid.

28 Eric Hobsbawm, *Nations and Nationalism since 1780* (Cambridge: Cambridge University Press, 1990), chap. 4, 6.
29 Ibid., 183.
30 Ibid.
31 Benedict Anderson, *Imagined Communities: Reflections on the Origins of Nationalism*, 2nd ed., (London: Verso, 1991), chap. 2, 3.
32 Ibid., 6.
33 Ibid., 7.
34 Pierre van den Berghe, "Do Races Matter?," *Nations and Nationalism* 1, no. 3 (1995): 357–68.
35 See Clifford Geertz, *The Interpretation of Cultures* (London: Fontana, 1973).

All larger communities are imagined.

nationalisms of Eastern Europe from the earlier political and mass-democratic nationalisms which harked back to the French Revolution. Curiously, his examples of invented traditions are drawn from the more unificatory and political nationalisms of the West—France, Germany, Britain, and the United States—which he regards as a necessary and progressive social and political force in their time. His ire is reserved for those nationalisms that, after 1870 and once again after 1989, appealed to the divisive and reactionary forces of ethnicity and language, which today only express the fear and weakness of people threatened by the massive economic changes and population movements of globalization.[28]

It might be thought that the contemporary resurgence of ethnic nationalism would damp down predictions of the imminent demise of nations and nationalism. However, for Hobsbawm, appearances merely mask the reality, which is one where nationalism has ceased to be a "major vector of historical change," and where it is at best derivative and secondary to the great forces of globalization.[29] This assumption allows Hobsbawm to conclude that "the owl of Minerva which brings wisdom, Hegel said, flies out at dusk. It is a good sign that it is now circling round nations and nationalism."[30]

Benedict Anderson does not draw the same conclusion. On the contrary, though his analysis proceeds from the same Marxist background as Hobsbawm's, it emphasizes the quasi-transhistorical qualities of nationhood, its roots in the universal fear of oblivion after death, and the fatality of global linguistic diversity. At the same time, Anderson also locates nations and nationalism firmly in the modern epoch. Several processes must first develop, he argues, for nations to appear. These include: the decline of great cosmological script communities and sacred monarchical centers—the great world religions and empires; a revolution in our conceptions of time, from a cosmological and messianic sense of prefiguring, to a linear conception of "empty, homogenous time" measured by clock and calendar; and, most important, the rise and spread of "print-capitalism" in the sixteenth century and its first mass-commodity product, the vernacular printed book. It was the invention of printing and its exploitation by an incipient capitalism, aided by a literate, Bible-reading Protestantism, as well as by state administrations, that favored the fixing of vernacular print-languages of state, below Latin and above the various dialects. The ensuing rise of vernacular reading publics through books and, later, newspapers, formed the basis for a new sociological

conception of the vernacular print-community, represented by novelists and poets to their fellow language speakers and compatriots in novels, poems, plays, and newspaper articles, all of which identify the reader with a sociological community, most of whose members she or he will neither know nor see and hear.[31]

The result of this complex of processes is the imagining of a nation, which Anderson defines as "an imagined political community—and imagined as both inherently limited and sovereign."[32] Of course, all larger communities are imagined. It is the manner in which they are imagined that is important. To the above qualities of a finite and sovereign imagined community, Anderson adds a third: a deep, cross-class horizontal fraternity, which makes it possible to explain the vast human sacrifices made on behalf of the nation, symbolized by those ghostly national imaginings at the Tomb of the Unknown Warrior: "Ultimately it is this fraternity that makes it possible, over the past two centuries, for so many millions of people, not so much to kill, as willingly to die for such limited imaginings."[33]

The very nobility and disinterestedness of the nation give rise to feelings of self-sacrificing love; in this respect, the nation is akin to the family and commands an analogous and enduring loyalty.

PRIMORDIALISM

These are just some of the most influential explanations of nations and nationalism that subscribe to the modernist paradigm. Benedict Anderson's account is one of the more complex versions of that paradigm. But it too proposes an explanation that relies heavily on a single factor, print-capitalism—just as Hobsbawm's relies on the idea of "invented tradition," Breuilly's on the modern, rational state, Kedourie's on the Enlightenment, and Gellner's on mass education and "high culture." Each of these factors is treated as a key element of modernity, and is used to account for the novelty and recent existence of nations and nationalism.

But suppose for a moment that nations are neither so recent nor so novel. (Nationalism, the ideology, we may allow to be relatively recent and novel, though it too may have premodern antecedents.) What, then, becomes of these factors and the explanations over which they preside? This question is often posed by critics of modernism, when they point to the possibility of "nations before nationalism" and "nations without nationalism"; and hence of nations before, and without, modernity.

Perhaps the most radical kind of critique is that mounted by the so-called primordialists. This label has been attached to a variety of views. The earliest, advanced by the German Romantics, was that nations are organic and natural, an inherent part of the human condition or, for Herder, of God's plan. Here, nationalism is an expression of a preexisting nation, which has been "forgotten" by most of its members and must be "awakened" by the nationalists. But all this, of course, is exactly what needs to be explained: the existence of nations, how they were "forgotten," why they still "slumber," and so on.

A second version of primordialism relies on sociobiology, and traces the source of nations to individual genetic reproductive drives. For Pierre van den Berghe, the need for cooperation to ensure the survival of individual genes requires kin selection and nepotism. Beyond the family, individuals have to rely on rules of endogamy and on cultural signs—shared language, customs, religion, color—to recognize larger kin groups with whom they share a genetic inheritance. Such "inclusive fitness" gives rise to ethnic groups and nations, whose myths of origin correspond closely to actual biological descent. But can we really extrapolate from the genetic endowment of small family units to large cultural and political groups? The moment we do so by allowing a special role for cultural signs, we necessarily reduce the explanatory power of genetic drives. As for unitary myths of ethnic origins, they rarely correspond to what we know about the historical diversity of ethnic origins.[34]

There is also a theory of primordialism as it applies to culture. Here, certain attributes are treated as assumed conditions of social existence; these include kinship, language, race, religion, customs, and territory. For Clifford Geertz, these cultural bases give rise to "primordial" attachments, by which he means that human beings endow these ties with a prior and overriding power. Geertz uses this idea to explain the situation in colonial states in Africa and Asia. When populations divided by primordial ties were brought together, existing conflicts were exacerbated, thereby making it difficult to build a rational, efficient political order based on civil ties.[35]

Geertz may well be right about many postcolonial societies, but as a general explanation cultural primordialism will not take us very far. It rightly highlights the primordial feelings and attachments of the members of ethnic groups and nations—what one might call a "participants' primordialism"—but it offers no explanation as to why these ties should override all others, nor how they relate

to nations and nationalisms in history. Steven Grosby has attempted to fill this lacuna by suggesting that such ties are widely felt to be life-enhancing, because they refer to beliefs about the things that sustain life—mainly, bounded territory and kinship. Again, this may well be the case at a general level. But it is not clear how this behavior relates to ethnicity and nationalism, let alone to specific historical nations.[36]

More generally, primordialism can be seen as neglecting historical change and variation. The result is a failure to place the development of nations and nationalism in their historical contexts, with a tendency to prefer sociological speculation to historical analysis.

NEO-PERENNIALISM

A disregard for historical context is not in evidence among the "neo-perennialists." Here we are dealing with historians who attack modernist and primordialist conceptions by assembling evidence of premodern ethnicity and nationhood. They depart from the older type of perennialism insofar as for them not all nations are immemorial (let alone natural), nor is the category of "the nation" universal throughout history.

There are two kinds of neo-perennialism. The first we may term "continuous perennialism." This version holds that certain nations can boast a continuous history back to premodern, usually medieval, times. As a result, modernism can only tell part of the story, the later part. And, we may add, in those cases where nations can trace their histories back to medieval times, the hold of the nation over its members is particularly strong, and is not easily eroded.

According to Adrian Hastings, such is the case of England. The English people's self-consciousness as a nation can be traced back to at least the fourteenth century, and possibly to the Anglo-Saxon kingdom of Alfred and his successors. The use of the term "nacioun" in medieval England, in Hastings's view, is very similar to today's use of "nation"; the period's defensive nationalism was similar as well, even if it lacked a theory of national self-determination. In this Hastings is not alone. The historical sociologist Liah Greenfeld has documented in massive detail the growth of an elite sense of the English people as constituting the nation just before the Reformation, and immediately bolstered by the English translations of the Bible and by Foxe's *Book of Martyrs* in the later sixteenth century. The historian John Gillingham has also found, in twelfth- and thirteenth-century English texts of William of Malmesbury and Geoffrey of Monmouth, a clear idea of an

36 Steven Grosby, "Territoriality: The Transcendental, Primordial Feature of Modern Societies," *Nations and Nationalism* 1, no. 2 (1995): 143–62.

37 Adrian Hastings, *The Construction of Nationhood: Ethnicity, Religion and Nationalism* (Cambridge: Cambridge University Press, 1997), chap. 1; Liah Greenfeld, *Nationalism: Five Roads to Modernity* (Cambridge, Mass: Harvard University Press, 1992), chap. 1; John Gillingham, "The Beginnings of English Imperialism," *Journal of Historical Sociology* 5 (1992): 392–409; James Lydon, "Nation and Race in Medieval Ireland," in Simon Forde, Lesley Johnson, and Alan Murray, eds., *Concepts of National Identity in the Middle Ages* (Leeds: School of English, University of Leeds, 1995): 103–24.

38 Hastings, *Construction of Nationhood*, 26.

39 Ibid., chap. 7.

40 Ibid., chap. 1, 8.

41 Hugh Seton-Watson, *Nations and States* (London: Methuen, 1976), chap. 2, 3; Charles Tilly, ed., *The Formation of National States in Western Europe* (Princeton: Princeton University Press, 1975), intro.

42 John Armstrong, *Nations before Nationalism* (Chapel Hill: University of North Carolina Press, 1982).

43 Ibid.

44 S. G. F. Brandon, *Jesus and the Zealots* (Manchester: Manchester University Press, 1967), chap. 2; Doron Mendels, *The Rise and Fall of Jewish Nationalism* (New York: Doubleday, 1992).

English nation and its myth of noble origins. But if England acted first to form a nation, it was quickly followed by others: Scotland, Ireland, Wales, France, Denmark, Sweden, and Spain, all before the Reformation and long before the French Revolution. And while a theory of nationalism may have been operative in the post-Revolutionary "Mark II" nationalisms, theory as such, according to Hastings, is unimportant in comparison with the particular nationalisms of historical nations.[37]

What enables Hastings and other neo-perennialists to discover "nations before nationalism" and therefore "nations before modernity," where the modernists fail to do so, results in part from their different definition of the concept of nation. For Adrian Hastings, nations are not necessarily mass phenomena: "one cannot say that for a nation to exist it is necessary that everyone within it should want it to exist or have full consciousness that it does exist; only that many people beyond government circles or a small ruling class should consistently believe in it."[38]

Nations are formed from looser, more fluid oral ethnicities, at the moment when their vernacular languages are committed to writing and used to produce a literature. The state and geography may aid the transition to nationhood, but writing, above all, fixes the boundaries of a speech community.[39]

Why, then, given the global distribution of oral ethnicities, did nations first emerge in Western Europe? The answer lies in the sphere of religion. According to Hastings, the concept of the nation is a Christian phenomenon, because only Christianity sanctioned a multiplicity of languages and the translation of its scriptures into other languages; and only Christianity (apart from the Jews themselves) inherited the Old Testament political ideal of the ancient Israelites, i.e., the prototype of the nation displayed in ancient Israel. Neither Islam, which had its own political ideal, nor the Eastern religions could accommodate vernacular translations or this national dynamic; hence, the countries of Asia and Africa only began to develop their own nationalisms after contact with a Christian West.[40]

Hastings's general argument suggests, then, that nations and nationalism are not specifically connected with modernity. This view goes further than the distinction made by Hugh Seton-Watson between the "old, continuous nations" of Western and Northern Europe, and the new, deliberately created nations of Eastern Europe ("nations of design," in Charles Tilly's phrase). Its polemic is directed, in the first place, against Hobsbawm's refusal to countenance nations

before the French Revolution, but more generally against Kedourie's and Gellner's insistence on the creation of nations by nationalism and modernity. Yet, while one may sympathize with Hastings' rejection of Kedourie's ideological determinism and Gellner's sociological determinism, his insistence on the Christian basis of nations, which leaves no room for possible medieval Far Eastern or Persian nations, seems equally exclusive and monocausal.[41]

Mention of other civilizations suggests the possibility of nations in every period and continent. This is where a "recurrent perennialism" may be helpful. It would see the category of "nation" as a recurrent phenomenon, with particular nations regularly emerging and declining for various reasons, but the analytic category would remain one of the basic forms of human association. This position is adopted by John Armstrong in his monumental study of premodern ethnicity, *Nations before Nationalism*.[42] For, despite its title, his study of medieval Christendom and Islam focuses on the persistence and renewal of ethnic identities before 1800. At times, Armstrong appears to identify these with nations; at others, he differentiates between pre-1800 "nations" (ethnic communities) and post-1800 nations. The distinction, and the problem, is important, but the book's seminal contribution to our understanding of nations lies in the range of factors it adduces in the study of premodern ethnic communities— from sedentary and nomadic lifestyles to law codes and urban planning, from imperial *mythomoteurs* and administrations to ecclesiastical organization and language fault lines. Such an array of factors is unlikely to produce any theory of nations and nationalism, but it sensitizes us to the many influences on the persistence of ethnic identity and, by extension, on the emergence of national identities.[43]

Armstrong concentrates on the intermingling in the medieval epoch of Middle Eastern genealogical forms of organization with the more territorial modes that stemmed from Greco-Roman civilization. But his account frequently turns back to the models derived from antiquity, and a number of ancient historians have underlined the importance of ethnicity in the ancient world. Some, indeed, have even talked about ancient "nations." Doron Mendels, for example, while differentiating ancient from modern types of nations, and equating the ancient variety more with ethnicity, nevertheless describes in great detail the symbols of "political nationalism"— temple, territory, kingship, army—found among many "nations" in the Hellenistic world. S. G. F. Brandon speaks of the Maccabean and Zealot revolts against the Romans in Judea as cases of guerrilla "nationalisms."[44]

Steven Grosby also sees in the ancient Jewish "nation" an excellent example of his idea, referred to earlier, regarding the close relationship between a land and its people. Nevertheless, after examining the Armenian, Aramaean, and Edomite cases, Grosby warns of the problematic nature of this kind of inquiry, both in terms of evidence and of methodology:

An analysis of these three cases further reminds us that in reality the boundaries separating the categories which we employ in our investigations of various collectivities, ancient and modern, are permeable. Rarely does a collectivity correspond with exactitude to a particular analytic category. This is true not only for the collectivities of antiquity, but for the modern national state as well.[45]

Modernists would counter these examples in two ways. Either they could dismiss them as exceptional and fortuitous, while reminding us that only in the modern epoch did the category of the nation become a near-universal norm—an argument that is open to doubt, depending on one's view of the number of possible premodern candidates for the category of nation. Or they could simply define the concept of the nation in such a way (as a large-scale, mass, public association, with clear borders, part of a network of similar nations, and legitimated by nationalist ideology) as to exclude the possibility of premodern nations. But even here the issue is not clear-cut. One can find similar large-scale, mass, public associations within clear borders and a network of national states in other epochs. Admittedly, there are differences: the networks are regional, rather than global (a matter of limited technology?) and the mass association is confined to males (a matter of premodern patriarchal norms?) But perhaps the decisive difference is the absence of any nationalist ideology to define the nation in premodern epochs. However, at this point the argument becomes somewhat circular, since the concept of the nation has been defined by nationalist ideology, which is a modern development; and as a result all premodern concepts of "nation" are ruled out, even if the other features of our definition of the nation are present.[46]

ETHNO-SYMBOLISM

From the foregoing, it is clear that the modernity or otherwise of the nation, if not of nationalist ideology, is one of the most problematic and contentious conceptions in history and the social sciences. If the modernists are right, if nations were created only in the last two centuries as products of modern conditions, then with the passing of those conditions and the advent of postmodernity, we should expect to see the withering away of the nation and its replacement by other forms of human community adapted to the new conditions of a postmodern epoch. If, on the other hand, the neo-perennialists are nearer the mark, if some or many nations can be traced back over centuries, then we would expect that, even if the conditions of modernity were to give way to new conditions and a new epoch (however we label it), these nations would be unlikely to be superseded for a long time to come; for just as these premodern nations survived, mutatis mutandis, into the modern epoch, so they might be expected to persist in any subsequent epoch and under any new conditions.

This is not simply a matter of a dispute over historical periodization and prediction, important as both are. It goes far deeper. Two opposed conceptions of the nation, and beyond that, of human community, are at stake. On one side lies the view that cultural communities, and certainly nations, are created through purposive will, through the more or less deliberate actions of elites. The other position holds that nations, and all collective cultural identities, answer to deepseated and widespread human needs of security, dignity, and belonging, and therefore cannot be tied down to the conditions of specific epochs. On this view, the differences between premodern communities and modern nations which the modernists emphasize, are changes of form and scale rather than of their nature and content. Kedourie may be right to underline the novelty of the ideology of nationalism, but both he and the other modernists have failed to grasp how the ideology is really only a novel expression of preexisting popular ideas of collective cultural identity and ethnic community.[47]

Yet a considerable measure of discontinuity lies between premodern and modern forms of community. Nationalism and nations are novel in that they bring together two lines of social development and belief-systems: an emphasis on genealogy and ethnocultural affinity on the one hand and, on the other hand, territorial attachments and the rights and duties of members of a political community. They fuse these lines of development through the institutionalization of mass citizenship and public culture in a delimited homeland, through the ideal of popular sovereignty. We find only hints of such a synthesis before the modern epoch.

The second discontinuity is the elevation of culture to act as the pivot of human community. Gellner was surely right to insist on the central importance of a mass, public culture, not only as one of the key elements in any definition of the concept of the nation, but as a key defining element of

modern society as such, and as an ideological commitment of all modern societies. Again, harbingers of such a role for culture can be traced, notably in those ethnic communities which elevate scriptural religion as the bond among members. But, in general, the idea of a single, mass, public culture, shared equally by all members, has been a post-Reformation development.

Following on from this, we can suggest a way out of the modernist-perennialist impasse. We could agree that nations, as well as nationalism, are generally modern, that is, both recent and novel, while conceding that some nations can trace their roots back to the medieval epoch. We could then go on to underline the importance of ethnic communities or ethnies and argue that most nations can point to preexisting, and often premodern, ethnic ties and sentiments which have formed the basis of their development as nations, even if the correspondence is only rough-and-ready.

This formulation rejects the more sweeping claims of both modernists and perennialists, and recognizes the variety of ethnohistories of particular nations, and hence the differences in their relations with "modernity." Some nations are indeed fairly recent, and are therefore, to a greater or lesser degree, indebted to the processes of "modernization." Others, by contrast, were fairly well formed before the advent of capitalism, the modern state, and mass participation in politics; many of their members already possessed a clear sense of their national identity. In yet other cases, the ethnic community was well formed, but its transition to nationhood was prevented by external factors—wars, exile, imperial expansion—though its members never entirely lost their aspirations to nationhood, nor their shared memories, myths, values, and symbols.[48]

Crucial to our understanding of each nation and nationalism is how these myths, memories, values, and symbols—the "ethno-symbolic heritage" of preexisting ethnies—were retained, or transformed, through different epochs, and especially in the transition to modern types of community. It is this inner world of ethnie and nation that is so important for our understanding of the impact of nationalism, not least the way in which, through artistic and literary representations, it has continued to influence so many people across the world. By means of these collective memories, symbols, myths, and traditions, nationalists and others have been able to strike a powerful collective chord; and while there have been cases where intellectuals and artists have had to fill in, improvise, and embellish the ethnosymbolic heritage, only those cultural motifs and themes that harmonized and

Artists from David, Constable, and Delacroix to Burne-Jones, Stanley Spencer, Repin, and Diego Rivera have been drawn to the heroic legends and ethnoscapes of their nations.

45 Steven Grosby, "Borders, Territory and Nationality in the Ancient Near East and Armenia," *Journal of the Economic and Social History of the Orient* 40, no. 1 (1997): 2.

46 See Anthony D. Smith, "The Problem of National Identity: Ancient, Medieval and Modern?" *Ethnic and Racial Studies* 17, no. 3 (1994): 375–99.

47 See Smith, *Nationalism and Modernism*, chap. 5.

48 Anthony D. Smith, *The Nation in History* (Hanover: University Press of New England, 2000), chap. 2, 3.

sprang from the preexisting popular heritage were authenticated and used for popular mobilization.

Thus, not any shred or patch of culture would do, but only those cultural elements that appeared "authentic," "of the people," and made "in our own way." As Herder put it: "Let men think well or ill of us; they are our language, our literature, our ways, and let that be enough."[49] In other words, it has been necessary to rediscover and politicize an ethnohistory (the members' own representations of their past) and a vernacular culture in order to appeal to "the people" and to mold them into a single, cohesive nation. By reminding the people of their cultural distinctiveness and the uniqueness of their culture values; by rediscovering and eulogizing their ancient heroes and heroines; by commemorating their great deeds in monuments, paintings, and processions; by designating and displaying golden ages of political, military, religious, and artistic splendor; by turning people's minds and hearts to the beauties of their ethnoscapes (the historicized nature of their ancestral homelands), nationalist intellectuals and artists were able to use the power of preexisting collective memories, myths, symbols, and traditions to give meaning to their modern, political purposes. This is what Tilak did in India, when he used the advice of Lord Krishna to the hero Arjuna in the *Bhagavad-Gita* as a political text for patriotic and anti-British ends; and what Akseli Gallen-Kallela and Sibelius did for the Finns, when they evoked in paintings and music the ancient and rediscovered world of seers and heroes in the epic of the *Kalevala*.[50]

Nations, or most of them, may be relatively recent creations, but they draw on much older ethnic motifs and symbols that have remained part of popular culture and memory. That is why the bonds of the nation, and the sentiments they evoke, are not easily eroded or dissipated. If anything, the challenges of global change, the vicissitudes of postmodernity, appear to have strengthened these bonds and deepened these sentiments, even while they have become more inclusive and multidimensional. Nationalism continues to resonate so widely, even among those who repudiate many of the political actions it legitimates, because it is a popular movement of collective freedom, and because it mobilizes people by drawing its strength from the vernacular cultures, the poetic landscapes, and the golden ages of what is felt to be an authentic ethnic past. These are also among the reasons why so many artists, from David, Constable, and Delacroix to Burne-Jones, Stanley Spencer, Repin, and Diego Rivera, have been drawn to the heroic legends and ethnoscapes of their nations, and why they have felt it necessary and important

to evoke the spirit and represent the dreams and aspirations of their peoples. Coexisting with cosmopolitan tastes and international aspirations, nations and nationalism show few signs of withering away, but rather of being rejuvenated by the tides of globalization.[51]

49 Cited in Isaiah Berlin, *Vico and Herder* (London: Hogarth Press, 1976), 182.

50 See Kedourie, ed., *Nationalism in Asia and Africa*; Anthony D. Smith, *The Ethnic Origins of Nations* (Oxford: Blackwell, 1986), chap. 8; Anthony D. Smith, *Myths and Memories of the Nation* (Oxford: Oxford University Press, 1999), intro.

51 See Anthony D. Smith, "Art and Nationalism in Europe," in J. C. H. Blom, et al., eds., *De Onmacht van het Grote: Cultuur in Europa* (Amsterdam: Amsterdam University Press, 1993), 64–80.

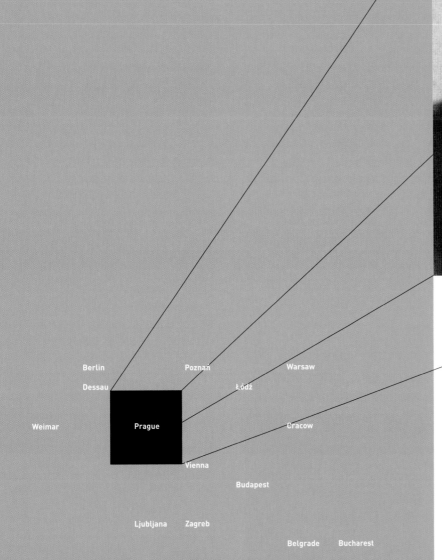

Berlin

Poznań

Warsaw

Dessau

Łódź

Weimar

Prague

Cracow

Vienna

Budapest

Ljubljana Zagreb

Belgrade Bucharest

prague

PRAGUE

Lenka Bydžovská

Few cities have garnered as many epithets as Prague: "magical," "golden," "the city of a hundred spires," "the heart of Europe," and the "mother of cities." But Franz Kafka observed, "This mother has claws. It's necessary to submit to her. Otherwise we would have to burn her at both ends, at Vyšehrad and at Prague Castle; only then would it be possible to break free of her."

Thanks to its location and rich history, Prague has been a crossroads for various intellectual, religious, and artistic currents. Cohabitation by Czech, German, and Jewish communities created an inspirational cultural environment during the decade that began in 1910. From the spring of 1911, Albert Einstein lectured at Prague's German university for three semesters; his stay coincidentally overlapped with the blossoming of Czech Cubism—the most characteristic manifestation of the prewar avant-garde in Prague. Picasso and Braque were received in Prague like nowhere else; Cubism there affected not only fine art but also the practical arts and even architecture, such as Josef Gočár's U Černé Matky Boží [House of the Black Madonna], a department store in the historical Old Town, or Josef Chochol's residential buildings below Vyšehrad. Art historian Vincenc Kramář—who formed a unique personal collection of Cubist art thanks to his provident purchases at Kahnweiler's Paris gallery before the First World War—referred, in his 1921 book *Kubismus*, to the essential relationship of the new art to "the transformation of our idea of the world, as reflected in Einstein's theory and in the studies of the fourth dimension." The work of theosophist, and later anthroposophist, Rudolf Steiner found an exceptional reception in Prague when he came there to lecture in the period from 1907 to 1924. In the early 1910s, figures such as Franz Kafka, Max Brod, and Albert Einstein attended his lectures—though Einstein naturally expressed doubts about Steiner's knowledge of non-Euclidean geometry. For the circle of Prague's German-speaking literati who later achieved international renown, the Austrian satirist Karl Kraus coined the term "Arconauts"—from the café Arco, which enjoyed fame from about 1909 through the First World War. Franz Werfel, Johannes Urzidil, and Egon Erwin Kisch gathered there and occasionally Brod, Kafka, and other writers and poets. While Arco was an elegant, mirrored café, designed by noted Czech modernist

p. 81:
Karel Teige, 1927

Above:
Gate and tower on Charles Bridge, Prague, photo c. 1910

architect Jan Kotěra, the bohemian café Montmartre on the Old Town Square, painted with parodies of Cubism, made a much more exotic impression. According to the recollections of Kisch, a pioneering cultural correspondent, "The walls were hung with Cubist and Futurist enigmas, which were gladly accepted here in place of payment." The local color included a headwaiter named Hamlet and the dancer Emča the Revolution. German writers, along with Jaroslav Hašek and his friends, could be found there. In 1918 the interior of Montmartre was redesigned by Jiří Kroha in a Cubo-Futurist style with elements of Constructivism and primitive figural motifs; rooms called Heaven, Hell, and Paradise represented a mock church.

Working meetings of the Czech prewar avant-garde usually took place in the traditional artists' café Union, in a classical house on the corner of Národní Třída and Perštýn, where the design of the interior—a system of small rooms arranged on a central axis—suited the circles of friends. Certain rooms were always occupied by groups connected by professional allegiance or common interests. University professors, literati, and artists alike sat in Union, and they had at their disposition

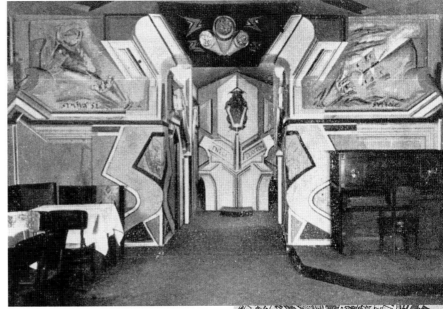

a wide choice of newspapers, cultural and artistic reviews, and specially ordered professional literature.

The radical young generation of painters, with Emil Filla and Bohumil Kubišta at the forefront, drew attention to itself in 1907–8, when the Czech-German group Osma [The Eight] held two exhibitions influenced by Expressionism and Fauvism. The members of Osma later joined the older artists' association Mánes (named for painter Josef Mánes), with whom they exhibited in Jan Kotěra's Art Nouveau pavilion beneath the Kinský gardens; they also published in Mánes's intergenerational magazine Volné směry [Free Directions]. In 1911 Osma demonstratively parted with Mánes and founded the Cubist-oriented Skupina výtvarných umělců [Visual Artists Group], which published Umělecký měsíčník [Art Monthly]. From 1912 to 1914 Skupina organized six exhibitions—four in Obecní dům (Prague's Municipal House) and two in Germany (at the Goltz Salon Neue Kunst in Munich and at Herwarth Walden's Berlin Galerie Der Sturm). These installations included paintings, graphic art, sculpture, architectural models, ceramics, glass, and furniture. For an international survey of modern art, the members of the group exhibited their Paris mentors—Picasso, Braque, Gris, Friesz, Derain—but also the German Expressionists—Heckel, Kirchner, Müller, Schmidt-Rottluff, Pechstein.

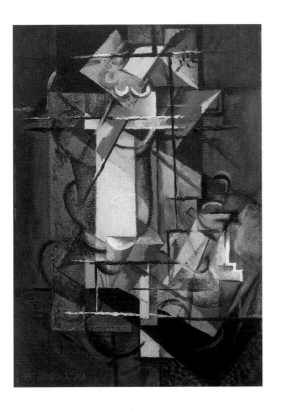

Above:
Jiří Kroha, interior design for Montmartre Cabaret, Prague, 1918

Left:
■ Antonín Procházka, *Still Life with Bottle*, 1913, oil on plywood

Modern work was confronted with the art of different historical epochs and cultures—folk art, Asian art, African statues, and examples of Gothic art were added to the expositions.

Despite openness to different stimuli, Skupina's artistic program had one distinct limitation: in contemporary art it strictly followed Picasso's example. For this reason in 1912 a wing of the group that accepted Futurism, Orphism, and the work of the so-called lesser Cubists, led by Josef Čapek, returned to Mánes. In February 1914, at the same time as Skupina's last show, Mánes organized a notable international exposition of contemporary art. For this exhibition, the Parisian poet Alexander Mercereau selected foreign avant-garde artists, including Delaunay, Mondrian, Archipenko, Brancusi, Villon, Duchamp-Villon, and others who, notably, were represented alongside young Czech artists. Thanks to the activities of Skupina and Mánes, prewar Prague encountered virtually all the tendencies of contemporary art immediately as they arose, especially if one includes the exhibition of Italian Futurists (Russolo, Severini, Carrà, Boccioni, and others) that was held by the private Havel gallery in December 1913. Cultural life in Prague died out during the war. Many artists either were called to the front, emigrated, or were taken prisoner. A group of advocates for modern art, Tvrdošíjní [Stubborn Ones], arose in the spring of 1918. Of the exhibits they organized through 1924, the most important was the third, in January 1921, in which local artists appeared in conjunction with interesting foreign guests—Paul Klee, Otto Dix, and Lasar Segall.

At that point Prague, which had become the capital of independent Czechoslovakia after the fall of the Habsburg monarchy in October 1918, entered the golden decade of the 1920s. The previously dominant position of French art to Czech was officially strengthened by actions of the new state. For example, thanks to the state's purchases at an exhibition of French art of the nineteenth and twentieth centuries, organized in 1923 by Mánes, a significant part of the French collection of the Modern Gallery (now part of the National Gallery) was formed. A Picasso retrospective, drawn from the collection of Paul Rosenberg, took place in September 1922, in the Mánes exhibition hall designed by Josef Gočár in the original and colorful style named Rondocubism.

Czech culture of that time absorbed stimuli from the most varied sources, including the new countries of Central Europe, Soviet Russia, and the United States. This international outlook is attested by the fact that the Czech government named a foreigner—the Slovene Jožef Plečnik—as chief architect for Prague Castle (the presidential seat) in 1920; he continued to remodel this important historical complex through the mid-1930s. Prague also served as a refuge for Russian intellectuals, who came in the 1920s either as emigrants or as the first envoys from Soviet Russia (who later turned into emigrants). Philologist

Top:
Vratislav Brunner, cover design for *Umělecký měsíčník* (Art Monthly) 1 (1911–12)

Above:
Václav Špála, exhibition poster for the group Tvrdošíjných [Stubborn Ones], lithograph

Roman Jakobson belonged to the second group. A friend to the writers Vladimir Mayakovsky and Boris Pasternak and the Russian Futurists, he worked in Prague from 1920 and quickly became acquainted with the young literati, visual artists, and theorists. In 1926, along with Vilém Mathesius, Jan Mukařovský, and other Czech and Russian scholars, he founded the Prague Linguistic Circle, which pioneered a structuralist approach to language. Several members of this Prague school were interested in contemporary artistic activity, so in interwar Prague the scholarly and artistic avant-gardes mutually influenced one another.

From the beginning of the 1920s the propagators of radical artistic movements enjoyed visiting Prague. The city became a successful stop in 1920 on the Dadaist tour of Richard Huelsenbeck, Johannes Baader, and Raoul Hausmann, and in 1921 the Dadaists returned in the persons of Hausmann, Kurt Schwitters, and Hannah Höch. The Futurist invasion of Prague took place at the same time. In October 1921 Enrico Prampolini organized an exhibit at Krasoumná jednoto [Artists' Emporium] dedicated primarily to Italian Futurists and showing twenty-one works by Boccioni. Two months later Marinetti came to Prague for the premiere of *Futurist Theatrical Syntheses*, a set of absurd sketches, at the Švanda theater in Smíchov. He directed them himself, gave a lively lecture, and led commentary and readings. In December 1922 Marinetti's play *Tamburo di Fuoco* [The Fiery Drum] was produced at the Stavovské theater.

Avant-garde activity in 1920s Prague was concentrated around the art group

Devětsil. It arose in October 1920—once again in the Union café—and it became the center of the ideological, literary, artistic, theatrical, and musical pursuits of the assertive generation born about 1900, whose theoretical leader and spokesman was Karel Teige. More than sixty artists participated in Devětsil during its existence. After its early phase, focused on proletarian art, spiritual realism, and naïve primitivism, and culminating in the Spring Exhibition of 1922, Devětsil quickly turned to the international avant-garde. In 1923 it organized the Bazar moderního umění [Bazaar of Modern Art], promoting a new perception of art and the world; the new idol of the Czech avant-garde, Man Ray, exhibited his photograms as a guest of Devětsil. The Devětsil exhibit of 1926, which was dominated by Constructivism

Top:
■ Karel Teige, cover design for *Devětsil Revolutionary Almanac*, 1922

Above:
Jindřich Štyrský, Vítězslav Nezval, and Marie Čermínová (Toyen), Prague, c. 1930

and Poetism, was also quite varied. It contained a broad architectural section, documented theater activity, and exhibited compositions of "colored music" (watercolors whose color relationships could be interpreted analogously with musical notes), photograms, pictorial poetry, photomontage, and book graphics. Le Corbusier, Amédée Ozenfant, and Man Ray were featured guests. The artistic forms prevalent at the exhibitions were also evident at the Osvobozené [Liberated] theater, founded as Devětsil's theatrical section and one of the most progressive European stages in the second half of the 1920s. It put on not only productions by Devětsil authors but also notable stagings of international plays—among them Jarry's *King Ubu*, Apollinaire's *Les Mamelles de Tirésias*, Breton and Soupault's *If You Please*, and Cocteau's *Orpheus*.

Many journals and magazines served to gradually spread the ideas of the Devětsil avant-garde: *Revoluční sborník Devětsil* [Devětsil Revolutionary Anthology], *Život II* [Life], the magazines *Disk*, *Pásmo* [Zone], and *Stavba* [Construction], and especially the monthly *ReD* [Review of Devětsil], whose editor and graphic designer was Teige. The progressive Prague publisher Odeon put out *ReD*, along with the majority of the poetic, prose, and theoretical works of the Devětsil members, and released important translated literature in typographically well-prepared editions. The publisher Aventinum also played an important role in Prague cultural life; its owner opened a Parisian-type exhibit hall in 1927 called Aventinská mansarda, where Josef Šíma, Jindřich Štyrský, Toyen (Maria Čermínová), and Adolf Hoffmeister exhibited. The Czech avant-garde actively collaborated with its foreign colleagues, and therefore Prague was visited by many interesting personalities. In the spring of 1923 Alexander Archipenko arrived for the Prague reprise of his traveling exhibition, put on by Devětsil; at the end of the same year Ilya Ehrenburg, considered the spokesman for Soviet Constructivism at the time, came at the invitation of Devětsil. In 1924–25 the Architects' Club in Prague and Brno held a series of lectures on new architecture with the participation of the world's foremost architects—Pieter Oud,

Walter Gropius, Le Corbusier, Adolf Loos, and Theo van Doesburg. In spring 1926 Klee exhibited in Prague; in June Schwitters held two "Evenings of the Grotesque" and in the same year attended the opening of his one-man exhibition; in 1927 Ehrenburg came again, as did Vladimir Mayakovsky, Philippe Soupault, and others. In October 1928 Le Corbusier lectured at the invitation of Devětsil at the Osvobozené theater, and Teige conducted him around Prague. Le Corbusier later confided in an interview that "it bothers me that Prague is so worldly. In that respect I typically prefer petit bourgeois Paris. Your luxurious cafes, full of mirrors, frighten me. I like a simpler lifestyle."

The members of Devětsil lived in cafés. They sat in the Národní café and in Slavia, Tumovka, and, later, Metro. They left them to go to exhibits, to the theater and cinema—where they were especially drawn to the premieres of Charlie Chaplin's films—and to bars and dance halls. The businesses of nighttime Prague were found mostly in the labyrinth of the Old Town and often had exotic names, reminiscent of Parisian nightlife. Jazz appeared there as something new. According to the poet Vítězslav Nezval, original "wild" jazz resembled "a little Cubist monster." Jazz drummers had devices for shooting blanks and regularly ended their numbers with a shot. Members of the avant-garde were fond of long nighttime walks through the streets, squares, and parks of Prague, often in pairs or groups of three. During these conversations they formulated their ideas and goals. When they led their foreign guests through the historical city, they frequently followed Apollinaire's steps to the Prague ghetto, to show how "the hands of the clock in the Jewish quarter run backwards" (from "Zone," 1911). Perhaps their ticking backward somewhat compensated for the forward motion of the Czech avant-garde.

Translated by Andrée Collier Záleská

■ Karel Teige, cover design for *ReD*, 1927 (vol. 1, no. 3)

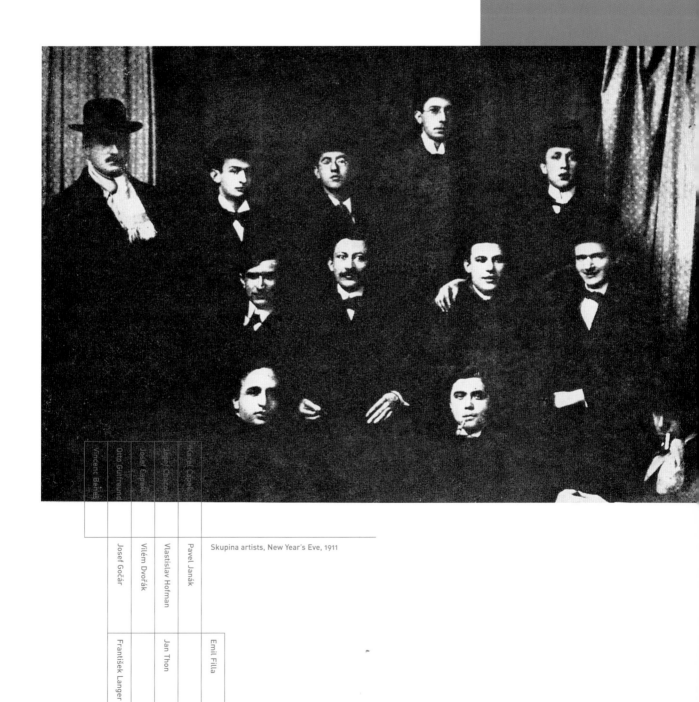

Skupina artists, New Year's Eve, 1911

Vincenc Beneš

Otto Gutfreund

Josef Čapek

Josef Čapek

Karel Čapek

Josef Gočár

Vilém Dvořák

Vlastislav Hofman

Pavel Janák

František Langer

Jan Thon

Emil Filla

The First Skupina Exhibition

Skupina's first exhibition was held in January and February 1912 at the Municipal House in Prague. The interior design by Pavel Janák used crystalline forms for the walls and ceiling. Josef Gočár exhibited an architectural model for his Cubist "House of the Black Madonna," then under construction (see wall case), as well as a table and chairs. Vlastislav Hofman displayed a chaise longue and matching chairs. Otto Gutfreund exhibited several plaster sculptures that were later cast in bronze.

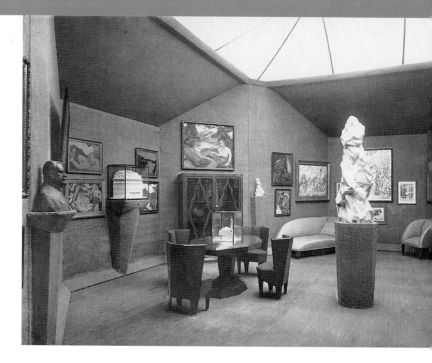

Left:
■ Otto Gutfreund, *Anxiety*, 1911, bronze

Above:
First Skupina exhibition, Prague, January–February, 1912

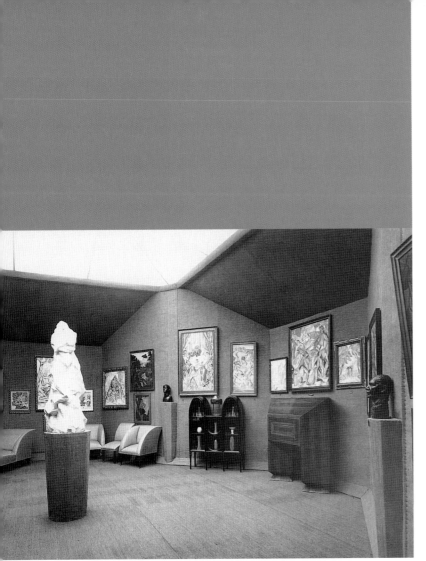

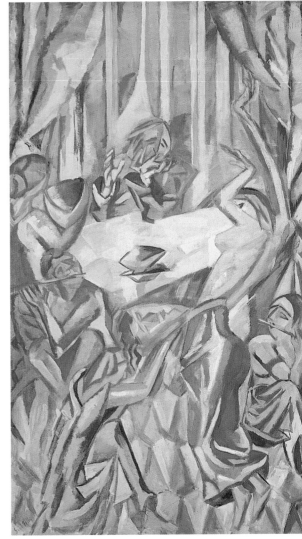

Above left:
■ Emil Filla, *The Dance of Salome I*, 1911, oil on canvas

Left–right:
■ Vlastislav Hofman, *Liqueur Service*, 1911, transparent glass, cut and frosted

■ Pavel Janák, *Large Convex Vase*, 1911, earthenware with black-and-white glaze

■ Pavel Janák, *Large Concave Vase*, 1911, porcelain with black glaze and white decoration

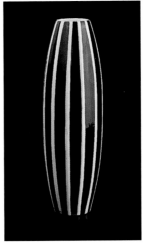

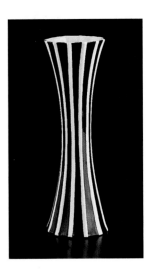

SURREALITIES

Derek Sayer

Hypothesis for discussion—that members of the avant-garde circles sought to overcome the forces of traditionalism and nationalism by cultivating both an internationalist social milieu and a new discourse using an elemental visual vocabulary they hoped could transcend national boundaries, an endeavor perhaps analogous to the aspirations of the Prague linguistic circle to derive a universal language.[1]

JUXTAPOSITIONS

Accompanied by his wife Jacqueline, the poet Paul Eluard and his wife Nusch, and the Czech painter Josef Šíma, André Breton arrived in Prague on March 27, 1935. More than seven hundred people turned out two nights later to hear his lecture at the Mánes Gallery, "The Surrealist Situation of the Object." Breton began by taking stock of his surroundings:

I am very happy to be speaking today in a city outside of France which yesterday was still unknown to me, but which of all the cities I had not visited, was by far the least foreign to me. Prague with its legendary charms is, in fact, one of those cities that electively pin down poetic thought, which is always more or less adrift in space. Completely apart from the geographical, historical, and economic considerations that this city and its inhabitants may lend themselves to, when viewed from a distance, with her towers that bristle like no others, it seems to me to be the magic capital of old Europe.

"By the very fact that [Prague] carefully incubates all the delights of the past for the imagination," he went on, "it seems to me that it would be less difficult for me to make myself understood in this corner of the world than any other."[2]

Breton gave a second lecture, to the Left Front, on April 1, entitled "The Political Position of Today's Art." He gloomily reported from Paris, where the Communist L'Humanité "made a specialty out of translating Mayakovsky's poems into doggerel" even as "the royalist journal L'Action française is pleased to report that Picasso is the greatest living painter" and "with the patronage of Mussolini primitives, classic painters and Surrealists were soon going to occupy the Grand Palais simultaneously in a huge exhibition of Italian art." Such improbable conjunctures, as Breton clearly regarded them, presented avant-garde writers and artists with an uneasy dilemma: Either they must give up interpreting and expressing the world in the ways that each of them finds the secret of within himself and himself alone—it is his very chance of enduring that is at stake—or they must give up collaborating on the practical plan of action for changing this world.[3] The lecture was warmly reviewed in the Communist press by Záviš Kalandra, who applauded the Surrealists for "not having tried to degrade their poetic activity by bringing it down to the level of doggerel, whose value to the good of the revolution would surely be quite illusory."[4]

On his return to Paris Breton immediately wrote Vítězslav Nezval, the Czech Surrealist poet who had organized his visit. It was more than just a formal letter of thanks. "Often, in the mornings, before we met up for lunch," Breton recalled, "I would look out of the window of the room at the rain as beautiful as the sun over Prague and I would enjoy this very rare certainty that I would take away from this city and from you all one of the most beautiful memories of my life."[5]

Some years earlier, Prague's same "legendary charms" had equally captivated Breton's compatriot Guillaume Apollinaire, the inventor of the term "sur-réalisme." Again it was the delights of the past that so seduced. In "Zone," the opening poem of his collection Alcools (1913)—a foundation stone in

the canon of international literary modernism—he juxta-
poses two places, two times, alternating poles for a continent.
One is a vigorous, bustling Paris, where all is movement and
modernity:

Executives laborers exquisite stenographers
Criss-cross Monday through Saturday four times daily
Three times every morning sirens groan
At the lunch hour a rabid bell barks

The other is a soft-focus, languorous Prague, conjured up
from a memory of a brief visit to the city in March 1902.
Here, time's very trajectory alters:

Karlovy Vary, 1935	André Breton	Jacqueline Breton	Karel Teige	Jindřich Štyrský	Toyen	Paul Eluard

Paul Eluard, Jacqueline Breton, André Breton, Prague, 1935

The hands on the clock in the Jewish Quarter run backwards
And you too go backwards in your life slowly
Climbing Hradčany and the evening listening
In the pubs they are singing Czech songs[6]

MODERNITIES

Tourists, especially those of a poetic inclination, may be misled. The quaint clock to which Apollinaire referred adorns the Jewish Town Hall in what was once the Prague ghetto. The district is known as Josefov, after Emperor Joseph II, who in 1782 "emancipated" the Jews, meaning he turned them into good Austrians. The old clock was fortunate to survive into the twentieth century. The Jewish Town Hall was one of a handful of buildings that escaped the modernizing clutches of the *asanace* launched by City Council in 1894, a "slum clearance" scheme rivaling Baron Haussmann's ambitions for Paris. Hundreds of other structures, often of no lesser antiquity but deemed to be less "historic," were reduced to rubble.

The roots of the Czech neologism *asanace*, like the English words *sanitation* and *sanity* and the French *cordon sanitaire*, lie in the Latin *sanitas*.

By the time World War I broke out, much of Josefov and parts of neighboring Staré město—Prague's Old Town—had been demolished. In their place arose a bourgeois quarter of high-priced Art Nouveau apartments. Pařížská [Paris] Avenue, as it was renamed in 1926, punched its elegant way clean through what had been a labyrinth of narrow medieval streets from the Old Town Square to the new Svatopluk Čech Bridge across the Vltava. Franz Kafka, whose parents moved to Pařížská in 1907, jokingly baptized it "Suicide Lane."[7]

After the war, in November 1920, seven years after "Zone" was published in Paris, the Jewish Town Hall had to be put under the protection of the United States Embassy to safeguard it from rioting Czechs. They targeted German and Jewish people and properties without discrimination—visible reminders of what were now seen, in the aftermath of a national independence few had foreseen, as three hundred years of foreign oppression.

Sitting, in all probability, in his parents' apartment in the Oppelt House on the corner of Pařížská Avenue and the Old Town Square, Franz Kafka wrote his Czech lover Milena Jesenská, who was living at the time with her Jewish husband Ernst Pollak in Vienna: "I just looked out the window: mounted police, gendarmes with bayonets, a screaming mob dispersing, and up here in the window the unsavory shame of living under constant protection."[8]

The Mánes Gallery, at which Breton gave his first lecture, opened in 1930. It sits on Slav Island—as the little sliver of land in the Vltava opposite the National Theater had been rechristened in 1925, in memory of the Slav Congress held there in 1848, the year General Windischgratz brought an earlier generation of Czech rioters to heel by shelling Staré město from the ramparts of Hradčany. Prior to its renaming the island had long been known as Žofín, after Austrian Emperor Franz-Joseph's mother Archduchess Sophia.

The gallery encompasses the tower and onion dome of a water mill dating from 1489. But its architect Otakar Novotný had surrounded this relic of "magic Prague" with a white glass and concrete housing that was uncompromising in its modernist purity, making it a showpiece of what Henry-Russell Hitchcock and Philip Johnson three years before had dubbed "The International Style." The visual disruption was not unlike that occasioned six decades later by Frank Gehry's Dancing House, known as "Fred and Ginger" after the way its two asymmetric towers lean amorously into one another a mile or so upstream on Jirásek Square.

The *asanace* was in full swing when Apollinaire visited Prague in 1902. Had he been less transfixed by metaphorical

clocks, he might have taken away a more contemporary image of the ancient city in the shape of a picture postcard. It carried a photograph of buildings in various stages of demolition, silhouetted against the gothic twin towers of the Týn Cathedral on the Old Town Square. Produced by the firm of Karel Bellmann, the card bore the jaunty legend "Greetings from Prague!"

As for André Breton, seeing, from a distance, its "towers that bristle like no others"—a Prague in which, never having been there, he was already quite at home—long ago intoxicated by Apollinaire's "alcohols," the father of Surrealism was just as blind to the (sur)realities all around him. The modernity of the landscape he was surveying is no more belied by Prague's bristling towers than is Paris's by the conjuncture of the Eiffel Tower and Notre Dame.

TEMPORALITIES

A little further along the riverbank stands, to this day, an empty housing for a figure unceremoniously transplanted to the lapidarium of the National Museum shortly after Czechoslovakia became an independent state in 1918, Austrian Emperor Francis I. The embankment, the oldest in Prague, which used once to be named for Francis too, shortly afterward became Masarykovo nábřeží in honor of the new state's "president-liberator" Tomáš Masaryk.

A competition was held in 1926 for a memorial to the "national composer" Bedřich Smetana to fill in the space left vacant by the departed Habsburg. The winning project was by the architect Pavel Janák, the painter František Kysela, and the sculptor Otto Gutfreund. Janák and Gutfreund had both been leading lights of the prewar avant-garde Skupina výtvarných umělců, founded in 1911. Janák went on to design Prague's celebrated functionalist villa colony overlooking the city at Baba (1928–33) and eventually succeeded Josef Plečnik as official architect to Prague Castle.

Gutfreund was one of the earliest Cubist sculptors (*Anxiety*, 1911) anywhere in the world. After the war he turned to civic realism. Working in brightly painted clay and plaster, he took many of his subjects (*Business*, 1923; *Industry*, 1923) from the pulsating repertoire of the modern city. His 1925 sketches for the decorations for Janák's Rondocubist Riunione Adriatica building, entitled *Modern Life*, include plaster reliefs of a coffee house, an office, a bar, dance—a modern-dress couple, not the traditional gossamer-clad muse—and, as befits the Roaring Twenties, jazz.

The plans for the Smetana memorial played on different imageries. According to Gutfreund's submission to the jury, it was to be surrounded by a "monumental wall," which would visually replicate the movements of Smetana's symphonic poem *Ma vlast* [My Country]—"Vyšehrad," "Vltava," "From Bohemia's Woods and Fields," "Šárka," "Tábor," "Blaník"— all patriotic motifs soaked in the sentimental pathos of the nineteenth century. Unorthodox in its style—as we would expect of this artist—the monument itself would be made up of ten freestanding groups that represented, in Gutfreund's own words again, "the voices of the land, to which Smetana listened."[9] Gutfreund's title for the monument was *The Genius of Music Revives the Nation*. The sculptor drowned while swimming in the Vltava the following year, and the monument was never built.

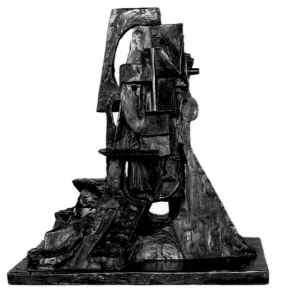

Otto Gutfreund, *Cubist Bust*, 1913, bronze

Otto Gutfreund, *Pastoral Group*, for the Bedřich Smetana monument, Prague, 1926, bronze

By no means was this Gutfreund's only essay in nation-building. Most famous is his memorial—squat, lumpish, self-consciously primitive, and damned at the time by the poet Otakar Březina as "vulgar, foreign, ugly, un-Czech, un-Slav"[10]—to Božena Němcová's *Babička*, which stands in the lush meadows of Babička's Valley in Ratibořice near Česká Skalice in northeast Bohemia. *Babička* [Granny, 1853], subtitled *Pictures from Country Life*, is the most beloved, and iconic, of all Czech literary works. The valley takes its name from the novel, not the other way around.

In the early 1920s, Rondocubism—a monumentalist out-growth of the pioneering Cubist experiments of Janák, Gočár, Chochol, and other Czech architects before the war—briefly aspired to become the national style. Rondocubism considered itself Slavic rather than Germanic in its handling of colors and volumes, consciously echoing what were alleged to be Old Russian archetypes. Janák and Gočár were leading figures in this attempt to incarnate nationality in brick and stone, outdoing themselves in born-again Slavic zeal.

Gutfreund furnished Josef Gočár's Bank of the Legions—named after Czechoslovak legionnaires, recruited from Austrian prisoners, deserters, and émigrés, who fought on the Allied side in World War I—with a frieze across the façade depicting what was fast becoming modern legend, the long march home of the nation's newest heroes across war-torn Bolshevik Russia.

Josef Čapek—elder brother of the writer Karel, who gave the twentieth century the word and image *robot*—and Václav Špála were also members of the Skupina. Later they were founders of the Tvrdošíjní, or Obstinates, who threw down the prewar modernist gauntlet again with their 1918 exhibition "And yet…" The title quotes the words Galileo supposedly muttered under his breath following his enforced recantation of heliocentrism in 1632: *eppur si muove*, "and yet it moves." It was Josef Čapek who provided the linocut illustrations for the first Czech translation, by his brother Karel, of Apollinaire's "Zone," which appeared in the Communist poet S. K. Neumann's magazine *Červen*—a major vehicle for Tvrdošíjní graphics—in June 1919.

Both Čapek and Špála drew many of their subjects in the 1920s from country life, employing a visual vocabulary of modernist simplification to contemporize and amplify a message of eternal bucolic simplicity—villages, the geometric patterns of fields, the harvest, dogs and cats, rain on cottage roofs, women peeling potatoes, children flying kites—a message of timeless Czechness.

Stylistics apart, this message would not have been ill-received at the Czechoslavic Ethnographic Exhibition in Prague in 1895, which drew more than two million visitors to Stromovka Park to marvel at simulations of a passing world that was busily being reconstituted as a "national tradition." These painters' visual abstractions differ in technique, rather than in spirit, from the exhibition's earlier transubstantiation of villagers' Sunday best into a "national costume." Nor, after the next war, would such visualizations altogether displease Czech Communists. They had their own fondness for folkish simplic-ities, representative of that grandest of modern abstractions—"the people." Despite the regime's often pathological antipathy toward artistic modernism of all stripes, the work of Čapek and Špála generally enjoyed official favor.

Recourse to "elemental visual vocabularies" does not—necessarily—imply "transcendence of national boundaries" or hostility to "the forces of traditionalism and nationalism," in interwar Central Europe or anywhere else. Consider this manifesto, entitled "Against Xenomania," published by Futurist F. T. Marinetti in the Italian *Gazetta del Popolo* on September 24, 1931, and subsequently reproduced in his *Futurist Cookbook*:

Therefore we Futurists, who twenty years ago cried at the top of our socially-democratically-communistically-clerically parliamentarily softened voices: "The word Italy must rule over the word Liberty!," today proclaim:

a) The word Italy must rule over the word genius.

b) The word Italy must rule over the word intelligence.

c) The word Italy must rule over the words culture and statistics.

d) The word Italy must rule over the word truth.[11]

Like most other European avant-garde currents, Futurism flowed through Prague too. Marinetti's open avowal of Fascism did not prevent his play *The Captives* from being staged at the avant-garde Liberated Theater in April 1929. The stage sets were by Jindřich Štyrský, who was to be a founder of the Czechoslovak Surrealist Group a few years later.

While contemplating conjunctures of sewing machines and umbrellas, we might finally pause to register the exhibition with which Veletržní Palace—the home, since 1994, of the Czech National Gallery's modern art collection—opened its doors on October 28, 1928, marking the tenth anniversary of Czechoslovak independence.

Oldřich Tyl and Josef Fuchs's vast, factory-like Veletržní palác—the name means Trade Fair Palace—epitomizes the functionalist aesthetic. From the outside the building is flat

Recourse to "elemental visual vocabularies" does not—necessarily—imply "transcendence of national boundaries"

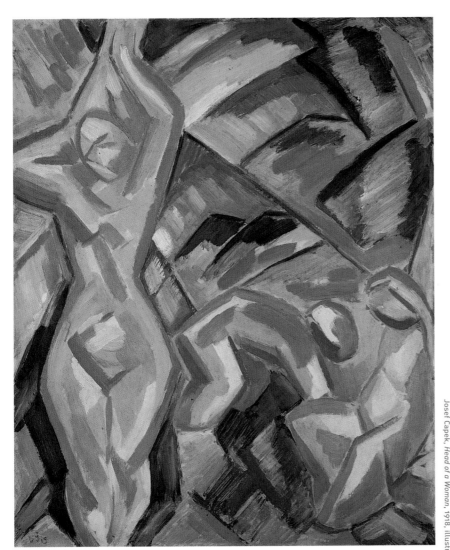

■ Václav Špála, *Bathing*, 1913, oil on cardboard

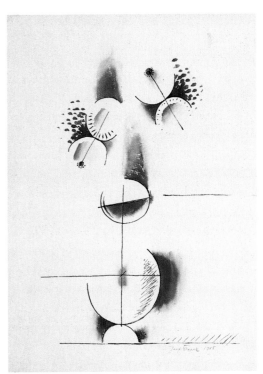

■ Josef Čapek, *Signal*, 1915, ink and watercolor on paper

Josef Čapek, *Head of a Woman*, 1918, illustration in Červen (no. 1, March 7)

and angular, the planar surface of its curtain walls broken only by horizontal ribbons of windows. Within lay a cavernous large exhibition hall, a seven-story atrium, a cinema, restaurants, cafés. Veletržní 's original intention was not to display modern art but to showcase the products of modern industry. The architects' sketches called for neon advertisements to blaze and blare across the palace's front.

Le Corbusier, who visited Prague that October, had his quarrels with Veletržní. But he still judged it to be "an extraordinarily significant building," a realized enterprise that was consonant with his own imaginings. It taught him—there is a shadow of envy here—"how I must create large buildings, I, who so far have built only some averagely small houses on miserly budgets."[12]

Incongruously—for the standpoints, at least, from which histories of the modern are normally written—this cathedral of modernism was inaugurated with the first public showing of Alphonse Mucha's completed *Slav Epic*, a cycle of twenty gargantuan historical canvases narrating the Czech national odyssey as part of a millennial Slavic apotheosis.[13] The *Epic* has routinely been judged by critics then and since as a throwback to the nineteenth century, a work academic in conception and anachronistic in style. Mucha is not even mentioned, for example, in Steven Mansbach's recent book *Modern Art in Eastern Europe: From the Baltic to the Balkans, ca. 1890–1939*, a survey of "the creativity…flourishing on the eastern periphery of Europe more than three-quarters of a century ago."[14]

We might well then ask: what does it mean to be a *modern* artist—for the *Slav Epic* was painted entirely in the twentieth century. Being modern evidently bears the same relation to time here as being Eastern does to place. At least, in his "Zone," Apollinaire was alive to *simultaneities*—to what may be encountered by chance on a single dissecting table at one and the same time.

Anticipating the upcoming show, *Nová Praha* reported: "The monumental hall of Veletržní Palace will be transformed into a splendid cathedral of the Slav spirit, love, and ardor, in which the individual pictures will be like symbolic stations in the historical pilgrimage of Slavdom toward the final victory of the Slavic race."[15]

Didn't it move?!

By one of those bizarre coincidences in which Surrealists delight, during World War II, when the Czech Lands were occupied by the Wehrmacht, it was outside Veletržní Palace that Prague's Jews were assembled by the neighboring Herrenvolk and the transports took them to Terezín, a fortress town named by Emperor Joseph II for his mother Empress Maria Theresa, now a way station en route to Auschwitz.

GEOGRAPHIES

There were other vantage points—other interweavings, other insinuations. Though this is apt to be forgotten by those for whom the study of Europe means the study of Europe, *Volné*

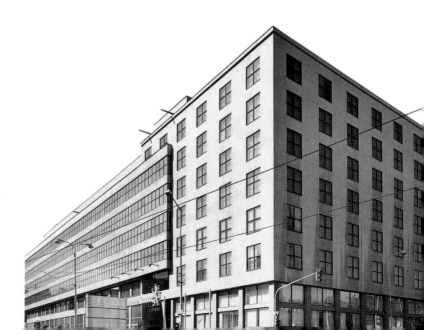

Směry [Free Directions], the magazine of the Mánes Artists' Society at whose gallery Breton gave his 1935 lecture, had educated its readers back in 1907 with reproductions of Katsushika Hokusai's *Thirty-six Views of Mount Fuji*.

There were even attempts to cultivate "an internationalist social milieu" and "to derive a universal language," albeit a language that remained strikingly European in the ways it enfolded the rest of the world.

The Devětsil group, founded in Prague's Café Union on October 5, 1920, by younger and angrier men, born around the year 1900, bluntly proclaimed the past dead: "The age has divided in two. Behind us remains the old time, which is condemned to molder in libraries, and in front of us sparkles a new day."[16]

Marinetti himself visited Prague in December the next year, directing a theatrical production of his "Futurist Syntheses," and giving a reading for Devětsil members at the apartment of their leading theoretician Karel Teige. Teige and the poet Jaroslav Seifert spent the following summer in Paris, where they met Le Corbusier, Amédée Ozenfant, Tristan Tzara, Man Ray, and other avant-garde figures. On their return they published what was in effect a manifesto, the *Revolutionary Miscellany Devětsil*. It contained, among other contributions, poetry by Seifert, Jiří Wolker, and Vítězslav Nezval (his "The Wonderful Magician"), fiction by Karel Schulz and Vladislav Vančura, and essays on modern Russian art, proletarian theater, and—by Teige—"The New Proletarian Art."

That same year Teige also edited, with the architect Jaromír Krejcar—who was later to become Milena Jesenská's second husband—another famous Devětsil anthology, *Život II* [Life II], subtitled *A Collection of New Beauty*. Much later, after a disillusioning sojourn in the Soviet Union, Krejcar designed the much-acclaimed functionalist Czechoslovak pavilion at the 1937 World Exhibition in Paris—the same exhibition at which

Albert Speer's German pavilion and Boris Iofan's USSR pavilion stared each other down in monumental pomposity across the mall that led onward to the Eiffel Tower.

The *Revolutionary Miscellany* carried a design by Krejcar for a large market hall framed by two skyscraper blocks. Intended for Prague's working-class district of Žižkov, Seifert's birthplace, it bore the title *Made in America*.

Side by side with this transatlantic gesture, the *Miscellany* also oriented itself to the New World in the East. It provided a résumé in Russian—not a language then much spoken in Bohemia—which anticipated Hitchcock and Johnson's nomenclature of ten years later in *The International Style*, albeit with a political twist the MoMA authors were careful to excise from their own survey of modern European architecture. (Philip Johnson later acknowledged that "Marxists and those interested in the social side of architecture objected to the [book's] emphasis on design and style.")[17]

The résumé began with a spatiotemporal cartography, a map of modernity, of its own:

The great French Revolution announced the dawning of the epoch, at whose grave we stand today. The World War was a cruel, depressing agony of this epoch. On the threshold of this new epoch is the Russian Revolution, which out of the great Eastern empire created the homeland of the proletariat and the cradle of the new world… The Russian Revolution and today's revolutionary ferment in all parts of the world announce the beginning of the great and glorious future. They open the way to a clear goal: for a socialist society, and when this goal is attained there will arise *a new style, a style of all liberated humanity, an international style*, which will liquidate provincial national culture and art.[18]

The cover for Jaroslav Seifert's *Samá Láska* [Sheer Love, 1923], designed by Otakar Mrkvička, montages these modernities—discordant and cacophonous, to latter-day eyes. An ocean liner and an airplane traverse the sky over the National

Museum on Prague's Wenceslas Square, which has been freshly furnished with skyscrapers, the tallest of them topped by a five-pointed red star.

The book, its afterword explains, "has no traditions besides its own." In Seifert's poems "there is romanticism of this great century. In his poems lives Kladno, lives New York—lives Paris, lives Jičín, Prague, the entire world."[19]

How was this great century, that entire world, envisioned? Romanticized? With no doubt deliberate irony, the best-known poem in *Sheer Love*, "All the Beauties of the World," takes its title from a comic aria in the most "national" of Bedřich Smetana's operas, *The Bartered Bride*.

The twenty-two-year-old Seifert throws down a gauntlet to art, of a kind common enough during those years from Paris to Petrograd:

Well then, adieu, allow us to leave you invented beauty
the frigate heads for the distance across the open sea,
muses, let down your long hair in grief,
art is dead, the world exists without it.[20]

The sea—the open horizon—is a recurring motif in the avant-garde art of this landlocked country in the 1920s. It flows through Devětsil's so-called pictorial poems. Karel Teige's *Travel Postcard*, emblazoned with the phrase "Greetings from a Journey," splices together a nautical flag, a Mediterranean town, a map, a pair of binoculars, and an envelope addressed to "Monsieur J. Seifert, Prague—Žižkov"; his *Departure for Cythera*—which he described as "a moment in a lyric film"—sequences an ocean liner, a yacht, staircases, a crane, the American Line logo, and the words "*Au revoir!*" and "*Bon vent*" in Constructivist space. Jindřich Štyrský's *Souvenir*, a picture-poem shaped just like a picture postcard, superimposes palm trees, a moon fish, a sea anemone, sailing ships, and a quintet of bathing beauties on a map of the Gulf of Genoa. A girl poses in a swimsuit, too, in the forefront of Antonín Heythum's "Underground." This collages the distinctive London Underground typography of the title—an acknowledged classic of modernist design—with a street map of the City of London, a medley of English, French, and Dutch train tickets, and a penny stamp for the British Empire Exhibition of 1924.[21]

Another poem in *Sheer Love*, entitled "A Black Man," draws on this same yearning imagery to lament Seifert's own imprisonment in the parochial heart of Europe. It is, in every sense, a Central European vision:

A fresh breeze blows on the ocean's shores
and between empty conches and pieces of washed-out coral
content black women prostrate they lie

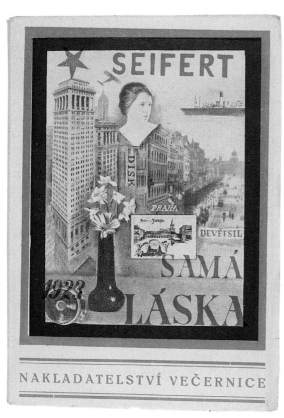

■ Otakar Mrkvička, cover design for *Samá Láska*, by Jaroslav Seifert, 1923

while the waves of the high tide slowly rise;
I believe it is a sad lot to be nothing but a European,
to this fate myself I cannot resign,
God, if only to sit in the shade of palms,
or like those black women on the shore to lie…
Oh, Master John,
first we must explode Europe to the clouds,
for until then are locked up and bolted shut
all those marvels and magic charms…[22]

It is not in Prague that magic is to be found. "Why, why did fate mete out to us to live our life / in the streets of this town on the fiftieth parallel line?" Seifert complains. Prague is pedestrian, mundane, a place where "life never derails in its trace," where "all emotion must wither before it even inflames."[23]

Still, he remembers, "There in the west on the Seine is Paris."[24]

Paris, "center of art and science, focus of contemporary culture, cradle of modern architecture," as it was described in an advertisement in Devětsil's magazine *ReD* for a tour guide to that city published by Jindřich Štyrský and his fellow painter Toyen (Maria Čermínová) in 1927.[25] The two

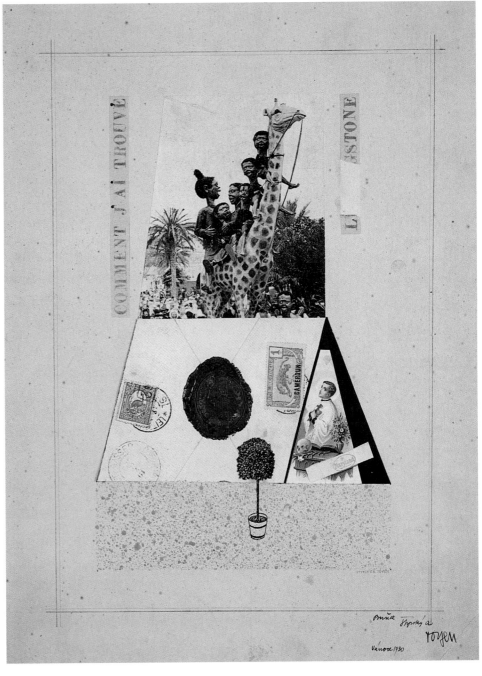

Jindřich Štyrský and Marie Čermínová (Toyen), *How I Found Livingston*, 1925, collage

Artificialists (as they were styling their then-abstract art) conduct us around "Musical Paris," "Fashionable Paris," "Literary Paris," and—inevitably—"Artistic Paris." They helpfully list the addresses of artists' ateliers.[26]

Štyrský and Toyen dwelt in the West on the Seine from 1925 to 1928, networking, exhibiting—Philippe Soupault, André Breton's collaborator on *Magnetic Fields*, wrote the introduction to the catalogue for their second Parisian show—drinking in all the beauties of the world:

At night, when the skies there light up with silver stars,
on the boulevards stroll crowds among numerous cars,
there are cafes, cinemas, restaurants, and modern bars,
life there is jolly, it boils, swirls, and carries away,
there are famous painters, poets, killers, and Apaches,
there new and uncommon things occur,
there are famous detectives and beautiful actresses,
naked danseuses dance in a suburban varieté,
and the perfume of their lace with love addles your brain,
for Paris is seductive and people cannot withstand.[27]

If Seifert cannot have Africa—or, like his hero in "The Sailor," possess "five sweethearts," taste tears dropping "onto bosoms that are red, black, yellow, brown, white"[28]— well, then, "Paris is at least one step closer to heavenly spheres."[29]

A couple of months before André Breton's visit to Prague in 1935, the Czechoslovak Surrealist Group staged their first exhibition in the same Mánes Gallery. On display were the paintings, sculptures, montages, and photographs of Štyrský, Toyen, and Vincenc Makovský. Here our erstwhile guides to Paris à la mode, Artificialists no longer, are transmuted into something altogether more weighty, historic, even.

Karel Teige wrote the preface to the exhibition catalogue. He begins by sternly reminding us that

SURREALISM IS NOT AN ARTISTIC SCHOOL

"To surrealists, art, painting, poetry, and theatrical creation and performance," he goes on to explain,

are not the aim, but a tool and a means, one of the ways that can lead to liberation of the human spirit and human life itself, on condition that it identifies itself with the direction of the revolutionary movement of history... The philosophy and world view of surrealism are dialectical materialism... And if the surrealists pronounce the word REVOLUTION, they understand by it exactly the same thing as the followers of that social movement which is founded upon the dialectical materialist world view.[30]

Three years earlier, Štyrský, Toyen, and Makovský had been among the Czech artists exhibited, alongside Arp, Dalí, Ernst,

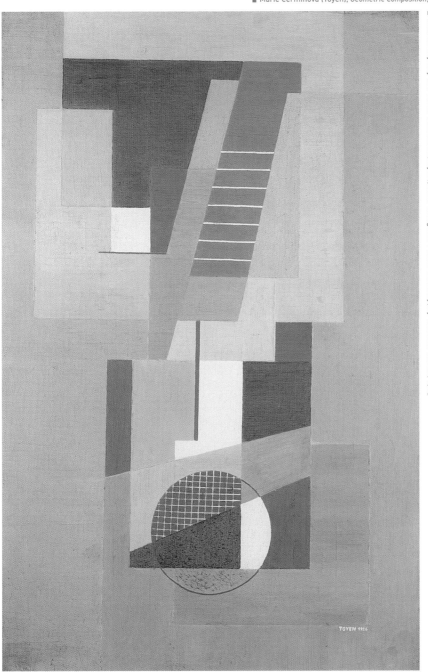

■ Marie Čermínová (Toyen), *Geometric Composition*, 1926, oil on canvas

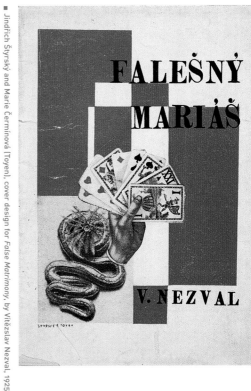

■ Jindřich Štyrský and Marie Čermínová (Toyen), cover design for *False Matrimony*, by Vítězslav Nezval, 1925

Giacometti, De Chirico, Klee, Masson, Miró, Paalen, and Tanguy, at the *Poesie 1932* show held at the Mánes Gallery. It was the largest Surrealist exhibition yet to have taken place anywhere in the world outside of France itself. Sutured into the displays of this self-proclaimed avant-garde—cannibalized, one might say—were a group of what were described in the catalogue as "negro sculptures."[31]

These wanderings have taken us a long way from Babička's Valley. Yet we have never once left Central Europe, any more than did Devětsil's picture-postcards, just complicated its location—its place not on the geographers' maps, but where it matters, in the landscapes of the mind.

Gutfreund, Josef Čapek, and other artists of the Skupina, too, were nourished by their periodic pilgrimages to the city of light—as was Alphonse Mucha, who made his name and for twenty-five years his home in Paris a generation earlier, when "the modern style" meant Art Nouveau.

Teige and Seifert also traveled further afield, though not to palm-fringed beaches on which black women loll. They followed up their Parisian summer of 1922 with a visit, as part of a delegation of the Society for Economic and Cultural Relations with the New Russia, to the homeland of the proletariat and cradle of the New World in 1925. Seifert was transported:

I believe that there is no modernity outside communism. When I was in Moscow, on the day of the anniversary of the revolution, I found myself caught up in the current of the enthusiastic crowd, which was rolling toward Red Square. In that moment I was dying with longing to become the poet of this people.[32]

DERANGEMENTS

Fifteen years after his visit to Prague, in a Europe that had meantime been exploded to the clouds and was busily rearranging its global spaces and times into a Surrealist landscape of First, Second, and Third Worlds, André Breton found it much more difficult to make himself understood in this corner of the world than he had ever imagined. His concern—an urgent one—was with the fate of Záviš Kalandra, the Communist journalist who had written so appreciatively in *Halo-Noviny* about his and Eluard's activities in 1935.

Kalandra joined the Communist Party in 1923, at the age of twenty-one. Along with wartime martyr Julius Fučík and future Minister of Information Václav Kopecký, he became one of the militant young newspapermen known as the Karlín Boys. He left—or was kicked out of—the party in 1936, and founded a left opposition journal called *The Proletarian*. He could not stomach the Moscow trials. Nor could Karel Teige,

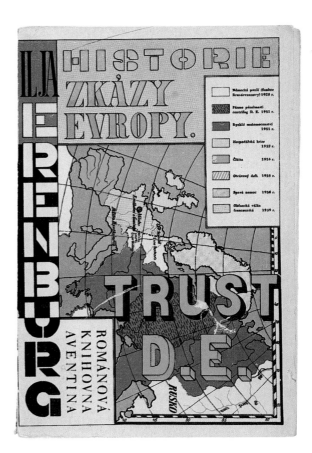

who was to equate the Nazis' infamous exhibition of "degenerate art" with Soviet denunciations of "monstrous formalism" when he introduced another Štyrský and Toyen show two years later at Topič's Salon.[33]

Then and there this conjuncture was much less thinkable than the beauty of a chance encounter between an umbrella and a sewing machine on a dissecting table. Vítězslav Nezval responded by "dissolving" the Czechoslovak Surrealist Group with the comment: "If Karel Teige was able…to chuck Moscow and Berlin into one basket, this testifies not only to a moral, but also—and above all—to an intellectual mistake."[34] Breton tried to reconcile Teige and Nezval, in vain.

In the same year as he parted ways with the party, Kalandra contributed to the Czechoslovak Surrealists' iconoclastic homage to the nineteenth-century Czech romantic poet Karel Hynek Mácha, *Neither the Swan nor the Moon*, which was edited by Nezval and illustrated by Štyrský and Toyen.[35] He spent the war in German concentration camps. Arrested for Trotskyism in 1949, he was piggybacked onto the trial of National Socialist parliamentary deputy Milada Horáková, the umbrella to her sewing machine.

One of Bohemia's more notable contributions to the theater of the absurd, the Horáková trial became an international cause célèbre. André Breton signed a telegram to the Czechoslovak government pleading for clemency, together with Jean-Paul Sartre, Albert Camus, Simone de Beauvoir, Max Ernst, and other prominent French leftist intellectuals. He also published a more personal "Open Letter to Paul Eluard," who had recently been a guest of the Czechoslovak government:

It is fifteen years since we, you and I, went to Prague at the invitation of our surrealist friends…and certainly you will not have forgotten how we were received in Prague then… Recall a man, who hovered around, who used to sit down often with us and really try to comprehend us, because this was an *open* man… I think you will remember this man's name: he is—or was—called Záviš Kalandra…according to the newspapers he was sentenced by a Prague court last Thursday to death, self-evidently after prescribed "confessions." You know as well as I what to think of these confessions… How can you in your soul bear such a degradation of a human being in the person of he who was your friend?[36]

Eluard's Olympian reply is infamous: "I already have too much on my hands with the innocent who proclaim their innocence to worry about the guilty who proclaim their guilt."[37]

Záviš Kalandra was hanged for treason and espionage in Pankrác Prison in Prague in June 1950. They did not sell postcards of the hanging, although they might just as well have done—that image is the opening line of a song written on the other shore of the modern world fifteen years later, Bob Dylan's "Desolation Row," in which Einstein bums cigarettes while Ezra Pound and T. S. Eliot duke it out on the bridge of the *Titanic*. "I had to rearrange their faces and give them all another name," Dylan says.[38]

The Czech Cubist Bohumil Kubišta, though, *was* transfixed by the specter of a hanging man, the head geometrically displaced on the neck. Perhaps he had in mind the fate of Czechoslovak legionnaires captured by the Austrians; or maybe he was just exploring modernist aesthetics. That picture was painted back in 1915.

Two years later, the circus was in town again. Prague hosted the still more spectacular show trial of former Communist Party general secretary Rudolf Slánský and thirteen other former high-ranking party and state officials. Ten of the accused, the official indictment took care to point out, were "of Jewish origin."[39]

One of those executed was Vladimír (Vlado) Clementis, who succeeded the defenestrated Jan Masaryk, son of Tomáš,

as Czechoslovakia's foreign minister. The airbrushing of Clementis out of photographs of party leader Klement Gottwald's address from the Kinský Palace balcony in the Old Town Square in "Victorious February" 1948 is notorious. It provides the opening scene of Milan Kundera's novel *The Book of Laughter and Forgetting*, setting the stage for the much-quoted line "The struggle of man against power is the struggle of memory against forgetting."[40] Jiří Kolář—who at the time of Clementis's hanging was penning odes to Stalin, but has lived in the West on the Seine since 1980—incorporates the original and doctored photographs in a collage dating from

1968, the year of the brief "Prague Spring," entitled *"But deliver us…"*

The accompanying text reads—"Malanthios: erasing Aristratos and replacing him with a palm tree, or, three socialist rules."[41]

Behind the balcony from which Gottwald harangued the masses is what used to be Franz Kafka's gymnasium classroom—and below it, what was once his father Herman's notions store. Now the notions store has become the Franz Kafka bookstore, a haunt much visited by tourists.

Josef Šíma, *Hot-Air Balloon*, 1926, oil on canvas

André Breton's other traveling companion to Prague in 1935 was the Czech painter Josef Šíma. Like his better-known compatriot František Kupka, whose place in the pantheon of modern art has never been in doubt, Šíma spent most of his adult life in Paris, where he settled permanently in 1921. He was a long-distance member of Devětsil who exhibited regularly in Prague, as well as a founder of the French group Le Grand Jeu. Though he was never a card-carrying Surrealist, his paintings depict landscapes of the mind as surely as do Miró's or Tanguy's or De Chirico's. Šíma is, perhaps, more lyrical. His objects—a female torso, an egg, a cube—drift in a world of soft colors, often verging on but seldom quite resolving into pure abstraction.[42]

I set foot in Veletržní Palace, which had been closed for twenty years after a devastating fire in 1974, for the first time in 1997. It was nice to see so many works of twentieth-century Czech art, which I was familiar with from reproductions, presented as an orderly sequence of avant-gardes in an appropriately modernistic setting.[43] But what struck me most, and stayed with me afterward—disassembling this self-contained tale of artistic progress—was not a painting or a sculpture. It was a found object, one might say, since I most certainly was not looking for it.

The picture, called *The Sun of Other Worlds*, was painted by Josef Šíma in 1936—the year after he returned from his trip to Prague with Eluard and Breton, the same year Kalandra wrote his essay for *Neither the Swan Nor the Moon*. The National Gallery purchased it in 1975. It is a typical Šíma dreamscape—perhaps it is darker in its hues than many. Or maybe that is just my imagination, as susceptible to Prague's necromancy, its seductions that people cannot withstand, as Breton's or Apollinaire's.

What made this into a jarring objet trouvé was not the picture itself but the words that the artist had carved into the frame—"To Vlado Clementis from his Šíma, 1948."

Josef Šíma, *The Sun of Other Worlds*, 1936, oil on canvas

MEMORIES

When he came to introduce a monograph on Toyen, who had now permanently exiled herself in Paris, in 1953, André Breton struck a more wistful, elegiac note. It is an era "[w]hen the sun, watched in anxious silence by myriad entreating eyes, plunges deeper into the water despairing as a cry..."

Though it still entrances him, Prague is no longer a *point de capiton* with which he can anchor an entire continent of the poetic imagination. He speaks now of "the repression already weighing on Prague, the enchanted capital of Europe."[44]

But he is not able to rethink its situation—the complexities, the ironies, the multiplicities of its modernities—in a story that is as much his own as Kalandra's. Where *Maldoror* would have been a useful guide, Breton's instinct for unexpected juxtapositions and chance encounters for once deserts him.

A faint but unmistakable aura of pure kitsch settles over the city on the fiftieth parallel, forever basking, like Seifert's black women on their African beach, in the imagined delights of Europe's ageless past. The old images take on a new poignancy as they recede into nostalgia:

Prague, sung by Apollinaire; Prague, with the magnificent bridge flanked by statues, leading out of yesterday into forever; the signboards, lit up from within—at the Black Sun, at the Golden Tree, and a host of others; the clock whose hands, cast in the metal of desire, turn ever backward; the street of the Alchemists; and above all, the ferment of ideas and hopes, more intense there than anywhere else, the passionate attempt to forge poetry and revolution into one same ideal; Prague, where the gulls used to churn the waters of the Vltava to bring forth stars from its depths. What have we left of all this now?[45]

1 This is the "hypothesis" to which participants were invited to respond at a symposium on "Exhibiting Central European Modernism" held at the University of California, Los Angeles, on June 4–5, 1999, in conjunction with the planning of the *Central European Avant-Gardes* exhibition. I delivered an earlier version of this paper, which is my own response to the hypothesis, at that symposium. Fuller discussion of many of the figures and events described here may be found in Derek Sayer, *The Coasts of Bohemia: A Czech History* (Princeton: Princeton University Press, 1998). I would like to thank Yoke-Sum Wong for encouraging me to write this paper, this way, at this time.

2 André Breton, "Surrealist Situation of the Object," in his *Manifestoes of Surrealism* (Ann Arbor: University of Michigan Press, 1972), 255.

3 André Breton, "Political Position of Today's Art," ibid., 214–15.

4 Article in *Halo-Noviny*, quoted in Mark Polizzotti, *Revolution of the Mind: The Life of André Breton* (New York: Da Capo Press, 1997), 413.

5 André Breton to Vítězslav Nezval, April 14, 1935, *André Breton: La beauté convulsive* (Paris: Éditions du Centre Georges Pompidou, 1991), 225.

6 Guillaume Apollinaire, "Zone," in *Alcools*, ed. and trans. Donald Revell (Hanover: University Press of New England, 1995), 2–11. I have slightly modified Revell's translation.

7 Franz Kafka to Hedwig W., *Letters to Friends, Family and Editors*, ed. and trans. Richard and Clara Winston (New York: Schocken, 1977), 41.

8 Franz Kafka to Milena Jesenská, *Letters to Milena*, ed. and trans. Philip Boehm (New York: Schocken, 1990), 212–13.

9 "Převodní zpráva k soutěžnímu návrhu na pomník Bedřicha Smetany v Praze," in *Otto Gutfreund: zázemí tvorby*, ed. Jiří Šetlík (Prague: Odeon, 1989), 249–51. On Gutfreund's art see also the exhibition catalogue *Otto Gutfreund* (Prague: Národní galerie, 1995).

10 Quoted in "Babička Vulgaris II," *Lidové Noviny*, July 23, 1994, 5.

11 F. T. Marinetti, "Against Xenomania: A Futurist Manifesto Addressed to the Leaders of Society and the Intelligentsia," in his *The Futurist Cookbook*, ed. Lesley Chamberlain, trans. Suzanne Bell (London: Trefoil Publications; San Francisco: Bedford Arts, 1989), 58–62.

12 Quoted in Karel Teige, "Le Corbusier v Praze," in Miroslav Masák, Rostislav Švácha, and Jindřich Vybíral, *Veletržní palác v Praze* (Prague: Národní galerie, 1995), 41.

13 Mucha's "Slav Epic" cycle is reproduced in full in Jiří Mucha, *Alphonse Maria Mucha: His Life and Art* (New York: Rizzoli, 1989), and (together with preliminary sketches and photographs) Karel Srp, ed., *Alfons Mucha: Das Slawische Epos* (Krems: Kunsthalle Krems, 1994).

14 S. A. Mansbach, *Modern Art in Eastern Europe: From the Baltic to the Balkans, ca. 1890–1939* (Cambridge: Cambridge University Press, 1999), 1.

15 *Nová Praha*, September 6, 1928, quoted in Masák, et al., *Veletržní palác*, 33.

16 "US Devětsil," December 6, 1920, reprinted in *Avantgarda známá a neznámá*, ed. Štěpán Vlašín, et al, vol. 1 (Prague: Svoboda, 1971), 81–83.

17 Philip Johnson, foreword to the 1995 ed. of Henry-Russell Hitchcock and Philip Johnson, *The International Style* (New York: W. W. Norton, 1995), 14.

18 Reprinted in Květoslav Chvatík and Zdeněk Pešat, eds, *Poetismus* (Prague: Odeon, 1967), 63.

19 Jaroslav Seifert, *The Early Poetry of Jaroslav Seifert*, ed. and trans. Dana Loewy (Evanston: Northwestern University Press, 1997), 93–94.

20 Seifert, "All the Beauties of the World," ibid., 91–92.

21 Examples of Devětsil's "pictorial poems" and other works are reproduced in the following exhibition catalogues: *Devětsil: Česká výtvarná avantgarda dvacátých let* (Prague: Galerie hlavního města Prahy, 1986); *Czech Modernism* (Houston: Museum of Fine Arts, 1989); *Devětsil: Czech Avant-garde Art, Architecture and Design of the 1920s and 30s* (Oxford: Museum of Modern Art; London: London Design Museum, 1990); *The Art of the Avant-Garde in Czechoslovakia 1918–1938* (Valencia: Ivam Centre Julio Gonzalez, 1993); *Karel Teige 1900–1951* (Prague: Galerie hlavního města Prahy, 1994); *Karel Teige: architettura, poesie-Praga 1900–1951* (Milan: Electa, 1996).

22 "A Black Man," in *The Early Poetry of Jaroslav Seifert*, 89.

23 "Paris," ibid., 58–60.

24 Ibid.

25 Advertisement in *ReD* 2, no. 9 (1929): 292.

26 Štyrský, Toyen, Nečas, *Průvodce Paříží a okolím* (Prague: Odeon, 1927).

27 Seifert, "Paris," in *The Early Poetry of Jaroslav Seifert*, 58–60.

28 Seifert, "The Sailor," ibid., 85–88.

29 Seifert, "Paris," ibid., 58–60.

30 *První výstava skupiny surrealistů v ČSR* (Prague: SVU Mánes, 1935), 3–4.

31 *Výstava Poesie 1932* (Prague: SVU Mánes, 1932).

32 Quoted in *Reflex*, 39 (1992): 68.

33 Karel Teige, *Výbor z díla*, vol. 2, *Zápasy o smysl moderní tvorby* (Prague: Československý spisovatel, 1969), 664. On the Nazi exhibition, see Stephanie Barron, *"Degenerate Art": The Fate of the Avant-Garde in Nazi Germany* (Los Angeles: Los Angeles County Museum of Art, and New York: Abrams, 1991).

34 Vítězslav Nezval, speech to students March 24, 1938, quoted in Ivan Pfaff, *Česká levice proti Moskva 1936–1938* (Prague: Naše vojsko, 1993), 130.

35 V. Nezval, ed., *Ani labuť ani Lůna*, facsimile reprint of 1st ed. of 1936, (Prague: Concordia, 1995).

36 André Breton, "Otevřený dopis Paulu Eduardovi, June 13, 1950," in *Analogon*, 1 (June 1969): 67. Originally published as "Lettre ouverte à Paul Éluard," in *Combat*, June 14, 1950.

37 Quoted in Polizzotti, *Revolution of the Mind*, 567.

38 Bob Dylan's song may be heard on the album *Highway 61 Revisited*.

39 See Bedřich Utitz, *Neuzavřená kapitola: politické procesy padesátých let* (Prague: Lidové nakladatelství, 1990), 16–17.

40 Milan Kundera, *The Book of Laughter and Forgetting* (London: Faber, 1992), 3.

41 Jiří Kolář, *Týdeník 1968* (Prague: Torst, 1993), plate 22.

42 For reproduction of Šíma's work see *Sima/Le Grand Jeu* (Paris: Musée d'Art Moderne de la Ville de Paris, 1992).

43 There now exists a thorough guide to the collection in English: Lenka Zapletalová, ed., *Czech Modern Art 1900–1960* (Prague, Národní galerie, 1995).

44 André Breton, "Introduction to the work of Toyen," in his *What Is Surrealism? Selected Writings*, ed. Franklin Rosemont (New York: Pathfinder, 1978), 286–87.

45 Ibid., 287.

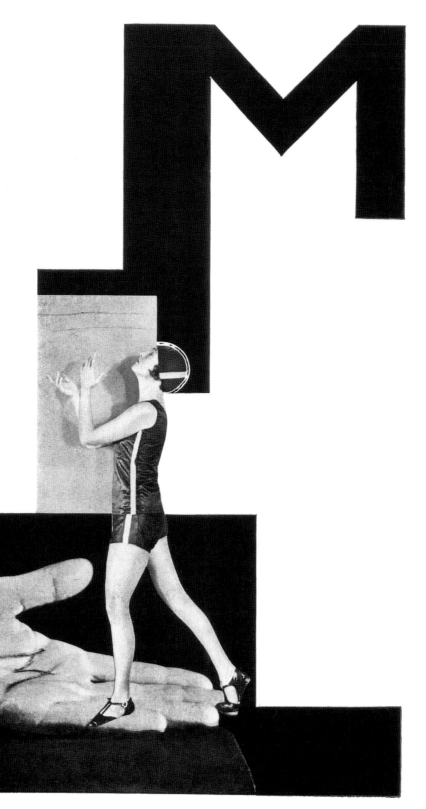

Karel Teige, design for the letter *M*, from *Abeceda*, by Vítězslav Nezval, 1926

Karel Srp

In the autumn of 1925 Karel Teige visited the Soviet Union as a member of the Czechoslovak delegation. More than by the latest artistic trends, he was captivated by scientific research concerning the economy of human movement in the work process. In April 1927 the journal *Fronta* featured photographic records of this research. The subtitle, "Russian Taylorism in the Gastev Institute," sounded promising to Teige. It was evidence that principles of productivity had migrated from the United States, where they supported the exploitation of the working class, to a country where they would be used to its benefit. The photographs published in *Fronta* dealt with "the most rational operation of firearms." Although the avant-garde had no great love for weaponry, with the exception of the Italian Futurists, in the same year as the *Fronta* publication Teige designed the jacket for Ilya Ehrenburg's novel *The History of One Summer*, on which a hand is aiming a revolver at the reader. This image captivated Teige so much that it also appeared in his later work, *Collage no. 68* (1939) as a clear phallic symbol, covering the head of a sitting female nude in the interior of a medieval church.

The photographs from the Gastev Institute can be understood as a paradoxical expression of the principles of economization and standardization, terms that became defining points for the common effort of the whole avant-garde. According to Bedřich Václavek, the main Brno theoretician for Devětsil, an immanent energy pervaded mechanical production, displacing humanity, which it was originally meant to serve: "Mechanization and functionalism have begun to successfully penetrate not only machine production but also the societal superstructure. Rationalization, standardization, normalization, and scientifically managed work, like the mass production of specialized and refined objects, are its last words, descriptive of the current order but at the same time evidence of its inescapability."[1] The principles are the same whether the system is capitalist or socialist, whether

the owner of the means of production is the state or a private individual, whether there is a smiling Soviet worker in the factory—as was featured in the propagandistic *Fronta* photographs—or an exploited slave, described in socially critical American novels.

The social and economic situation at the beginning of the 1920s changed the character of art practice, which wrenched itself free from the influence of bourgeois society and became a tool for society's critics. The change was powerfully noted by Walter Benjamin: "Artistic work, which in the past attracted the gaze…became a projectile in the Dadaist's hand. It assaulted the onlooker. It had a tactile quality."[2] This projectile also moved on a temporal axis. It bounced off the future in order to crush the present, and also off the past in order to alter the future.

Benjamin's emphasis on tactility may seem out of place from the perspective of the 1920s, when visuality was emphasized in an unprecedented way. However, Karel Teige's characterization of the art of this period, above all its shocking quality, absolutely supports Benjamin's idea.

SIGNALS OF OPTICAL WORDS

At the close of an article by Teige on the short history of photomontage, he apologetically declared: "In photomontage and *typophoto* the present day has a new type of writing and a visual language… We are stuck on the alphabet. Only through many experiments will we learn to use this new means of communication, this new way of writing. With it, we will be able to write new truths and new poetry."[3] The prototype for this visual language, in which, according to Teige's well-known declaration from 1923, the picture becomes a poem and the poem becomes a picture, was the collectively produced 1922 cover for the annual journal *Život* [Life]. This was the work of four figures of the growing avant-garde movement: architect (and *Život* editor) Jaromír Krejcar, Purist architect and

scenographer Bedřich Feuerstein, painter Josef Šíma, and theorist, critic, and typographer Karel Teige. The simple photomontage was composed of two pronounced motifs: a Doric column with the sea in the background, and a Praga automobile wheel with a Michelin tire. This cover, based on two concrete shapes, could be easily objectified into an abstract composition—an open horizon penetrated by a slowly narrowing plane, accented by a closed circle (which in its abstract form became the black disc, an important Devětsil ideogram). The root ideas that gave rise to this collective optical word are clearly drawn from Parisian Purism, which responded to the complexities of postwar life with simple, instantaneous comprehensibility. Though Purism grew out of the wreckage of prewar artistic movements, it was free from psychologizing and a fixation on destruction. It became an expression of the new order, in which emotion is governed by mathematical calculation. Purism had an identifiable absence of visual ambiguity. It was marked on the one hand by a strong relationship to modern technology, and on the other by an equal bond with Greek architecture. These motifs were eagerly conjoined in the pages of its main journal, *L'Esprit Nouveau*. In this way an arresting visual analogy was created between the latest automobiles and classical temples.[4]

Avant-garde periodicals played the most important role in disseminating this visual language. Their titles and covers in the 1920s greatly resembled each other, and so it wasn't immediately obvious in what country a journal was published. The changeable personnel moving from journal to journal in the first half of the 1920s found a mutual understanding through the new visual language. Lajos Kassák, for example, produced covers not only for his own journal *Ma* (1921), but also for Berlin's *Sturm*, the Yugoslavian *Zenit* (1922), and Bucharest's *Contimporanul* (1924). Through this migration there quickly took root a common avant-garde style, easily differentiated from other periodicals and comprehensible to a narrow but regionally widespread group of recipients. In contrast to the journals *Veshch*, *Ma*, *Zwrotnica*, and *Sturm*, whose covers were often printed from woodcuts, the cover of *Život II* was a manifestation of machine production, free of any handiwork. It was an elementary example of the visual language, meant to be concrete and optically vivid.

The whole conception of *Život II* vividly shows how the visual language of the newly formed avant-garde spread out of various European centers after the war. As its direct predecessors we can point not only to the Parisian *L'Esprit Nouveau*, whose ideas dominated the first half of the 1920s, but also

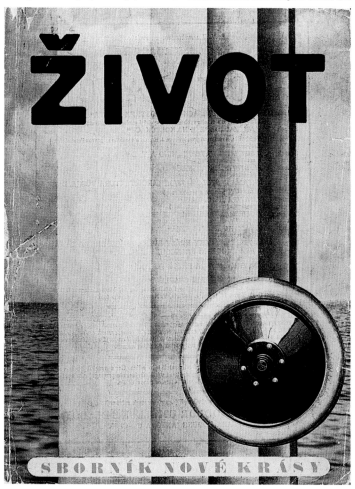

■ Jaromír Krejcar, Karel Teige, Bedřich Feuerstein, Josef Šíma, cover design for *Život II*, 1922

to Ehrenburg's book *It Does Revolve*, published at the beginning of 1922 (and partially reprinted in the Devětsil journal and in *Život II*), and to two issues of the trilingual Berlin journal *Veshch/Gegenstand/Objet* (March–May 1922), edited by Ehrenburg. The latter was important in the formation of the visual language through its typography, which was, thanks to El Lissitzky, more advanced than that of *L'Esprit Nouveau*, and also in the diversity of its content, ensured by the international environment of Berlin during that period. *Život II* was dependent primarily on correspondents. Among them were Ehrenburg, editor of *Veshch*; Charles Edouard Jeanneret and Amédée Ozenfant, editors of *L'Esprit Nouveau*; and Ivan Goll, subsequently to become the Paris correspondent for *Disk*, whose caricature of Teige came out in *Život II*, and who clearly stood behind a traveling exhibition of Alexander Archipenko, shown in Prague thanks to Devětsil.[5] Other collaborators on *Veshch* and *Život II* overlapped only in exceptional cases: Both journals coincidentally introduced Charlie Chaplin; although he obviously knew nothing about being a member of their international team, nonetheless the young avant-garde fortified itself with his name. While the environment of Berlin enabled natural contacts between individual contributors, the composition of the Prague collaborators on *Život II* was markedly Western in direction: it led through France to the United States, where it came to rest with Hollywood stars like Douglas Fairbanks and Mary Pickford.

The changeable personnel of the avant-garde journals in the first half of the 1920s found mutual understanding through the visual language, primarily a blending of modern technology and classical culture. A reproduction in *Veshch* of the stern of a ship with enormous propellers was entitled *Parthenon and Apollon XX*. Even more pointed was the confrontation between the biting blade of a railroad snowplow, reproduced in Ehrenburg's *It Does Revolve* and reprinted in the

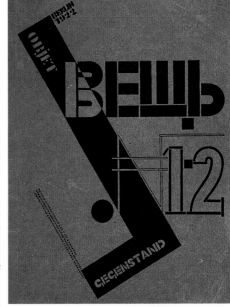

El Lissitzky, cover design for *Veshch/Gegenstand/Objet*, 1922 (no. 1–2)

■ Lajos Kassák, cover design for *Der Sturm*, 1922 (vol. 13, no. 11)

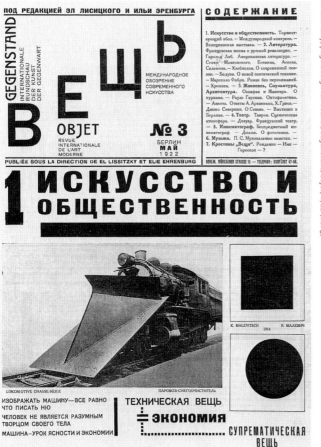

Blok, 1924 (no. 2)

BLOK CZASOPISMO AWANGARDY artystycznej № 2

CENA 3.500000.

Warszawa, kwiecień 1924 roku. — Redakcja i Administracja: ulica Wspólna № 20, m. 39.
REDAKCJA: Henryk Stażewski, Teresa Żarnowerówna, Mieczysław Szczuka, Edmund Miller.

Artyści tworzący dzieła bezinteresownie — bez celu pedagogicznego. Jednak dzieło jego potencjalnie zawiera pedagogiczne wartości: kształtuje styl epoki.

Nowoczesne dzieło sztuki, którego budowa oparta jest na zasadach, zbliżonych do zasad matematycznych, wpływa dyscyplinująco, koordynująco i mechanizująco na kształtowanie zewnętrzności przedmiotów wytwarzanych.

ARTYŚCI DZISIEJSI ALBO TWORZĄ BEZINTERESOWNIE W SENSIE SZTUKI MUZEALNEJ NOWEGO KLASYCYZMU (dzieło sztuki jako rzecz sama w sobie), **ALBO ODCHODZĄ OD SZTUKI Z JEJ ZDOBYCZAMI KU ŻYCIU PRAKTYCZNEMU.**

Artyści, zajmujący się dotychczas zdobieniem tworu techniki, stosowali doń formy, tradycyjnie przyjęte, pomijając tę okoliczność, iż formy takie nie łączą się w jedną nierozerwalną całość ze względami praktycznymi danego objektu. Ten sam błąd popełnia inżynier, technik i w rezultacie widzimy dziś np. mające tradycyjne kształty karety, ciągnionej przez konia, lub nowoczesny okręt, doskonale rozwiązany pod względem konstrukcji technicznej z bezsensownie zastosowanym stylem Empire'u, czy Renesansu w urządzeniu wnętrza.

Artysta nowoczesny rozumie, iż są to rzeczy karygodne. Nie wolno psuć piękna dzieł techniki. Nie należy nawet uzupełniać ich jakimiś dodatkami artystycznymi.

Konstruktywista, który przechodzi do warsztatów przemysłowych, nie uprawia sztuki zdobniczej, a — jako technik — przekreśla ją i tworzy rzeczy użytkowe, licząc się tylko z celowością ich, z materiałem i ekonomią. W ten sposób oczyszcza technikę z tradycyjnych pozostałości estetycznych i ukazuje piękno utylitaryzmu, jako nowy typ piękna wogóle.

ROBOCZY TANK

Nowa religią nos amis de nous envoyer des choses ph, ographies, dessins et articles en les adressant: Warszawie — Pologne, ul. Wspólna 20 m. 39.

Unsere Freunde werden gebeten uns Clichés Photographien, Zeichnungen und Artikel schicken zu wollen. Adresse: Warschau, Polen, ul. Wspólna 20, m. 39.

BLOK reprezentuje ludzi, związanych w bojową grupę hasłem bez względnej konstrukcji. W łonie grupy jednak zachodzą różnice kierunków, których przedstawicielami są poszczególni współpracownicy pisma.

Sztuka drukarska jest w Polsce zupełnie zaniedbana. Brak nowoczesnych czcionek i ozdób drukarskich utrudnia eksperymentowanie w tym kierunku.

Pismo nasze zapomocą środków, jakie rozporządzamy, dawać będzie nowe typy graficznego układu. Każdy numer pisma będzie coraz to inaczej pod tym względem rozwiązywany. W ten sposób wytkniemy nowe drogi w drukarstwie.

A Z
A Z

second issue of *Veshch*, and Malevich's 1914 Suprematist pictures composed of black squares and black circles. Both were referred to as objects—one as a technical object, and the other as a Suprematist object. In concert they exhibited an economy of form, terminology, and content. Jaromír Krejcar, editor of *Život II*, was so fascinated by this that he found his own reproduction of a railroad snowplow, even more austere and Constructivist. He placed it on a page beneath the reproduction of the deck of a steamship with the commentary: "Here are two masterful works of American technology. The purity of form, beauty of the proportions, specific usefulness— these characteristics should unconditionally set the example for architecture."[6] Ehrenburg's book became inspirational for the rising avant-garde of the 1920s. Aside from the snowplow, it also contained views of New York, and of airplanes, ships (Ehrenburg gave special attention to the ocean liner *Aquitania* and *Život II* to the *Vollendam*), and Tatlin's *Monument to the Third International*.

Technical and industrial products—most often machines and their parts—served as a source of confrontation with the artistic works of the whole Central European avant-garde. For example, in Kassák and Moholy-Nagy's 1922 *Book of New Artists* a Futurist image by Umberto Boccioni and a dynamo were contrasted; on a 1924 cover of the Warsaw journal *Blok* a Caterpillar tractor was featured. The majority of these correlations regarded the machine not only as an analogy, but also as a direct model, with which the artistic work was compared, even though from the very beginning the inadequacy of such comparisons was pointed out. Printed declarations, comprehensible to only a limited circle of readers, were replaced by the visual tropes of an international language, which wasn't dependent on written expression and was immediately "legible." The "nouns" of the new visual alphabet were often items related to transportation: ships, automobiles, airplanes, Caterpillar tractors, dynamos, ball bearings, motors, and tires, featured outside of their context. What was typical for a machine began to be asked of poetry: "Legibility-visibility-rapidity are characteristics that are as optical, filmic, graphic as they are poetic: transposition instead of description, indication of photogenic details, the optical system, rapid and unexpected technology, the life of images, mechanical precision, an atmosphere of simultaneous reality and dreams, ideographic schematization—this is a formulation of the order and standard of poetry, pictures, and film."[7] The most important organ for Teige remained the eye. The principles of machine production influenced the manner of perception. The eye was meant to adjust to them. Bedřich Václavek advocated

a similar concept: "The eye is our most important organ. Our generation is returning it to the primary position that it held in all great eras of construction. We see illuminated advertisements cast up on the sky. We expect optical poetry in the cinema. We perceive the world synoptically with our eyes: Its present multiplicity we gather into one picture. The synoptical view of the world: a synchronicity of images, colors, sounds, ideas, and forces…"[8]

The motherland of this new manner of communication was, according to Teige, the United States, where the new visual language was born quite naturally out of daily reality and began to spread: "Americanized Europe is becoming a single, chaotic, cinematic, great city, and the social transformation taking place there will sooner or later create a harmonious international place. In this Europe, the web of our dreams, there arises like clear movies the electrogenic poetry of illuminated signs, gaudy posters; what speaks to us are illuminated, lively boulevards, colored traffic lights and signs, the language of flags, nervously tapping Morse code, and the extremely abbreviated jargon of messages and emotions. This poetry in the midst of the world doesn't arrive in rhyming alexandrines."[9] The new visual language was directly emotive: "It's the poetry of the travel journal, the Eiffel Tower, the Baedeker, posters, postcards, maps, anecdotes, the grotesque; the poetry of nostalgic memories, because memories of a city are like memories of love; the poetry of cafés full of light and smoke, the song of the modern sirens of the Red Star Line, the traveler's poetry of long corridors, hotels, and ships…"[10] Every aspect of modern life contained poetic value. Its effect, as is evident in Teige's quote, was not limited to the sensory present.

The visual language of the contemporaneous world strangely also led to forgetting; it called up and liberated memories. This language, though forward-looking, possessed a certain melancholy, which came out of the simple recognition that the modern will be old by tomorrow, that a new model of car will replace the previous one, and that it will be produced according to the current demands of standardization. The visual language was formed out of the concrete, changeable matter of life, out of fleeting sensory experiences, out of a momentary sense of captivation, which remained in the mind as a memory. For example, Teige's mood by the sea during his second trip to France, in 1924, spontaneously grew into a strong visual experience: "The most beautiful evening of the whole trip was at a dance hall in Nice called La Plage Negresco: dancing above the sea, the waves breaking onto the shore, two lighthouses corresponding with light-signals, and

on the wooden platform jazz is thundering, and beautiful girls of various nationalities are dancing."[11]

This type of experience has a literary precursor in Baudelaire's book of prose poems *Le Spleen de Paris*. Baudelaire was probably Teige's favorite poet, whose *Fleurs du Mal* he seemingly knew by heart and would recite on various occasions. Prose poem XLI, "The Harbor," begins: "The harbor is a delightful shelter for a soul tired of life's struggles. The spread of the sky, the moving architecture of the clouds, the changing colors of the sea, the blinking of the lighthouse form a prism, strangely designed to entertain the eye without ever tiring it."[12] These two sensory experiences are marked by their times, but they express very different dispositions. Baudelaire's nineteenth-century ennui, which was always infecting the atmosphere of the early Devětsil, was veiled by the technical élan of the early 1920s. While Teige could perceive the lighthouse signals as words in the new visual alphabet, for Baudelaire the lighthouse was an emblem of the nostalgia of passing time and resignation over any sort of activity. For Teige modern life directly created the visual language, and its most topical example temporarily became the machine. From the perspective of the history of modern technology this can seem paradoxical, because the cult of the machine, which began in the nineteenth century, was ending. The machine had become a natural component of everyday life, no longer either adored or condemned. Art, on the other hand, which was in the eyes of the avant-garde a remnant from the nineteenth century, had stopped being a natural component of life. It seemed to be a superfluous, withering nerve. Only that which came out of the real needs of modern life could now be accepted. Otherwise one had academic art, which served the bourgeois class, or the anti-academic modernist art that still accepted the ideals of autonomous, individual work.

The city where Teige most directly perceived the effect of the new visual language was Paris, as is evident in a letter he sent to Ema Hauslerova during his first stay there: "Paris is certainly a beautiful city. There is truly life here, and where there is life, there is everything—beauty, industriousness, zeal, everything, everything. It's certainly no accident that the most beautiful forms of modern art arose in this city: But you know that this art, however interesting, is not nearly as beautiful as the life."[13] For Teige artistic form emerged from the needs of life and reflected life's dynamism. Perhaps that's why the Eiffel Tower retained its attraction for the young more than thirty years after it was completed. It became a fundamental example of technical construction and remained the first place that the steps of Central and Eastern European avant-gardists led to in the 1920s—a place that could be eclipsed perhaps only by skyscrapers. They had themselves photographed on the tower and made it the object of their own photographs, collages, and visual poems.

To verify his notions about the new beauty, Teige turned primarily to the United States as the source and originator of the visual language, or to the East, where this language was meant to find its content, since in 1917 a state was founded there whose goals were similar to those of the avant-garde at the beginning of the 1920s. The politically contrasting blocs had their distinct representatives, whose simultaneous activities Ehrenburg called attention to in his 1922 book *It Does Revolve*: "Who is today the most popular man in France, England, Italy, and other countries? There are two: Lenin and Chaplin. While enthusiasm for Lenin's name wakens insults and disputes, Chaplin's name causes blissful amusement."[14] Lenin and Chaplin became the role models for the new visual alphabet. Chaplin especially fascinated the young generation. Photographs from his film *The Pawnshop* (1916) were printed as the last reproductions in Ehrenburg's book and as the first ones in *Život II*. Ivan Goll's poem *La Chapliniade* (1920), accompanied by Léger's drawings, was reprinted in the book *It Does Revolve*, in *Veshch*, and in *Život II*. Chaplin and Lenin appeared unusually often in the verses of many of the Devětsil poets. Both figures were also utilized in collages, book jackets, and photomontages. (Chaplin, for example, appeared on book jackets by the Mrkvička-Teige duo and in the collages of Mieczysław Berman, Mieczysław Szczuka, and Avgust Černigoj; Lenin as the creator of the new world, standing astride one-sixth of the earth, was placed by Teige on the jacket of *ReD* in 1927, and on a poster for the tenth anniversary of the Soviet Union.) Ehrenburg's characterization of Chaplin as the "rigorous designer" was similar to the contemporary view of Lenin as the "great engineer," building the new world of a classless society from the foundations. If Lenin represented a sort of ruthless selflessness, then Chaplin stood for a freed unconscious.

POETRY INSTEAD OF ART

"What an exhibition that was!" recalled Karel Teige in 1938, in Štyrský and Toyen's monograph on the 1923 Bazaar of Modern Art in Prague. "We called it the Bazaar of Modern Art because we wanted to avoid the word 'exhibition,' which reminded us of the boredom that we had endured in official salons. We wanted to get along without the word 'art' as well, but we couldn't find a better term. The Bazaar was a diverse and provocative mixture of pictures and architectural projects,

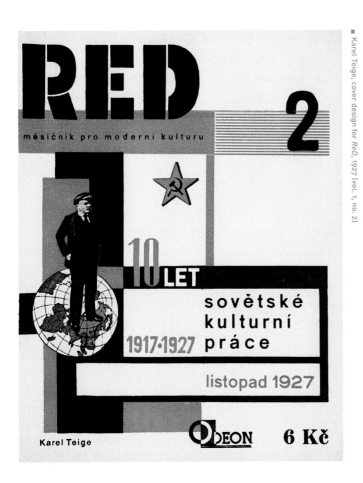

Karel Teige, cover design for *ReD*, 1927 (vol. 1, no. 2)

with photographs of the world, posters, and 'ready-made' objects. As on the pages of the almanac of *Život II* and other later publications of ours, modern pictures and poetry were featured side by side with photographs from the circus and the cinema and with other documents of real life. So at this bazaar as well, aside from a small number of pictures, drawings, and books, nonartistic objects and exhibits also provoked the viewer—in this context they were meant to be (in the words of the Futurists) 'a little field of ordinary beauty.' Next to each other we placed artistic works, machine parts, film stills, photographs of fireworks and circus shows—it was enough to give the sextons of the temple of art goose bumps."[15] The revolutionary spirit is still present in Teige's description. Over the years it has become clear that the Bazaar of Modern Art—of which no photographs have been found, only a list of exhibitors and an invitation—was more important in the history of Czech modernism than any other exhibition of the 1920s or 1930s. It can even be said that these two actions—the journal and the exhibit—dominated the whole of the Czech art scene of the 1920s: No other journal or exhibit was able to capture the attention of the public in the same way.

The Bazaar of Modern Art was incomparably more inspiring than the second Devětsil exhibit of 1926, in which pictorial poems were more widely represented. It opened new roads to actual installations, which were not common in Czechoslovakia at that time. From the very first it was a purposefully drafted artistic gesture. Thanks to its name and to four exhibited objects—ball bearings, a wax wigmaker's dummy, a mirror, and a life preserver—it was connected by the critics of the times with the 1920 Berlin Dada Fair. (Josef Čapek, a representative of the original Cubist-Expressionist generation, who didn't have any special sympathy for Teige and Devětsil, remarked in a review that the exhibit of four objects had taken place "as it already did in Germany." In fact this type

of authentic object was not exhibited at the Dada Fair; the connection was mainly in the names.) The programmatic goals of the two exhibitions were different. The strongly anti-militaristic, politically engaged, self-promoting nature of the Dada Fair contrasted with the Bazaar of Modern Art, the ideals of which had little in common with Berlin Dadaism. The Bazaar of Modern Art represented the whole spectrum of expressions of that generation, including distinct schools of architecture. Nevertheless, these four imported objects eclipsed the personal artistic works of the Devětsil representatives. Art historian František Šmejkal determined many years ago where the Bazaar's organizers found the inspiration for their choice of single objects, pointing to sources more contemporary than the Dada Fair. The choice of the ball bearings was inspired by the photography of Paul Strand, published in the magazine *Broom* in November 1922. The mirror, with the caption "Your portrait, viewers," paraphrased an idea of Philippe Soupault's from the Paris Salon Dada (1922), which coincidentally was taking place at the time of Teige's first visit to Paris. The dummy might have been prompted by de Chirico's paintings, and the life preserver emphasized Devětsil's interest in ocean voyages and steamships. Šmejkal noted that these objects were unsigned and that their choice was most likely a collective one. In this respect they differed from Duchamp's ready-mades, though they had the same status as objects.

The Bazaar of Modern Art was most likely the only exhibit in Central Europe during the 1920s in which concrete objects appeared. There are a number of reasons why these specific objects were chosen. Aside from the fact that they retained the identity expressed in their primary function, they were meant to shock the bourgeois public by appearing in an art exhibit. They were also meant to be the first words of Devětsil's new language, as vivid and comprehensible as possible. Like Duchamp's ready-mades, the objects of the

Wigmaker's dummy from Devětsil exhibition, Prague, 1924

Illustrations from *Disk*, 1923 (vol. 1, no. 1)

LIPCHITZ

KULIČKOVÁ LOŽISKA

MODERNÍ PLASTIKA

ZADKINE

Modern Art Bazaar represented a tool for critiquing the art of the times. The ball bearings and the dummy questioned the very meaning of the term when they were referred to as examples of "modern sculpture" in the Bazaar's catalogue. The mirror served as an ironic commentary on portrait painting, which, according to Teige, has been replaced by the "unpretentious products of the photography studio." Only two of the four objects were represented in the catalogue list. In the category of "Film, Machines, Airplanes, Ships" the ball bearings and "fashionable sculpture" were included as "modern plastics." The mirror and the life preserver, not included in the catalogue, most likely fell under the last category, "The Theater of the Street and the Biomechanics of Sports."

The import of this vivid act is evidenced by Walter Benjamin's reflections from the 1930s concerning the relationship of sculpture and painting to photography and montage. In "The Author as Producer" he reminded the reader that in Dadaism the "most insubstantial piece of everyday life says more than painting."[16] In Paris, the capital city of the nineteenth century, "photography has led to the destruction of the great profession of the miniaturist portrait painter."[17] Of artistic work in the age of technical reproducibility, he wrote, "the decline of sculpture in the age of the montage of artistic works seems unavoidable."[18] Benjamin's observations are evidence of the lasting relevance of the opinions that Teige asserted at the beginning of the 1920s in Czechoslovakia.

Strand's photographs of ball bearings were also published in the first issue of Disk (1923) and in Teige's book Film (1925). They served a different goal in each place. In Disk Teige placed the photograph in the middle of the page between two post-Cubist sculptures, by Lipchitz and Zadkine; all three reproductions were united by the title "modern plastic arts." In Film, beneath the reproduction of ball bearings Teige printed Ingres's well-known statement that "beautiful shapes are flat surfaces with rounded edges," along with three programmatic concepts, each set in different type: "Mechanical beauty. The photogenics of steel. The constructivist esthetic of the machine." Each of these phrases suggests the idea that a useful industrial product has aesthetic qualities, aside from its functional aspects, belonging to its immanent character but until then not discerned. The dominant idea of the avant-garde of the 1920s was vividly featured in the ball bearings: a functional object, a technical product that keeps machines in motion, began to be seen not only as something beautiful, but was even declared to be art, which in radical moments it was meant to substitute for. As an industrial object ball bearings

had quite a long history, going back to the days of Seurat. Since about 1883, around the time that the Eiffel Tower was conceived, ball bearings were made in the German town of Schweinfurt by Friedrich Fischer. They became a focus of attention for artists almost forty years later, when this much-used item became a visual word on which the avant-garde agreed. Aside from Strand's photographs they appeared in Man Ray's still life Danger (1920), in the collages of Hannah Höch, and on an advertising kiosk proposed by Lajos Kassák. Printed in boldface on Život II were Marx's comments on the ambivalence of the machine, which is "in the hands of the capitalist the most powerful tool of despotism and enslavement," and yet enables the "maintenance of true socialist system of production." In the early 1920s this dichotomy was strongly aestheticized. The machine part was admired for the beauty that came out of its function, not for the beauty of the function itself.

Ball bearings were a clean, perfect technical product, apparently without a past, standing almost outside of time and space. Wigmakers' dummies, on the other hand, could be seen in window displays, which drew the attention of the Surrealists in the late 1920s and early 1930s, and were photographed by Eugène Atget before the First World War. Even though both objects appealed to the avant-garde, their character was not at all avant-garde: they extended the boundary of the nineteenth century into the twentieth. The temporal break between eras was only an apparent one. Teige proclaimed that it was still possible in the 1920s to see circus acts in Paris just as Seurat had seen them in his day. A reproduction of Seurat's Circus was printed on the back cover of Život II, thus forming a complementary whole: technology and the classical era on the front cover as examples of the "high" style, and a "lower" form of social entertainment on the back. Seurat, long dead at that point, was even named as a Devětsil collaborator.

The goal of the Bazaar of Modern Art was above all to damage the conventional, endlessly repeating clichés of painting and sculpture exhibits from within, in such a way that not only critics would remark on it. Thanks to the Bazaar a meaningful change took place in the history of Czech exhibitions: the main bearer of artistic expression ceased to be the autonomous, unique work and now became the exhibition as a whole, composed of many diverse elements subordinate to the intentions of the program. The notorious penetration of "authentic reality" into the exhibit hall, where the mirror warns viewers that their role is not only a passive one, but that they also determine what art is, encroached on the

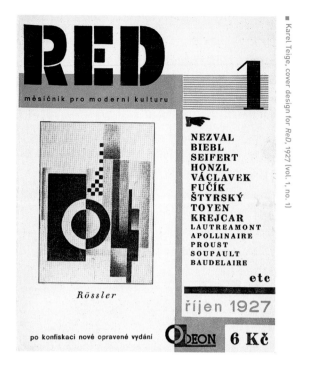

Karel Teige, cover design for ReD, 1927 (vol. 1, no. 1)

border between art and reality. It was much easier to declare objects as art when they had not previously fallen into this category than it was to identify with Ehrenburg's thesis, printed in boldface in *Život II*, "The new art will cease to be art." Ehrenburg envisioned a purifying upheaval during which the concept of art would be relieved of everything that had been layered onto it in the previous century. However, the dynamism of art and life was leading in a different direction than Teige had perhaps originally thought. It was as if art contained a self-revitalizing potential. Instead of blending into real life, art incorporated elements of reality that had hitherto stood outside of itself.

The use of the four objects at the Bazaar of Modern Art remained unique for a long time. Devětsil didn't return to these or other objects in the following years in seeking a transformation in the understanding of artistic works, nor were they used to create assemblages. They served only as a momentary, vivid example. In contrast to the Surrealist objects of the 1930s, they gained their relevance primarily from visual persuasiveness, their clearly legible meaning and use. They were understood above all as objects brought into the exhibit from the outside world, which had only temporarily changed their location and after the exhibit would return to their ordinary habitat.

After the Bazaar of Modern Art the next step was showing artwork in an environment that was not meant for it. The Polish group Blok took this the furthest. In 1924 their members appeared simultaneously in two Warsaw automobile showrooms: Henryk Berlewi was photographed among Austro-Daimler cars, and the remaining members of Blok exhibited themselves at Laurin-Clement Company.

THE SANCTUARY OF PHOTOGENICS

One of the frameworks in the 1920s for the realization of the visual language and its optical word involved a way of working with film and photographic images that concerned their expressive means as such. The term *photogénie* [translated here as "photogenics"] was coined after the First World War by the Paris film critic Louis Delluc. This concept, which he used as the title of a 1920 book (a partial translation of which was printed in *Život II*), especially helped the Czech avant-garde to clarify their relationship to film. Delluc's books *Charlie Chaplin* (1921) and *Drames de cinéma* (1923) were translated into Czech. Teige named the United States as the "sanctuary of photogenics," although he had never visited and knew it only from newspaper photographs. This however, didn't prevent him from admiring its metropolitan agglomerations, its ports and its neon advertising, although never its natural beauty: "The photogenics of the avenues of the southern tip of Manhattan, the skyscraper-city of New York with its glowing electric signs—this everyday experience alone can call up deeper feelings, and can be more poetic, than any kind of artistic work. And presently you will see Harold Lloyd, with his toothy face, black hair, black-rimmed glasses, straw hat, dark coat, and gray trousers—the whole doctrine of photogenics in the attire of this person."[19] Teige didn't remain uncritical of the imitation of historical styles applied to skyscrapers, the interiors of cinemas, and in decorative details. He regarded such attempts as decadent. If Lloyd embodied in film the perfect example of photogenics to Teige—even more characteristic than Chaplin, who was presented as a model by Delluc—then in photography Teige's exclusive representative was Man Ray, the only photographer in the Modern Art

118

Bazaar, featured with his album *Les champs délicieux* in the category "Mechanical and Photogenic Art."

Teige applied the same principles to photography and film. Thanks to the harmonizing legitimation of photogenics one can speak of "pure film," which has no "literary action" and which exists "only through film-events: through motion." According to Teige this photogenic quality is simple but nonetheless difficult to achieve: "Photography, ingenious reproduction, transparency, concealment, and nothing more… The black-and-white of film in motion."[20] The most successful such films were, as a rule, short, lyrical études, minimizing dramatic narration. These principles had a direct parallel in avant-garde photographs, whether those of Jaroslav Rössler, whom Teige had known since 1923, or Jaromír Funke. Rössler precisely realized Teige's program theses. Before Teige commissioned him to make a cover for the first issue of *ReD*, Rössler had made several photographs that appeared to be on the edge of abstraction but were made concrete by specific, often trivial, physical details. This type of shot matched Teige's requirement of film, which was not meant to be completely abstract, because its viewer requires "A least one little word. At least one optical word."

■ Jaroslav Rössler, *Abstraction*, 1923, photograph

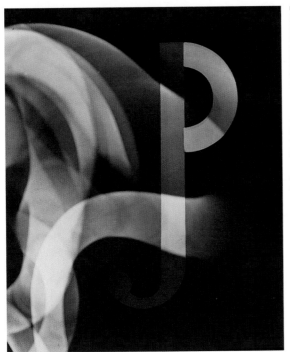

■ Jaroslav Rössler, *Abstraction (PJ)*, 1929, photograph

Jaroslav Rössler, *Radio Marconi*, 1926, collage

As a rule Rössler chose details that were connected to contemporary civilization.

More than any other member of Devětsil, Rössler was interested in radio receivers and transmitters. This was obviously a response to the onset of public broadcasting, which remained, however, at the edge of Devětsil's attention, in contrast to film. The stimulus of the new and accessible medium resulted in several photographs and collages: Rössler photographed himself in front of a radio receiver wearing headphones, and later he used single motifs—transmitters, amplifiers, and receivers—in collages such as *Radio* (1925) and *Radio Marconi*

(1926). These motifs corresponded to Teige's theories: Poetry was, in his view, a machine product.

Jaromír Funke understood photogenics differently from Rössler and Teige. He didn't particularly accept Teige's high estimation of Man Ray's album *Les champs délicieux*. He found photogenics mainly in Man Ray's relationship to ordinary objects, as evidenced by his *Egg in a Glass*, reproduced in *Život II*: "*Egg in a Glass*, with its oval shape and rich light, provides a singularly beautiful picture of everyday life. The ordinariness that contains beauty is well photographed by a capable hand and a perceptive mind. Man Ray's great contribution consists

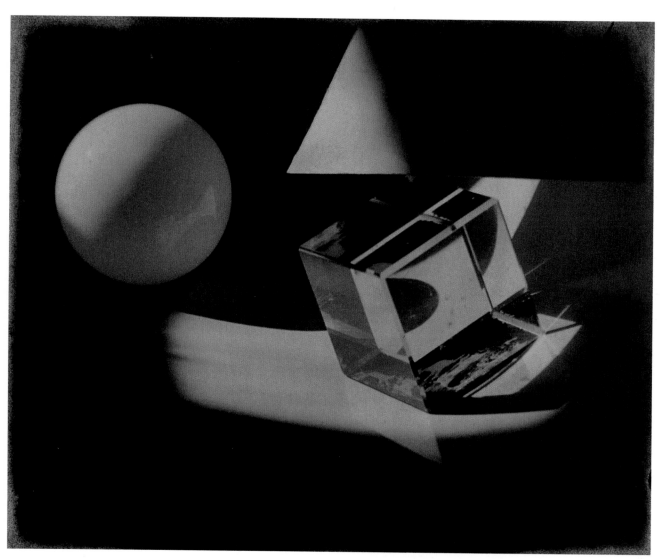

■ Jaromír Funke, *Composition: White Ball and Glass Cube*, 1923, photograph

in these things. It was a great discovery, which he made through the representation of tones of light combined with a beautifully formed sculpture."[21] In contrast, the experiments later called "rayograms" were considered by Funke to be "an infatuation with principles and an overestimation of the photogenic capacity of the photograph by itself."[22]

Film and photography had a different goal than to be in constant dialogue with their medium. They became avant-garde at the moment when they began to move the boundary of their own expressive means, when they made their machine foundations specifically thematic. As an example of modern photography, even before the advent of the photographic avant-garde, Teige pointed to photojournalism, reporting on the world around, never on itself. Although Teige never stopped emphasizing the importance of mechanical reproduction for cleansing the artistic process of the individual's mark, it was photography that reemphasized the necessity of the individual view, not for the subject, but for the specific technical means of its realization.

THE MACHINE AND EMOTION

In Teige's view the most important thing for the Czech avant-garde of the 1920s was the suppression of individual expression in works of art. The temporary goal, expressed in their program declarations, became the increasing use of reproductions, an aspiration realized through the use of machinery. The inside back cover of *Život II* ran an ad for the Smichov firm Neubert showing a photograph of a man standing next to an enormous copying machine, which gives the impression that it's about to devour the person it is supposed to serve. Other magazines published around 1920 showed photographs of workers so surrounded by machines that there was no escape. Although Teige always asserted that even in the machine age the human being remained the measure of all things, machines themselves skirted this claim: people slowly became servants of the machine, which robbed them of their individuality. Pictorial poems, an example of work made for reproduction, were meant to be mass-distributed on postcards, according to Devětsil's ideal vision. The paradox was that though photography and film were valued by the avant-garde above all because they enabled machine reproduction, the medium itself was not especially obvious—it remained as a sort of mute witness. The reason why so few originals of reproduced pictorial poems were retained came unmistakably from the fact that they were designed only for printing. Printing blocks saved money and time. Publishers borrowed them from each other instead of photographs,

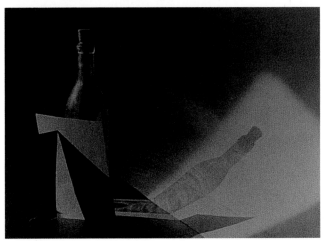

■ Jaromír Funke, *Composition*, c. 1921, photograph

■ Jaromír Funke, *After the Carnival*, 1921, photograph

from which they would have had to remake blocks. A printing block became more acceptable than a photographic copy, which was already the reproduction of the original, whose fate most of the authors of pictorial poems were not much interested in.

The machine, according to Teige, contributed to the simplification and increased effectiveness of production. It not only suppressed manual work but could be used specifically for the realization of artwork, perceived until then only as an individual matter. Here was an embryonic formulation of the ideas that distinctly influenced the artistic scene in the 1960s and 1970s: By means of reproduction a new definition of "original" was found. It is, however, emblematic that today original vintage prints and authentic pictorial poems are much more highly valued than their reproductions. The coveted originality is once again sought—that which was meant, in its day, to be replaced by mass reproduction, thanks to which the work of art became an overriding social phenomenon meant for a wider public. Accessibility and comprehensibility were decisive—qualities that were not fundamental for the preceding generation of prewar avant-gardists, whose works were understood by only a narrow circle of viewers and an even smaller share of potential buyers. Characteristics taken from machine production were transferred to artistic work, and Teige's conception of visual language played a mediating role in this process. For him it was expressed most of all in typography, which was "extremely elastic, exemplary, clear and rapidly legible…"[23] A poem was meant above all to express itself as a visual signal, in which the words would be secondary. In the poem "Premier Plan" Nezval mentions city searchlights, "which wrote on the clouds in the terse poetry of light-signals."[24]

Reverence for the perfection of machines seemed limitless. While Teige declared America to be the continent of photogenics,[25] Jaromír Krejcar considered it the homeland of

Josef Šíma, *Portrait of Auguste Perret (Paris 1922)*, illustration in *Život II*, 1922

the machine. According to him America "has no art in the academic-esthetic sense, but the form of its products speaks a new language, incomprehensible to art historians."[26] Krejcar illustrated what this language was like with a comparison of two cars—one from the turn of the century and the other a 1923 model: "The more perfect the form, the more beautiful it is. A form that is absolutely perfect, useful, precise, and unchanging—a standard, a poem of purist aesthetics—is and always will be the most beautiful form."[27] This standard cannot, however, be unchanging, as is clear from technological developments; it is primarily an ideal degree of technological quality, whose gradual changes art should reflect.

The concept of the machine led Krejcar to seek examples from past cultures and civilizations that would correspond with modern technical products. He compared the functionalism of a Düsseldorf operating theater to a burial ground in Lima, and he dedicated himself to Tibetan architecture and the

designs of transatlantic steamships. *Život II* featured the most progressive trends in current world architecture. While Teige ensured contributions to *Život II* from Amédée Ozenfant and Le Corbusier, it was thanks to Krejcar that Peter Behrens and Frank Lloyd Wright were also given significant space. In the background of these contributions appears a limit, beyond which the admirers of machines did not want to go. This came out of the comparison between the Eiffel Tower and Vladimir Tatlin's *Monument to the Third International*. Krejcar felt that the use of machine esthetics always had to be justified functionally: "Why is Tatlin constructing a monument to the Third International, with various official meeting rooms, in the form of a tower? This is nothing but blind imitation in the fever of machine delirium, which transplants without proper consideration certain achievements to a place where they are inappropriate and lack usefulness."[28] Teige had similar reservations: "The tower is a useful form for a wireless telegraphic station, an observatory, a watchtower, a lighthouse—not for a congressional hall."[29]

The fondness for machines was double-edged. The initiators of comparisons between works of art and machines, coming mainly out of the *L'Esprit Nouveau* circle, disengaged themselves from this trend in the second half of the 1920s. In a response to an article by the Brno editors of *Fronta*, Amédée Ozenfant even warned of "the danger of love for machines. Even though we admire the beauty of some mechanisms, we are aware that the goal of the mechanism is usefulness... The aim of art is emotion; the aim of the machine is energy."[30] Emotion arising from the beauty of a machine must confirm its functionality. Overvaluation of the original avant-garde perspectives brought about a marked split of art into abstraction and Surrealism in the second half of the 1920s. As soon as the communicative and the emotive elements began to be separated—and even placed in opposition—it brought about a marked intensification of Teige's original visual language,

which was founded on the emotive resonance of communication emerging from its functional basis (for example, Teige's fondness for lighthouse signals and neon advertising). The originally simple lineage—function–form–beauty–emotion—taken from machines, in which the first quality undermines the following ones, had its limits, which were expressed in the second half of the 1920s. The division of visual language into communicative and emotive aspects, worked out by the semioticians Roman Jakobson and Jan Mukařovský, led on the one hand to the autonomy of the esthetic object, and on the other to a pointed criticism of the capitalist way of rationalizing production.

FRONTA AS A SOCIOLOGICAL FACT

Though the avant-garde incessantly proclaimed its support for the proletariat in the latter part of the 1920s, artists were not successful in convincing the working class to accept avant-garde art as its own. This conflict increased to an ever greater extent in the next decade. It was reflected in the April 1927 issue of *Fronta*, whose austere cover by Zdeněk Rossman was dominated by a red circle in which the title of the journal was printed, a sign of collective revolutionary effort. It is, however, paradoxical that *Fronta* was published precisely during the period when the distance between the avant-garde and the public was greater than it had been throughout the 1920s. Even though *Fronta* remains in the shadow of the early Devětsil journals such as *Devětsil* (1922) and *Život II* (1922), it filled a vacancy in the period when *Disk* and *Pásmo* had stopped publishing and *ReD* hadn't yet begun. The subtitle was "an international journal of current activity." The Brno editors František Halas, Zdeněk Rossman, and Bedřich Václavek opened with a blunt declaration, translated into German and French: "We print everything in lower-case letters, because it saves time and materials. Why use two alphabets, when one is enough?"

They quickly amassed contributions from 150 authors, mostly reacting to questionnaires that had been mailed out (but which were not published). They remarked: "All contributions are original, written for *Fronta* and printed from the manuscripts." In this way they created a unique collection of statements on the current state of art and culture, oriented toward German-speaking countries, or to authors writing in German. The magazine primarily devoted itself to abstraction and Functionalism, and to a small degree Surrealism. The goal was not to push a certain artistic direction but to bring about a split in the avant-garde. *Fronta* opened with a collective foreword and ended with Václavek's extensive afterword (in which he elaborated several theses from the foreword, so it can be assumed that he was its main initiator). Although the editors didn't write a manifesto, they did have a certain position: "Art today is not any kind of direct force in life—it's not capable of usefulness. Therefore it is necessary to remove all specific uses from it, to cleanse it of elements which are nonfunctional, and reduce art to the only function it can fill. That is the only way: an art that is 'pure,' 'abstract,' absolute, elementary. But here is the question: Does art still have any legitimacy in life?"[31] Such radical questioning of art's role provoked a rejoinder from Kurt Schwitters, published in *Sturm* (July/August 1927) and then subsequently translated in *ReD* (October 1927), and signed by the group Die Abstrakten Hannover: "The legitimacy and goal of art in life is the creation of new people, who will create the new society."

While Die Abstrakten Hannover saw the "evolution of art unconditionally in the direction of abstraction," the approach of the *Fronta* editors was more open. The role of abstraction, calling more and more attention to itself after 1925, was understood by Teige and Václavek in different ways. Teige saw in abstraction the "induction of emotion," in which the "quality of these emotions, which the work awakens in the viewer, is a measure of the worth of the work." Václavek, on the other hand, saw how an originally complex culture was differentiating, so that the "social function that art still has today—to be a form for emotional human life, or better, for esthetic experience, esthetic accents within perception—is very narrow…"[32] Art had not merged with life, but was eking out a living somewhere on its outskirts, like its creators. The one-sided restriction of art to a mere source of emotion, the result of which was a reduction in depiction, caused art to cease to be understandable to the general public. As a result, Václavek began to distinguish "experimental, laboratory art," which is "today furthest from the masses," and art of the

Vítězslav Nezval and Karel Teige in the Liberated Theater, Prague, 1926

šíme na formu písma budovanou na základ-
ních tvarech. Dosud se pracuje s písmy in-
dividuelního výrazu, jako důsledku psací
techniky, které svou dekorativní formou
odvádějí pozornost od obsahu. Proto je
třeba dáti přednost písmům výrazným
(grotesky), která však, jsou-li použita ve
velkých plochách s dlouhým textem, tedy
jako dílové písmo, způsobují nesnadnou

barvení. Stará typografie nevyuživa funkce
papíru (příčina v řádkování na osu) jako
důležité součásti tiskopisu. Nová typogra-
fie svým asymetrickým systémem uplatňu-
je papír jako optický prostředek. Nejed-
notnost základních formátů papíru, svízelná
a nehospodárná, je jeho nepraktickou vlast-
ností. Všeobecné užívání normalisovaných
formátů vyžádá si asi ještě dlouhé doby.

abcdefghi | abcdefghi
jklmnopqr | jklmnopqr
stuvwxyz | stuvwxyz

herbert bayer: návrh jednotného písma | k. teige: návrh reformy bayerova písma

písmo bez rozdílu mezi velkou a malou abecedou. Písmena g a k považuje bayer za nedefinitivní. teige navrhuje
reformu písmen a, g, k, v.

socialist period, which would have its day after the defeat of
capitalism and imperialism and would only then express the
merging of art and life.

The authors of *Fronta* anticipated a wider reception for their
achievement, but abstract art was facing a time of minimal
public interest. Its creators, who had different aims than
the pioneers of abstraction, found themselves in an equivocal
position. Rather than eliciting a response from people in
everyday life, they were communicating primarily among
themselves. Václavek noted this indirectly when he men-
tioned the inadequate reviews of *Fronta* in Czechoslovakia,
in contrast to the increased interest elsewhere: "The critical
reaction was really weak. Was *Fronta* not provocative enough
to disturb anyone? Or is it that our opponents can really no
longer come to terms with us? While we happily read letters
from abroad—what is being polemicized about *Fronta* in
Germany; the interest in *Fronta* in the U.S.S.R., Romania,
Poland, and Finland—so far we have been able to read only
one domestic encounter with *Fronta*: it was the letter of a
worker, from prison."[33]

Fronta had published ideas that represented a retreat from the
original avant-garde positions of the 1920s. Ehrenburg and
Ozenfant, for example, began to move away from their early,
often extreme theses, which sometimes had a distinctly jour-
nalistic tone. Teige declared that it was necessary to defend
Ehrenburg's original perspective, in the book *It Does Revolve*,
against its author's later statements. This book remained the
"first manifesto of Constructivism" for Teige. Although he
never stopped regarding it as a discovery, and maintained
its relevance, he remarked that "when [Ehrenburg] lectured
in Prague in 1923 as a guest of Devětsil, he was no longer in
complete agreement with his book…"[34] Ehrenburg departed
definitively from his original theses in the second half of the
1920s. Jiří Voskovec, among the more promising members of
Devětsil, satirized in *Fronta* the single-minded idea of progress.

He was aiming at two main motifs of *Život II*—that "the
new art ceases to be art," and that modern technology is
beautiful, an idea coincidentally proclaimed by Ehrenburg
and Ozenfant: "Mr. Ehrenburg has long since forgotten us…
The eyes of the public have long since fallen from 'the poetry
of drills and central heating.'"

KAREL TEIGE'S TWO ALPHABETS

Typography was central to Karel Teige's artistic concerns,
and in the second half of the 1920s he was involved with two
different projects concerning the alphabet. One was a pro-
posed reform of four of the letters in Herbert Bayer's alphabet
design. He respected Bayer's types, although he used them on
book jackets only occasionally. He determined that he should
"create a single type without upper- or lower-case letters"
and that Bayer's type "…is an improved new form that is
leading to the perfecting of type with regard to the required
simplification…"[35] After several years of effort he changed
the letters *a*, *g*, *k*, and *x*. The other project was the opportu-
nity to supply typographical accompaniments to the dance
creations of Milča Mayerová, which were inspired by Vítězslav
Nezval's *Abeceda* (Alphabet, 1926).

According to Nezval, in *Abeceda* he was reacting to current
notions about proletarian poetry. He created loose poetic
reflections on the optical and aural forms of individual letters
(although he didn't approach the project entirely systemati-
cally, and unselfconsciously devoted only one poem to the
letters J and Q). *Abeceda* quickly acquired a following, as Nezval
recalled in his book *From My Life*: "Almost from the beginning
of our avant-garde movement we organized readings. We took
part in them ourselves and were met with rounds of applause.
A poem as thematically free as *Abeceda* became almost a stan-
dard at our meetings. Later Milča Mayerová began to dance
her movement compositions and the poem became extremely
popular."[36] Nezval's poem, Mayerová's evocation of the letters

of the alphabet with her body, and Teige's *typofotos* utilizing Karel Paspa's photographs of Mayerová represent three autonomous approaches whose relationship to one another is unusually loose, and yet which together create a mutually corresponding whole, despite the fact that Nezval's poem was written four years earlier. Teige commented on the form of the book shortly before its publication: "In Nezval's *Abeceda*, which is a cycle of poems on the shapes of letters, I attempted a purely abstract and poetic *typophoto*, a graphic equivalent of Nezval's verse: both were poems, evoking the magic of the marks of the alphabet."[37]

Teige linked the shapes of the letters to Mayerová's body, sometimes by imitation within the orthogonal frame, and other times by diagonal opposition. The connection between Nezval's text and the typographical presentation can be seen in the letter *M*, in which Mayerová is standing on an open palm, along the "fate line" of which an *M* is inscribed. This corresponds to the first verse: "clear star chiromancy." Teige had previously used the image of an *M* on a palm, on the 1925 book jacket for *Jimmie Dollar, Americans in Leningrad*. (The *M* may also be connected with Nezval's personal life. His lover in 1924, at the time of an emotional breakdown that

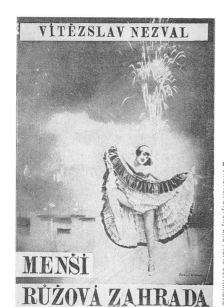

■ Jindřich Štyrský and Marie Čermínová (Toyen), cover design for *The Smaller Rose Garden*, by Vítězslav Nezval, 1926

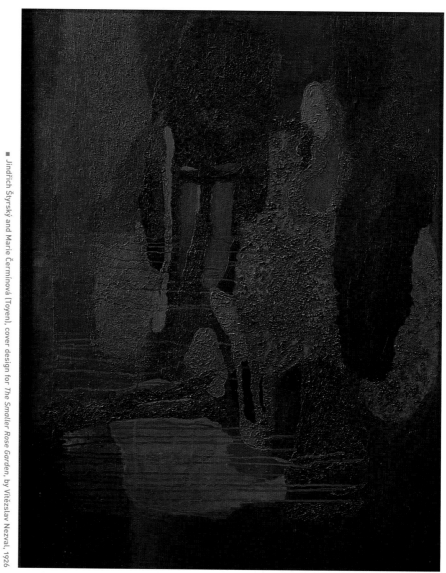

■ Maria Čermínová (Toyen), *Twilight in a Virgin Forest*, 1929, oil and tempera on canvas

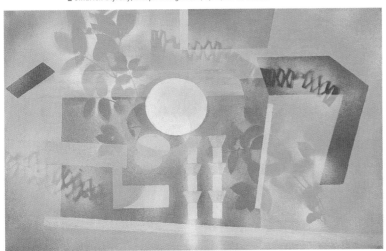

brought him to the brink of suicide, was nicknamed Mereio.) What remains attractive about the 1926 *Abeceda* is the close conjunction of the body and the typographical preparation, and the way in which Teige gave space to individual letters. In a manner that overrode many conventions of the times, Teige approached the alphabet as an abstract motif. In this way he created a book that belonged, according to Jiří Voskovec, among the "most genuine and perfect creations that came out of the Devětsil circle."[38]

X RAYS OF DIFFERENT WORLDS

Man Ray's album *Les champs délicieux* (1922) had an inspirational effect on Czech art in the second half of the 1920s. This is a period when the representatives of the original Czech avant-garde abandoned the instantly readable visual language to make way for more complex artistic processes, pointing to different sources of inspiration. Karel Teige's essay "Words, Words, Words," which came out in installments in the first months of 1927, was a theoretical justification of this upheaval, evident in the work of painters Jindřich Štyrský, Toyen, and Josef Šíma, sculptors Hana Wichterlová and Vincenc Makovský,

and photographer Jaromír Funke. Here Teige moved away from his assumption, set out at the beginning of the 1920s, that "modern posters, bills, ads, and signals have assumed the optical meaning...of typographical material: this is where the word as an optical value arose."[39] He gravitated instead toward new experiences, framed on one side by Jakobson and Mukařovský's separation of communicative language and poetic language, and on the other side by artistic movements of the day such as Artificialism and Surrealism, which embodied this division. "The words that the dictionary communicates to us," Teige remarked, "are words illuminated by the daylight of practical reason. And the art of words, literature, which has these words as material, discerns only that which can be discerned by daylight: infrared and ultraviolet realities fatefully elude it."[40]

The way to such alternate realities was opened by Man Ray's photograms. In evaluating them, Teige noted Tzara's idea of Surrealism, which he later connected to the infrared spectrum, while relating Man Ray's activities to the ultraviolet spectrum. With the terms ultraviolet and infrared Teige distinguished phenomena that exist outside of everyday reality, which is governed by word-signals representing "the grammar of the international language," embodied in traffic signs and advertisements, "railroads, airplanes, ships." For Teige this new language was different from the "word of the white day, technical and civilized, which flies like a flag on the highest point of the word, abbreviation and symbol visible and audible everywhere."[41] The lighthouse-word and the poster-word no longer concerned him, but rather the word that shines from the depths of the subconscious (Freud's writings on the unconscious were translated into Czech in the 1920s) and the heights of the supra-conscious.

An example of the merging of photogenics and hidden meanings is Brâncuși's photograph of a single object, *Beginning of the World* (1920). In this work, light coming around a solid ovoid

casts a dark shadow, yet at the same time distinct iconographic themes indicate archetypal content. While the first half of the 1920s would have been interested primarily in the photogenics of the shot, the second half of the decade focused on the inner meaning of the object. This is noticeable in the works of Czech authors living in Paris during the 1920s, who were quite captivated by Brâncuşi's ovoids. Sculptors Hana Wichterlová and Vincenc Makovský also reacted to them, as well as the painters Josef Šíma and Jindřich Štyrský.

The rapid change in the Paris art scene in the 1920s is reflected in the titles of two of Teige's informative articles recounting his trips to Paris: "Cubism, Orphism, Purism, and Neoclassicism in Contemporary Paris" from 1922,[42] and "Abstractivism, Surrealism, and Artificialism" in 1928.[43] They not only provided important information about the current state of the art scene, but also placed the work of Czech authors into an international context. While the manifold groups of international artists living in Paris took part in the birth of abstraction and Surrealism, Artificialism, which also came from Paris, remained in the hands of two of its initiators, Štyrský and Toyen.

Teige was the first theorist and critic to recognize the meaning and contribution of Artificialism within the framework of international trends in the later 1920s. Štyrský and Toyen organized independent exhibits in Paris in 1926 and 1927 (the introduction to the first one was written by Philippe Soupault), and put together basic texts on Artificialism. Their experimental approaches were expressed in one way by spraying concrete objects placed on the canvas (sugar cubes and thumb tacks, for example) and alternatively by the direct pouring of paint without a brush, later called "drip painting." Štyrský and Toyen went beyond Teige's linking of pictures and poetry by declaring that "Artificialism is the merging of the painter and the poet. It negates painting as a simple form of play and entertainment for the eyes (subjectless painting). It negates painting as a historicizing of forms (Surrealism). Artificialism has an abstract consciousness of reality. It doesn't dispute the existence of reality, but doesn't operate with it. Its interest is concentrated on POETRY, which fills the gaps between material forms and which reality radiates."[44] Artificialism was already far from elementary optical signals. When Roger Gilbert-Lecomte asserted that "in a painter I am essentially not looking for anything other than a poet," he was thinking not of Štyrský and Toyen, however, but of Josef Šíma, the main artist representative of the group Le Grand Jeu.

While the Artificialists found new sources of poetry "through the spaces between material forms," Gilbert-Lecomte tried also to capture layers of sensory experience found outside of ordinary perception: "It's necessary to try to see like a blind person, hear like a deaf person, and smell like someone without a nose." If Štyrský and Toyen created a "picture" directly on the canvas in such a way that the image became clear only during its creation, Šíma's concept was markedly different: the picture was composed of individual motifs, representing the basic foundation blocks of his visual alphabet.[45] Štyrský and Toyen were unafraid not only of technical improvisation, but even of thematic references to the original state of nature, while Šíma visualized the lost metaphysical unity of the world. Teige compared Artificialism to the ultraviolet supra-conscious; Surrealism (in which he strangely included Šíma in 1927–29) he compared to the infrared subconscious. For Teige, the "Artificialist picture was a poem in the original Greek meaning of the word poetry: *poiesis*, that is, a supreme and independent work. It is an independent and specific poem of colors and lines, not a reflection of poetry created by others and in other manners."[46]

The classification of Šíma under Surrealism (which seems somewhat hasty today, in that his pictures came from sources other than psychic automatism and concrete irrationality) enabled Teige's conception of Surrealism, suggesting on one hand Freud's psychoanalysis and on the other Bergson's essentialism. While the Artificialists perceived time as a process of change, allowing the visualization of natural forms from solid to deteriorating, Šíma's nature motifs hover in a kind of timeless zone. At the end of the 1920s Artificialists wanted, in their pictures, to go down to the place where language is formed, to the material which is just finding a shape. They captured phenomena before they were named, they visualized processes on canvas, drawing content from the "depths" that were meant to be the source of primary material—from a sort of liquid, ever-changing matter. In contrast, Šíma's work emerged from elementary archetypal substances, free-moving motifs, floating through the space of the picture, in whose various forms the original unity of the world was reflected. The differences between Artificialism and Šíma are apparent in the comparison of two pictures. In 1927 Šíma painted *Europa* and Štyrský *Deluge*. Although both defy categorization, the first can be loosely called a figural work, and the second a landscape painting. Despite their differences they have one common motif: the ovoid, which is present in Šíma's work as a sculpturally treated volume

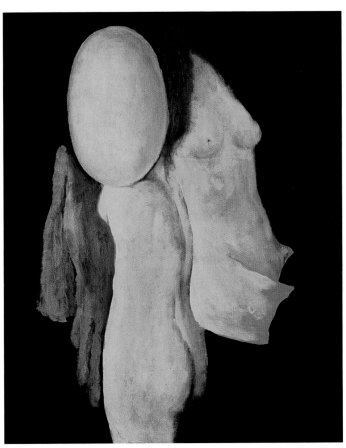

■ Josef Šíma, *Europa*, 1927, oil on canvas

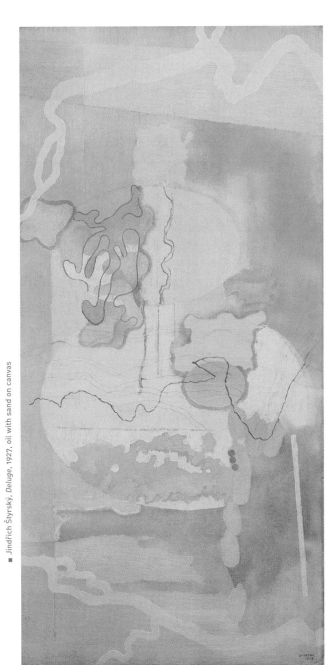

■ Jindřich Štyrský, *Deluge*, 1927, oil with sand on canvas

and in Štyrský's as a flat, colored linear outline penetrating an abstract plane. In *Europa* Šíma painted two women's torsos outlined against a dark background, supporting an egg that is placed on the back of one of them. Teige commented: "The enigmatic...and monstrous shapes of Šíma's drawings are reflections of the negative in life...just as ordinary and everyday and just as incomprehensible and transcendental as the life of a dream."[47]

Teige's polarity of infrared and ultraviolet didn't necessarily have a single meaning. Šíma's pictures couldn't be directly equated with dreams. They also fell into the ultraviolet category, as Gilbert-Lecomte remarked. He felt that Šíma's painting came out of monistic, metaphysical roots, expressing "the mad excitement of the soul and the penetrating quality of the ultraviolet ray, so that the place in the world that is the core of all worlds could be captured by itself for at least a moment..."[48]

In the second half of the 1920s photographer Jaromír Funke also came to the edge of phenomenality. By composing still lifes of objects on a glass surface sharply lit from the side, he could capture both the objects and the shadows they cast on the irregular background. Although Funke called for material themes in his critical articles, he unexpectedly made several still lifes that could be called "exotic." After earlier aiming at the highest possible degree of abstraction, Funke underwent a transformation, along with the Artificialists, when they searched for visual motifs that were not worn out. In one especially distinctive photograph he combined a kingfisher, a shell, a starfish, and ferns. These juxtapositions, though bizarre, can't be called Surrealistic. If his photographs were close to Artificialism, then Šíma's pictures resembled the essentialist sculptural forms of Makovský and Wichterlová.[49] Like Šíma, both sculptors, who lived in the same quarter of Paris during the same years as Štyrský and Toyen, were inspired by ovoids. The ovoid became for

Makovský and Wichterlová a sculptural target: they could meditate on its form, and also brutally cleave it. Echoes of Šíma's *Europa* resonated in Makovský's *Girl's Dream* (1932), which contains a prone female torso on whose hip an ovoid is set. This is not the sign-signal of ten years before, but the shape as a sculptural eruption of the collective unconscious.

Translated by Andrée Collier Záleská

130

1 Bedřich Václavek, "Doslov," *Fronta* (Brno 1927): 195.

2 Walter Benjamin, "Umělecké dílo ve věku své technické reprodukovatelnosti," *Dílo a jeho zdroj* (Prague: Odeon, 1979), 37.

3 Karel Teige, "O fotomontáži," *Žijeme* (August 3–4, 1932): 107–12; (October 6, 1932): 173–78.

4 Claude Leclanche-Bouléová, "Šíření purismu ve střední a východní Evropě," *Umění* 35, no. 1 (1987): 16–29.

5 The catalogue for Alexander Archipenko's exhibit was Karel Teige's first independent publication. The exhibit was put on by Devětsil in April and May of 1923 in the rooms of Krasoumné jednoty—where the Modern Art Bazaar took place in the autumn of the same year.

6 An unsigned note, whose author is most likely Jaromír Krejcar, in *Život II* (1922): 196.

7 Karel Teige, *Film* (Prague: Václav Petr, 1925), 44.

8 Bedřich Václavek, "Nové techniky v básnickém řemesle," *Disk* 2, (spring 1925).

9 Teige, *Film*, 38.

10 Ibid., 39.

11 Růžena Hamanová, "Dopisy Karla Teiga Emy Hauslerové," *Literární archív roč* (Prague), no. 24 (1990): 236.

12 Charles Baudelaire, *Malé básně v próze* (Prague: Vilém Šmidt, 1946), 96.

13 Hamanová, "Dopisy," 200.

14 Ilya Ehrenburg, *Und sie bewegt sich doch* (Baden: LIT, 1986), 152–54.

15 Teige's afterword for the monograph *Jindřich Štyrský a Toyen* (Prague: František Borový, 1938), 189–95.

16 Walter Benjamin, "Autor jako producent," *Agesilaus Santender* (Prague: Hermann & synové, 1998), 162.

17 Walter Benjamin, "Paříž hlavní město devatenáctého století," *Dílo a jeho zdroj* (Prague, Odeon, 1979), 70.

18 Benjamin, "Umělecké dílo ve věku své technické reprodukovatelnosti," 25.

19 Teige, *Film*, 66.

20 Ibid., 64.

21 Jaromír Funke, "Man Ray," *Fotografický obzor* 35 (1927): 36–38.

22 Ibid.

23 Teige, *Film*, 109–10.

24 Vítězslav Nezval, "Premier plan," *Menší růžová zahrada* (Prague: Odeon, 1926).

25 Lenka Bydžovská, "Auf der Suche nach der neuen Welt," *Stifter Jahrbuch*, Neue Folge 7 (Munich, 1993): 90–97.

26 Jaromír Krejcar, "Made in America," *Život II* (1922): 189–95.

27 Unsigned note, most likely by Krejcar, ibid., 46.

28 Ibid., 45.

29 Karel Teige, "Umění soudobého Ruska," *Host* 4, no. 2 (December 1924): 34–46.

30 Amédée Ozenfant, "Současná situace umění," *Fronta* (Brno 1927): 120–21.

31 Foreword signed by editors Halas, Průša, Rossmann, and Václavek, *Fronta* (Brno 1927): 5.

32 Bedřich Václavek, "Doslov," *Fronta*, ibid., 198.

33 Bedřich Václavek, "Fronta," *ReD*, no. 1 (October 1927): 30.

34 Karel Teige, "Přednáška Ilji Erenburga v Praze…," *Stavba* 5, no. 9 (1926–27): 145–46.

35 Karel Teige, "Moderní typo," *Typografie* 34, no. 7-8 (1927): 189–98.

36 Vítězslav Nezval, *Z mého života* (Prague: Československý spisovatel, 1959), 115.

37 Teige, "Moderní typo," 48.

38 Jiří Voskovec, "Nezvalova Abeceda," *Přerod* 5, no. 6 (1927): 4.

39 Karel Teige, "Slova, slova, slova," *Horizont* 1, (January): 1–3; (February): 29–32; (March): 44–47; (April): 70–73.

40 Teige, ibid.

41 Ibid.

42 Karel Teige, "Kubismus, orfismus, purismus a neoklasicismus v dnešní Paříži," *Veraikon* 8 (October–December 1922).

43 Karel Teige, "Abstraktivismus, nadrealismus, artificielismus," *Kmen* 2 (June 1928): 120–23.

44 Jindřich Štyrský and Toyen, "Artificielisme," *ReD* 1, no. 1 (October 1927): 28–30.

45 Lenka Bydžovská, "The Avant-Garde Ideal of Poiesis: Poetism and Artificialism during the Late 1920s," in *Karel Teige 1900-1951: L'enfant Terrible of the Czech Modernist Avant-Garde*, ed. Eric Dluhosch and Rostislav Švácha (Cambridge: MIT Press, 1999), 46–63.

46 Karel Teige, "Ultrafialové obrazy čili artificielismus," *ReD* 1, no. 9 (June 1928): 315–17.

47 Karel Teige, "Obrazy Josefa Šímy," *Rozpravy Aventina* 3, no. 15 (March 29, 1928): 179–80.

48 Roger Gilbert-Lecomte, "Malba Josefa Šímy," *Vysoká hra*, ed. Miloslav Topinka (Prague: Torst, 1993), 60.

49 Karel Srp, "Sochařství dvacátých a třicátých let," *Dějiny českého výtvarného umění, 1890-1938* (IV/2) (Prague: Akademia, 1998), 355–88.

CENTRAL EUROPE: THE LINGUISTIC TURN

Michael Henry Heim

To repeat the truism that Central Europe comprised a potpourri of nations is to imply that differences among the national groups predominated, that they coexisted in a state of alienation. Yet the fact that as minorities they all differed from the majority Austro-German culture proved an enormously important common denominator. Language, the most salient carrier of cultural differentiation, can provide valuable insights into what held Central Europe together, what made it a cultural as well as a political unit.

The ethnic diversity of the region goes back to a mass migration unparalleled until the population shift shaking the world today. This *Völkerwanderung*, as it is called, occurred in Eastern Europe between the fourth and eighth centuries, beginning approximately with the invasion of the Huns. By 800 Charlemagne could stand on the banks of the Elbe, in the center of present-day Germany, and ruminate on the contrast between the barbarian East and civilized West, and by the time the Habsburgs had in essence taken over the Holy Roman Empire—that is, in the early sixteenth century—the Elbe marked an important economic and social border to the west of which feudalism had broken down and to the east of which it continued to thrive. Up to then the Habsburgs' hereditary lands had centered in the Alps, their borders more or less contiguous with those of present-day Austria, but in 1526 the Habsburgs acquired the crowns of Hungary, Bohemia, and Croatia, thereby gaining sway over not only their own Germans but also Hungarians (Magyars), Czechs (Bohemians and Moravians), Slovaks, Ruthenians, Croats, Slovenes, and significant numbers of Italians and Romanians. Segments of the Polish and Serbian populations came under their rule in the following centuries.

Cultural consciousness in the modern sense did not make itself felt among the constituent ethnic groups until the rise of Romanticism, more specifically German Romanticism, and most specifically the Romanticism of Johann Gottfried von Herder. His much-read *Stimmen der Völker in Liedern* (Voices of the Peoples in Songs, 1778–79), a collection of the folk poetry of a number of ethnicities, and his much-cited *Ideen zur Philosophie der Geschichte der Menschheit* (Ideas on the Philosophy of the History of Mankind, 1784–91) epitomize the German reaction to the universalism of the neoclassical Enlightenment. As against the French-cosmopolitan utopia of the philosophes (Voltaire, Diderot, Montesquieu), Herder posited a utopia of the *Volk*: *Blut, Boden, Sprache* (blood, soil, language). But his was not the political nationalism of later German *völkisch* thinkers (beginning with Fichte and including Wagner and Nietzsche); it was an ecumenical nationalism that allowed for and even encouraged the blood, soil, and language of each and every *Volk*. Herder and his followers viewed themselves as purveyors of the natural over the artificial, the instinctual over the cerebral, and the specific over the general.

Herder's cultural peculiarism had a political counterpart in the policies of the Austrian monarch on the throne at the time, Joseph II. Like his mother, Maria Theresa, Joseph wished to see himself as an enlightened monarch and ipso facto as a product of the Enlightenment. His many very real reforms included a patent of religious tolerance, the abolition of serfdom, and the first glimmer of social mobility in the form of a highly hierarchized civil service. True, the latter involved centralizing the state administration and replacing Latin with German as the official language of the bureaucracy, but it also meant granting legal rights for minority languages: once German became the official language, recognition of the other languages followed naturally. Paradoxical as it seems, the first chair for Czech at Prague University came into being in 1791 as much out of the need to train officials able to deal with the Czech *Volk* as out of the Romantic idea of the Czech *Volk*.

Since the situation of the Czech language was in fact the most drastic in the monarchy, I shall use it as the prime example of the series of linguistic rebirths that took place during this period. After the Battle at White Mountain in 1621, when the Czech aristocracy was forced into exile, towns in the Czech Lands became so Germanized that Czech was almost exclusively relegated to the countryside. Education in Czech, such as it was, amounted to several years at most, just enough to instill basic literacy; education beyond that level was in German and Latin (not until 1784 did German replace Latin as the language of instruction at Prague University). As a literary language—and it had flourished as such from the fourteenth century—Czech all but expired.

Artificial resuscitation came from a small but determined and highly talented group of Herder-inspired intellectuals who went back to the country and—as one Czech scholar has put it—shook their grandmothers until they came up with the Czech words and expressions they themselves had forgotten. To legitimatize the language and its literature, the first generation wrote grammars and histories in German and Latin. The second generation compiled dictionaries, borrowing (and occasionally even inventing) words with Slav roots for the Germanisms that had crept into the language. It also made collections and adaptations of Slav folk songs (to stress Czech's Slav roots) and translations from the German of Goethe (to prove that Czech could reproduce the finest of what German literature had to offer), the English of Milton (to prove that Czech could express the loftiest of thoughts in the appropriate poetic form), and the French of Chateaubriand (to prove that Czech could convey the latest in lively prose). The third generation composed the first viable original works. These include such classics of nineteenth-century literature as Karel Hynek Mácha's stunning Romantic narrative poem *May* and Božena Němcová's folk-realist novel *Granny*.

Early on, the theater played more than its part. Czech speakers who had not quite made the transition to Czech readers could still appreciate a play; moreover, going to the Czech theater was as much political statement as social occasion. It is not far-fetched to hypothesize that the special role played by theater in the revival of Czech culture influenced Central European Czech voters, if only subconsciously, when they elected a playwright, Václav Havel, as the first post-Communist president of Czechoslovakia.

Along the way there were attempts to bolster national traditions by fabricating imitations of the heroic poetry of other cultures and presenting them as authentic. The Scot James Macpherson invented *Fragments of Ancient Poetry Collected in the*

Highlands of Scotland and Translated from the Gaelic (1760) and, a few years later, created a bard named Ossian, the supposed author of two epic poems, *Fingal* and *Temora*, actually of Macpherson's own making. Similarly, the Czech Václav Hanka "discovered" two epic fragments, *The King's Court Manuscript* and *The Green Mountain Manuscript* (1817), purporting to date back to the ninth century and to represent a theretofore lost heroic tradition.[1] (Culture and politics being closely inter-twined in Central Europe, Hanka's hoax had far-reaching historical consequences: T. G. Masaryk, the first president of the First Czechoslovak Republic, rose to prominence at least partly by debunking the forged manuscripts and convincing his fellow Czechs that a nation cannot rest on a foundation of sand.)

But the Czechs spearheaded another, broader—indeed, by definition multinational—intellectual and cultural move-ment in the mid-nineteenth century: Pan-Slavism. Herder had singled out the Slavs in his monumental *History* with a brief passage ending in a left-handed compliment: the Slavs could look forward to a glorious future because they were backward and therefore untainted by Western civilization. In other words, the Slavs were Europe's noble savages. Undaunted by Herder's condescension, Pan-Slav enthusiasts used him to awaken ethnic solidarity in their wide-flung constituency. Since many of the Habsburg minorities were Slavs (the Czechs, Slovaks, Poles, Ruthenians, Croats, and Serbs), a movement promoting their unity necessarily had political overtones. Yet at the first Pan-Slav Congress, held in Prague in the midst of the events of 1848 and presided over by the eminent Czech historian František Palacký, the movement's ideologue, the chief mission consisted in forming a unified Slav *culture* to replace the prevailing—and what the delegates perceived as the dying—Latin and especially German cultures of Europe. The mission proved unsuccessful, its most humiliating defeat perhaps being that the attempt by each speaker to use his native Slav language foundered miserably. The majority simply could not understand any Slav language but their own, and the only viable lingua franca turned out to be German. So much for the dream of a unifying Slav koine (a pipe dream, actually, because most of the languages in question had been mutually incomprehensible for centuries), but even more important, so much for what had been touted as "Slav reciprocity."

In fact, a centrifugal tendency more than the required cen-tripetal one was making itself felt. For example, what we now call Slovak was until the 1840s a cluster of dialects on a continuum with Czech, and speakers of all the dialects along

the Czech-Slovak continuum could understand one another. Like the Czechs, Slovaks had German to contend with and, unlike the Czechs, they had Hungarian as well: long before the Habsburgs, but also under them, the Slovaks were ruled by Hungary. Moreover, when educated Slovaks wrote, they wrote in Czech, there being no codified, literary Slovak for them to write in. Their most prominent writer of the period, Ján Kollár, composed a cycle of more than six hun-dred sonnets in Czech called *Sláva's Daughter*, Sláva meaning "glory" in all Slavic languages. For Kollár it was also the etymology of the ethnonym. (Germans at the time preferred to derive it from the German word *Sklave*, "slave.") Kollár dreamed of the reunification of the Slavs, much as his German fellow students (he studied theology at Jena) dreamed of German reunification. The sonnets represent an allegory of that dream: the title character is at once the daughter of the Slav goddess Glory and his lady love, a Saxon pastor's daughter by the notably un-Slav name of Friederike Schmidt. Kollár opposed the formation of a sepa-rate Slovak literary language as divisive to the Slav cause, but he lost the battle.

The battle was joined and won in only one camp, and it was sealed in Vienna in 1850 with the signing of a treaty of sorts, the Literary Accord, which laid down the principle of a unified literary language for the Serbs and the Croats. Significantly, the signers shied away from naming the lan-guage, though it eventually came to be called Serbo-Croatian. That it broke up into two languages with the breakup of Yugoslavia in 1991 is hardly coincidental. As in the case of the Pan-Slav movement, the language issue is as emblematic as it is concrete: linguistic unification provided a symbolic first step toward political unification. The linguistic relationship between the Serbs and Croats bears certain resemblances to the one between the Czechs and Slovaks: Serbian and Croatian comprise a cluster of dialects along a continuum. When the Illyrian movement, which saw the South Slavs (Serbs, Croats, and Slovenes, and sometimes Bulgarians and Macedonians as well) as one nation, gained popularity in the 1840s, political action was unthinkable: Serbia belonged to Turkey, Croatia and Slovenia to Hungary and hence the Habsburgs. But declaring Serbian and Croatian one language appeared innocent enough. Slovenian proved linguistically recalcitrant: it was not mutually comprehensible with Serbian and Croatian.[2]

There were of course technical problems to be solved, the most important of which was to determine which dialect would form the basis for the new standard language. The

choice fell on a proposal by Vuk Karadzic, a Serb whose native speech—he was from Herzegovina—was close to that of the Dalmatians (if not to that of the Croats from Zagreb, the capital). But more important, it was close to that of the folk songs he had collected and started publishing in 1814. These and, even more, the heroic songs celebrating derring-do against the Turkish invader—works the Croats too could lay some claim to—gave South Slav culture the sort of legitimacy that Hanka felt compelled to forge, in both senses of the word, for his Czechs.

Vuk's linguistic slogan was "Write as you speak," which was all well and good if the literary language happened to be based on the dialect you spoke, but the problems inherent in the new literary language went much deeper: the lexicon, the morphology, and the syntax it reflected could be cobbled into a unified language, but the cultural traditions of the Serbs and Croats differed radically. The Serbs, who belonged to the Orthodox Church, not only wrote their language in the Cyrillic alphabet but until well into the eighteenth century the language they wrote was Slaveno-Serbian, a mixture of Church Slavonic (a purely written language somewhat analogous to Latin in the West) and the vernacular. Equally important, if not more so, they were virtually cut off from all secular Western genres of literature. The Catholic Croats, on the other hand, cultivated the full panoply of Western genres, both ecclesiastical and secular, and while it has been claimed that Italian was the chief literary language of Dalmatia, and Latin of Zagreb, a varied literature in Croatian abounds.[3]

A similar dichotomy holds for the two major non-Slav Habsburg peoples, the Hungarians and the Romanians (the latter in Transylvania only, not Walachia or Moldavia). The Hungarian language is Finno-Ugric in origin, the Romanian, as the name implies, Romance. Although the Romans introduced Latin and Christianity into the region as early as the second century, by the Middle Ages most of the population belonged to the Orthodox Church and the written language was exclusively Slavonic, the earliest written form of the Slav language family. The analogy with the Serbian situation is clear: Romanian came into use for certain liturgical and historical texts in the eighteenth century, and it was not until the mid-nineteenth century that Western genres made their appearance (and that Romanian adopted the Roman instead of the Cyrillic alphabet). The nineteenth century also saw a successful attempt to purge the word stock of many of the Slav, Hungarian, Turkish, and neo-Greek elements that had suffused it over the centuries. They were replaced by

Linguistic unification provided a symbolic first step toward political unification.

1 For an illuminating discussion of the controversy the fragments eventually provoked, see Andrew Lass, "The Manuscript Debates," *Cross Currents* 6 (1987): 445–60.

2 The Slovenes thus went their own way linguistically (taking a path similar to that of the Czechs, with whom their situation had a number of parallels), but joined the Serbs and Croats politically after World War I to form the Kingdom of Serbs, Croats, and Slovenes, the official name of the "first" Yugoslavia.

3 The Poles, who came late and only partially to the Empire (Galicia went to Austria as part of the first partition of Poland in 1772), excelled in an equal if not fuller range of genres, and the development of their literature as well as their literary language was unbroken.

massive borrowings from the French in a conscious attempt to reinforce what the Romanians like to call their Latinity. Thus *frontieră* (cf. Fr. *frontière*, "border") came to compete with the Slav and Hungarian borrowings *graniță* and *hotar* respectively, and *a se agita* (cf. Fr. *s'agiter*, "fret") with words of pure Latin origin like *a se frămînta* (cf. Lat. *fragmentare*). The Hungarians—partly Catholic, partly Calvinist—were fully immersed in Western culture and, like the Croats, practiced all its genres first in Latin, then, increasingly, in Hungarian. When the need for modernizing the language made itself felt in the nineteenth century, Hungarian, an agglutinative language, turned to loan translations from the German instead of borrowings. In other words, Hungarian translated each of the elements of a German word into Hungarian (e.g., Germ. *zusammenhängen*, "cohere" > Hung. *összefügg*, "cohere," *zusammen-* and *össze-* meaning "together" and *-hängen* and *-függ* meaning "to hang"), rather than importing the German word itself. Outwardly the language looked as Hungarian as ever, but much of the lexicon and phraseology bore a German stamp.

If I opened this essay by arguing that an important point the Habsburg minorities shared was that they were not German and hence remained outsiders, I would now argue that they had another point in common: though *not* German, the educated among them *had* German as a second or sometimes even first language, and during the four hundred years of linguistic contact and interaction German made inroads into their languages and thought processes. Despite the differences in the structure and development of their languages, they all were influenced, consciously or not, by the German linguistic substratum.

With language, of course, comes culture. Hence willy-nilly the minorities were privy to German culture, intimate with it, in fact. Even access to the world beyond the Empire came to them almost exclusively via German sources. Their weltanschauung, their perception of the zeitgeist, their cultural outlook in general was thus thoroughly Germanized. But this more obvious component of Central Europe has attracted ample attention, ranging from observations on the newspapers hanging from wooden sticks in the cafés and the "Maria Theresa yellow" of the railway stations to ruminations on the prevalence of one or another literary genre—the aphorism, the philosophical novel, the theme and variations.[4] Another fruitful tack has been to trace the authority of the Catholic Church and the consequent tendency of Central European art and letters to flourish in periods that downplay the rational and glorify fantasy and the fantastic: the

baroque, Romanticism, modernism.[5] Yet another has been to study the unique symbiotic relationship between Central European art and letters and Central European history and politics.[6] And much has been written about the influence of "inside outsiders" like the Jews and Turks dispersed throughout the region.[7]

What I have tried to do here is make a case for the role played by linguistic factors, especially the predominance of German as the region's common linguistic substratum. The breakup of the Austro-Hungarian monarchy into nation-states after World War I coincided, not by chance, with the rise of a generation of monolingual—that is, non-German-speaking and hence non-German-thinking—intellectuals, writers, and artists.[8] The first generation freed from the German linguistic prism, they were by the same token the first generation freed from the stigma of lagging a generation behind: no longer needing to assimilate innovations through German models, they had caught up at last. They had come into their own, culturally at least, in part by coming into their own linguistically. What better motivation for the linguistic exuberance penetrating the visual arts of the Central European avant-garde?

To show how the new situation makes itself felt in the avant-garde movement of the interwar period, I shall again use a Czech example, the Czechs having immediately stood out for their originality. Several works of Czech literature made a sudden impact throughout the Western world in the early postwar years (as no works of Czech literature had done before). Perhaps the most influential abroad—and certainly the most important for Czech identity—was Jaroslav Hašek's virulently satirical and hilariously irreverent antiwar novel *The Good Soldier Švejk*.[9] Czechs were quick to identify with the eponymous hero, who outwits officers and bureaucrats alike by playing the fool. Or *is* he a fool? One of the features that has made the work a classic is the fine line Hašek walks in his characterization of Švejk.

But there is another characterization of Švejk, a graphic one. The illustrations to the novel have become so inseparable from its Czech editions that the name of the illustrator, Josef Lada, invariably appears on the title page in tandem with that of the author. Lada's illustrations are in fact interpretations of the work, interpretations that have clearly found favor with the Czechs. They portray Švejk as a beatifically round-faced naïf, an older version of the Czech folk figure hloupý Honza (Johnny the Fool), for whom things always manage to turn out well in the end. When Erwin Piscator, the German avant-garde director, staged an adaptation of

Josef Lada, illustration for *The Good Soldier Švejk*, by Jaroslav Hašek, 1930

4 Several major Central European writers have themselves written on the subject: Danilo Kiš, "Variations on Central European Themes," *Homo Poeticus* (New York: Farrar Straus Giroux, 1995), 95–114; Milan Kundera, "The Tragedy of Central Europe," in Gale Stokes, ed., *From Stalinism to Pluralism: A Documentary History of Eastern Europe since 1945* (New York: Oxford University Press, 1991); György Konrád, "Central Europe Redivivus," in *The Melancholy of Rebirth* (New York: Harcourt Brace, 1995), 156–63. Also informative on various fronts is Claudio Magris's book-length evocation of the Central European cultural space *Danube: A Journey through the Landscape, History, and Culture of Central Europe*, translated by Patrick Creagh (New York: Farrar Straus Giroux, 1989).

5 For a highly lyrical yet scholarly instance of this approach see Angelo Maria Ripellino, *Magic Prague*, translated by David Newton Marinelli (London/Berkeley: The Macmillan Press/University of California Press, 1994).

6 For a stimulating account of the interpenetration of public values and cultural and linguistic ones, an account that offers new insights into the Yugoslav tragedy, see Andrew Wachtel, *Making a Nation, Breaking a Nation* (Stanford: Stanford University Press, 1998).

7 See numerous passages in Carl Schorske, *Fin-de-Siècle Vienna* (New York: Knopf, 1980), the work that has done the most to delineate the Central European phenomenon from the standpoint of cultural history, and Péter Hanák, *The Garden and the Workshop: Essays on the Cultural History of Vienna and Budapest* (Princeton: Princeton University Press, 1998).

8 There was even a certain movement in the other direction, that is, a tendency for German speakers to acquire the local language. Kafka's native language was German and he of course wrote in German, but he took pride in having learned Czech (he tried, without success, to persuade his favorite correspondent, Milena Jesenská, to write to him in Czech) and having become conversant with Czech culture.

9 The novel, *Osudy dobrého vojáka Švejka za světové války* [The Adventures of the Good Soldier Švejk during the World War], appeared serially between 1921 and 1923. Hašek died in 1923 before completing it. There are two English versions, the first—abridged and expurgated—by Paul Selver (*The Good Soldier Schweik* [New York: Doubleday, 1930]), the second—complete—by Sir Cecil Parrott (*The Good Soldier Švejk and His Fortunes in the World War* [London: William Heinemann/Penguin, 1973]). *Švejk* has spawned a number of works dealing with the sequel of the War to End All Wars. Most directly, it gave rise to the Brecht play *Schwejk im zweiten Weltkrieg* [Švejk in the Second World War], which, given that Brecht worked closely with Piscator, is not surprising; less directly (and outside Germany), it provided an impetus—if not *the* impetus—for Joseph Heller's *Catch-22* and Vladimir Voinovich's *Zhizn' i neobychainye prikliucheniia soldata Ivana Chonkina* (The Life and Extraordinary Adventures of Private Ivan Chonkin).

Josef Lada, illustration for *The Good Soldier Švejk*, by Jaroslav Hašek, 1930

10 That the desire for specifically Czech works of art was still unfulfilled as late as the beginning of the twentieth century is evident from the essay "The Czechness of Our Art," by Miloš Jiránek, reprinted in *Between Worlds: A Sourcebook of Central European Avant-Gardes* (Cambridge: MIT Press, forthcoming). In 1900 Jiránek felt compelled to state: "If we want to conquer foreign parts, we must send not simply art, but *Czech* art into the fray. Two questions: have we ever had such art, and do we have it today?"

11 For a succinct overview of the history and principles of Poetism, with numerous quotations from its theorists and practitioners, see the afterword to the anthology *Poetismus*, by Květoslav Chvatík and Zdeněk Pešat (Prague: Odeon, 1967), 363–82.

George Grosz, *The Outpouring of the Holy Spirit*, illustration for *The Good Soldier Švejk*, 1928, rotogravure

Švejk in 1927 at his highly politicized epic theater in Berlin, he commissioned a series of drawings for the production from George Grosz. Grosz's drawings too are very much interpretations, but, as might be expected, Expressionist in orientation. His Švejk is less stylized, more worldly-wise and wily than Lada's. The difference between the Czech and the German vision of Švejk is even more evident in the two artists' depiction of the episodic but memorable Chaplain Otto Katz serving mass. Both point to the collusion between the army and the Church by pairing him with representatives of the military, but while Lada's Katz has much of the innocent Švejk in him—the round face, the stubble around the mouth—Grosz's has the countenance of a corpse and a mouth that is spitting not only bullets but whole cannons. Grosz drives home the Expressionist's ideological message by including the crucifix and the Lamb of God, and the soldiers in his congregation, their vices writ plain on their faces, could have easily have peopled the Berlin streets he so loved to paint. Lada's single soldier, in contrast, wears an expression of such devotion that it can only be mocking that devotion on another level. Clearly the Czechs have come into their own: they have developed not only specifically Czech material but also a specifically Czech approach. And for the first time the Germans are borrowing from them rather than vice versa.[10]

Czech cultural independence went beyond individual works, however; the Czechs created an entire movement. Poetism, as the movement was called, had its roots in a group of leftist-oriented artists who banded together in 1920 to oppose the prewar Cubist and Futurist and postwar Constructivist emphasis on technology and the machine. In other words, the Czechs did their best to provoke everyone: West and East, capitalists and Communists.

The group was known as Devětsil (a word denoting an obscure plant, but having the literal meaning of "nine forces") and was masterminded by the polymath critic Karel Teige, who wrote in a programmatic article, "Types and Prototypes" (1921): "During the red-hot days of the European bloodletting that led to unprecedented destruction the world of industry and technology, of civilization, factories, transatlantic steamers and aeroplanes that had once amazed and exalted us took the ruinous form of a civilization of poison gas, submarines, and land mines, the technology of war."[11] Having thus confronted the dual nature of progress, Devětsil started questioning the hymns offered up to progress in both word and image. The group's adherents called for an art that was human-centered rather than machine-centered, an art capable of laying the foundations for a kingdom of love and brotherhood. They remained leftists in that they rejected art for art's sake and saw their mission in bringing the benefits of art to the masses, making it part of their lives. And life, not art, was primary.

In another programmatic article, "Art Today and Tomorrow" (1922), Teige wrote: "We do not need an art made of and for life; we need an art that is part of life... Art should be as much spiritual hygiene as sport is physical hygiene." Teige's statement presages the functionalism that was to become a hallmark of Central European avant-garde aesthetics in the twenties and that had its theoretical nucleus in the Prague Linguistic Circle of Roman Jakobson, Vilém Mathesius, and Nikolai Trubetzkoy: again the linguistic turn is very much in evidence. In the same article Teige pinpointed another hallmark of the Central European avant-garde, one that follows from the emphasis on function, namely, the horror of ornament: art must not decorate life; it must *be* life.

Shades of the Neue Sachlichkeit and the Bauhaus? Yes, but Poetism cast its nets more widely—it encompassed all forms of art—and, what is more important, it promoted a new, highly popular sensibility. In "The New Proletarian Art" (1922)

Teige formulated that sensibility as follows: "Western adventure stories, Buffalo Bill and Nick Carter novels, romances, American serial movies, especially slapstick comedies of the Chaplin variety, music hall jugglers, wandering singers, bareback riders and circus clowns, spring festival country dances, the Sunday soccer match—that is about all that keeps the overwhelming majority of the masses alive." What was the point of making art about work and machines and foisting it upon a proletariat exhausted after long hours in the factory? Nor was abstract lyricism likely to bring the workers back to life. Poetism combined the high and the low, the image and the word, to produce works of art that defied traditional genre specifications: collages, illustrated poems, improvisational cabaret sketches, primitive paintings, riddles in verse.[12] But its most "Czech" characteristic was its playfulness.[13] In this and in its enthusiasm for what we would today call "pop culture" and "the visual" it is reminiscent of postmodernism. Unlike postmodernism—and like all leftist art—it had its didactic, utilitarian strain, but what it preached was the joy of life and what it taught was how to enjoy it. Poetism is not literature, Teige insisted, Poetism is not art, Poetism is not an ism, Poetism is the "liquidation of artistic categories," but most of all Poetism is a modus vivendi: we live in hard times; let us turn them into good times.

With the end of the war, the end of the monarchy, and the end of German-language hegemony, Central Europe's ethnic groups acquired more than nation-states. Along with political independence they acquired cultural independence. Freedom from the Austro-German mold also meant the freedom to engage directly with general European trends. As I hope to have shown on the basis of the Czech scene, the resulting vitality made itself felt not only in individual works but in entire movements. And the same holds to a greater or lesser extent for the other non-German-speaking ethnic groups. Does Central Europe then dissolve as a cultural unit? Not in the least. Centuries of mutual influence need not—cannot—be jettisoned. The very fact that a new sense of self, buttressed by the exuberance of the avant-garde, led to an outburst of creativity everywhere in the region testifies to the viability of the Central European concept.

12 Teige's call for "picture poems,"—the expansion of poetry into the realm of the pictorial—may be found in the essay "Painting and Poetry," in *Between Worlds.*

13 While Teige was formulating his Czech Poetist aesthetics, Ilya Ehrenburg was formulating an aesthetics for the new Soviet state. Who were the most popular men in Europe? he asked in 1922. Lenin and Charlie Chaplin, he replied. (See Il'ia Erenburg, *A vse-taki ona vertitsia* [Moscow/Berlin: Gelikon, 1922], 127.) But the Soviets clearly favored the former, the Czechs the latter. Teige eventually paid dearly for giving primacy to life and the ludic over the political: he died of a heart attack as the result of a Soviet-inspired campaign against him after the Communist takeover.

Berlin Poznań Warsaw

Dessau Łódź

Weimar Prague Cracow

Vienna

Budapest

Ljubljana Zagreb

Belgrade Bucharest

"Our isolation related only to Hungary. In foreign countries we already had comrades, in art as well as in politics." Lajos Kassák

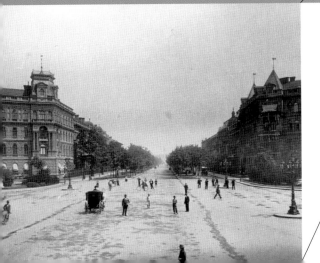

budapest

BUDAPEST

Lee Congdon

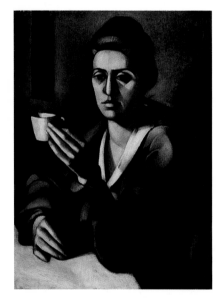

In one of his oft-cited poems, Lajos Kassák, doyen of the Hungarian avant-garde, sang of the "new face" of the times in Rome, Paris, Moscow, Berlin, London—and Budapest. Shortly after the turn of the century, he had taken up residence in the Magyar capital, by then the Habsburg monarchy's second city. A school dropout, he eked out a living as an ironworker and reacted with enthusiasm to the kinetic energy of the fastest-growing metropolis in Europe. Everywhere he turned he saw new thoroughfares, new bridges linking Buda and Pest, and new edifices, such as the splendid opera house and imposing parliament. He went from place to place on new electric trams and rode the continent's first subway.

But even more important to Kassák was the urban culture that was taking shape in the city's democratizing coffeehouses and bustling editorial offices. It was a left-liberal culture critical of the right-liberalism that had ruled Hungarian political life since the 1867 *Ausgleich* (constitutional compromise) with Austria. The makers of this new culture, mainly assimilated Jews and déclassé members of the gentry, had turned sharply against their fathers' political and social conformism. Refusing to join the national self-congratulations of the year 1896, which marked the millennium of a Magyar presence in Central Europe, they insisted that Hungary was a wasteland of backwardness and injustice.

The "wasteland" metaphor was borrowed from Endre Ady, a prophetic poet who consciously identified himself with Hungary's historical experience. His personal joys and sorrows, successes and failures, strengths and weaknesses were those of his country,
refracted through the prism of a poetic sensibility. To understand him was then, and is now, to understand the hope of national regeneration that animated Hungarian cultural life during the years leading to the First World War.

The scion of an impoverished noble family, Ady quit law school, joined the staff of a newspaper, and began to write poetry. In 1906 he published *Uj Versek* [New Verses], a revolutionary volume that electrified his countrymen and opened a new era in Hungarian cultural history. "Ady," his friend Oszkár Jászi wrote, "was not a prophet simply because he castigated the numerous sins of gentry society, but because, with his new cadences, symbols, and accents, he forged a spiritual unity out of all those who desired a new Hungary, but who would never have been able to unite on the basis of economic interest, class affinity, or political conviction."

As editor of *Huszadik Század* [Twentieth Century], a radical journal of sociology and social reform, Jászi made the case for universal suffrage, land reform, and the honest implementation of the liberal Nationalities Law of 1868, which made significant concessions to the non-Magyar populations, particularly with regard to the use of non-Magyar languages. Influenced by French and English social thought, Jászi could only sympathize with the views expressed in *Nyugat* [West], the outstanding literary review that featured the work of Ady and other modernist writers and welcomed submissions from Sándor Ferenczi, Freud's devoted disciple and the leader of the most important psychoanalytic movement outside Vienna.

György Lukács, who was to become the foremost Marxist theorist of the twentieth century, contributed to both *Huszadik Század* and *Nyugat* but, steeped as he was in German culture, never felt at home in either. Nevertheless, he shared the two journals' reverence for Ady. A cofounder of Budapest's Thália Theater, a modernist experiment modeled after Paris's Théâtre-Libre and Berlin's Freie Bühne, Lukács soon gained a reputation in Central Europe as a philosopher and literary critic. He gathered around himself a small company of like-minded Hungarians which included the poet-dramatist Béla Balázs.

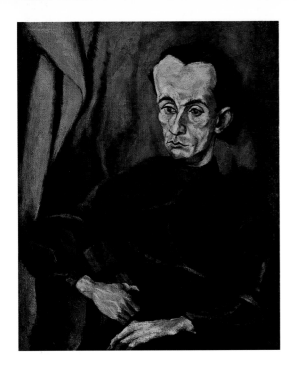

Kassák decided upon a more confrontational approach, in the confidence that he would not be acting alone. "Our isolation," he later recalled, "related only to Hungary. In foreign countries we already had comrades, in art as well as in politics." He was thinking primarily of the writers and artists grouped around Franz Pfemfert's left-wing Expressionist review, *Die Aktion*. His own antiwar journal, *A Tett* [The Action], was to be a cross between *Die Aktion* and Herwarth Walden's *Der Sturm*. Essentially a literary magazine with a political edge, *A Tett* also championed the new visual art, not only in Hungary but throughout Europe. When, in the fall of 1916, Kassák published an international number that showcased the work of artists and writers whose countries were at war with Hungary, the authorities banned further publication.

As an autodidact, Kassák did not possess the intellectual and cultural sophistication that Lukács expected of his followers, but he did read *Nyugat* and soon decided to try his hand at fiction and verse. He placed some of his work in the prestigious review, but he knew from the beginning that he would always remain an outsider. For one thing, he resented those who were well born, educated, and knew nothing of physical labor. In his eyes, such people could never become true revolutionaries. Even Ady seemed to him to belong to the past. "He is not a socialist," Kassák once observed, "but a Hungarian aristocrat with wounded pride." By the time the First World War broke out, Kassák was an isolated figure in Hungarian cultural life.

His was not, however, the only voice raised in protest against the war. Ady was deeply pessimistic about the conflict's outcome, but he was already suffering from the debilitating effects of tertiary syphilis. For their part, Lukács and Balázs began the Sunday Circle, a group of young men and women who withdrew from a world at war to discuss a Dostoyevskian one in which human beings would form a genuine community. Although opposed to the war, Lukács and his disciples—among whom were the future social thinkers Karl Mannheim and Arnold Hauser—did not concern themselves with it directly.

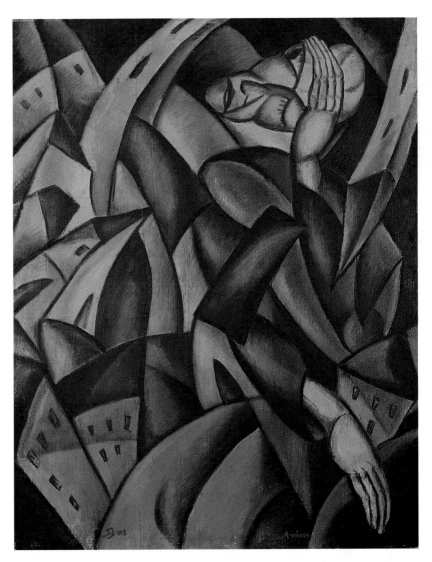

Undaunted, Kassák immediately launched a new journal, *Ma* [Today], and announced that it would not restrict itself to the sphere of the printed word, "as *Nyugat* does." He promised *Ma*-sponsored art exhibitions and music matinées at which forward-looking interpreters would perform the work of struggling modernists such as Béla Bartók, who had not yet gained recognition in the homeland he so loved. The New Hungarian Music Association, which Bartók and composer Zoltán Kodály created in 1911, had failed, and Bartók's String Quartet No. 1 (1908) would not have been performed had the Waldbauer-Kerpely Quartet not formed itself for that express purpose in 1911. This admittedly difficult piece impressed Kassák so greatly that he sent Bartók complimentary copies of *A Tett* and *Ma*. When Bartók's *The Wooden Prince*, a ballet based on Balázs's libretto, opened to enthusiastic reviews in 1917, Kassák was more certain than ever that he and the composer were moving in the same revolutionary direction.

A month after *The Wooden Prince* had its premiere, *Ma* published the score of Bartók's setting of an Ady poem and its February 1, 1918, issue was given over entirely to the composer and his work. "[Bartók] was a revolutionary," Kassák said in a late interview, "and so am I, but neither he nor I wished to take up arms." He meant that the revolution they envisioned was to be moral; it would produce "new men"—"collective individuals," as Kassák often referred to them—who would create a new society and a new world. To provide them with vision and direction Kassák, who would later take up the brush himself, turned increasingly to art. By creatively altering the forms of nature, he believed artists could inspire new conceptions of society.

Most of the Budapest-based artists whom Kassák christened "Aktivisták" [Activists] were of humble social origin. No ties bound them to aristocratic Hungary or to the patrician world inhabited by cerebral rebels like Lukács. Free of the burden of tradition and open to the possibility of

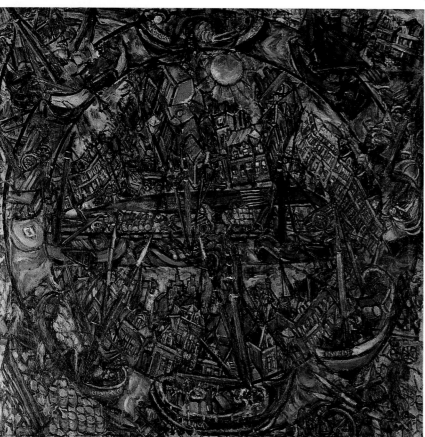

Top left:
■ Valéria Dénés Galimberti, *The Street*, 1913, oil on canvas

Left:
■ Sándor Galimberti, *Amsterdam*, 1914, oil on canvas

Above:
■ Lajos Tihanyi, *Self-Portrait*, 1912, oil on canvas

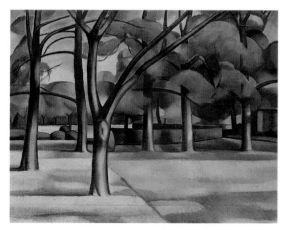

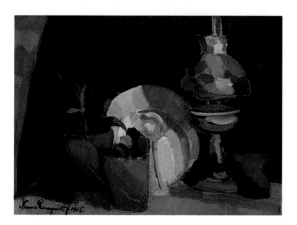

an apocalyptic war, they explored new ways of seeing. In doing so, they borrowed eclectically from Fauvism, Futurism, Expressionism, and Cubism without committing themselves to any single movement. They took notice, too, of pioneering Hungarian modernists, especially those who styled themselves "A Nyolcak" (The Eight) and drew much of their inspiration from Cézanne; indeed, one of the Nyolcak, Lajos Tihanyi, eventually joined the *Ma* circle. But despite a leaning toward Cubo-Expressionism, these artists resisted the idea of a common Aktivisták style. Nor, despite their close association with Budapest, did they paint cityscapes, perhaps, as Éva Forgács has suggested, because they considered the Hungarian capital to be too provincial and deaf to cries of injustice. Instead, they produced portraits of themselves or their comrades (particularly Kassák) as avatars of a revolutionary future.

At war's end, a hastily improvised democratic republic quickly gave way to a Soviet Republic, and Kassák and the *Ma* critic Iván Hevesy called upon artists to paint revolutionary posters. Bursting with agitational energy, the poster suited a century that was urban and socially conscious, one in which art would be for the masses. During the 133 days of the Soviet Republic's existence, the people of Budapest could scarcely enter a street without coming upon a red poster by such Aktivistáks as Béla Uitz or János Kmetty. But neither Lukács, the republic's cultural czar, nor Béla Kun, its leader, credited the visual propaganda to *Ma*'s account. Both understood that for Kassák and his circle, revolution was a way of life, an end rather than a means; it was for that reason that the avant-garde leader had refused to join the Communist Party. This stubborn independence so enraged Kun that he characterized *Ma* as "a product of bourgeois decadence" and suppressed it; not long after that, he and his government had to relinquish power. And when, in November 1919, Admiral Miklós Horthy brought counterrevolution to Budapest, he vowed to punish "the sinful city" for adopting the modernist heresies that—in his view—had contributed to Hungary's defeat and ruin.

Translated by John Bátki

László Moholy-Nagy, Lucia Moholy, and friends, Berlin, c. 1920

BETWEEN CULTURES: HUNGARIAN CONCEPTS OF CONSTRUCTIVISM

Éva Forgács

Avant-garde art was meant to envision a better future for the whole of mankind, as the Comte de Saint-Simon and his friend Olinde Rodrigues proposed in their correspondence of 1825, when they assigned artists the role of developing the poetic aspect of Saint-Simon's scientific social system. The avant-garde, as the military term indicates, was politically charged since its inception during the Enlightenment. This aspect, which in Western Europe during the first decades of the twentieth century evolved into a more subtle aesthetic radicalism, intensified into a profound political messianism in many parts of Central Europe, where redemption could be expected only in the cultural sphere.

There stakes were different. The bold elimination of the perspectival box by the Cubists in France; the visualization of spiritual experience and inner knowledge by the Expressionists in Germany; even the tremendous politicized energy of the Futurists in Italy prior to the First World War—these were intellectual and artistic adventures (if at times politically tainted). But the same ideas could spell the difference between life and death in Central Europe, where artists were persecuted, jailed, and could be killed for the ideas they espoused, since for long periods art was the primary venue and code for political expression.

The socially committed avant-garde was caught between an inhospitable present and a world yet to come in Russia, in Berlin, and in the countries between these two cultural superpowers. The projection of social and cultural desires visualized by Constructivism—an umbrella term, as it has come to be used—greatly differed in each country of Central Europe. Constructivism promised a social and technological utopia, so local social and technological conditions played a pivotal part in shaping its regional variations. The use of the new, supranational geometric idiom identified both the artwork and its creator as promoters of a better world to come, one that will have resolved issues of nationalism and social classes.

In Russia, the birthplace of Constructivism, the movement was rigorously anti-art and politically engaged.[2] According to Varvara Stepanova, the word "construction" signified an object "purged of esthetic, philosophical and religious excrescences"[3] and was seen as diametrically opposed to "composition," which connoted deliberate artistic creation. Constructivism was meant to be the epitome of changes in the organization of society and industry—which were, in fact, already under way. The Constructivists, committed to radically reassessing the artist's role and function in the new Communist state, undertook to adjust the concepts of "art" and "artist" in accordance with the needs of Soviet Russia. They may have been guided by idealistic concepts of their new state, but their adjustment to it was strictly pragmatic.

In contrast to the situation in Russia, the German political revolution, which turned the country from monarchy to republic in 1918, did not bring about a corresponding revolution in the structure of the society. In Berlin, the crucible of the Russian, East European, German, and Dutch avant-gardes, the leftist art community expected a world revolution. Material conditions there greatly differed from those in Russia: In Germany the industrial infrastructure was arrested for only a short period by World War I. The new technologies underpinning the development of mass production and design were in place as early as 1921–22. The political situation of the artists was also different. Whereas Russian artists supported their new regime, progressive artists in Germany were in opposition, finding that Weimar Social Democracy fell short of their more radical ideals. Moreover, whereas Russian artists attributed a moral and political stance to object design, seeing it as a great new service to the people in shaping the new world, design in Germany—even in the Bauhaus—was part of capitalist business, with few ethical ramifications apart from the duty of delivering good-quality

products to consumers. The purpose of design was the promotion of modernist aesthetic living. This differed as well from De Stijl's philosophy of spiritualized living, where interior design optically dissolved architectural boundaries and aimed at projecting a universal harmony that De Stijl's artists saw as the ultimate goal of art. Although design in Germany throughout the 1920s anticipated a freer and better life, and its streamlined functionalism pointed toward a society of rational planning, it had ceased to have a transcendental message.

Lacking both a society in rapid transformation and one with advanced technology, the Hungarian artists and writers deviated from both models and understood Constructivism as a purely redemptive doctrine. Although they were, according to all evidence,[4] the first group in Berlin to have had firsthand information on Russian Constructivism, and with Lajos Kassák's Vienna group played an active part in the development of International Constructivism, they needed the new idiom, among other things for the purposes of instant cultural emancipation. As Ernő Kállai phrased it:

It seemed that [constructivism] would fit immediately, without the detour of evolution through national traditions, into the overall artistic framework of the longed-for new, collective world. For artists coming from the uncertain peripheries of this emerging international Europe, this was bound to seem an extraordinary opportunity: the impact of the utopian prospects presented by constructivism on the Eastern temperament, with its unfailing capacity for enthusiasm and overactive imagination, had the force of a new Revelation.[5]

This "force of a new Revelation" pervaded the version of Constructivism that the Hungarians developed in the early 1920s. They demonstrated a preference for timeless classicism and invested its geometric vocabulary with a majestic and authoritative aura, in contradistinction to the pragmatism of both Russian and International Constructivism. While Constructivism in Russia was born out of the realistic need for artistic survival, even at the cost of permanently redefining the concept of "art," and International Constructivism was created in Germany by the desire for a utopian society, which was symbolized by such artworks as mobile sculptures, transparent constructions, and real-space compositions, the Hungarian concept of Constructivism sought ultimate balance, authority, and order.

It may be immediately interjected that one of the outstanding documents of International Constructivism, the 1922 *Dynamisch-konstruktives Kraft System* [Dynamic-Constructive System of Forces] manifesto, was authored by two Hungarians,

the artist László Moholy-Nagy and the critic Alfréd Kemény. Though this document was published in *Der Sturm*, in the context of Berlin's international art scene, it still perhaps asks for explanation. Without going into the intricacies of national identities—quite irresolvable in the case of many émigré artists—I want to clarify that my examination of the Hungarian concepts of Constructivism will focus on the ideas of Lajos Kassák and Ernő Kállai for the following reasons: Kassák spent his formative years in Hungary. As a prominent socialist and leading cultural agent of the Hungarian Commune between March and August 1919, he was forced into a six-year Vienna emigration, which he always meant to be transitory. When he returned to Hungary in 1926, once again he became the decisive figure in the avant-garde and neo-avant-garde and remained so for four more decades. Though he established connections with the international avant-garde and became part of it, his journal *Ma* [Today] unfailingly addressed a Hungarian readership, both within and outside Hungary, even while it was in exile.[6] Ernő Kállai was a bilingual art critic who lived in Berlin between 1920 and 1935, yet maintained intense connections with the art life of Hungary. The characteristic differences between his publications in the German press and those in *Ma* clarify the particular features of the Hungarian forum. Kemény (who died upon his return to Hungary from the Soviet Union in 1945), Moholy-Nagy, and the Constructivist László Péri did not remain part of the Hungarian cultural context after they had left Hungary, and they integrated with the international community far more flexibly than Kassák.

Not that Kassák's idiosyncrasy was programmatic. On the contrary, like all of the Hungarian artists who lived in emigration and accepted the Constructivist idiom, he found an intellectual home in the new language and community of the movement, which anticipated the international world of the future. But the Hungarian version of Constructivism was also shaped by the Hungarian cultural tradition, the inner contradictions of the group and the social utopias attached to it, and by the personal characteristics of Kassák himself.

THE OLD IN THE NEW

The vibrant cultural and artistic life of Budapest in the first decade of the twentieth century was energized by the struggle against both Impressionism and positivism, against, on the one hand, everything individualist and subjective, and, on the other, everything that lacked a metaphysical dimension. A sense of greatness deriving from German philosophy and German Romanticism imbued this vision of a future synthesis

of the arts and sciences. The writer Béla Balázs expressed such ideas in 1906, when he spoke to the composer Zoltán Kodály[7]:

[I have a] secret dream about the great new Hungarian culture that we have to create… It would be a unified "Sturm und Drang" movement, a spiritual rebirth which would cleanse the present of its journalistic art and clownish science and would build in its place a fresh new art, a new science, a great new culture… I spoke to [Kodály] of the rehabilitation of art, of the religion of art, which would form the basis of the future culture. Its temple would be the concert hall, the art gallery, and the theater. I spoke to him of the redeeming power of art, that people will improve and society will once again become healthy.[8]

Balázs's use of the words "religion of art," "temple," and "redeeming power of art" underlines the serious nature of art discourse in Hungary as well as the desire for a unified community that would transcend existing social and cultural categories. Art was seen as the ultimate spiritual power through which the new synthesis and the new world could be achieved. Nothing frivolous or playful could be part of it. True art was sacred and majestic, and precisely on that account it could not be identified with such evanescent works as Impressionist paintings. Echoing Cézanne, whose art embodied the substantial (as opposed to merely optical) and concentrated (as opposed to uncomposed) nature of things that modern artists and thinkers embraced in Budapest, the art critic and philosopher Lajos Fülep pointed out that a new art with a "solid foundation" was needed, "more solid than the individual."[9]

Keresők [Seekers, a name they used from 1909 to 1911, when they changed it for the less-meaningful Nyolcak, or The Eight] was the first modernist Hungarian painters' group to assert the new values—which transcended art issues—of the young generation of writers, philosophers, and artists. They championed tectonic solidity in painting as an awareness of the truth beneath appearances. In February 1910 Károly Kernstok, the leader of the group, gave a talk to the Galilei Circle[10] titled "Investigative Art," which emphasized his aversion to the elusiveness and superficiality of Impressionism and urged the development of painting based on underlying structures in nature rather than mere optical perception: "It is not science we are seeking in painting, nor the play of emotions, but intellect: yes, we want disciplined human brainwork in painting."[11] This position was enthusiastically supported by philosopher and critic György Lukács, also in a lecture at the Circle,[12] although he had more of a political agenda than the painter.

What Lukács celebrated in Kernstok's ideas was not a leap into the unknown, but a return to values more solid than those of Impressionism. "Today once again we long for order among things… We long for permanence, for our deeds to be measurable, our statements unequivocal and verifiable… This art is *the old art* [emphasis added], the art of order and values, the art of the constructed. Impressionism turned everything into decorative surface… The new art is architectonic in the old and true sense."[13]

While Balázs had foreshadowed the messianism of what later became International Constructivism, Lukács forecast the strict architectural quality and rigorous symbolic economy that became particularly characteristic of Hungarian Constructivist works and concepts. In his 1910 assessment of Kernstok's artistic ideal, he wrote (as if anticipating Kassák's "picturearchitecture" of twelve years later):[14] "And every line and every mark, as in architecture, is only beautiful and of value in so far as it expresses this: the equilibrium of the stresses and forces that constitute any thing in the simplest, clearest, most concentrated and most substantial way."[15]

The appeal to Cézanne and "disciplined human brainwork" was, in the context of Hungarian culture, an appeal to supranational qualities such as logic and order, and was a rejection of the academic conservatism and the cult of the national past that dominated the officially supported Hungarian art. Both Kernstok's rationalism and the "great new Hungarian culture" envisioned by Balázs referred to a renewal that rejected conservatism and urged, at long last, the replacement of *couleur locale* by the international values of the Enlightenment.

LAJOS KASSÁK

The founder and longtime leader of the Hungarian avant-garde, Lajos Kassák, was not only a poet, writer, painter, and editor. He also created the position of countercultural leader—a role that survived him by decades. He carved into the structure of Hungarian culture the niche of an antiauthoritarian authority who defines his own boundaries and whose moral integrity is the paragon of the avant-garde artist. He put great emphasis on enacting his role by wearing the same type of Russian-style shirt and the same Slovakian hat all his life. When accepting a high state award at the age of eighty, he refused to wear a tie for the occasion.

Born in 1887 in Érsekújvár (then Upper Hungary), Kassák came from a proletarian family and trained to be a blacksmith when still a child. He moved to Budapest, was associated with

the Socialist Party, and involved himself in workers' move-
ments while very young. He was educated in pubs and in
party meetings by older workers and activists, and traveled
as far as Paris and Brussels on foot. He attended the Galilei
Circle, and, in 1917–18, the Free School for Humanistic
Studies.[16] A stubborn, self-made man, he often described
himself as a storm-ridden tree, firmly rooted in the ground,
withstanding even the strongest tempest without changing
position.[17]

Kassák started to publish poetry in 1909–10; he contributed
to the socialist daily *Népszava* [The People's Word] shortly
before the Great War broke out; and when he launched his
own periodical *A Tett* [The Action] in 1915, he gave visibility
to a group of young authors that had not been represented
in Hungarian culture before. He recruited them in literary
cafeterias and in the socialist movement. Eventually
editors of established journals sent radical youngsters over
to him.

A Tett was modeled upon Franz Pfemfert's Berlin publication
Die Aktion in title, layout, tone, and political stance. Kassák
dedicated it to the expression of grief and misery caused
by the war and social injustice, and, like Pfemfert, published
an international issue with the works of artists who were
citizens of Hungary's war enemies. Retaliation was harder
in Hungary than in Germany, where Pfemfert got away
with it by putting more emphasis on German artists after
the incident: *A Tett* was immediately banned in the summer
of 1916, whereupon Kassák tactfully launched a new journal,
titled *Ma* [Today].

In the "Program" published in *A Tett*[18] Kassák used the term
"New Literature," a precursor, in its categorical inclusiveness,
of his later "picturearchitecture." He defined it in twelve
points—a reference to an important tradition in Hungarian
history: In the 1848 revolution the people's demands were
listed in twelve points.

The ecstatic tone of the program derived from Kassák's back-
ground in socialist agitation, from Expressionist poetry,
and from his profound faith in his prophetic mission. As it
proceeds from the expression of his hopes for an "age of a new
moral order" to the terrifying reality of the war, it becomes
more and more heated, and the term "New Literature" is ele-
vated far above a merely pragmatic agenda: "The new litera-
ture must be a pillar of fire arising from the very soul of the
age! The subject of the new literature is the entirety of the
cosmos!... The glorified ideal of the new literature is Man,
enlightening into infinity!"[19] Thus the meaning of the pro-
gram shifts from the strategic scheme that it began as into

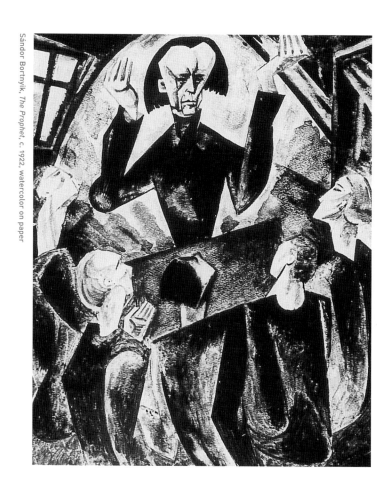

Sándor Bortnyik, *The Prophet*, c. 1922, watercolor on paper

"The new literature must be a pillar of fire arising from the very soul of the age!"

a vision of the glorious future that will emerge out of the blood and death of the present.

The language of Kassák's poetry, prose, and manifestos did not remotely resemble any literary tradition of the Hungarian language, nor the vernacular of any existing social group. It reflected the dramatic visions of German Expressionism, and the Futurists' use of syntactically unconnected words,[20] which Kassák further enhanced by inflecting nouns as if they were verbs. It also demonstrated Kassák's kinship with Walt Whitman, an equally independent spirit, and his free verse. These ingredients were foreign to Hungarian readers, and their combination with socialist contents resonated in sophisticated Budapest culture at first as childish, aggressive, and coarsely ignorant.[21] Still, it was such language that connected Kassák to the international community of socialist antiwar groups, and using this connection he urged international solidarity to oppose war profiteering.

Kassák's prophetic manner was the result of his stubborn belief that Expressionist language was the spontaneous vehicle of a primordial force common to every human being, springing from a rebellious primitivism. He believed that this language constituted a bond with the masses, who represented an original, culturally uncorrupted source of future creativity. He kept on writing in the Expressionist mode, even when composing such a Constructivist manifesto as "Picturearchitecture."

The gap between Kassák's language and his audience foreshadowed one of the lasting features of the avant-garde: the fact that its unfailing radicalism kept it distant from the mass audience it always hoped to cultivate.

COUNTERCULTURE AND POLITICAL POWER

The image of unfailing integrity that Kassák maintained required a policy of never cooperating with any political power in return for support or privileges, and never requesting any such support. Kassák wanted unconditional independence both as artist and as editor. Accordingly, he relates that when in 1919, during the Hungarian Commune, the former *Ma* contributor József Révai, assistant editor of the Commune's official daily paper, informed him in a phone call that a party decision had been made to have *Ma* as the official cultural journal of the Commune, he reacted in fury, telling Révai, "You can ban it, you can take it away from me, but I will go on editing it only if you let me do it as before."[22]

Documents, however, reveal that *Ma* had in fact lobbied to be the official journal of the Commune. *A Ma művészcsoport munkaterve* [The working projects of the Artists' Group Ma], which Kassák submitted to the cultural commissariat at the end of March 1919 and which was signed by "The journal *Ma* and the artists grouped around it," presented the merits of the group in furthering the proletarian dictatorship and made an emphatic request for administrative and financial support.[23] The monopoly over cultural life to which the group felt entitled was strongly expressed in Béla Uitz's article "Diktatúra kell!" [We Need a Dictatorship!], in which he declared: "We insist that the art of a communist society be directed by men without a trace of compromise in their art and in their political past... We, artists with a social revolutionary world view, profess our belief that the sole means of developing new cultural needs is likewise a dictatorship, an intellectual dictatorship."[24]

Kassák himself was employed by the Cultural Commissariat of the Commune as the censor of street posters. He conscientiously tended this job until a conflict with one of the leading poster designers, after which he was assigned to censor the Commune's theater productions.

Ma was granted exceptional treatment during the Commune, which lasted from March 21 to late August 1919. After May 15, at the time of a serious paper shortage, it became a biweekly

instead of a monthly, on thirty-six pages instead of the former twenty-eight. In return for this, however, the Commissariat for Public Education maintained tight control over its activities: A document dated July 1, 1919, for example, orders Kassák to give a written report to the Commissariat because he had published a leaflet addressed to Béla Kun, whereas neither he nor the print shop had had the permission to use paper for this purpose.[25]

This was probably Kassák's *Letter to Béla Kun, in the Name of Art*,[26] addressed to the leader of the Commune, who had criticized *Ma* at a party assembly. In the letter, which opened with "Dear *Comrade* Kun" [emphasis added], Kassák presented himself, the leader of the avant-garde, as more competent than any political figure in both artistic and political issues. In dramatic tones he outlined to Kun how his knowledge of and position in the international socialist and Communist movement were superior to Kun's, who had spent time in the Soviet Union while Kassák and his friends "had done propaganda work, both in speeches and writings, in Hungary."[27] As an artist and leader who came from the lowest ranks of society, Kassák regarded himself as an alternative to political authority. His later decisions, such as choosing Constructivism over Dada in 1922, or acknowledging in the 1930s the special interests of young workers in his journal *Munka* [Work], were also grounded in his strategy of keeping open the possibilities of both countercultural and mainstream leadership.

Kassák and the *Ma* group wanted the impossible: as old-time socialists, to play a leading part in the official culture of the Commune and, at the same time, to be entirely independent of its political leadership. In principle they refused to accept the low cultural level of the proletariat, and proudly declared that if "The artists of *Ma* did not cater to the bourgeois society, they will not cater to the dictatorship of the proletariat, either."[28] In practice, however, it was impossible to adhere to

this position. Not only did they need political support, but if they wanted to reach out for a wide audience, they had to give up their Expressionist language. For example, when the Ma group presented a revolutionary drama in a working-class neighborhood of Budapest, the reception was disastrous. The proletarian audience ridiculed János Mácza's Expressionist tragedy and burst out in frantic laughter at inappropriate moments. In his evaluation of the incident Kassák blamed the failure on the ignorance of the audience. He decided to give up dramatic performances altogether and return to a more traditional program: "A scientific introduction, poems, recital of epic pieces, and music… Yes. This was already an impressive show of seriousness and importance," he wrote about their next effort.[29]

In the light of this experience, which was certainly not the only one of its kind,[30] it appears that the prophetic solemnity of Kassák's poetry, prose, and journalism inadvertently served, through its stylistic and emotional power, to fill the cultural gap between a highly elitist language and "the people," who did not appreciate this language.

Kassák's concept of the relation between the avant-garde and political power was rather inarticulate while in exile, but it was based on his firm belief that "this [Hungarian] society needs redemption, not a reform."[31] The Commune, although it banned *Ma* in the summer of 1919, came to an end before Kassák would have had to actually fight the political leaders and address the problem of miscommunication with the masses. His unresolved conflict with Béla Kun left him with the intact belief that he was superior in both competence and moral power and that, having switched from Expressionist dramas to serious talk, he had firm hold of a mass audience. However, the period of the Commune was not a realistic experience for the avant-garde. As there was no time for the regime to consolidate, neither the avant-garde nor the political leadership could work through their conflicts and

rivalry rooted in their original antagonism. The fact that neither Kassák's countercultural stance nor the Commune's oppressive power had time to fully evolve foreshadowed the sense of unreality that the *Ma* circle faced during the six years of Vienna exile.

Following the defeat of the Commune, Kassák's idea of the state followed the Soviet model, as he knew it or thought he knew it. For Kassák art in the socialist state was to be made for and *given* to the people, and consequently had a purely moral value. Only the representatives of the state could judge the authenticity and value of artwork; the people with whom it is supposed to communicate were excluded from the process. Since it was freely given, they could not assess it as buyers or critics. Art is "of sacred nature,"[32] above being exposed to individual comments. This attitude is reflected in the answers the "Activists of Hungary"—Kassák's *Ma* group, that is— gave to the questionnaire of the Provisional Moscow Office of International Creative Artists,[33] sent to *Ma* on October 25, 1920.[34] Direct state control is welcomed, in fact, in the hope of protecting the artist as an individual: "We reject the notion of a trade union for artists," they say, because "we cannot envision collective collaboration for artists, who are individuals with widely different specific gravities. Therefore in lieu of trade unions we propose the establishment of a management agency by the state."[35]

In response to the question "What are the creative artists' obligations (to produce) and what benefits will they receive in a socialist state?"[36] they declared, "the social value of the artistic product cannot be measured by any objective parameters. The sole determinant of the value of the artistic product is the degree of the artist's revolutionary humanity." Kassák, the likely author of this response, described a centralized socialist model, where "the distribution of artistic products should be in the hands of the state," while "state-operated mobile art dealerships" would be authorized to sell art to individuals, who could make the payments in installments "as long as money will remain in effect." In answer to a question specifically regarding the relation of artists and state, the response was the *Ma* group's frequently repeated view that art is "permanent revolution," while the state is, by definition, created to conserve the status quo. So the only possible relation between radically subversive art and the state is: "You feed us so that we can fight against you."[37]

On a psychological level this statement—a document of the intimacy between political power and its opposition—can be interpreted as a transference of the child-parent relationship to the artist-state relation, where the state is protective and

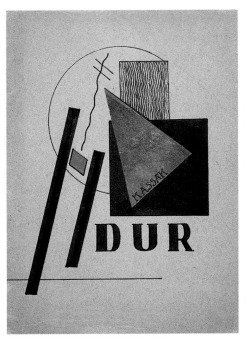

Lajos Kassák, *Dur*, 1921, ink drawing from bound portfolio

Lajos Kassák, *Dur*, 1921, bound portfolio, cover collage with gold leaf and ink drawing

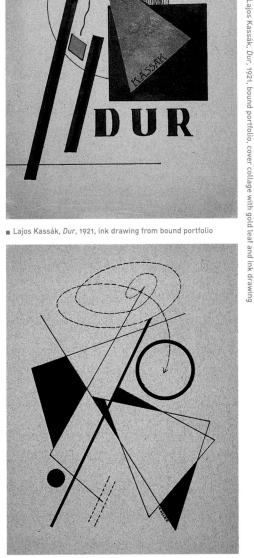

nurturing, bearing with the artist's necessary rebellion. Reading it in terms of political philosophy, it betrays Kassák's political and pragmatic incompetence and suggests that it is the duty of the state to encourage artists to work on its own deconstruction. In any case, the statement suggests a symbiotic relationship between the antagonists. The artist forever needs a strong state to fight against, and the state forever needs a challenger, who keeps it strong by trying to destroy it. The image of an eternally strong state (the counterpart of Kassák's self-image as a firmly rooted tree) invokes the concept of a timelessly powerful and majestic art, which materializes as the final *moral*—as opposed to physical—triumph of the artist over the state.

ERNŐ KÁLLAI'S CONCEPT OF CONSTRUCTIVISM IN BERLIN

The development of *Ma* into an international forum of the avant-garde during the Vienna exile was tremendously aided by two Hungarians who lived in Berlin: the critic Ernő Kállai and (until the end of September 1921) László Moholy-Nagy. Both provided Kassák with information, texts, and photos; Kállai, starting in the summer of 1921, sent him essays and reviews. Occasionally Alfréd Kemény and László Péri also contributed, but Kassák's Berlin pillar was, until 1924, Kállai. Kállai was born in 1890 to a Serbian father and a German mother. He was a young teacher in Budapest during the First World War when he met Kassák in *Ma*'s exhibition room; Kassák singled him out for his enthusiastic and inspired guidance to visitors. He asked for a leave of absence in 1920 and settled in Berlin, where he dedicated himself to art criticism and soon became one of the most respected interpreters of modernist art. His first article in *Ma*, titled "Új művészet" [New Art], was an overview of the European art scene from the perspective of what he called "objectivism." With this term Kállai identified an emerging trend that was a desirable counterpoint to Expressionism's extreme subjectivity. This approach echoes Kernstok's and Lukács's 1910 opposition to Impressionism and their appeal to "structure." Just as Lukács discerned what he called "the old art" in the architectural rationalism of Kernstok, Kállai used the term "the newest classicism" in a highly positive sense to describe the recent works of Carlo Carrá, George Grosz, and the Section D'Or (a Paris group that offered a geometric-purist alternative to Cubism), referring to their solidity and self-contained forms as opposed to what was seen then as inchoate Expressionist individualism. In these works, he wrote, "the creative power was not arrested as an irresponsible deluge of lyrical impulses, but deepens and widens factual statements into

collective, and even cosmic truth... It is not adventure, but knowledge; not emotion, but action; not a process, but a result. *Objectivity*."[38] Having discussed the classicism inherent in the new realism, Kállai remarks: "Let us not go as far as art. How much classicism: clear, transparent order, delicacy, and the beauty of form and dynamism manifests itself in modern machinery! How much earthly, human solemnity in the proud verticality of the factories, sky-scrapers, in the slow movement of steam liners, in the flight of airplanes, and in the span of bridges!"[39]

This description, as well as much of what follows in the article, is suggestive of what will soon be known as Constructivism, and parallels the ideas widely circulated by the Futurists in Italy as well as the Rayonists in Russia.[40] In the second part of the essay Kállai even uses the term "construction" in a sense that is very close to that established at the Moscow Inkhuk [Institute of Artistic Culture] in March 1921: "In terms of purely form-related issues, objectivism has got rid of painterly effects. It emphasizes linearity or volume. Eschewing expression as well as academic composition, it achieves integrity and law in *constructions*."[41]

As Oliver Botar's chronology of the events of 1921 and 1922 indicates, however,[42] it was impossible for Kállai to know anything of Russian Constructivism, even the term, before the end of the year. His only likely source of information, Konstantin Umansky, left Russia late in 1920, prior to the formation of the First Working Group of Constructivists at Inkhuk the following spring, and Alfréd Kemény provided him with firsthand information only upon his return to Berlin at the end of December 1921. It thus seems that Kállai employed the terms "constructive" and "construction," as opposed to both expression and composition, simultaneously with the Russians. He may have used them in reference to the grid structure of De Stijl works, in particular those of Theo van Doesburg, although there is no mention of him. "The construction of geometric and technical forms" is a phrase that comes up in relation to Archipenko's nudes, and Kállai also writes of the "constructive force of Cubism."[43]

By the summer of 1921 Kállai had outlined the concept of a new objectivist art that was the harbinger of the future, based on forms and gestures that refer to constructing, whether in architecture or painting. He instantly found artworks that demonstrated this concept. His short article on Moholy-Nagy[44] is celebratory and was apparently inspired by Kassák's tone: "Not only is Moholy-Nagy the monumental lord and master builder of today's life and

"How much earthly, human solemnity in the proud verticality of the factories, sky-scrapers, in the slow movement of steam liners, in the flight of airplanes, and in the span of bridges!"

■ László Moholy-Nagy, *F in a Field*, 1920, gouache and collage

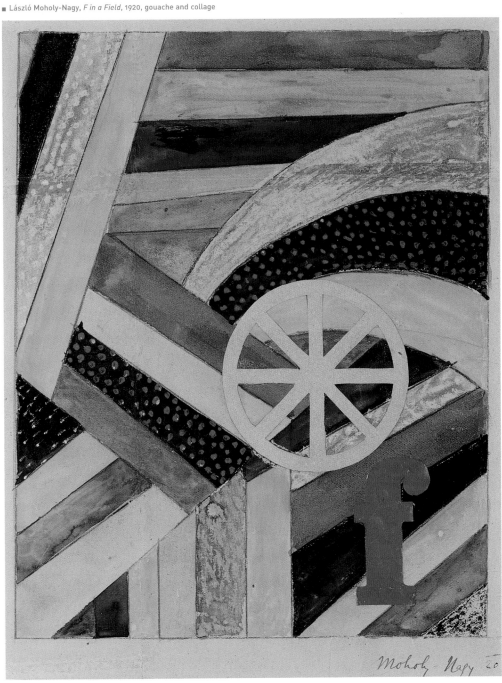

form, but also an ecstatic onlooker of it... Moholy-Nagy elevates his pictures into visions."[45]

Moholy-Nagy's works were the first to corroborate the vision of a self-contained, mechanically constructed model world for Kállai, and he describes them as a new universe in the making:

The Anarchy is being visibly organized towards a concentric system. New particles emerge from new systems in the place of disrupted conglomerates, although they do not evolve into closed and concentric constructions. The newer constructions are still open-ended, but they are more articulate, and more concentric. It is the mechanics and dynamism of the modern machines that is being transformed into art in the synthesis of concentric and non-concentric picture-constituents, and of the creative principles drawn on cubism and dada.[46]

His description of the "constructive" picture culminates, once again, in exalted solemnity: "Moholy-Nagy declares freedom and law, which illuminates the infinite perspectives of the future."[47]

In an article on the geometric abstract works of Kassák, who made his debut as an artist in 1921, Kállai envisioned a new social context for objective art:

Architectonic articulation is all the more severe, and its forms all the more abstract and simple, the less self-secured the social and economic order of the collective spirit is. For every new collective signals the elevation of a victorious, objective historical will into an accomplished fact. The launching of every collective involves the welding together of various forces into the most solid agglomeration of power—thus it is construction, in the most inexorable sense of the word.[48]

With all his rigor and passionate social consciousness, Kassák nonetheless produced drawings and paintings that lacked dynamism. Rather than being models of engineering or mechanical systems like those of the Russian and International Constructivists, they visualized a static, flat, and hieratic order. Exploiting the inherent authority of geometry, Kassák imprinted his personal style on "picturearchitecture," which was to become the Hungarian version of Constructivism, in a manifesto of 1922. This inspired Kállai to use a similarly austere tone: "It is the spirit of frontality that commands an egolessness that transcends the differentiations of an objective view, to construct a monument out of its own inner world. In Kassák's picture-architecture the essence of collective civilization asserts itself with severe sovereignty."[49]

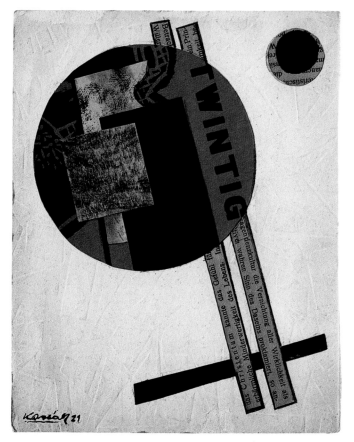

■ Lajos Kassák, untitled ("Twenty"), 1921, cut-and-pasted printed papers, ink, and pencil on paper

This tone is the more remarkable because, between the articles on Moholy and Kassák, Kállai published a survey titled *Jungungarische Malerei* [Young Hungarian Painting] in *Der Ararat* in Munich for a German readership, in which he used a lighter, down-to-earth tone and adopted an objective rather than an exalted perspective. Although he did mention the monumentality of Moholy's works, he put him in historical perspective with Kassák, Uitz, and Bortnyik as representatives of "the collective, impersonal spirit of the social revolution."[50] Similarly, the article titled "Constructivism"[51] that he published in *Ma* marks the pinnacle of his utopian ecstasy, whereas another article with the same title, published in *Jahrbuch der jungen Kunst*[52] in the following year, is a straightforward professional overview of the movement. It was specifically in the Hungarian cultural context and particularly in Kassák's journal that an aura of solemnity enveloped the geometric idiom, and not even Kállai used this intonation in German forums.

Kállai's journey from "objectivity" and newfound classicism in art to visionary descriptions of self-generating and self-sustaining abstract systems—his Constructivist vision—outlines the evolution of utopian expectations in Germany

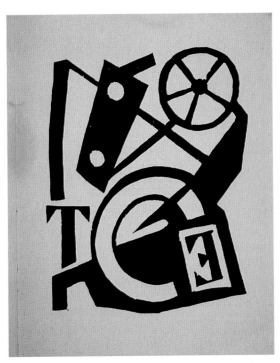

Lajos Kassák, page from Ma book *To My Woman*, 1921, print after woodcut

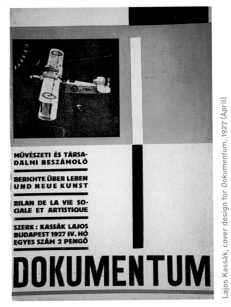

Lajos Kassák, cover design for *Dokumentum*, 1927 (April)

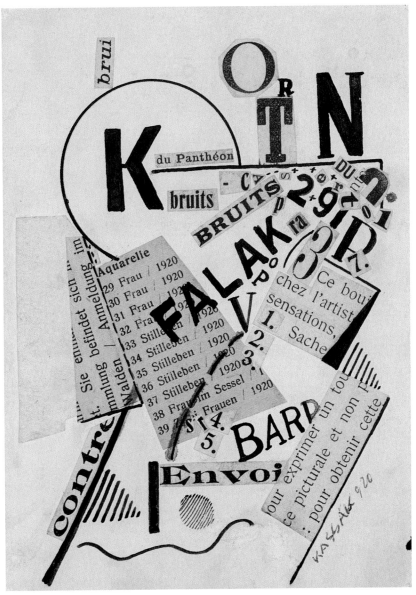

■ Lajos Kassák, *Noise*, 1920, collage and ink on paper

between 1921 and 1924. As the Weimar Republic consolidated as a moderately leftist and clearly capitalist state, and thus solid ground slipped out from under the feet of the radical community of artists and writers; and as hope for the world revolution, the new collective, and international brotherhood drifted by, Kállai's system became simultaneously more ethereal and more detailed, a parallel world of visionary social utopias.[53] Such utopias were generated in compensation for actual losses and functioned like wish-fulfilling images. In Berlin, in the midst of a "fanatic will to a global future which will transcend races and nations, as the inspiration and spiritual center of creative work,"[54] Kállai declared that "the European future needs the society of the superior, collective people."[55] The art of such people would be architectural, its forms self-contained, meeting the viewer with a majestic frontal view "in which hard laws and freedoms, far beyond individuality, stretch into infinity."[56] With, once again, exalted phrasing consistent with the tone of *Ma*, where the article was published, and echoing Kassák's Program, he envisioned "A civilization elevated into religion, a new cultural perspective, a manifesto out of love and negation: A CALL FOR ACTION!"[57]

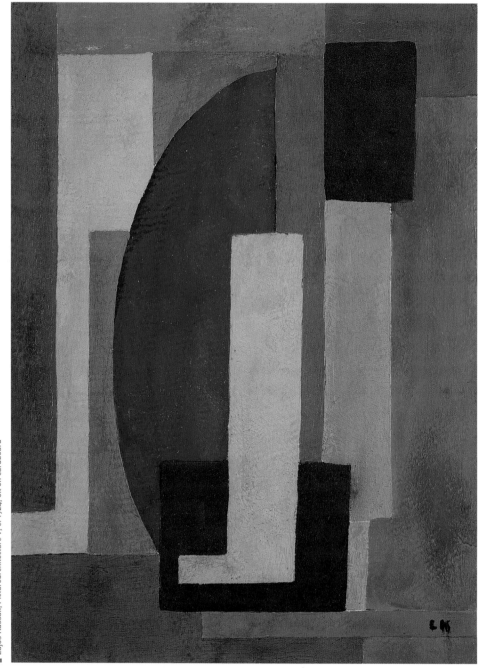

■ Lajos Kassák, *Picturearchitecture V*, c. 1924, oil on cardboard

CONSTRUCTIVISM VERSUS DADA: SCHISM IN THE VIENNA GROUP

This expansion into global dimensions dominates Lajos Kassák's 1922 manifesto "Képarchitektúra" [Picturearchitecture]. Kassák, who embraced Dada in 1921 as the expression of postwar chaos, bitterness, and disillusionment, and published picture-poems himself in the manner of Kurt Schwitters, emerged from his despair at the defeated socialist cause by inventing his own contribution to International Constructivism. The term "picturearchitecture" was not coined by Kassák. First used by Moholy-Nagy in 1920 as the title of a series of paintings ("Bildarchitektur"), then by Bortnyik for his portfolio in the spring of 1921, and later by Kállai in his article on Kassák, in the manifesto the term stands for every positive value that Kassák discerns in art and society. Repeated throughout the text like a chant, it is so all-inclusive that it amounts to the declaration of a general renewal of Kassák's program: validating Constructivism at the expense of Dada. Its "architecture" component metaphorically refers to the great new era of engineering and modernist constructions, the inclusion of which will distinguish *Ma* from that point on from the *Ma* of the pre-picturearchitecture period.

Even though Huelsenbeck's "Dadaizmus" was printed on the same page as "Picturearchitecture," the Dada period was behind Kassák, whose focus from now on would be the majestic order and discipline he saw in Constructivism. Although Dada rejected bourgeois materialism, and its freedom, montage technique, and inherent anger made it possible for Kassák to express his pain and disappointment over the lost revolution and his forced emigration to Vienna, it did not satisfy his need for seriousness, rigor, and prophetic vision. Nor did it agree with his concept of the new art. The overall negativism of Dada was directed not only against the petit bourgeois, but also against everything that Dadaists thought pretentious, including modernist art itself. A self-made man, Kassák could not appreciate humor regarding what was for him a hard-earned aesthetic culture. Lacking a middle-class education, he did not enjoy Dada jokes and was not able to switch back and forth between straight talk and irony. Unlike Karel Teige, he did not have a conceptual framework that could encompass both Dada and Constructivism. Modernist art was Kassák's religion and ethical standard. He was unable to tolerate frivolity: for him, even Dada had a tragic overtone.

Deliberately infantile, nihilist, and challenging every kind of authority, Dada was, however, the only trend within the avant-garde that, by definition, did not have the potential to rise to

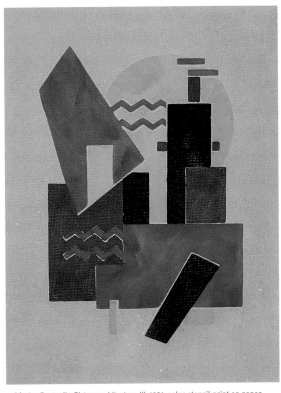

■ Sándor Bortnyik, *Picturearchitecture III*, 1921, color stencil print on paper

a position of authority. Its black sarcasm and ruthless critique of culture and society did not offer a constructive position for a leader; Dada rejected the very idea of leadership altogether. But Kassák was inherently a leader, conscious of his own strength as an artist and as a high priest of the avant-garde, and he fought for a strong position in the counterculture. At first he welcomed Dada as a revolt against traditionalism. He saw, for a short while, a great potential in its destruction of old values. But ultimately he needed a positive, authoritarian program to fulfill his ethical and strategic demands, something for his group and audience to follow; this he found in picturearchitecture, which he posited as the artistic and conceptual framework of the future.

Kassák never ceased to publish Dada and, later, Surrealist and other non-Constructivist works. His decision to discard Dadaist anarchy and identify with the affirmative stance of Constructivism is not a mere interpretation of his activity. Shortly after his decision he wrote a letter to one of his friends and contributors, the poet Ödön Mihályi, in which he explained why he thought Dada was inferior. "Rest assured, the dadaists have nothing to do with *Ma*... They are nothing more than a conservative *school*, so I have no desire to join them and will not allow *Ma* to shift under their umbrella; but I will not allow it to be strangled by clever principles, either."[58] He also explained that he had published the Dada piece "Green-Headed Man," by Sándor Barta, in order to help Barta forget such senseless experimental writing, rather than think that these "razzle-dazzles of despair" were too innovative to be published.[59]

His will to assert himself and *Ma* as the firm representatives of Constructivism and the imposition of his austerity onto the journal cost Kassák both the unity and diversity of his group. He never rejected the publication of Dada and Surrealist works, but insisted on the strict underlying tone and ethical standard set by Constructivist abstraction. This decision to prioritize Constructivism over Dada led to a split within Kassák's group. Barta, a devoted Dadaist in spite of Kassák's expectations, did not "come to his senses." Unwilling to succumb any longer to Kassák's dramatic pronouncements and to give up his interest in the grotesque as well as his increasing commitment to the Communist Party, he launched his own journal, *Akasztott ember* [Hanged Man] in the summer of 1922. This journal reflected the spirit of Berlin Dada, using George Grosz's drawings as illustrations. Liberated from Kassák's dominance and taste, Barta plunged into satire, black humor, and absurdity. He also targeted Kassák and his wife, representing them as the Lajos Collective and

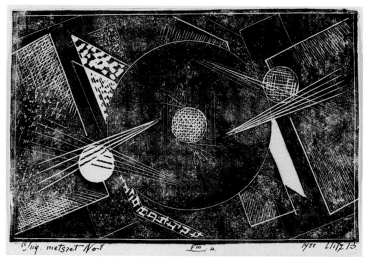

■ Béla Uitz, *Analysis VIII*, 1922, linocut on paper

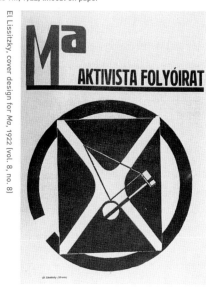

El Lissitzky, cover design for *Ma*, 1922 (vol. 8, no. 8)

Kassák attempted to harness the authority of geometry and architecture to sustain the fragile utopia of the Constructivist worldview.

Jolán Simple. In 1923 Barta launched *Ék* [Wedge] and then, along with his wife, the poet Erzsi Ujvári, Kassák's sister and contributor, quit Vienna and followed Uitz, who had already cut ties with Kassák in 1921, and left for the Soviet Union.

Seriousness, literary theorist Mikhail Bakhtin persuasively argues, is opposed to farce in the rhetoric of power.[60] The genetic connection between the geometric vocabulary of the 1920s and minimal art of the 1960s and 1970s sheds light, in retrospect, on the "will to control and dominate"[61] that was inherent in the severity of Kassák's picturearchitecture. In the modernism of the 1920s, as in the age of the Enlightenment, architecture and geometry symbolized the future, avowing the infinite potential of rational planning. Kassák's work endowed the picture with the higher authority of geometry and architecture. The Constructivism he created was thus the true precursor of minimal art. Anna C. Chave observes that

Minimalism's fundamentally architectural, classical visual language invites comparison also with the classically founded architectural mode of the International Style [of the 1920s and 30s]. By the 1960s, those elegant, precise, and antiseptic-looking glass boxes that we recognize as the legacy of the International Style had become well established as the architecture of big business... For Western civilization, classicism is conventionally the art of authority, authoritative art.[62]

There is a straight line from Uitz's call for "an intellectual dictatorship" and Kassák's for an "ideational dictatorship"[63] to picturearchitecture, and then to the rigorous geometry of the Hungarian neo-avant-garde of the 1960s and 1970s.

Much like the "old art" that Lukács saw in Kernstok's painting, the taciturnity and absolute quality of geometric abstraction was recognized as the epitome of a worldview. Echoing Kállai's 1921 lines "We are fighting for synthesis, style, a world

view,"[64] Kassák wrote in "Picturearchitecture": "Having a world view means to have the feeling of certitude: the greatest of realities. The only measurement of an artist is his world view."[65]

This worldview was based on what Rosalind Krauss calls, speaking about the grid, "an absolute beginning," with the avant-garde artist manifesting "absolute self-creation."[66] This new beginning was the result of an intellectual decision claiming that the crystal-lucid structure of geometry had the power to render the old world obsolete, and the authority to announce the birth of a new one.

Kassák attempted to harness the authority of geometry and architecture to sustain the fragile utopia of the Constructivist worldview. But Hubertus Gassner has called attention to the paradox of the term "picturearchitecture"[67] regarding the materiality of Kassák's works, pointing out that these were, in fact, *paintings*. Kassák tried to resolve this paradox by claiming that "picturearchitecture builds space not behind the picture plane, but before it. The picture plane is a simple base. No perspective is opened up into it, because that could be mere illusion only, but layers of forms and colors are superimposed on it, entering real space in front of the plane..."[68] He also said that his pictures were meant to be a "revelation...not of the picture of the world, but of its substance. Architecture."[69] Although their emphasis on real space ties his work to Russian Constructivism, and the concept of the picture plane as background was later theorized by Lissitzky,[70] they were, in fact, paintings and linocuts with layered geometric forms that did not, even virtually, create the space he described *in front of* the picture plane.

BETWEEN CULTURES

Hungarian Constructivism inhabited a nowhere-land not simply because it rejected the present for a nonexistent future, nor because of its ambiguous location between East

and West in what is called, in German, "Zwischen-Europa" [Between-Europe], but also because it was created in the equivocal intellectual space of emigration. This cultural homelessness—which continued even after the *Ma* group's return to Budapest in 1926, when the political situation had consolidated in Hungary and they no longer feared persecution or jail—was also a significant reason why it relentlessly pursued the creation of a timeless, classicist, well-structured model universe, rooted in the elusive image of a better world.

Few pragmatic activities were open to these artists in interwar Hungary. Kassák and Bortnyik were temporarily engaged in graphic design, hoping to reach, finally, the mass audience of city dwellers. Kassák became preoccupied with the role advertisements played in the socialist state and declared that "the advertising artist is a social creator,"[71] ignoring the fact that advertisements are a crucial part of capitalist enterprises and their business interests. In 1928 Bortnyik opened a design school called Műhely [Workshop], which many saw as "the Hungarian Bauhaus," in order to realize the concept of the artist and designer "as social creator."[72] Ernő Kállai, who had lost faith in Constructivism in the mid-1920s,[73] partially revived his utopias of the early 1920s when he agreed to serve as the editor of the *Bauhauszeitschrift* under Hannes Meyer's directorship between 1928 and 1930, but he had disavowed the concept of a new monumental art that he had described in many of his earlier essays. He pointed out that in the absence of a pervasive ideology with a cult around it, "it is impossible to have an architecture in the old sense of the word, where an all-encompassing form dominates all the formal and functional components."[74] Dedicated to Hannes Meyer's pragmatic architectural ideas, Kállai discarded the notion of grand new constructions and redirected his interest to the interrelationship between European politics and contemporary art.

Kassák, by contrast, did not relinquish the idea of a monumental and authoritative art based on socialist ideology. During the 1930s the language of his poetry turned classicist, and his periodical *Munka* shed elitist artistic idioms. It included a sports column as well as one for letters, where readers could share their problems and opinions with each other. He and his wife organized a "recital choir," with performers reciting poetry in large stage productions, investing it with the power of the crowd. He also organized a "sociophoto movement" for young photographers whose socially critical images portrayed the poor, the homeless, and working people, and were comprehensible by all.

While the avant-garde movements in the West cycled through the art market and were eventually integrated into mainstream culture, the same visual vocabulary was frozen into the sacred icons of the avant-garde in the East.[75] That these tendencies had already diverged in the mid-1920s is clearly demonstrated by Malevich's book *Die gegenstandslose Welt* [The Nonobjective World].[76] What in the West was the dynamism of ever-renewed and ever-discarded art trends, a system of "obsolescence cycles,"[77] appears in Malevich's book as a purely abstract, metaphysical process: the repeated burst of an "additional element" into the established aesthetic order that disrupts it to organize its own different system. The spiritual procedure that Malevich describes is in fact the blueprint of the incessant dynamism of the art life and art market in the West.

In Hungary Kassák's commitment to the exclusively moral value of the artwork prevailed until the late 1970s. In 1968, a year after his death, he was reverently celebrated by the young Budapest neo-avant-garde as one who had unfailingly insisted that "The artist never produces for a market of luxurious commodities, but for his chosen kin-spirited friends only"[78]—a statement of independence that was also a sign of retreat into, if not the ivory, the ferroconcrete tower of the avant-garde.

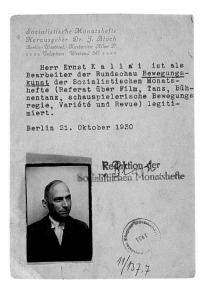

Ernö Kállai's *Socialist Monthly* identification card, October 21, 1930

1 Theo van Doesburg-El Lissitzky-Hans Richter: "Declaration," Düsseldorf, May 30, 1922. *De Stijl* vol. 5, no. 4 (April 1922): 64.

2 See Christina Lodder's seminal book *Russian Constructivism* (New Haven and London: Yale University Press, 1983).

3 Varvara Stepanova, lecture at Inkhuk, Dec. 22, 1921, in Alexandr Lavrentiev, *Varvara Stepanova: The Complete Work*, ed. John Bowlt (Cambridge: MIT Press, 1988), 175.

4 See Oliver Botar, "Constructivism, International Constructivism, and the Hungarian Emigration," *The Hungarian Avant-Garde 1914–1933*, trans. Éva Pálmai (Storrs: University of Connecticut/The William Benton Museum of Art, 1987), 90–97.

5 Ernő Kállai, *Új magyar piktúra* (Budapest: Amicus, 1926), 181.

6 Even if some articles were published both in German and in Hungarian, and he published an international theater issue in German. Throughout the years spent in Vienna, Kassák's wife made trips back to Budapest, where she clandestinely distributed copies of *Ma*, and kept in touch with like-minded artists.

7 The philosopher György Lukács, the critic László Bánóczi, the writer Béla Balázs, and the composer Zoltán Kodály founded the Thália Társaság [Thalia Society] in 1904 to stage new plays that had not been known or performed in Hungary before.

8 Quoted from Balázs's diary (manuscript), Mary Gluck, *Georg Lukács and His Generation 1900–1918* (Cambridge: Harvard University Press, 1985), 138.

9 Lajos Fülep, "Új művészi stílus, 3. Rész," in *Új szemle* (April 1908): 207.

10 A forum of radical students in Budapest.

11 Kernstok, "Kutató Művészet," *Nyugat* (1910, I): 96. Trans. in *Between Worlds: A Sourcebook of Central European Avant-Gardes, 1910–1930* (Cambridge: MIT Press, forthcoming).

12 György Lukács, "Az utak elváltak," *Nyugat* (1910, I): 190–93. Trans. in *Between Worlds*.

13 Ibid., 191.

14 The term is usually translated as "pictorial architecture." The Hungarian word "képarchitektúra," however, just as its German mirror-translation, "Bildarchitektur," whoever invented it, is a blatantly new creation: a nonexistent word in the language, just like the Gropius-coined "Bauhaus." Its English translation as "picturearchitecture" conveys the irregularity and the provocative disregard to the traditions of usage of the term, in which two nouns are combined. I am thankful to Yvette Biro for her consultation with me about this.

15 *Nyugat* (1910, I): 193.

16 A series of lectures organized by liberal Budapest intellectuals in 1917–18, including lectures by György Lukács, Béla Balázs, Arnold Hauser, Béla Bartók, Zoltán Kodály.

17 E.g. Lajos Kassák, *Szénaboglya* (Budapest: Szépirodalmi Könyvkiadó, 1988), 139.

18 Lajos Kassák, "Programm," *A Tett* (1916/10):153–54. Trans. in *Between Worlds*.

19 Ibid.

20 For a detailed analysis of Kassák's language, see Pál Deréky, *A vasbetontorony költői* (Budapest: Argumentum, 1992), 32–34.

21 For more on Kassák's early reception and his debate with the poet Mihály Babits see Deréky, ibid.; and Éva Forgács, "Constructive Faith in Deconstruction: Dada in Hungarian Art," *The Eastern Dada Orbit*, ed. Gerald Janecek and Toshiharu Omuka (New York: G. K. Hall, 1998), 63–91.

22 Lajos Kassák, *Egy ember élete* (Budapest: Magvető Könyvkiadó, 1974), 521; my translation.

23 Kassák Múzeum, Budapest, Km-an 12. Published in Ferenc Csaplár, ed., *A magam törvénye szerint* (Budapest: Petőfi Irodalmi Múzeum-Múzsák Közművelődési Kiadó, 1987), 154–56.

24 Published as "A Commentary on Comrade József Révai's Article 'We Need Proletarian Politics,'" in *Vörös Újság* (Apr. 10, 1919), referred to by Csaplár, ibid. 149. Trans. in *Between Worlds*.

25 The document is published in Csaplár, 153. In an article *Vörös Újság*, April 18, 1919, titled "Felvilágosításul," György Lukács explains that "*Ma* is not the official organ of the Commissariat for Public Education." As Csaplár points out, the need for such apology confirms the privileges that *Ma* enjoyed.

26 Lajos Kassák, "Levél Kun Bélához a művészet nevében," *Ma* 4, no. 7 (June 15, 1919): 146–48. Trans. in *Between Worlds*.

27 Ibid., 146.

28 Mózes Kahána, "A *Ma*—több ízben ért támadásokról," *Ma* 4, no. 6 (June 1, 1919): 142.

29 Lajos Kassák, *Egy ember élete* (Budapest: Magvető Könyvkiadó, 1974), 513–14.

30 See, for example, a review by "z.a." in *A Nap* (April 17, 1919), "A Ma propagandaestje," where all the poetry, particularly that recited by Kassák's wife Jolán Simon, was ridiculed.

31 Lajos Kassák, endnote to his pamphlet *A világ új művészeihez*, Budapest, after July 8, 1919, in Csaplár, 156.

32 "Az alkotó művészek provizórikus, moszkvai interna-cionális irodájának kérdései a magyarországi aktivista művészekhez.," *Ma* 6, no. 2 (Nov. 1, 1920): 18–19. Trans. in *Between Worlds*.

33 Probably identical with the International Office set up within the Department of Fine Arts, Moscow. For more details see Lodder, *Russian Constructivism*, 233–34; and 303–4, n. 28, 29, 30.

34 See note 31.

35 Ibid.

36 Ibid.

37 Ibid.

38 Mátyás Péter (Ernő Kállai), "Új művészet," part 1, *Ma* (June 1, 1921): 99.

39 Ibid., 115.

40 For comparison, see Larionov's and Goncharova's Rayonist Manifesto, 1913: "We declare: the genius of our days to be: trousers, jackets, shoes, tramways, buses, airplanes, railways, magnificent ships—what an enchantment—what a great epoch unrivalled in world history." Quoted in Camilla Gray, *The Russian Experiment in Art, 1863–1922* (London: Thames and Hudson, 1962), 136.

41 "Új művészet," part 2, *Ma* (Aug. 1, 1921): 114.

42 Botar, op. cit.

43 Ibid.

44 Mátyás Péter, "Moholy-Nagy," *Ma* (Sept. 15, 1921): 119.

45 Ibid. My translation.

46 Ibid.

47 Ibid.

48 Mátyás Péter, "Kassák Lajos," *Ma* (Nov. 21, 1921): 139. Trans. in *Between Worlds*.

49 Ibid.

50 Ernst Kállai, "Jungungarische Malerei," *Der Ararat* (1921/10): 256–58. Reprinted in *WechselWirkungen: Ungarische Avantgarde in der Weimarer Republik* (Marburg: Jonas Verlag, 1986), 103–4, and Csilla Markója, ed.: *Kállai: Gesammelte Werke*, vol. 2 (Budapest: Argumentum Kiadó, MTA MKI, 1999), 10–12. A difference between writings published in Hungarian forums and abroad was not unusual, and the difference was often more than just the intonation, as in Kállai's articles. The writer Tibor Déry, a regular contributor to Kassák's 1927 *Dokumentum*, wrote Dadaist plays in Italy in the early 1920s, but published an anti-Dada essay in Budapest: "Dadaizmus," *Nyugat* (1921): 552–56.

51 Ernő Kállai, "Konstruktivismus," *Ma* (May 1, 1923): 8.

52 Ernst Kállai, "Konstruktivismus," *Jahrbuch der jungen Kunst* (1924): 374–84.

53 For a detailed analysis of this series of Kállai's articles, see Éva Forgács, "Kállai Ernő és a konstruktivizmus," *Ars Hungarica* (1975/1).

54 See n. 27.

55 Ernő Kállai, "A kubizmus és a jövendő művészet," *Ma* (Jan. 1, 1922): 32.

56 Ibid., 31. It is to be noted that since this article was published on Jan. 1, 1922, it too had to be written before Alfréd Kemény returned to Berlin from Moscow with his personal experience and news of the Russian Constructivists and Inkhuk, where he had given lectures on December 8 and December 26.

57 Ibid., 32.

58 Lajos Kassák, letter to Ödön Mihályi, not dated (probably spring 1921). Archives of Petőfi Irodalmi Múzeum, Budapest, V.2293-113. My translation.

59 Ibid.

60 Mikhail Bakhtin, *Rabelais and His World* (Bloomington: Indiana University Press, 1984), 94.

61 Anna C. Chave, "Minimalism and the Rhetoric of Power," *Arts Magazine*, no. 64 (January 1990): 51.

62 Ibid., 53.

63 Lajos Kassák, "An die Künstler aller Länder," *Ma* (May 1, 1920): 3.

64 See n. 33.

65 Lajos Kassák, "Képarchitektúra," *Ma* (March 15, 1922): 52–54.

66 Rosalind Krauss, "The Originality of the Avant-Garde," in *The Originality of the Avant-Garde and Other Modernist Myths* (Cambridge: MIT Press, 1985), 157, 158.

67 Hubertus Gassner, "'Ersehnte Einheit' oder 'erpresste Versöhnung,'" in Gassner, ed., *WechselWirkungen*, 195. My translation.

68 Ibid., 53.

69 See note n. 35, page 52.

70 El Lissitzky, "K. und Pangeometry," *Europa Almanach* (Potsdam: Gustav Kiepenhauer Verlag, 1925), 103–13.

71 Lajos Kassák, "A reklám," *Tisztaság könyve* (Budapest, 1926): 82–84. Trans. in *Between Worlds*.

72 Ibid.

73 See his article "Ideológiák alkonya," *365* (April 1925): 19–20.

74 Ernő Kállai, "Architektúra," *Ma* (Feb. 20, 1924): 2.

75 For a detailed description of these processes see Géza Perneczky, "A fekete négyzettől a pszeudo kockáig," *Magyar Műhely* (1976): 27–45.

76 First published as volume 11 of the Bauhausbücher series in 1927, translated from Russian to German by Alexander von Riesen.

77 Brian O'Doherty, "Minus Plato," in Gregory Battcock, ed., *Minimal Art* (Berkeley: University of California Press, 1995), 252.

78 Tölgyesi János, "Megnyitó beszéd" [Opening Words] at the *Iparterv* exhibition, Budapest, December 12, 1968. *Iparterv 68–80* (Budapest: Iparterv Print, 1980), 39. My translation.

vienna

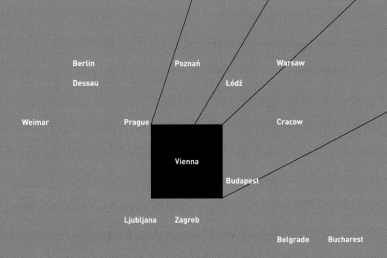

Berlin Poznań Warsaw

Dessau Łódź

Weimar Prague Cracow

Vienna

Budapest

Ljubljana Zagreb

Belgrade Bucharest

Although the Hungarian Activists fled to Viennese exile in defeat, they perceived their failure as something great,

something tragic—and they saw themselves as heroes who had sacrificed themselves for a better world.

VIENNA

Pál Deréky

p. 165:
Friedrich Kiesler, Theater in Space, stage with artists, 1924

Below:
Lajos Kassák, cover design for Ma book no. 1, *To My Woman*, book of prints after woodcuts

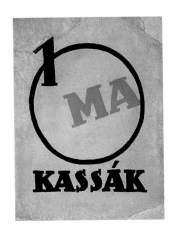

Hungarian Émigrés and Activists in Vienna

The political and social restructurings that followed the First World War shook Central Europe like the aftershocks of an earthquake. The Hungarian Soviet Republic, which lasted from March to August 1919, is one example. Budapest's Activists doubtless had helped to precipitate its formation, despite the fact that as early as February 1919 they had rejected the Communists' hegemonic cultural policies and declared unmistakably that they would never recognize the party's authority in matters of literature and art. This declaration, which would be asserted repeatedly in the years to come, essentially determined not only the form and content of Hungarian Activism but also the fate of its artists and writers.

As a result of these circumstances—as well as others that cannot be addressed within the limited framework of this essay—the composition of the émigrés who found themselves in Vienna after the fall of the Hungarian Soviet Republic was extremely heterogeneous. Contemporaries perceived this "disunity" as tragic, but in retrospect it must be seen as a stroke of luck, because to it we are indebted for the large, varied, and interesting cultural heritage of the émigré community. More than thirty Hungarian periodicals were published in Vienna at the start of the 1920s, including the daily newspapers *Bécsi Magyar Újság* [Viennese-Hungarian Gazette] and *Jövő* [Future]. Even the avant-garde periodicals, committed to differing ideals, stood in sharp contrast to one another. At one end was the widely circulated, internationally known journal *Ma* [Today], from the circle around Lajos Kassák, which offered space to all the competing movements. At the other were the journals of the productionist Constructivists dedicated to the "proletcult," such as *Akasztott ember* [Hanged Man], *Ék* [Wedge], and *Egység* [Unity]. The content of these journals is interesting. For example, in 1922 *Egység* published the first translation of the *Realist Manifesto* (1920) by the brothers Antoine Pevsner and Naum Neemia Pevsner (Gabo), as well as a refutation of it authored by Vladimir Tatlin, Alexander Rodchenko, and Varvara Stepanova. *Egység* also presented Malevich's Suprematism in 1922. There were numerous Hungarian-language publishers—some of their publications will be briefly discussed below—and many Hungarian avant-garde artists resided in Vienna for long or short periods, foremost among them Lajos Kassák, Béla Uitz, Sándor Bortnyik, Aurél Bernáth, Róbert Berény, and Lajos Tihanyi.

The Viennese Avant-Garde in the 1920s

Although the Hungarian Activists fled to Viennese exile in defeat, they perceived their failure as something great, something tragic—and they saw themselves as heroes who had sacrificed themselves for a better world. Their comrades in Austria, however, did not succeed in establishing a Communist Soviet Republic. The literary champions of such a republic—such as Franz Blei, Albert Paris Gütersloh, Franz

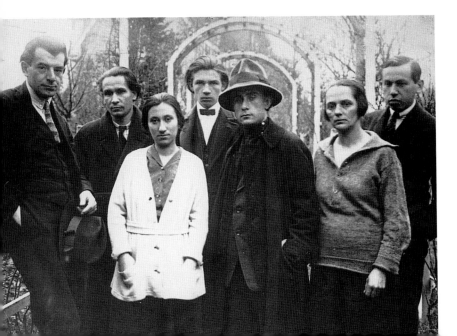

Sándor Bortnyik	Béla Uitz		Andor Simon			Sándor Barta
		Erzsi Újvári		Lajos Kassák	Jolán Simon	

Ma group, Vienna, c. 1922

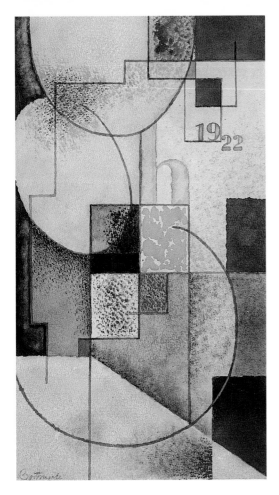

Werfel, and Egon Erwin Kisch—hoped to be its intellectual leaders, but they found themselves reviled instead. As a result of this inglorious failure, many Viennese artists and writers in the postwar years emigrated to Germany, especially Berlin. But the intellectual climate in Vienna remained stimulating enough, even after this wave of emigration.

The Viennese Activist writer Robert Müller died in 1924, without having had significant contacts with the Hungarian Activists. His Activism, oriented more around the German Kurt Hiller, was concerned with logocracy—the dominance of an intellectual elite—and differed starkly from Kassák's view, in which Activism was above all popular education, that is, workers' education, with the help of new art and literature. In literature there was virtually no contact between the Hungarian émigrés and the Viennese. There were intersections, however, in the visual arts and music, and in the realms of theater and dance. Arnold Schoenberg (who was, famously, not only a musician but also a painter) remained in Vienna until 1925 and was a decisive influence on Alban Berg and Anton Webern. *Ma*, however,

published the work of another twelve-tone composer, Josef Matthias Hauer, who derived his musical theory independently of Schoenberg. Expressionist dance was represented by several schools in Vienna. Kassák's stepdaughter Eti received her education in one of them and became one of the most sensational dancers of her day.

The circle around Kassák also paid attention to developments in Austrian film. The same was true of theater. *Ma*'s theater critic, János Mácza, had already published extensively on the theory of the new theater while still in Budapest. He went on to publish *Teljes Színpad* [Complete Theater] in Vienna as a special issue of *Ma*, in which he gave a perceptive summary of the theoretical principles and evolutionary perspectives of the theater of the avant-garde. In 1924, on the occasion of a large theater exhibition in Vienna, *Ma* published an issue in German on music and theater in which Kassák and many others presented their views. In addition Kassák wrote on avant-garde theater for the Viennese journal *Diogenes*. László Moholy-Nagy's

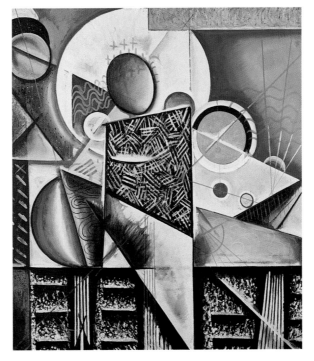

Above left:
■ Sándor Bortnyik, *Geometric Composition*, 1922, watercolor on paper

Above:
■ Josef Matthias Hauer and Emilie Vogelmayr, *Interpretation of Melos*, 1921, watercolor over pencil on paper

Left:
■ Béla Uitz, *Analysis on Purple Base*, 1922, oil on canvas

essay of this period on theater appeared first in the March 1927 issue of *Dokumentum* in Budapest. Friedrich Kiesler's concept of "spatial theater" [*Raumbühne*], also presented at the 1924 theater exhibition, was discussed extensively within the *Ma* circle. What the special issue of *Ma* actually published, however, was a somewhat similar concept by a Romanian-born theoretician then living in Vienna, Jacob Levy Moreno. Under the designation "improvised theater" [*Stegreifbühne*], he presented what amounted to his theory of psychological drama. In the next-to-last issue of *Ma* (January 15, 1925), an Austrian panel mentioned the differences between Kiesler and Moreno, coming to the conclusion that Moreno had been the first to develop the concept.

Not even a brief sketch of Viennese painting between the world wars is possible here. Therefore I will merely mention that the Viennese works of Béla Uitz had a decisive effect on the Viennese painter Erika Giovanna Klien. Klien began with Pointillist paintings, moved on to Expressionism, and finally reached Constructivism by way of Viennese Kinetism, developed by Franz Cizek at the Kunstgewerbeschule (today the Hochschule für angewandte Kunst). She was influenced by the Constructivist works shown by Uitz at the Österreichisches Museum in 1923. Lajos Kassák was very impressed by Klien's artwork when he visited the Kunstgewerbeschule in 1924.

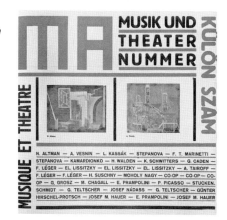

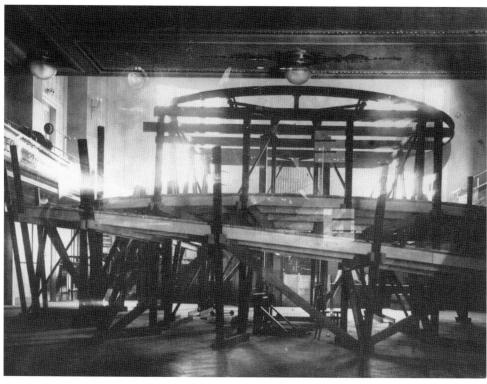

Left:
Ma, 1924 (vol. 9, no. 8–9)

Below:
Friedrich Kiesler, Theater in Space, Vienna Concert Hall, 1924

Bottom left:
■ Friedrich Kiesler, cover design for *Catalogue of the International Exhibition of Theater Technology*, Vienna, 1924

Bottom right:
Friedrich Kiesler, display system, International Exhibition of Theater Technology, Vienna, 1924

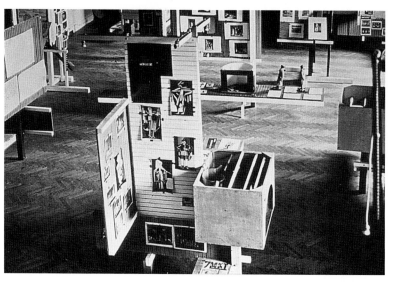

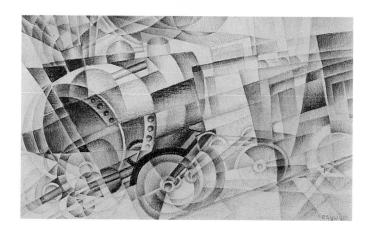

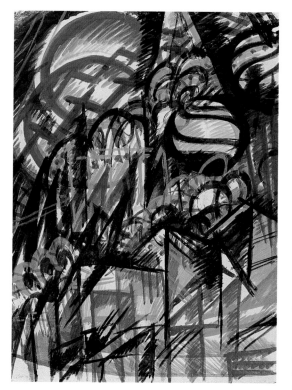

The Hungarian Activists' Debate on Dadaism and Constructivism

In terms of form, Budapest Activism, both in the visual arts and in literature, was a mixture of the stylistic features of Italian Futurism and German Expressionism. Although neither component can be considered the decisive one, the Futurist part is important insofar as it prefigured the line of development from Activism to Dadaism to Constructivism. The line of development that passed from Dadaism to Surrealism was possible only for those writers and artists who did not join the *Ma* circle until Vienna—that is, those who had no Activist past.

These principles of classification are, admittedly, post hoc. *Ma*'s readership experienced it as an exceptionally open, interesting journal of the international avant-garde which happily accepted materials from all over for publication and dissemination. The cooperation between the Viennese *Ma* circle and Berlin (*Der Sturm*, especially the theoretician Ernő Kállai) as well as the Bauhaus (László Moholy-Nagy, Marcel Breuer, Farkas Molnár) was especially intense. Additionally, *Ma* served—particularly in the Hungarian-speaking world—as a model for other avant-garde groups and their publications. In the Kingdom of the Serbs, Croats, and Slovenes (later Yugoslavia), a group of young Hungarian avant-garde writers centered around the journal *Út* [Path] in Novi Sad tried, with substantial intellectual and financial support from *Ma* in Vienna, to duplicate exactly, from 1922 to 1925, the Activist line of *Ma* in Budapest from 1916 to 1919. This attempt was naturally doomed to fail. The divergences are, however, extremely interesting, as *Út* was substantially influenced by

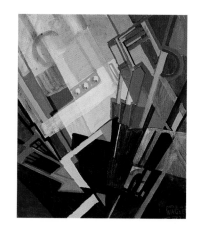

Top left:
Erika Giovanna Klien, *The Train*, 1925, pencil, charcoal, crayon, and watercolor on paper, laid down on tagboard

Above left:
Béla Uitz, *St. Basilius Cathedral in Moscow*, 1921, watercolor and tempera on paper

Left:
■ Otto Erich Wagner, *Composition*, 1924, gouache

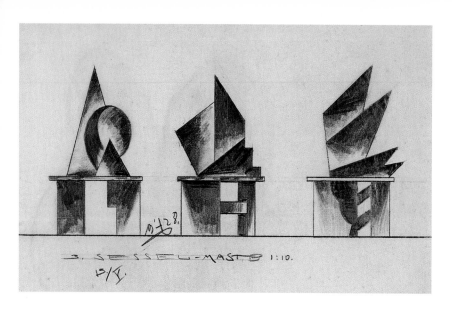

both Dadaism and Zenitism. Equally interesting are the less obvious but nonetheless demonstrable connections between *Ma* in Vienna and the avant-garde journals *Periszkóp* and *Genius*, published in Arad (Transylvania, Romania) in 1925 and 1926. In the last two years of his stay in Vienna, Kassák established especially close relationships with Das Junge Schlesien [Young Silesia], a group of German-speaking artists. He dedicated the final issue of *Ma* to them (June 15, 1925); the leftover material was published a year later in his Budapest journal *Dokumentum*.

In the worlds of literature and art, the lasting contribution of the Viennese Hungarians between 1920 and 1926 was the journal *Ma*. It is not just that the Viennese *Ma* circle was in contact with nearly all the known avant-garde groups and journals in Europe and America, and that it presented the international avant-garde from neighboring countries and distant lands to its readers. It also functioned as a high-quality vehicle for popular education and as a publishing house. Several *Ma* publications deserve mention here. Having been exiled from Budapest, the journal took up activity in Vienna on May 1, 1920, and shortly thereafter began to publish special issues. Several of these, beautifully and richly illustrated, were more like illustrated books than journals. The literary works of Mózes Kahána were illustrated with abstractions by János Máttis-Teutsch; Erzsi Újvári's prose poems were paired with the social criticism of George Grosz's

drawings. János Mácza's theory of drama was illustrated by Lajos Kassák, and Lajos Kudlák's volume of poetry was accompanied by the author's own "picturearchitecture." (Arising in Kassák's circle, picturearchitecture [Hungarian *képarchitektura*; German *Bildarchitektur*] was a kind of spiritual Constructivism, developed and used only by Viennese Hungarian artists in the 1920s.) Sándor Bortnyik and László Moholy-Nagy each published a volume of picturearchitecture as a special issue of *Ma*. The special issue with Sándor Barta's *Tisztelt Hulláház* (Honorable Morgue) is a uniquely interesting collection of Hungarian Dadaist visual poetry.

One book that was conceived originally as a special issue of *Ma* took on an autonomous life with international influence. *Új Művészek Könyve/Buch neuer Künstler* [Book of New Artists], published in 1922 in Vienna by "Ludwig Kassak and L. Moholy Nagy," was the first conscious overview and inventory of the various "isms," and not just in the visual arts. In addition to painting and sculpture of the international avant-garde, the authors gave examples of new architecture, music, industrial design, and technology. Photographs document high-voltage wires, film projectors, racing cars, dynamos, power plants, airplanes, and even ventilators. It is no coincidence that Hans Suschny, an Austrian disciple of Kassák's, wrote in the second issue of *Ma* for 1925 that the Kassák circle wished to work "under the ventilators of the technological economy and scientific dialectic, under the searchlights of elementary design and proletarian simplicity."

This half-utilitarian, half-idealistic attitude was characteristic of the picturearchitecture of Sándor Bortnyik, Aurél Bernáth, Lajos Kudlák, and especially Lajos Kassák—all of whom should certainly be counted among the lasting contributors of the Viennese years. The essence of their picturearchitecture is a Constructivist concept of the *Gesamtkunstwerk* [total artwork]—with this idea in mind Ilya Ehrenburg characterized the Viennese Hungarians as the Romantics of Constructivism—that had grown organically from the Activism of the Kassák circle. Kassák conceived picturearchitecture as a modern model for the world, almost as a formula

Top:
■ Franz Pomassl, *Three Chairs*, 1928, graphite on tracing paper

Above:
Lajos Kassák, cover design for *Book of New Artists*, edited by Kassák and László Moholy-Nagy (Hungarian version), 1922

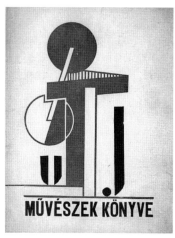

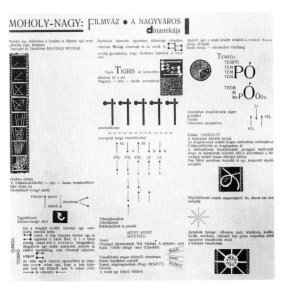

for the world. He adhered to the view that even young, untrained artists could appropriate it to achieve outstanding results through an autodidactic education. By contrast, the critics of picturearchitecture, in particular Béla Uitz and Sándor Barta, emphasized its hermeticism and its utter lack of societal effect.

Other important publishing events included Moholy-Nagy's sketch for a film script, "Dynamik der Gross-Stadt" [Dynamism of a Metropolis], which was first published in *Ma* in 1924 and later realized at the Bauhaus. Two long avant-garde poems from the Viennese period, Lajos Kassák's "A ló meghal, a madarak kirepülnek" [The Horse Dies, the Birds Fly Out] and Tibor Déry's bilingual, illustrated "Az Ámokfutó/ Der Amokläufer" [The Madman], were decisively influenced by the stylistic features of Dadaism. "Az Ámokfutó" is also interesting for the visual arts as a "Merzgedicht," or Merz poem, in the style of Kurt Schwitters. Kassák's poem appeared in 1922 in the Viennese avant-garde journal *2 x 2*, which he edited with Andor Németh. He illustrated it himself with black-and-white picturearchitecture and also designed the text block as an artwork. The poem treats a month-long journey he had undertaken in 1909 by foot

from Budapest to Paris, which he considered a kind of "university." It is a sort of anti-*Bildungsroman* in the sense that it explicitly confirmed for him that a classical bourgeois education was useless to young workers. In its place Kassák recommended and praised the individual experience of work, which is to say that both "A ló meghal, a madarak kirepülnek" and the "Constructivist" poetry he published during the same decade are just as much part of a unified model for the world as his picturearchitecture. Déry's Madman represents the general uncertainty and poverty that followed the First World War. He illustrated his poem with clippings from Viennese illustrated magazines, and it was probably the difficult and costly reproduction of these materials that caused the poem, written in Vienna in 1922, to remain in manuscript until 1985.

Kassák left Vienna in 1926 with *Tisztaság Könyve* [The Book of Purity], his carefully produced Constructivist *Gesamtkunstwerk*, which also contained several English translations of his *számozott költemények* [numbered poems]. The works of the Austrian and Hungarian avant-garde writers and artists produced in the Viennese years began falling into oblivion during the interwar years. Their contributions to the cultural multiplicity of Central Europe, to the international avant-garde, and to the intellectual life of Austria were not evaluated and appreciated again until the 1980s by scholars in the visual arts, and then by literary scholars in the 1990s.

Translated by Steven Lindberg

Above left:
László Moholy-Nagy, *Dynamism of a Metropolis*, 1924, illustration in *Ma* (vol. 9, no. 8–9)

Left:
Aurél Bernáth, *Villages*, 1922, from Graphic portfolio, stencil, india ink, gouache, and gold paint on paper

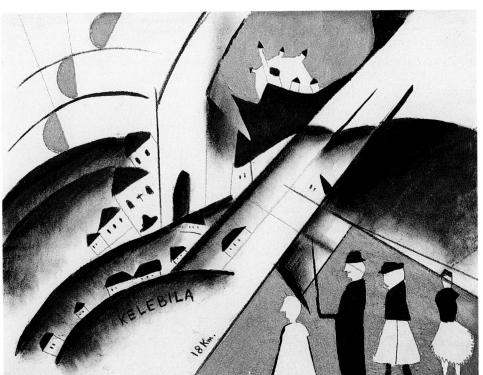

Max Burchartz	Lotte Burchartz	Karl Peter Röhl	Hans Vogel	Lucia Moholy	László Moholy-Nagy	Alfréd Kemény	Bernhard Sturtzkopf	Hans Arp

Participants in the International Congress of Constructivists and Dadaists, Weimar, 1922

Alexa Röhl	El Lissitzky	Nelly van Doesburg	Theo van Doesburg	Tristan Tzara

Werner Graeff	Nini Smith	Harry Scheibe	Cornelis van Eesteren	Hans Richter

ART INTO LIFE:
INTERNATIONAL CONSTRUCTIVISM IN CENTRAL AND EASTERN EUROPE

Christina Lodder

In the 1920s artists from Central and Eastern Europe were among the foremost practitioners of the new geometric abstraction. They produced paintings and sculptures that were created from artistic components alone—shapes, planes, colors, lines, textures, materials—rather than derived from the representation, however stylized, of some observed or imaginary subject. Figures like Katarzyna Kobro and Władysław Strzemiński, working as a husband-and-wife team in Poland, and the Hungarian László Moholy-Nagy, living in Germany, made important contributions to the development of this aesthetic.

The label under which such art was commonly produced was Constructivism. At the beginning of the 1920s this new term acquired a powerful resonance. With its connotations of engineering and architecture, it vividly encapsulated the idea that an art constructed from abstract elements could be concerned with a great deal more than formal harmony and pleasing designs. As far as its makers were concerned, Constructivist art properly understood implied that society, culture, and the whole fabric of man's understanding of himself and the world were in a process of radical transformation. Artistic construction was a metaphor for, and indeed a stimulus to, reconstruction in the broadest possible sense. The artist enjoyed a freedom to experiment with forms and materials that made abstract art an effective point of departure for radical innovation in more practical spheres as well, such as graphic design, furniture, and architecture.

A socially utopian outlook was pervasive among the international avant-garde of the early 1920s. This view is evident in the retrospective testimony of the German artist Hans Richter, himself a convert from the subversive activities of Dada to the more high-minded cause of Constructivist abstraction, which he explored both in fine art and in experimental films:

As if by magic, a new unity in art had developed in Europe during the isolation of the war years. Now that the war was over, a kind of aesthetic brotherhood suddenly emerged... fundamental tasks on which we could all agree. These tasks were given different names in different countries and were pursued by different groups: *De Stijl*, *L'Esprit Nouveau*, *G*, *Veshch*, *Ma* and others. There was one common purpose...to start from the beginning again by returning to the most elementary and basic concepts and to build something new upon the fundamentals, be it Gabo's Constructivism, Mies van der Rohe's "New Building," Werner Gräff's "New Technology," Eggeling and [Richter's] "Universal Language," Kiesler's "New Spatial Theatre," Lissitzky's Suprematist "Proun"... or Mondrian and Van Doesburg's "Neo-Plastic Creative Principles."[1]

The aspiration to return to fundamentals had various points of reference. The most obvious was political. If the First World War had marked the apocalyptic self-destruction of the old social order, it was the Russian Revolution that, for progressive men and women everywhere, signaled a fresh beginning and the first step toward a new world. The revolution of October 1917 established the first workers' state in history, promising at long last a society free from oppression and privilege. In developing a new egalitarian order, science and the machine acquired enormous practical and symbolic significance. It was not just everyday things that could be engineered from carefully thought-out plans; whole societies as well could and should be made to run efficiently and smoothly, like a machine, for the benefit of all rather than the fortunate few.

Such idealistic convictions were widely held, but they did not prescribe any particular approach to art. Conflicting views were possible as to the role and identity of artists and the activities that they could most profitably engage in as a means to further social progress. The key point at issue was

the autonomy of art. How, if at all, should the artist be differentiated from the designer of practical objects, or the architect, or the ordinary worker? How, and at what point, should art be inserted into life?

THE RUSSIAN PARADIGM

In Russia itself, as soon as the revolutionary government was well established, committed artists started to explore ways in which art might serve the new Communist order. They designed propaganda posters and street decorations. They took over and reformed the art schools. They produced magazines and engaged in debates about the role and contribution of artists. It was in this very particular context that the Constructivist label was coined. In March 1921 a self-styled Working Group of Constructivists was established in Moscow by writer and critic Aleksei Gan, who wrote the group's program, and the artists Alexander Rodchenko, Varvara Stepanova, Karl Ioganson, Konstantin Medunetskii, and Georgii and Vladimir Stenberg. As their declaration made clear, the Constructivists rejected the traditional notion of the work of art as a product of individual genius and a marketable commodity. They wished to develop a fresh form of creative activity appropriate to the new social needs and ideological circumstances.[2]

The group's most decisive point of departure was Vladimir Tatlin's model for a *Monument to the Third International* of 1919–20. This seemed a truly revolutionary work: the dynamic, spiraling form symbolized social progress, and the openwork steel-beam construction proclaimed solidarity with the industrial proletariat. The structure as exhibited was merely the model for a vast functioning edifice, to be a third higher than the Eiffel Tower. Enclosed geometric volumes, rotating at different speeds, were to house diverse aspects of the Third International, the organization devoted to fomenting world revolution. Tatlin's wildly utopian synthesis of practical, ideological, and artistic objectives vividly demonstrated the heights to which the radical artist could aspire.

The Constructivists subsequently displayed their Tatlin-inspired "laboratory works" at the exhibition of the Obmokhu [Society of Young Artists] in May 1921. As visible in documentary photographs, the show included abstract sculptures constructed from wooden rods, cardboard, glass, wire, and various kinds of metal, loosely evoking contemporary engineering structures such as cranes and bridges. Such transitional experiments were, the Constructivists emphasized, not artistic ends in themselves. Rather, they were

Vladimir Tatlin's model for the *Monument to the Third International*, c. 1920

demonstrations of a commitment to modern materials and technological processes, indicative of their ultimate goal of designing everyday objects for mass production. During the following year Rodchenko and his colleagues moved into more practical areas, designing posters, books, magazine covers and layouts, items of furniture and complete interiors, propaganda kiosks, and architecture, extending in each case the bold planar idiom that had first emerged in a purely artistic context. The appearance in 1922 of Gan's book *Constructivism* served to give the term, and the ideas it encapsulated, a wider currency among the Russian avant-garde.[3]

By 1922 the notion of Constructivism had already begun to migrate westward, thanks to the missionary zeal of radical artists from Russia itself and of well-informed sympathizers from Eastern Europe. Russian Constructivism was the point of departure for the increasingly widespread appropriation of the term, just as the work it had served to define in Russia remained a seminal point of reference for much of the art that was produced under the Constructivist label elsewhere. Yet as it moved across geographical, cultural, and ideological boundaries, Constructivism underwent subtle changes. Though the term was applied to innovatory work in practical

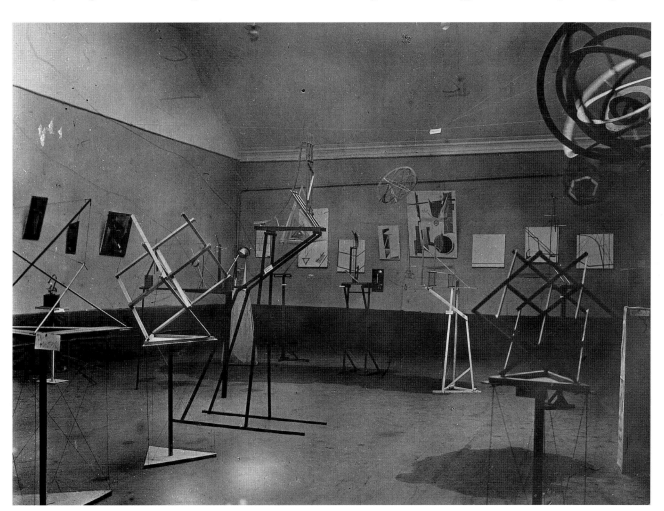

The second spring exhibition of Obmokhu, Moscow, 1921

design, it also came to be associated with a new and distinctive approach to the making of traditional art objects, paintings, and sculptures, as opposed to the Russians' repudiation of such activities on ideological grounds. The value given in the West to both art and design was, of course, epitomized by the teaching programs of the Bauhaus. The comparison between East and West has sometimes been used to demonstrate that International, as opposed to Russian, Constructivism entailed a process of depoliticization, a purely aesthetic misunderstanding of the Russian paradigm.[4] An examination of the attitudes of the Russian and East European artists involved illustrates that this was far from being the case. These artists did not necessarily become fully committed Marxists or indeed members of any left-wing political party. Most, in fact, espoused a rather inchoate commitment to social and political progress.

BERLIN

Germany, and Berlin in particular, became the main locus of International Constructivism, and the conduit for the dissemination of information about the new Russian art. This was due to the presence of artists like El Lissitzky and Naum Gabo, who had arrived in Germany from Moscow in late 1921 and spring 1922 respectively, and also to the remarkable spectacle of the First Russian Art Exhibition, in which both artists were involved. The Galerie Van Diemen in Berlin hosted this gigantic survey of contemporary Russian art between October and December 1922.[5]

Lissitzky played an especially crucial role in the adaptation of Constructivism to Western social and artistic conditions. Before he left Russia for a four-year sojourn in the West, Lissitzky had been closely associated with Unovis [Champions of the New in Art], the group that had grown up around Kazimir Malevich after the latter moved to Vitebsk in the autumn of 1919. This faction was in its way just as idealistic and committed to developing a revolutionary visual culture as were the Moscow Constructivists. From their perspective, it was the abstract language of Suprematism, stripped down to colored planes interacting spatially against pure white grounds, that could serve as the aesthetic complement of the new social order. Such an idiom was universal in its artistic impact, and also in its potential application, beyond the confines of art, to the design of posters, books, items of everyday use, and even buildings. Unashamedly aspiring to transform the world through Suprematism, the Unovis artists were less hampered by political dogma than the Moscow Constructivists.

In essence, this was Lissitzky's outlook when he first moved to Berlin and established himself as the most authoritative spokesman for the new Russian art in the West. He and the writer Ilya Ehrenburg edited the magazine *Veshch/Gegenstand/Objet*, two issues of which appeared in spring 1922. Their first editorial announced the renewal of contacts between Russian and Western artists and the emergence of a "new collective, international style."[6] Totally rejecting the "negative tactics of the dadaists," they declared:

We hold that the fundamental feature of the present age is the triumph of the constructive method. We find it as much in the new economics and the development of industry as in the psychology of our contemporaries in the world of art. *Objet* will take the part of constructive art, whose task is not to adorn life but to organize it.[7]

While they asserted that "*Objet* stands apart from all political parties," they also stated that "we are unable to imagine any creation of new forms in art that is not linked to the transformation of social forms."[8] They stressed, however, that artistic activity still had a distinct and significant role to play: "...[W]e consider that functional objects turned out in factories—airplanes and motorcars—are also the product of genuine art. Yet we have no wish to confine artistic creation

to these functional objects... Primitive utilitarianism is far from being our doctrine."[9] This clearly signaled Lissitzky's opposition to the Russian Constructivists' stance, which in its most extreme form declared "Death to Art."[10] The use of the term "constructive" was clearly intended to emphasize a wider resonance:

The new art is founded not on a subjective, but on an objective basis. This, like science, can be described with precision and is by nature constructive. It unites not only pure art, but also all those who stand at the frontier of the new culture. The artist is companion to the scholar, the engineer and the worker.[11]

Paintings by Lissitzky such as *Proun G 7* were the practical corollary of these ideas. They were extensively exhibited and reproduced in the early 1920s and exerted an enormous influence on many Central and East European artists who converged on Germany, especially Moholy-Nagy. The geometric precision, structural emphasis, and transparency of such works evoked the impersonal realms of science and engineering, the intellectual and moral values of clarity and order, in short the possibility, expressed in visual terms, of collective human progress. They seemed the artistic harbingers of a new way of life that would eventually spread from Russia

■ El Lissitzky, cover design for *Veshch/Gegenstand/Objet*, 1922 (no. 3)

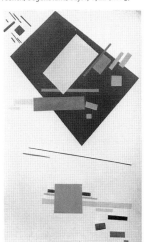

Kazimir Malevich, *Suprematist Painting*, 1915, oil on canvas

■ El Lissitzky, *Proun 3A [Proun 62]*, 1920–23, oil on canvas

Artistic construction was a metaphor for, and indeed a stimulus to, reconstruction in the broadest possible sense.

to the entire world. Equally influential was Lissitzky's work as a graphic designer. His numerous designs for journals, books, and posters revealed an astonishingly inventive approach to typography, layout, and the integration of word and image. *Objet* acted as a flagship, visually reinforcing the message through typography. Different typefaces, heavy lines, diagonal arrangements, and the background were used as positive organizational elements within the whole. Lissitzky's designs for *About Two Squares* and for Vladimir Mayakovsky's book of poems *For the Voice* demonstrated the enormous versatility and potential of this approach. At the same time, Lissitzky indicated how the architectural possibilities of the Proun compositions might be developed in three-dimensional terms in the Proun Room, which he constructed for the Great Berlin Exhibition of 1923.

Paradoxically, although Lissitzky was not at all a Constructivist according to the original 1921 Russian definition, he became a founding member of the International Faction of Constructivists when it was formed in May 1922 at the Congress of International Progressive Artists in Düsseldorf. The term provided an effective umbrella for like-minded individuals and movements of various nationalities. Lissitzky represented *Objet*; his cofounders were Theo van Doesburg (of De Stijl) and Hans Richter (representing Constructivists in Romania, Switzerland, Scandinavia, and Germany). The new grouping still embodied *Objet*'s values, stressing an opposition to subjectivity, demanding "the systemization of the means of expression," and declaring, "Art is a universal and real expression of creative energy, which can be used to organize the progress of mankind; it is the tool of universal progress."[12] In September 1922 the group issued the similarly worded "Manifesto of International Constructivism," which was also signed by the Belgian Karel Maes and the German Max Burchartz.[13] This was launched at the International Congress of Constructivists and Dadaists held in Weimar,

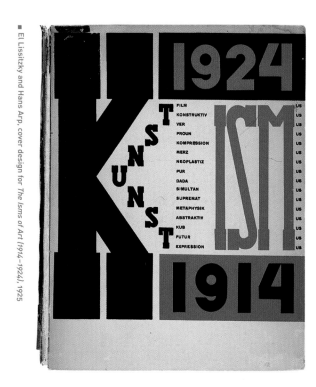

■ El Lissitzky and Hans Arp, cover design for *The Isms of Art (1914–1924,)* 1925

which was attended by the signatories and numerous others, including Kurt Schwitters, Tristan Tzara, and a Hungarian contingent comprising Moholy-Nagy and Alfréd Kemény. Lissitzky was evidently aware that he had hijacked the label. In a lecture on Russian art given in Berlin the following winter, he asserted that Malevich's Unovis group and the group around Rodchenko and Gan had both "claimed Constructivism." Each faction aspired to the fusion of art and life, but whereas "the Obmokhu group...went as far as a complete disavowal of art," Unovis represented the viewpoint that art, as a language of symbolic expression, had a separate validity. The new form served as "the lever which sets life in motion," and "gives birth to other forms which are totally functional."[14] There is no other evidence that Unovis had "claimed Constructivism." Lissitzky seems to have been trying to justify his own appropriation of the term by providing it

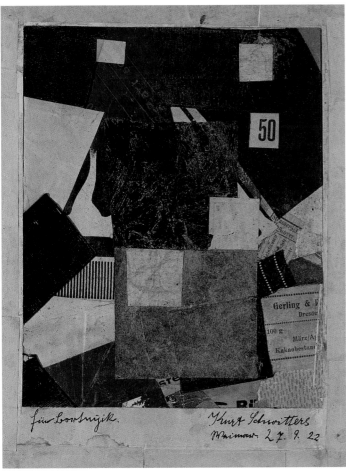

Kurt Schwitters, *Merz Composition*, 1922, collage

with a Unovis lineage in Russia, and also to defend and promote in the West an outlook that was losing ground in Russia itself, where the more explicitly Marxist and utilitarian orientation was increasingly dominant.[15] Outside Russia, little evidence for an alternative conception of Constructivism was available; the First Russian Art Exhibition, for example, did little to highlight the move into design projects on the part of figures like Rodchenko.[16]

Thanks to Lissitzky, the theory and practice of Constructivism that gained most currency outside the Soviet Union was a hybrid, devoid of the ideological and utilitarian fanaticism of the Moscow Constructivists and of the mystical extravagances of Suprematism. What remained was an aesthetic language of precise geometric forms that took its inspiration from the world of mathematics, industry, and the machine, was associated with vaguely socialist ideals, and aimed to expand its activities beyond the traditional confines of art into the wider environment. It is for this reason that many of the paintings produced in Central and Eastern Europe, categorized at the time and since as Constructivist, had such strong affinities with the abstract language of Suprematism, while the sculpture also derived some stimulus from the earlier three-dimensional "laboratory work" of the Moscow Constructivists.

The particular aesthetic paradigm Lissitzky promoted also resembled those of related movements in the West such as De Stijl and L'Esprit Nouveau. This was explicitly acknowledged by *Objet*, which published several articles from the journals of both groups as well as important statements and essays by individual members.[17] The conflation of ideas makes it difficult to disentangle specific influences, in this case those of Russian Constructivism, from the contributions of figures such as Theo van Doesburg and movements like De Stijl. If Lissitzky's own aesthetic represented a synthesis, so did International Constructivism. Precisely because of this, some writers have emphasized its autonomy from the Russian movement, arguing for instance that Constructivism in Germany was a separate movement with its own issues.[18]

The boldly utopian and cosmopolitan outlook of International Constructivism as it emerged in Germany was unfortunately at odds with the profoundly nationalistic ethos engendered by the country's defeat in the First World War. This schism was replicated elsewhere in Central and Eastern Europe, where the fragmentation of the Russian and Austro-Hungarian Empires had led to the formation of newly independent states like Hungary, Poland, and Czechoslovakia, which were

fiercely nationalist and intent on reinvigorating their identities and cultures. While the Constructivists anticipated a social revolution on a world scale, emphasizing the unity between peoples and stressing the universal technological and aesthetic bases of art, their fellow patriots limited their horizons to far more domestic concerns.[19]

HUNGARIANS

Lissitzky's idea of an International Constructivism compatible with the approach to abstraction developed in the West by De Stijl artists found an echo in the thinking and practice of a group of Hungarian artists and theorists. These included Moholy-Nagy, László Péri, Ernő Kállai, Lajos Kassák, and Alfréd Kemény, all of whom played a decisive role in the development of the new movement. The evidence of their extensive writings from the period suggests that they, like Lissitzky, were motivated not by an impulse to aestheticize Constructivism, but rather by a concern to adapt the idea of an ideologically radical art to the conditions of the capitalist environment in which they were, of necessity, working.

The Hungarians' outlook was informed by long-standing utopian ideals and by their experiences of working for a Communist regime during the short-lived Hungarian Revolution of 1918–19.[20] Like their Russian colleagues, avant-garde artists in Hungary had also become involved in artistic administration, designing monuments, organizing and creating decorations for revolutionary festivals, and producing propaganda posters, such as Uitz's *Red Soldiers Forward* of 1919.[21] When the Republic collapsed they went into exile, in many cases to Berlin.[22] Even before they encountered Lissitzky and Gabo, however, the Hungarians knew about developments in Russia, having been the first foreigners to establish close contacts with the Soviet regime. In the summer of 1921 Sándor Ek, Béla Uitz, and Jolán Szilágyi were in Moscow for the Congress of the Third International and visited the Vkhutemas [Higher Artistic and Technical Workshops], where they met Rodchenko and other Constructivists.[23] Kemény also visited Moscow and actually participated in Constructivist debates at Inkhuk [Institute of Artistic Culture] in December of that year.[24]

The impact of the Russian art they had seen is apparent in the experiments conducted by Hungarian artists in the early 1920s. Uitz's abstract linocuts of 1921–22, such as *Analysis XXIV*, emphasizing the structural qualities of line and the interrelationship of form and texture, can readily be compared with Rodchenko's portfolio of prints of 1919. Uitz's sequence

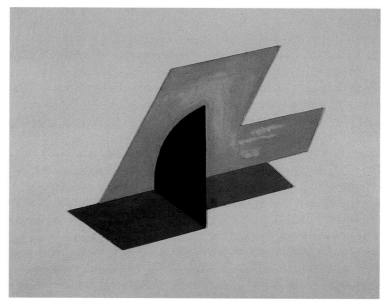

■ László Péri, *Space Construction 17*, 1922–23, tempera on shaped board

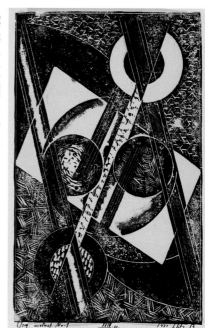

■ Béla Uitz, *Analysis XXIV*, 1922, linocut on paper

Lajos Kassák, cover design for *Ma*, 1921 [vol. 6, no. 5]

of images also corresponds to the intensive way Rodchenko investigated permutations of structure and form by producing works in series, such as those he devoted to the line. In contrast, Kassák's print for the cover of the March 1921 issue of *Ma* and his *Spatial Construction* of 1922–23, with their clear geometry, transparency, and white grounds, show more affinities with the visual language and compositional principles of Lissitzky's Prouns. László Péri started producing architecturally inspired paintings composed of large, interlocking geometric planes, such as *Room (Space Construction)* of 1920–21 and a series of linocuts in 1922. He also began designing Constructivist-inspired cement reliefs, which explored the aesthetic potential of new building materials, a development which culminated in works like *Design for Wall Forms for the Great Berlin Art Exhibition* (1923). Likewise, Moholy-Nagy's *Nickel Sculpture* of 1921 aspired to express modernity and progress; the soaring spiral suggests dynamic forces, while the use of highly polished metal lends the work an elegant technological gloss and the reflections generated by the sheen help to visually dematerialize its components. The overall shape and open spatial quality clearly refer to Tatlin's *Monument to the Third International*, while avoiding the latter's explicitly Communist overtones. In 1922 Moholy vividly demonstrated the Constructivists' repudiation of subjectivity and the artist's individual mark when he dictated to a professional sign painter, by telephone, the colors and compositions of two paintings, *Em 1* and *Em 2*, using a color chart and a piece of graph paper. While the technological approach might be in line with that of Russian Constructivism, the resulting compositions, consisting of sparse geometric forms on powerful white grounds, are highly reminiscent of Suprematism. Moreover, although the telephone paintings could be mechanically manufactured in quantity, they were actually only made in single copies and therefore retained their status as individual compositions instead of becoming

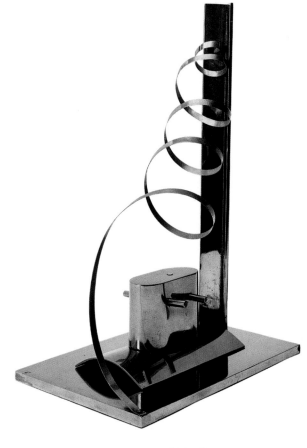

László Moholy-Nagy, *Nickel Sculpture*, 1921, nickel and iron

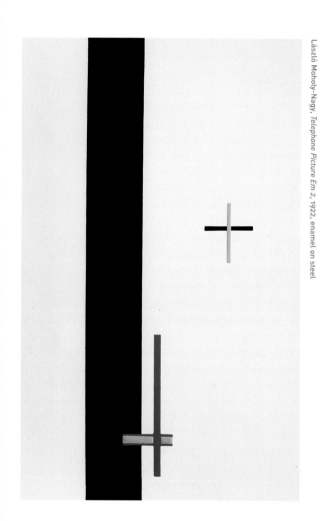

László Moholy-Nagy, *Telephone Picture Em 2*, 1922, enamel on steel

mass-produced items. Like Péri, Moholy-Nagy also derived inspiration from Lissitzky's Prouns, as can be seen in the lithographs he devised for his Kestnermappe of 1923. These featured spatial and volumetric ambiguities created through intersecting surfaces in combination with light and dark strips, the juxtaposition of semicircular and rectangular elements, the use of various tonalities, and the exploitation of transparent and translucent effects. Not surprisingly, Lissitzky discerned kindred spirits when he saw the work that Moholy-Nagy, Péri, and Sándor Bortnyik had shown at Berlin's Galerie Der Sturm.[25] He observed: "Begotten of the Revolution in Russia, along with us they have become productive in their art...the clear geometry of Moholy and Péri stand out in relief. They are changing over from compositions on canvas to constructions in space and material."[26]

As Moholy-Nagy later acknowledged, Naum Gabo provided the model for Moholy-Nagy and Kemény's manifesto "Dynamic-Constructive System of Forces," published in December 1922.[27] Kemény had visited Gabo's studio in Moscow in 1921 and had received explanations of "the principles of kinetics in sculpture" and a German translation of *The Realistic Manifesto*.[28] Gabo and the Hungarians subsequently moved in the same circles in Berlin.[29] Gabo's *Kinetic Construction (Standing Wave)* (on display at the First Russian Art Exhibition) inspired Kemény and Moholy-Nagy's anticipation of creating "freely moving (free from mechanical and technical movement) works of art."[30] In pursuit of such objectives, Moholy-Nagy began in 1923 to develop his *Space-Light Modulator*, on which he worked until 1930. With its dynamic interplay of light and three-dimensional metallic structures moving in space, it epitomized the Constructivists' commitment to scientific progress and the artistic assimilation of new technological possibilities.

In 1923 several members of the Hungarian group outlined their own highly politicized conception of Constructivism in a manifesto. The signatories, Kállai, Kemény, Moholy-Nagy, and Péri rejected the work of the Russian Constructivists of the Obmokhu, especially "their constructions depicting technical devices."[31] Asserting their independence from both Russian and Western practice, they insisted that true Constructivism could only spring from "our communist ideology" and could be "fully realised only within the framework of communist society," both as a "new constructive architecture" and as "a nonfunctional but dynamic (kinetic) constructive system of forces which organizes space by moving in it, the further potential of which is again in practice dynamic architecture."[32] They were explicit about art's

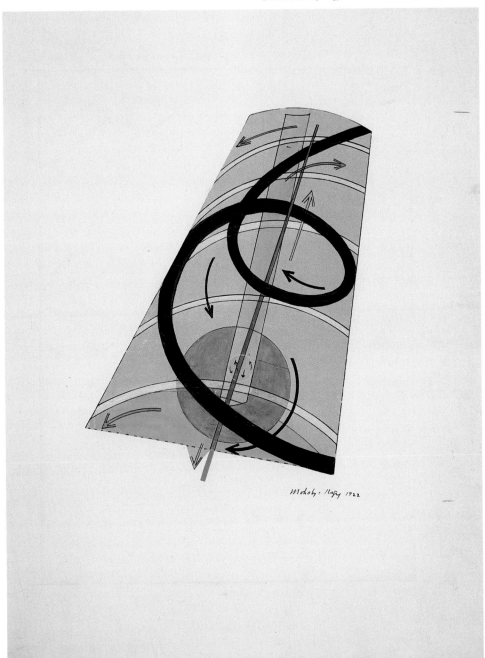

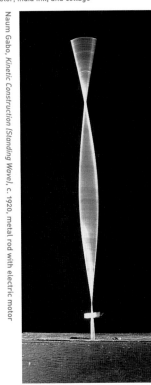

■ László Moholy-Nagy, *Kinetic Constructive System*, 1922, watercolor, india ink, and collage

Naum Gabo, *Kinetic Construction (Standing Wave)*, c. 1920, metal rod with electric motor

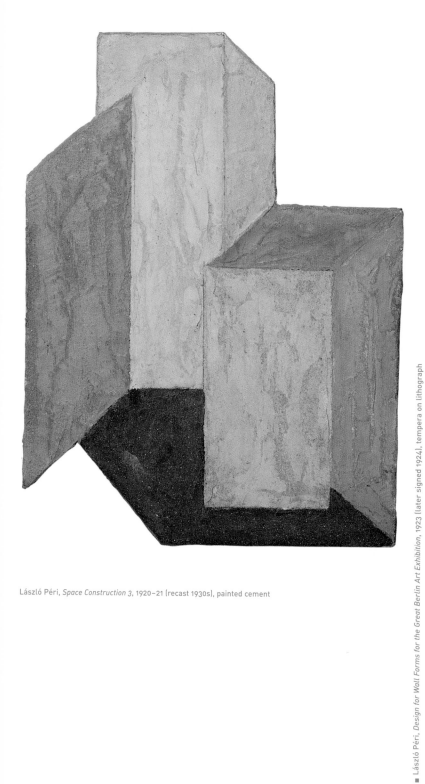

László Péri, *Space Construction 3*, 1920–21 (recast 1930s), painted cement

László Péri, *Design for Wall Forms for the Great Berlin Art Exhibition*, 1923 (later signed 1924), tempera on lithograph

■ László Péri, Untitled (Plate 10 of the portfolio Linoleumschnitte), 1922–23, linocut

■ László Péri, Untitled (Plate 9 of the portfolio Linoleumschnitte), 1922–23, linocut

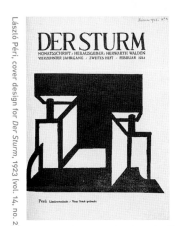 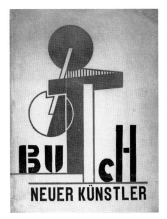

■ Lajos Kassák, cover design for *Book of New Artists*, edited by Kassák and László Moholy-Nagy (German version), 1922

political agenda, asserting that "we artists must fight along-side the proletariat and must subordinate our individual interests to those of the proletariat."[33]

A strong desire to spread the word about Russian artistic developments was evident in journals like *Ma*, edited by the socialist poet Kassák, initially in Budapest and then in Vienna. From its inception *Ma* had closely associated the overthrow of artistic conventions with political change and social revolution. The May Day 1922 issue included Nikolai Punin's text on Tatlin's tower and an illustration of a Proun by Lissitzky.[34] The following issue contained an article by Kállai on Constructivism, alongside an extensive report on the Düsseldorf congress and a declaration from *Ma* calling for an "International Organization of Creators with a Revolutionary World View."[35] The Hungarians clearly felt an affinity with the aims of the International Faction of Constructivists, although they had not attended the congress.[36] A Lissitzky Proun adorned the cover, while his statement formulating the concept of the Proun was published in the following number.[37] Yet *Ma* consistently presented Constructivism as a pan-European rather than as a purely Russian phenomenon.[38] This was equally true of the *Book of New Artists*, which Kassák produced with Moholy-Nagy in early 1922 and which can be seen as the first real primer on the modern movement.[39] Alongside work by artists from all the new European movements, it provided the fullest coverage of contemporary Russian art hitherto available to a European audience. *Book of New Artists* was illustrated with paintings by Lissitzky and Gustav Klucis, constructions by Tatlin and Rodchenko, and the installation of the Obmokhu exhibition (see p. 175) with the caption "Exhibition of the Constructivists in Moscow."[40] Moreover, the incorporation of images of machine parts and engineering structures presented these products of industrial culture as parallel with works of art.

It was Kállai in 1924 who published the first real survey of Constructivism as a movement, which covered the Dutch and Russian founders as well as contemporary German and Hungarian practitioners.[41] His definition of the movement perpetuated Lissitzky's emphasis on its broad metaphorical resonance: "Constructivism, with the will to an extraordinary realism, economy and exceptional precision…is the aesthetic paraphrase of the technical, intellectual, precise organizational and production methods of our modern civilisation and science."[42]

Yet within the Hungarian grouping there were dissenting voices who resisted this mainstream Lissitzkean position. The 1923 manifesto had represented a high point of consensus. By 1924 Moholy-Nagy had parted company with Péri and Kemény, while the latter had even attacked Moholy-Nagy for his lack of interest in social and political problems.[43] Even earlier a belief that the artist should aspire to a more direct social utility, in the manner of the Russian Constructivists, led Uitz to split from Kassák and *Ma* in 1922 and launch *Egység* [Unity], a magazine committed to Communism and conceived as "a communist cultural organ."[44] This ideological stance ensured a more extensive coverage of Soviet developments. The second issue presented the most detailed and focused survey of Russian Constructivism published to date, incorporating material that Uitz and Kemény had collected in Moscow the previous year.[45] It included the first translation of the "Program of the Working Group of Constructivists," photographs of work by Stenberg and Ioganson, and an installation view of the Obmokhu exhibition that was different from the one published in *Objet*.[46] The issue also contained a full, albeit unattributed, translation of *The Realistic Manifesto*.[47]

An overwhelming allegiance to radical politics inspired other Hungarians to reject abstraction altogether and espouse a more legible visual language for a more accessible,

ideologically challenging art. As early as 1923 Uitz had turned to realism, while Kemény became an active member of Berlin's Rote Gruppe, an association of Communist artists working in a figurative idiom that was comprehensible to the masses. Kemény also edited the Marxist periodical *Die Rote Fahne* [The Red Banner]. The revolutionary fervor of both artists led them ultimately to emigrate to the Soviet Union, Uitz in October 1926 and Kemény in 1933. Péri also abandoned Constructivism in 1924, rejecting his abstract explorations of hypothetical spatial structures in order to study and practice architecture for the Berlin city council. In 1928 he returned to art, producing sculptures that celebrated the heroism of the working class, along with caricatures for Communist papers. He remained in the West, fleeing the Nazis and settling in Britain. Meanwhile, Kassák returned to Hungary in 1926, followed by Kállai in 1934.

This left Moholy-Nagy as the most prominent representative of Hungarian Constructivism in Germany. Despite his lack of overt political commitment, his work epitomized the universalist aspirations of Constructivism, embracing as it did sculpture, photography, graphics, advertising, and design. The latter included projects for the theater, such as his concept for a new type of stage. He taught at the Bauhaus and expounded his broadly Constructivist position in texts like *Painting, Photography, Film*, which was produced as one of the Bauhaus books in mid-1925 and reprinted in 1927. His photomontages such as *Between Heaven and Earth (Look Before You Leap)* 1 of around 1926 frequently combined drawing with photographs. Here the thin lines linking the three figures emphasize the stages of the jump, intensifying the emotional qualities of the image and its nightmarish overtones. Enthusiastic about technology and the new media, Moholy-Nagy aspired to create a film and published a series of photographs with texts in *Ma* as a *typofoto*, which he defined as a mixture of image and text.[48] His concern with light manifests itself in his photograms, while his photographs possess strong stylistic similarities to those of Rodchenko. Both artists exploited the camera's potential to the full, employing bird's-eye and worm's-eye views to defamiliarize everyday subject matter. The two men seem to have developed their styles independently. Both began working in photography at about the same time in 1925, and although Rodchenko undoubtedly read *Painting, Photography, Film* as soon as it appeared, the first edition contained no examples of Moholy's own photographs and merely provided a summary of the current understanding of the medium and its potential, a conception already shared by Rodchenko.[49]

■ László Moholy-Nagy, *Hand Photogram*, c. 1925, gelatin-silver print

Blok, 1924 (vol. 1, no. 1)

POLES

The version of Constructivism that emerged in Poland was at once as robust and as factional as its Hungarian counterpart. Mieczysław Szczuka, Władysław Strzemiński, Teresa Żarnower, Katarzyna Kobro, and Henryk Stażewski were the key figures in a Constructivist grouping that was centered around the magazines *Blok*, *Praesens*, and *a.r.* The beginnings of the movement may be located in the 1923 Exhibition of New Art in Vilnius.[50] The catalogue of the show emphasized the relationship between art and social revolution. It spoke of the need to use "new elements for construction" and modern materials such as "iron, glass, cement" but also stressed the aesthetic integrity of the artwork as a "direct interaction of plastic forms organized into a single whole."[51] Although the term Constructivism appeared in the 1923 *Blok* manifesto "What is Constructivism?," the term was not used afterward. Subsequently, groups of artists were defined mainly in relationship to various avant-garde publications.[52]

By 1925 the group had polarized. At one extreme Szczuka and Żarnower expounded a utilitarianism that was closely based on Russian Constructivism. They called on artists to dedicate themselves exclusively to industrial production in the service of social and political revolution.[53] Szczuka, who was allied to the Polish Communist Party, devoted himself increasingly to architecture, typography, and photomontage. In practice as well as in theory his graphic work, especially his cover designs for *Blok* and his architectural projects, strongly resembled those of his Russian colleagues. His early works like *Sculpture with Chains* from around 1922, with their use of manufactured components, closely paralleled the work of the Stenberg brothers. Photographic compilations like the cover of *Blok* no. 6/7 emulated the typography and layout of Russian publications such as those Rodchenko was producing for the covers of the magazine *Lef* [Left Front of the Arts].

The heavy sans-serif typeface and mechanized elements created a visual equivalent of the machine which symbolized both the proletariat and the means of its eventual liberation. In contrast, Strzemiński and Kobro valued the autonomy of the artwork and so were more in line with the paradigm of International Constructivism, which was emerging in Germany in the 1920s.[54] They arrived at this position independently from Lissitzky, but from a standpoint of radical social commitment they shared with him. The two artists had been born and brought up within the Russian Empire, and when they settled in Poland (Strzemiński in 1922, Kobro two years later) they possessed firsthand experience of the revolution and its artistic ramifications.[55] Through their studies at the Vkhutemas and their work for the Smolensk branch of Unovis they had acquired an intimate knowledge of the theory and practice espoused by Tatlin and Malevich. They understood, but were also critical of, both Suprematism and Constructivism.

Strzemiński's "Notes on Russian Art," published in late 1922, is a closely argued repudiation of the anti-art stance of the Moscow Constructivists and their alliance with the Bolsheviks.[56] Like Lissitzky and Gabo, Strzemiński used the term "Constructivist" for the transitional sculptural phase associated with the Obmokhu exhibition, reserving "Productivist" as a pejorative tag for those who subsequently

embraced a utilitarian position. He argued that "the methods and aims of technology and art are totally opposed."[57] Strzemiński attributed the identification of the machine with the proletariat to the influence of the ideology of the Communist Party, and he regarded Productivism as an accommodation with the new state, since "in Russian conditions, art exists as official art, or it does not exist at all."[58] He implied that Productivist ideas had developed precisely because the government needed to export goods, and stated that the avant-garde had to defend itself against "the avalanche of naturalistic art."[59]

Strzemiński acknowledged that the new abstract art had ramifications for the design of the everyday environment, but considered that this longer-term process was not the responsibility of the experimental artist; on the contrary, he believed, "the social influence of art is indirect."[60] He emphasized the importance of Malevich, who himself had Polish origins, in establishing the fundamentals of the new art, which, he declared, aspired "to base construction on the principles of an objective law."[61] Yet Strzemiński believed that Malevich had not gone far enough in pursuing the establishment of such laws. In this respect Strzemiński, and by extension

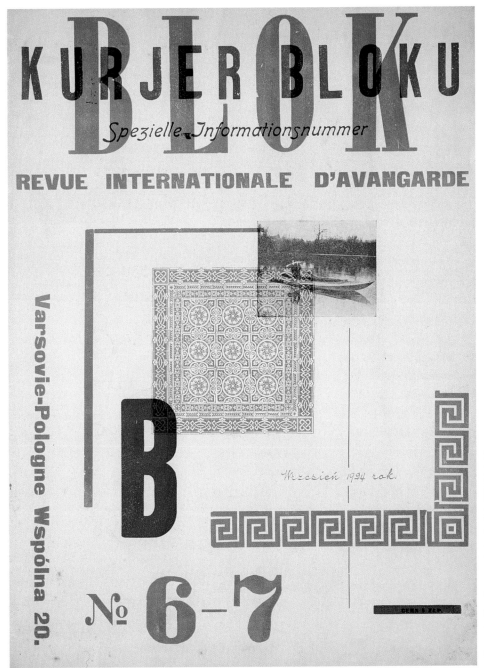

■ Mieczysław Szczuka, cover design for *Blok*, 1924 (no. 6–7)

Kobro, were self-consciously continuing to investigate the fundamental elements of art (line, space, color, plane, etc.) in the rigorous, quasi-scientific spirit adopted by Inkhuk when it was set up in Moscow in 1920.[62]

By 1927 Strzemiński had arrived at his doctrine of Unism, expressing an aspiration toward the greatest possible unity of elements within a painting, and the integration of the surface, physical scale, and materials of the work. He had earlier referred to a "post-Suprematism" and indicated how his approach stemmed from a critique of the residual figure/ground relationships, fragmentation, and illusionism inherent in Malevich's paintings. The term Unism retained this resonance, appearing to refer back to Malevich's Unovis, of which Strzemiński had been a member.[63] While placing greater emphasis than Malevich on the material reality of the picture surface, Strzemiński attempted to achieve the "organic unity that would unite the shapes in the picture with its planes and borders, constituting a flat visual unity, cut off from the environment by the sides of the picture."[64] Although his aim was fairly constant, the practical means he employed to attain it varied. In *Architectural Composition 6b* of 1928 the entire canvas is divided into two irregular geometric shapes of roughly the same scale. The equilibrium and static quality of the composition are enhanced by the fact that the two colors are of similar tonal quality and saturation. *Unistic Composition 7* of 1929 achieves similar effects. It consists of a monochrome surface covered with impastoed lines that produce an almost uniform overall pattern.

During the 1920s Kobro and Naum Gabo were arguably the most inventive exponents of a distinctively Constructivist sculpture. They developed individual languages on the basis of a searching engagement with Russian models such as the painting of Malevich and the constructions of Tatlin and the Obmokhu group. Kobro had certainly established an independent idiom by the time she made *Abstract Sculpture 1* of 1924 from painted metal, wood, and glass. This work goes further than any construction by Medunetskii or Gabo in its simplicity and its distillation into sculptural form of sensations of spatial penetration and immateriality. The intersecting glass planes contrast with the yellow sphere suspended in the middle of the voluptuously curvilinear pinkish form, providing an experience of space that links the worlds of mathematics and nature. Also distinctive is Kobro's separation of the exploitation of modern materials from any direct allusion to machine technology, the "expressionless technical pseudo-naturalism" that Hungarian observers found so distasteful in the work of the Obmokhu.[65] Yet mathematics was

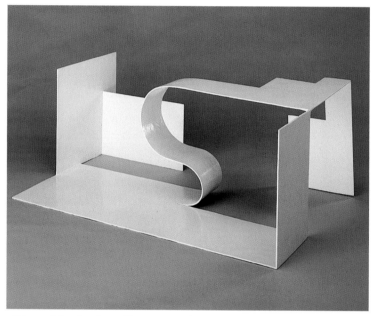

■ Katarzyna Kobro, *Space Composition 5*, 1929–30, painted steel

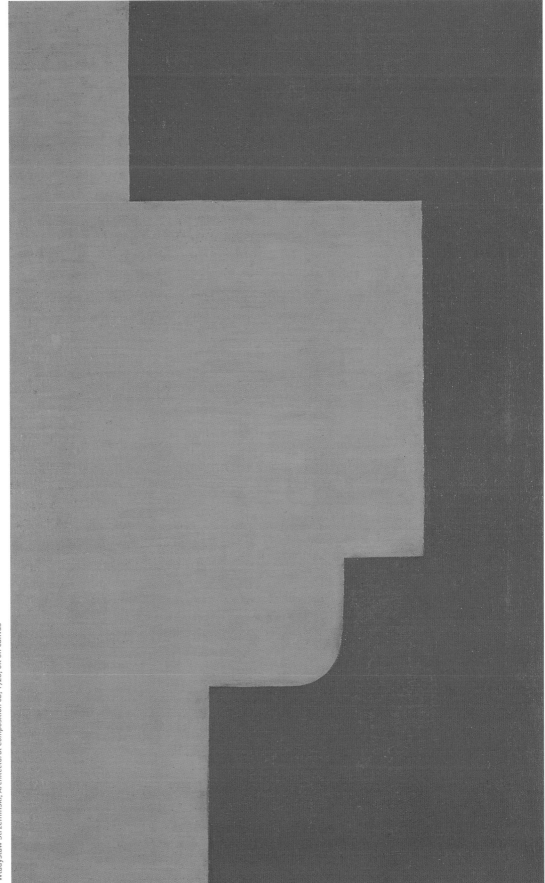

■ Władysław Strzemiński, *Architectural Composition 6b*, 1928, oil on canvas

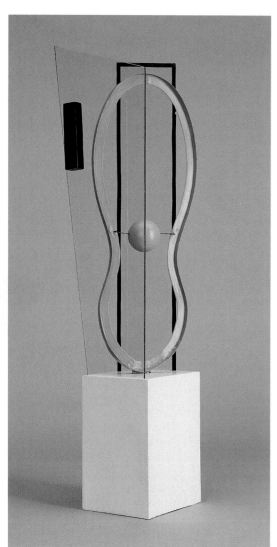

fundamental to her working processes. Many of her later Space Compositions were based on the ratio 5:8, derived from the progression of numbers developed by Leonardo of Pisa and known as the Fibonacci series.[66] Kobro also employed a type of modular structure, using a vocabulary of curved and straight segments in the 5:8 proportion to explore the permutations of spatial forms. In this respect her sculptures possess distinct affinities with Rodchenko's modular constructions as well as his series of hanging sculptures based on geometric forms such as the triangle, ellipse, and circle. In contrast to Rodchenko, however, Kobro placed a particular emphasis on spatial continuity, asserting that the fundamental problem of sculpture concerns the relationship between "the space situated outside the sculpture and the space contained within the sculpture."[67] She stressed that: "[Unist] sculpture sculpts space… The unist sculpture, based upon the organic unity of sculpture and space, does not want the form to be an end in itself, but only the expression of spatial relationships."[68] Painted white constructions such as *Space Composition 5* of 1929–1930 achieve this in part by minimizing the presence of the form. Sometimes Kobro used the De Stijl palette of primary colors, gray, and black to qualify the solidity of the planes and destroy the optical unity of the sculpture, permitting a more effective sense of spatial flow.[69] To intensify this, each side of the same plane was painted a different color, as in *Space Composition 4* of 1929, which has been described as "one of the most extraordinary works of twentieth-century sculpture."[70] These strategies encouraged the spectator to move around the sculpture, a process that elicited its spatial-temporal rhythms, as Kobro pointed out: "[W]hen the spectator moves, certain forms present themselves, others hide; the perception of these forms changes."[71]

Toward the end of the 1920s Kobro and Strzemiński became increasingly preoccupied with the environmental ramifications of the new abstract art. Kobro regarded her works as a laboratory for a future architecture that would help to reconstruct humanity. In 1937 she wrote:

The task of a spatial composition is the shaping of forms which can be translated into life. The spatial composition is a laboratory experiment that will define the architecture of future cities…

The task of art is co-operation in achieving the victory of higher forms in the organization of life.

The domain of art is the production of socially useful form. The ultimate test of art is its production utility achieved with the aid of means offered by contemporary industry.[72]

"Poetism is...the art of living in the most beautiful sense of the word."

Just before this she had produced *Design for a Functional Nursery School* (1932–34), closely based on her *Space Composition 8* of 1932. In 1929 Strzemiński and Kobro had designed the Neoplastic room for the National Exhibition in Poznań to demonstrate the relationship between painting and architecture in a functional interior.[73] Their ultimate goal was to "remodel the cities; to re-organize the whole of urban life."[74] This did not mean that the couple had adopted the stance of the Russian Constructivists.[75] On the contrary, they continued to make a strong distinction between the work of art and the functional space of architecture, which concerned the movements of people within buildings. For them, "a work of art can only be the field of a plastic experiment, offering more or less useful solutions of forms for a utilitarian realization of functionalism."[76] Andrzej Turowski suggests that the couple's architectural explorations might be best understood in relation to Malevich's Cosmism as exemplified by his concept of *planits* (dwelling complexes in space), and thus as science-fictional speculations with utopian, mystical, and quasi-scientific associations.[77]

CZECHS

In Czechoslovakia Constructivism was first expounded in December 1922 in the second issue of the magazine *Život* [Life], published under the banner "New Art—Construction—Intellectual Activity" and illustrating the work of Jaromír Krejcar, Josef Šíma, and Karel Teige. Subsequently the movement was embraced by Devětsil, which aimed to destroy the boundaries between art and life and included photographers, architects, writers, and musicians. Devětsil's twin principles of Constructivism and Poetism were elaborated by Teige, the leading theoretician of the group. He regarded the two activities as complementary: "Constructivism is the method of all productive work" relying on mass production and standardization, while "Poetism is…the art of living in the

most beautiful sense of the word."[78] Poetism involved making "poetry by means of optical form" and revealing a "lyrical and visual excitement over the spectacle of the modern world." This concept is evident in *Departure for Cythera* of 1923–24 and *Travel Postcard* of 1924, where apparently random fragments of images—a bridge, ships, a badge in one instance and a map, stamps, and lettering in the other—act as signs carrying multiple meanings and associations.[79]

In contrast, Constructivist typography entailed eliminating all decoration; using typefaces with "clearly legible, geometrically simple lines"; taking into account the purpose of the text; balancing space and arranging type "according to objective optical laws"; employing a "clear, legible layout and geometrical organization"; exploiting the latest technology; combining photography and typography as in Moholy-Nagy's *typofoto*; and ensuring a fruitful collaboration between the graphic designer and the printer.[80] Teige's covers for *ReD* exemplify these principles. In them Teige used a variety of typefaces, including stenciled sans-serif letters and emphatically asymmetrical arrangements of elements; similar ingredients were employed by Lissitzky in his layouts for *Objet*. The ideological commitment underpinning Teige's concerns was made explicit in the cover for November 1927, which incorporates an image of Lenin standing on a globe and the insignia of the Red Army (a five-pointed star enclosing a hammer and sickle). The linear design at the left also articulates the letter *L*. The fact that Teige considered that the cover acted as "the poster for the book" indicates the importance he attached to the genre.[81]

It was only after his visit to Moscow in 1925 that Teige became an active proponent of Russian Constructivism, publicizing its ideas and achievements. He also began to write more extensively on the theory and practice of architecture.[82] As a fervent Communist Teige stressed the link between architecture and the social structure it serves: "Changes in architecture

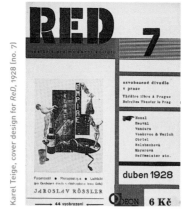

◼ Karel Teige, *With the Ship that Brings Tea and Coffee*, by Konstantin Biebl, 1928

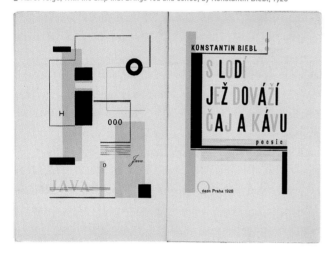

cannot be effected without changes in the organization of production and society, in other words without a social revolution."[83] Hence the new dwelling should not be the individual family unit but the communal house, where fully emancipated men and women live in single rooms while sharing essential services such as cafeterias and nurseries.[84] In the late 1920s Teige became more firmly identified with a hard-line functionalist position in relation to architecture and became closely aligned with Hannes Meyer and Ernő Kállai, whose architectural theory had much in common with the Russian Constructivists. However, Teige's concept of functionality was more creative and less narrowly utilitarian than that developed by his Soviet colleagues. For him the architectural accommodation and promotion of a more perfect social order also encompassed psychological and poetic factors.[85] Teige's defense of authentic Constructivist values against the encroachment of architectural pretensions found one of its most celebrated expressions in his 1929 criticisms of Le Corbusier's Mundaneum project, which he castigated for its reliance on archaism, monumentality, and a priori aesthetic formulas. Teige stressed that "the only aim and

scope of modern architecture is the scientific solution of exact tasks of rational construction."[86]

Yet as a creative figure Teige was never exclusively a Constructivist. During his visit to Paris in the summer of 1922 he had developed a lifelong passion for Man Ray's photographic work, which strongly influenced his own experiments in this direction, especially his design for Vítězslav Nezval's *Abeceda* [Alphabet] of 1926, which combines simplified lettering and photographs of the dancer Milča Mayerová in poses corresponding to the shapes of the letters. The permutations achieved in correlating images and alphabet reflect the methodological approach of Constructivist typography, although the delightfully playful result has strong affinities with Surrealism, the dominant influence in the collages Teige produced in the 1930s and later.

An equally innovative brand of International Constructivism was developed by the hitherto rather neglected sculptor and designer Zdeněk Pešánek, who also combined a commitment to Poetism and the ideals of Devětsil with membership in the Communist Party.[87] He shared his enthusiasm for Communism and contemporary technology with the Moscow Constructivists, but his creative output displays closer affinities with the work of Gabo, who shared his interests in kinetic sculpture, public monuments, and the use of electric lights in art and advertising.[88] Pešánek brought these elements together in his design for the world's first public kinetic sculpture, which was mounted on the Edison Transformer Building in Prague in 1930. Lacking the transparency of Gabo's single vibrating rod of around 1921 (*Kinetic Construction: [Standing Wave]*) or the spatial and formal complexity of Moholy-Nagy's *Space-Light Modulator*, the "Edisonka's" smooth circles and quadrilaterals with curved ends create an open assemblage reminiscent of an esoteric precision-made machine, constituting a highly polished vision of modernity.

The large rings evoke a sense of radiating energy and suggest electric coils and Saturnlike planets, while the vertical skeletal structure exemplifies contemporary engineering. The allusions to cosmos and technology recall Tatlin's utopian model for a *Monument to the Third International*, which employed the spiral and motion as metaphors for social and political progress. Pursuing his interest in technology, Pešánek produced a light-and-motion display for the set of the opera *Flames* by Ervin Schulhoff (1932), the first illuminated advertisements for the Löbl department store in Prague (1933), and a system of nighttime illumination for the sculptures in the garden of Prague's Modern Gallery (1933). Yet a traditionalism tempered his innovations. He frequently incorporated figurative elements into his lightworks (especially later), and throughout his career he explored kinetic art by means of a mechanical color-piano. Even the Edisonka's design employed this technique. Ultimately such works had more in common with earlier experiments than they did with those of his contemporaries Richter, Moholy-Nagy, and Teige, who were interested in developing the kinetics of abstract form on film, using music to complement the resulting compositions rather than to generate them.

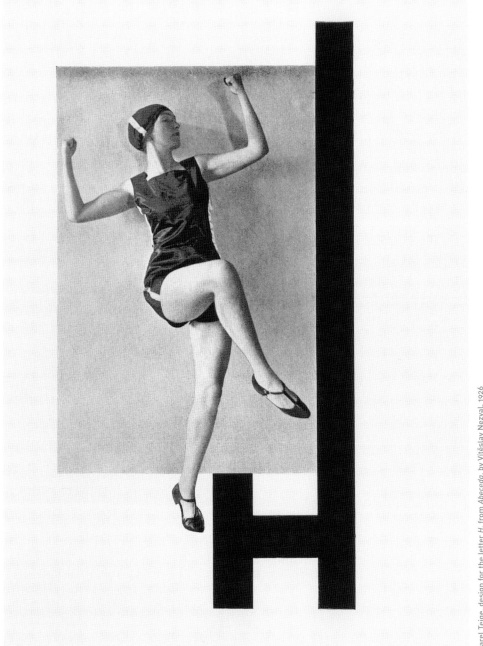

Karel Teige, design for the letter *H*, from *Abeceda*, by Vítěslav Nezval, 1926

"individualists, arrangers, oil painters, decorators, the whole venture are marching under [the banner of] Constructivism…as long as the catchword is fashionable."

CONCLUSION

By the mid-1920s Constructivism had begun to lose its radical ideological identity. Even in Russia, Osip Brik railed in 1923 against heretics who had "rapidly adopted the fashionable jargon of Constructivism" but had produced entirely conventional artworks.[89] In Germany the following year Hans Richter lamented that Constructivism had been hijacked by painters such as Moholy-Nagy and noted how the term had metamorphosed: "[T]he art trade in oil painting has covered up the name, and individualists, arrangers, oil painters, decorators, the whole venture are marching under [the banner of] Constructivism…as long as the catchword is fashionable."[90] The Constructivist label initially prevailed precisely because it associated innovative developments in avant-garde art and design with the wider progress of culture and society. Those involved were forced to assume the role of keepers of the flame, as the prospects for utopia receded and Constructivism gradually turned into a mere stylistic tributary within modernism.

1 Hans Richter, *Dada Profile* (Zurich: Die Arche Verlag, 1961), 27. The texts mentioned refer to material published in *G: Material zur elementare Gestaltung*.

2 "Programme of the Working Group of Constructivists" in Selim O. Khan Magomedov, *Rodchenko: The Complete Work* (London: Thames and Hudson, 1986), 289–90. See also Christina Lodder, *Russian Constructivism* (New Haven: Yale University Press, 1983), 94–101.

3 Aleksei Gan, *Konstruktivizm* (Tver, 1922).

4 See Lodder, *Russian Constructivism*, chapter 6.

5 See Helen Adkins, "Erste Russische Kunstausstellung, Berlin 1922," in *Stationen der Moderne: Die bedeutenden Kunstausstellungen des 20. Jahrhunderts in Deutschland* (Berlin: Berlinische Galerie, 1988), 185–96.

6 El Lissitzky and Ilya Ehrenburg, "Die Blockade Russlands geht ihrem Ende entgegen," in *Veshch/Gegenstand/Objet* (Berlin), no. 1–2 (March–April 1922): 1–2; translation from Stephen Bann, *The Tradition of Constructivism* (London: Thames and Hudson, 1974), 56.

7 Bann, *The Tradition of Constructivism*, 55.

8 Ibid., 56.

9 Ibid.

10 Gan, *Konstruktivizm*, 18.

11 "Statement by the Editors of *Veshch/Gegenstand/Objet*," in Bann, *The Tradition of Constructivism*, 63.

12 "Statement by the International Faction of Constructivists," in Bann, *The Tradition of Constructivism*, 69; originally published in *De Stijl* 5, no. 4 (1922).

13 See *De Stijl*, no. 8 (1922).

14 El Lissitzky, "New Russian Art: A Lecture, 1922," in Sophie Lissitzky-Küppers, *El Lissitzky: Life, Letters, Texts* (London: Thames and Hudson, 1968), 340.

15 By early 1922, according to the recollections of Galina Chichagova, nearly all the students at the Vkhutemas were embracing this, as it were, more authentic version of Constructivism; see G. D. Chichagova, "Gody Vkhutemasa. Pervyie vpechatleniya," in V. A. Stepanova, ed., *A. M. Rodchenko. Stat'i. Vospomianiya. Avtobiograficheskie zapiski. Pis'ma* (Moscow: Sovetskii khudozhnik, 1982), 141.

16 See Martin Hammer and Christina Lodder, *Constructing Modernity: The Art and Career of Naum Gabo* (New Haven: Yale University Press, 2000), 107–13.

17 See, for example, Theo van Doesburg, "Monumental'noe iskusstvo," *Veshch/Gegenstand/Objet*, no. 1–2 (March–April 1922): 14–15; and Korbyus'e-Son'e, "Sovremennaya arkhitektura," ibid., 20–21.

18 Victor Margolin, *The Struggle for Utopia: Rodchenko, Lissitzky, Moholy-Nagy 1917–1946* (Chicago: University of Chicago Press, 1997), 46, n. 5.

19 Such antagonisms were not alleviated by the fear of Soviet political influence. After all, *Object*'s ambition to foster international artistic cooperation had a political dimension and can be related to a deliberate Soviet strategy to create a phalanx of sympathizers in Europe, as a cultural corollary to its plan for world revolution, on which it counted for survival.

20 The democratic republic set up by Count Mihály Károlyi in the autumn of 1918 was replaced by a Soviet Republic under Béla Kun in March 1919, which in turn was toppled by reactionary forces led by Admiral Miklós Horty on August 1, 1919.

21 See John E. Bowlt, "Hungarian Activism and the Russian Avant-Garde," in Steven A. Mansbach et al., *Standing in the Tempest: Painters of the Hungarian Avant-*

Garde 1908–1930 (Cambridge: MIT Press, 1991), 149–50; and Krisztina Passuth, "Autonomie der Kunst und sozialistische Ideologie in der Ungarische Avantgardekunst," in Hubertus Gassner, ed., *Wechselwirkungen: Ungarische Avantgarde in der Weimarer Republik* (Marburg: Jonas Verlag, 1986), 12–14.

22 During late 1919–1920, Kassák and Uitz settled in Vienna, while Kállai, Péri, Kemény, and Moholy-Nagy based themselves in Berlin.

23 Oliver A. I. Botar, "From the Avant-Garde to 'Proletarian Art': the Émigré Hungarian Journals *Egység* and *Askasztott Ember* 1922–23," *Art Journal* (New York) 52 (spring 1993): 34–45.

24 See Alfréd Kemény, "Vorträge und Diskussionen am 'Institut für Künstlerische Kultur' Moskau 1921 (nach den Protokollen zusammengefasst von Selim O. Chan Magomedov)," in Gassner, ed., *Wechselwirkungen*, 226–30.

25 For example, *Moholy-Nagy, Péri: Gesamtschau des Sturm* (Berlin: Der Sturm, 1922).

26 El [Lissitzky], "Vystavki v Berline," *Veshch*, no. 3 (May 1922): 14; translation from Sophie Lissitzky-Küppers, *El Lissitzky: Life, Letters, Texts* (London: Thames and Hudson, 1968), 341.

27 László Moholy-Nagy, *Von Material zu Architektur* (Munich: Alebert Langen, 1929); translation *The New Vision: From Material to Architecture* (New York: Brewer, Warren and Putnam, 1932), 162. For a fuller discussion of the relationship between the two texts see Hammer and Lodder, *Constructing Modernity*, 105–7. L. Moholy-Nagy and Alfréd Kemény, "Dynamisch-konstruktives Kraftsystem," *Der Sturm* (Berlin) 13, no. 12 (December 1922): 186; translation in Krisztina Passuth, *Moholy-Nagy* (London: Thames and Hudson, 1985), 290.

28 Naum Gabo, draft letter to Dr. J. P. Lochner, n.d., Gabo Papers, Tate Gallery Archive, London.

29 The Berlin artist Gert Caden recalled that Gabo, Pevsner, Kállai, Kemény, Moholy-Nagy, and Péri had attended a meeting at the beginning of 1922 in his studio (Kai-Uwe Hemken, "'Muss die neue Kunst den Massen dienen?' Zur Utopie und Wirklichkeit der 'Konstruktivistischen Internationale'," in *Konstruktivistische Internationale Schöpferische Arbeitsgemeinschaft 1922–1927: Utopien für eine europäische Kultur* (Düsseldorf and Halle: 1992), 58. Caden's recollection of the date must be incorrect, since Pevsner did not arrive in the West until 1923.

30 Moholy-Nagy and Kemény, "Dynamisch-konstruktives Kraftsystem," in Passuth, *Moholy-Nagy*, 290.

31 Ernő Kállai, Alfréd Kemény, László Moholy-Nagy, László Péri, "Nyilatkozat," *Egység* (Vienna) no. 4 (1923): 51. Translation in *The Hungarian Avant-Garde: The Eight and the Activists* (London: Arts Council of Great Britain, 1980), 120.

32 Ibid.

33 Ibid.

34 N. [Nikolai] Punin, "Tatlin üveg-tornya," *Ma* (Vienna) 7, no. 5–6 (1 May 1922): 31; Lissitzky's drawing was reproduced on page 20.

35 Ernő Kállai, "A konstruktiv müvészet társadalmi és szellemi távlatai," *Ma* (Vienna) no. 8 (30 August 1922): 55–59; and "A haladó müvészek elsö nemzetközi kongresszusa Düsseldorf, 1922 május 29–31," *Ma* (Vienna) 7, no. 8 (30 August 1922): 61–64. Bann did not include *Ma*'s statement in *The Tradition of Constructivism*.

36 See Stephen von Wiese, "Ein Meilenstein auf dem Weg in dem Internationalismus," in Ulrich Krempelclassen, ed., *Am Anfang: Das Junge Rheinland. Zur Kunst- und Zeitgeschichte einer Region 1918–1945* (Düsseldorf: Stadtische Kunsthalle, 1985), 60.

37 El Liszickij, "Proun," *Ma* 8, no. 1 (1922): [8].

38 There were numerous articles on Dada and De Stijl as well. See, for instance, Theo van Doesburg, "Az épitészet mint szintetikus müvészet," *Ma* 7, no. 7 (1 July 1922): 35 (plus 11 illustrations of works).

39 Ludwig Kassák and L. Moholy Nagy, *Büch neuer Künstler*, Vienna, [1922]. Kassák's preface is dated 31 May 1922.

40 Ibid.

41 Ernst Kállai, "Konstruktivizmus," *Jahrbuch der jungen Kunst* (Leipzig), 1924, 374–84; reprinted in Gassner, ed., *Wechselwirkungen*, 163–67.

42 Kállai, "Konstruktivizmus," Gassner, ed., *Wechselwirkungen*, 163.

43 See Alfréd Kemény, "Die abstrakte Gestaltung vom Suprematismus bis heute," *Das Kunstblatt*, no. 8 (1924): 246.

44 Aladár Komjat and Béla Uitz, "Der Weg und das Arbeitsprogramm der Egység (Einheit)," *Egység* (Vienna), no. 1 (1922); German translation in Gassner, ed., *Wechselwirkungen*, 234.

45 Botar, "From the Avant-Garde to '"Proletarian Art,'" 34–45.

46 "A Konstruktivisták csoportjának Programmja," *Egység* (Vienna), no. 2 (June 1922): 5 (and photographs on pages 7 and 9).

47 "Realista Kiáltvány," *Egység* (Vienna), no. 2 (June 1922): 5–6.

48 László Moholy-Nagy, "A nagyváros dinamikája," *Ma* 9, nos. 8–9 (1924): unpaginated (a two-page spread within a special number devoted to music and theater).

49 See Peter Galassi, "Rodchenko and Photography's Evolution," in Magdalena Dabrowski, Leah Dickerman, and Peter Galassi, *Aleksandr Rodchenko* (New York: Museum of Modern Art, 1998), 114–15.

50 Andrzej Turowski, "A Chronicle of the Polish Avant-Garde," *Constructivism in Poland 1923–1936: Blok, Praesens, a.r.* (Essen: Museum Folkwang; and Otterlo: Rijksmuseum Kröller-Müller, 1973), 21.

51 Ibid., 21–22.

52 "Co to jest konstruktywizm?" *Blok* (Warsaw), no. 6–7 (September 1924). Translation in Hilary Gresty and Jeremy Lewison, eds., *Constructivism in Poland, 1923–1936* (Cambridge: Kettle's Yard, 1984), 30–31. The term Polish Constructivism was first used by Andrzej Turowski in *W Kregu konstruktywizmu* (Warsaw, 1979), 103–4, 222.

53 Statement in *Katalog Wystawy Nowej Sztuki w Wilnie* (Vilnius), 1923.

54 See Yve-Alain Bois, "Strzemiński and Kobro: In Search of Motivation," *Painting as Model* (Cambridge: MIT Press, 1990), 123–56.

55 Strzemiński was born in Minsk to Polish parents in 1893. Kobro was born in Moscow in 1898 of mixed parentage; her father was of German extraction and her mother was Russian. Her name is given as Ekaterina Nikolaevna in Russian, although it has been rendered as Katherina.

56 W. Strzemiński, "O sztuce rosyjskiej," *Zwrotnica*, no. 3 (1922): 79–82, and no. 4: 110–14; French translation as "Notes sur l'art russe," in W. Strzemiński and K. Kobro, *L'Espace Uniste: Ecrits du Constructivisme Polonais*, ed. and trans. Antoine Baudin and Pierre-Maxime Jedryka (Lausanne: L'Age d'Homme, 1977), 41–51.

57 Strzemiński and Kobro, *L'Espace Uniste*, 49. In early 1922 Malevich had criticized the Constructivists' concentration on the "object of

practical necessity" as completely antithetical to the spiritual ambitions of Suprematism. See "A Letter to the Dutch Artists," in K. S. Malevich, *Essays on Art*, ed. Troels Andersen, trans. Xenia Glowacki-Prus and Arnold McMillin, vol. 1 (London: Rapp and Whiting, 1969), 186.

58 Strzemiński, "Notes sur l'art russe," 49.

59 Ibid., 47–48.

60 W. Strzemiński, "'a.r.' 2" (1932), in *L'Espace Uniste*, 129.

61 Strzemiński, "Notes sur l'art russe," 50.

62 For details of the Inkhuk program see Lodder, *Russian Constructivism*, 78–94.

63 Strzemiński retained a strong allegiance to Malevich and his ideas, corresponding with him and expressing a deep concern about his fate. He translated *On New Systems of Art* into Polish, ensured that Malevich displayed his *planit* designs in May 1926 in an architectural exhibition in Warsaw, and was instrumental in arranging Malevich's visit to Poland and exhibition in Warsaw in 1927. Strzemiński also asked *Zwrotnica* to raise the issue of Malevich's relocation to Poland with the Ministry of Culture and Art (editorial statement, *Zwrotnica*, no. 3 [1922]). For this and other details see Olga Shikhireva, "Władysław Strzemiński," in *Malevich's Circle: Confederates, Students, Followers in Russia, 1920s–1950s* (St. Petersburg: Palace Editions, 2000), 85–90.

64 Katarzyna Kobro and Władysław Strzemiński, *Kompozycja przestrzeni; obliczenia rytmu czasoprzestrzennego* (Łódź, 1931). French translation as "La composition de l'espace, les calculs du rythme spatio-temporel," in *L'Espace Uniste*, 85–125. English translation of extracts in *Constructivism in Poland*, 38–39.

65 See Ernő Kállai, "A berlini orosz kiállitás," *Akasztott Ember* (Vienna) 2 (February 1923). German translation in Ernst Kallai, *Vision und Formgesetz: Augsätze über Kunst und Künstler von 1921 bis 1933*, Tanja Frank, ed. (Leipzig and Weimar: Gustav Keipenheuer Verlag, 1986), 29.

66 Janusz Zagrodzki, "Inside Space," *Katarzyna Kobro 1898–1951* (Leeds: Henry Moore Institute, 1999), 74. He indicates that Space Compositions 3, 4, and 5 had overall dimensions (cm) based on the number 8 (i.e., height 40 = 5 x 8, depth 64 = 8 x 8, and width 40 = 5 x 8). This formula also provided the basis for Strzemiński's eleven Architectural Compositions of 1929–30.

67 Strzemiński and Kobro, "La composition de l'espace," 85.

68 Ibid., 106.

69 Kobro admired De Stijl and praised Neoplasticism for having eradicated the arbitrary, simplified form "to the highest degree," implemented strict economy, and standardized movement (Kobro, "Functionalism," in *Katarzyna Kobro*, 166).

70 Bois, "Strzemiński and Kobro," 151

71 Strzemiński and Kobro, "La composition de l'espace," 115.

72 Katarzyna Kobro, "Rzezba stanowi…," *Glos Plastyków* (Cracow), no. 1–7 (1937): 42–43; translation in *Katarzyna Kobro*, 169.

73 Janina Ladnowska, "Katarzyna Kobro—An Outline of Her Life and Work," in *Katarzyna Kobro*, 68.

74 Katarzyna Kobro, "Funkcjonalizm," *Forma*, no. 4 (1936): 9-13; translation quoted in *Katarzyna Kobro*, 166.

75 Bois, "Strzemiński and Kobro," 134.

76 Kobro, "Functionalism," in *Katarzyna Kobro*, 166.

77 See Andrzej Turowski, "Theoretical Rhythmology, or the Fantastic World of Katarzyna Kobro," *Katarzyna Kobro*, 83–88.

78 Karel Teige, "Poetismus," *Host 3*, no. 9-10 (July 1924): 197–204; translation quoted in Eric Dluhosch and Rostislav Svácha, eds., *Karel Teige 1900–1951: L'Enfant Terrible of the Czech Modernist Avant-Garde* (Cambridge: MIT Press, 1999), 69.

79 Teige, "Poetismus," 68 and 69.

80 Karel Teige, "Moderni typo," *Typografia*, no. 34 (1927): 189–98; translation in Dluhosch and Svácha, eds., *Karel Teige*, 92–105.

81 Teige, "Modern Typography," in Dluhosch and Svácha, eds., *Karel Teige*, 104.

82 Such as *Mezinárodni soudobá architektura* (Prague, 1929) and *Nejmensi byt* (Prague, 1932).

83 Karel Teige, "Soudobá mezinárodní architektura," *ReD* (Prague) 1, no. 5 (1928); translation in T. and C. Benton, eds., *Form and Function* (London: Crosby, Lockwood and Staples, 1975), 201–2.

84 Karel Teige, "Minimálni byt a kolektivni dum," *Stavba* (Prague) no. 9 (1930–1931): 28–29, 47–50, 65–68; translation in Dluhosch and Svácha, eds., *Karel Teige*, 196–215.

85 Eric Dluhosch, "Teige's Minimum Dwelling as a Critique of Modern Architecture," in Dluhosch and Svácha, eds., *Karel Teige*, 152.

86 For translations of Teige's attack and Le Corbusier's defense see *Oppositions* (New York), no. 4 (1975): 79–108.

87 See Jiři Zemanek, ed., *Zdeněk Pešánek 1896–1965* (Prague: Narodni Galerie, Sbirka moderniho a soucasneho umeni, 1996).

88 Hammer and Lodder, *Constructing Modernity*, 141, 165, 170, 171.

89 O.B. [Osip Brik], "V proizvodstvo," *Lef* (Moscow), no. 1 (March 1923): 105; translation in Bann, *The Tradition of Constructivism*, 84.

90 H. R. [Hans Richter], "An den Konstruktivismus," *G: Material zur elementaren Gestaltung* (Berlin), no. 3 (June 1924): 72.

was primarily due to foreigners, mainly Eastern Europeans.

German artists contributed to Berlin's creative life, but the decidedly intellectual profile of the city in the 1920s

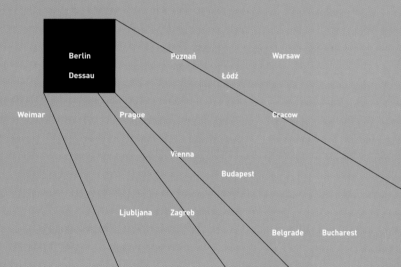

Berlin

Dessau

Weimar

Poznań

Łódź

Warsaw

Prague

Cracow

Vienna

Budapest

Ljubljana

Zagreb

Belgrade

Bucharest

berlin

BERLIN

Krisztina Passuth

p. 199:
Potsdamer Platz, Berlin, c. 1930

Below:
Kaiser-Wilhelm Bridge and castle, Berlin, 1905

Bottom:
Friedrichstraße, Berlin, c. 1930

If Berlin at the opening of the 1920s had become a model metropolis, it was not for its beauty. Berlin—contrary to Rome, Paris, or even Prague—cannot be called beautiful in the usual sense of the word. The city cannot pride itself on unforgettable buildings, intimate streets, attractive parks, or impressive art memorials. The magic of Berlin is not in its architecture or open spaces, its navigable canals or series of lakes, but rather in its lifestyle, established during the first decades of the twentieth century. Almost no one could resist its drive and rhythm.

The inextricably intertwined forces of politics, topography, economics, and culture play an active role in the development of any city. Above all, the era in which a metropolis comes of age is decisive. For Berlin, directly after the First World War, the critical element was the ongoing political struggle in Germany between the straining factions of the left and the right. Tensions—particularly before 1920—exploded in skirmishes and coups d'état. These opposing and irreconcilable divisions should have been mediated by Berlin, which was home to the head of government, the new parliament, the many different political parties, and the leaders of the military. The city was home, too, to several million people, a considerable number of whom resided in enormous and oppressively crowded tenements. Administratively, Berlin had just become a unique, centralized metropolis. A parliamentary vote taking effect in April 1920 redrew the city's limits, giving birth to Greater Berlin, with 3.8 million inhabitants. This consolidation of the city's environs meant that transportation became an organic part of daily life, and if Berlin had not modernized its transportation system, the city certainly would have remained a loose conglomeration of smaller and bigger villages or residential districts. Residents said farewell to the romantic horse-driven omnibus, replacing it with an integrated system of public conveyances. Rapid transit trains, the Schnellbahn (S-Bahn) and the Untergrundbahn (U-Bahn); streetcars and, later, autobuses; boats navigating the canals; and automobiles all were part of this transformation. People moved around a great deal between their work and their homes, as well as to places of amusement, and they gladly accepted and liked the new means of transportation. Accordingly the city did not entirely bury the U-Bahn underground, and the design of some stations—for instance, Friedrichstrasse-Gleisdreieck—represented the new industrial aesthetic ideal. Many other ingredients of the modern lifestyle, such as the telegram, the telephone, neon signs, and newspapers, some published three times daily, became very popular.

Residents of Berlin conducted hectic, feverish, nervous lives. Contemporary writings depict Berliners as always on the move, with never any time to spare and engaged in a million things all at once. The city is not characterized by the peace and quiet of comfortable coffeehouses, like many other contemporary urban areas, but rather by an endless chain of events at theaters, cabarets, movie houses, and art galleries. While influential intellectuals lived in beautifully furnished, spacious apartments, including a so-called Berlin room (an L-shaped room), and

often received guests among valuable collections of precious art objects, their real life mostly occurred beyond the walls of home. People frequented a variety of places for the purpose of meeting others: modest art workshops, galleries and exhibitions, ateliers (at which spontaneous exhibitions sometimes occurred), bookstores, and cafés and theaters, such as the Romanisches Café, the Café Leon, and the Piscator Theater, at Nollendorfplatz. The Hungarian writer Sándor Márai, who was in Berlin from 1920 until 1923, later characterized the city: "There was something floating and dandyish at the time in Berlin; it was the time of the 'Spleen de Berlin.' We lived an easygoing, oblivious life in the big city, which simmered with artificial life. The city was appealing in its ugliness and architectural desolation; and if I remember now the time spent there, I realize with wonder that later on nowhere did I feel, when abroad or even at home, as unencumbered, light, young, and irresponsible as I felt in Berlin one-and-a-half years after the armistice. From time to time the 'revolution' erupted, but after the bloody serious days of Spartacus [a Communist-led revolt in 1919], these intermittent scandals were not taken very seriously, not even by the participants. The German people, who gave themselves a gift in Weimar with a new constitution and rights to freedom, were not able to accept freedom."

German artists contributed to Berlin's creative life—the group Die Brücke, for instance, moved there from Dresden in 1911—but the decidedly intellectual profile of the city in the 1920s was primarily due

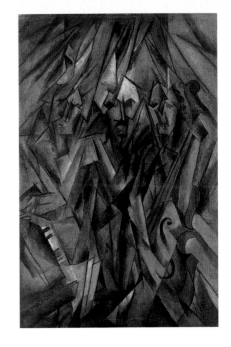

to foreigners, mainly Eastern Europeans. The new immigrants, much more so than established residents, struggled for their livelihood and for recognition, since they were starting from nothing at a time when the German currency was devalued, and only speculators and clever manipulators could secure a good living. In this feverish race, Russian emigrants were in front; some had arrived earlier in Berlin as refugees of the October Revolution (1917), but the majority came after 1920. Konstantin Umansky, a Berlin resident and a journalist for the Soviet news agency TASS, published in 1920 the first comprehensive book in German about Russian art: *Neue Kunst in Russland, 1914–1919* [New Art in Russia, 1914–1919]. During the same year, Berlin Dadaists organized the Dada Fair with the slogan: "Art is dead, long live the new

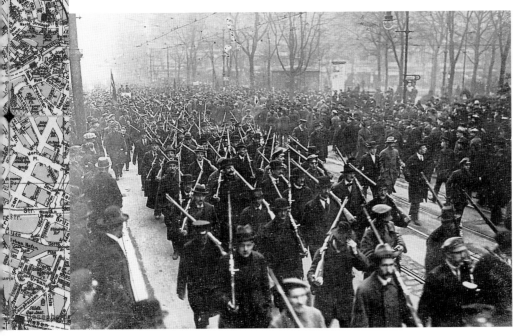

Top right:
■ Antonín Procházka, *Concert*, 1912, oil on canvas

Above:
Berlin, Unter den Linden, January 5, 1919

Right:
Newspaper kiosk designed by A. Grenander, Leipziger Platz, 1905

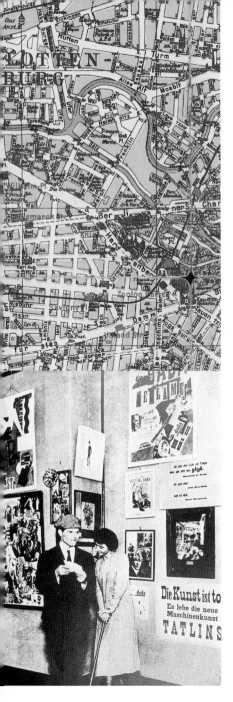

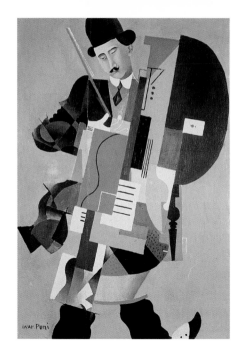

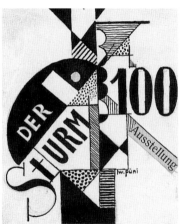

machine art of Tatlin." While his art was not strictly mechanized, Vladimir Tatlin, still resident in Russia, had a great influence on the ideology of Constructivist artists living in Berlin who had divorced themselves from Dada. Before this influence manifested itself, a lively event took hold of the artistic public of Berlin: Ivan Puni, a painter from Petrograd living in the city, arranged a truly avant-garde exhibition in 1921 at Galerie Der Sturm. Colorful, decorative spots on the wall connected the exhibited creations into asymmetric, animated unities, and Suprematist art objects decorated the entrance to the gallery. The true success of the event was assured, however, at the opening when young people wearing Suprematist costumes marched in the street. It was a rare meeting of mass entertainment and the avant-garde.

Political events also played a role in artistic life. In April 1922 Germany and Russia signed the Treaty of Rapallo, which restored diplomatic relations between the countries. It legitimized vital commercial contacts as well as a series of cultural exchanges. Berlin hosted the enormously influential Erste Russische Kunstausstellung [First Russian Art Exhibition] in November 1922, and two years later an equivalent exhibition of German artworks was organized in Moscow (in which several Hungarian artists participated).

Unlike the Russian emigrants, Eastern Europeans did not establish an independent, administrative, or cultural order in their native language. Hungarians came to Berlin after the downfall of the Hungarian Soviet Republic, partly because they feared retribution and partly because they wished to live in a more open, freer world. After the Russians, they were the émigré group most firmly settled in Berlin. The Hungarians preserved a sense of revolutionary momentum even while they joined fully with the German and international intellectual community. An important member of German artistic circles was Arthur Segal, a Romanian painter and longtime resident of Berlin, whose school became a meeting place and a radical organizational force. Among the Poles, it was Henryk Berlewi who had the most

affiliations to Berlin and the Der Sturm circle. The Serbians Ljubomir Micić and Branko Poljanski—just like the Hungarian Lajos Kassák—spent only a short time in the German capital; and representatives of the Czech avant-garde preferred Paris at that time.

Eastern Europeans did not exhibit independently but joined German artists at Galerie Der Sturm, Galerie Fritz Gurlitt, and Galerie Ferdinand Möller, and within the framework of the leftist Novembergruppe and the Grosse Berliner Kunstausstellung [Great Berlin Art Exhibition]. Some Hungarian critics, such as Ernő Kállai and Alfréd Kemény were bilingual, and their articles were devoted to both Hungarian and German artists. German critics—Adolf Behne, Eckhard von

Above:
Raoul Hausmann and Hannah Höch at Dada Fair in front of poster "Art is Dead, Long Live the New Machine Art of Tatlin," Berlin, 1920

Top right:
Ivan Puni (Jean Pougny), *Synthetic Musician*, 1921, oil on canvas

Right:
■ Ivan Puni (Jean Pougny), *Exhibition Announcement— Der Sturm*, 1921, pen, ink, and pasted paper on paper

Sydow, and others—reciprocated by sometimes mentioning Hungarians. These interchanges grew from personal connections, social meetings, and debates. El Lissitzky, Gert Caden, Erich Buchholz, László Moholy-Nagy, Ivan Puni, and many more formed their own small or large, brief or enduring circles of friends, with whom they discussed their latest ideas. An outgrowth of these exchanges was the creation of art that teetered on the edges of various styles, competing with each other and showing some characteristics of later Expressionism, Russian Constructivism, Berlin Dada, and the about-to-be-born abstraction.

As artists connected, they sometimes quoted each other, either in confirmation or contradiction. The Dadaist films of the Swede Viking Eggeling, which began as a series of abstract drawings on endlessly long scrolls, achieved completion in the abstract films of his friend and colleague Hans Richter, who gave birth to an entirely new art form that moved between painting and film. Such possibilities were not only of interest to Eggeling and Richter. The Novembergruppe in May 1925 sponsored a film screening in Berlin entitled "Die Filmmatinee, 'Der absolute Film.'" At this event, called "legendary" by the contemporary press, film as an art form was for the first time accessible to the broader public. On the whole the films shown in the program were original and experimental. This idea of film influenced even those who were not—or not yet—active in camera work. In September 1924 for example, before the Hungarian Moholy-Nagy ever made a film, he published a concept for one in the Viennese journal *Ma*. Entitled "Dynamism of a Metropolis," its essence was the rhythm and accelerated tempo of ever-changing pictures and picture fragments. The scenario is presumed to have inspired Walter Ruttmann in his famous 1927 film *Berlin, Symphony of a Great City*, a kaleidoscopic montage of urban life.

Artists liked Berlin not only for its accelerated pace but for its value both as a subject and as a location in which to set their dramas. By showing certain parts of the city and its inhabitants—figures, street corners, squares—they indicated a sense of the whole breadth of Berlin. In the background of his full-figure self-portrait, the Hungarian Lajos Tihanyi painted the buildings of Berlin's Schöneberg district, viewed through a window, to convey the presence

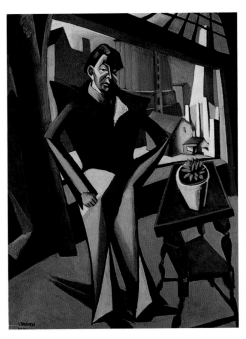

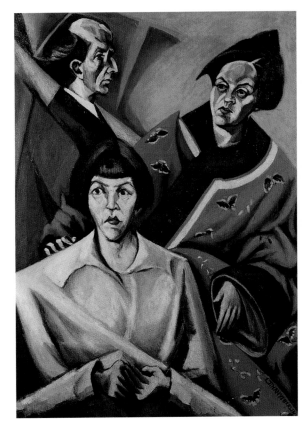

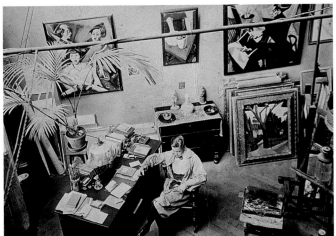

Above left:
■ Lajos Tihanyi, *Man Standing at the Window (Self-Portrait, Berlin Schöneberg)*, 1922, oil on canvas

Above right:
■ Lajos Tihanyi, *Working-Class Family*, 1921, oil on canvas

Left:
Lajos Tihanyi in his studio, Berlin, c. 1922

Above:
■ Miroslav Ponc, *Chromatic Turbine in Eighth-Tones*, c. 1925, ink and watercolor on paper

Below:
El Lissitzky, *Proun Room*, 1923 (reconstruction 1965)

of a big city. George Grosz, Otto Dix, Raoul Hausmann, and Hannah Höch all made emphatic caricatures of the politicians and criminals of Berlin, sharp-edged figures that looked as though they had been cut out with a knife.

The photomontage, the characteristic language of the Dada masters, appeared for the first time in Berlin after 1918. Grosz, Hausmann, and Höch were the first to use the contradictory elements of cut-up fragments to create a new, energized whole. This new art form was introduced to the public in 1920 at the Berlin Dada Fair. After 1920 it was used by those artists belonging to the so-called International Constructivism movement, including El Lissitzky, Naum Gabo, Erich Buchholz, Moholy-Nagy, Werner Graeff, László Péri, Gert Caden, Oscar Nerlinger, Hans Richter, and others. These artists did not arrange common exhibitions nor did they even form a close group like the Berlin Dadaists. But with their geometrical forms and shared architectural ideals, they

opened new possibilities for visual art. At the Great Berlin Art Exhibition El Lissitzky installed his Proun Space, and Erich Buchholz altered his workshop at Herkulesufer so that the space itself became the work of art, the artist's creation stepping out of a two-dimensional confinement to be reborn in truly three-dimensional form.

Moholy-Nagy used projected scenery of Berlin at the Piscator Theater for the staging of *Der Kaufmann von Berlin* [The Berlin Merchant], showing the city's department stores and shops aglitter. Berlin does not die at night; on the contrary, it is very much alive. It shows another of its whimsical faces, with cabarets, dancing, and nightclubs, and building façades suffused with light. This multiplicity of faces reflects the city's true character and provides a strong attraction, even to those who mean to stay only a short time but cannot depart for years. They, too, eventually become a living part of the metropolis of Berlin.

Translated by John Bátki

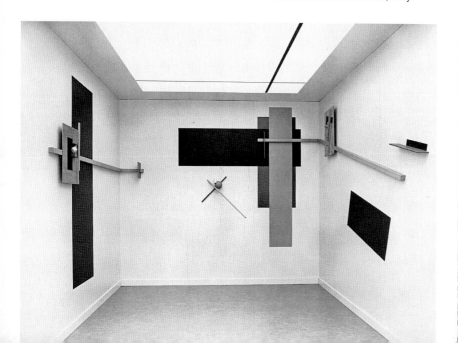

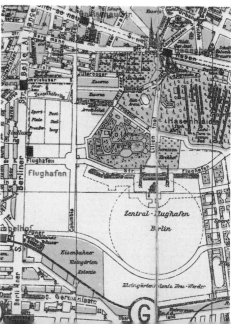

weimar

"Three days in Weimar, and you cannot tolerate a square any more."

Berlin Poznań Warsaw

Dessau Łódź

Weimar Prague Cracow

 Vienna

 Budapest

 Ljubljana Zagreb

 Belgrade Bucharest

WEIMAR

Éva Bajkay

The historical traditions of Weimar, a small town near the Thuringian woods in central Germany, have exerted a powerful cultural magnetism since medieval times. Weimar is rich with associations to the multi-talented writer-philosopher Goethe and his friend the poet Schiller, to the composers Bach and Liszt, and, at the end of the nineteenth century, to the philosopher Nietzsche. It was this world-famous reputation in the arts that attracted a young Berlin architect, Walter Gropius, to Weimar in 1919. Gropius reorganized the local academies of fine and applied arts into a new school, which he named the Bauhaus. It would become one of the touchstones of the avant-garde.

Following Germany's defeat in the First World War, its national assembly met in Weimar in 1919 and adopted a modern democratic constitution. Foreigners were drawn to Germany by its new open system as well as the country's rapidly inflating currency. Students from Central and Eastern Europe, who had long come to Weimar for their schooling, now flocked there in especially large numbers. At the Bauhaus a good portion of the students came from German-speaking Jewish families, and an unusually high proportion were women. The Bauhaus admitted talented applicants without regard to traditional gender bias or the intensifying racial prejudice. Gropius selected his new faculty from among recognized artists, many of whom were affiliated with the internationally renowned *Der Sturm*, the Berlin periodical and gallery, which were broadly receptive to artistic influences, including those from Eastern Europe. In Weimar from 1919 to 1924, then in Dessau from

1926 to 1932, the Bauhaus held out, for a time, the prospect of an open and free creative community.

Appearing as it did in the era of intense nationalism in Central Europe between the wars, this supranational educational and artistic community was unique. As Paul Klee put it, "The Bauhaus represents art in Germany, but not German art." In a reinterpretation of the concept of the *Gesamt-kunstwerk*, or total artwork, the school attempted to develop new approaches to life and art that would correspond with new scientific and technological discoveries. While the academies witnessed the last flowering of historicism, the Bauhaus sought to bring life and art closer together by training specialists in practical workshops whose concerns ranged from formal analysis to utopistic architecture, and from the design of objects to environmental design.

In its manifesto the Bauhaus proclaimed the central idea behind its program: "The artist is a craftsman on a higher level," a statement intended to win the support of the local citizenry and artisans. Paradoxically, the cover of the manifesto brochure depicted a cathedral of the future; the Bauhaus originated in the art of the Secession but soared on Romantic wings and was fueled by German Expressionism. As early as the 1910s Gropius had admired American industrial architecture, and in this German town with its powerfully conservative traditions the catchwords "Americanism," "progress," "the marvels of technology and invention," and "the metropolis" buzzed in the ears of the new faculty, among them Lyonel Feininger and Oskar Schlemmer.

Caught in the crossfire of heated political, economic, and technical debates, the program at first could be launched only in the area of crafts. After this chaotic beginning, however, a new theory of rational and efficient forms, deemed to be applicable to all areas of life, gained ground. The Swiss painter and art theoretician Johannes Itten, invited from his school in Vienna, laid the groundwork for the introductory parts of the innovative training program. Shaking off convention, Itten set his sights on the integral human

p. 205:
Lyonel Feininger, *Cathedral*, printed to accompany Bauhaus Manifesto, 1919, woodcut

Below:
Oskar Schlemmer, Bauhaus emblem, *Bauhaus Drucke Neue Europäische Graphik*, 1922

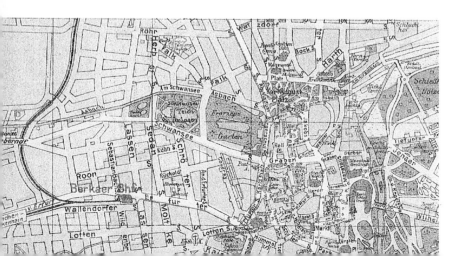

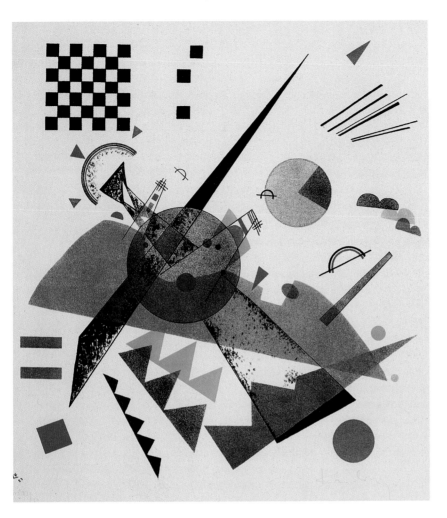

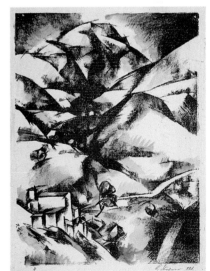

being, whose creative forces would be unleashed through the acquisition of first-hand, practical knowledge of the technical qualities and facture of materials, color theory, and composition, acquired by analyzing classical works. Itten's methodology placed equal emphasis on intuition and method, emotion and objective givens. He considered discoveries in the natural sciences to be on par with Eastern doctrines (particularly the sect of Mazdaznan) in the purification of the body and soul. Itten's teachings, proclaimed with a near-religious fervor, prompted enthusiastic responses from students but were rejected by Weimar's citizens.

By 1922 Itten's teaching could not be reconciled with Gropius's practical notions oriented toward mass production and consumption. Faculty member Lyonel Feininger, scion of a German family in America who had returned to Europe, was head of the graphic printing workshop in the Weimar period, and during his tenure it made the transition from art printing to commissions and commercial print production. Even so, Feininger encouraged autonomous creative work among his students. Other faculty members and their avant-garde contemporaries supported the graphics workshop by publishing their works in a series of portfolios titled "European Graphics." One of the few examples of student work in the series is the portfolio Italia (1921–22) by Farkas Molnár and Henrik Stefan. Its very first sheet is evidence of the Constructivist about-face the Bauhaus was about to make. This direction was reinforced by the new faculty joining the Bauhaus, most significantly Oskar Schlemmer and Paul Klee in 1921, and the highly regarded Wassily Kandinsky in 1922.

The Dutch artist Theo van Doesburg was instrumental in promoting the Constructivist approach at the Bauhaus. With a

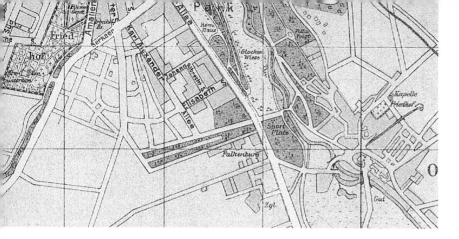

Above:
■ Farkas Molnár, *Lovers in Front of House and Horn*, 1923, drypoint and etching

Right:
László Moholy-Nagy, *Score to a Mechanical Eccentricity: Synthesis of Form, Movement, Sound, Light (Color) and Noise*, illustration in *Die Bühne im Bauhaus [The Stage at the Bauhaus]*, by Moholy-Nagy and Oskar Schlemmer, 1924

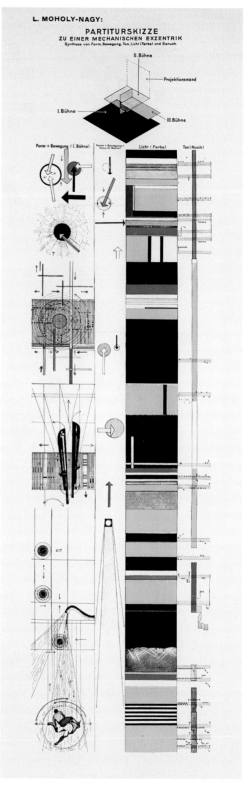

background in theosophy, he taught a new theory of art that emphasized right angles and primary colors. Van Doesburg's Neo-plasticism stressed practicality as well as collective rather than individual solutions. After sojourning in Leiden, Antwerp, Paris, and Rome, he arrived in Weimar to pro-claim his views via his periodical *De Stijl* and through his famous private course. He recruited a large number of disciples from the Bauhaus student body, who formed the group Kuri; its slogan was "Constructive, Utilitarian, Rational, International." Farkas Molnár and Andor Weininger were the outstanding Central European members.

After Berlin, Weimar was the crossroads of international modernism in Germany. Van Doesburg helped to convene the International Congress of Constructivists and Dadaists there in September 1922 (a previous congress had been held in Düsseldorf). Russian Constructivism was energetically represented by El Lissitzky; and the Hungarian László Moholy-Nagy also played a prominent part. In March 1923 Moholy-Nagy joined the Bauhaus faculty and saw the trend toward Constructivism gain ascendancy under a fresh slogan coined by Gropius: "Art and technology—a new unity." In contrast to Itten, Moholy-Nagy insisted on strict formal analysis over intuition, and indus-trial production took the place of artisan activity. Moholy-Nagy was an innovator and a polyhistor whose influence spanned areas as diverse as the metal workshop and the theatrical stage. Experimenting with new media such as film and photo-graphy, he gave expression to his ideas in a multitude of novel forms as well as

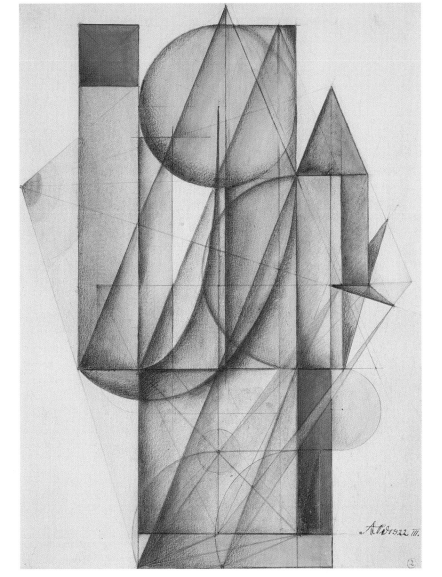

Above:
Andor Weininger, *Kuri 2*, 1922, pencil and gouache on paper

Below:
■ Andor Weininger, *De Stijl–Composition II*, 1922, gouache and graphite on paper

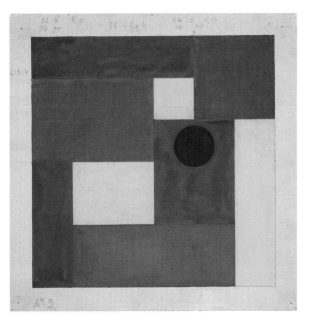

in the traditional modes of oil painting, etching, and lithography.

By 1923 the time was ripe for the Bauhaus to demonstrate its new goals at Weimar. Mounting an exhibition that was both retrospective and forward-looking, the school intended to win over the traditional municipal leadership, who had provided a loan to equip production workshops. The central motif was no longer a cathedral, but an up-to-date family dwelling, which was to be built and fully furnished. The design for the house, by Georg Muche, was selected in a general competition (Molnár submitted plans for a red cube house, which may be thought to have symbolic significance). The model home was erected as an example of a maximally

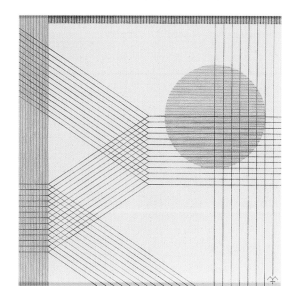

exploited, minimal dwelling space and furnished with objects from the workshops. These were prototypes suitable for mass production, and proceeds from their sale were earmarked to provide financial support for students.

This was the period of highest inflation in Germany, and there was little chance for actual commissions. Instruction at the Bauhaus of necessity was aimed more toward the future, with the school considered to be a practice ground for experiments in the handcrafted production of objects suitable for mass manufacture by machine. In the metal, furniture, textile, ceramics, glass, mural, and graphics workshops, students produced pieces along geometricizing and rational lines whose rarefied, if debatable, technicalization marks them as unavoidable stepping stones of modern design.

The theater workshop directed by Oskar Schlemmer turned out to be the paramount creative locus of the Bauhaus community at Weimar. Human figures, abstracted into puppets in an effort to eliminate individuality, put on peculiar "abstract revues," often in the midst of geometric spatial elements. Andor Weininger, a Hungarian, designed light, color, and sound shows, and sketched out plans for a utopistic Spherical Theater—just one example of the many theatrical experiments at Weimar. It was on the stage, expressing scintillating ideas, performing jazz, dances, and masked festivities, that

Right:
Alfréd Forbát, *Abstract Composition*, 1921, colored chalk on paper

Below:
■ Sándor Bortnyik, *Composition with Lamp*, 1923, oil on cardboard

students and teachers managed to forge a creative community.

These efforts to create a new, shared visual language remained alien and separate from the tradition-bound local culture of Weimar. The town eyed with disapproval the flamboyant youths who flocked in ever greater numbers to the Bauhaus from abroad. Memoirs and recollections documenting everyday life at the school offer evidence that it was not only an innovative educational establishment but also a utopian social unit. In the words of the architect Alfréd Forbát, "The Bauhaus may be analyzed in many ways and it in fact eludes analysis... It was not exclusively an educational institution, although I consider this role to be paramount. For me it was the pooling of all those energies that are, for one reason or another, formative." The red square, the yellow triangle, and the blue circle, read as symbolic indications of energy and form, became the emblem of the rationalistic

Above:
■ Walter Gropius, *Working Model for the Monument to the March Dead*, 1922 (reconstruction 1988), plaster

Right:
■ Farkas Molnár, *Grave Monument to the March Dead, Weimar*, 1923, lithograph

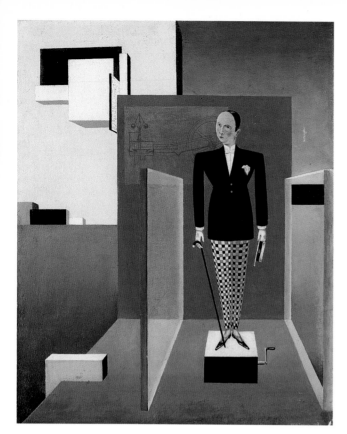

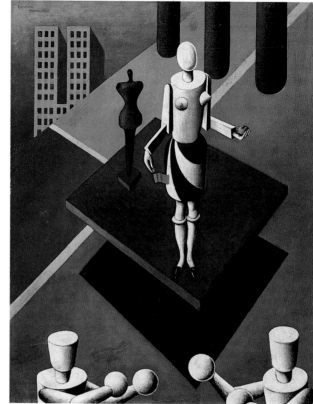

Left:
■ Sándor Bortnyik, *The New Adam*, 1924, oil on canvas

Right:
■ Sándor Bortnyik, *The New Eve*, 1924, oil on canvas

Bauhaus outlook, which began as rigidly geometricizing and turned to the functional. "Three days in Weimar, and you cannot tolerate a square any more," pronounced a contemporary reporter, somewhat simplistically, and to this day, an echo of this sentiment recurs in negative assessments of the school.

The international, modern Bauhaus could not establish a lasting foothold in traditional, German Weimar. In March 1925 the school, up to that time a state institution, was closed, a victim of political pressures between old-guard German nationals and the Western-style Weimar Republic. Municipal authorities in Weimar reacted as well to a climate of increasing nationalism and anti-Semitism. The school reopened in 1925 under a municipal charter in the industrial town of Dessau, where it was housed in a new, functionalist building designed by Gropius and financed by the town. The increasing politicization of Germany and the rise of the Nazis eventually forced the Bauhaus from Dessau in 1932. It persisted briefly, until 1933, in Berlin before closing its doors forever. Its ideology, however, was disseminated throughout the world as faculty and students dispersed.

Translated by John Bátki

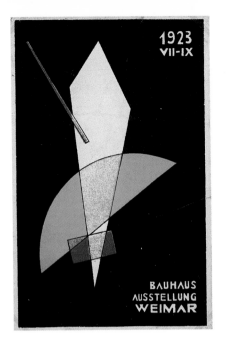

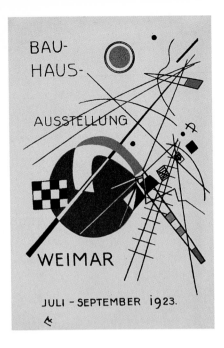

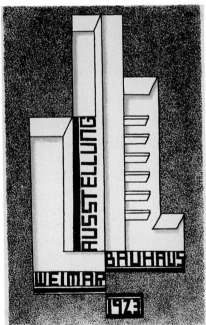

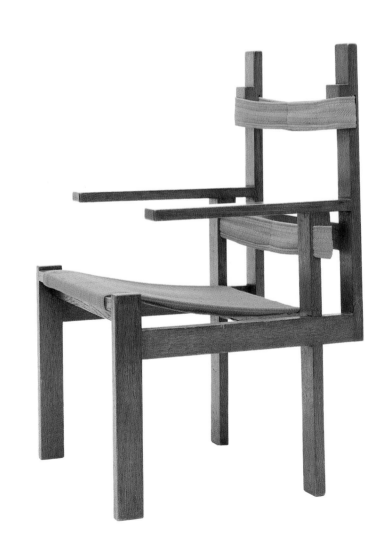

p. 213:
Staatliches Bauhaus in Weimar, published on occasion
of the 1923 Bauhaus exhibition, Dessau, typography by
Herbert Bayer

Top left:
■ Wassily Kandinsky, *Postcard Announcement for 1923
Bauhaus Exhibition*, color lithograph on cardboard

Top right:
■ László Moholy-Nagy, *Postcard Announcement for 1923
Bauhaus Exhibition*, color lithograph on cardboard

Above:
■ Farkas Molnár, *Postcard Announcement for 1923 Bauhaus
Exhibition*, color lithograph on cardboard

Right:
■ Marcel Breuer, *Chair*, 1922, stained maple and wool

1923 Bauhaus Exhibition

The first comprehensive public exhibition of Bauhaus production was held in August and September 1923 in Weimar. It featured a complex amalgam of tendencies: the Bauhaus workshops presented handmade objects, many suitable for mass production; other displays were devoted to the innovative preliminary course, painting, sculpture, graphic arts, and international architecture. During the Bauhaus Week festivities in August, director Walter Gropius established the agenda for the future in his lecture "Art and Technology: The New Unity."

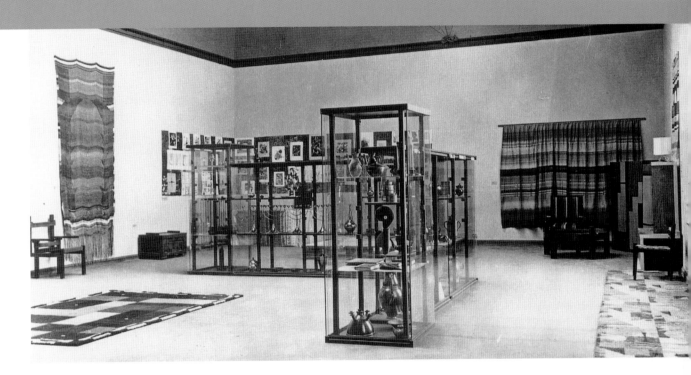

Above:
Bauhaus exhibition, Weimar, 1923

Far left:
■ Gyula Pap, *Candleholder with Seven Arms*, 1922, brass

Left:
■ Gyula Pap, *Tall Pitcher*, 1923, copper, brass, and silver

Mural for a Passageway

Created for the mural workshop at the Bauhaus, this proposal uses colors and typographic elements to moderate an architecturally extreme passageway thirty feet long, nearly fifteen feet high, and ten feet wide. The walls (indicated by the word *Seite*) are optically widened using yellow, while the height of the ceiling (*Decke*) is reduced using black and blue. A huge arrow halfway up the wall, with a background of progressively lighter grays, is accompanied by human-size letters spelling *immer durch* (straight ahead). The elementary forms embody the principles of movement in space espoused by the Kuri group, made up largely of Hungarian students at the Bauhaus.

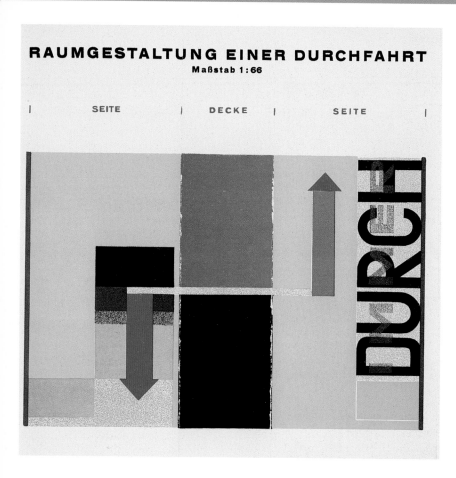

■ Peter Keler and Farkas Molnár, *Mural for a Passageway*, c. 1923, color lithograph

In Dessau, a center of machine manufacture, it became easier to accept the importance of collective creativity, mass production, and serial manufacture than it had been in Weimar, a town proud of its conservative craft tradition.

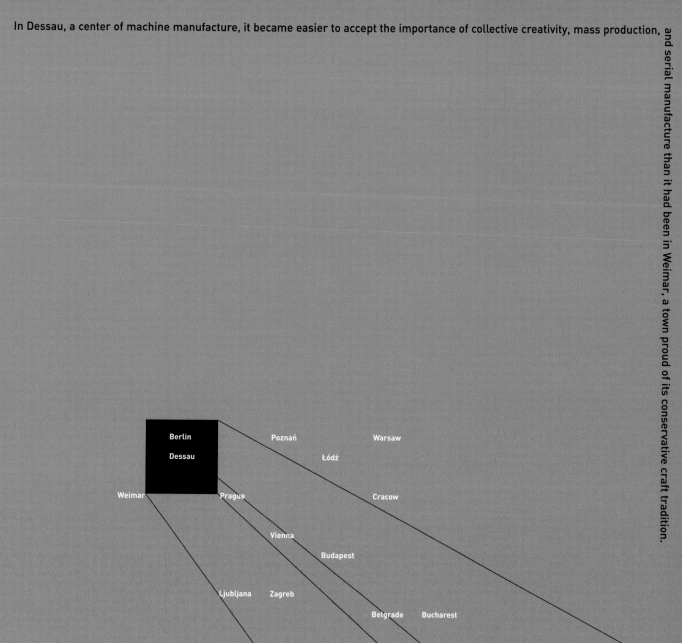

Berlin

Dessau

Weimar

Poznań

Warsaw

Łódź

Prague

Cracow

Vienna

Budapest

Ljubljana

Zagreb

Belgrade

Bucharest

dessau

DESSAU

Éva Bajkay

p. 217:
Irena Blühová, 1932

For centuries the capital of the duchy of Anhalt-Dessau, Dessau owes its prosperity in modern times to its port on the river Elbe and to the heavy industry, most notably the Junkers airplane factory, that has established itself there since the end of the nineteenth century. This industrial region of central Germany truly came into its own during and after the First World War. In 1923 the neighboring settlements incorporated to form Greater Dessau, a town of some 70,000 inhabitants, and its civic leaders began to entertain ambitious dreams, wanting not only to improve the local economy but to better the town's image by developing a central cultural role for it. They were not thinking of following the example of Berlin, a mere one hundred kilometers to the northeast, which was rapidly turning into an international metropolis, but the precedent set by the smaller Weimar, 150 kilometers to the southwest. Dessau's leaders planned the revival of the local academy of applied arts and crafts as an addition to the town's already thriving musical and theatrical life, which included the recently inaugurated Goethe Association and a new municipal library. Rapid industrialization of the town brought large numbers of workers, causing a shortage of apartments and an impetus for a multitude of building projects. At the same time, the increasingly right-wing Thuringian provincial government, which encompassed Weimar, had as of April 1925 withdrawn its support of the Bauhaus art school. The school had become the international center of modernism because of its well-known social commitment to the concept of the basic living unit and its prominence in modern environmental design.

A month before Thuringia cut off its funding to the Bauhaus, the municipal council of Dessau voted to invite the school to establish itself in their town. In a bid to elevate Dessau's cultural standing the mayor, Fritz Hesse, a liberal Social Democrat, tendered the best offer among the competing sites. It made an enormous difference that Hesse treated the institution as a pet project. He was fully aware that the presence of director Walter Gropius and his distinguished faculty—Wassily Kandinsky, Paul Klee, László Moholy-Nagy, Oskar Schlemmer, Lyonel Feininger, and others—would effectively ensure the unfolding of the town's pedagogical and architectural destiny.

Thus Gropius could carry on with the Bauhaus, relocating the school to Dessau and a building of his own design. In addition to workshops, student dormitories, and faculty housing, Gropius designed a workers' housing project from prefabricated elements in the suburb of Törten, and he created the semicircular Labor Bureau building. During this brief period

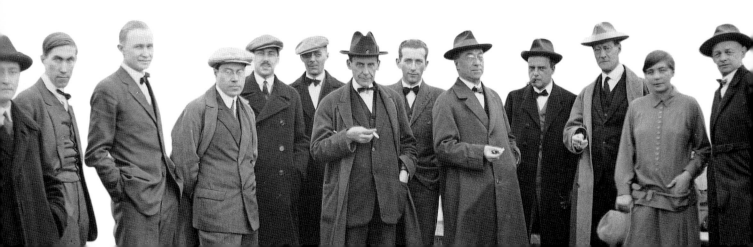

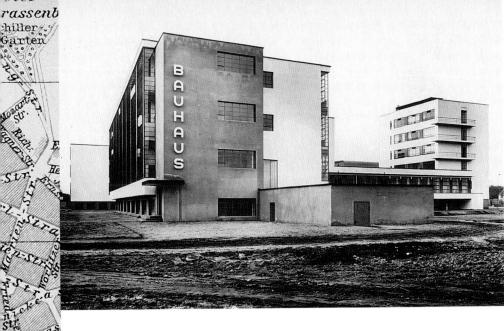

Left:
Lucia Moholy, *View from Southwest of Bauhaus Dessau*, 1927

Below:
Bauhaus, 1928 (vol. 2, no. 2–3)

Bottom:
Bauhaus, photograph by Lotte Beese, 1928 (vol. 2, no. 4)

of economic prosperity, modern architecture was afforded a number of significant opportunities in Dessau.

Throughout 1925 Bauhaus classes continued in temporary quarters until the completion of the impressive main building in December 1926. Its dedication at last brought the worldwide recognition Dessau had hoped for. At a remove from the center of town, the glass and concrete architectural complex comprised an education center and a five-story workshop wing connected to it, with twenty-eight studio apartments for students. Today, visitors who enter the recently renovated glass-walled building can easily imagine themselves transported back to the 1920s. This imposing structure, subsequently the subject of such wide-ranging debate and criticism from so many quarters, was erected in a year's time on a commission given solely by the municipality of Dessau. Remarkable for the era—especially in view of the area's climate—a vast glass curtain wall was employed for the educational center, which filled a multiplicity of functions, from theater to cafeteria, and was connected by means of a bridge to the faculty and administrative offices. A dream realized, this multipurpose building became a *Gesamtkunstwerk*, suitable for activities as diverse as education, entertainment, and sports. To this day it forms a separate cultural island within Dessau, a utopist crystalline symbol of the principles of organization in the modern world.

This was indeed a rare moment in history—comparable to the school's Weimar beginnings in 1919—a time when the beliefs of the town's Social Democratic leadership coincided with those of the school's director. Thus what had been only theory and pedagogical exercise in Weimar now assumed an actual architectural

Josef Albers	Hinnerck Scheper	Georg Muche	László Moholy-Nagy	Herbert Bayer	Joost Schmidt	Walter Gropius	Marcel Breuer	Wassily Kandinsky	Paul Klee	Lyonel Feininger	Gunta Stölzl	Oskar Schlemmer

Teachers at the Bauhaus Dessau, 1926

shape in Dessau. All this enhanced the influence of the Bauhaus and its host city. The school attracted more and more students, especially from the countries of Central and South Europe. Lucia Moholy, Czech by birth, was the expert photographer of Bauhaus products from 1923 and passed on her photographic expertise to her husband. She was responsible for photographing the Bauhaus architecture, which she did in a severely objective manner, her images illuminated by a diffuse light. Her factual, unembellished photos effectively reflected the spirit and achievements of the Dessau Bauhaus and were most successful in characterizing the new institution in periodicals, postcards, and books.

In search of a fresh creative atmosphere, young men and women arrived from all over Central Europe to study at the Bauhaus, which now added "Hochschule für Gestaltung," or design institute, to its name to emphasize its focus. These students from provincial agricultural lands such as Czechoslovakia, Hungary, Poland, Latvia, Ukraine, Croatia, Serbia, Bulgaria, and Turkey brought with them attitudes of wonderment and openness that provided color and variety to the institution while enhancing the town's international reputation. Not only the student body but the faculty as well possessed an increasingly international flavor. The Hungarian Moholy-Nagy (along with Josef Albers) taught an introductory course, which provided a general grounding in the elements of formal design; he and his compatriot Marcel Breuer gained increasingly prominent roles through their leadership, respectively, of the metal and carpentry workshops. An

Austrian, Herbert Bayer, was an innovator in modern typography, using exclusively lowercase letters.

In Dessau, a center of machine manufacture, it became easier to accept the importance of collective creativity, mass production, and serial manufacture than it had been in Weimar, a town proud of its conservative craft tradition. From 1925 the Bauhaus aimed for functional practicality in its angular constructions based on elemental forms and primary colors. Klee and Kandinsky through their theories of form elaborated on this goal in the visual arts, in the wake of fundamental aesthetic experiments by Russian, Dutch, French, and German artists—which had been conducted in places where their realization on a comparable scale was impossible. Those who wanted to find out more about these new endeavors and who, especially after

Top:
■ Lucia Moholy, *Portrait of László Moholy-Nagy*, 1926, photograph

Above:
■ László Moholy-Nagy, *Lucia Moholy*, 1924–25, gelatin-silver print

Left:
Herbert Bayer, design for *Dessau*, 1926, brochure

Opposite:
■ Václav Zralý, design for a Bauhaus poster, 1930, collage

1928, professed increasingly leftist views, came to study at Dessau. The young applicants were attracted by the relatively open admission policies and the possibility of earning their tuition expenses through employment in the workshops. In place of the Europe-wide taste for a neo-Baroque Expressionist dynamism, which was becoming more and more attenuated and degenerating into mere decorativeness, the ordered and reductive design style of the Bauhaus was far more suited to the modest state of the German economy. In the latter half of the 1920s, as the world was heading toward a new economic crisis, such materially efficient design was a natural companion to modern aesthetic standards. Breuer, for example, arrived at the concept for his famous tubular furniture by making use of bicycle handle-bar parts, signaling the fruitful inspiration to be obtained from objects of everyday life. The school developed more and more contacts with factories, including the local Junkers airplane plant, which was to gain such prominence during the Second World War.

Even in the midst of debates about the primacy of market orientation versus formal experiments in instruction, the aim of the educational program remained focused on the ideal of the gifted, creative, and multi-faceted professional. The innovative nature of the program as well as the open and mutually inspiring atmosphere proved most attractive. Eventually it would come to pass that as many as two hundred new students would apply—from thirty-eight countries on three continents—in one week. Then came the visitors, not only from Central Europe but all over the world, from

Below:
■ László Moholy-Nagy, *Light-Space Modulator (Film Still from "Black-White-Gray")*, 1930, gelatin-silver print

Bottom:
■ László Moholy-Nagy, *The Broken Marriage*, 1925, gelatin-silver print of a photomontage

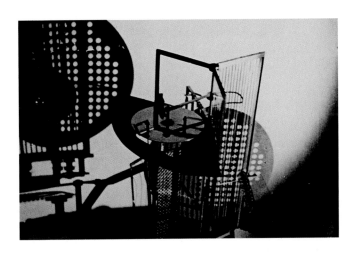

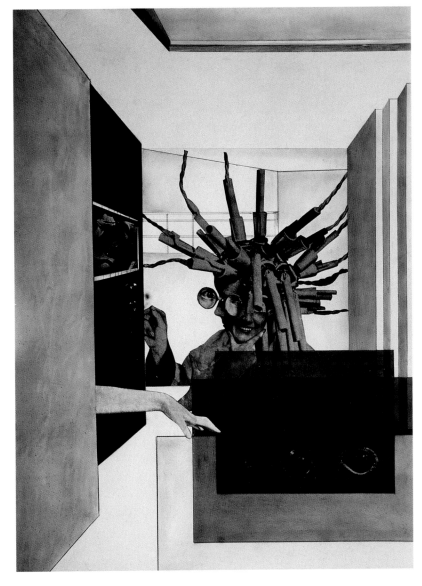

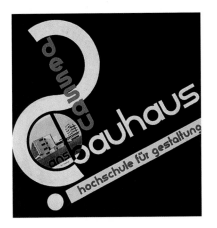

nearby Switzerland and far-off Tokyo. A quarter of the 160 to 180 students each year came from abroad. In the order of their relative numbers, the Swiss were followed by Austrians, Czechs, Hungarians, Poles, and Americans.

The institution's financial difficulties abated for a while after the move to Dessau. Gropius assured the students that they would share a financial interest in the production of prototypes designed for industrial applications. But after 1926 new problems arose in the municipal finances of Dessau. Payments due from local industry were late in arriving, even as a growing number of attacks were mounted against the school from political, economic, and artistic quarters. Gropius, the quality-oriented director who had always taken an apolitical stance, was now finding it increasingly difficult to navigate a straight course, caught as he was in the increasing polarization of the political left and right. After repeated ad hominem attacks were launched at him, Gropius handed in his resignation in 1928. The Central European portion of the faculty—Moholy-Nagy, Breuer, and Bayer—left the school at the same time. They would again take up education in the Bauhaus spirit ten years later, in the United States.

In the intervening years, however, they worked at transplanting and broadening the Bauhaus idea in Central Europe. The example proved effective in Hungary, where Sándor Bortnyik directed a private academy, the Műhely [Workshop], in Budapest between 1928 and 1938. The new design look became accepted first in the fields of advertising graphics and book design. It also turned up at the new school of applied

Below:

■ Irena Blühová, *Siesta on a Balcony in Front of Canteen*, 1932, photograph

Bottom:

Irena Blühová, Bauhaus: Albrecht Heubner, Otti Berger, Albert Kahmke, 1931–32

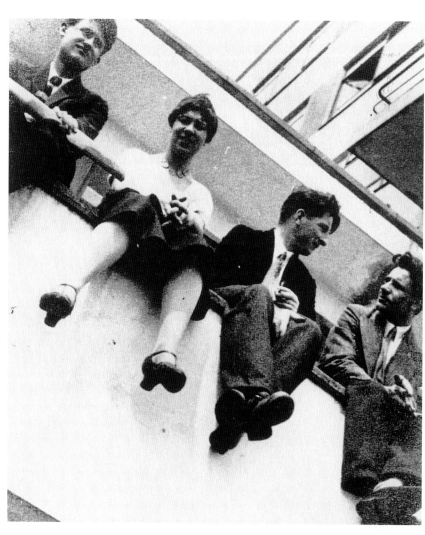

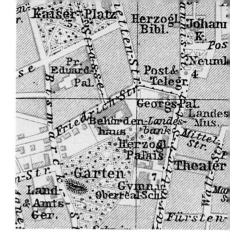

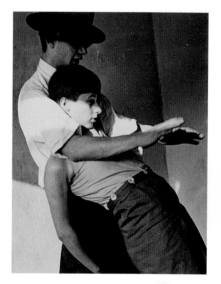

Blüh and Maria Dolezalova from Pozsony, Judit Kárász from Budapest, Etel Mittag-Fodor and Ivana Tomljenovic from Zagreb, Ruth Hollós-Consemüller, born in Poland, and Irene Bayer, born in Chicago but raised in Hungary. Among the men, Moses Vorobeichic (Moshe Raviv) came from Vilnius, and Horacio Coppola was born in Buenos Aires. Going beyond formal and material experimentation, the views of Bauhaus life left by these photographers have more than documentary value; with their innovative, bold angles, the Dessau photographs accurately portray an era. Unconventional poses and multiple exposures enhance the faces of companions and human figures. Such innovative compositions asserted themselves amid the emerging trend of social photography, which came to prominence about 1930,

arts in Pozsony (now Bratislava), where lecturers included, among others, Moholy-Nagy, Ernő Kállai, Hannes Meyer, and Karel Teige, the Czech avant-gardist who had been invited to the faculty at Dessau. Publications appeared, and Gropius himself went on a lecture tour of cultural centers in Central Europe to keep the Bauhaus concept alive in the region and to maintain personal contacts.

At Dessau the new director, Hannes Meyer, a German passionately committed to the left wing, in 1928 restructured the workshops and the school's theoretical training and incorporated the photography department within the architecture program. Until 1932 these were the most productive areas of the school and those most directly linked to Dessau. The photo workshop, run by Walter Peterhans, is associated with the well-known names of Walter Funkat, Xanti Schawinsky, Erich Consemüller, and F. Lux Feininger. The program's women photographers, many of whom either came from or ended up in Central or South Europe, to this day have received little recognition. I can mention only a few of the most talented here: Irén

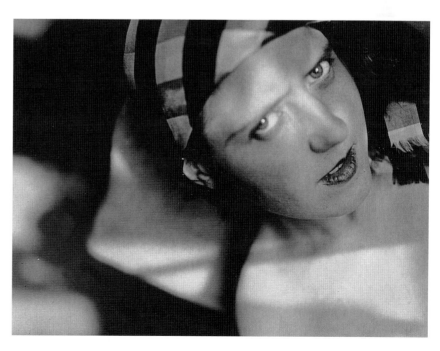

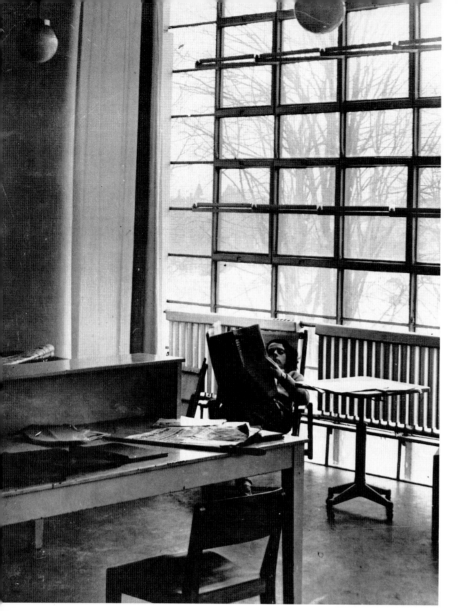

Judit Kárász, *Irena Blühová Reading Newspaper in Dessau Bauhaus*, c. 1931

showing the hardships of workers in urban environments.

The municipal elections of 1928 brought about a shift to the right and further polarized relations between Dessau and the Bauhaus. In spite of a prohibition against political involvement, more and more students became active, going so far as to participate in demonstrations alongside local workers. The school's more or less openly leftist orientation only exacerbated its fraying relationship with the town.

These political and consequently material problems gradually made it impossible for the Bauhaus to realize its utopia, in which formal modernism would combine with creative work that elevated communal

interests above those of the individual. But experimentation with new materials and techniques continued, as in the weaving workshop, where cellophane, synthetics, and metallic filaments were employed. Women who would have been prevented by convention or prejudice from receiving training in their home countries gave free rein to their talents while letting themselves be inspired by the formal and material usages prevalent in the folk arts of their native lands. In the workshop run by Gunta Stölzl of Germany, Otti Berger, from Southern Hungary (today Serbia), achieved prominence as one of the most talented weavers. She stressed the concept of "materials in space" [*Stoffen im Raum*] to disassociate wall tapestry from its connotation of luxury and to convey the notion that the triumph of a work came from the spirit of building exercised in its creation. Equally important was the successful procurement of industrial commissions. The Bauhaus was under contract with the Berlin firm of Politex Textil and the Rasch Corporation, a wallpaper manufacturer.

In supplying furnishings for the Bauhaus buildings and the professors' residences, the carpentry workshop under Breuer's leadership aimed to manufacture modern, practical, and ergonomic furniture. Breuer's tubular furniture, intended for mass consumption and production, has achieved the status of a classic. The wood and metal workshops created their pieces in close cooperation with the weaving workshop.

In 1930, a time of general economic crisis, a systematic course in advertising graphics was instituted, based on the

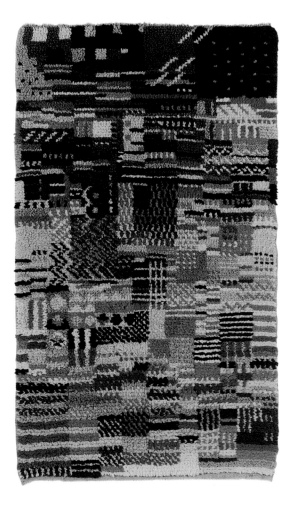

achievements of Moholy-Nagy and Herbert Bayer, whose work married modern typography and photography. By distributing flyers and prospectuses about the school and the town, and through the series of Bauhaus books edited by Moholy-Nagy, the school easily disseminated the innovations of its graphics program. From Dessau, the Central European students—such as the Czech Zdeněk Rossmann—transmitted to their homelands the new style of advertising graphics.

Dessau, already noted for its theater, received something radically new in the form of the Bauhaus-developed stage, which could be opened on two sides to form a partial theater in the round. Abstract experiments based on minimal movement and sound-and-light effects nourished the collective spirit of the school. The Hungarian Andor Weininger, author of the *Mechanical Revue*, was a founding member of the Bauhaus orchestra and an actor. His good humor made him a favorite of the international collective, and his improvised piano pieces, with songs wittily mixing Hungarian, Serbian, Yiddish, and German, promoted the school's function as a melting pot. The "Bauhäuslers" from Dessau toured far and wide with their theatrical and musical productions. The Bauhaus theater presented the public with a microcosm of the school by way of its comical skits using minimalist image, sound, and movement effects and figures in abstract costume, intended to represent a technological civilization.

This social commitment and fanatical reductivism continued to intensify until 1930. Hannes Meyer was assisted in this respect by the Hungarian theoretician Ernő Kállai, who, in the name of social utopia, probed the school's problems in the Bauhaus periodical. It was increasingly obvious that the school was gradually shifting to the left within a Germany that was sliding to the right. Students openly participated in political gatherings and Communist activities. All this made a bad impression on the Dessau leadership and led to the dismissal of the leftist Meyer in 1930. The numerous foreign students began to be looked on with growing suspicion. There were daily denunciations of the school's "Jewish-Bolshevik international" spirit and its minimalist aesthetics. Disdain for the main building, mockingly referred to as "the aquarium," reached such a fever pitch that only a shortage of funds prevented its planned demolition. In 1932 the National Socialists came to power in Dessau and forced the Bauhaus to close. Under the direction of Mies van der Rohe, the school functioned for one more year, as a private institution, in Berlin. Under straitened circumstances, it offered a more limited menu of training until its final closing in 1933, after the Nazis came to power.

In 1977 the Bauhaus Foundation reopened the building in Dessau and continues to operate it as a school, museum, and creative research center in Gropius's renovated building complex, which embodies the utopia of the 1920s. This historic entity constitutes the chief cultural attraction of Dessau today.

Translated by John Bátki

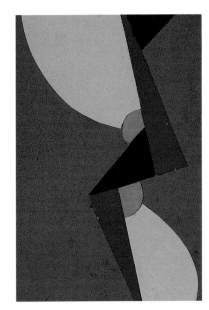

THE EXHIBITION AS A WORK OF ART:
AVANT-GARDE EXHIBITIONS IN EAST CENTRAL EUROPE

Krisztina Passuth

An exhibition is a unique and unrepeatable event. For this reason reconstructions of past shows, though accurate and authentic, will be missing their very essence, the atmosphere of a given moment in time. An exhibition—like a concert—occurs at a particular time, in a specific city and a certain gallery space, for the particular audience that happens to be present. It has its own context, so that without that context—or in another context—everything would be different. The exhibition opening marks the occasion when the work escapes from the sheltered microcosm of the atelier to confront other works, other artists and, most important of all, the viewers. "An exhibition is a site of manifestation. It is the materialization of a topological space. For its duration the constitution of spiritual sites incarnates as a real site," writes Eberhard Roters in his analysis of the most significant Berlin exhibitions.[1]

Just as the overall effect of an exhibition is impossible to plan in advance, in the same way it is impossible to predict its reception. Later, given the benefit of hindsight, our task is far easier.

According to our hypothesis the concept of an exhibition, no matter how long ago, may be tracked down and, with the help of archived materials, excavated from the past. This applies as long as the proceeds of a conference, a manifesto, exhibition texts, or other contemporary material has defined, at least in its outlines, the exhibition's purpose, so that we know who organized it, approximately what works were exhibited, and what sort of installation was employed. In an ideal case we will be familiar with the catalogue itself. The above are more or less objective factors, but we must also make use of subjective factors, such as contemporary descriptions, critiques, and later memoirs. These can turn out to be even more interesting and colorful than the objective factors and give a far better sense of the mood of the event.

The exhibition as a work of art is realized in two stages. The first is accomplished when the objects (which, in addition to the works of art, may include supplementary and reference material) are arranged according to the given concept and circumstances, and remain so for a predetermined period of time. The second stage arrives when the exhibition opens, which is a twofold event, for the audience plays an important part in its reception, and in a given case an interactive relationship may be established, via the works of art, between the artists and the audience.

In this examination of the East Central European avant-garde between 1920 and 1930 we will only consider the exhibitions that gave voice to the avant-garde groups, movements, and trends that consciously deviated from traditional modes.

Are there any exhibitions about which we may state with certainty that they were major events at the time and still count as such? As expected, subjective judgments differ in this regard. Thus for instance Bruce Altshuler's volume, *The Avant-Garde in Exhibition: New Art in the 20th Century*,[2] which opens with the 1905 Paris *Salon d'Automne* and closes with the 1969 Berne *Works-Process-Concepts-Situations-Informations* exhibition, does not analyze a single exhibition between 1921 and 1938, as if nothing worthwhile had occurred between the 1920 Dada Fair and the 1938 International Exposition of Surrealism. However, even a cursory glance reveals numerous important group shows from the period that were crucial in their own time and may still be considered so.[3]

Regarding the manner of their organization and development, these exhibitions may be roughly divided into three categories. The first category consists of shows that arose within an existing framework, chiefly that of a state institution, perhaps as a result of international diplomatic agreement and only partially in consideration of the concepts of individual artists or artists' groups. In spite of their official

sponsorship, some among these have assumed permanent importance, such as the *Erste Russische Kunstausstellung* [First Russian Art Exhibition], noteworthy for its explosively powerful group of Constructivists.

The second category includes shows that are of an entirely different nature. In the shadow of the large-scale, state-supported exhibitions with their guaranteed press coverage hide more modest private enterprises, launched through the initiative of individual associations or galleries. Here too the artists are usually invited participants and not organizers. In this category we may list the events initiated by the Berlin

<div style="writing-mode: vertical">The way these shows are prepared may be utterly amateurish and contrary to existing professional rules and practices, yet inexplicably they are successful.</div>

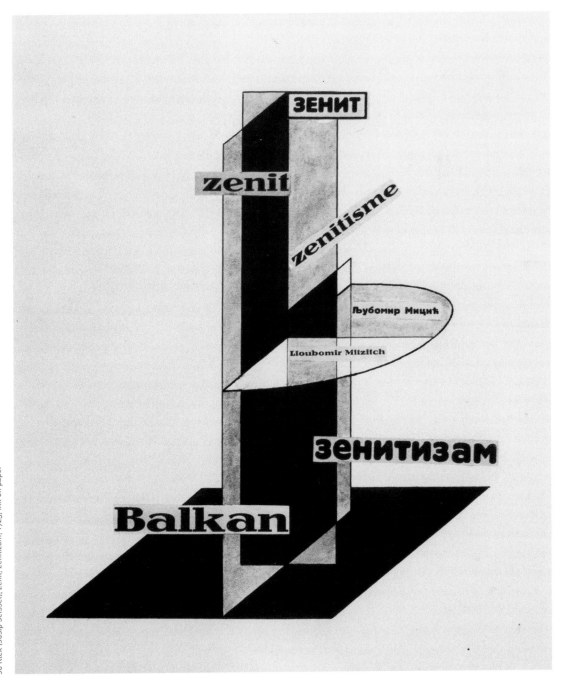

Jo Klek (Josip Seissell), *Zenit, Zenitizam*, 1923, ink on paper

Galerie Der Sturm, the Kästner Gesellschaft in Hannover, and numerous other organizations large and small. The most significant role in this category was played by the Sturm gallery and its eponymous periodical, which during the first half of the 1920s continued its practice of organizing and directing avant-garde activities instead of merely reflecting them.[4] Der Sturm gallery gradually prepared Berlin audiences for avant-garde art and paved the way for the acceptance of Russian Constructivism, which they first witnessed in 1922 at the Galerie van Diemen.

However, neither the official exhibitions nor the well-meaning but still commercially motivated private enterprises proved to be truly crucial for the avant-garde. The historically important exhibitions were the ones brought about by the artists and their writer friends themselves, without any institutional framework or significant financial assistance. These constitute the third category. The way these shows are prepared may be utterly amateurish and contrary to existing professional rules and practices, yet inexplicably they are successful. Not only does the exhibition itself become a work of art, but even the preparations for it may be regarded as "work in progress" in which writers, editors, and painters play an equal role. To realize their aims the participants are obliged to fight the same battles as in the realization of the individual works themselves. They must create everything from scratch, from the posters to the installation design, from the shipment of works to the production of the catalogue. Thus the exhibition is simultaneously a means of self-realization for the artists as well as a strategy directed toward reaching the movement's goals. The organizers participate not so much as individuals, as representatives of the group. They collaborate closely in the given situation even if their paths will diverge soon afterward. In most instances the show is organized when the particular movement has reached its zenith. Thus the exhibition is evidence of self-confidence and a sense of security and implies further activities to come. Such activities do not always materialize, for many avant-garde groups run out of energy after one large, representative exhibition. In what follows we shall analyze the most noteworthy national and international exhibitions held in East Central Europe in the 1920s.

The artistic groups functioning in the period between 1920 and 1926 in East Central Europe were the following, in the order of their formation: the Hungarian Ma group, in Vienna from 1920; Devětsil in Prague from 1920 on; starting in 1921, the Zenit group in Zagreb, then in Belgrade; Contimporanul in Bucharest from 1922 on; and Blok in Warsaw, from 1924 on.

All of these were formed around one or more periodicals, on the pages of which their ideas took form, developed, and confronted other theories. Their various viewpoints crystallized in these periodicals before any exhibitions were conceived. Such periodicals were the offspring of the same kind of individual effort as the exhibitions and remained free of any institutional affiliation. Nonetheless the groups' situations were different, depending on the "microclimates," the contexts of the cities and times that gave birth to them. Ma in Budapest was the only one already in existence during the First World War; it was able to regularly organize exhibitions in addition to the publication of a magazine. After emigrating to Vienna in 1920, Ma even grew in significance; however, the editors' energies were consumed by the periodical and by the organization of evening programs. Beyond this they lacked the resources to hold a large group exhibition, and there was no realistic opportunity to realize any such event.[5]

The situation of the Czech group Devětsil was considerably more favorable. Formed in October 1920 at the Union coffeehouse in Prague, it remained in existence for a record number of eleven years, with many members participating until its demise. In Prague, capital of the recently formed Czechoslovakia, Devětsil could operate in total freedom, in an atmosphere of optimism and confidence in which anything seemed possible. The array of intellectuals belonging to Devětsil was possibly even more colorful than that of Ma. The association included writers, painters, photographers, theater people, musicians, and critics, all meeting regularly in coffeehouses; many poems celebrate the activities of the group, which produced several periodicals and even had its own press (Odeon).[6]

In contrast to Devětsil, which fit naturally into the local art world in Prague and became an acknowledged and valued part of it, the Serbian Zenit group remained misunderstood and marginal throughout its existence from February 1921 to December 1926. Both Ma and Devětsil had a large number of active participants, whereas Zenit was kept alive by the superhuman efforts of a pair of brothers, Ljubomir Micić and Branko Ve (Virgil) Poljanski. The character of the group was determined by the fact that its founders were embattled to the end, never accepted in their immediate environment. This explains their aggressively anarchistic attitude toward the existing social order. Zenit was not only a forum for literature and the visual arts but also a political one, and its militancy resembles that of the Italian Futurists. In a paradoxical manner Zenitism proclaimed the ideas of

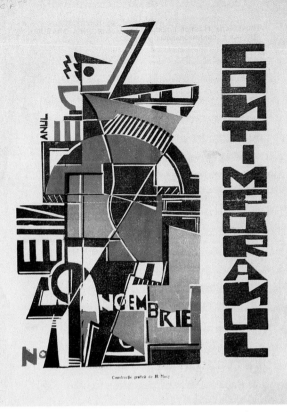

M. H. Maxy, cover, *Contimporanul*, 1924 (no. 49)

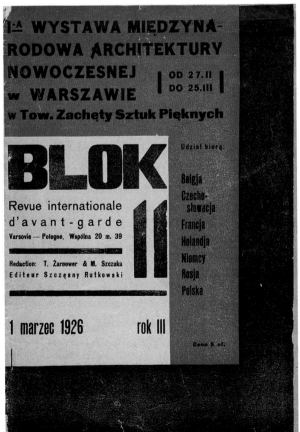

Blok, 1926 (vol. 3, no. 11)

internationalism in art alongside its nationalist politics, a combination already evident with the Italian and Polish Futurists. All of this went into the evolution of its idiosyncratic art policies, which were embodied in the 1924 international Zenit exposition.

The magazine *Contimporanul*, the most important forum of the Romanian avant-garde, began publication one year after the monthly periodical *Zenit*. It had, however, antecedents abroad, namely in the Zurich Dada movement, starting with the first Dada evening organized at the Cabaret Voltaire by Tristan Tzara, Marcel Janco, and Hugo Ball in 1916. The foundation of Contimporanul in 1922 in Bucharest marks a watershed moment in the history of Romanian modernism. By making contact with the local art movements these writers and visual artists were able to somewhat diminish their isolation. The real breakthrough, however, was achieved by an international exhibition in 1924, *Expositia internationala à Contimporanuliu*.[7]

The Polish avant-garde movement differed from the Hungarian, Czech, Serbian, and Romanian ones insofar as the birth of its most important forum, the Warsaw periodical *Blok*, had been preceded by significant exhibitions that carried the germs of later Constructivism. The first avant-garde show in Warsaw was organized by students in their last year of art school. The second collective public showing of the Polish Constructivists took place two years later, in May 1923 in Vilnius, and was titled *Nova Sztuka* [New Art]. Thus the Polish avant-garde had barely been born when it was already organizing group shows. However, this was no mere improvisation: the event was planned in advance on every level, including that of a publication.

In East Central Europe there were smaller avant-garde exhibitions, organized by artists using their own resources, in Ljubljana (1924 and 1925) and in Trieste (1927). Although the Slovenian movement was considerably smaller in

Ljubomir Micić in his studio, 1924

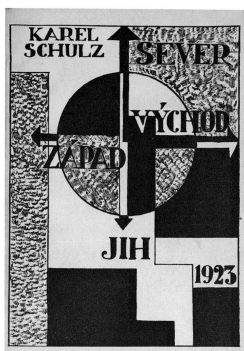

numbers than the above-mentioned ones, and its views were primarily derived from *Zenit*, it nonetheless managed to convey an autonomous vision, especially in the installation of exhibitions.

The activities of these groups—the publication of periodicals, the organization of exhibitions and related events—were determined not only by the given microenvironments but even more so by the strong personalities behind them. These individuals, as diverse as they are significant, were: in Budapest and later in Vienna, Lajos Kassák (1887–1967); in Prague, Karel Teige (1900–1951); in Zagreb and later in Belgrade, Ljubomir Micić (1885–1971); in Bucharest, Ion Vinea (1895–1964), Marcel Janco (1895–1983), and M. H. (Max Herman) Maxy (1895–1971); in Warsaw, Mieczysław Szczuka (1898–1927) and Władysław Strzemiński (1893–1952); in Ljubljana, Avgust Černigoj (1898–1985).

The Czech, Hungarian, and Serb movements were dominated by writers. In the Polish movement, after 1924, the visual artists were the major factor. In the Romanian movement the leading roles were taken alternately in various periods. In general the concepts of the exhibitions were equally shaped by writers and painters. The three outstanding writer-editors were Kassák, Teige, and Micić. Kassák's picturearchitectures became prototypic models of the very geometric compositions that purported to demonstrate a new structure for art as well as for society. Many artists adopted this model, and Kassák played an important role as a painter after 1920. Teige had started out as a painter, then went on to international renown with his picture-poems, collages, and especially his typography. The writer Micić on certain occasions also exploited the propagative possibilities of typography. Kassák and Micić, however, did not act primarily as visual artists in shaping the exhibitions, whereas Karel Teige decidedly did. Therefore, if we analyze individual shows from the points of view of the organizers and the movements they represented, we encounter a considerable diversity of conceptions. For Kassák the exhibitions were tied intimately to his magazine, visualizing the previously published texts, as it were. Conversely, the periodical *Ma* printed the texts of the exhibition catalogues and illustrations of exhibited works. (However, this applies only to the pre-1920 Budapest period.)[8] For Kassák the exhibition itself never became a true work of art; he was interested only in the works themselves and not so much in their setting and presentation. The creative gifts of both men were principally manifested in their picture-poems, in which individual verses, sentence fragments, and single words assume pictorial forms. Teige's views on art

were even more radical than Kassák's. "For Teige, the passing of generations brought with it new means of expression that could not coexist side by side. Instead, the former was to be replaced by the latter—as, for example, the drawing by the photograph, or the novel by reportage," writes Karel Srp.[9] New media must be used, for they express the changing of the guard and herald a new era. These ideas were programmatically realized in 1923 at the Bazaar of Modern Art, the modernity of which is especially remarkable when we compare it to the 1922 *Jarni výstava* [Spring Exhibition], the first show put on by Devĕtsil. However, it was conceived along traditional lines and still bore the marks of spiritual realism and naive primitivism.

The modernist outlook of the Devĕtsil group, and especially of Karel Teige, saw its first realization in the anthology *Život II*, then took form in a far more audacious way in the Bazaar of Modern Art. The openings in November and December of 1923 at the Rudolphinum [*Dům umĕlců*] in Prague marked the birth of the exhibition as a work of art in a manner totally divergent from earlier conceptions. "The exhibition bore a similarity to the Berlin Dada Fair not only in its name but in its conception; it wanted to present a multifaceted review of

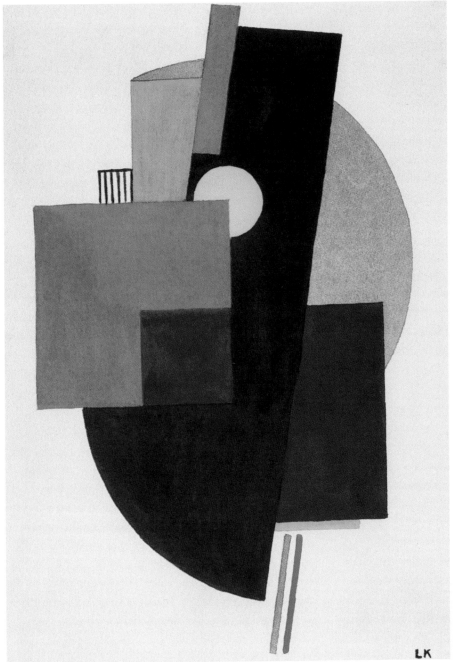

■ Lajos Kassák, *Picturearchitecture*, 1922, watercolor on paper

For Kassák the exhibitions were tied intimately to his magazine, visualizing the previously published texts, as it were.

Devětsil activities, in which paintings, drawings, photographs, theater designs, architectural plans, and picto-poetry would stand alongside each other, as well as books, travel posters, circus scenes and film…," writes František Šmejkal.[10] Thus the show created an utterly new and in its own way complete world, which also included a subtle sense of irony and humor. Most of the exhibited materials had some further meaning or connotation beyond the immediate spectacle. Similarly to the Dada Fair[11]—where reproductions were displayed alongside original works—here, too, original creations were complemented by objects that functioned primarily as references. In contrast to the Dada Fair the originals and reproductions were not intended to confuse the viewer, but were present to clarify the exhibitors' conceptions of modernism. Side by side with the original works were film stills and photographs of ships and circus scenes. But the most original idea was the inclusion of a few surprising objects: a ball bearing, a life preserver, a hairdresser's dummy topped by a wig, and a mirror. These objects were displayed without any alterations. The life preserver was a reference to the dream of overseas travel, one of the common themes for paintings at the time. The window display dummy evoked the poetry of the urban scene. The ball bearing brought the functional beauty of modern industrial civilization to stand in for the as yet unrealized sculptural creations of Devětsil.[12] And "The mirror," writes Šmejkal, "with its inscription, 'This is your portrait, viewer,' turned into a provocative gesture that mocked portrait painting and questioned the very grounds of its existence, and that of mimetic painting of any kind, functions that, according to Teige, have long since been taken over by photography."[13] These nonartistic objects were, to use an expression favored by the Russian Futurists, "a slap in the face of public taste."[14]

Nonetheless the exhibition included drawings and paintings in traditional media, works by Štyrský, Toyen, Teige, Jelinek-(Remo), and Mrkvička. These were mostly abstract creations, planar compositions with a preponderance of orthogonal structures, as may be seen on cover designs by Devětsil artists. This was the first showing of Štyrský's earliest photomontages, which differed essentially from contemporary Czech Cubist still lives as well as from Constructivist photomontages. His works introduced a new mode. It was Teige's view that modernist paintings were becoming increasingly poetic in nature, whereas modernist poetry was taking on an increasingly visual form. The fusion of the two modes gave birth to the picture-poems.[15] The more unexpected the juxtaposition of the included elements, the more intense the electric sparks caused by the poetry, he later wrote.[16] Teige would have liked to put an end to panel painting as well as to traditional poetic forms, but this goal was only partially realized at the Bazaar of Modern Art.

The Bazaar did introduce something quite new to visual art exhibitions: the display of architectural drawings. These mainly demonstrated the influence of Le Corbusier's Purism. Like the painters of Devětsil, the architects emphasized orthogonal structures free of decorative flourishes. (This was not the first instance of such boundary expansion: The 1922 Russian exhibition in Berlin included, in addition to traditional art objects, stage designs and architectural models as well as posters, fashion designs, and toys.)[17] The American artist Man Ray was also invited to participate with his photos.

The Czech exhibition took place at the most optimal moment in the development of Devětsil, at a time when many of the most important publications had already appeared. The concept of the exhibition had been formed by the four outstanding members of the group, Karel Teige, the two architects Bedřich Feuerstein and Jaromír Krejcar, and the painter Josef Šima, after the rebirth of the Devětsil movement and the publication of the anthology *Život II*, which they had edited.[18] Constructivism and Poeticism were simultaneously paramount in the exhibition. The influence of Russian Constructivism was represented by Ilya Ehrenburg, who was invited by Devětsil to lecture in Prague in December 1923. His wife, the Constructivist artist Lyubov Kozintsova, participated in the abridged Bazaar held in Brno.[19] On this occasion the slogans written in the Constructivist-Dadaist spirit became an integral part of the show. "When preparations were being made at the beginning of 1924 for a condensed version of the Bazaar of Modern Art exhibition, Teige sent the following instruction to Artuš Černik: 'It would be good to include the following slogans, using beautiful script on long, colored strips of paper…'"[20] The totality of the exhibition proclaimed a new era as if it were already well on the way to realization. But alongside the streamlined steamships and ball bearings of the new era were the symbols of the passing period, such as the window display dummy. It was obvious that something else was at stake beyond the narrowly conceived limits of visual art. Although the Bazaar ultimately championed the utopia of the future, it also embodied the atmosphere of the past, a nostalgia for things distant in time and space. The worldview posited by the combination of paintings, graphics, inscriptions, and objects was one belonging to a group that had in actuality, in spite of generational conflicts, no real

bone to pick with its surroundings, inasmuch as it did not have to fight for acceptance. It would appear that the exhibition was organized by the artists for their own delight, for themselves as it were, and not for strategic reasons. By virtue of the ensemble of objects on display and their installation, the exhibition in itself naturally became a work of art, precluding the need for other events such as a spectacular opening, a conference, posters, or a catalogue.

The situation was quite different in the case of the *Nowe Sztuki* exhibition, held in Vilnius in May 1923. This show, unlike the one in Prague, was organized exclusively by visual artists, seven of whom exhibited in it.[21] Among these were Szczuka, Stażewski, Strzemiński, and Żarnower, the outstanding personalities of Polish Constructivism. In contrast to the Czechs and the Hungarians, the first collective manifestation of the Polish avant-garde was not directly involved with a periodical, but took place in the form of an exhibition. Nonetheless the Polish Constructivist movement, too, had its intellectual antecedents and its own writer and editor in the person of the poet and theoretician Tadeusz Peiper, publisher of the monthly *Zwrotnica* in Cracow.

Although Peiper first formulated the group's radical theories,[22] he did not participate in its activities. The exhibition took place in Vilnius and not in Cracow, where he was active. The venue was neither a gallery nor a museum but the local Corso Kinematograph, presumably as an indication of the organizers' commitment to the new medium of cinema. A total of forty-seven works were displayed[23]; in spite of the limited number, the exhibition constituted a breakthrough in Polish art because of its installation—which may be compared to that of the Bazaar of Modern Art—and also by virtue of its catalogue. As Andrzej Turowski has written,

The concept of construction became the catchword only in 1923. When an Exhibition of New Art was arranged in Vilna, its catalogue brought statements defining the direction of the new pursuits, and the peculiar arrangement of the exhibition itself served to stress its claims to innovation. At the beginning there was an original 'collection of rude gaudy postcards with blue-pink skies,' with a caption 'for those who look for beautiful landscapes in art.' This collection was balanced by a display in the same room of avant-garde periodicals and foreign books on modern art. Only after that came an exhibition of works by seven young artists...[24]

In contrast to most exhibitions of the time, the catalogue was also a work of art, which in its design, typography, bold layout, and exuberant text was aesthetically comparable to such contemporary productions as Malevich's Unovis album

■ Mieczysław Szczuka, *Abstract Composition*, 1924, ink on paper

■ *Zwrotnica*, 1922 (no. 1)

or El Lissitzky's Proun album. Theoretical statements by participating artists briefly discussed ideas that were subsequently developed in detail (such as Strzemiński's Unism and Szczuka's belief in art with a social purpose). Thus the fundamental themes of Polish Constructivism were already present in this small catalogue.

The next exhibition of the Polish avant-garde, held in the spring of 1924, was far more representative by virtue of being a "double feature." It began with a one-man show, organized by Henryk Berlewi from his own work. A photograph shows the elegantly attired young artist posing in the company of mechanical parts and a luxury automobile, while his artworks are visible only in the background.[25] The event continued with a group show that opened the following day, organized by the recently formed Blok group.[26] Both exhibitions took place in automobile showrooms in Warsaw: Berlewi's at Austro-Daimler, and the group show at the Laurin-Clement Company. The Blok exhibition opened one week after the publication of the first number of the magazine *Blok*. The difference between this and movements such as Devětsil and Zenit was that in this case the periodical had not had much opportunity to publicize the show. The

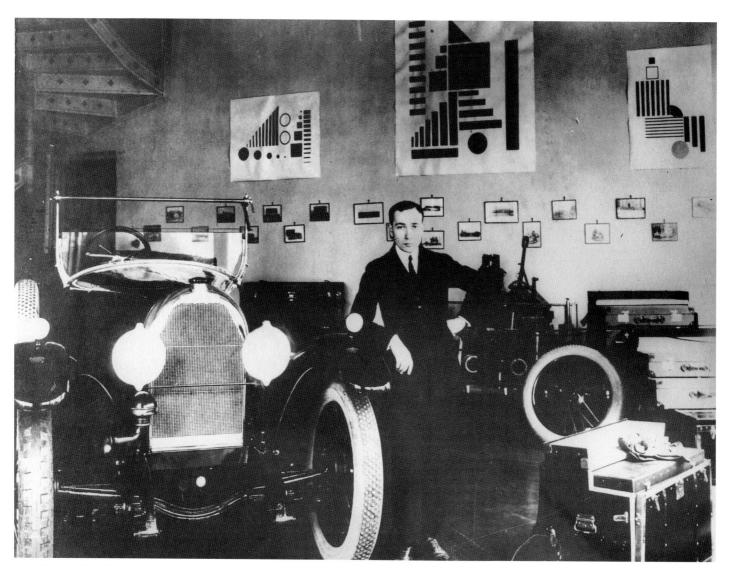

Henryk Berlewi at his exhibition in the Austro-Daimler showroom, Warsaw, 1924

234

majority of artists exhibiting had already shown their works in Vilnius. However, Katarzyna Kobro, the outstanding talent in Polish Constructivist sculpture, was a newly recruited exhibitor.

The group show included Berlewi, Kobro, Krynski, Szulc, Kairiúkštis, Stażewski, Strzemiński, Szczuka, and Żarnower. Though there is no record of the works shown, presumably they were, just as in Vilnius, representational and nonrepresentational works characterized by a geometrical approach, simplification, and schematization.[27] It is quite conceivable that this show was intended to be a polemic rather than an exhibition in the traditional sense. The reference material and the allusive context was furnished by the exhibition space, the environment of the auto salon, and the ensemble of automobiles on display. The exhibition commemorates that fleeting moment when practically the entirety of the Polish avant-garde had aligned itself with Blok, a moment lasting only until 1925.

Barely a month after the spectacular introduction of the Blok group, the First Zenit International Art Exhibition was held in Belgrade from April 9 to April 19, followed in November and December by an exhibition in Bucharest organized by Contimporanul. They were sponsored by the periodicals *Zenit* and *Contimporanul*, respectively, and included numerous participants from abroad. Both exhibitions were unwelcome in their artistic environments but served the strategic purpose of strengthening their position through international contacts.

Unfortunately neither exhibition was recorded in contemporary photographs, nor were catalogues prepared. In *Zenit* 25 and *Contimporanul* nos. 50–51 we can find only lists of the exhibitors along with a few illustrations of poor quality. In spite of this both exhibitions proved to have a significance in this region of Europe that rivaled the similarly international Düsseldorf exhibition held two years earlier.

Preparations for the Zenit exhibition reached back as far as 1922, when Ljubomir Micić had opened the International Gallery of New Art at the Zenit editorial offices, still in Zagreb at the time. There he had gathered works by Archipenko, Gleizes, Grünhoff, Kozintsova, Larionov, El Lissitzky, Moholy-Nagy, and Teige, among others. In September and October of that year he published an international issue of *Zenit*, edited by Ilya Ehrenburg and El Lissitzky, introducing the Russian avant-garde and especially Constructivism. Micić had come into contact with Ehrenburg and El Lissitzky in the summer of 1922 in Berlin, and it is possible that the idea of an inter-

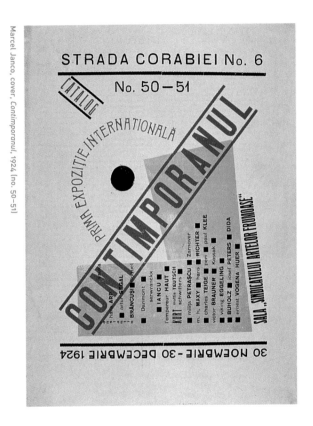

László Moholy-Nagy, *Composition*, 1922, tempera on board

national exhibition originated with them. On April 13, 1923, Micić sent a letter of invitation to Herbert Behrens-Hangeler: Our Zenit is organizing a large-scale international exhibition around January 20, 1924, in Belgrade, tied in with a congress and several Zenitist courses. Our goal is to represent the best of the avant-garde world in a worthy manner. The exhibition must be the first demonstration of the triumphs of the new art in Serbia and in the Balkans and we invite You as a brother to take part by sending us a selection of your paintings... The works should be sent to the Zenit gallery, which is owned by the editorial office...[28]

The opening of the exhibition was eventually postponed from January to April. Its location at the Stankovic music school as well as its brief ten-day duration did not do justice to the magnitude of the undertaking. The importance with which it was viewed can be seen in a painting by Mihailo S. Petrov that resembles an exhibition poster, but can be considered merely a virtual poster, since it only exists in a single copy. On this vividly colored composition geometric and representational motifs surround what appears to be the exhibition catalogue, in front of which vigorous Cyrillic lettering carries the inscription: "Zenit Exhibition 1924."[29]

Petrov's poems and linocuts had already been published in *Zenit*. Micić considered him and Josif Klek to be the representative "Zenitists." Klek exhibited a total of nineteen works—more than any other artist—at the 1924 show. His characteristic medium was the so-called Pafama (from *Papier-Farben-Malerei*, or colored-paper painting). His colorful small-scale collages on black backgrounds, the utopian architectural plans for the Zeniteum, and his advertising kiosk design attempted to transmit the influences gleaned from photography, cinema, radio, and advertising. Klek also created posters for the exhibition, an idea that occurred as well to another East Central European, Henryk Berlewi (who later started an advertising agency). The works displayed at the 1924

exhibition were in part those which had been gathered at Micić's gallery, first in Zagreb, then in Belgrade. Some were gifts from the artists; others were perhaps purchased by him; the rest were submitted specifically for this occasion. A list of artists according to nationality appeared in the February 1924 issue of *Zenit*, but since the exhibition opened on April 9, there is no way to tell how accurately the list reflects the actual participants. The list also indicates the number of works exhibited but without specifying their titles, since Micić considered these to be superfluous.[30] Artists from eleven countries were included; among the better known were: Louis Lozowick (United States), Jozef Peeters (Belgium), Robert Delaunay, Albert Gleizes (France), László Medgyes, László Moholy-Nagy (Hungary), Alexander Archipenko, Ossip Zadkine, Wassily Kandinsky, El Lissitzky, Serge Charchoune (Russia), Jo Klek (Kingdom of Serbs, Croats, and Slovenes), and Mihailo S. Petrov (Italy).[31] Certain works by Mikhail Larionov, Karel Teige, Lyubov Kozintsova, and Juan Gris, shown at the Zenit gallery in Zagreb as early as 1922, were not in the 1924 exhibition, presumably because they were no longer in Micić's possession by then.[32]

The Russians were predominant in both numbers and quality among the exhibiting artists. Micić's anti-Austrian stance and general political orientation are in part responsible for his interest in the Russians, but that interest grew deeper through the personal and artistic contacts he developed during his visit to Berlin, including Archipenko and El Lissitzky. He maintained contact with Kandinsky, who was teaching at Weimar at the time, only by way of correspondence, but the Russian painter sent four watercolors and two lithographs to be exhibited.[33] Among the Hungarians, Moholy-Nagy was represented by three ink drawings and one watercolor, all characteristic pieces from his early mechano-architectural period. (By way of contrast, Kassák, Bortnyik, and Uitz were not included in the exhibition.) The presence of Robert

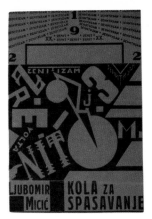

Ljubomir Micić, cover for *The Rescue Car*, book published by *Zenit*, 1922

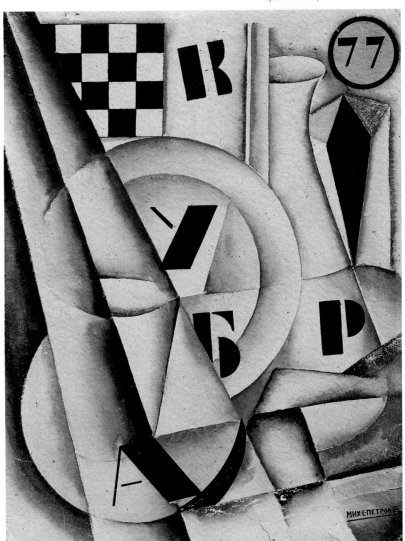

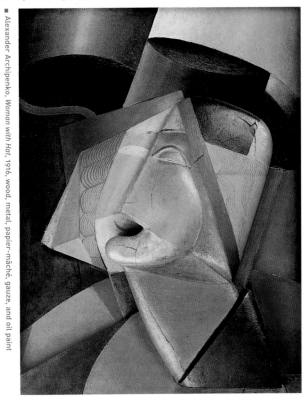

Alexander Archipenko, *Woman with Hat*, 1916, wood, metal, papier-mâché, gauze, and oil paint

Zenit, 1921 (no. 10)

Mihailo S. Petrov, *Composition 77 [77 Suicides]*, 1924, watercolor

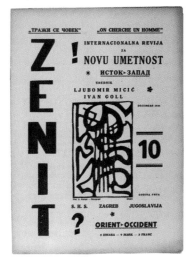

Delaunay might be attributable to the fact that his wife, Sonya, was Russian. The Delaunays provided a home and an orientation point for East European artists in Paris.[34]

From our vantage, the Zenit exhibition of 1924 was a defining event, being the first large-scale international exhibition organized in East Europe by artists on their own initiative. However, a contemporary eyewitness saw things in a different light:

Mr. Ljubomir Micić…is inadequately acquainted with the tastes of the public. Placing his trust in Klek's colorful posters he announced the first international exhibition by Zenit, to be opened by a conference on modern painting. Only a handful of viewers were attracted sufficiently by the names of the exhibitors to attend the opening. Since the organizer was not too proud not to be disturbed by this lack of response and to read his lecture to the 20 persons who showed up… he decided to cancel the planned symposium… As the exhibition was an interesting one, it would have deserved a larger audience.[35]

Petrov remembers that the press remained completely unresponsive; this may be attributed "partly to the embarrassment of the critics faced with problems for which most of them were absolutely unprepared, and partly on account of intolerance between the critics and organizers. People returned from this exhibition embarrassed, sometimes even revolted, and usually prepared to mock everything they had seen."[36]

These two congruent reports are somewhat contradicted by texts of lectures supposedly delivered at the opening, published in *Zenit* 34 (November) and 35 (December). In a deliberately provocative and even aggressive tone Micić claims that anyone who denies or belittles the significance of the exhibition is obviously a laughable or pathetic person. This exhibition, he goes on to say, represents all the major movements in the arts over the last two decades, if not by the founders themselves then at any rate by the most fully qualified individuals. On the other hand it is the timing that constitutes the importance of this show, since it was the first occasion that afforded the opportunity for the public to see the creations of the new art in the original.[37]

Whether or not the text was actually delivered at the opening, it addressed itself not so much to the exhibited works as to an overall strategy of which the exhibition formed only one part. Micić had only two artists that he considered to be part of the Zenit movement. The rest were foreigners, which is why it became so important for him to use the international scene in general as a point of reference to prove the importance of the Zenit movement for his own country, Serbia. Thus the opening, in this instance, existed virtually rather than in actuality, in contrast to the opening of Contimporanul in Romania.

The Contimporanul exhibition was a direct offshoot of the activities of the eponymous periodical, founded in 1922 by former Dadaist Marcel Janco, together with the writer Ion Vinea. Subtitled *The Organ of the Romanian Constructivist Movement, Contimporanul* appeared weekly. The information presented was thus always fresh and timely, but the format resembled that of a daily paper far more than a monthly magazine, and the contents of individual numbers were not planned ahead or coordinated. Thus, in contrast to *Ma* or *Blok*, the individual issues do not possess visual artistic value in themselves.

It was only in 1924 that the most important painters taking part in the regeneration of painting began to define the aims of their artistic movement. On the one hand, in the words of Andrei Pintilie, "the beginnings of modern Romanian visual art are tied in with the receptivity to Constructivist theory,"[38] while on the other hand this receptivity did not automatically or immediately guarantee the birth of independent theory or the paintings associated with it. According to Pintilie, "In this period, however, we cannot yet speak of Constructivist works in Romania. Painters, through 'integralism,' attempted to realize a modernist synthesis of Cubism, Futurism and Constructivism."[39] A pure form of Constructivism appeared a bit later.

At the time of the birth of *Contimporanul* there was no group of visual artists organized around it, and in spite of the subtitle the magazine had more of a literary than a visual arts orientation. Although it was not as revolutionary or politically committed as *Ma* in Budapest or *Zenit* in Belgrade, it still outraged the locals with its articles attacking anti-Semitism,[40] its style of *épater le bourgeois*, and Janco's aggressive illustrations.

Marcel Janco was, together with Tristan Tzara and Hans Arp, one of the founders of Dadaism in Zurich. But after 1918 he distanced himself from that group, and from Tzara's aggressive, anti-art attitude in particular. Thus the exhibition he organized in 1924 was more Constructivist than Dada in its conception.

The antecedents of the Contimporanul exhibition also lead back to the Novembergruppe, the association of radical Zurich artists, and to the 1922 International Faction of Constructivists in Düsseldorf, whose statement, signed by Richter, Viking Eggeling, and Janco, had been published

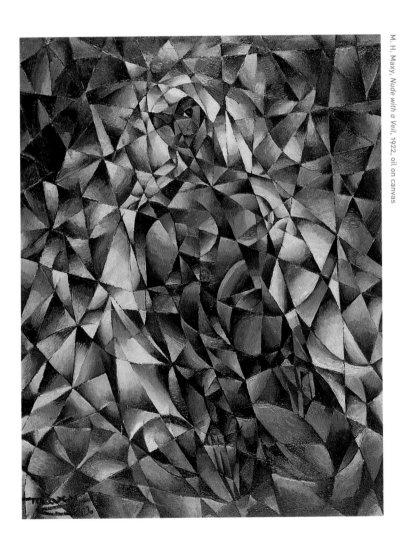

M. H. Maxy, *Nude with a Veil*, 1922, oil on canvas

in *De Stijl 4*. Back in his Zurich Dada days Janco had been producing, in addition to his Dada masks, plaster reliefs in a Constructivist spirit, which he exhibited at the Zurich Kunstgewerbeschule as early as 1918. He also gave a series of lectures about abstract art in 1919. Although the Dada movement fell apart in 1919, a new association was formed,[41] and it was as a member that Janco in April 1919 signed the "Manifest radikale Künstler Zurichs 1919."[42] The signatories included Arp, Viking Eggeling, Janco, and Hans Richter, who five years later were among the participants and organizers of the Contimporanul exhibition. Another chain of causation was formed in Berlin at Arthur Segal's studio, within the framework of Novembergruppe, in a revolutionary spirit akin to that of the Zurich movement. Segal, after having participated in the exhibitions held at the Cabaret Voltaire, became one of the founding members of Novembergruppe and a perennial exhibitor in its shows from 1921 on.[43] He had settled in Berlin in 1920 and formed an intimate artistic circle in his atelier. His friends and disciples were influenced by his theories of "equivalence" as much as by his light-saturated "prismatic" paintings.

In 1922 M. H. Maxy arrived in Berlin from Romania.[44] He became a disciple of Segal, whose style he adapted and carried further. In 1923 he returned to Bucharest to become the most important organizer of the Contimporanul exhibition, and naturally included four works by Segal. Presumably, however, the event could not have taken place without someone who had stayed in Romania, laying the intellectual and artistic groundwork there, and this person was the poet Ion Vinea. Vinea was basically not a militant individual; his subtle poetry only rarely switches into a more aggressive voice, as in his "Activist Manifesto for Youth," published in issue 46 of *Contimporanul*, where he assails "Art, for having prostituted herself, while Literature played the role of the douche bag." In a subsequent number of the magazine Vinea proclaimed,

"we must turn against art that imitates nature, and create a new nature in its place, in which the possibilities of the creative artist are unlimited."[45]

In contrast to the Zenit show, the Contimporanul exhibition, open from November 30 to December 30, was held at an art venue, the Sala Sindicatului Artelor Frumoase [Hall of the Arts Syndicate]. There is no surviving evidence of a poster, and the catalogue—simply a list of pictures and their titles—was published in *Contimporanul* 50–51. This exhibition was also an emphatically international affair, though only two of the participants appeared in both, Jo Klek and Jozef Peeters. Here

too the artists are listed according to nationality, not always in a consistent manner (Brâncuși is termed Romanian, while Segal is described as a German). Romanian artists predominated over foreign ones, and other East Europeans were also included in large numbers (Poles, Hungarians, Czechs, and Jo Klek from Zagreb). Next to the Romanians the German contingent was most numerous, consisting of Kurt Schwitters, Hans Arp, Arthur Segal, Paul Klee, Hans Richter, Erich Buchholz, and others.

The Romanian section was the most impressive.[46] The two organizers, Maxy and Janco, are represented by numerous

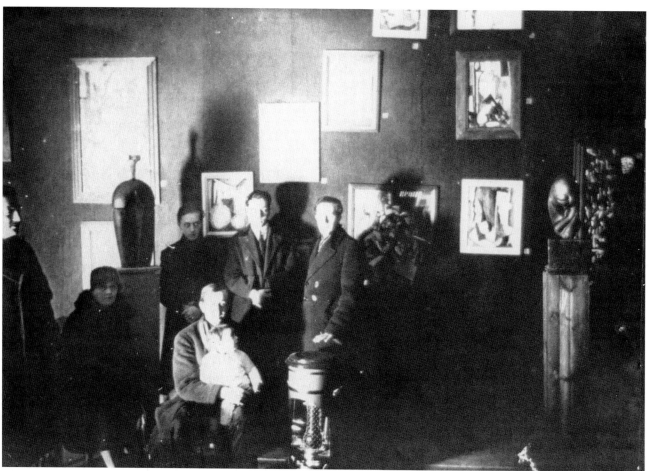

Contimporanul Exhibition, Bucharest, 1924

Marcel Janco | Milita Petrascu | M. H. Maxy | Victor Brauner | I. Voronca | Ion Vinea

works (Maxy nineteen, Janco twenty-nine) consisting of portraits (including one of Tristan Tzara) and constructions by Maxy, and various compositions, architectural plans, and a painting depicting the Cabaret Voltaire by Janco. János Máttis-Teutsch exhibited ten paintings and ten sculptures, Victor Brauner four constructions, and Milita Petrascu (Brâncuși's student) four sculptures. The greatest sensation was created by Brâncuși, who on earlier occasions had participated only sporadically in the Romanian art scene. Here he presented a representative selection of his oeuvre, including atelier photos and four important early sculptures, *The Kiss*, *Maïastra*, *Mlle Pogàny*, and *Child's Head*. Also shown were Dida Solomon's puppets, East Asian idols and Ceylonese masks, and applied-art objects. The masks and idols served to indicate the contemporary identification with the spirit of primitive art, while at the same time resurrecting the mood of the now somewhat remote times at the Cabaret Voltaire. Viking Eggeling's abstract film designs and architectural drawings had expanded the traditional exhibition framework by embracing the new media; now the masks and idols further pushed the boundaries of European art. This material had a totally different aim than the poetic objects at the Bazaar of Modern Art or the didactic ones in the Vilnius exhibition, and its effect was far removed from the modernistic ambience of the Warsaw automobile showrooms.

In Bucharest, eight years after the inauguration of the Cabaret Voltaire, the opening ceremony, the exhibited reference materials, and Janco's pictures combined to evoke a mood reminiscent of Dadaism. Only Eugen Filotti's lecture remained as a last vestige of customary exhibition practice. He raised objections to the inclusion of Asian masks and Ceylonese carvings, refusing to see the connections between primitive aesthetics and the intellectual creations of European art.[47] But his dissent, according to Tudor Vianu, a contemporary observer, did not have much of an effect:

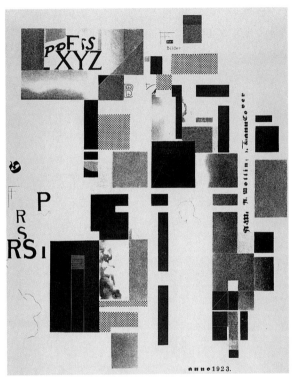

■ Kurt Schwitters, *Lithograph 4*, from Merz 3 portfolio, 1923

Victor Brauner, untitled, *Punct*, 1925 (no. 6–7), linocut

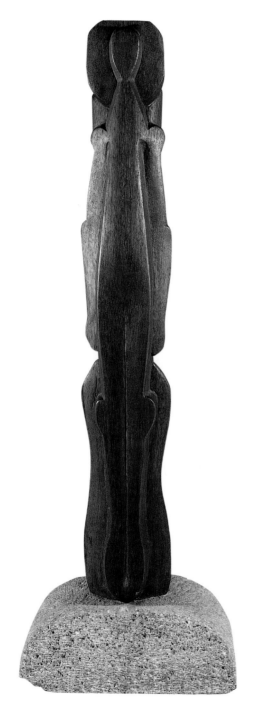

A large crowd was amassed in the dark hall, and in the general hubbub Filotti's introductory remarks were lost. A sudden drumroll silenced the crowd, the lights all came on and focused attention on the jazz band, complete with a Negro musician. The music of the band, the sound of drums and sirens, held back the crowd which advanced with great difficulty... The intervention of the jazz band was no mere directorial effect but a veritable modernist ritual similar to Dadaist manifestations, so that only later was there an opportunity to view the exhibition itself. The wall on the right was entirely preempted by Marcel Janco's works, the wall on the left displayed Maxy's. The Brassov artist Máttis-Teutsch occupied the area near the entrance. In the center, in the corner, and on the platform at the far end of the hall stood sculptures by Brâncuși and Petrascu, as well as furniture and vases, and also small wooden sculptures by Máttis-Teutsch. This general layout was augmented on the left and right by Mr. Janco's pictures showing the Cabaret Voltaire, with individualized figures and gestures...[48]

According to the recollections of Sașa Pană (later a central figure of Surrealism), when he entered the exhibition hall there was darkness and chaos. "Then two candles were lit on a table covered by black linen, in front of which appeared the figure of Eugen Filotti, standing tall, and armed with a text to introduce modern art to us..."[49]

In contrast to the Zenit show, this exhibition received considerable attention in the press.[50] One article stated that "Contimporanul has announced an exhibition for May, with participants from Italy, France, Spain, and Russia,"[51] countries not represented here. Unfortunately however, this planned exhibition was never realized.

The years 1923 and 1924 proved to be the most fruitful for international avant-garde exhibitions organized by artists. Naturally there were numerous shows to follow, such as the Constructivist one in Trieste in 1927, and several others in Poland by 1932, but the momentum of 1923 and 1924 was never regained. The exhibition as self-realization, as strategy, and as a model of a worldview remained a mode of expression chiefly of the 1920s. Today, we must resort to fragments in order to reconstruct these signal events, and use our imagination to fill in what is missing from contemporary descriptions, lists, and photographs.

Translated by John Bátki

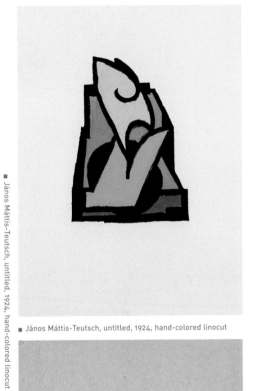

János Máttis-Teutsch, untitled, 1924, hand-colored linocut

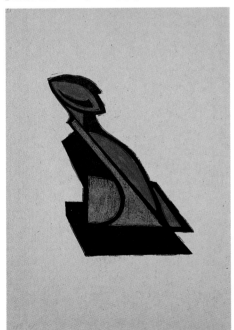

János Máttis-Teutsch, untitled, 1924, hand-colored linocut

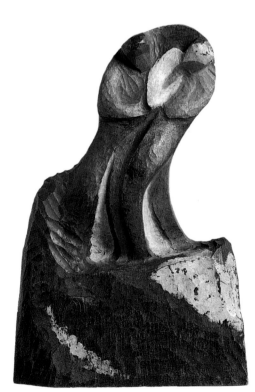

János Máttis-Teutsch, *Kiss: Composition with Two Figures*, 1921, painted wood

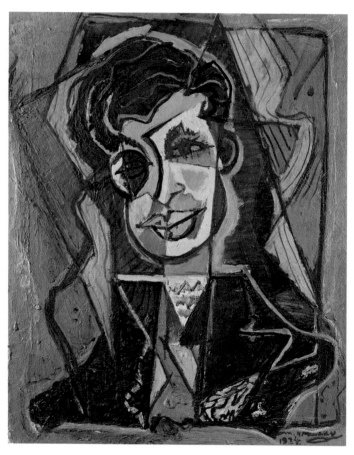

■ M. H. Maxy, *Tristan Tzara*, 1924, oil on cardboard

1 Eberhard Roters, "Ausstellung, die Epoche machen," in *Stationen der Moderne* (Berlin: Berlinische Galerie, 1988), 16.

2 Bruce Altshuler, *The Avant-Garde in Exhibition: New Art in the 20th Century* (New York: Harry N. Abrams, 1994).

3 Obmokhu, Moscow, 1921; 5x5=25, Moscow, 1921; I. Internationale Kunstausstellung [Congress of International Progressive Artists], Düsseldorf, 1922; Erste Russische Kunstausstellung [First Russian Art Exhibition], Berlin, 1922; Grosse Berliner Kunstausstellung, Berlin, 1923; Bazar moderniho umeni [Bazaar of Modern Art], Prague, 1923; Wystawa Novej Sztuki [Exhibition of New Art], Vilnius, 1923; Prva Zenitova medunarodna izlozba nove umetnosti [First International Zenit Exhibition], Belgrade, 1924; Internationale Ausstellung neuer Theatertechnik, Vienna, 1924; Wystawa grupy "BLOK" [Blok Group Exhibition], Warsaw, 1924; I. Internationale Ausstellung Junger Kunst, Bielefeld, 1924; Expozitive international de art plastica in Romania [International Exhibition of Contimporanul], Bucharest, 1924; L'Art d'aujour-d'hui, Paris, 1925; Neue Sachlichkeit, Mannheim, 1925; Revolutionäre Kunst des Westens, Muzej Novovo Zapadnoevropeiskovo Isskustva, Moscow, 1926; Wege und Richtungen der Abstrakten Malerei in Europa, Mannheim, 1927; Salon Modernistow [The Modernist Salon], Warsaw, 1928; PRESSA, Cologne, 1928; Internationale Ausstellung der Deutsche Werkbunds Film und Foto, Stuttgart, 1929; and we could go on almost endlessly, until we come to the 1932 show of the a.r. group in Łódź.

4 Krisztina Passuth, "Berlin—Mittelpunkt der Kunst Osteuropas," in *Paris–Berlin*. Musée national d'art moderne (Munich: Prestel Verlag, 1979), 222–31; also Passuth, *Les avant-gardes de l'Europe Centrale 1907–1927* (Paris: Flammarion, 1988).

5 Ferenc Csaplár, "Kassák Lajos Berlinben," in Ferenc Csaplár, *Kassák körei* (Budapest: Szepirodalmi, 1987), 14–19.

6 František Šmejkal, "Česka vytvarná avantgarda dvadcátych let," in *Devětsil Česka vytvarné avantgarda dvadcátych let* (Prague: Galerie hlavniho mešta Prahy, 1986).

7 Bucharest in the 1920s–1940s between avant-garde and modernism (Bucharest: Simetria, 1994).

8 Letters of Lajos Kassák from Vienna to Ödön Mihályi, undated (probably 1920). Petöfi Muzeum, Budapest, inv. no. V.2293/116. From among the exhibitions listed here only Béla Uitz's show became realized in Vienna, at the Freie Bewegung hall, as the *Ma X* exhibition in 1920.

9 Karel Srp quoting Karel Teige's *Obrazy a predobrazy* (Prague: Musaion, 1921), 52–58. Karel Srp, "Teige in the Twenties: The Moment of Sweet Ejaculation," in Erich Dluhosch and Rostislav Svacha, eds., *Karel Teige: L'Enfant Terrible of the Czech Modernist Avant-Garde* (Cambridge: MIT Press, 1999), 17.

10 František Šmejkal, "Devětsil," in manuscript, 15.

11 *Dada-Messe* (Berlin: Buchhandlung Dr. Otto Buchard, 1920).

12 František Šmejkal, "Česka výtvarná avantgarda dvadcátych let," in *Česka vytvarná avantgarda dvadcátych let Devětsil* (Dom umeni mesta Brna, 1986), n.p.

13 Ibid.

14 Karel Teige quoted by Anna Fárova, "Une tchèque, Jindřich Štyrský," in "Colloque Atget," *Photographie* (Paris, March 1986): 76.

15 Karel Teige, "Malirstvy a poezie," in *Disk* no. 1 (Prague, 1923).

16 Karel Teige, "Od artificialismu k surrealismu," in Karel Teige and Vítězslav Nezval, *Štyrský a Toyen* (Prague, 1938), 360–77.

17 Horst Richter, "I. Russische Kunstausstellung Berlin 1922," in *Stationen der Moderne*, kommentarband, ed. Eberhard Roters (Cologne: Walter König, 1988), 115.

18 Srp, "Teige in the Twenties," 25–26.

19 Výstava noveho uměni, with the participation, in addition to Devětsil members, of Kozintsova/Ehrenburg. Brno, Salon uměni, 1924. Kozintsova also took part in the 1924 Zenit exhibition in Belgrade.

20 Karel Teige to Artuš Černik, presumably at the end of 1923. Literature archives, PNP, Prague, quoted in Srp, "Teige in the Twenties," 27.

21 Wystawa Novej Sztuki, Vilna, Kinematograf "Corso," May–June 1923. The participants were Vytautas Kairiúkštis, Karol Kryński, Maria Puciatycka, Mieczysław Szczuka, Henryk Stażewski, Władysław Strzemiński, and Teresa Żarnower. About the exhibition see S. A. Mansbach, *Modern Art in Eastern Europe: From the Baltic to the Balkans, ca. 1890–1893* (Cambridge: Cambridge University Press, 1999), 112–20.

22 Andrzej Plauszewski, "Tadeusz Peiper," in *Constructivism in Poland 1923–1936* (Essen: Museum Folkwang, 1973), 132–33.

23 The complete list of exhibited objects is published in Andrzej Turowski, *Konstruktywizm Polski* (Wrocław, Warsaw, Cracow, Gdańsk, Łódź: Ossolineum, Polska Akademia Nauk Instytut Sztuki, 1981), 276.

24 Andrzej Turowski, "Groups of the Constructivist Avantgarde," *Constructivism in Poland, 1923–1936*, 36.

25 Wystawa Prac H. Berlewiego, Austro-Daimler Automobile Salon, Warsaw, March 14, 1924.

26 Wystawa Groupy "BLOK," Salon samochodowy Laurin-Clement, Warsaw, March 15, 1924.

27 Andrzej Turowski, "The Polish Revolutionary Avantgarde (Constructivism)," in *Constructivism in Poland, 1923–1936*.

28 Ljubomir Micić wrote a letter to Herbert Behrens-Hangeler on April 13, 1923. The undated invitation, typed in French and bearing the Zenit stamp in the upper left corner, is part of this letter. Herbert Behrens-Hangeler Bequest, Berlin, Zentralarchiv Preussischer Kulturbesitz. Documented by Anasztazia Kasza. See also Irina Subotić, "Zenit and the Avant-Garde of the Twenties," in *Zenit and the Avant-Garde of the Twenties* (Belgrade: National Museum, 1983), 66.

29 Mihailo S. Petrov, *Plakat Izlozba Zenit 1924*, 1924, collage, 65.5 x 50 cm, Narodni Muzej Belgrade.

30 See Micić's lecture on new art in *Zenit*, no. 35, and in *Zenit and the Avant-Garde of the Twenties*, 66.

31 The designation of national origins has been taken from the catalogue published in *Zenit*, no. 25. Micić had counted on the participation of Vinicio Paladini and Enrico Prampolini, two artists mentioned in the catalogue list, but we have no definite information about whether they actually were represented in the show (*Zenit and the Avant-Garde of the Twenties*, 67–68).

32 Ibid., 69.

33 For the contact between Kandinsky and Zenit see Zoran Markus, "'Zenit', Ljubomir Micić i Vasilije Kandinski," in *DELO* 19, no. 6 (Belgrade, June 1973): 733–36, 738–39.

34 Krisztina Passuth, "Le soleil bleu: Les Delaunay et les pays de l'Est," *Cahiers du Musée national d'art moderne*, no. 16 (1985): 109–17.

35 Dusan Timotijevic, "Zinetova izlozba nove umetnosti," *Pokret* 1, no. 12 (Belgrade, April 19, 1924): 197.

36 The 1926 article by Mihailo S. Petrov, "Izlozba savremenich pariskih majstera," is quoted by Irina Subotić in *Zenit and the Avant-Garde of the Twenties*, 73.

37 Ljubomir Micić, "Nova Umetnost," *Zenit*, no. 25 (Belgrade, December 1924): n.p.

38 Andrei Pintilie, "Considérations sur le mouvement roumaine d'avant-garde," *Revue Roumaine Histoire de l'Art* 24 (1987): 47.

39 Ibid.

40 S. A. Mansbach, *Modern Art in Eastern Europe*, 249, 351.

41 Pintilie, "Considérations sur le mouvement roumaine," 47, 58.

42 "…Kunst zwingt zur Eindeutigkeit, soll Fundament des neues Menschen bildens jedem einzelnen und kleiner Klasse gehören." The manifesto is quoted in Justin Hoffmann, "Hans Richter und die Münchener Räterepublik," in *Hans Richter, 1888–1976* (Berlin: Akademie der Künste, 1982), 22. In English: "Art in the state must reflect the spirit of the whole body of the people. Art compels clarity, should form the foundation of the new man and belong to each individual and no class" [sic]; Justin Hoffmann, "Hans Richter, Munich Dada, and the Munich Republic of Worker's Councils," in Stephen C. Foster, ed., *Hans Richter: Activism, Modernism, and the Avant-Garde* (Cambridge: MIT Press, 1998), 61.

43 Wulf Herzogenrath and Pavel Liska, eds., *Arthur Segal, 1875–1944* (Cologne: Kölnischer Kunstverein, 1988), 41–44, 237.

44 Krisztina Passuth, "M. H. Maxy figure cl. de la peinture roumaine dy XXe siècle et l'avant-garde internationale," *Bulletin du Musée Hongrois des Beaux-Arts* 85 (1996): 61–92.

45 Martina Vanci, "Concept de modernisme et d'avant-garde dans l'art roumain entre les deux guerres" (Thèse de Doctorat, Université de Paris, École Pratique des Hautes Études, 1972), 76–77. See also S. A. Mansbach, "The 'Foreignness' of Classical Modern Art in Romania," *Art Bulletin* 80, no. 3 (Sept. 1988): 534–54.

46 Luminita Machedon and Ernie Scoffham, *Romanian Modernism: The Architecture of Bucharest, 1920–1940* (Cambridge: MIT Press, 1999). On page 37 the dates of the exhibition are incorrectly given as October 30–November 30; also, Max Mary is named as "having commissioned the show." To my knowledge the name of Max Mary as the organizer of the exhibition does not appear anywhere in the contemporary articles or in the literature to date. Nor do we have any indication that he was a student of Segal's in Berlin (page 34). Possibly the authors had M. H. Maxy in mind.

47 Petru Comarnescu, "Curente in Arte Romanesca Moderne I–II," *Arta Plastica*, nos. 6–7 (Bucharest, 1967).

48 T. V. [Tudor Vianu], "Prima expozitie internationala *Contimporanul*," *Miscarca literara* (Bucharest, December 6, 1924).

49 Sașa Pană, "Nascut," *02* (Bucharest, 1973): 174–75.

50 "L'Exposition internationale du Contimporanul," *Contimporanul*, no. 52 (Bucharest, January 1925); O. W. Cisek, "Expozitia internationala a reviste *Contimporanul*," *Gandirea*, no. 7 (January 1925): 15; M. H. Maxy, "Contributiuni sumare la cunoasterea miscarii moderne de la noi," *Unu*, no. 33 (Bucharest, February 1931), etc.

51 S. C. [Scarlat Callimachi], "Expozitia *Contimporanului*," *Punct*, no. 3 (Bucharest, December 1924).

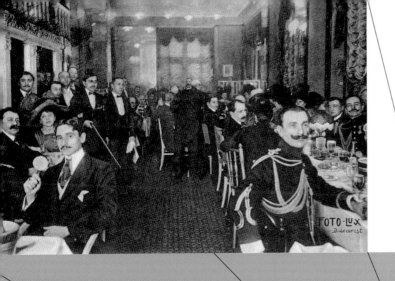

bucharest

Berlin Poznań Warsaw

Dessau Łódź

Weimar Prague Cracow

Vienna

Budapest

Ljubljana Zagreb

Belgrade **Bucharest**

Marcel Janco, avant-garde artist and architect of the first Cubist-inspired houses in Bucharest, mentioned in his theoretical texts the extraordinary display of abstract art offered by the rugs stretching along the banks of the river.

BUCHAREST

Ioana Vlasiu

p. 247:
Café de Paris, Bucharest, before 1914

Below:
Romanian Athenaeum, c. 1930

In the case of Bucharest the cliché—"a city of contrasts"—is especially true. This is how its inhabitants experience it and how foreign travelers see it, with sympathy and perplexity. Beginning in the nineteenth century and continuing today, successive waves of modernization, with their ravages and transformations, have only confirmed the mixed nature of this medieval and largely Oriental town.

At the end of the First World War Bucharest extended over a wide area, but its population did not exceed 400,000; in ten years, this number would double. During the reign of Carol I (1866–1914), Romania saw the construction of imposing public buildings, many of which were designed by French architects who brought to the city diverse examples of Western European styles. Nevertheless, immediately after the war and before the economic boom of the 1920s, Bucharest was still a parochial city in which most houses did not exceed one story and were surrounded by large gardens.

Even before the end of the nineteenth century, Romanian architects became preoccupied with the creation of a proper Romanian style, adapting elements of medieval and peasant architecture to new urban buildings and homes. Around 1900 the architecture of Bucharest turned its back to Western classicism, and the rejuvenating spirit of Art Nouveau permeated the country as architects aspired toward a national style. The neo-Romanian style, as it is called, with its triumphs and missteps, emerged from the confluence of historicism and the modernity of Art Nouveau.

Like many Western cities, downtown Bucharest is filled with commemorative sculptures. The poet Ion Minulescu, a promoter of modern art and a sagacious supporter of progressive artists, revolted against the invasion of "horrible statues," which, he claimed, stalked passersby on every corner. In 1913 Constantin Brâncuşi received a commission to build a monument dedicated to a past minister of education. Attempting to forsake the form prescribed for public statuary, he refused to sculpt a "frocked gentleman" and proposed instead an archaic fountain. The project was rejected. Twenty years would pass before he was able to raise, at Tîrgu-Jiu, a monument radically novel in conception, *Endless Column*. In Bucharest, conventional statues reflecting an academic classicism and commemorating figures from Romanian culture and history were situated in front of the Romanian Athenaeum building, where cultural events of note took place. Concert and conference hall, exhibition showroom, headquarters of the city's foremost gallery and an important library, the Romanian Athenaeum in the 1930s finally received a long-planned fresco representing the history of the Romanian people, from their origins to the modern era, by the academic painter Costin Petrescu.

In spite of efforts at Europeanization, many of Bucharest's streets remained narrow and tortuous. Health and hygiene were lacking. There were droughts and dust in the summer, mud in the fall, and winter's frost quickly made one forget spring's explosion of green, which the French writer Paul Morand described enthusiastically in a 1935 book about Bucharest. Its slums seemed to exist in a century more ancient than the city center. Peasants walked about, shouting to call attention to the wares on their backs; horse-drawn coaches and trams competed with the emerging automobile. Old-book dealers and sellers of multicolored peasant rugs displayed their wares on both shores of the Dambovitza River. Marcel Janco, avant-garde artist and architect of the first Cubist-inspired houses in Bucharest (1926–27), mentioned in his theoretical texts the extraordinary display of abstract art offered by the rugs stretching along the banks of the river and used them as a guide in educating the Romanian public about abstract painting.

It has been said that Bucharest is a gate to the East, but it has also been called Little Paris, Little Berlin, and even Little New York or Petersburg. Situated at the crossroads of so many contradictions, Bucharest has its own irreducible charm. Calea Victoriei [Victory Way], Bucharest's most elegant and animated street, was notable for its important public buildings, sumptuous homes, and elegant window displays. Many bookstores, well stocked with volumes from other countries,

occupied the same area. Calea Victoriei was also home to the National Theater, built in 1847 by a Viennese architect. In the vicinity were famous cafés, among which were Capsa and Terasa Otelesteanu, the meeting places for journalists, politicians, writers, painters, and actors. Capsa was the heart of the city, and all those who were or aspired to become public figures took their lunch there. For someone from the provinces, or a foreigner, it was the place to get to know Bucharest, or to conquer it. Freshly landed in the capital from the provinces in 1918, Sașa Pană, the future editor of the avant-garde magazine *Unu*, recalled: "Calea Victoriei lured me with its dense crowd that moved leisurely, like lava, and I could hardly make my way through it... In the window displays wallowed plates of boiled sturgeon (that made your mouth water) and tins of black caviar...and who knows what other delicacies. [But] the newspapers spoke about misery and suicides, about hungry people."

Romania emerged on the winner's side in the First World War and realized its ideal of national unity through the annexation of surrounding territories. Expansion, however, had the effect of destabilizing the country economically and deepening the divide between social classes. Corruption was the order of the day in an era noted as a moral desert. The men who returned from the front, the "trench generation," shared the sentiment that they had been a sacrificial generation. At the same time many elements of society radicalized themselves, feeling the need to press in the public arena their ambitions to reform society. Newspapers and magazines multiplied and found large audiences. In politics, the conservative party disappeared and new ones emerged, among them the National Peasant Party, the People's Party, and the Communist Party. Electoral campaigns were sometimes veritable street spectacles, direct and spontaneous, meant to attract indifferent passersby. Sașa Pană tells humorously about the campaign unleashed by N. D. Cocea, a well-known journalist of the left, in the popular quarters of Bucharest. On the back of a truck that traveled from place to place, he improvised a sketch in which three rats strung up by a rope could be seen chewing an immense wheel of cheese, an allusion to the day's politicians.

Artistic life reorganized itself with much difficulty after the war. The fine arts academy was headed by an academic painter, but too few of the professors were artists. Many students abandoned their studies, finding the free education of artistic and literary bohemianism more attractive. The most important artistic event, immediately after the war, was the establishment of

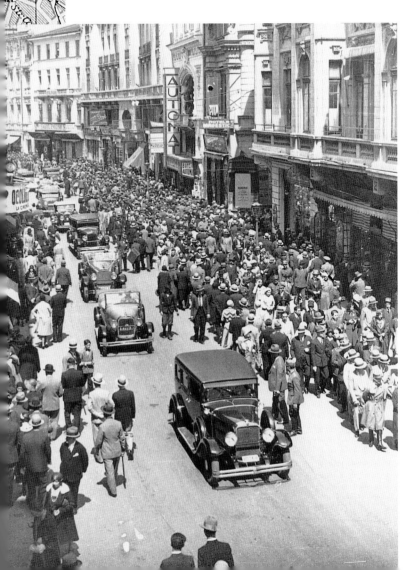

Victory Way, Bucharest, 1931

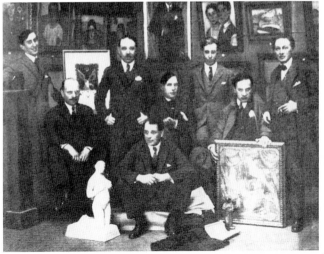

Max Herman Maxy	Oscar Han		Stefan Dimitrescu	Camil Ressu
	Marius Bunescu	Ion Theodorescu-Sion		Traian Cornescu

Arta Română, Bucharest, 1922 N. N. Tonitza

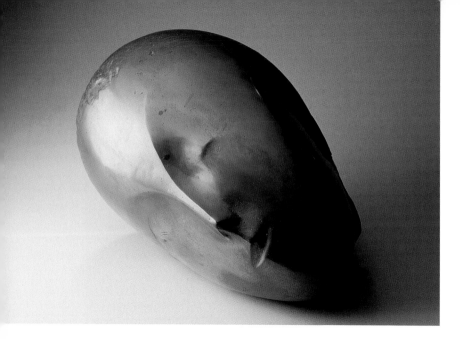

Above:
■ Constantin Brâncuși, *Sleeping Muse*, 1909–10 (cast circa 1920–29), bronze

Below right:
■ Lajos Tihanyi, *Portrait of Tristan Tzara*, 1926, oil on canvas

Arta Română [Romanian Art], which united artists who refused to make commercial art; but the modernism practiced in Romania remained only moderate. Max Herman Maxy, who in only a few years would become one of the leaders of the avant-garde, was a member of Arta Română, along with important artists such as Iosif Iser and Camil Ressu, who were Maxy's first painting teachers. Constantin Brâncuși, although already established in Paris, insisted on joining Arta Română and exhibiting in Romania. Until 1924 the group organized annual exhibitions that marked Romanian cultural life. It is perhaps not a simple coincidence that the first international avant-garde exhibition in Bucharest took place in 1924, just as Arta Română fizzled out. The first official salon since the end of the war opened that same year under the patronage of Ion Minulescu, a poet receptive to the audaciousness of modern art. Maxy, Marcel Iancu, and Corneliu Michăilescu exhibited paintings designated Cubist by current fashion. Cubism had other practitioners as well, among them talented women artists such as Nadya Bulighin and Merica Ramniceanu. Accepted by knowledgeable critics, Cubism nonetheless aroused a polemic so strident that it provoked a narrowly averted duel between Michăilescu and a denigrator.

The focus of Romanian modernism at this time was the group Contimporanul and its journal of the same name. In late 1924 the group organized an international exhibition at the headquarters of the Syndicate of Plastic Arts, near Calea Victoriei and the Romanian Athenaeum. Though viewed as iconoclastic and a call for change, the exhibition was not Bucharest's first encounter with artistic defiance or rebellion. Alexandru Bogdan-Pitești, an eccentric landowner with anarchist sympathies and a collector of modern art, had patronized independent artists before the war; Maxy and others had benefited from his support. Ion Vinea, an avant-garde poet, evoked in the novel *Lunatecii* [Lunatics] the mixture of farce, triviality, and intellectual stimulation that Bogdan-Pitești entertained around him.

The renowned aesthetician Tudor Vianu described the Contimporanul event: "Sunday, November 30, was the opening of the first international exhibition organized by the magazine *Contimporanul* under the direction of Mr. I. Vinea. The obscurity of the salon where a multitude of guests fluttered in agitation…was suddenly sundered by a drum roll. The lights which then erupted revealed on the stage, behind the master of ceremonies, a jazz band,

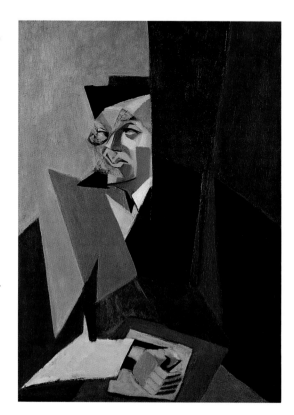

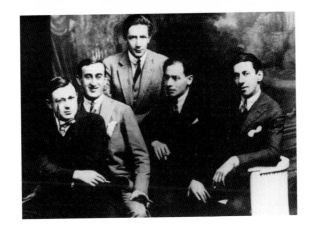

Ion Vinea			
	Bucharest, 1923		
Tristan Tzara	M. H. Maxy	Henri Bad	Jacques Costin

replete with Negro musician. The sounds of strings, sirens, and drums. The perplexed multitude attempted without much success to advance toward the stage. Did the directors of the exhibition plan perhaps this general first impression, the bewildering amalgam of tones like a gigantic collection of colored butterflies? Because, at least as far as the intervention of the jazz band is concerned, it is certain that we were not only dealing with an effect of stage direction but with a veritable modernist ritual of dadaist manifestation."

Some of the most competent art critics of the period wrote with erudition about this unusual exhibition, explaining little-known notions of abstract and Constructivist art. The exhibition and its fashionable success even permeated the period's literature. In a 1933 novel by Camil Petrescu, *Patul lui Procust* [Procust's Bed], characters meet at the opening, where viewers yearning for novelty filled the salon to the brim. The fact that the exhibition was directed against art and, paradoxically, was about progress in the arts did not escape the

writer's attention. Examples of functional furniture designed by Maxy and Marcel Janco elicited great surprise: "Throughout the salon (whose walls were dressed in burlap the color of cardboard and illuminated from above by some sort of small zinc pipes that housed white bulbs like theater footlights) there were some low easy chairs in the American style, but made of one piece of thick wood cut into black slices alternating with yellowish ones. They all sported an easy air of improvisation, of theatrical decor," says one character. The paintings, "with a geometry of long rays and concentric circles," suggested to the viewer, perhaps surprisingly for today's spectator, the apocalypse. The same author describes in luxurious detail a "Cubist interior," a sign that the new art was accepted aesthetically, if not ideologically.

What prelude led to this uncommon exhibition in Bucharest's artistic landscape? In 1922 Maxy left for Berlin, where he studied painting with his compatriot Arthur Segal, whose studio was frequented by numerous foreign painters. Maxy exhibited in Berlin at Herwarth Walden's Galerie Der Sturm and participated in an exhibit of the Novembergruppe. In 1923, back in Bucharest, he opened an exhibit of works from Germany, some Cubist, others abstract. In its catalogue Maxy defined his own painting as Constructivist, and Constructivism as the "left extreme of Cubism," a definition with clear political implications. A year earlier Marcel Janco had returned from Zurich. There, along with his compatriot Tristan Tzara, a friend from high school, and with Hugo Ball and Richard Huelsenbeck, he had participated in 1916

Victor Brauner, *Construction (Ilarie Voronca and Victor Brauner)*, 1924, ink on photograph

in the nonconformist Dada evenings at the Cabaret Voltaire, spectacles whose purpose was to scandalize and exasperate, to jolt spectators from inertia and unleash a new sensibility in them.

The protagonists of these spectacles looked for "liberated words" that would negate grammatical rules, and cultivated the absurd and the nonsensical. Jazz music blared freely; people danced frenetically. Provocation and scandal became law. "Every man must shout. We must accomplish a great negative, destructive task. To sweep up, to clean up once again," wrote Tristan Tzara in one of his manifestos. African art was exalted. This explosion of nonconformism that went under the name of Dadaism, this need to shock, to undermine and destroy artistic convention, had in Janco one of its most active supporters. In Zurich, Janco made posters for the Dada evenings, collaborated on illustrations for the Dada magazine, and made masks and costumes for the spectacles; he also created collages and abstract reliefs. Back in Romania in 1922, Janco reunited with Ion Vinea, another friend from adolescence. In high school in 1912 Janco, Vinea, and Tzara had published the magazine *Simbolul* [Symbol], in which they exercised, timidly, their attitudes of juvenile rebellion. A much more ambitious project was *Contimporanul*, which in 1924 reunited

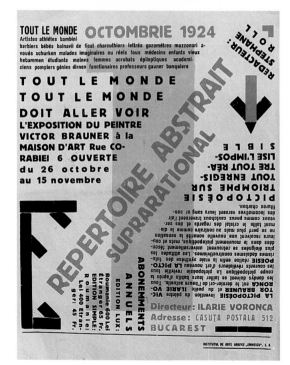

Right:
Victor Brauner and Ilarie Voronca, exhibition advertisement from *75HP*, 1924

					Simbolul Group, Bucharest, 1912–13
Tristan Tzara	Unknown youth	Marcel Janco	Jules Janco	Poldi Chapier	Ion Vinea

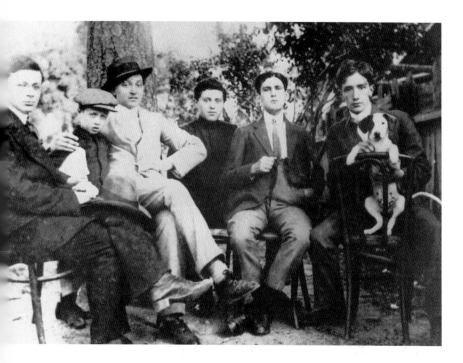

Janco, Vinea, and Maxy in a common effort to introduce new artistic and social ideas to Romania and to gain public support for them. Janco believed that nihilism must be surpassed and assumed with missionary zeal the propagation of the new art. A designer of many of the city's International Style buildings, Janco participated in the architectural reformation that engulfed Bucharest. That is perhaps why he was the artist most able to put into practice, within the constraints of Romania's economic and social realities, the Constructivist utopia.

These artists and others—the painters Victor Brauner and János Máttis-Teutsch, the sculptor Milita Petrascu, and a series of writers—in the 1920s practiced their ideological and cultural activism with conviction and enthusiasm. They edited magazines (some short-lived)—*75HP*, *Integral*, *Punct*, *Unu*, *Urmuz*—and organized exhibitions, conferences, performances, and literary circles.

A weekly literary circle at Maxy's home was attended by artists, actors, and writers of the left. There were discussions of sketches by Maxy, literature readings, and lectures. These meetings were chronicled by Geo Bogza, Stephan Roll, and Saşa Pană. Pană wrote: "Important discussions,

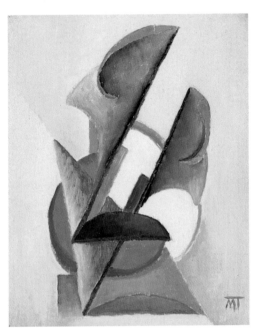

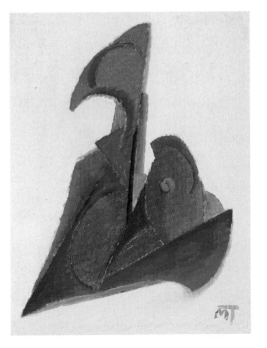

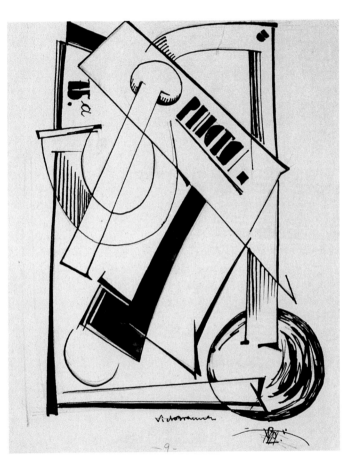

Above left:
■ János Máttis-Teutsch, *Composition*, c. 1924, oil on board

Left:
■ János Máttis-Teutsch, *Composition*, c. 1923, oil on board

Above right:
■ Victor Brauner, *Construction ("Punct")*, 1924, ink on paper

the raising of problems in relation to art, to literature, and to sociopolitical aspects of the day, all took place in Maxy's home. Here the host raised issues for debate, social problems. Maxy, and especially Mela, his wife, had an interesting mode of introducing debate and inciting dialectical controversy regarding current events."

A workshop associated with the magazine *Integral* played an important role in propagating the taste for the new Constructivist art. Later named the Academy of Decorative Arts and led by Maxy, the school was modeled on the Bauhaus. Artists sympathetic to the avant-garde (but who in practice limited themselves to a moderate modernism) were invited to teach there.

One Bucharest location that would enter avant-garde mythology was the popular café Enache Dinu, on Baratia Street, near the Piata Mare ["big market"] in the city's center. Frequented by the youngest of the avant-garde generation, headed by poets Stephan Roll and Geo Bogza, the shop was run by Roll's father. Sașa Pană enthusiastically described his first visit in 1928: "Entering the shack full of porters, chimney sweeps who wolfed down food at the small tables of greasy marble, in the smoke of cheap tobacco and steam from the range stove where Roll beat omelets, I didn't know that from that day on, for many years to come, I would be a daily customer, and even many times in one day. Because there beat the heart of the avant-garde modernist movement in Romania. There, around Roll, for the last four years, gathered all the iconoclasts of a time which none will forget till death. There

was the most original literary circle that Romania ever knew, and perhaps not only from our country." In this ambience *Unu* was born, the magazine that would mark the passage of the Romanian avant-garde into a new age, that of Surrealism.

In the 1990s, a café in Bucharest's exhibition center Artexpo was named Enache Dinu. Its walls, adorned with many photographs, evoke the exploits of the Romanian avant-garde seventy-five years ago.

Translated by Julian Semilian

Stephan Roll at the café Enache Dinu, Bucharest, 1930

nor did they understand the language of, the new revolutionary art.

Even those inclined toward leftist politics or organized as Communists were not favorably inclined toward,

Berlin Poznań Warsaw

Dessau Łódź

Weimar Prague Cracow

Vienna

Budapest

Ljubljana Zagreb

Belgrade Bucharest

zagreb

ZAGREB

Želimir Koščević

In the period between 1895 and 1914, Zagreb underwent a transformation from a sleepy *kaiserlich und königlich* provincial town of the Dual Monarchy to an important economic, industrial, financial, and cultural center. Croatia's turbulent political life and regional wars—the First and Second Balkan Wars and the First World War—had no great impact on the dynamic cultural life of the city. In fact, with the collapse of the Austro-Hungarian Empire in 1918 and the creation of the Kingdom of the Serbs, Croats, and Slovenes (the future Yugoslavia), Zagreb assumed even greater importance, and it played a leading cultural role in southeast Europe between the world wars. The cultural life of the city, and particularly its visual art, rested on a firm foundation. Other Croatian cities (e.g., Rijeka, Split, and Dubrovnik on the Adriatic coast, and Osijek on the Drava River) were important, but Zagreb was the country's main cultural center.

Culture itself depends on social life in general. A recent retrospective publication about fashion in Zagreb gives a taste of the city's lifestyle in 1926: "The Zagreb woman loves the theater, concerts, movies, coffeehouses, and bars. She loves sports, parties, five o'clock tea, dogs, traveling, cigarettes... The Zagreb woman cuts her hair ruthlessly, bobs her hair, and transforms herself into a man." The press, mainly headquartered in Zagreb, including the influential weekly *Svijet* [The World], did much to promote the "modern" life of the rising "global village." Art critic Vladimir Lunaèek used this expression (one identified with Marshall McLuhan and the early 1960s) in a commentary on the modern press which appeared in Zagreb in 1924. Installation of the first "photomaton," an automatic photography machine, in Zagreb's Edison cinema in the fall of 1930 caused no small outcry. The photographers of Zagreb protested vociferously against what they saw as a threat to their profession, and the owner, himself a local photographer, was ejected from the union of photographers. The world-renowned Zagreb School of Animation of the 1960s actually dates back to 1928 and originated in a public health educational program. In 1935 the first comic strips produced by Andrija Maurović appeared in the Zagreb daily press, and the weekly *Svijet* featured the brilliant covers of Otto Antonini.

In a photograph of a coffeehouse in the heart of the city, taken in the 1940s by Zagreb photographer Tošo Dabac, one can detect Marcel Breuer chairs among the furnishings. We do not know who ordered such furniture, but it was seemingly in connection with a broader public taste. We should not be surprised to see Breuer's chairs in this setting, because Zagreb's architects had personal contact with the most prominent European architects of the day—Adolf Loos, Hans Poelzig, Pieter Oud, Le Corbusier, Peter Behrens.

To conclude this brief introduction to the terrain upon which a slight but nevertheless significant stratum of the avant-garde movement was laid, it is useful to illustrate how the "global village" affected—for good or bad—the city of Zagreb. A photograph of the disastrous conflagration that destroyed the super-dirigible *Hindenburg* at Lakehurst, New Jersey, on the evening of May 6, 1937, appeared in Zagreb daily newspapers by the morning of May 10. When we remember that the nearest telephoto receiver was located in Graz, 220 kilometers from Zagreb, and if we consider the level of press technology of the period, as well as the time difference between Zagreb and New York, and the time it took to travel to and from Graz to collect the photograph, we realize just how promptly the media reacted. This was the modern era in the city of Zagreb.

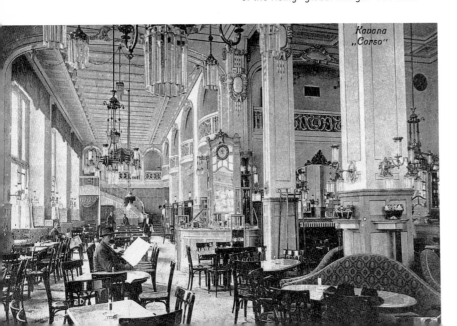

Kavana „Corso"

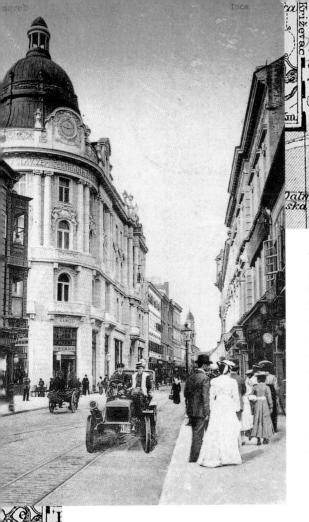

Ilica (main shopping street), Zagreb, 1908

The one-track, more-or-less unidimensional history of Croatian art in the twentieth century (customarily only of local interest) has undergone considerable correction over the last twenty-five years. New and different aesthetic sensibilities and an altered cultural map have undoubtedly influenced a shift and expansion of scholarly interests. This widening of interests to include neglected areas of the national artistic heritage of the twentieth century, and a recognition that aesthetic valorization must cover a wider cultural context, have revealed the considerable deficiencies of critical interpretations made to date. Totally new insights can now be offered about some of the general determinants and values of twentieth-century Croatian art. This is particularly relevant to the period between the two world wars.

This new and expanded understanding of the artistic heritage of the first half of the twentieth century provides us with a far more interesting and dynamic picture of those times. Admittedly, neither the shifts in the hierarchy of general values nor the shifts in the valuation of individual artists had any influence on the existing general periodization. Consequently, no significant changes occurred within that framework, starting with Postimpressionism and ending around 1930 with the socially committed artistic efforts of Neue Sachlichkeit [New Objectivity]. Expressionism, particularly in its artistically milder versions, has always been highly valued and regarded locally, although there were occasions when its more radical forms were degraded and marginalized. It is rather curious to note that Constructivism and all the expressive

poeticism related to the avant-garde were almost totally ignored. The intellectual and artistic circles of Zagreb began to consider that particular heritage and its actors—in those days still living—as late as the 1950s and 1960s, while the systematic research and discovery of exceptionally interesting material came about only in the mid-1970s.

There are three basic reasons for the suppression of Croatia's Constructivist and more radically oriented art history. First, although possessing all the features of Central European urbane culture, Zagreb—with its Austro-Hungarian heritage and typical bourgeois citizenry, a feature in which it differed in no way from Łódź, Budapest, Pécs, Brno, Ljubljana, and so on—was neither able nor willing to accept artistic excess. Despite the fact that one cannot negate the participation of Zagreb, or its ninety thousand inhabitants, in the general modernistic progress of the twentieth century, or the city's sound infrastructure in both general and artistic education, or indeed the fact that information was timely and up-to-date—the poet, writer, or painter was and remained socially extreme. The world fame of certain individuals, such as the painter Vlaho Bukovac or the sculptor Ivan Meštrović, did nothing to alter their status back home.

Second, the majority of academically trained artists, who acquired their artistic education at the academies of fine art of Munich, Vienna, Prague, Milan, Rome, and Paris, were simply not prepared to take on the challenges of the avant-garde. In most cases their academic background enabled them to successfully meet the

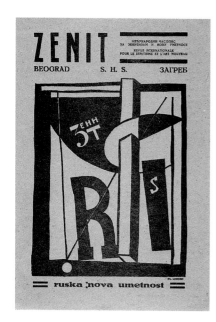

needs and tastes of the social environment to which they returned after completing their schooling. Monographic studies of a later date, and particularly those published recently, have shown that individual artists were able to reach beyond the framework prescribed by society to create works akin to avant-garde poeticism. Such works, however, did not enable the artists to secure their living, and although today we regard them as milestones in Croatian art of the twentieth century, for a long time they remained known only to a narrow circle of experts. Part of the bourgeoisie and enjoying a fairly secure middle-class existence (as professors at the Academy of Fine Arts in Zagreb or at secondary schools of general or professional education), those artists were not prepared to accept the risks involved in embracing the avant-garde. Additionally, the Academy of Fine Arts in Zagreb, founded in 1907, supported rejections of the avant-garde, thereby bestowing legitimacy and authority to its disavowal.

Third, in those times Constructivist ideas emanated only from Soviet Russia or, only slightly modified, via Berlin, and they came under the same suspicion that greeted anything tainted by leftist revolutionary theory and the practice of Bolshevism. The political structure of the Kingdom of the Serbs, Croats, and Slovenes, which came into existence in 1918, coupled with the influence of emigrants who began arriving in Zagreb from Russia after 1917, formed a clear and solid line of resistance to the revolutionary events of that October. Even those inclined toward leftist politics or organized as Communists were not favorably inclined toward, nor did they understand the language of, the new revolutionary art. The subsequent dictatorship

imposed by King Alexander in 1929, the Second World War, and the period of social realism that emerged after 1945—as well as the milder, academic forms of its recurrence—together created an environment in which avant-garde art faced a growing neglect and eventually almost total marginalization.

Today we can define with certainty three phases of avant-garde activity in Croatian art of the first half of the twentieth century. The first two gave voice through Expressionism and occurred, approximately, between 1916 and 1928, that is, from the first Proljetni [Spring] Salon in Zagreb to the final exhibition of the same name, and from 1921 until 1926, from the first issue of the journal *Zenit* until the police imposed a ban on it in Belgrade. The Proljetni Salon attracted the young and rebellious generation of Croatian artists who, filled with youthful enthusiasm but severely affected by the traumas of the First World War, embraced the spirituality of Expressionism as a creative alternative to the dated forms of academicism and the ingratiating flattery of the Secession. It was from that same Expressionistic spiritual environment that the Zenitism of Ljubomir Micić originated. In early 1921 in Zagreb Micić initiated publication of *Zenit*, his international journal of art and culture. It was published there until May 1923, when Micić moved it to Belgrade, where publication continued until 1926. In 1922, again in Zagreb, Dragan Aleksić briefly and intermittently published his journals *Dada Jok*, *Dada Tank*, and *Dada Jazz*. As early as 1922 *Zenit* detached itself from Expressionism, and an issue of that same year was almost entirely dedicated to the new Russian art. One of those cooperating closely with the Zagreb group of Zenitists, under the pseudonym Jo Klek, was the architect Josip Seissel. His renowned Pafama, as well as a whole range of other paintings and collages, are anthological works of the early abstract and experimental art of this part of Europe.

The third avant-garde phase of Croatian art appeared in Zagreb in the fall of 1929. The group Zemlja [Earth], initiated by the painter Krsto Hegedušić and the architect Drago Ibler, believed that art should focus

on its social function. Although Zemlja was comparatively heterogeneous and, in principle, adhered to the structure of Neue Sachlichkeit, the themes of their works, manifestos, and programs challenged bourgeois taste. What made the activities of the group particularly interesting were the strong and extremely influential presence of architects brought up on functionalism and the involvement of a small group of naive peasant-painters from Hlebine (beginning in 1931). Due to political circumstances and police repression, Zemlja ceased to exist in 1935.

The subsequent course of events, not specific to Croatia alone (or, indeed, to Yugoslavia), led to the utter collapse of the avant-garde utopia and its disappearance from the European stage. The general flagging of enthusiasm for the avant-garde, the overall dominance of bourgeois taste, and the ideologizing of art, in the service of not only Fascism, Nazism, or Socialist Realism but also Western democracies, brought about the end of one of the most turbulent periods in European art. It would take twenty years, and in some places much longer, before the heritage of the European avant-garde would imbue new generations with its creative charge.

The recent widening of professional interests among art and cultural historians has resulted in some surprises. One of those to be rescued from almost total oblivion was the Zagreb-born student of the Bauhaus Ivana Meller Tomljenović. Today, what little remains of her work is housed in the Museum of Contemporary Art in Zagreb. It has become apparent that a Croatian photographic heritage abounds, and in the first half of the twentieth century photographers such as Tošo Dabac were creating series of enviable quality. More recent research and intensified interest in mass communication have resulted in reconsideration of the entire oeuvre of Andrija Maurović, a superb master of the art of cartoon. A general belief had prevailed that the Surrealist movement of the late 1920s and early 1930s had not affected Zagreb, but this is only partially true. Monographs dedicated to individual artists have demonstrated they were not immune to Surrealism, and that they knew how to transform the poetics of Surrealism into works of exceptional attraction.

In my research I have never ventured so far as to identify the above-mentioned Croatian phases and movements with European avant-garde movements. The only instance in which, in my opinion, this possibly excessive caution may not be necessary is in the case of the journal *Zenit* and events related to Ljubomir Micić, whose Zagreb phase was almost obliterated from the national history of art. As for all other groups, movements, and individual creative efforts occurring in the first half of the twentieth century, I have regarded them as tendencies, with distinct leanings toward the European avant-garde. This should by no means be interpreted as an intention on my part to demean Zagreb's dynamic artistic and cultural events. A realistic assessment of artistic achievements of one's own social environment can only enrich the panorama of avant-garde happenings on a wider European stage and contribute to a better understanding of the period.

Translated by Maja Starčevic

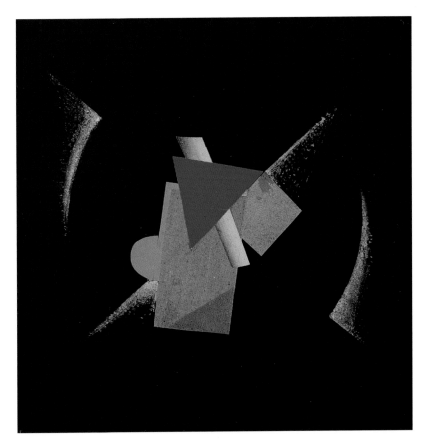

LJUBOMIR MICIĆ AND THE ZENITIST UTOPIA

Esther Levinger

Ljubomir Micić (1895–1971), poet and essayist, defined Zenitism, the art movement he initiated in Zagreb in 1921, as the "third guest" at the table of history. It had arrived, he contended, after Expressionism and Cubism to triumph over the fossilized, material forms of the cube and the cylinder and to resolve the struggle between spirit and matter.[1] For Micić, the resolution of this conflict, which had divided the arts before and immediately after the First World War, lay in a synthesis of opposites that involved both art and life. In regard to art, *Zenit*, the journal of Zenitism, published reproductions from all schools of art, provided information on all art movements, and covered the contradictions and controversies that shaped the avant-garde of the early twentieth century.[2] *Zenit* integrated opposing styles and currents into its own original work of art. Regarding life, Zenitism was to initiate a new tradition of spirituality. Micić sought to construct "the universal human epoch," and to create a new individual, one who would reach the zenith of human nature.[3]

To achieve these goals Micić pushed for a rejuvenation of old Europe by Barbarian young forces, a name which in this case referred to the Slavs in general and to the people of the Balkans in particular. The idea was to "Balkanize" Europe, that is, to reverse European cultural dominion and to infuse the West with Balkan spirit. Micić described his spiritual plan with intense, earthy metaphors. He claimed he would "fertilize" the West with "healthy Barbarian blood" and to "fecundate" it with the "semen" of what he called the "Barbarogenius."[4]

A similar ambition to spread "Balkan beauty" all over the world and to regenerate the West with South Slavic spirituality animated Micić's younger followers in Ljubljana, the Slovenian avant-garde, who came together around the stage director Ferdo Delak (1905–68) and the journal *Tank*.[5] *Tank's* two issues in late 1927 failed to attract the attention of the

international avant-garde, but Micić's utopian plan to inform Western materialist culture with Eastern idealism appeared reactionary and nationalist to some contemporaries, like Hans Richter.[6] These severe charges disregarded Micić's critical positions, but they were prompted perhaps by the journal's inherently paradoxical messages and the editor's anti-rationalist stance.

The oppositional nature of *Zenit's* utopia tied the Yugoslavian avant-garde to other such movements in East Central Europe.[7] Yet despite certain similarities, such as the critique of bourgeois mercantile values and a rejection of reification, *Zenit* differed from its contemporaries in its utopian aspirations in several important ways. For example, unlike the major figures of both Russian and International Constructivism, Micić did not propose to advance Enlightenment rationalism but to invert it. He ignored production forces and conditions of labor, and until the final stages of the *Zenit* venture he never mentioned the working classes. He never called for class struggle or the dictatorship of the proletariat, and never presented Communism as an ideal state. Consequently, I will argue, rather than as a concrete form of social organization, Micić regarded utopia as a function, whose motivating power resided in poetry and works of art.[8] The form of these artworks remained open, as Micić refrained from imposing specific models just as he avoided rigid dogma. He alternately upheld and rejected technological civilization, fought for and against individualism, and both praised and condemned Expressionism and Constructivism. In his view, all were essential components in the process of change. This integration of contradictory principles drew accusations of eclecticism. To some, Zenitism looked "chaotic, intoxicated with burning confusion that destroys…creation." According to this position, Zenitism was "hotheaded, young, wild, direct, and stirring," and for the reviewer this seemed inadequate.[9] Others considered *Zenit* a hodgepodge of ideas, much ado about nothing,

Ljubomir Micić in front of poster for First International Zenit Exhibition, 1925

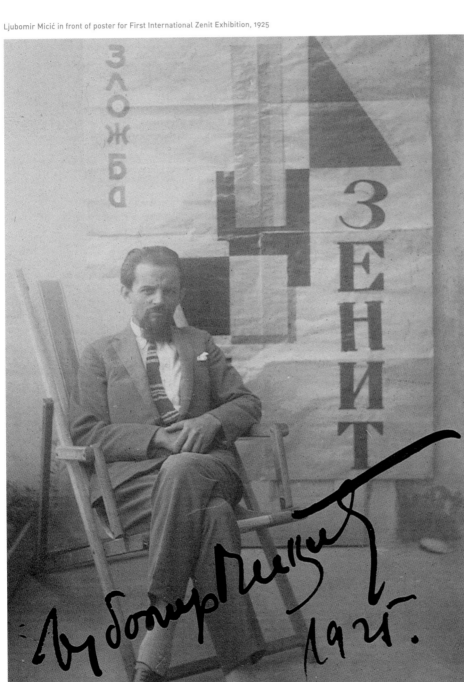

Micić compared intellectual Europeans to moths that devoured more paper than all the mice in all the harbors in all the continents.

and dismissed it as disturbing Dadaist noises.[10] With Micić's help, I will attempt to clarify the heterogeneity that characterized the Zenitist utopia and to argue that the avant-garde never presented a monolithic modernist discourse.

Micić's eclecticism was not accidental. On the contrary, it was essential to his plan to integrate all poetry and avant-garde art into a new, superior synthesis. "Zenitism," he claimed, "aspires to unite the streams of all movements until they become one single waterfall."[11] *Zenit* orchestrated those multiple sounds of the waterfall by publishing the works of a wide array of international artists who, in Micić's view, transcended national idioms and boundaries and united around a common cause.[12] The cause demanded a critique of reason to arrive at the revolutionary transformation of humanity through art and poetry. To support this claim for an essentially spiritualist end, which discarded all materialist considerations, we must consult Micić's program articles and pronouncements on art. Before we proceed, however, we should note that Zenitism was largely a one-man school, which other artists joined and left after varying periods of collaboration. Furthermore, for Yugoslavian (Serbian and Croatian) painters their experience with *Zenit* represented their only courtship with the avant-garde; for after their association with Micić they returned to order, to mainstream Yugoslavian art.[13] This essay, therefore, concentrates on Micić's texts. Since they have not yet been translated from the original Serbo-Croatian into any Western European language, it will be necessary to quote them at some length. In what we might term a declaration of faith, Micić explained that, in his opinion,

art means Expressionism, a strong will to create new values and new forms. It is a mighty will…and a passion for eternity. It is the cry of our love. A cry for salvation and regeneration… *Zenit* advances to face young Yugoslavia and announces its rebirth: New Man! New Spirit! New Art!

Oh zenith sun! You blaze like the fire of sacrifice. Our eyes are yellow from the fire and long for the highest throne—that of the Spirit. Our soul overflows with the will to reveal itself. Art is the great manifestation of the spirit, the great satisfaction of man's desire… Art has found its most significant affirmation in Expressionism.[14]

Micić further equated Zenitism with Expressionism and stated that the two movements acted as "reflecting mirrors, in which we glimpse our terrible inner pains, the dramas of our souls."[15] It follows that the journal's publication of works by Yugoslavian and foreign artists who might be loosely defined as Expressionist indicated a deliberate choice on Micić's part.[16] The first artist to appear on the pages of *Zenit* was the Croatian Vilko Gecan (1894–1973) with two drawings, *Luđak* [Madman] of 1920 and *Konstrukcija za portret cinika* [Construction with Portrait of a Cynic] of 1921.[17] In the second drawing, in particular, Gecan treated the subject in a manner that recalled compositional devices associated with German Expressionism: exaggerated facial expressions and conspicuously bony hands in a shallow space traversed by long diagonals that close in on a figure. *Zenit's* two subsequent issues reproduced works by Egon Schiele, but Micić soon turned to publishing Cubist canvases—works by Leopold Survage, Albert Gleizes, and early Cubistlike linocuts by Karel Teige, for example.[18] Yet neither the appearance of Cubism in the journal, nor the later reproductions of works by El Lissitzky, László Moholy-Nagy, and Alexander Rodchenko, signified that Micić embraced Cubism or that he endorsed the precepts of Constructivism, Russian or International. Rather, *Zenit's* mission, according to Micić, was to propagate information on all forms of avant-garde art; and Micić, in fact, thought nothing of contradicting himself.

On one occasion Micić insisted that like Hungarian Activism, Zenitism rejected Expressionism. But just a few months later,

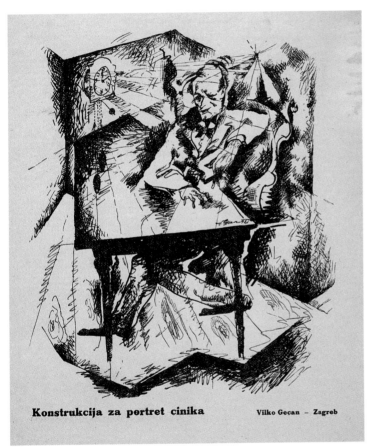

Konstrukcija za portret cinika Vilko Gecan – Zagreb

Vilko Gecan, *Construction with Portrait of a Cynic*, 1921, illustration in *Zenit* (no. 2)

after *Zenit's* publication of Cubist works, Micić declared his distance from rational construction and confirmed his affinity with the work of Wassily Kandinsky and Marc Chagall.[19] In his view, in stark opposition to Cubism,

the will seethed to create a new spiritual atmosphere…in which spirituality gushes forth as a necessity = expressionism = open form = dematerialization = metaphysics. The creation of new and larger worlds, whose existence is not conditioned by nature… In the first place stands the spiritual-absolute and mystic core that is at the depth of the soul—Kandinsky. Or the feeling of color…as a means to express the imaginary tremor of the heart and the mind, the flesh and the spirit; a deep spiritual hurling of the animal and the human—despair—the interior world of man— Chagall. Possibly, the only artist who as an Expressionist offers a synthesis which Western Cubism coerces in a mad and limiting fashion. And Paris, with its egotistic jealousy devised a cruel model (art does not tolerate models) and set the foundation for geometric paintings. Construction and mathematics, which in no way stand close to our Yugoslavian heart, and our heart is in no way inclined to them.[20]

Similarly, Micić praised the work of painter Jovan Bijelić (1886–1964) for its genuine Expressionist idiom. The artist, he observed, created symphonies of colors like Kandinsky. The free, open, and elemental forms in his *Borba dana i noći* [The Battle of Day and Night] of 1921, for example, communicated an experience of purity. He further argued that the painting was "spiritual, abstract" and that it reflected the Slavic "melancholic spirit and poetry."[21]

Another artist whom Micić praised and considered an independent spirit of great promise was Mihailo S. Petrov (1902–83), a native of Belgrade. Petrov composed his abstract linocuts like *Rhythm* (1921) and *Linoleum* (1921) on the expressive contrast of black and white, full and empty, and on the rhythm of lines. The first translator into Serbo-Croatian of

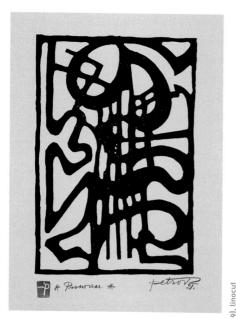

Mihailo S. Petrov, *Rhythm*, 1921, linocut

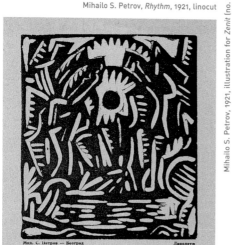

Kandinsky ("Painting as Pure Art"), Petrov associated sounds with forms and bound them together with a contemplation of imminent gloom. A free translation of one poem, "Contemporary Sound," which concluded his published work in *Zenit*, might read as follows:

All spirals are strained / cynical and gray / and the circle / O / appears on the snow-white field / Triangles carry the world on their shoulders / and in the center a magic dream! / Today / in this dull repentance day / our seven sins / we pray in vain. / Oval is Pain / the parabola a cry / and the disjoined red sound is we / who flow through the ether / and tone![22]

Petrov's work appeared in *Zenit* until Micić ended the relationship, after the artist participated in a Dada evening and published in Dada-oriented journals.[23]

Despite the break, Micić entrusted Petrov to design the poster for the First Zenit International Art Exhibition that opened in Belgrade in April 1924.[24] The poster's grid pattern of straight lines, a similar layout to that used by Micić for the cover of *Zenit* and his books such as *Archipenko: Plastique Nouvelle*, led some scholars to conclude that Zenitism was a variant of Russian and International Constructivism.[25] According to these historians, Micić converted to the Constructivist program after meeting Lissitzky and Ilya Ehrenburg in Berlin on a visit to Herwarth Walden[26]— a conversion, moreover, that resulted in *Zenit*'s subsequent Russian issue.[27] To support the Constructivist thesis, the art historian Irina Subotić quotes Micić as arguing that "[t]he new painter must collaborate with the engineer and create works that serve real life, works that do not act only as documents of artistic and cultural values but serve people who live in urban societies, that is, in societies of trains and cars."[28] It is true that Micić's poetry of "words in space" and his montagelike prose of very short sentences (some examples of which we have seen in the quotations from his texts) emulated the quick pace of modern life. He also printed Ivan Goll's lengthy poem "Paris brennt," his hymn to modern urban culture.[29] The cover of this edition of *Zenit* features the Eiffel Tower, the icon of modernity for an entire generation of avant-garde artists, and other illustrations depicting similar symbols of recent technological conquests, like a giant wheel.[30] Yet, Subotić's quotation represents the only case in which Micić pressed artists to produce useful objects. On all other occasions, both before and after his introduction to the Russian avant-garde, he defended the autonomy of art. He viewed poets as rebels and "spiritual anarchists," and he insisted that Zenitism was fighting for the revolution of the spirit.[31]

Micić condemned all realist works of art that were created in Yugoslavia before the advance of Zenitism

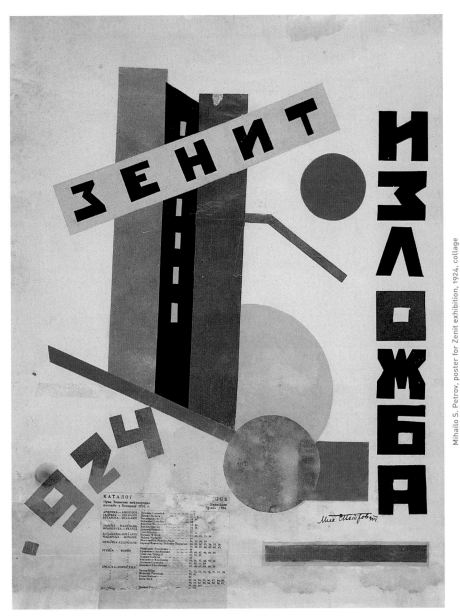

Mihailo S. Petrov, poster for Zenit exhibition, 1924, collage

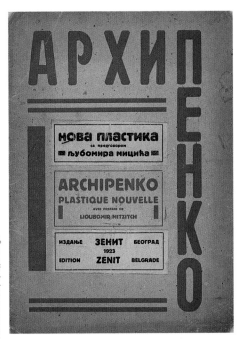

Ljubomir Micić, *Archipenko: Plastique Nouvelle*, Zenit Publications, 1923

My counterargument to the assertion of Micić's Constructivist leanings has two goals. First, the refutation of *Zenit's* accord with Russian Constructivism will confirm the latter's fundamental connection with industrial production, a theme that others have discussed at some length, and which falls beyond the limits of my present subject.[32] Second, and more in line with my topic, a study of their relationship will elucidate Micić's antirationalist discourse and his particular utopian impulse. This dimension of Micić's philosophy will be considered in due course, with the study of his alleged Communist convictions, but first we must examine *Zenit's* ties to Constructivism.

Zenit's Russian issue presented the gamut of Russian avant-garde art and poetry, and it included mostly material that Lissitzky, the guest editor, had previously published in his and Ehrenburg's Berlin journal *Veshch/Gegenstand/Objet*. As is well known, *Veshch* did not aggressively promote Constructivism; it even ignored the movement's final anti-aesthetic, Productivist resolutions.[33] Except for Vladimir Mayakovsky's poem "Svolochi" [Swines], Vladimir Tatlin's *Monument to the Third International*, and a Rodchenko hanging construction, *Zenit's* content can hardly be termed Constructivist. It included, among other things, poems by Sergei Esenin and Boris Pasternak, a short note on new poetry by Velimir Khlebnikov, reproductions of Kazimir Malevich's linocuts *Black Square* and *Black Circle*, and his "Resolution 'A' in Art."[34] But even if the issue had endorsed Constructivism, it would not have signified Micić's adherence to Constructivist designs, just as the material on Dada did not indicate that he applauded Dadaism's destructive objective. Concerning Dada, Micić published a small, short anti-Dadaist book *Dada-Jok* (*jok* is "no" in Turkish) to counter Dadaist allegations made against him.[35] And *Zenit* remained as eclectic as ever.

A Moholy-Nagy linocut appeared on the cover of the following issue, but subsequent issues depicted reproductions of works

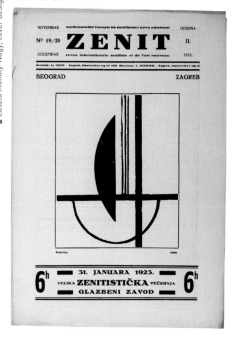

Dada-Jok, 1922

Micić converted a presumed Balkan cultural deficiency into a Barbarian virtue.

by Kandinsky, Alexander Archipenko, and Jozef Peeters, among others, and the design for the Einstein Monument by Erich Mendelsohn. Micić's program article, which appeared soon after the Russian issue and from which Subotić quotes, conveyed ideas that both echoed and refuted Constructivist causes. Micić argued that the new collective expression should be consistent with the current epoch of "airplanes and machines, of radiotelegraphs, technological acrobatics, and speed." By itself, this may have been consistent with Constructivist ideas, but his next claim echoed Italian Futurist notions, as Micić affirmed that Zenitism was a "savage eruption" that would introduce "healthy male virility" into art. He further defined "male virility" in alarming terms, for he promised that the new age of virile males would banish "coffeehouse decadents—heirs of Baudelaire...[and] European degenerates—heirs of Casanova and the Marquis de Sade."[36] In a later essay, one that Micić must have considered most important, for he used it to introduce Zenitism to readers from Warsaw to Brussels and from Berlin to Paris, he claimed that poetry was born in a sphere "beyond reason" (*vanum*: a Serbo-Zenitist word).[37] In sum, Micić held to his own opinions. For him, a poem erupted from the depths of the soul, of "vanum," that is, free of "utilitarian reason," which, as Malevich used to say, only answered specific, utilitarian needs. Similarly, a poem for Micić stood above national and class exigencies; it could never "connect to ideology [for] connective strings and garters are used by women to keep their silk stockings in place."[38]

To prove Micić's equally anti-instrumentalist notion of the visual arts we must consider his artistic statements and his evaluations of particular works. Works of art presented a cognitive understanding of the universe, and through them artists sought to reveal "the soul's affinity with the cosmos."[39] Micić agreed with Kandinsky, who equated abstraction with spirituality. Such spiritual revelations, therefore, required abstract paintings. Micić condemned all realist works of art that were created in Yugoslavia before the advance of Zenitism, because, in his view, they represented coarse matter and displayed mere craftsmanship: "And generations lived in error, for they did not know what art was." But Micić departed from Kandinsky in his assertion that a work of art had "nothing to express but itself."[40] In a lecture at the opening of the Zenit International Art Exhibition in Belgrade in April 1924 (that is, after his supposed conversion) Micić defended this unconditional autonomy of art.

Uncharacteristically, and contrary to his usual declamatory style, in this lecture Micić reasoned. He explained that he objected to extra-artistic references in a work of art because art connoted absolute creation and was a manifestation of the spirit. To prepare the visitor for the exhibition, he advised his audience not to look for resemblance with nature but only for the "vitality of painting, nothing more." The artist, he affirmed, could add even peasant shoes at the base of a crucifix or paint an upside-down head, like Chagall, because "from the point of view of a painting, the important things are the principles upon which it is based. These may be sorted into three groups: form, color, and space." This assertion, which was not a major revelation in 1924, here applied to the work of the last artist to join *Zenit*, the young Jo Klek (1904–85, pseudonym of Josip Seissel). Klek's nonobjective compositions, many of which appeared on *Zenit*'s pages and in the exhibition, prompted Micić to further declare that "finally, painting has freed itself from literature, history, and amateurish copying" and thus had approached the condition of music. This art, according to Micić's startling association, never repeated "the braying of donkeys, the neigh of horses or the howling of Mary Magdalene at Christ's feet,"[41] because art, like music, should never seek to reproduce what is found in nature.

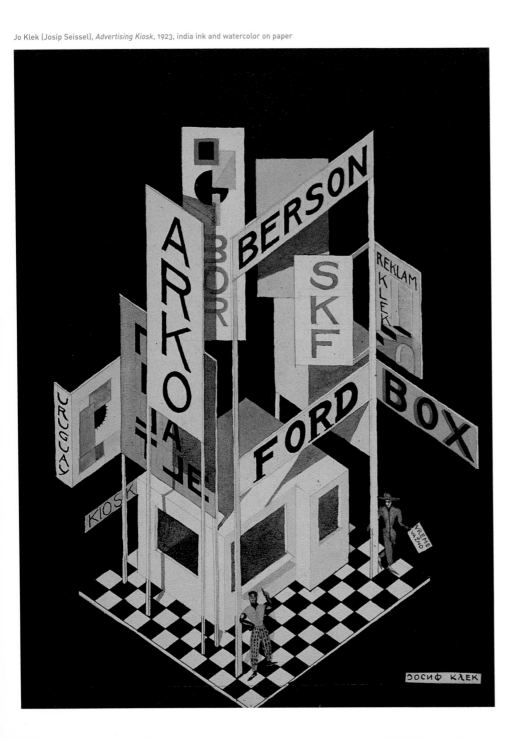

Jo Klek (Josip Seissel), *Advertising Kiosk*, 1923, india ink and watercolor on paper

[t]he Zenitist verb must electrify / Zenitist art must be a radiogram.

Klek, a twenty-year-old student at the time, drew visionary street scenes in which he juxtaposed interior and exterior spaces from contrasting perspectives. He also proposed imaginary projects for advertisement kiosks and fantastic plans for Zenitist villas, the instability of which was at odds with the architectural order that dominated Constructivism. Other works consisted of small-scale collages of colored paper and occasional photographs such as *Pafama* or *Nevero moja*, which Klek called Pafama [*Papier-Farben-Malerei*]. In Serbo-Croatian this translated as Arbos [(h)artija-boja-slika (paper-color-painting)], and Micić decided to name Zenitist painting after Klek's invention. Namely, instead of the fixed grid that ruled Constructivist photomontage Micić opted for randomly structured collages that fulfilled his anticipation for an art of illogic and free play. The artist's economy of means and scarce use of materials would produce, according to Micić, forms that appeared to be cut in marble and glass, whose purity was comparable to musical compositions. Micić concluded the lecture by asserting that "artists connected in a wonderful manner heaven and earth, hearts and souls."[42] Accordingly, he ignored Avgust Černigoj's self-termed Constructivist work, of which he must have been aware.[43]

Micić did not approve of Constructivist order. In fact, after close collaboration with the Slovene artists, Ferdo Delak, and his journal *Tank* Micić condemned their overt identification with Constructivism and censured Černigoj's contributions, Delak's principal ally in *Tank*.[44] Certainly, these reservations dated from a period after Micić's forced emigration to Paris, but while still in Belgrade, during the publication of *Zenit*, he failed to mention Černigoj's one-person "Constructivist" exhibition in Ljubljana in August 1924.

A native of Trieste, Černigoj (1898–1985) studied one semester in 1924 at the Bauhaus in Weimar with Kandinsky and Moholy-Nagy. Upon his return to Slovenia he settled for a short while in Ljubljana and quickly proceeded to mount a Constructivist exhibition in the city.[45] The show included disparate objects: various abstract constructions from 1924; machine parts; a motorcycle; the overalls of an American worker; and banners that declared "Capital is theft," "The education of workers and peasants is necessary," "Technological progress means redistribution of wealth," and "Artists must turn engineers, engineers must turn artists." Some constructions such as *Relief El* and *Relief g* were made of waste material, tin, wood, glass, and pasteboard. Models of architectural projects like *Wien Kolin* and *Klinika* were also included in the show. The strict orthogonals, stark white surfaces, and overall clarity of conception no doubt recalled works by

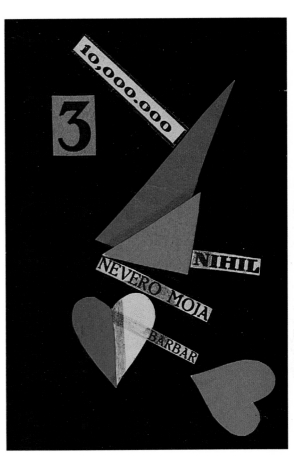

Jo Klek (Josip Seissel), *Nevero Moja*, 1924, collage

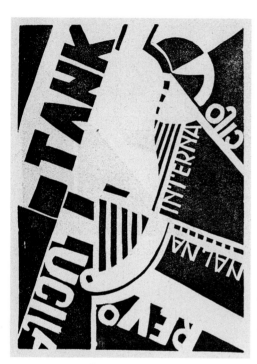

Avgust Černigoj, untitled, linocut, *Tank*, 1927 (no. 1 1/2)

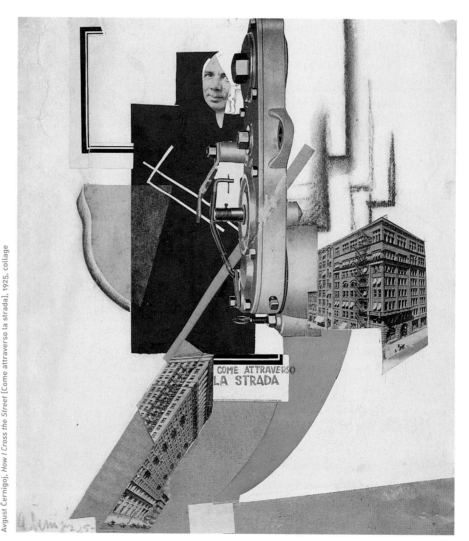

Avgust Černigoj, *How I Cross the Street* [Come attraverso la strada], 1925, collage

many Constructivist-affiliated artists in Germany and East Central Europe during the 1920s. Similarly, the slightly later photomontage *Come attraverso la strada* (1925), composed of regular geometric forms and machine parts, directly referred to Devětsil picture poems, and more particularly to Mieczysław Szczuka's contemporaneous photomontages. However, they contrasted greatly with Klek's collages of free-floating forms made from colored paper set against a dark background.[46] Černigoj's linocuts, some figural and others abstract, appeared in *Tank*, and he was responsible for the journal's dust jacket, layout, and typography.

Published by Delak and Černigoj, *Tank* appeared in Ljubljana in late 1927 and lasted through two issues, no. 1½ and no. 1½–3. The name might have referred to Dragan Aleksić's earlier Dadaist journal *Dada Tank* (Zagreb 1922), but the unusual numbering, according to the art historian Vida Golubović, was drawn from Lissitzky's description of planimetric space in his "A. and Pangeometry."[47] If this reading is correct, the combination of influences reflected perfectly *Tank*'s eclecticism, which was even more remarkable than *Zenit*'s. Already on the title page of the first issue contradictory references could be detected; it declared that *Tank* was an "international activist journal," a subtitle that hinted at Lajos Kassák's activist journal *Ma*, and it directly quoted the Hungarian poet: "Here you have the heroes of destruction and here you have the heroes of construction." But the illustration for the title page was a Veno Pilon (1896–1970) print, which for brevity we will call a traditional reclining nude.[48] Inside both issues, representatives of all the "isms" of early twentieth-century art neighbored one another. The poems and essays revealed a similar variety, authored by Micić, Tristan Tzara, Anatoly Lunacharsky, Henri Barbusse, and Kurt Schwitters, to name a few of the most famous.

The declarations that opened the first issue, especially Černigoj's "moj pozdrav!" [greetings], recalled others of the kind. Written in lowercase throughout, "moj pozdrav!" closed with the signature "tovariš prof. avgust černigoj, konstruktivist." It contained many underlined words and consisted of short declamatory sentences that often ended with exclamation marks. Černigoj thus proclaimed:

long live new art = constructive / long live new art = synthetic / long live new art = collective … / our art is the creation of the spirit!/ our friend, who fights for new ways of life, is a spiritual hero!…/ tank is the organ of our aspirations and our spiritual struggle … / tank is the organ of truth and war / tank is the organ of the new artistic generation.[49]

So far there was nothing to contradict Micić's program, but he must have opposed identification with a movement other than Zenitism, and he surely rejected the Slovene artist's claim that "At the origin of the Slavic avant-garde stands Constructivism."[50]

To prove my anti-Constructivist argument and to clarify *Zenit*'s relationship with Russia and the Bolshevik Revolution, it is necessary to consult Branko ve Poljanski's review of the First Russian Art Exhibition in Berlin in 1922.[51] Poljanski devoted a large part of the essay to Malevich, "the great creator of Suprematism," and to other artists who, in his view, followed the principles of Suprematism. Malevich's strong-colored forms, he explained, were divorced from objective reality, and thereby attained the highest level of pure sensation. He marveled at *Red Square* and exclaimed, "A frame, a red square. Nothing else. In front of this picture, I learned how red attained its most intense expression. It is an essential red that remains red forever." In the work of Lissitzky, whom he considered a Suprematist, Poljanski detected the translation of the master's visionary ideas into useful constructions such as trains, bridges, submarines, and airplanes. He attributed this application of Suprematism to an urgent need to reconstruct Russia (not the Soviet Union). Constructivist sculpture seemed to Poljanski equally to follow Malevich, and he suggested calling it "Supremasculpture," a term he used to qualify Tatlin's work. In his view, Tatlin created autonomous works of art that could never serve as decorations for "aesthetic onanism." He was thus moved by the artist's counterreliefs, which, he claimed, filled his soul with "pancosmic" happiness; through them he felt "the break of the Revolution's thunder." Rodchenko appeared to Poljanski as a meteor and a "Russian Archimedes." His hanging constructions were permeated with a "silent balance," and since they depended on cosmic laws, no artificially produced power could disturb them. Poljanski mentioned other artists such as Naum Gabo and David Burljuk, yet he never noted the constructions of the Obmokhu group (Karl Ioganson, Vladimir and Georgii Stenberg, and Konstantin Medunetskii). It was Malevich whom he credited with working for factories.[52]

Poljanski commended the artists' efforts to rebuild their homeland—Russia. In his view, Malevich was a great artist endowed with the Russian spirit (he ignored Polish insistence on Malevich's Polish origins), and the preeminent representative of an independent, non-European, Russian movement. Lissitzky, as noted earlier, focused on reconstructing Russia; Tatlin contributed to the glory of all

Russians; and Rodchenko embodied contemporary Russia. Poljanski never mentioned the Soviet Union, and the exhibition did not present the achievements of the Soviets. Micić's preface to Poljanski's article is striking in that he claims to have published the review, even though the exhibition was long over, "so that a little more could be heard of the Slavs in the sea of Latins."[53] Only at the end of *Zenit's* history, in early 1926, does Micić eventually refer to the proletariat and equate Zenitism with Marxism.

Until then, Micić's war was fought exclusively between Moscow and Paris, where the forces engaged in a battle of cultures, not of classes.[54] He called for artists to revolt against, destroy, and reform the world order, but he never mentioned October, the revolution that had been.[55] The transformation of the world awaited him, and he urged "a heroic struggle for the spirit…for fraternity among people." He thought that it was time for a man from the East, "from the Urals, the Caucasus, and the Balkans, whose birthplace is in the cradle we name Russia," to create a new universal culture.[56] It was as if the Bolshevik Revolution simply had never happened; Micić objected to Yugoslavian anti-"Russian" politics and to the staging of anti-"Russian" plays, for these offended his compassion for his "Russian brothers." He protested the stirring of "quarrels, hatred, and disputes between sister nations."[57] There was no October because unlike the Russian and International Constructivists, Micić did not share the ideal of social stability under Communism and he rejected the order of its pictorial representation. He longed for another revolution sparked by another utopian impulse. The two parties in his war were the Slavs and the Latins, with the Slavs as the new Barbarians who had arrived to revolutionize the weary civilization of old Europe.

The association of Slavs with Barbarians first appeared in *Zenit* in Alexander Blok's poem "The Scythians." Blok urged the West not to fear the Russian people, whom it deemed a horde of Barbarians, and ended the poem with the Barbarian lyre's invitation to a fraternal feast "[w]here labor beckons and where peace abounds."[58] Micić adopted the label "Barbarian" and coined the term "Barbarogenius" to indicate Balkan creative energy. In its early uses the sign had no fixed referent and sometimes carried negative connotations. For example, Micić lamented that the Balkans' only cultural heritage consisted of stories of "Prince Marko and Kossovo," of "a Barbarian yesterday," and he refused to be a Barbarian any longer. He further deplored the fate of men and women who for centuries died as "Barbarian slaves" for the freedom of their "race," and declared that the first Zenitist (himself)

replaced the last Barbarian.[59] "Barbarian"—without a fixed referent and akin to a two-decade-old attraction to the "primitive"—appeared also in the Zenitist manifestos written by Boško Tokin and Ivan Goll in the early years of *Zenit*. In one text Tokin argues that "Barbarian" signified "initiation, aptitude, and creation," and claims that "Nietzsche, Whitman, and Dostoevsky were Barbarians, for they marked new beginnings."[60] Similarly, Goll presses for a return to the original sources of experience, to the "simplicity of words to barbarity! We must transform ourselves into Barbarians of poetry / The barbarity of the Mongol, the Balkan, the Negro, the Indian."[61] In the slightly later "Der Expressionismus stirbt" [Expressionism is Dying], Goll puts his hopes in young forces that have arisen after the war to new tasks: "Beyond the Urals, the Balkans, and the oceans, new countries announced their will to live and to have power. Young countries, young men. Their first word to us is electric."[62]

Goll's electric word was "Zenit" and it echoed Micić's contemporaneous demand that "[t]he Zenitist verb must electrify / Zenitist art must be a radiogram."[63] Zenitism, according to Goll scholar John J. White, unleashed new visions for the poet as it introduced a "vertical aesthetic."[64] In accord with the Zenit image, then, Goll proclaimed that the sign of modernity was the ascending line:

The sonnet was square / Ancient drama was triangular…/ The poetry of our time is VERTICAL / it climbs to the Zenith with airplanes, lifts, cars, in Eiffel towers, in chimneys / man climbs vertically / OBELISK.[65]

Micić, unlike Goll, trusted that the diagonal would pierce the heavens on its own.[66] He had no use for electric or other devices since, more than simply a literary or artistic style, Zenitism was, figuratively speaking, a self-propelled apparatus for spiritual ascension. Micić asserted that *Zenit* partisans were children of the sun, who would rise over the mountains, "soar high above the terrestrial sphere of the globe."[67] Gradually, however, and as "Barbarian" acquired fully positive connotations to denote men and women of the Balkans, Micić identified an inner spiritual disposition found only in the people of the East and announced that "Zenitism = East, the airplane of the Spirit."[68] Zenitism thus acquired the dimension of West and East, the contrast of master and slave, for Micić converted a presumed Balkan cultural deficiency into a Barbarian virtue. He then articulated his argument in terms of race. The racist undercurrents of this line of thinking should not be ignored, but a charge of racism must be qualified, for prior to World War II racial allusions did not carry significant weight, and in fact Micić's

racist terminologies only countered French Latin arguments of exactly the same time.[69] Zenitism, Micić now contended, was born out of racial distress and aimed to introduce Europe to the positive elements of the Slavic race. Referring to the Balkans in particular, he accused the West of debasing its innate generosity and numbing its moral integrity. Nonetheless, he continued, the Balkan race bore a new spirit, which would eventually annihilate the "rotten fruit" of European pseudoculture.[70] He called for people to Balkanize Europe, to infuse it with new spirituality. So much was Micić taken by the Balkan discourse that he repeatedly insisted, albeit incorrectly, that it was not the Italian Guglielmo Marconi but Nikola Tesla, "a Serbian Barbarogenius from the Balkans," who had invented the wireless telegraph.[71]

Micić pitted Western rationalism against Eastern informal ethics, and opposed the Kremlin, the seat of Russian Orthodox piety, to the Eiffel Tower, a sign of Western technological feats.[72] To be sure, Micić never presented his position in a systematic fashion, but the study revealed that both before and after his purported conversion to Constructivism he rejected reason. He attributed Western decay to several major failings and saw the solution to the West's excessive rationality in the East. The West was doomed, Micić argued, because it exchanged the "religion of feeling for the religion of reason." By way of compensation, such feelings were reborn in "Iugoistok" [the Southeast] and the Barbarogenius carried "his pure faith, unfalsified soul, and good open heart" over the Balkans to Europe.[73] The major flaws of reason were Latin political thought, capitalist economy, and academies of formal studies.[74] Micić promised that Serbs and Russians, out of love for humanity, had ended the curse and had prepared a new life for a new human race. More precisely, Micić compared intellectual Europeans to moths that devoured more paper than all the mice in all the harbors in all the continents; Zenitism, by contrast, was "an eruption of the deep need for inner liberation from dust-covered academism."[75] With regard to the economic system, Micić roused his readers to an anticapitalist rebellion: "Demolish the big infected suburbs of Western European towns! Smash the windows of gold-coated palaces housing stock exchanges and national banks! Go home, you overblown war profiteers!" On the ruins of capitalism, Micić proposed to build "Zenitism–the third church."[76]

The "third church," despite the religious terminology, simply referred to Zenitism's role as the "third guest," mentioned earlier. Certainly, Micić's writing carried racist undertones,

"A frame, a red square. Nothing else. In front of this picture, I learned how red attained its most intense expression. It is an essential red that remains red forever."

and he permeated his diatribe against the West with sexist metaphors like "We wish to hang your perverse culture / of bordello keepers / precisely when you are on all fours / and laugh: aha…!" or "Dame Europe! We spit on your…abscess-full feet… Europe, stinking shark! In the name of Barbarian purity, we want to lift the mask off your lies."[77] Nonetheless, the resolution of the conflict concerned all humankind, as Micić planned to liberate East and West, Slavs and Latins, from the capitalist-cum-rationalist's grip. He did not propose to terminate European civilization but to temper it with what he considered Eastern values. For Zenitist humanity and human culture emerged from a synthesis in which Western rationalism was the thesis and Balkan spiritualism was the antithesis. It was, indeed, the idea of synthesis that motivated *Zenit*'s universalist aspirations; Micić was unrelenting in his efforts to spread *Zenit*'s message in Europe, to inform of its echoes in Western avant-garde journals, and to publish works of international poets and artists. When the Belgrade authorities forbade *Zenit*'s further publication, and the journal ceased to appear, Micić helped Delak in *Tank* work toward essentially the same ends.[78] Micić was the Paris correspondent, and to judge from the French material in the Ljubljana journal and from Delak's letters, he was an active collaborator.

Delak wished to continue where Micić left off and to prove that the Balkans were not lagging behind Europe. He wanted to be a "Barbarogenius" and to turn Ljubljana into a center from which messages of the revolution of the spirit would spread over the world.[79] In a declaration of intent written in Italian, Černigoj announced that *Tank* would form a bridge to connect all artistic groups in Europe and the Balkans, and invited artists in Italy to join the Constructivist art of the Slavs. Černigoj emphasized the international character of the journal. He promised to promote the activities of Slavic and international artistic avant-gardes, to publish the works of artists from all over the world, and to print essays and poems in all languages. Finally, he proclaimed that the editors' guiding principle was international collaboration, and that the journal would ensure the dynamic forces of the Constructivist spirit.[80] Despite this universalist stance, in his "East and West" article, addressed primarily to Trieste's Slovenian public, Černigoj qualified Constructivism as Slavic art and opposed it to Western excessive flourishes.[81] Similarly, in a letter to Micić, he tried to comfort his older colleague, who was living in Paris and complained of the decadent salon art exhibited in that city. He assured Micić of his faith in the Balkan race and shared with him his belief that Barbarians were better informed in all matters of art, and that their artistic talent was much finer than French, Italian, and German "commercial prostitution."[82]

Barbarian poets and visual artists had become agents of a world transformation and builders of a new pluralist, anti-rationalist future, whose precise image was left unspecified. Equally absent were concrete social conditions and questions of labor and politics, because Micić firmly believed that "[c]ulture and politics are never twin sisters. On the contrary. They are declared enemies. The eternal and the transient cannot mix."[83] He agonized over social injustice and cautioned that "satisfaction will not reign among people as long as some are flogging and others are being flogged,"[84] but he never recommended seeking a remedy in reasonable social institutions, in the revolution of production methods, or in a fair redistribution of wealth. He reiterated that the Barbarians—Serbs and Russians—would reform poetry and art, that they would destroy old forms and infuse them with Barbarian raw material, but he failed to measure his plans against verifiable data or to compare them with computable economic systems.[85] Up until the end of *Zenit*'s history Micić permeated his texts with words like "revolt," "revolution," "rebel," "rebellion," and "liberation," as in the assertion: "The only genuine, contemporary, and great poets are those whose verses are cries of rebellion and revolt against culture. The perfect deliverance from imaginary culture is the basic liberation of mankind."[86] Similarly, in the last issue of *Zenit*, in an essay that resulted in the ban on further publication, he announced that the source of Zenitism lay in Marxism and that their aims coincided, but still he exclaimed, "Long live the Barbarians!"[87] And "Barbarian," we remember, allowed for the irrational motives of men and women of the East in general, and of the poet in particular.

After Nietzsche, Micić marked the poet "insane" and dared the masses to distinguish the genius from the mad, if ever the difference existed.[88] Furthermore Zenitism, like Nietzsche's Zarathustra, rose up against Enlightenment humanism. According to Micić:

Zenitism addresses the man of heights and summits—a man who is capable of ascending indefatigably, a man who does not suffer vertigo when he looks down at the abyss below. Zenitism is for a man who will not die of the heat of the sun, a man who is destined to bear an abyss in his soul, to rise and touch the clouds, and carry the sun on his shoulders. A man who knows and accepts the fact that he stands above the crowd, whose laughter is like the bark of dogs at the full moon.[89]

It was to this superman that Micić left the task of revolution-izing Western materialist civilization and forming a different culture, one whose contours and contents he left open. His occasional religious references, the recurrence of terms like "resurrection," "salvation," and "deliverance," might tempt us to rank *Zenit*'s utopian longing among traditional, hence conservative or nostalgic, utopias. As Michael Gardiner argues, such utopias tend to form the future in the image of the past.[90] But Micić did not advocate a return to a lost paradise nor did he nurture fantasies of ideal cities to come. The charge of the poet was both narrower and higher, and Micić assigned him the role of the eternal agitator, of the Barbarian who would forever criticize and subvert the existing order. This conclusion, however, fails to fully account for the Zenitist utopia. For the one time Micić ventured into a depiction of what he deemed the desirable future, the image augured totalitarian regimes and genera-tions that squandered their poets. His new age banished the heirs of Baudelaire, Casanova, and the Marquis de Sade; it prohibited "long-haired youth, bearded men, or 'geniuses' with unkempt hair," unless they transformed themselves into "poet workers," who worked among the people for the common good.[91]

A man of many contradictions, Micić numbered contrariety among the equations of Zenitism (= East = third church = third guest) and declared that Zenitist poetry was the sign of an epoch of animated paradoxes.[92] Coherence belonged to reason whereas incoherence pertained to the Zenitist "vanum," the beyond-reason sphere, where one could be both for and against long-haired youth and white-haired academi-cians. Micić thus refused certainties; he preferred Klek's collage to Černigoj's photomontage, since the first accorded best with his own montagelike prose that precluded fixed and positive readings. Spiritual manifestations, he argued, could not be clothed in definite forms or preconceived direc-tions, because nothing could define the biological aspect of man, let alone the spiritual. "There are," he claimed, "hermaphrodites and there are dwarfs; there are giants and hunchbacks… There are some with the heart on the right-hand side. And there are Barbarians."[93] But in the history of the twentieth century the conflict between East and West did not result in a higher synthesis. Irrationality did not prove preferable to reason, and Barbarians perpetrated bar-barous acts that some still think would have been better fought with greater determination.

All translations from Serbo-Croatian are by the author. I wish to thank Mrs. Dina Kattan Ben-Zion for her invaluable help in this process.

1 Ljubomir Micić, "Savremeno novo i slućeno slikarstvo" [Contem-porary, new, and anticipated painting], *Zenit* 10 (December 1921): 12.

2 Micić published *Zenit* first in Zagreb, from February 1921 until May 1923, and then in Belgrade from February 1924 until December 1926. For a history of *Zenit* see Irina Subotić, "Avant-Garde Tendencies in Yugoslavia," *Art Journal* 49, no. 1 (Spring 1990): 21–27 and "*Zenit* and Zenitism," *Journal of Decorative and Propa-ganda Art* (Fall 1990): 15–24.

3 Micić, "Zenitizam kao balkanski totalizator novoga života i nove umetnosti" [Zenitism as a Balkan integrator of life and new art], *Zenit* 21 (February 1923): n.p.

4 Ibid.

5 Ferdo Delak, "Mladina podaj se v borbo!" [Young man forward to the battle], *Tank*, 1½ (October 1927): 5.

6 For the accusations of reaction and nationalism see *Veshch/ Gegenstand/Objet* 3 (May 1922): 9; *G* 4 (March 1926): 98. This was also the verdict of one Prague journal: see Jovan Krišič, "Zenitism," *Studentská revue* 1, no. 5 (February 1922): 103.

7 For a succinct summary of recent conceptualizations of utopia and much more see Michael Gardiner, "Bakhtin's Carnival: Utopia as Critique," *Critical Studies* (1993): 20–47.

8 On function and form in utopian thought see Ruth Levitas, *The Concept of Utopia* (New York: Philip Allan, 1990), 100–2.

9 Fr. Götz, "Zenitizmus," *Host* 2, no. 2 (November 1922): 64.

10 The Hungarian journal *Akasztott ember* quoted some passages from the German version of "Kategorički imperativ zenitis-tičke pesničke škole" [The cate-gorical imperative of the Zenitist school of poetry], *Zenit* 13 (April

1922) ["Kategorischer imperativ der Zenitistischen Dichterschule," *Zenit* 16 (July–August 1922)] and concluded that "All this does not only mean that the international clichés of Dadaism have reached the Balkans, it also means that the stink of bourgeois cultural decay has leapt geographical distances." *Akasztott Ember* 3–4 (December 20, 1922): 14. Karel Teige was not hostile, but for him *Zenit* was definitely Dada: see his "*Zenit*. Internacionalna revija za novu umetnost: Zagreb S. H. S.," *Červen* 4, no. 12 (June 1921): 181. The Czech poet A. M. Píša accused Teige of dilettantism and claimed that everything he wrote was but "dull reverberations of Dadaist Zenitism" (1923). In Artur Zádovský, ed., "Vzájemná Korespondence Jiřího Wolkra a Karla Teiga," *Česka literatura* 13, no. 6 (November 1965): 528.

11 Micić, "Nova umetnost" [New art], part 1, *Zenit* 34 (November 1924): n. p..

12 Micić, "Čovek i umetnost" [Man and art], *Zenit* 1 (February 1921): 2.

13 On the Serbo-Croatian world of art prior to and immediately after *Zenit*, see S. A. Mansbach, *Modern Art in Eastern Europe: from the Baltic to the Balkans, ca. 1890–1939* (Cambridge: Cambridge University Press, 1999), 226–35.

14 Micić, "Čovek i umetnost," 2.

15 Ibid.

16 For more on some of the Serbian poets who were published in the early issues of *Zenit*—Miloš Crnjanski (1893–1977), Rastko Petrović (1898–1949), and Stanislav Vinaver (1891–1955)—see Milne Holton and Vasa D. Mihailovich, eds., *Serbian Poetry from the Beginnings to the Present* (New Haven: Yale Center for International and Area Studies, 1988). Surprisingly, and to my regret, the authors failed to

mention Micić and *Zenit* in their Serbian anthology.

17 *Zenit* nos. 1 and 2, respectively. On Gecan, his relationship with Micić, and his later work see Subotić, *Zenit i avangarda 20ih godina* [*Zenit* and the avant-garde of the 1920s], exh. cat. (Belgrade: National Museum, 1983), 110.

18 I use "Cubism" loosely for brevity, since my topic does not concern Cubism.

19 For Micić's censure of Expressionism see his "Ma i madarski pokret aktivista," *Zenit* 6 (July 1921): 12.

20 Micić, "Savremeno novo i slućeno slikarstvo," 12.

21 Ibid., 13. On Bijelić's subsequent work see Subotić , *Zenit i avangarda 20ih godina*, 87–88, and Mansbach, *Modern Art in Eastern Europe*, 234.

22 *Zenit* 6 (July 1921), 10.

23 In early 1922, Petrov contributed two linocuts and one poem to *Dada-Tank*, a Dada publication by Dragan Aleksić (1901–1961), former collaborator of *Zenit*, and one linocut in the Novi Sad Hungarian journal *Út. Út* bore the subtitle "Activist Journal" and Kassák considered it a "brother" periodical to *Ma*. For Micić, however, it represented Dadaist tendencies and he objected to the publication of his "Zweiter Barbarendurchbruch" in its pages [*Út* 2, no. 1 (April 15, 1923)]. He refused to be neighbor to "cabaret writers and worthless Dada epigones." *Zenit* 24 (May 1923): n.p. On Petrov's work after 1925 see Subotić, *Zenit i avangarda 20ih godina*, 145–148, and Mansbach, *Modern Art in Eastern Europe*, 231–232.

24 On the exhibition see Subotić, *Zenit i avangarda 20ih godina*.

25 On Zenit's alleged Constructivist choice see Subotić, "Avant-Garde Tendencies in Yugoslavia," 22, and "*Zenit* and Zenitism," 20.

See also Vida Golubović, "The Constructivist Group in Trieste," in Aleš Erjavec, ed., *Coexistence among the Avant-Gardes* (Ljubljana: Društvo za estetiko, 1986), 77.

26 Herwarth Walden was the founder of Der Sturm gallery in Berlin and the Expressionist journal of the same name.

27 Krisztina Passuth has argued that Micić decided on the Russian issue and entrusted it to Lissitzky because he was attracted to the Bolshevik Revolution and to the persons of Trotsky and Lenin. See K. Passuth, *Les avant-gardes de l'Europe centrale: 1907–1927* (Paris: Flammarion, 1988), 176.

28 Subotić, "Un caractère international—destin de *Zenit*," in Erjavec, *Coexistence among the Avant-Gardes*, 257. The quotation is from Micić, "Zenitizam kao balkanski totalizator novoga života i nove umetnosti."

29 On the logic of "words in space" see Micić, "Kategorički imperativ zenitistčke pesničke škole," 17. It is significant that Micić chose to publish one poem that celebrated modernity in Kassák's journal *Ma*. A free translation of the opening lines of the poem "Howling" could read: "Poets / High over your heads airplanes rove / Radiotelephones defeated limp rhymes." *Ma* 8, no. 8 (August 1922): 59.

30 For an accessible reprint of Goll's poem in its first *Zenit* edition, together with illustrations, see Johannes Ullmaier, *Yvan Golls Gedicht "Paris brennt"* (Tübingen: Max Niemeyer Verlag, 1995). On Goll's modernity in general and on "Paris brennt" in particular see John J. White, "Iwan Goll's Reception of Italian Futurism and French Orphism," in Eric Robertson and Robert Vilain, eds., *Yvan Goll–Claire Goll: Texts and Contexts* (Amsterdam: Rodopi, 1997).

31 Micić, "Delo zenitizma" [The Zenitist work], *Zenit* 8 (October 1921): 2; and Micić, "Manifeste aux barbares d'esprit et de la pensée sur tous les continents," *Zenit* 38 (February 1926): n.p. French in the original.

32 See Hal Foster, "Some Uses and Abuses of Russian Constructivism," in *Art into Life: Russian Constructivism, 1914–1932*, exh. cat. (Seattle: The Henry Art Gallery, University of Washington, 1990), 241–53.

33 On the Inkhuk discussions and on *Veshch* and Constructivism see Christina Lodder, *Russian Constructivism* (New Haven and London: Yale University Press, 1983), 100–3 and 228.

34 The new material that Lissitzky printed in *Zenit* included David Sternberg's introduction to the catalogue of the *First Russian Show* and his own declaration at the congress of "progressive artists" in Düsseldorf in 1922, probably because *Veshch* ceased publication.

35 For Micić's explanations of the book see *Zenit* 14 (May 1922): 2. For comments on the publication of Dada material see his "Umetnički klub 'Zenit' u Pragu," *Zenit* 6 (July 1921): 12. Micić published a short excerpt from Amédée Ozenfant's and Charles E. Jeanneret's (Le Corbusier) "Purisme" and stated that he printed it without comments. See *Zenit* 15 (June 1922): 34.

36 Micić, "Zenitizam kao balkanski totalizator novoga života i nove umetnosti," n. p.

37 Micić, "Zenitozofia ili energetika stvaralatchkog zenitizma" [Zenitozofia, or the creative energy of Zenitism], *Zenit* 26–33 (October 1924): n.p. Full translations or shorter versions of this essay appeared in *Der Sturm* 15, no. 6 (September 1924); *Blok* no. 6–7 (September 1924); *7 Arts* 3, nos.

20 and 22 (April 2 and March 19, 1925); *Het Overzicht* 2, no. 24 (1925); and in French again as "Autour de Zenitisme" in *Zenit* 42 (July 1926): 1–2. Micić claimed that the article appeared also in *La vie des Lettres* and in the Southampton journal *4SN*, but I have not been able to obtain the relevant issues.

38 Micić, "Kategorički imperativ zenitističke pesničke škole," 18.

39 Micić, "Savremeno novo i slućeno slikarstvo," 11.

40 Micić, "Duh zenitizma" [The spirit of Zenitism], *Zenit* 7 (September 1921): 4.

41 Micić, "Nova umetnost," part 2, *Zenit* 35 (December 1924): n.p. On Seissel's work and his relationship with Micić, see Vera Horvat-Pintarić, *Josip Seissel*, exh. cat. (Zagreb: Galeria nova, 1978); Subotić, *Zenit i avangarda 20ih godina*, 121–26; and Mansbach, *Modern Art in Eastern Europe*, 231–32.

42 Micić, "Nova umetnost," part 2, n.p.

43 Branko Ve Poljanski, Micić's younger brother and closest collaborator, arrived in Ljubljana in April 1925 to prepare for a Zenitist evening there. Černigoj worked with Poljanski on the stage settings and the hall's decoration. See Peter Krečič, "L'avanguardia storica jugoslava: Il costruttivismo e lo zenitizmo," *Frontiere d'avanguarda gli anni del futurismo nella Venezia Guilia*, exh. cat. (Goricia: Musei Provinciali, 1985), 86–87. On Poljanski and the circumstances of his death see Subotić, *Zenit i avangarda 20ih godina*, 171–76.

44 Micić's criticism is inferred from Delak's answer: see F. Delak, letter to Micić, December 9, 1927, in *Tank Reprint* (Trieste: Mladinska Knjiga, 1987), 111.

45 For a detailed biography and for Černigoj's activities first in Ljubljana and then in Trieste see Krečič, *Avgust Černigoj*, exh. cat. (Idrija: Mestni muzej, 1978), and Krečič, "L'avanguardia storica jugoslava," 128.

46 On Černigoj's affinities with Russian and International Constructivism see my "The Avant-Garde in Yugoslavia: 1921–1927," *The Structurist*, 29/30 (1989–1990): 69–71. For Szczuka's photomontages see reproductions in *Dźwignia* 5 (November 1927): 12–15.

47 For the rapprochement between the names see Janez Vrečko, "Die Slowenische historische Avantgarde," in Aleš Erjavec ed., *Slovene Historical Avant-Garde* (Ljubljana: Društvo za estetiko, 1986), 169; Golubović, "Constructivism and the Slovenian Model," *Journal of Decorative and Propaganda Art* (Fall 1990): 62. On the Slovene art scene before and after World War I and on *Tank* in particular see Mansbach, *Modern Art in Eastern Europe*, 205–17 and notes on page 346.

48 On Veno Pilon see ibid., 214; and *Frontiere d'avangarda gli anni del futurismo nella Venezia Guilia*, 169–70.

49 Černigoj, "Moj pozdrav!" [Congratulations] *Tank* 1½ (October 1927): 7.

50 Černigoj, "Saluto!" *Tank* 1½ (October 1927): 8.

51 Branko Ve Poljanski, "Kroz rusku izložbu u berlinu" [Through the Russian exhibition in Berlin], *Zenit* 22 (March 1923): n.p.

52 On the participants and the works in the exhibition, and for a short reference to Poljanski's review see Andrei Nakov "This Last Exhibition Which Was the First," *The 1st Russian Show: A Commemoration of the van Diemen Exhibition, Berlin 1922*, exh. cat. (London: Annely Juda Fine Art, 1983), 24–25 and 36.

53 Micić, preface to "Kroz rusku izložbu u berlinu" [Through the Russian exhibition in Berlin] by Branko Ve Poljanski, *Zenit* 22 (March 1923): n.p.

54 See Micić, "Delo zenitizma," 2.

55 This was the accusation leveled against *Zenit* by the writer in *Akasztott ember*. In his view, the Zenit group sensed the chaos, but not the road out of it. "Even when Micić refers to Russia, he does so only as an enthusiast of Panslavism."

56 Micić, "Delo zenitizma," 2.

57 Micić, "Protiv jugoslavenskog antirusizma" [Against Yugoslavian anti-Russianism], *Zenit* 15 (June 1922): 36.

58 "Skify" [The Scythians] appeared in *Zenit* 3 (April 1921): 1. On the poem see Avril Pyman, *Alexander Blok: Selected Poems* (Oxford: Pergamon Press, 1972), 276–84. For an English translation see Albert C. Todd and Max Hayward, eds., *20th-Century Russian Poetry: An Anthology* (New York: Doubleday, 1994), 81–83.

59 Micić, "Duh zenitizma," 4. The foreign personalities who congratulated Micić on the fifth anniversary of *Zenit* (February 1926) used the name Barbarian to connote any agent of significant change. Fortunato Depero held that one had to consider a violent, Futurist, and Zenitist rebuilding of Europe, and that "It was necessary to combat barbarously." Theo van Doesburg welcomed Micić's idea of a Barbarian reconstruction of Europe and appreciated his fresh and primordial barbarism. But Carl van Eesteren inquired whether Micić was a true Barbarian and if he felt the necessity of barbarism for Europe. "I think," he wrote, "that barbarism is necessary for Europe. It will give her force." *Zenit* 38 (February 1926). In Russia, in the early years of the twentieth century, Barbarian often denoted anti-Hellenic forces that perturbed classical culture. See Sergei S. Khoruzhii, "Transformations of the Slavophile Idea in the Twentieth Century," *Russian Studies in Philosophy* 34, no. 2 (1995): 10.

60 Boško Tokin, untitled manifesto, *Manifest Zenitizma* (Zagreb: Biblioteka Zenit, 1921), 14.

61 Ivan Goll, untitled manifesto, ibid., 11.

62 Ivan Goll, "Der Expressionismus stirbt," *Zenit* 8 (October 1921), 9.

63 Micić, untitled manifesto, *Manifest Zenitizma*, 6.

64 White, "Iwan Goll's Reception of Italian Futurism and French Orphism," 24–26.

65 Goll, untitled manifesto, 12. Upper case in the original.

66 Micić, untitled manifesto, 7.

67 Ibid., 3.

68 Ibid. The Hungarian poet Reith Tivadar, editor of *Magyar Irás*, shared Micić's views and agreed with the Zenitist idea of East against West. In an introduction to Poljanski's presentation of Zenitism, Tivadar affirmed that the revival of the European spirit would be decisive in the East where young and vital masses had only recently awoken. But for him, East referred to Hungary and he asserted that "Unlike pseudo-intellectuals and loyal henchmen…we believe in the future constructive power of Hungarian culture and Hungarian spirit." *Magyar Irás* 5, no. 10 (December 1925): 125.

69 A vast recent literature exists on French Latin arguments, whose sources lay in considerations of race. See, for example, Kenneth E. Silver, *Esprit de Corps: The Art of the Parisian Avant-Garde and the First World War, 1914–1925* (Princeton: Princeton University Press, 1989).

70 Micić, "Zenitizm kao balkanski totalizator novoga života i nove umetnosti," n.p.

71 Nikola Tesla, as is well known, invented many things, but not the wireless telegraph. Micić defended Tesla's reputation on several occasions: "O elektrogeniju Nikoli Tesli," *Zenit* 15 (June 1922): 37–38, "Zweiter Barbarendurchbruch," *Zenit*, special German issue (July 14, 1922): 1; and *Avion sans appareil: poème antieuropéen* (Belgrade: Biblioteka Zenit, 1925), 12. French in the original.

72 "Delo zenitizma," 2. The contrast of East and West and Micić's critique of the latter's rationalism recall Slavophile concepts. I refrain from comparing the two notions because, as I will argue, Micić did not support the Slavophiles' regressive utopia. Micić's contemporaries sometimes held opposite views. Thus Jovan Krišič qualified *Zenit*'s project as new Slavophilism. In his view, Prague journals paid little attention to *Zenit*'s content because it was written in Serbo-Croatian and therefore incomprehensible. This seems a real possibility. The Hungarian Janos Macza founded his positive review of *Zenit* on Goll's Zenitist manifesto, which was written originally in German. Similarly, *Akasztott ember* quoted from the German version of "Kategorički imperativ zenitističke pesničke škole" (see note no. 10). For Krišič's review see *Studentská revue*; for Macza see his "A Zenitizmus," *Napkelet* 17 (1921): 1011–13.

73 Micić, "Duh zanitizma," 4; and "Zenitizm kao balkanski totalizator novoga života i nove umetnosti," n.p.

74 Micić, "Delo zenitizma," 2; and "Was ist Zenitismus?" *Zenit* 22 (March 1923): n.p.

75 Micić, "Zenitizm kao balkanski totalizator novoga života i nove umetnosti," n.p.

76 Micić, untitled manifesto, 3.

77 Micić, "Zweiter Barbarendurchbruch" and "Manifeste aux barbares d'esprit et de la pensée sur tous les continents."

78 On the circumstances of *Zenit*'s interdiction in Belgrade and Micić's further activities see Subotić, *Zenit i avangarda 20ih godina*, 164–66.

79 Delak, "Mladina podaj se v borbo!," 5; and "Mi" [We], *Tank*, 1½–3 (December 1927): 69.

80 Černigoj, "Saluto," 8.

81 Černigoj, "Vzhod in zahod v umetnosti" [East and west in art], *Učiteljski list*, 5 (March 1, 1926). In Krečič, *Avgust Černigoj*, n.p.

82 Černigoj, letter to Micić, March 3, 1927, in *Tank Reprint*, 102.

83 Micić, "Protiv jugoslavenskog antirusizma," 36.

84 Micić, "Zenitozofia ili energetika stvaralatchkog zenitizma," n.p.

85 Micić, "Moj susret sa Anri Barbissom" [My meeting with Henri Barbusse], *Zenit* 41 (May 1926): 22.

86 Micić, "Manifeste aux barbares d'esprit et de la pensée sur tous les continents," n.p. Emphasis mine.

87 Micić, "Zenitizam kroz prizma marksizma" [Zenitism through the prism of Marxism], *Zenit* 43 (December 1926): 13.

88 Micić, "Duh zenitizma," 3–4.

89 Ibid.

90 See Gardiner, "Bakhtin's Carnival: Utopia as Critique," 23–26.

91 Micić, "Zenitizm kao balkanski totalizator novoga života i nove umetnosti," n.p.

92 Micić, "Kategorički imperativ zenitističke pesničke škole," 17.

93 Micić, "Duh zenitizma," 4.

belgrade

Berlin Poznań Warsaw

Dessau Łódź

Weimar Prague Cracow

Vienna

Budapest

Ljubljana Zagreb

Belgrade Bucharest

In Belgrade the avant-garde was a literary phenomenon first, an artistic one second.

BELGRADE

Miško Šuvaković

Belgrade rests on the divide between Central Europe and the Balkans. Its architecture is a mix of Austro-Hungarian Baroque, Turkish orientalism, Serbian folk style, pseudoclassicism, and emergent modernism. In 1919 Belgrade became the capital of the new multiethnic Kingdom of Serbs, Croats, and Slovenes, later to become Yugoslavia. Between 1910 and 1930 its village-based feudal society turned into a bourgeois industrial one. The Belgrade Jewish community was both influential and active in public life, and feminist groups formed in the 1920s. In the next generation, descendants of merchants, industrialists, bank owners, and clerks were educated in European schools and began discovering modern and avant-garde art. In the world of painting, a paradox occurred. Modernist art (post-Cubism, Expressionism, *rappel à l'ordre*) and avant-garde art (Futurism, Dadaism, Zenitism) appeared concurrently between 1920 and 1925. At the same time, in complete opposition to these new movements, mainstream national artists pursued post-Romanticism and its great historical and national themes as well as utilitarian and bourgeois realism and Intimism, modeled after Bonnard, Lhote, and Utrillo.

Avant-garde art arose among small, closed, and often conflicted groups of students, intellectuals, and writers. In Belgrade the avant-garde was a literary phenomenon first, an artistic one second. Painters of the avant-garde were rare—the exceptions were the Dadaist and Zenitist Mihailo S. Petrov and the Surrealist Radojica Živanović-Noe. For members of the Belgrade avant-garde, magazines were much more than vehicles for presenting literary works. Their visual typographies were not purely decorative—they were agents for the new collage and montage practices as well as intertextual experimental structures. The development of avant-garde strategies began with semantic experiments within literary texts themselves. These strategies continued via typographic elaborations, in which typography cannot be separated from literary meaning. At the same time advertisements and their graphic design acquired the status of artistic intervention. These explorations extended finally to abstract painting, photography, and sculpture.

The writers Miloš Crnjanski, Rastko Petrović, Boško Tokin, and Stanislav Vinaver used the modernist techniques of collage, montage, and citation in their poems, novels, and essays. They collaborated for a time with Ljubomir Micić, founder of the Zenitist movement, but in 1921 formed the modernist-oriented Alpha group in opposition to Micić's anti-aesthetic interdisciplinary artistic practices. The writers of the Alpha group wanted to maintain the autonomy of their discipline while articulating the high aesthetics of an elite modernist art.

Accused of being a Serbian nationalist and an anarchist, Micić moved from Zagreb to

p. 279:
Mihailo S. Petrov, *Zeppelin above Belgrade*, 1930, photograph

Above:
Two Belgrade feminists, c. 1930

Left:
Circus Terazije, Belgrade, 1928

11

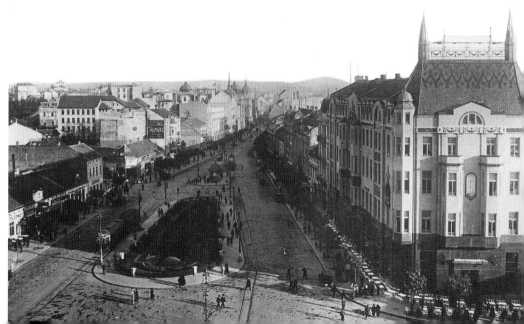

Belgrade in 1923, where he continued publication of his journal *Zenit*. The Zagreb issues of *Zenit* had been marked by Expressionism and Dadaism, and they showed connections to the German journal *Der Sturm* and the Hungarian avant-garde *Ma*, issued by Lajos Kassák. The last Zagreb issues point to certain links with Russian Suprematism and Constructivism. With the move to Belgrade, Micić began editing the magazine in the eclectic spirit of Zenitism. This can be seen in Dadaist and Constructivist typography and the often paradoxical, exotic, and varied content, which ranged from the leftist and revolutionary, to capitalist *Amerikanismus* and modernism, to right-wing utopian visions that approached the Nietzschean idea of the Superman.

Micić opened the *First Zenit International Art Exhibition* in April 1924 at Belgrade's Stanković Music School. The exhibition featured Louis Lozowick, Jozef Peeters, two artists identified only as Balsamdjieva and Bojadjieff, Robert Delaunay, Albert Gleizes, László Moholy-Nagy, Alexander Archipenko, Wassily Kandinsky, El Lissitzky, Jo Klek, Mihailo S. Petrov, Enrico Prampolini, and others. Notable among the Zenitists in the sphere of visual art were the Dadaist and Constructivist experiments of Belgrade-based graphic artist and painter Petrov and those of Klek, a Zagreb architecture student. Petrov's modernism began with Expressionism and continued through Cubism, Dada, and social realism. Klek's small opus is reminiscent of the Neoplasticism of the Dutch De Stijl as well as El Lissitzky's Constructivism.

In 1926 Micić was put on trial because he had used obscene words in a poem ("Motorless Airplane"). He defended himself in court, claiming that the words could be found in Paul's New Testament epistles. The last issue of *Zenit* was banned on account of Communist propagandizing, and Micić, denounced as a Bolshevist, left Belgrade. With the help of the Italian Futurist F. T. Marinetti he arrived in Paris, via Rijeka and Trieste, where he wrote and published Zenitist novels and poetry in French.

Branko Ve Poljanski, Micić's brother and *Zenit* collaborator, was active in Ljubljana, Zagreb, and Belgrade in the first half of the 1920s. He published in Ljubljana an Expressionist-Futurist magazine, *Svetokret* [Turning World], and in Zagreb the anti-Dadaist *Dada Jok* [Dada No]. In 1924 he exhibited his works at the Exhibition of Revolutionary Art of the West in Moscow. He had contacts with the artists of the Dutch De Stijl movement, and he polemicized with Marinetti. His last avant-garde gesture was to distribute his books *Tumbe* [Upside Down] and *Crveni Petao* [Red Rooster] to chance passersby on Belgrade's main square, Terazije, on a July Sunday in 1926. After that he left for Paris, where his paintings took on the character of the Parisian *rappel à l'ordre* style. In 1930 he published "The Panrealism Manifesto" and exhibited at the Parisian Zborowski gallery.

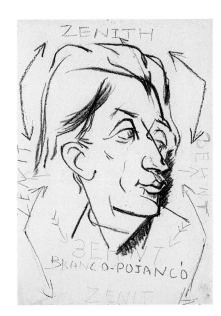

Dragan Aleksić, the third great avant-garde artist working in Zagreb and Belgrade in the 1920s, was the creator of *yugo-dada*, or Yugoslavian Dadaism. His interest in Dada began in 1920 in Prague, where he was a student. After breaking off a collaboration with Micić's *Zenit*, to which he had contributed verse and manifestos, Aleksić published the journals *Dada Tank* and *Dada Jazz*. He moved from Zagreb to Belgrade, where he renounced public Dada activity and began to work as a journalist with particular interests in sports and modern mass culture. His Belgrade period is marked by his attempt to make a movie in the manner of American burlesque, titled *Kačaci u Topčideru* [Smugglers in Topčider]. Nothing remains of the 1924 film besides a few still photos and newspaper clips.

Belgrade Surrealism emerged in the early 1920s from modernist experiments. Its beginnings can be traced from the radical modernist journal *Putevi* [Paths] through the journals *Crno na Belo* [Black on White] and *Hipnos*, and the Dadaist, pro-Surrealist *Svedočanstva* [Testimonies] and *50 u Evropi* [50 in Europe]. In the early 1930s members of Belgrade's Surrealist movement put out the almanac *Nemoguće* [Impossible] and journal *Nadrealizam Danas i Ovde* [Surrealism Here and Now]. The Belgrade Surrealist ideology was formed by poets, prose writers, painters, and photographers, among them Marko Ristić, Vane Bor (Stevan Živadinović), Aleksandar Vučo, Nikola

■ Lajos Tihanyi, *Portrait of Poet Branko Poljanco*, 1925, red and black crayon on paper

Vučo, Dušan Matić, Koča Popović, and Moni de Buli. Typically the Belgrade Surrealists were members of the upper classes who had been educated in Paris, where they had direct contact with André Breton. Their work was based on a Freudian-Marxist philosophy, and although the movement began with literary experiments, it soon began exploring painting (Živadinović-Noe), photography (Nikola Vučo, Vane Bor), and collage and assemblage (Marko Ristić, Dušan Matić). In the latter half of the 1930s, the Belgrade Surrealists renounced the movement in the name of the Communist revolution and socialist art.

Pavle Bihalji, Oto Bihalji, and Branko Gavela edited the left-wing modernist *Nova Literatura*. The magazine followed German leftist theory critical of society and art. Pavle Bihalji created Dadaist-Constructivist photomontages, similar to those of John Heartfield, for the magazine's covers as well as for book jackets.

A number of Belgrade artists formed more individualistic approaches to the avant-garde. Maga Magazinović, a philosopher, dancer, choreographer, and dance theoretician, founded a school for dance and gymnastics in 1910. She developed Expressionist dance pieces following the teachings of Jacques Dalcrose, Mary Wigman, and Rudolf von Laban. The composer Miloje Milojević used the libretto of future Surrealist Marko Ristić to compose Expressionist-Surrealist music for a performance of *Sobareva Metla* [The Valet's Broom], which was performed in 1923 at a ball called Hiljadu i Druga Noć [A Thousand and Two Nights].

Fatal interruptions and neglect characterized the fate of modernity within Belgrade culture. Throughout the twentieth century the city has been a battleground of opposing tendencies. One side pursued pro-Western avant-gardism, while the other was dominated by a conservative national culture that is strong even today. Branko Ve Poljanski moved to Paris, married, and had a family, but entered a mental hospital, and is said to have died, homeless, beneath one of the Seine's bridges in 1940. Dragan Aleksić died in Belgrade in 1958, and his collection of Dadaist artworks, including examples by Schwitters, Picabia, Tristan Tzara, and Huelsenbeck, was

destroyed after his wife's death in the 1960s. Ljubomir Micić lived, forgotten by everyone, in Belgrade from 1940 until 1970, followed and isolated by the Communist government as a decadent modernist, an eccentric, and a nationalist. He died in 1971 at a home for the old and the poor in Pančevo, near Belgrade. The Surrealist Vane Bor emigrated to England at the beginning of the Second World War. The Surrealist Marko Ristić was the first ambassador of Tito's Yugoslavia in Paris as well as an influential cultural persona during socialism. The Surrealist Moni de Buli studied in Paris and collaborated with the magazine *La Revolution surrealiste* and in the late 1920s worked with the movement Le Grand Jeu. No one knows what became of Mid, an unidentified Belgrade writer who was connected with Micić's Zenitism. His books *Seksualni Ekilibr Novca* [The Sexual Equilibrium of Money] and *Metafizika Ničega* [The Metaphysics of Nothing] appeared in 1925 and 1926. He disappeared, as did the others, in the subsequent rejection of the avant-garde by the mainstream national culture.

Translated by Maja Starčević

Above:
Vane Bor, 1927–29

Right:
Jelka Vučo, Marko Ristić, Ševa Ristić, 1929

When avant-garde art had been just a report from abroad, it had been understood as a sign of the decadence and degeneracy of Western culture.

Berlin Poznań Warsaw

Dessau Łódź

Weimar Prague

Vienna

Budapest

Ljubljana Zagreb

Belgrade Bucharest

Cracow

ljubljana

LJUBLJANA

Lev Kreft

If you visit Ljubljana today, your guide will outline its profile in a few obligatory strokes as the capital of the newly independent Republic of Slovenia, with 375,000 inhabitants. Site of the first-century-B.C. Roman city of Emona, Ljubljana has long occupied a strategic location at the crossroads of Alpine and Mediterranean Europe and the Balkan region, from the Central European Pannonian plain and beyond, to the Orient. But such a touristic description misrepresents Ljubljana as an important site of exchange, for despite its location, Ljubljana did not become a flourishing and important center. Until the First World War, even its position as the capital of the Slovenian nation was challenged. Modernity came to Ljubljana, but tradition resisted it. Even the arrival of the Southern Railway in 1857, connecting Vienna and Trieste via Ljubljana, did not bring the expected development and progress.

Slovenia came under Habsburg dominion in 1815; the Dual Monarchy of Austria and Hungary was introduced in 1867, and the Slovenes remained part of it until 1918. Regional administrative borders prevented territorial and political unity of the nation. Proposals to provide for an administrative region of "United Slovenia"—comparable to designations afforded other areas within the Habsburg imperium—were never actualized. The defeat of Austro-Hungary in the First World War enabled the Serbian monarchy to establish the Kingdom of the Serbs, Croats, and Slovenes as a centralized state, which forestalled Croat and Slovenian federalist nationalist tendencies. In 1920, a popular vote in Carinthia decided that the region would become part of the newly democratic Austria; in the same year the Treaty of Rapallo aligned one-third of the Slovenes with Italy, which would soon become a Fascist nationalist dictatorship. Thus, in spite of all the postwar political changes, independence and unity for Slovenia remained just a dream.

As in all Central European "dream nations," indigenous national languages, arts, and culture were the most important creators and representatives of national identity. Burdened with such expectations, artistic activity was far removed from any modern sense of autonomy. Artistic and cultural life took shape around organized movements and associations. There was a county museum of Carniola built in 1885, but a national gallery of Slovenian art was not established until 1918. Schoolteachers taught in the Slovenian language, and Slovenian books and journals were printed in abundance, but the Slovenian national university in Ljubljana did not open until 1919, and the National University Library, designed by Jožef Plečnik, was built only just before the Second World War. Among other things, this meant that intellectuals went to universities abroad, especially to Vienna and Prague. Along with their diplomas they brought back modern ideas and initially fought to introduce them in the parochial atmosphere, but each generation found that Ljubljana repeatedly suppressed and renounced their ambitions. This Romantic pattern of unrecognized artistic genius was the recurrent result of an inherent conflict in the demand for art that represented the unspoiled, true soul of the nation but that in artistic terms was equal to contemporary European movements. Each new artistic touch was confronted with reproaches that its up-to-date manner was alien to the national soul and

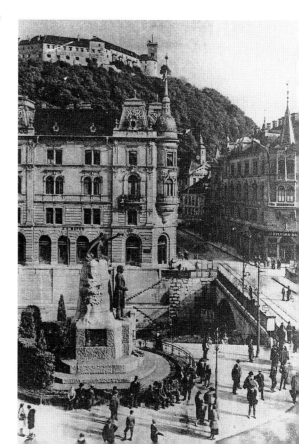

pernicious for national values. Nonetheless, critics lamented that Slovenian art and culture lagged behind developments in European artistic centers.

Anton Podbevšek and the Spring of 1920

The Slovenian avant-garde publicly announced its presence in the 1920s. Ljubljana at the time still matched a description written in 1895 by a German reporter who found it to be "a small town and great village in one." Because Ljubljana was well connected to other parts of Europe, prewar avant-garde movements from abroad were well known among local artistic and intellectual circles. Italian Futurism was presented as a new movement immediately after the appearance of Marinetti's first manifesto. Russian Futurism received attention from its prewar beginnings. The first wave of Slovenian avant-garde artists gathered informally at Novo Mesto, a small town near the Croatian border. In the spring of 1920 they mounted a group presentation there and, in what they termed their "attack on Ljubljana," in the autumn they organized an exhibition that expressed their belief that in the postwar atmosphere the time had come to shake the Slovenian artistic scene at its core. Subject to many influences and sources, among them German Expressionism and Italian Futurism, their art did not adhere to a consistent avant-garde attitude, with the exception of the poet Anton Podbevšek. After the show in Ljubljana, Podbevšek developed his program along anarchist "proletcult" (proletarian culture) lines for the journal *Rdeči Pilot* [Red Pilot], but none of the original group joined him. By the time his book of poems *Človek z bombami* [Man with the Bombs] appeared in 1925, he

had already ceased his avant-garde fight. Although in 1920 he had inspired the young generation with his "cosmic anarchism" (as his friend Miran Jarc labeled his beliefs derived from Nietzsche, Whitman, and social criticism) and his Futurist adoration of radical technological modernity, for the next wave of the avant-garde he was already a part of the past.

While the younger generation accepted the new art as an expression of excitement and as a break from tradition, Ljubljana's artistic, intellectual, and political establishment felt their basic values were under attack. This was not just about art and its new style but about power and leadership. When avant-garde art had been just a report from abroad, it had been understood as a sign of the decadence and degeneracy of Western culture. Now, when it was being presented as a genuine domestic movement, it elicited reproach as something alien to the Slovenian national values of humanism and nationalism. To attack national art and universal aesthetic values was seen as dangerously parallel to events in Russia. An art movement that conflated Western cultural decadence with the Russian breakdown of civilization could only be seen as the gesture of lunatics.

Srečko Kosovel: A Missing Link

Known to only a few of his contemporaries, poet Srečko Kosovel (1904–26) was the

■ Avgust Černigoj, untitled, 1926, collage

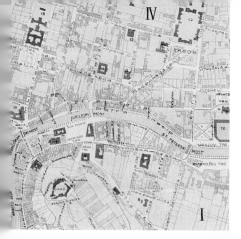

leader of an avant-garde group gathered around the journal *Mladina* [Youth]. He was in touch with Anton Podbevšek but rejected his ideas; he could have participated in the *Tank* projects of Avgust Černigoj and Ferdo Delak, but refused their invitation. After his early death in 1926, Kosovel disappeared from the public's consciousness, and his avant-garde poems surfaced only in the 1960s, when they were published for the first time. Written in a brief period during 1925, they represent a bridge in his development from his early "velvet modernism" to his later proletarian social radicalism. Debate over the sources of his potent avant-garde poetry has not ceased. Within this body of work, "construction" is the poetic motive as well as the title for numerous poems, and the Constructivist montage of fragments, together with "visual poetry," is the poem-building method.

Important to the development of Kosovel's avant-gardism (as in the case of Podbevšek and Černigoj) were the journal *Zenit* and the Zenitism of its founder and leader, Ljubomir Micić. For Kosovel and all other protagonists of the Slovenian avant-garde, the journal was an ongoing source of information about the different European movements—Dada, Hungarian groups, Suprematism, Czech Poetism, Russian Constructivism and Productivism, De Stijl, and so on—all of which were represented by their manifestos, poetic texts, and visual products. Kosovel's poems contain a radical criticism of Western European culture and civilization that refuses to follow the Zenitist path. They embrace some features of Marxist criticism, early Communist radicalism, and constructive proletarian

culture. Kosovel's avant-gardism was not purely destructive or negative but a socially productive artistic gesture that aimed for constructive synthesis. With his Constructivist poetry unpublished for so long, after his death Kosovel served as a model poet for Slovenian literature and politics, a kind of connection between the Slovenes' traditional national humanism ("velvet poetry") and revolutionary social activism. Publication of the long-lost poems destroyed this role and radically changed Kosovel's public image, but it helped to open the way for the new art of the 1960s and 1970s. In this way Kosovel represents a missing link between the historical and new avant-gardes.

Avgust Černigoj and Ferdo Delak

The journal *Tank*, edited by Avgust Černigoj and Ferdo Delak, first appeared in the autumn of 1927 and represented all that was new and dramatic in the Slovenian avant-garde. Černigoj returned from a short but meaningful Bauhaus experience in 1924, intent on bringing revolution to Ljubljana and organizing exhibitions. Delak started with similar ideas, influenced by the Futurist and proletarian theater of Enrico Prampolini and Erwin Piscator, respectively. Together Černigoj and Delak introduced Constructivist art to Ljubljana. To them it meant an artistic form influenced by Russian Constructivism and the Bauhaus, political ideas of proletarian revolution, and the "Futurist" modernization of backward-looking Ljubljana. Their efforts frightened artistic, political (even Communist), and bourgeois circles. When Černigoj was expelled from Ljubljana and the Yugoslav state in 1925 as politically dangerous, he continued his activities with the Constructivist group active in Trieste, thus bringing Constructivist projects and Communist revolutionary ideas into an environment already affected by Italian Futurism and Fascist ideology. Delak remained in Ljubljana and, besides *Tank*, continued his efforts in theater.

Černigoj and Delak's collaboration represents the highest point of the Slovenian avant-garde, both for their clear and manifest ideology and for the artistic value of their works. They released theater from its traditional discursive literalness into a

■ Avgust Černigoj, cover design for *Der Sturm*, 1928 (vol. 19, no. 9)

more visual and spectacular direction, and they turned from a flat pictorial sensibility toward a spatially aware, Constructivist avant-garde *theatrum mundi*. As they could not hope for immediate recognition in Ljubljana or Trieste, they looked to the international community. Ljubomir Micić's *Zenit* was the first likely outlet, but Yugoslav authorities had banned the journal in 1926 as Communist propaganda, and Micić went from Belgrade, via Rijeka and Trieste (meeting Černigoj), to his Paris exile. In spite of his international network, he could not continue his activities and could not promote Slovenian Constructivism there. The first international presentation of the Slovenian Constructivist avant-garde occurred in 1928 in Berlin, and their work was recognized by a special number of Herwarth Walden's journal *Der Sturm* in 1929. This recognition was in reality a finale, for the time of the historical avant-garde in Slovenia was already at an end. The artistic careers of Avgust Černigoj, Ferdo Delak, and members of their groups went in different directions.

Černigoj himself is here a unique figure because he represents an active and creative link between the historical avant-garde movement and the neo-avant-garde activities of the 1960s and later. He was the rare artist who became an important, even leading, influence to both. This linkage was important, because memories of the avant-garde in Ljubljana were buried deeply and in unconsecrated land. What Anton Podbevšek, Srečko Kosovel, Ferdo Delak, and Avgust Černigoj brought to the city—an artistic and proletarian revolution, a push to modernize life, culture, and art—has rarely been fully acknowledged.

Translated by Marjan Golobič

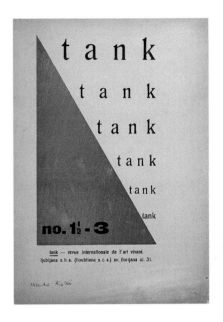

■ Béla Kádár, *The Visit of Shepherds*, c. 1925, tempera on paper

METHODOLOGY AND MEANING IN THE MODERN ART OF EASTERN EUROPE

S. A. Mansbach

It is only in the last few years that scholars have begun to recognize that the aesthetic production in Eastern Europe was as crucial to the evolution of modern art in the West as it was essential to the emergence of modern culture in the East.[1] Yet for more than a half century the history of modern art has been presented in the West—and mostly accepted in the East—as if twentieth-century advanced culture had been almost exclusively created in and defined by a succession of styles in Paris, Munich, New York, or Berlin. The narrative resulting from this now-canonical perspective has constrained the practice of art history and restricted the appreciation of the scope of modern art in general.[2] Through focusing narrowly on the Western centers of aesthetic creativity, a more historically accurate perception of the richness, diversity, and complexity of the classical modern art created through the entirety of Europe (and beyond) has been foreclosed. Moreover, privileging Paris, Berlin, and other Western cultural capitals has compromised the assessment of the seminal role played by artists active in Eastern and Southeastern Europe, from where modern art derived much of its authority and originality: Constructivism from the empire of the Romanovs, Dadaism from royal Romania, and unique forms of Cubism from Habsburg Bohemia, among other creative impulses.[3]

The limited appreciation of modern art's creative complexity was paralleled in the West by a towering insistence on modernism's universality. By insisting that advanced styles could be comprehended absolutely without acknowledging the determining factors of local traditions, indigenous reference, and contingent meanings stripped art of its deeper resonance and deprived it of its less obvious meanings. Indeed, much of the critical apparatus developed in the West—to assess the art created there—was incapable of seeing in the modern art of Eastern Europe its most distinctive character: its effective negotiation between the universal and the particular, between the local and the transnational. Because modern art in the West was created in an environment so different from that prevailing on the margins of industrialized Europe, critics in France, England, and especially the United States were unprepared to see in the modern styles from the East strategies of communication that departed decisively from those current at home. This restricted vision had a dramatic impact not only on the reception of Eastern European modernism in the West but also on the evolution of advanced art and avant-garde aesthetics in the East.[4]

A restricted and, ultimately, partisan perspective was not confined to Western Europe and North America, although the belief in modernism's pervasiveness was most avidly promoted there. In the East as well there was a commensurate narrowing of scope and critical perception, though it was often animated by different concerns and with differing consequences. Local social conditions and political agendas, as well as indigenous aesthetic expectations, positively shaped the language, content, and context for modern art from the Baltic North to the Balkan South. By attending to the specificity of place, one may grasp the creative ways in which transnational styles and avant-garde strategies were selectively adapted and inventively transformed. To do so, however, one needs to set aside prevailing paradigms.

Within the last few years, several publications have begun to rechart the intellectual geography of modernism.[5] In this context, the present project provides a timely stimulus for a further reassessment of the achievements (and failings) of artists active in this complex region. By attending to the strengths and weaknesses of the ways in which Eastern European modern art has been heretofore presented and received, the present volume may overcome the partiality and partisanship that has limited its appreciation and compromised the understanding of the modernist enterprise in general.

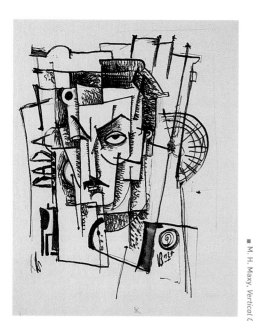

■ Victor Brauner, *Portrait of Marcel Janco*, 1924, ink on paper

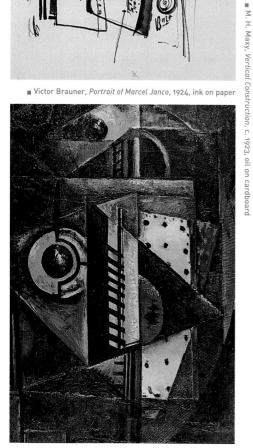

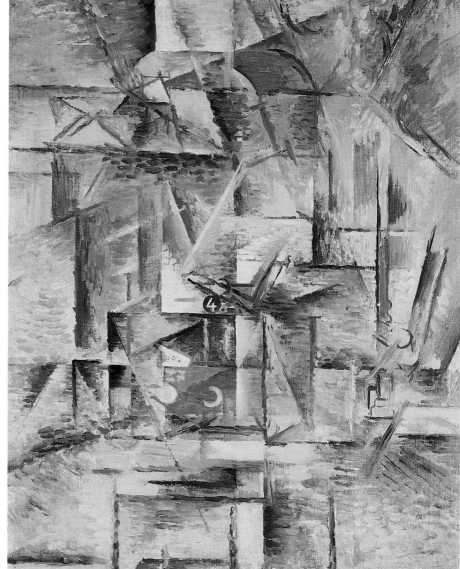

■ M. H. Maxy, *Vertical Construction*, c. 1923, oil on cardboard

■ Vincenc Beneš, *Tram, No. 4*, 1911, oil on canvas

Scores of painters, sculptors, and designers in Central, East Central, and Southeastern Europe audaciously and creatively defined the nature of modern visual expression and its social aspirations. Well into the 1930s—and then again beginning in Poland in the mid-1950s and in Hungary a decade later[6]— leading artistic personalities forged new visual cultures and educated new audiences in revolutionary ways of thinking, seeing, and behaving. Nevertheless, for the last seventy years a succession of mostly political developments, commencing with the rise of authoritarian regimes during the 1920s and 1930s and continuing to the close of the Cold War in the early 1990s, made access to Eastern European modern art difficult for Westerners and often politically precarious for Easterners.[7] As a result, awareness of the major modern monuments, their authors, and their contexts has been partial at best, and the discussion of modern art in the scholarly literature all too doctrinaire, both in the West and the East.

The cultural, political, and physical geography treated here should have been resistant historically to simplistic reductionism and deceptive uniformities. The complex record and diversity of the region—its range of nationalities, scope of cultural and linguistic traditions, and breadth of political experiences—might have been approached over the last seventy years with an appropriate multiplicity of viewpoints and addressed open-mindedly. Yet the region as a whole has been the victim of Great Power politics, cultural chauvinism, and shortsighted presuppositions. As a consequence, over time many in the West have been persuaded to adopt the misleading monolithic label of "Eastern Europe" to characterize as a whole those lands whose subtleties of culture and history could not easily be accommodated under the reigning (Western) paradigms. Thus instead of perceiving distinction and individuality, critics chose to see generality and uniformity; in lieu of acknowledging deep structural differences between "East" and "West," commentators promoted consistency and parallelism.

The motivation for this simplification and its resultant distortion was not purely political, although deeply held ideological and moral attitudes were decisive. Complementing the political, whether or not promoted by the state, was an equally significant aesthetic ideology, one inextricably linked to modernism itself.[8]

The traditional focus of modern art studies has been the visual culture in the industrialized nation-states of Western Europe and North America: the Low Countries, Italy, Germany, the United States, Great Britain, and especially

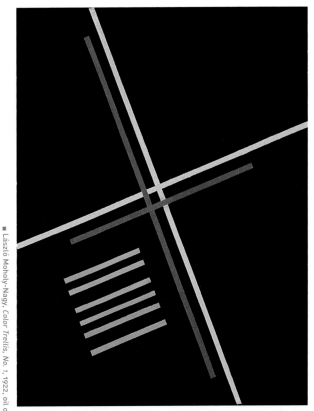

László Moholy-Nagy, *Color Trellis, No. 1*, 1922, oil on canvas and board

■ László Péri, *Space Construction 20*, 1922–23, tempera on shaped board

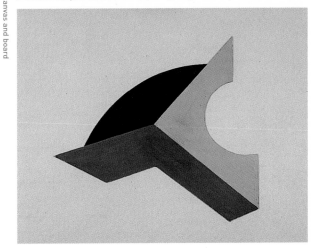

a modernist narrative based on a teleology of style lent itself to the nature and practices of the academy

■ János Máttis-Teutsch, *Composition*, 1923, oil on board

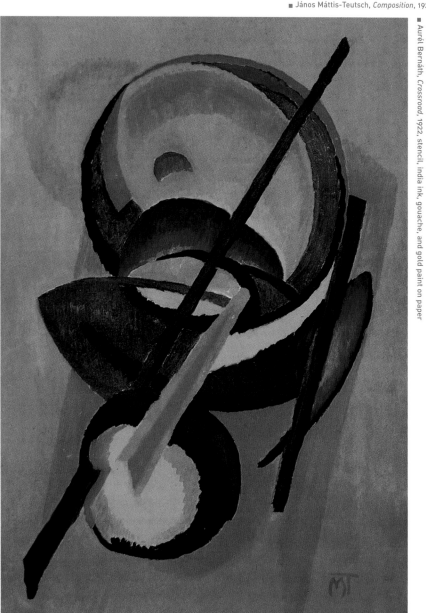

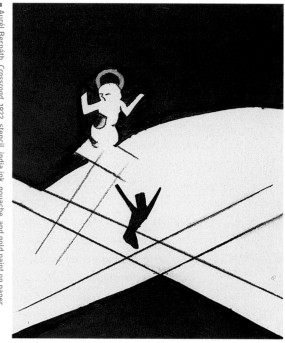

■ Auréi Bernáth, *Crossroad*, 1922, stencil, india ink, gouache, and gold paint on paper

France. Other countries' art production has, of course, figured in the academic account, but most often as secondary considerations or as comparanda. But even within "Europe"—understood conventionally as ending culturally somewhere between the Oder or Bug Rivers on the east, the Baltic Sea to the north, and between Milan and Rome to the south—a hierarchy was well established by the eighteenth century, with Paris functioning consistently as the originary source, or primary locus, of authentic creativity. By the tenets of the resulting narrative, Paris was celebrated as the absolute cultural capital; and from this consummate City of Light progressive styles were perceived to radiate to the far reaches of the globe.[9] Artists resident in other European centers were to be judged on the basis of their faithful emulation of Parisian styles and their work's congruence with what was understood as the aesthetic standards, interests, and "audiences" found on the Seine.

The problem with the canonical perception of Paris as the international capital of modern art is twofold: first, of emphasis, and second, of effect. There is little doubt that Paris played both a pivotal and seminal role in the generation, reception, and criticism of modern art. From Diderot through Derrida, David to Delaunay, successive waves of artistic originality, marketing inventiveness, and critic perspicacity made the city a mecca for modern artists, their dealers, and much of their public. Other locations—cities, riverside or seaside towns, mountain villages, and artists' colonies—from New York to Nagybánya contributed decisively to the mainstream of modernism, as all recognize. Yet the primacy awarded Paris too frequently skews the relative balance of other locations, deprecating many other consequential crossroads of modernism to mere byways,[10] and on occasion attributing to Paris achievements that originated elsewhere. This issue of assigning a just emphasis belongs to a larger concern with setting aside a historical prejudice in favor of Paris for a more considered assessment of other dynamic sites, places that may come less readily to mind but were nonetheless crucial to the creation of modern art.

Paris's primacy is not the principal issue, nor is the establishment of a more accurate balance among artistic centers a principal objective, even though such an adjustment might be a beneficial result of new lines of scholarly enquiry. A quarter century ago academic and museum-based scholars began the process of publicly questioning the notion of Paris as the absolute center of modernism.[11] For most investigators, the relationship between the French capital and other cultural centers can no longer be accepted uncritically as one between a dynamic metropolis and a passive periphery. Academics in general, and art historians in particular, have been increasingly sensitive to the reciprocal influences and creative interactions that prevailed among modern artists throughout the entirety of Europe, and well beyond. For our present purposes, then, the "problem" of Paris is not its physical place or absolute value in the geography of modernism, but rather the ideological consequence for comprehending Eastern European art of the long identification of Paris as the center of the aesthetic universe.

As a result of a more critical perspective, today's historian might attribute the high estimation of Paris to a combination of social, economic, and political forces or events, rather than exclusively to aesthetic ones.[12] A nuanced understanding of extra-artistic criteria in constituting "Paris" would necessarily establish a methodological framework for assessing the art created, displayed, and marketed there, just as it would enable one better to understand the conditions of artistic production elsewhere. Nevertheless, for more than two centuries a legion of perceptive critics fastened upon artistic style as the most revealing sign of meaning. Moreover, the succession of styles in Paris led many to attribute to it a profoundly indicative function. For the founding figures of art history as a discipline, style was affirmed as the most efficacious index by which to chart and ultimately to assert the development of a national character,[13] an artist's maturation,[14] an age's essential character,[15] or even humankind's spiritual evolution.[16] Consequently, by the early twentieth century, style—and most emphatically the styles that critics chronicled in Paris—was invoked as an indicator of progressive thinking, a proof of creative achievement, and even as a barometer of society's spiritual or cultural health. But for critics concerned primarily with the art of their own times, style was endowed with an even deeper function. From Roger Fry to Clement Greenberg, Alfred Barr to Władysław Strzemiński, a work's formal characteristics—composition, surface treatment, method of application or construction, and so forth—were vested with the signal authority of prognostication. By the lights of Paris-oriented modernism, style not only illuminated the current state of culture, but it also could reveal the path toward future development.

Drawing upon nineteenth-century philosophies of history, both materialistic and metaphysical, style became for modernist figures—critics, aestheticians, and, significantly, artists, too—a kind of aesthetic motor force by means of which art was seen to "advance" ineluctably: Impressionism to Postimpressionism, Cubism to Futurism, Dadaism to

Surrealism, and so on. Although essentially derived from a subjectively retrospective interpretation of art history, style was nevertheless affirmed by modernism's advocates as a teleological process. Adherents of this view thus presented style as a powerful, formal unfolding of "visuality," moving ever progressively toward ultimate self-realization (*pace* Greenberg). In essence, the "mind-spirit" (*Geist*) that Hegel had recognized as historically immanent was transposed to the aesthetic realm, where modernism incarnated the process of style *becoming* the ultimate fulfillment of art.

By vesting style with consummate authority, other aspects of art's generation and reception were necessarily downplayed—or at least revalued to serve the dictates of style's imperative. But then the "style-as-process" and "style-as-essence" of modernist theory was structured primarily to satisfy several self-affirming needs. First, style could be presented as a coherent narrative, an effective way of making sense out of a welter of artworks. Museums might then exhibit objects that could be intelligibly integrated into a visible story, one whose promotion was in the institution's own interest of further acquisitions and prestige. In such manner has New York's Museum of Modern Art effectively manifested (and acquired) a canon

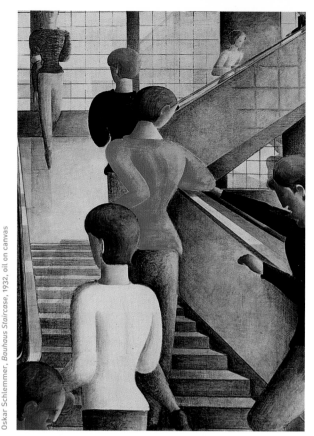

Oskar Schlemmer, *Bauhaus Staircase*, 1932, oil on canvas

■ Hugo Scheiber, *Amusement Park*, 1920s, oil on cardboard

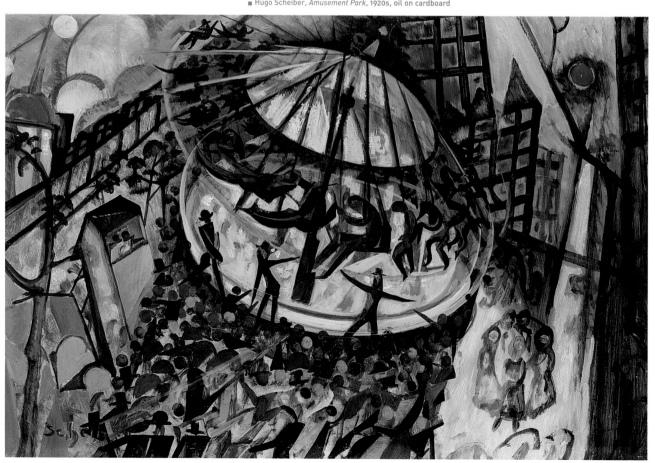

Eastern European modernists were obliged to reconfigure progressive styles to accommodate local needs

of modernist masterpieces, and a compelling art historical narrative through which its own primacy of place has been confirmed.

Second, a modernist narrative based on a teleology of style lent itself to the nature and practices of the academy, where ideologies of art history are easily transformed into institutional pedagogy. Since the mid-1920s, schools of art and design (and, to an extent, architecture too) have constructed curricula that integrate their characteristic technical and conceptual instruction with "mainstream modernism," a blend which elevates style to an idealized model toward which predominating academic preferences are directed. In this regard, it is not surprising that many of the leading American and European institutes of art and design orient their instruction toward the Bauhaus, which has been reconfigured conceptually and reinterpreted historically into a practical ideology through which the inexorability of modernism is validated. In this manner pedagogy perpetuates the primacy of style as the visible expression of progress.

One must stress that the canonical modern art taught, exhibited, and celebrated in the West rightfully enjoys tremendous respect; moreover the objects created in conformity with its precepts frequently embody great intelligence, discrimination, and beauty. The reservations raised here, therefore, should not be understood as objections to the aesthetic quality of modernist art. Nor should the observations made above be misconstrued as a denigration of the perspicacity of modern critics or of the analytical powers of art historians. Rather, the point to be developed here is an acknowledgment of the (negative) consequences for a fuller understanding of modern art's richness, its creative complexity, and its remarkable inventiveness that the canonization of style as the consummate standard of evaluation has produced. By looking at classical modern art with a broader perspective, a different

focus, and a more nuanced methodology, one might not only better appreciate the unique forms of creativity that took place on the periphery of Europe, but also reclaim the rich foundation of modern art generally.

In the advancement of modernism as the consummate transnational style of art and philosophy of contemporary cultural life, Western art historians have too often ignored or dismissed the many and varied ways in which artists of Eastern Europe have essentially embraced local cultural legacies, national conventions, and individual character in creating a "style" simultaneously modern in its formal display and highly topical in its references. Whereas the classical Western avant-garde and its apologists advocated an aesthetic uniformity—as, for example, Neoplasticism or Purism—which would transcend national boundaries and historical references, Eastern modernists readily embraced a multiplicity of progressive styles through which to accommodate the very literary, political, or historical associations disdained by their colleagues in Holland, France, Germany, and elsewhere. Thus, not only did modernist movements in Eastern Europe depart from the mandate of Western absolutism by encouraging diverse formal expression, but they also sanctioned levels of reference abjured in the West as inappropriately individual, national, or otherwise extra-aesthetic.

In part, the differences in origin, function, and meaning between Eastern and Western classical modern art of this period stem from the singular forces—historical and cultural—to which artists felt obliged to respond. From Estonia to Slovenia, the makers of modern art were subject to pressures (and opportunities) that differed from those affecting artists in the West. As a consequence of nineteenth- and early twentieth-century constraints on the free exercise of political, economic, and personal liberties in Romanov-,

Hohenzollern-, Habsburg-, and Ottoman-dominated regions of Eastern Europe, the visual arts assumed a primary responsibility as cultural custodian for the respective subject nations—or at least their self-appointed representatives. Hence, artists of these regions often elected to emphasize national individuality rather than universality. They responded variously to a public demand for expressions of national self-consciousness through which an emerging nation might stake its claim simultaneously to singularity and to membership in a modern world. Such profession of national identity by means of avant-garde art was a cultural phenomenon as widespread in Eastern Europe as it was rare in the West. Among the developed political states of Western Europe (and in the United States), modern national identity has been primarily the province of politicians and statesmen and only incidentally the concern of progressive artists; but then the nations of the West have often been free to express their identities politically. In the East, by contrast, before the collapse of empires in the ashes of World War I, the political, economic, and spiritual restrictions imposed by supervening powers meant that only through cultural expression could the national self-consciousness of the "subject people" be preserved, developed, and manifested. And in these circumstances, so different from those prevailing in the West, legions of modern artists rushed to enlist their talents in service to their respective nations—as well as to the perceived demands of universal modern aesthetics as they understood them, mostly at second hand.[17]

An instrumental stimulus for the development of these currents of modern art in Eastern Europe came initially from the various mid- and late nineteenth-century movements of "national awakening."[18] Promoting cultural expression and preservation rather than the revolutionary political action and social reconstruction that was advocated in the West—particularly in Germany and Italy—informal groups of writers, poets, ethnographers, and musicologists originated the revival movements from the Baltic North to the Adriatic South that only then inspired visual artists to their expressions of a distinctively national modern character.[19] Regardless of the specific local inflection of the national cultural revival, each movement affected visual artists profoundly and often prompted painters, sculptors, graphic designers, and architects to reshape neo-Romantic references into modernist aesthetics. To appeal to the interests of the awakening national partisans and their local patrons, Eastern European artists introduced onto their canvases, in their graphics, and into their sculpture essential narrative, literary, and even folklorist dimensions. As ethnographic reference has invariably been a building block of a modern national expression, allusions to historical myths, events, heroes, and folk styles are as common in Eastern avant-garde design as they are rare in Western progressive art. Eastern artists creating within the context of national modernism have thus moved easily and without contradiction between, say, Constructivism and folkloric patterning, or between canvases depicting Cubist still lifes and heroes from the national mythology.[20] In its reconciliation of literary reference and abstraction, narrative context and nonobjective styles, the modern art of Eastern Europe has departed fundamentally from the absolutist purity espoused by most Western modernist artists and demanded by their apologists.

An example here might assist in better visualizing the strategies typically pursued in the East and characteristically abjured in the West. Although one might select a building, monumental sculpture, or a painting as an effective incarnation of national identity, one should not ignore the decorative arts as expressive vehicles to harmonize transnational modernity and local reference. In furniture and theater design, and especially in ceramic ware, the pressures of local

events and the influence of international styles were as decisive as they were for the fine arts. For Latvian artists,[21] in particular, the decorative arts proved to be an ideal medium in which to manifest the creative synthesis between international modernist aesthetics and national cultural formation that lay at the core of Eastern European objectives during the early decades of the twentieth century.

Prompted by painters and sculptors who had produced innovative designs for the Latvian opera, theater, and ballet stages, a porcelain manufactory was established in the mid-1920s. The intention of the founders was to disseminate as broadly as possible modernist-designed articles of everyday use. Inspired both by the nativist Art and Crafts movement—which advocated the medium of ceramics to promote awareness of the national folk culture—and by the inventive Suprematist porcelain being produced by Russia's modernists (Kazimir Malevich, Nikolai Suetin, and Ilya Chashnik, among others), Romans Suta (1896–1944), Aleksandra Beļcova (1892–1981), and Sigismunds Vidbergs (1890–1970) made effective use of ceramic ware to propagate the evolving Latvian culture. Indeed, the name "Baltars" was coined for the porcelain works in order to signify a melding of Baltic tradition and the new art forms then being articulated from England to Estonia. Of all the artists who contributed to Baltars's

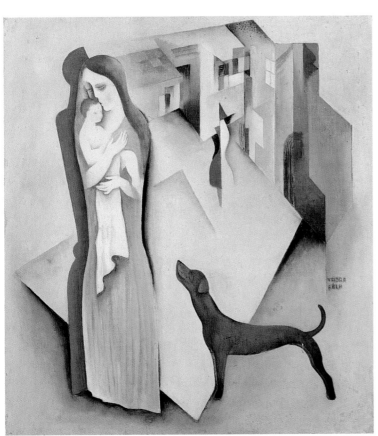

■ Béla Kádár, *Mother with Child*, late 1920s, tempera on paper

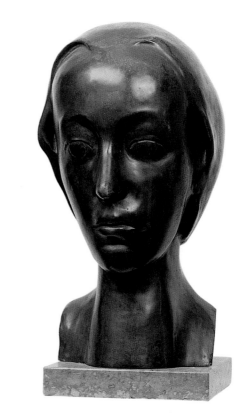

■ Béni Ferenczy, *Portrait of Noémi Ferenczy*, 1920, bronze

creative synthesis of local traditions and international style, Romans Suta's efforts are among the most germane to the present discussion. A cofounder of the manufactory in 1924, he remained active in its affairs until its closing in 1928. His work for the factory during the four years of its existence provides a barometer for measuring the success of the decorative arts as a medium for the expression of national folk traditions in a field of modernist engagement. Suta's first works in porcelain reflect the embrace of Cubism and Constructivism that is evident in his contemporaneous painting (and in Latvian sculpture). In two works from 1926 one can witness the versatility of his fusion of folkloric and modernist elements. In *Young Woman with Bird* the sweeping arc of the figure's right arm, the repeated curving folds of her native costume, and the sophisticated use of color to suggest motion all demonstrate Suta's skillful orchestration of geometrical forms, spatial planes, and rhythmic cadences. But the forceful centrality of the figure predominates, and even the color rings on the edge of the plate function more as a decorative pattern than as part of an abstract composition.

In a ceramic plate from the same year, the folkloric theme of a Latvian wedding, though taking center stage, is carefully balanced compositionally and coloristically by the abstract forms along the rim. Here Suta invokes not just the modernist geometry of Suprematist circles and Constructivist parallelograms; he makes reference through geometrical forms—combined with glyphs of animal forms—to Latvia's contemporaneous preoccupation with native origins. As excavators, ethnologists, and anthropologists were revealing the primitive sources of the young republic, artists were re-presenting their findings in a modern visual language. The earthen tones, abstracted forms, and intentionally primitivist figuration are intended to connote for a *local* audience the nation's origins. Yet these same forms could be and were affirmed as proof of Suta's modernist credentials. Thus the abstract forms were intentionally handled ambiguously: on one level they were readable as original syntactic codes of indigenous language, religion, and community; and on another these simple forms participated in the international modernist discourse of geometrical abstraction. By looking simultaneously domestically and externally, Suta and his confederates provided Baltars with a repertoire of forms and themes that allowed the ceramics to be praised abroad for their international contemporaneity while at the same moment servicing a domestic market with essentially native fare.[22]

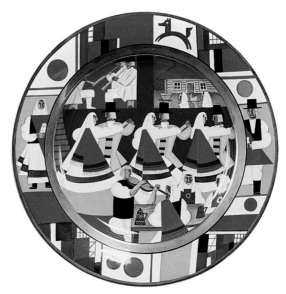

Romans Suta, *Latvian Wedding*, 1926, ceramic

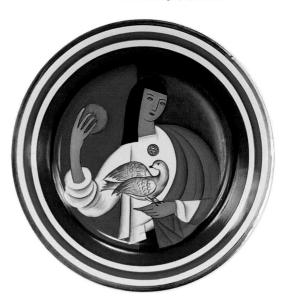

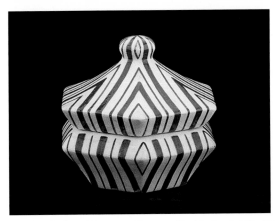

■ Pavel Janák, *Covered Box*, 1911, earthenware with white glaze and blue decoration

The originality evident in the decorative arts, sculpture, painting, and architecture not just in Latvia but throughout Eastern Europe attests not only to creative solutions for aesthetic problems. Modernism in this part of the world ventured to transcend conventional formal considerations in order to cope with a profound communal challenge: projecting a vision of the nation with which the populace might readily identify. From Estonia to Macedonia, modern artists adapted progressive styles to accommodate indigenous traditions and references. By exploiting the capabilities of Cubism, Futurism, Constructivism, and other languages of abstract form and composition to allude to native themes and contemporary issues, the makers of modern art were thus able to negotiate a remarkable synthesis of the local and universal, the traditional and progressive. Consequently, a consideration of the culture of Eastern Europe needs to employ strategies that can penetrate the surface plane of images and the superficial category of style.

In order to promote progressive seeing and thinking at home, and to establish cultural credibility abroad, Eastern European modernists were obliged to reconfigure progressive styles to accommodate local needs, just as they endeavored to conform to international expectations of how modern art should appear. Moreover, artists had to balance external perceptions with the often pressing internal need to articulate and represent a national self-image, one that could allow the citizenry to recognize themselves culturally, if not always politically. This dual aspect differentiated artists (and audiences) in Eastern Europe from those in the West, where the combination of modernism and nationalism was more the exception than the rule,[23] and where local references were subsumed by transnational aspirations. Whereas international modernism promoted universal visions (as seen from Paris, New York, and other cultural capitals of the industri-

alized West), Eastern European modernism necessarily perceived the function of art bifocally: looking simultaneously at the distant world while concentrating on imagery close to home.

In their desire to be taken seriously as fellow modernists by their Western colleagues,[24] Eastern Europeans embraced Western styles critically, freely adapting them to suit local conditions. More often than not, however, the adaptations took place in the meanings each style conveyed rather than in the formal attributes displayed. What this widely held strategy suggests for those attempting to understand Eastern European modern art is the need to guard against relying too heavily upon interpretive models imported from outside. Rather, one might best bracket customary interpretive paradigms in favor of alternative methods more suited to comprehend the functions, understand the reception, and assess the implications of artworks, both individually and corporatively. Thus, instead of censuring artists who moved freely between abstraction and representation, or between narration and nonobjectivity, one might set aside Western archetypes to allow that such shifts were in no way perceived as inconsistent with or oppositional to the objectives of Eastern European modern art. To the contrary, local needs, traditions, and references were frequently affirmed by employing creatively the language and authority of international styles. In opening one's eyes to this common practice, one might then recognize that Kazimir Malevich, for example, was only following regional convention by pursuing both Suprematism and figuration; and his constant shift between abstraction and representation (often criticized in the West as a "retreat") should not be judged by Western expectations of consistency.[25] Like legions of his contemporaries from the Baltic to the Balkans, Malevich likely saw no contradiction in taking seriously primitive or native folk imagery *and* geometrical abstraction, as each addressed essential issues for

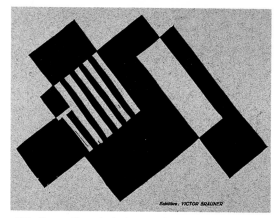

■ Victor Brauner, illustration for *Punct*, 1925 (no. 6–7), linocut

■ Victor Brauner, illustration for *Punct*, 1924 (no. 1), linocut

■ Władysław Strzemiński, cover design for *Six Hours! Six Hours!*, by Tadeusz Peiper, 1925

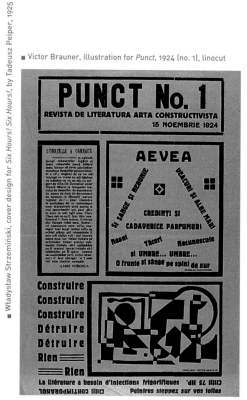

Integral, 1925 (no. 3)

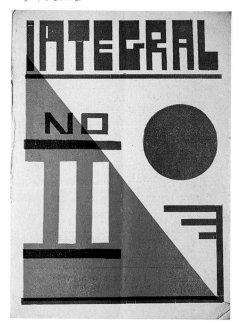

which style served less as an index of universal meaning than it functioned as a strategy to signify locally and communicate internationally.[26]

Just as methodological distinctions must be drawn between approaching the modern art in the West and East, comparisons stand out between assessing analogous styles within the Eastern region as a whole. As opposed to the Baltic Surrealist variant of Eduard Wiiralt, which had been designed as a conservative counterbalance to the collectivist programs of Constructivism, the Czech Karel Teige advocated a progressive Surrealism (in part) as a means to promote Communist systems of art and social life. Likewise, Constructivism in the East manifested a diversity of meanings beneath its restricted formal vocabulary. Believing in "using the streets as a school for aesthetic and moral education," the Poles Mieczysław Szczuka and Władysław Strzemiński turned to the organizational principles of the factory and regularized urban planning for socialist cities for their collaborative prescriptions. In contrast to their formal purity and moral rigor, the Romanians Marcel Janco and M. H. Maxy exploited the irregularities and stimulating cacophony of Romania's urban capital as a model for contemporary art. Both the playful dose of Dada irreverence introduced into Constructivism in Bucharest by the Integral group and the abstract lyricism promoted there by the Punct formation were eschewed by the avant-garde in Warsaw.

Similar juxtapositions can be drawn for Expressionism and Cubism—for instance, the Czech manifestation of Expressionism, through which to register the existential anxiety and spiritual decline of the Habsburg imperium, versus the Hungarian variant, which perceived Expressionist aesthetics as an effective vehicle for promoting social regeneration with the empire of the Dual Monarchy. What these examples force one to acknowledge is the methodological danger in seeing *uniformity* within the geographically immense

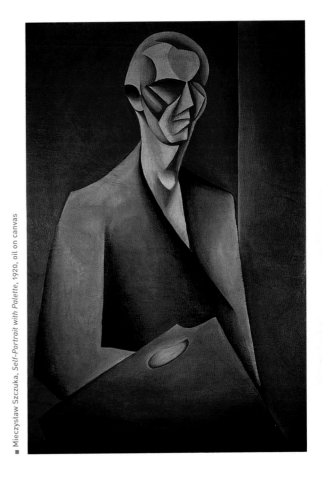

■ Mieczysław Szczuka, *Self-Portrait with Palette*, 1920, oil on canvas

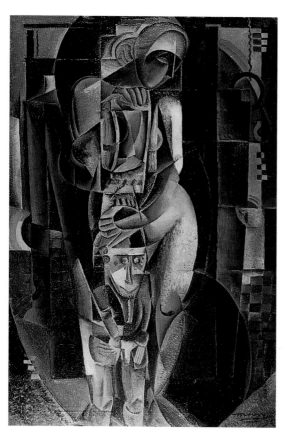

■ M. H. Maxy, *Nude with Idol*, 1924, oil on canvas

■ Otto Gutfreund, *Viki*, 1913 (cast 1960s), bronze

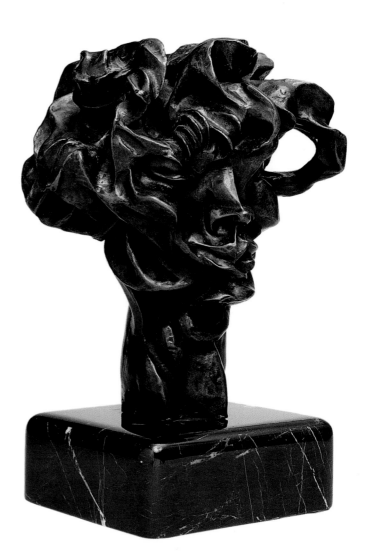

and culturally diverse region of Eastern Europe. The perception of stylistic affinity should not lead one to an assumption of parallel meaning or analogous reception.

If style must be dethroned from its imperial status by which modernist art is recognized and validated, what should take its place; or, at the least, what methodological considerations should modify its role? Moreover, what is gained by revaluing the canonical standards by which modern art has been measured?

By realizing the limitations of style as the dominant mode of approach, the way can be opened for alternative methods. These methods must not and perhaps cannot be the same for each area or even for artists who emerge from the same region; for the generation of art—just as is true for its reception—is conditioned by a host of forces and events, both social and personal. Thus, the questions posed and the approach taken to understand the Expressionist art of the Jewish-Polish Jung Idysz may not be productive for comprehending the uses of Expressionism by such Czech figures as the Bohemian-Jewish Otto Gutfreund or Bohumil Kubišta. As a result, one should recognize the contingency of all methods and the need for flexibility and inventiveness. A familiarity with the distinctive native histories, social traditions, and political conditions can well sensitize one to the decisive role of indigenous forces on the choices available to the Eastern European artist. Moreover, an awareness of local geography—social, political, cultural, and personal—will enable one better to appreciate how these artists chose to be influenced by the "foreign" artistic forms they encountered directly through exhibitions or, more frequently, at second hand through periodicals. By means of an awareness of what was expected of artists in Eastern Europe and of the choices available to them, one might better comprehend how styles were appropriated and then adapted to correspond to domestic needs (which often included achieving external recognition).

These observations on methodology and cultural geography, although set forth within the context of understanding the classical modern art of Eastern Europe, should not be understood as limited to a single region. Ultimately, an exhortation to open-mindedness, methodological inventiveness, and liberality of spirit applies to art history generally. The purpose here is to urge the historian, the critic, and the public to look beyond formal characteristics in order to understand how style was actually used: to communicate local (often literary or historical) meanings, to signal participation in a broad international movement, and to avow ideologies—social, political, and national. With sensitivity to local developments, references, and meanings, the observer might begin to recapture the rich complexity and occasional contradictions that characterized modernist aspirations in Eastern Europe. But to take this conscious methodological step, one must restore "history" to the practice of modern "art history." A keen eye is essential, but it alone is insufficient without an equally sensitive grasp of the historical matrix from which artistic work emerges and in which it communicates its deepest meanings to its multiple audiences. In the context of Eastern European developments, this means preparing ourselves to recognize the diversity of meanings—as well as the miscellany of forms and compositional motifs—that have for too long lain outside the canonical vision of modern art. Moreover, by divesting ourselves of the belief in an absolutist progression of modernist aesthetics—defined too narrowly by the art created in Paris, Berlin, and New York, and defended too ideologically by generations of critics— we might be rewarded with a richer and more complex modernism. Diversity, complexity, and contradiction may then be understood as strengths rather than liabilities—and as productive means to comprehend the lofty ambitions of modern art universally.

1 For the sake of convenience and in accordance with the prevailing custom in the West, the present essay employs the nomenclature "Eastern" Europe as a catchall term, embracing both inaccurately and somewhat uncomfortably the diverse territory of Central, East Central, and Southeastern Europe that Cold War convention assigned to the East.

2 The standard narrative has been institutionalized in the collection and exhibitions of New York's Museum of Modern Art. The presentation of progressive art as an inexorable unfolding of styles has been more or less uncritically accepted among collecting institutions, in the pedagogy of art academies, and most decisively in the standard textbooks adopted for college and university level courses. Only in specialized studies, more often found in academic journals than in books for a general adult audience, does one encounter a challenge to the authority of style as a dominant determinant or index of a modernist aesthetic, forcefully asserted as universally valid.

3 The prevailing "Western" stylistic paradigm has been by and large uncritically manifested in numerous recent exhibitions containing substantial Eastern European art. Both the exhibition of Futurism held at the Palazzo Grassi in Venice (*Futurismo & Futurismi*, ed. K. G. Pontus Hulten, 1st American ed. [New York: Abbeville Press, 1986]) and the *Europa, Europa: das Jahrhundert der Avantgarde in Mittel- und Osteuropa* (ed. Ryszard Stanislawski and Christoph Brockhaus, exh. cat. [Bonn: Kunst- und Ausstellungshalle der Bundesrepublik Deutschland, 1994]) exhibition mounted in Bonn, to mention the two largest, tellingly accommodated and harmonized the art from the European "periphery" to the critical categories and theoretical framework employed for Western art. The essential distinctiveness of the "unfamiliar" art from the margins was therefore erased— or at the least ignored—in favor of a claim for the universality of modernist styles and interests.

4 Although it is customary for many European scholars to distinguish conceptually and critically among the adjectives "avant-garde," "modern," and "modernist," this practice is less common in North America. Moreover, the present essay has as a principal objective an appeal to reexamine critical paradigms and historical patterns. In this context, a reconsideration of terminology is essential. For present purposes, then, the three terms cited above are provisionally employed synonymously.

5 See, for example, Piotr Piotrowski, "Modernism and Socialist Culture: Polish Art in the Late 1950s," in *Style and Socialism: Modernity and Material Culture in Post-War Eastern Europe*, ed. S. E. Reid and D. Crowley (Oxford: Berg Publishers, 2000); Piotrowski, "Totalitarianism and Modernism: The 'Thaw' and Informel Painting in Central Europe, 1955–1965," in *Artium Quaestiones* X, (Poznań [Poland], 2000); Andrzej Turowski, *Éxiste-t-il un art de l'Europe de l'Est? Utopie et ideologie* (Paris: Editions de la Villette, 1986); Stephen C. Foster, ed., *The Eastern Dada Orbit*, vol. 4 of *Crisis and the Arts: The History of Dada*, (New York: G. K. Hall, 1998); S. A. Mansbach, *Modern Art in Eastern Europe: From the Baltic to the Balkans, ca. 1890–1939* (Cambridge: Cambridge University Press, 1999).

6 See Piotrowski, "Modernism and Socialist Culture," for a discussion on the reception of modern art in Poland during the 1950s. In Hungary, a greater openness toward classical modern artists is noticeable in the 1960s, when, for example, the work of Lajos Kassák, the impresario of the avant-garde in Central and Eastern Europe, was publicly exhibited for the first time under the Communist regime. For a comprehensive overview of the literature on the Hungarian avant-garde, and the consequent bibliographical chronicle of its fate under both the right-wing authoritarianism of Miklós Horthy and the left-wing Communism of 1919 and during the 1947–89 periods, see S. A. Mansbach, *Standing in the Tempest: Painters of the Hungarian Avant-Garde, 1908–1930* (Cambridge: MIT Press, 1991).

7 At various moments during the late 1920s, and increasingly with the consolidation of various and successive authoritarian regimes from Estonia in the north to the Balkan peninsula to the south, it was forbidden to display, publish, or even study formally the major figures and monuments of experimental modern art—from both Eastern and Western Europe. Those who endeavored to do so not infrequently met with official obstruction or more severe consequences, sometimes being prosecuted as Bolshevist sympathizers (especially during the 1930s and early 1940s) or, in later decades, as bourgeois decadents. In the mid-1990s, the rise of nationalist intolerance and the resulting chauvinistic programs of exclusion imperiled the free inquiry into and advocacy of modern art, both classical and contemporary.

8 Prompted in part by earlier studies of the role of governments in employing art to advertise abroad the (often idealized) social and political values at home (see, for instance, Serge Guilbaut's *How New York Stole the Idea of Modern Art: Abstract Expressionism, Freedom, and the Cold War* [Chicago: University of Chicago Press, 1983]), scholars are beginning to address the effective role of international exhibitions—the Venice and São Paulo biennials, for example—in fostering extra-aesthetic policies.

9 The most effective vehicles for transmitting the modernist message were the myriad small-circulation journals that surfaced in all parts of the world. By reprinting one another's articles, reviewing one another's sponsored exhibitions, and reproducing one another's images, most every periodical participated in distributing modernist aesthetics to the widest audiences, even if the readership remained quite small. Through such "little journals" Paris's reputation as a cultural capital—and the progressive styles celebrated there—spanned the globe from Japan (*Mavo*), to Madagascar (*Latitude sud 18*), to Buenos Aires (*Inicial*). The role of journals as a principal forum for the display (through reproduction), criticism, and discussion of Eastern European modernism merits further study. In a region where travel among the various sites of modernist activities was frequently dificult, journals played a major part in uniting those of shared commitments to progressive aesthetics. Furthermore, magazines of sophisticated design and elevated content—which most all of the Eastern European journals fostered—could overcome the peripheral geography and comparatively less economically and socially developed environment of the editors' home countries. This may help to explain the large number of small-circulation and short-lived publications from Bulgaria to Estonia; and it may

help to account for the impressive number of little reviews in Poland and Romania in particular, where political, class, and "national" divisions remained even after political independence or consolidation.

10 For a counterview to Paris's primacy, see the essays in the section "Berlin: Crossroads of Art," in *Künstlerischer Austausch: Akten des XXVIII. Internationalen Kongresses für Kunstgeschichte*, ed. Thomas W. Gaehtgens (Berlin: Akademie Verlag, 1993).

11 Most noteworthy in this regard was the sequence of exhibitions begun in the 1970s and held in Paris's Centre national d'art et de culture Georges Pompidou: *Paris-Berlin, 1900–1933: rapports et contrastes France-Allemagne* (1978), *Paris-Moscou, 1900–1930* (1979), and *Présences Polonaises* (1983), to cite but a few. In order not to vitiate Paris's importance, the Centre Pompidou mounted a large exhibition in 1981 significantly entitled *Paris-Paris 1937–1957*.

12 For English-speaking students, the studies published by T. J. Clark (e.g. *The Absolute Bourgeois: Artists and Politics in France, 1848–1851* [1973] and *Image of the People: Gustave Courbet and the 1848 Revolution* [1982]) and Thomas Crow (for instance, *Painters and Public Life in Eighteenth-Century Paris* [1985]) inaugurated a series of studies for the newest generation of students of the social history of Paris-based early modernism. These books were preceded by a host of social histories of art, a tradition carried into the present by Albert Boime.

13 One might cite in this context the late-nineteenth- and early-twentieth-century debates on the meaning of the Gothic as an indigenous expression of German or French national character.

14 For a discussion of the concept of an "old-age style," see the special issue of the *Art Journal* (vol. 46 [Summer 1987]), edited by David Rosand, "Old-Age Style."

15 See for instance Heinrich Wölfflin's *Kunstgeschichtliche Grundbegriffe: das Problem der Stilentwicklung in der neueren Kunst* (Munich: H. Bruckmann, 1917), 2d ed.

16 Viz. Wilhelm Worringer's *Abstraktion und Einfühlung, ein Beitrag zur Stilpsychologie* (Munich: Piper & Co., 1911) 3d edition; and Henri Focillon's *Vie des formes* (Paris: Alcan, 1939).

17 Serious Eastern European students of the visual arts often traveled abroad in order to matriculate in academies of art. For those living under Russian rule, the Academy of Arts in St. Petersburg held attraction. However, the *numerus clausus* established by the imperial authorities persuaded many from the Baltic lands of the empire to enroll in art schools set up in distant Kazan and elsewhere in the vast interior of the Romanov empire, at least until the establishment of an academy in Riga and of the Pallas School in Tartu. Academies, private and state supported, in Germany drew significant numbers of students from throughout Eastern Europe. Düsseldorf and Munich (both the Bavarian Royal Academy and Anton Ažbé's private school), and later Dresden and Berlin, were the preferred places of study, surpassing both Vienna and Budapest. Beginning with the reforms promulgated reluctantly by the czar in 1905, there was somewhat greater liberty offered to students from the sprawling empire both in the curriculum and in the freedom to travel. For those subject to rule from Vienna, Budapest, Berlin, or the representatives of the Sublime Porte, the opportunities for education in the visual arts varied significantly, though the possibilities offered to Poles who journeyed to Cracow, Transylvanians who traveled to Nagybánya (Baie Mare), or Slovenians who migrated to Italy, for example, were considerable. What is remarkable in the present context is the comparatively lesser allure of Paris, at least as a primary choice. Considerable numbers of artists did indeed visit Paris, but most often after having formally studied for years in Central or Eastern European academies. Only from the 1920s—and then not infrequently for domestic political reasons—did young artists journey to Paris for informal instruction. By the mid-1930s, coincident with the rise of authoritarian regimes throughout Europe, support for study "abroad," especially in the traditional centers of art, dropped markedly.

18 National revivals were not limited to the region, of course. They were apparent in most of Europe from the mid-nineteenth century. Although each revival had distinctive "national" aspects, especially apparent in the Nordic lands, Germany, and Italy, there was also potent regional revivalism, most clearly manifested in France, where Breton, Norman, Provençal, and other identities contended with a centralizing (national) authority.

19 Notable in the development of these national cultural revivalisms is the prominent—and frequently formative—role of (those later labeled as) "non-native" or "non-indigenous" groups and individuals: the Baltic-Germans in Estonia and Latvia, the "Germans" in Bohemia, the Jews in the Hungarian Kingdom, the Poles in Lithuania, and so forth. What this demonstrates is the immanent fluidity of the concepts of "national," "native," and "foreign," as each is contingent on time, place, and circumstance. Moreover, these concepts are easily invoked anachronistically, and they can be politically perilous, as one has witnessed in the contemporary tragedies unfolding in the Balkans, Africa, and elsewhere. Thus, one might rightfully question the ready assignment of labels to people and events. When Friedrich Reinhold Kreutzwald codified the Estonian oral epic *Kalevipoeg* in 1862, was he doing so as a Baltic-German whose Germanic forebears arrived six hundred years earlier? as an "Estonian" whose national traditions he sought to promote? as a subject of the Russian czar who bestowed economic privileges on Kreutzwald and those of his class who demonstrated loyalty to the interests of imperial government? or as an individual of a latter-day Baltic Enlightenment? Whatever may be adduced of Kreutzwald's intentions may or may not have been shared by the members of the various academically liberal revivalist associations. Further, their motivations and objectives may well have differed from the adherents of the Young Estonians (Noor-Eesti), who sought to assert a national self-awareness, though from a different perspective and with differing emphases from those of Kreutzwald's Baltic-German liberals.

20 See Mansbach, *Modern Art in Eastern Europe*.

21 Latvian ceramics are chosen as a representative model of the successful negotiation between (what in the West—but rarely in the East—was perceived as conflicting) local and supranational demands. Even though the scope of the *Central European*

Avant-Gardes exhibition does not extend to the Eastern Baltic, the issues to which Latvian ceramics point are applicable throughout the entire region and suggest an instructive paradigm for treating Eastern European classical art in general.

22 The international prestige of Baltars's modernist inventiveness is warranted by the three medals, including the gold, garnered in Paris at the 1925 *Exposition internationale des arts décoratifs et industriels modernes*.

23 The most striking exception was the embrace of a reactionary modernism by Germany's National Socialists. See Jeffrey Herf, *Reactionary Modernism: Technology, Culture, and Politics in Weimar and the Third Reich* (Cambridge: Cambridge University Press, 1984). To a lesser degree, Italy's support of rationalist architecture and late Futurist visual art attest to a parallel form of conservative modernism.

24 For artists who were active in nations where the intellectual class was few in number, validation of their cultural efforts was often sought abroad, and not just from among those perceived as aesthetically advanced Westerners. Frequently, one desired legitimation from Russia as well, or at least recognition by progressive figures active (or trained) there. In this regard, one might understand the receptiveness to Suprematism and Constructivism in general, and in Latvia and Estonia in particular. Despite the residual animosity harbored toward the Soviet Union and all things Russian following the civil strife in each land, warfare in which Bolshevist aggression imperiled the survival of the struggling republics from 1918–1920, Baltic artists such as Teodors Zaļkalns, Kārlis Zāle, Uga Skulme, Marta Liepiņa-Skulme,

Niklāvs Strunke, Henrik Olvi, Ado Vabbe, and Arnold Akberg enthusiastically embraced Russian Constructivism—and creatively adapted it to local purposes.

25 By contrast, one might cite the telling adjectives used by Piet Mondrian, the adherents to De Stijl, and the movement's supportive critics to describe the modern art they most highly prized, often their own: "pure," "absolute," and "abstract."

26 The strategy of using style to address different audiences with different messages—which the present essay advances as a convention of the classical modern artists of this region—was not limited to the picture plane. It can be found in other visual media and, significantly, in the writings of many of the artists and their (local) apologists. In Malevich's manifold published essays, theoretical tracts, and aesthetic musings, for example, one might understand his use of language—customarily decried in the West as idiosyncratic, contradictory, or inherently illogical—as fitting a regional (and thus not solely an individual) pattern of introducing a welter of references and beliefs without the need for consistency. Not to be overlooked, as well, was Malevich's occasional practice of subtitling his Suprematist designs with explicit references to the peasantry and to life in the Russian/Ukrainian countryside, especially in the years of "high" Suprematism, roughly 1914–17. As a result, one can recognize the consistent concern with local themes, whether expressed in representational imagery or through abstract association. The manner in which local meanings were manifested to a knowing audience by means of progressive international styles varied among artists and movements, and by

location. Thus, the way in which Malevich was simultaneously "local" and "universal" differed from the solutions pursued by János Máttis-Teutsch or Zbigniew Pronaszko, for example. Future research into the history of classical modern art in Eastern Europe will likely reveal further general patterns and individual departures from the methodological model suggested here.

Berlin

Poznań

Warsaw

Dessau

Łódź

Weimar

Prague

Cracow

Vienna

Budapest

Ljubljana

Zagreb

Belgrade

Bucharest

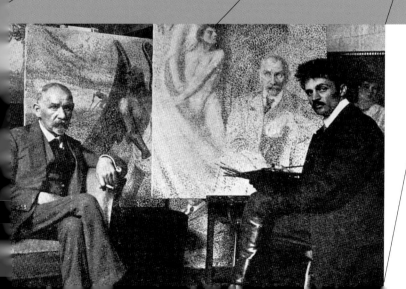

poznań

POZNAŃ

Jerzy Malinowski

p. 307:
Jerzy Hulewicz painting portrait of Stanisław
Przybyszewski, 1916

After the third partition of Poland, in 1795, Poznań—the principal city of Western Poland (Wielkopolska)—was occupied by Prussia, and from 1870 by the German Empire. Carrying out a policy of Germanization, particularly in the second half of the nineteenth century, the Germans refused to allow Poles to found institutions such as universities. Still, the Poznań Society of Friends of the Sciences, the Teatr Polski, and the Polish press were allowed to operate. In the first half of the nineteenth century Poznań was essentially a German garrison city. After decades during which the German population predominated, by the end of the nineteenth century the Poles regained a majority.

In 1880 Poles organized in Poznań a branch of Cracow's Society of Friends of the Fine Arts, which organized art exhibitions in the foyer of the Teatr Polski (and after 1902, in a building on Berlińska Street). In 1909 the branch became independent. One of its leaders was the painter and writer Jerzy Hulewicz. The society emphasized its national scope, and its most important exhibition, in 1909, featured a Cracow Society of Polish Artists group, Sztuka [Art]. The society showed mostly the works of well-known artists from Cracow and Lwów, and of Polish artists living in Paris (for example, a one-man show of the work of Elie Nadelman in 1913). In 1909 Poznań painters founded the Association of Artists, whose aim was to support local artists. Among its members was graphic artist Jan Jerzy Wroniecki.

Periodicals played an important role in communicating new trends in art. The liberal-bourgeois *Dziennik Poznański* and the national democratic *Kurier Poznański* published correspondence on art from France and Germany as well as Cracow, Lwów, and Warsaw. The first periodical to discuss new art was *Przegląd Tygodniowy*, published by Władysław Rabski between 1894 and 1896. The Polish art critic Wiktor Jozé-Dobrski, active in Paris, published an extensive article on Paul Gauguin; there were also reviews of the first exhibition of the Munich Secession and the art salons of the Champ de Mars in Paris.

Artist Stanisław Przybyszewski left Wielkopolska in 1889 for Berlin but kept his contacts in Poznań. A friend of Munch's, Przybyszewski was a significant advocate for Expressionism. His friend Franciszek Flaum, a Poznań sculptor, participated in 1912 in the first exhibition of Berlin's Galerie Der Sturm, alongside Fauvists, Georges Braque, and Brücke and Blaue Reiter artists. After Flaum returned to Poznań, he presided over the Association of Artists. *Przegląd Wielkopolski*, appearing between 1912 and 1914, published on avant-garde movements—Fauvism, Cubism, Futurism, and Expressionism. Among its correspondents from Paris and Berlin were painter Gustaw Gwozdecki and critic Feliks Jordan-Lubierzyński; the latter was the first in Poland to use the term "Expressionism." Poznań artists who studied and worked in Paris, Berlin, Munich, and Cracow had by 1914 become familiar with the new movements. Nevertheless, they either followed realist tendencies in their art or emulated the naturalism that prevailed around 1900. The outbreak of the First World War scattered the art community, though the Society of Friends of the Fine Arts continued to organize exhibitions.

The most important artistic phenomenon in Poznań after the war was the activity of Bunt [Revolt], a group of artists and writers founded in late 1917 and active until 1922. The origins of the group dated back to 1916, when Stanisław Kubicki first showed his Expressionist paintings at the Society of Friends of the Fine Arts, and Jerzy Hulewicz started a collaboration with Przybyszewski, who had visited him on his estate in Kościanki. It was then that the idea of publishing a new literary and art periodical, *Zdrój* [Source], was born. While

Akt (drzeworyt oryg.) — Jerzy Hulewicz

Zdrój – Listopad 1918.

Left:
■ Jerzy Hulewicz, *Nude X*, 1918, linocut on paper

Right top:
Władysław Skotarek, cover design for *Zdrój*, 1918 (vol. 4)

Right bottom:
Stanisław Kubicki, poster for Bunt exhibition, Poznań, 1918

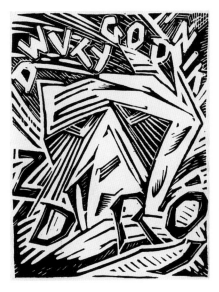

BUNT
WYSTAWA
EKSPRESJONISTÓW
MALARSTWO ● RZEŹBA
GRAFIKA
POZNAŃ UL. BERLIŃSKA 10
OD 1. DO 30. KWIETNIA 1918
OTWARTE OD 10. DO 5. GODZ.

officially Hulewicz was its editor, until March 1918 Przybyszewski—then living in Munich—had the more active hand. *Zdrój* was the most important Polish avant-garde art journal of its time. In *Zdrój* members of Bunt published their Expressionist linocuts and paintings alongside literary pieces and manifestos. Besides Hulewicz and Kubicki, members included German painter and graphic artist Margarete Kubicka, Kubicki's wife; poet Artur Bederski; graphic artists Stefan Szmaj, Władysław Skotarek, and Jan Panieński; writer and graphic artist Artur Maria Swinarski; sculptor August Zamoyski; and Hulewicz's brothers, Bohdan and Wiktor.

The first Bunt exhibition was to take place at the Salon of the Society of Friends of the Fine Arts in April 1918. The jury, however, rejected the works of August Zamoyski and Stefan Szmaj on the grounds that they were an offense against decency, causing the group to move its show to a new location on Berlińska Street. The exhibition and an accompanying special issue of *Zdrój* were a radical declaration for Expressionism. Bunt's next exhibition was organized in September 1918 in the Berlin gallery of the periodical *Die Aktion*. Until late 1918 Poznań remained within the German state where Bunt was active. In 1917 and 1918, Bunt was the first artistic group in Germany to represent the radical ideology of the later "activist" phase of Expressionism. Bunt was founded almost a year before the Berlin Novembergruppe and two years before other German groups, one of which, the Dresdner Secession (participants included Lasar Segall from Vilnius), was close to the Poznań group in terms of its artistic ideology and stylistic formulas.

Bunt had contact with the Cracow Formiści [Formists], with whom they exhibited in Cracow (1918), Poznań (1919–20), and Lwów (1920). Buntists also exhibited with the Łódź Jewish group Jung Idysz [Young Yiddish]. Jung Idysz members Jankiel Adler and Vincent Brauner visited, in autumn 1919, Buntists in Poznań, where Marek Szwarc, a member of Jung Idysz, had taken a temporary residence. At their meeting they discussed new trends in art, such as Expressionism and abstraction, and poet Janina Przybylska, Skotarek's wife, performed an improvised dance, naked, in a darkened room, casting her shadow onto a screen that separated her from the spectators. Adler accompanied her on the harmonica. Plans to organize a joint Bunt/Jung Idysz exhibition in Poznań and other Polish towns failed to materialize.

Bunt had strong ties with the Lwów and Warsaw art communities and organized art events in Poznań and Lwów. The publishers Ostoja [Mainstay], associated with *Zdrój* and headed by Jerzy Hulewicz, published Expressionist poems and plays illustrated with prints by Bunt artists.

The painting and graphic art of Bunt members evolved from Postimpressionism

(in the case of Kubicki) and Art Nouveau (Jerzy Hulewicz) to geometric Expressionism and deformation, influenced by Die Brücke and—in the case of Skotarek—by the apocalyptic visions of painters Ludwig Meidner and Jakob Steinhardt (who came from Wielkopolska). The first abstract Bunt paintings—inspired by the works of Kandinsky—notably those by Hulewicz, appeared at the end of 1918, accompanied by the manifesto by Hulewicz entitled *My* [Us]. Władysław Skotarek came close to geometric abstraction in his linocut series *Formy* [Forms], but it is Kubicki who can be called the first geometric abstractionist in Polish art, in his cycles *Entering* and *Ecstasy*.

One can find typical Expressionist motifs—love and ecstatic dance, psychiatric illness and depression—in the works of Bunt members. As characteristic in Expressionism, Bunt artists displayed their pacifist ideology with references to New Testament iconography and the figure of Christ—the "new man"—acknowledged as the ethical ideal and the first revolutionary. Influenced by the revolutionary climate, notably the November 1918 revolution in Germany, and by the anarchist ideology of the Kubickis, then living in Berlin, representations of revolution began to appear in the works of Szmaj and Skotarek, among others. Hulewicz, in turn, actively supported the political activity of Józef Piłsudski. Most of the group's members

participated in or supported the anti-German uprising in Wielkopolska in December 1918 and the 1920 war between Poland and Soviet Russia. The Kubickis, Szmaj, and Skotarek, as well as some members of Jung Idysz, represented the Polish art community at the 1922 Congress of International Progressive Artists in Düsseldorf. With Jankiel Adler, Otto Freundlich, Raoul Hausmann, and Franz Wilhelm Seiwert, Bunt in collaboration with the group Die Kommune organized the International Exhibition of Revolutionary Artists in 1922 in Berlin. In Poznań it was Bunt that defined the twentieth-century tradition of the artists' community. The group influenced the metaphysical painter Jan Spychalski and Zygmunt Szpingier, an Expressionist connected for a time with the Polish artists of the École de Paris.

After Poland regained its independence in November 1918, Poznań, alongside Cracow, Lwów, and Vilnius, became an important cultural center. The university was founded, followed by, in 1919, the School of Decorative Arts and Craft Industry, whose head, Fryderyk Pautsch, was a leading Expressionist painter from Lwów. (A professor at the Academy of Art from Wrocław, he later became dean of the Academy of Fine Arts in Cracow.) The school collected many prizes at the 1925 Exposition Internationale des Arts Décoratifs in Paris. On Pautsch's initiative, an association of Poznań artists called Świt [Dawn] emerged in 1921. Its members included school lecturers Erwin Elster, Karol Zyndram Maszkowski, Władysław Roguski, previously a Formist, and Jan Jerzy Wroniecki, as well as artists from Cracow, Lwów, Warsaw, and Vilnius who settled in Poznań after the war. Unlike the Society of Friends of the Fine Arts and the Association of Artists, Świt was dominated by local artists, most of whom were realists. It was not an avant-garde group; the predominant tendencies were Expressionism (Elster, Wroniecki), neoclassicism (Władysław Lam), and a stylization close to Art Deco (Roguski). After Świt broke up in 1926, some of its members joined Plastyka [Plastic Art], a group of Wielkopolska artists whose members worked in Postimpressionist and

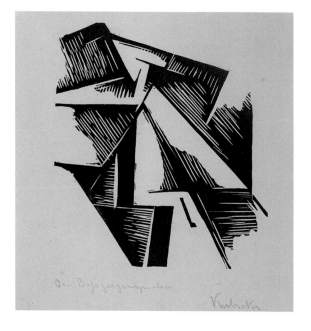

■ Stanisław Kubicki, *The Contrabassist*, 1919, linocut on paper

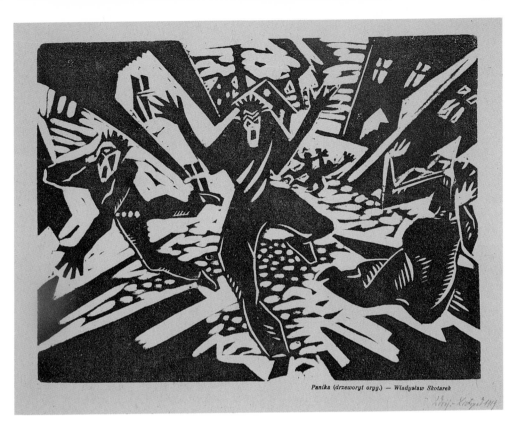

Panika (drzeworyt oryg.) — Władysław Skotarek

Above:
■ Władysław Skotarek, *The Panic*, 1919, linocut on paper

Right:
■ Władysław Skotarek, *Embrace*, 1918, linocut on paper

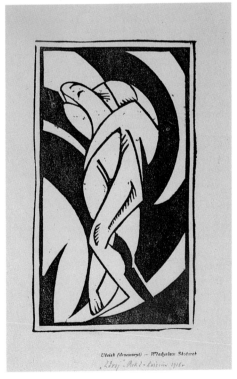

Uścisk (drzeworyt) — Władysław Skotarek

neoclassical styles. Active from 1925 until 1939, Plastyka organized many exhibitions in Poland and participated in Polish exhibitions abroad.

In 1929, to commemorate the tenth anniversary of Poland's independence, the Universal Exhibition of Art opened in Poznań. With about seven hundred artists showing some twenty-five hundred artworks, it was the largest show of Polish visual art in the interwar period. Fourteen groups representing pure and applied arts took part, including the Cracow group Sztuka; the Warsaw-based Rytm [Rhythm], with neoclassical works by Leopold Gottlieb and Eugeniusz Zak; Wileńskie Towarzystwo Artystów Plastyków [Vilnius Association of Plastic Artists]; and Warsaw's Bractwo Świetego Łukasza [Brotherhood of Saint Luke]. Onetime Formists and members of Bunt showed their works, as did a group of Polish artists then resident in Paris (Gustaw Gwozdecki, Alicja Halicka, Rajmund Kanelba, Mela Muter, August Zamoyski, and Tamara de Łempicka). Szymon Syrkus and Henryk Stażewski, members of the Warsaw Constructivist group Praesens, designed some of the exhibition pavilions. Painters who exhibited with Praesens included Władysław Strzemiński, Stażewski, Tytus Czyżewski, Marian Malicki, Maria Nicz-Borowiak, Andrzej Pronaszko, Aleksander Rafalowski, and Hipolit Polański; Katarzyna Kobro showed her sculptures. This would be the last joint appearance of Praesens artists, whose group broke up after the exhibition.

Translated by Wanda Kemp-Welch

Art has always been a popular outlet for the expression of national feelings .

Jacek Malczewski, *Melancholy*, 1894, oil on canvas

MODERNITY AND NATIONALISM:
AVANT-GARDE ART AND POLISH INDEPENDENCE, 1912–1922

whether they are intended by an artist or revealed only in the interpretation of a work of art.

Piotr Piotrowski

In 1894 Jacek Malczewski completed one of his more important works, *Melancholy*. On the back of the canvas he inscribed the following subtitle: *Prologue. Vision. The Last Century in Poland (Tout un siècle)*. Now in the collection of the National Museum in Poznań, the painting has been analyzed repeatedly and can be seen as a perfect example of the end-of-the-century consciousness in Poland—the convergence of art and Polish national sentiment.

Before the turn of the century Poland did not exist on the map of Europe. It was a kind of land of King Ubu.[1] Within Poland, however, strong feelings of national identity prevailed, largely as resistance to the occupation of the Polish state by three neighboring empires: Austria-Hungary, Prussia, and Russia. *Melancholy* explores many of the fundamental problems of Polish national thinking at the turn of the century. Unlike most Western European countries whose nationalism stems from a strategy of modernization begun in the eighteenth century, Poland's nationalism is more accurately described as premodern, one based on its ethnic, linguistic, and cultural traditions. In the absence of political independence, a collective ideology informed the Polish national conscience[2] and provided a substitute for an independent state.

At first glance *Melancholy* appears to depict a whirling mass of people, but upon closer inspection a narrative emerges from the canvas.[3] On the left we see a painter sitting on the edge of a chair with his back to the viewer, a palette in his left hand. He is not painting, but rather thinking, as figures stream from his head to fill his large studio. The characters form a crucifix, with children depicted at the base and older men, many dressed in military coats, at the top. The intersection of the cross is guarded by a group of armed men, some with scythes—a mythical weapon of Polish insurrectionists. The armed men in the center turn toward a wide window in the studio and run up against a wall of light that evokes

enemy artillery fire. The light also impedes the movement of several old men in military coats, who appear to be approaching the end of their lives. These are a pendant to the group of children on the opposite side. With their exile and eventual deaths in Siberia, the destination for Polish insurrectionists caught by the Russians, the aging soldiers close the life cycle, a lifetime of armed struggle for the country's independence.

Set apart from the crucifix of people, a strange figure, a woman cloaked in black with her head covered, looms near the studio window. The woman is depicted standing in the garden, opening the window from the outside; yet her torso is positioned in front of the window, inside the room, leaning on the ledge. This figure is often interpreted as an allegory of death, a death that not only expresses the end of life but also a vision of a new life—outside, in a new age (proposed by the "prologue" of the picture's subtitle)—in the twentieth century. This interpretation is confirmed by the painting's dominant crucifix, and is also reminiscent of the ideas of the early nineteenth-century poet Adam Mickiewicz, who compared the fate of Poland to the Passion of Christ, whose death and resurrection brought redemption and new life to mankind. The death of the aging Poles can be seen as redemptive, a necessary step toward resurrection—that is, the emergence of a new Polish state. Life, from birth to death, is seen as part of a cycle that must be completed; life comes only through death, which is both an end and a beginning. The life of a nation follows a similar path; it must first die before achieving rebirth and redemption. *Melancholy* is thus an allegory of Poland, a country which will regain its independence only after suffering defeat in several national insurrections.

This interpretation of Malczewski's painting is popular in Poland.[4] It aligns the work with the Polish philosophy of history, rooted in the ideology of Romanticism, whose

greatest authority was Mickiewicz. The painting's narrative tells the story of the nineteenth-century struggle for independence which, though ill-fated, awoke in the Polish people almost mystical hopes for future independence. The end of the nineteenth century, therefore, can be seen as both the culmination of events and a "prologue" to new times.

Melancholy also illustrates the artist's role in this historical process. In the painting the artist appears in several guises. We see him on the far left, seated in front of a canvas. On the opposite side of the picture, at the head of the cross, the artist is embodied in three figures: one holding a violin, another reading a book, the third holding a brush. In addition, in the bottom right corner of the picture, a small segment of a table juts out slightly, with the painter's tools arranged on it. One could argue that the table belongs to the author of *Melancholy*, to the reality of the external world rather than to the painting's imagery. It appears as if the author—Malczewski—is standing in front of the painting and examining his own vision with the eyes of a spectator. It is as if he has taken a photograph of this vision, and in doing so has captured a fragment of his real studio, the table, in the picture. The artist through whose eyes we see this view of Poland in the last century, whom we might also call the real artist, is the alter ego of the meditating painter represented in the upper left corner. In a significant gesture, the seated artist is not painting but imagining this vision of history, which he will later transfer to canvas. Through this vision he understands the historical processes and the meaning of Polish history.

Polish art historians emphasize the duty of the artist to translate history for the people, to express national feelings, and to demonstrate a sense of loyalty to the country. These obligations often are bound together with the Romantic concept of the myth of the artist, drawing upon the symbolism of melancholy, which has existed in European culture since the Renaissance. Yet in examining how national feelings are aroused, as presented by Malczewski, scholars have yet to consider the psychology of melancholy.

Sigmund Freud, though finding similarities between the states of mourning and melancholy, also differentiates them.[5] Melancholy has its roots in narcissism and, in a related sense, in the crisis of identity. The loss of an object to which we have strong attachment, according to Freud, causes the transference of those feelings onto ourselves. However, such feelings find no fulfillment there—they are rejected and, with them, so is the self. The intensity of the feelings toward the lost object causes the self to begin to lose itself. The self is questioned, producing an identity crisis. Furthermore, unlike with mourning, this identity crisis has permanence, like an open wound exacerbated by perpetual feelings of loss. Returning to our example, we can argue that a similar mechanism was in place in nineteenth-century Poland with regard to national sentiment. When the nation lost its independence, it also lost its self-respect, and ultimately a crisis of identity ensued. Nationalism came about when, after having lost their independence, their object of attachment, the Polish people were forced to question their values. The failed insurrections that followed exacerbated the wound in the manner described by Freud.

In preparing his work, Malczewski was conscious of the mechanism of national feelings and of the nation's narcissism. His *Melancholy* seems to reveal the identity crisis of the Polish nation. It serves to justify the defeat and, by bringing consolation, recover the self and the lost object of attachment—independence—through death.

In 1918 Poland regained its independence. The country reappeared in Europe in a definite place (not "nowhere," as with King Ubu's country). But by then Europe had undergone far-reaching changes, and the newly transformed Europe differed considerably from its eighteenth-century predecessor. The monarchy of the Holy Alliance was replaced by several independent states. Some, like Poland, regained an independence that had been formerly lost, while others, like Czechoslovakia or Yugoslavia, achieved independent status for the first time. In spite of the many political, ideological, and cultural differences among the independent states, central Europe, as a whole, became modern.

The process of building a new Polish state posed a political challenge, yet it was quick and dramatic. However, even during the war, talk of reviving the monarchy could still be heard. On November 5, 1916, decrees were announced simultaneously by the Prussian authorities (then occupying part of the Russian territory of Poland) and the Austrians. By the end of the war, however, monarchical rule in Poland seemed unrealistic; conditions were set instead for the creation of a modern national state and its administration—its internal and foreign policy. The Polish state resembled those in the European tradition of an ethnic state, that is, a state composed of one dominant nation. Nationalism in Western Europe has been associated with the demise of feudal structures and the emergence of a modern state.[6] In Poland, where such a transformation occurred later than in Western Europe (and, necessarily, outside the state, since there was no Polish

314

state at the time), modern nationalism was preceded by a form of nationalism based on language and ethnicity. With independence, the conditions for a Western type of ideology, conditions directly connected with the creation of a modern state, finally appeared.

Many factors contributed to Poland regaining its independence, and I will not discuss them here. Let us note only that the partitioning powers lost World War I, and at once all three empires disappeared from the map of Europe.[7] The new state—to some extent given over to the Poles and ethnic minorities by a historical coincidence—began to function in completely different circumstances than those that had been imagined during the nineteenth-century struggle for independence. Thus, the framework of the "nation problem" had to change. Nationalism, as Rogers Brubaker notes, is not a substance, an immanent element of the national consciousness, but a discursive and ideological practice. A nation's strategy for achieving its goal may differ in each case. Nationalism, therefore, must be understood according to how it functions in terms of institutions and practices, in terms of the ideological constructions generated within the political, economic, and cultural spheres.[8]

Poland's independence in 1918 transformed the need for national self-definition. It forced a change in the strategy for shaping this identity and provided concrete goals for political and discursive practices that were different from the earlier ones. With their history of having been divided among the three former powers, the reunited territories differed politically, economically, and culturally. Each functioned on the basis of a different legal system. Poles under Russian rule shared a mentality that differed from those in the German or Austrian areas, since the means of divesting Poles of their national identity varied greatly among the occupying powers. National ideology was helpful in bridging those gaps. It allowed an appeal to simple, common values that strengthened national identity. The new state felt a lack of security on the international platform. Poland's boundaries were questioned, and its diplomatic position was weak. National ideology was also useful in that it affirmed the necessity of maintaining and strengthening the independent state. Without entering into the different options represented by various political parties, it can be stressed that the function of such ideology was quite different than it had been in the nineteenth century. Even if the rhetoric had been the same, it now indicated different tasks and was inscribed in different political strategies. How, then, did a national ideology manifest itself in modern art?[9]

Art has always been a popular outlet for the expression of national feelings (or has been interpreted as a place where such feelings might appear), whether they are intended by an artist or revealed only in the interpretation of a work of art. Art can convey nationalist impulses that emerge from outside the state as well as those that arise from within.[10] Malczewski's *Melancholy* represents the nature of nineteenth-century feelings, both cultural and ethnic. However, around 1918, when the new state was being formed, this model seemed anachronistic and useless. In the changed political environment a new type of national ideology was required, one that would support the construction of an independent modern state within the new Europe, rather than reopen the wound of Polish national identity. The values of the Polish state were now modernity, the will to build anew, and activity directed toward life rather than meditation on the meaning of death. These values manifested themselves in new forms of art. The melancholic artist, the Romantic missionary preaching the rebirth of life after defeat and death, lost his appeal. While few ideologists of nationalism realized this at the time, modern nationalism required a different, more modern ideological expression. A number of spokesmen for a national ideology supported older forms of art—even anachronistic art derived from conservative nineteenth-century traditions—but the more dynamic and effective demonstrations of national ambition were represented by the modernist movement. In contrast to the nineteenth-century preoccupation with memory, culture, and language, the attitude inherent in modern art reflected a completely new understanding of the nation as a political organization with various institutions.

If we examine Polish modern art of the period, it is generally accepted that it emerged simultaneously during World War I in all three regions of Poland. In Poznań, a Prussian province until the end of the war, the Bunt group surfaced in 1917–18; in Łódź, Jung Idysz appeared in the Jewish community in 1919; in Cracow, located in the Austro-Hungarian province of Galicia, the Formists emerged in 1917. The Formists continued the independent exhibitions that had been organized in Cracow beginning in 1911. These exhibitions featured the first "modern" pictures in Poland, by the artists Tytus Czyżewski, and Andrzej and Zbigniew Pronaszko. Their work, manifesting a multiplicity of planes and the destruction of solid forms, revealed a mixture of Cubist and Expressionist influences.[11] This syncretic type of painting—as Andrzej Turowski observes—involved participation in a universal modernist ideology that stemmed from Cubism, the source

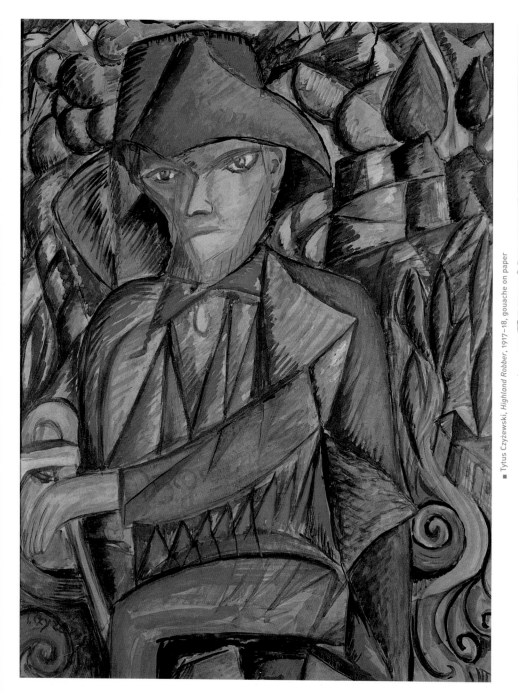

■ Tytus Czyżewski, *Highland Robber*, 1917–18, gouache on paper

Jankiel Adler, illustration for *Jung Idysz*, 1919

of all modern art, and pointed the way for art in the new state.[12] At the time of World War I the differences among Cubism, Futurism, and Expressionism were not discerned. They were all braided together, and a common modern nucleus was emphasized. In practice, artists often looked to tradition for discursive and ideological support when undertaking new forms of visual expression. Zbigniew Pronaszko, in his article "Before the Great Tomorrow," published in 1914, recalls the Romantic poet Juliusz Słowacki. In his search for a rationalization of the movement toward deformation and away from realism in painting, Pronaszko turned to Słowacki's works for their glorification of spirit and devaluation of matter.[13] While Turowski stresses the influence of Cubism on the syncretic Cubo-Expressionist style, Piotr Łukaszewicz and Jerzy Malinowski lay emphasis on Expressionism.[14] The popularity of religious themes, absent in the Cubist formula but present in German Expressionism, also played its part.[15] Łukaszewicz and Malinowski see in the special brand of Polish Cubo-Expressionism not so much an attempt to rationalize the painterly surface, but a pretext for the artist to express his emotions and spirituality.

The authors identify the beginnings of modern Polish art in Pronaszko's and Czyżewski's first individual interpretations of Cubism in 1912.[16] In analyzing what remains of the work from this period, we detect a significant shift that betrays the influence of Cubism and Expressionism, as in the altar designs for the Church of the Missionaries (1912) by Pronaszko; numerous drawings by Tymon Niesiołowski and Zygmunt Waliszewski; *Madonna* (1913) and later works including multi-plane paintings by Czyżewski; and selected drawings by Gustaw Gwozdecki from approximately that period.[17] After the war the art world moved toward Futurism, as it was generally understood, which Turowski associates with the Dada matrix. (There were no Dadaists in Poland, only their sympathizers, who were not aware of the name, Turowski explains.) What passed as Futurism was usually "polemical with the futurology of Marinetti's programme."[18] It was in those terms that a new art began to be defined, as Polish art moved away from its Expressionist phase, even creating a sort of distance, particularly on the part of the Formist and Jung Idysz groups.[19]

An important role in the promotion of the new art was played by exhibitions of foreign art in Poland such as *Futurists, Cubists, and Expressionists* in 1913 in Lwów, organized jointly with the Berlin Galerie Der Sturm (Alexander Jawlensky, Wassily Kandinsky, Oskar Kokoschka, Bohumil Kubišta, and others). Most of the Polish artists had been working abroad around

that time. Returning to Poland during or after World War I, they brought with them their familiarity with Russian, German, and French art. Some of them, like members of Jung Idysz and Bunt, remained in close contact with their foreign colleagues and returned to join them after a few years in Poland.

Jung Idysz deserves particular mention in the discussion of national ideology in modern art, given the group's multinational orientation. Jung Idysz found itself somewhere between the Polish majority and the Jewish minority. In addition, some of the members of the group had leftist leanings (as did members of Bunt). The opposition of some "national minorities" to the "nationalization of the state" (to use Brubaker's terms) soon became evident.[20] Pierre Bourdieu argues that this type of national expression has less to do with different ethnic groups finding themselves within larger national organisms than with the strategy of diversifying positions to best compete in the marketplace of intellectual values.[21] According to Jerzy Malinowski, Jung Idysz was the only community in Poland with wide international connections to emphasize that their art belonged to Jewish-Yiddish culture.[22] The name of the group itself has both modern connotations (Jung = "young"), and national ones (Idysz = "Yiddish"), hinting at such movements (and their discursive strategies) as Młoda Polska [Young Poland], Young Belgium, or Das Junge Rheinland. Das Junge Rheinland was cofounded by Jankiel Adler from Jung Idysz.[23] It is worth noting the difficulties of research into Jung Idysz. Most of the historical documentation has disappeared; only a few works on paper and photographic reproductions in rare copies of publications remain. This situation has discouraged exhibition of the material. At the monumental exhibition *Europe-Europe*, though there was some emphasis on modern Jewish art from Central and Eastern Europe, the works of the Łódź group were barely represented. Thanks to Malinowski we know more about the group, even if we cannot see its art.

Malinowski identifies Jung Idysz with Jewish Expressionism, a rather enigmatic notion in stylistic terms, but one which makes sense when we consider the group's attempt to create a Jewish national art—one based both on Yiddish culture and on European modernism.[24] It was not, however, a homogenous milieu: members of Jung Idysz represented diverse attitudes toward Jewish culture. Mojżesz Broderson and Vincent Brauner identified with the Jewish national tradition. Marek Szwarc, after converting to Catholicism, declared himself a "Catholic Jew," thus uniting both traditions. For Adler, with

his anarchist sympathies, Hassidic themes became a metaphor for the human predicament, while the religiously indifferent Henryk Barciński was a Jewish artist and political leftist.[25] Still another position was taken by Henryk Berlewi, who was also involved with Jung Idysz. In his speech at the opening of the exhibition of Jewish artists *What Do We Want?* in June 1921 in Warsaw, he stated that national art manifests itself "not in national themes, but in the individual form, corresponding to the essential character of a nation."[26] Berlewi acknowledged the dilemma of whether to cultivate Jewish tradition or break away from it. In other words, he confronted the implied alternatives: Jewish nationalism or cosmopolitanism."[27]

One prevalent model of Jewish art was the work of Marc Chagall. A similar element of inspiration could be found in the art of Maurycy Gottlieb and Samuel Hirszenberg. In his writings Szwarc refers to this tradition and points out that a Jewish style still had not been created. The search for it, he argues, needed to include traditional Jewish themes and elements of Jewish ornament, and the latest achievements in modern art. Various stereotypical forms and notions were added to the Jewish cultural references, such as spiritualism, irrationalism, and the grotesque fairy-tale motifs of traditional Hassidic literature. To give modernist traits to these subjects the artists either employed modern formal treatment or made references to Christian themes more representative of modernist iconography. The resulting combination was an interesting expression of Jewish artistic identity. Christian motifs, in obvious conflict with Jewish religious tradition, began to function as an exposition of universal values with regard to the ideology of the "new man," the spiritual rebirth of humanity, and the anticipation of times to come. In the work of some members of the group we can see the image of Christ as a prefiguration of the "new man," as noted by Malinowski. Christianity was intellectually attractive to progressive Jewish artists because it could be readily combined with Expressionist, or more generally, modernist influences. Artistic progressivism was thus legitimized as an expression of modern European culture. In addition, Christian iconography gave Jewish artists a chance to merge their art with activist, revolutionary, and anti-bourgeois attitudes.

To understand the strategy of Jung Idysz in positioning itself within the artistic community one must examine the context within which it functioned. The early 1920s witnessed a tide of strong Polish nationalism as a consequence of several historical factors: the Polish-Soviet war, the Silesian uprisings,

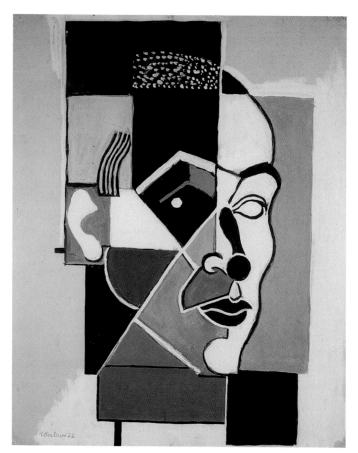

Henryk Berlewi, *Self-Portrait*, 1922, gouache on paper

Piotr Piotrowski

Christian motifs, in obvious conflict with Jewish religious tradition, began to function as an exposition of universal values

Polish-Lithuanian conflicts, economic crisis, social tensions, and the polarization of power elites. This climate created a fertile ground for the expansion of a nationalist ideology. Its culmination was the assassination in 1922 of Gabriel Narutowicz, the first Polish president, in the Zachęta art gallery. The assassin was Eligiusz Niewiadomski, an artist and art historian connected with the nationalist camp. Polish right-wing politicians did not like Narutowicz, because they felt he was more cosmopolitan than Polish. Following his election as president, the conservative press began an aggressive nationalist campaign, which targeted not only Narutowicz, but also all minorities. This campaign did not stop after the assassination. On the contrary, a surge in nationalism following the assassination intensified the unease felt by minorities in Poland. Associated with Polish nationalism was anti-Semitism, which had emerged during the nineteenth century and began to spread among some political parties.[28] Polish-Jewish national conflicts had both an economic and religious foundation. The Catholic Church, not an institution known for its openness, failed to use its enormous influence to mitigate anti-Semitism. On the other hand, Catholicism may have attracted national minorities because it allowed for emancipation, offering people a chance to break away from a social and cultural ghetto. Moreover, at that time an ideology of modernization gained both popularity and national legitimacy. The Jewish groups that made reference to universal Christian or modernist iconography and European artistic styles were able to compete with the Polish art communities for recognition. This was probably the aim of the Jung Idysz group in its expressions of nationalist sentiment. The Jewish artists' national-modernist discourse and artistic model was part of a strategy of differentiation and competition in the exchange of intellectual values. The elements of modernism ensured them a platform for communication with the greater public within the nationalized

state. Despite the national—Jewish—element of their work, the modern leanings of Jewish artists allowed them to remain within the system and to avoid the status of outsiders (unlike their fellow artists with strictly orthodox or conservative attitudes). The strategy did not bring the desired results, however. Jung Idysz would disperse in 1922–23, and national concerns would be replaced by a cosmopolitan position in politics and culture—a case in point was Henryk Berlewi's art during his stay in Berlin.

The Bunt group from Poznań took a different approach to the issue of nationalism. The group emerged in 1918 and was affiliated with the periodical *Zdrój* [Source], founded a year earlier by Jerzy Hulewicz.[29] Most of the artists of the group had strong ties with Germany. Stanisław Kubicki, the group's leading figure, was born and educated in Germany, and his wife, Margarete, was German.[30] He was in Poznań for only a short period—between 1917 when he deserted the German army and 1919 when he returned to Berlin—but he later visited Poland occasionally. Adam Bederski, Stefan Szmaj, Jerzy Wroniecki, and August Zamoyski also lived in Germany for some time; Władysław Skotarek spent a brief stay there. Jerzy Hulewicz, the prime mover of this literary-artistic milieu, and his brother Bohdan settled in Germany for a lengthy period. When the group was founded it had contacts with the Berlin periodical *Die Aktion* which, on the occasion of some Polish exhibitions, devoted two of its issues to Bunt. The group also had contacts with Der Sturm gallery, which exhibited works by Kubicki. Bunt's political position is best characterized by these extensive German connections. Nevertheless, most of its members were associated to a degree with nationalist and patriotic organizations, both in Poland and Germany, some of them clandestine.

While its members were artistically similar, in political and ideological terms Bunt was not a uniform group. Two distinct positions were represented among the artists. One showed

■ Stanisław Kubicki, *Oarsman*, c. 1918, illustration in *Die Aktion* (vol. 8, no. 25–26), woodcut on wove paper

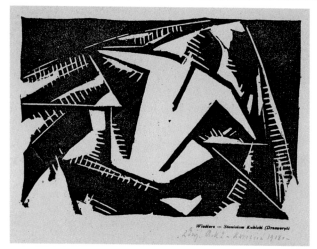

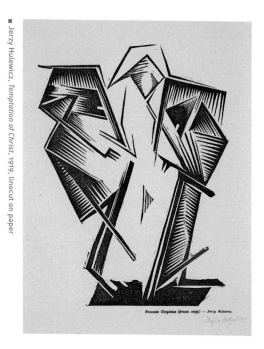

■ Jerzy Hulewicz, *Temptation of Christ*, 1919, linocut on paper

support for Józef Piłsudski, an undoubtedly charismatic leader and fighter for Polish independence who was unpopular in Wielkopolska (a western area of Poland) due to its nationalist and separationist tendencies. Piłsudski advocated armed struggle to establish a unified, multinational Polish state on the territory of the three partitioned sectors, and hoped to eventually rebuild the Jagiellonian Federation.[31] Jerzy Hulewicz, who agreed with this position, was also deeply committed to organizing support for Marshal Piłsudski. Together with Stanisław Przybyszewski, who was visiting from Germany, Hulewicz founded the publishing company Ostoja [Mainstay] and the periodical *Zdrój*, and considered instituting a center for national culture in Poznań.

Other members of the Bunt circle supported a universal socialist revolution that would bring about a unified utopian community, devoid of national and social conflicts. While some of the artists had held this position from the outset, the high point for the group came when the Kubickis, Skotarek, and Szmaj participated in the Berlin International Exhibition of Revolutionary Artists in October 1922.

Kubicki, the leading artist of socialist orientation, tended toward anarchism (as noted by Malinowski) or, more precisely, to anarcho-syndicalism and the political ideas of the Spartacus circle—Rosa Luxemburg and Karl Liebknecht.[32] Kubicki made clear his leftist views during his stay in Poznań with texts published in *Zdrój*, including the manifesto *A Little Something for Them*.[33] Both his art and his views on art were anti-aesthetic. For him the political motivation, commitment, and spiritual aspect of artistic activity were more important than formal or aesthetic values. Through its spirituality, art was to contribute to the destruction of capitalism—a system he considered adverse to culture. Kubicki's drawings and pictures of dynamic, simplified forms were directed against bourgeois aesthetics. The early paintings were very

expressive, the later ones more ordered, revealing his interest in Constructivism. His works after his return to Germany testify to a more radical commitment to politics. He criticized the Novembergruppe, signed the manifesto *Die Kommune* in 1922, took part in breaking up the Congress of International Progressive Artists, and helped write the second *Die Kommune* manifesto. The Congress in Düsseldorf was attended not only by the Kubickis but also by artists from the Jung Idysz group: Jankiel Adler, Pola Lindenfeld, Marek Szwarc, and Henryk Berlewi. For Berlewi the Congress was a turning point in his artistic career.[34] Having met earlier with the Russian artist El Lissitzky (their first meeting took place in Warsaw in the autumn of 1921),[35] in Düsseldorf Berlewi made a final conversion to Constructivism.[36]

Within Bunt, conflicts between Hulewicz and Kubicki eventually grew insurmountable. However, the two artists were in agreement on some issues regarding Polish nationalism, such as their shared disapproval of the position taken by their former ally—the Berlin periodical *Die Aktion*—toward the Polish-Soviet War in 1920. When *Die Aktion* declared itself on the side of the Soviets, both *Zdrój* (edited by Hulewicz) and Kubicki, affiliated with *Die Aktion* at the time, broke off relations with Franz Pfemfert, its publisher and editor. What had earlier consolidated the group was their conflict with the National Democratic party, highly influential in Poznań and the Wielkopolska region. Yet, for many of the critics of the National Democrats, both Hulewicz's perspective on statehood and Kubicki's revolutionary ideals were unacceptable. Their rejection was due not only to the party's aesthetic conservatism, but to the German connotations of the Bunt Expressionist style. Aggressive attacks on artists and their exhibitions by *Kurier Poznański* [The Poznań Courier], the leading nationalist journal of the political right, made it crystal clear that the National Democrats could not condone the Bunt group's artistic and political views. The modern, Expressionist form of Kubicki's work, combined with his references to anarchism and his leftist, cosmopolitan sympathies, undermined the artist's declarations of patriotism in the eyes of the conservative nationalists. The National Democrats sought a national identity in traditional rather than modern culture. In their program to build a Polish state they disregarded the German minority and rejected "federalist" efforts to resurrect the former multinational, multicultural Polish Commonwealth. The National Democrats strove to create an ethnically pure state, an idea alien to Piłsudski and his supporters (among them Hulewicz), who felt that national minorities (inhabiting primarily the Eastern territories) should be granted full rights in the new Polish state, and in a federation with other states like Ukraine. Given Bunt's strong affinities with German culture, as well as its cosmopolitan sympathies and modern aspirations, the group could not find acceptance among members of the right. In addition, Bunt's alliance with the Jewish Jung Idysz group also provoked the anti-Semitism of the National Democrats.

These various differences among political rivals did not prevent attempts at an alliance around 1918 between modern art and a more traditional, nineteenth-century position on national identity. Using Brubaker's terminology one can say that an attempt was made at the "nationalization of modernism." This was apparent in the third group of modern artists, the Formiści [Formists], the best known and most influential of the period.

Although some of the Formists, such as Tytus Czyżewski and Zbigniew Pronaszko, began their interest in modern form before World War I, the group's activities began officially in November 1917 at the First Exhibition of Polish Expressionists in Cracow. The participants included Leon Chwistek, Tymon Niesiołowski, and Andrzej and Zbigniew Pronaszko. Together with Stanisław Ignacy Witkiewicz (who returned from Russia the following year), August Zamoyski (connected then with Bunt), and Konrad Winkler (author of the first monograph on the Formists), they made up the nucleus of the group.

The changes to the group's name between 1917 and 1919 are symptomatic of the issues debated among the artists. At the end of 1917 the group exhibited as the Polish Expressionists. "Polish" indicated the group's national character; "Expressionists" signaled its adherence to a global movement. The name thus contained a contradiction—the tension between the local or national and the universal or cosmopolitan. Ultimately, the former came to be given more weight. In 1918 the name "Expressionism" gave way to "Formism," and later exhibitions in independent Poland were held under the name Formists. In numerous publications members of the group emphasized the issue of form (rather than expression, as earlier), and thereby exposed their interest in a primary concern of modern European art. The name "Formists" had no reference to the language of art criticism, but instead signaled the group's unique, national character. Art critic Joanna Pollakówna argues that the change in the name from "Expressionists" to "Formists" was intended to distance the artists from the Poznań Group,[37] while Irena Jakimowicz suggests it was meant to separate

them from the German movement.[38] Whichever reason we accept (the first is more likely, since there were no anti-German feelings in Cracow), one must note the Formist artists' efforts to create a Polish modern movement and to "nationalize" modernism.

Polish art historians agree that Cracow artists strove to express Polish identity in contemporary art, even though the artists themselves did not directly discuss the subject. Their first exhibition (while still the "Expressionists") gathered not only their own works but also folk paintings on glass. In preceding decades, folk art had been synonymous with Polishness. The Polish Expressionists/Formists often drew upon the iconography of folk art from the Podhale mountain region near Cracow. Tytus Czyżewski, for example, painted numerous Madonnas, and his famous *Robber* (1917–18) referred to the well-known folk legend of the noble outlaw Janosik of the Tatra mountains, who robbed the rich and gave to the poor. Irena Jakimowicz writes that the group's borrowings from folk culture are "proof of Formism's Polishness."[39] However, in the process of nationalizing modernism what is important is not so much the folk iconography—often based on religious subjects—or the use of folk art as a rich source

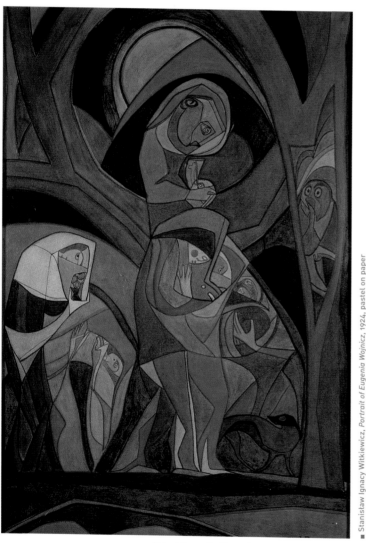

Andrzej Pronaszko, *Procession*, 1926, watercolor on paper

■ Stanisław Ignacy Witkiewicz, *Astronomic Composition*, 1918, pastel on paper

■ Stanisław Ignacy Witkiewicz, *Portrait of Eugenia Wojnicz*, 1924, pastel on paper

folk art relied upon forms as yet untainted by civilization.

of national culture, but that folk art relied upon forms as yet untainted by civilization. These "primitive" forms could be both truly Polish and modern.[40]

It is worth noting here that Picasso used a similar strategy. For him "primitive" art had not only an aesthetic significance but also a political one. Picasso looked for inspiration to simplified, authentic forms that had been spared the terror of European artistic convention. He also sought an alternative to the colonial practices of the Western world, and of France in particular.[41] For Picasso the "primitive" embodied an expression of antinationalist, anti-French sentiment. For the Formists, however, the primitive was nonconventional, yet also nationalistic. The Cracow artists, like Picasso, looked to the "primitive" for modern form and nonartistic values. But unlike Picasso, they looked for national expression in art. Moreover, as Pollakówna suggests, they searched for the source of the modern national style in highland folklore.[42] One of the reviewers of their first exhibition (*Polish Expressionists*) noted: "Polish Formism, grown on local soil and controlled exclusively by Polish primitives, has become the national art... [F]or the first time in the history of artistic ideas in Poland a movement has appeared that is demonstrating the will to create an independent Polish style."[43]

Unlike the Poznań Bunt and the Łódź Jung Idysz, the Formist group soon found itself at the center of national modern culture. The strategy of nationalizing modernism brought about the desired effects. This secure position allowed the Formists to distance themselves from the Poznań Expressionists and their radical political views, and from the Łódź artists and their identification with the cultural minority. Jung Idysz and some artists from Bunt emphasized their cosmopolitanism and links to the international art community, which in Poland was not viewed favorably. The Formists, in contrast, demonstrated how modernity could be tamed—through nationalization. Herein lies the reason for the bad relations

between the Formists and the groups from Poznań and Łódź. Despite a few joint exhibitions and personal connections (notably August Zamoyski, who grew closer to the Formists than to Bunt), the Cracow artists had little contact with the members of Bunt.[44] The latter more readily found a common language with the artists of Jung Idysz. They were united by a shared sense of modernity without frontiers, and a revolutionary community of ideas, both artistic and social, though not entirely free from national elements. The Formists, whose international contacts were limited almost exclusively to Polish artists in Paris,[45] were firmly focused on the new Polish state.

The nationalization of modern art proved to be an effective strategy. Formism was, and still is, considered the most important art community in the years immediately following World War I. However, many artists found it difficult to move beyond the unyielding platform of the group, which some deemed superficial, or even alien. While Tytus Czyżewski and Andrzej Pronaszko can be regarded as the national wing of the Formists, Leon Chwistek and Stanisław Ignacy Witkiewicz were at the opposite end. In their art and writings we find no indication of an effort to nationalize modernism. On the contrary, despite an almost total lack of international contacts, their (quite different) interests in art and philosophy were universalist, which is not necessarily cosmopolitan. Around 1922 the group broke up, and the nationalists formed a new group, Rytm [The Rhythm],[46] which had a staggering career in interwar Poland on the basis of its extremely eclectic formula. Henryk Anders, reconstructing the program of Rytm, writes: "The Rhythmists wanted to create a modern national style exploiting the principles of classicism, folk art and, finally, present-day principles of formal construction."[47] The group's artistic production combined stylized elements from the folk tradition and from modernism. The group was extremely popular among the power elites of the 1920s. More than an adaptation

of modernism to national culture, their art can be seen as an integral part of the state and its political strategy.

The year 1922 not only witnessed the breakup of the Formists and the emergence of Rytm, but also marked the end of the first wave of modern art in Poland. At more or less the same time, Bunt and Jung Idysz ceased to function. However, in the same year, *Jeune Pologne*, an exhibition drawn largely from the art of the Formists' circle, was organized in Paris. Though shown outside Poland (and perhaps largely due to this fact) it became a symbol of the state's institutionalization of nationalized modernism. The exhibition was not a great success. It exposed the hidden ambitions of Polish artists in Paris, the center of modern art, and helped to perfect the formula for nationalized modernism, following from the Formists' nationalist style. Borrowing Władysław Strzemiński's term, the art was a manifestation of "snobbish modernism"—simultaneously superficial and tactical.[48] Such modernism—"soft," filtered through middle-class tastes, and an eclectic combination of folklore, classicism, and modernity—fulfilled the expectations of the new Second Republic. It accorded with the new state's national policy.

Paintings by artists of the Rytm group often decorated the walls of politicians' offices, state administration buildings, and other respectable institutions such as churches and banks. These same artists designed postage stamps, banknotes, posters, and other popular visual images. They were the artists chosen for prestigious exhibitions, and the recipients of many prizes in the Polish section at the Exposition Internationale des Arts Décoratifs et Industrielle in 1925 in Paris.[49] In the Polish press and also in some French periodicals the Polish exhibition was regarded as a great success. Indeed, the Poles received 172 prizes, including thirty-six Grand Prix. The artists associated with Rytm represented only a part of the Polish section, but a significant part.

This eclectic cultural strategy was successful. The Polish section opened with a sculpture by Henryk Kuna in the courtyard of the Polish pavilion. It is difficult to find any modern or national features in it; its references were instead classical. Jan Szczepkowski's reliefs drew upon various religious and folk motifs combined with Cubist forms. According to the reviewers of the exhibition, a similar approach was detected in the art of Zofia Stryjeńska, who like Szczepkowski was awarded a Grand Prix. Polish cultural policy required such an eclectic formula to adequately represent the nation's image. Folk motifs signaled the centuries-old traditions of the Polish nation and the persistence and stability of national identity. They legitimized Polish independence, which until then had

been questioned politically by some in both the East and West. Modernist references signaled to those same observers that the new state was ready to occupy a significant place among the highly civilized countries of Europe and to look toward a modern future in Europe. They signified a country whose national identification was not simply ethnic and linguistic. This modern character was to contribute to the international prestige of Poland, but also testified that the strategy of "modernist nationalism" had aided Poland in its efforts to cement a national identity, and was consistent with the history of other modern European states.

The difference between the program of the Rytm group and the nationalization of modernism of the Formists was that the latter was spontaneous, created in response to the need for a modern and national style. Later the strategy of institutionalizing modernity became an elaborate program of state cultural policy. From among the potential styles on offer in the art market the state had chosen the formula of "snobbish modernism." The breakup of the Formists in 1922 (as well as the end of early modernism as such) allowed for the popularization of the Rytm group's less radical formula of state-institutionalized modernity.

The counterpart to the Formists and the Rytm group was the radical avant-garde movement of Polish Constructivism. Its history began with the Exhibition of New Art in 1923 in Vilnius; a later show, Berlewi's *Mechanofaktura*, at the automobile salon of Austro-Daimler; and the founding of the Blok group. The Polish Constructivists marked their inauguration with an exhibition in another automobile salon, that of the Laurin-Clement firm, and the publication of the first issue of the journal *Blok*.

According to most Polish art historians, the roots of modern art in Poland trace back to Formism,[50] something Strzemiński also notes in his writings,[51] though he oddly fails to mention Bunt or Jung Idysz, where he had connections. Such an approach reveals a strong and often unconscious need to place the history of art movements within a national context. To this end the Formists, unlike Bunt and Jung Idysz, were well suited. They were at the center of Polish cultural life, and through their presence in museums and collections their works grew to represent the history of the avant-garde. Almost everything published in Polish on modernist twentieth-century Polish art supports this claim. The "nationalization of modernism" carried out in the 1920s went beyond its historical framework to become a paradigmatic model of Polish art historiography, responding, it seems, to the need for a national identity by asserting a Polish presence on the map of modern Europe.

The Formists . . . demonstrated how modernity could be tamed—through nationalization.

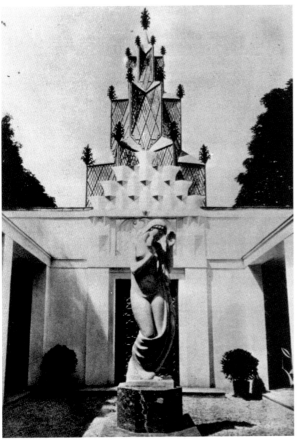

Courtyard of Polish Pavilion, Exposition des Arts Décoratifs, Paris, 1925

Tadeusz Gronowski, design for postage stamp commemorating November 1830 uprising, 1930

1 A reference to the early Surrealist play *Ubu roi* by the French playwright Alfred Jarry (1873–1907). The play was first performed in Paris in 1896.

2 See the following critical review of contemporary discussions on the theory and history of nationalism: A. D. Smith, *Nationalism and Modernism: A Critical Survey of Recent Theories of Nations and Nationalism* (London and New York: Routledge, 1998).

3 A discussion of the painting can be found in *"Melancholia," Jacka Malczewskiego*, ed. P. Juszkiewicz (Poznań: Poznańskie Towarzystwo Nauk, forthcoming).

4 For what are considered authoritative interpretations of Jacek Malczewski's work see the publications by well-known Malczewski scholar Agnieszka Ławniczak. See, among others: *Jacek Malczewski* (Warszawa: Krajowa Agencja Wydawnicza, 1976), 30–35.

5 S. Freud, "Żałoba i melancholia" in: K. Pospiszel, *Zygmunt Freud. Człowiek i dzieło* (Wrocław: Zakład Narodowy im. Ossolińskich, 1999).

6 A. D. Smith, *Nationalism and Modernism*.

7 See H. Wereszycki, *Historia polityczna Polski, 1864–1918* (Wrocław: Zakład Narodowy im. Ossolińskich, 1990).

8 R. Brubaker, *Nationalism Reframed: Nationhood and the National Question in the New Europe* (Cambridge: Cambridge University Press, 1996).

9 P. Piotrowski, "Art and Independence: Polish Art in the 1920s," *Artium Quaestiones* 6 (1993): 31–37.

10 These two types of nationalism, both in theory and in history, are analyzed by Eric Hobsbawm in *Nations and Nationalism since 1780* (Cambridge: Cambridge University Press, 1990). Hobsbawm takes into account the differences between Eastern and Western Europe in regard to social development. See also A. D. Smith, *Nationalism and Modernism*, 121 nn.

11 See the following chronologies of events of the early modern art movements in Poland: *Ekspresjonizm w sztuce polskiej*, ed. P. Łukaszewicz, J. Malinowski (Wrocław: Muzeum Narodowe, 1980), 36 nn; *Formiści*, ed. I. Jakimowicz (Warszawa: Muzeum Narodowe & Wyd. Arkady, 1989), 19 nn.

12 A. Turowski, "Czym był kubizm w Polsce," in A. Turowski, *Awangardowe marginesy* (Warszawa: Instytut Kultury, 1998), 59.

13 Z. Pronaszko, "Przed wielkim jutrem," in H. Blum, *Zbigniew Pronaszko* (Warszawa: KAW, 1983), 64–66.

14 *Ekspresjonizm w sztuce polskiej*, 7–11.

15 Ibid., 10.

16 Ibid., 8.

17 It is difficult to attribute precise dates to Gwozdecki's works.

18 A. Turowski, "Dadaistyczne konteksty," in A. Turowski, *Awangardowe marginesy*, 36, 43, 46.

19 J. Malinowski, *Grupa Jung Idysz i żydowskie środowisko "nowej sztuki" w Polsce, 1918–1923* (Warszawa: Instytut Sztuki PAN, 1987), 101. See also *Antologia polskiego futuryzmu i nowej sztuki*, ed. Z. Jarociński, H. Zaworska (Wrocław: Zakład Narodowy im Ossolińskich, 1978).

20 R. Brubaker, *Nationalism Reframed*, 61.

21 Ibid.

22 J. Malinowski, *Grupa Jung Idysz*, 13. The group was founded in 1919 in Łódź and included Jankiel (Jakub) Adler, Henryk (Henoch) Barciński (Barczyński), Wincenty (Icchak) Brauner (Brojner), Ida Brauner, Mojżesz Broderson (a leader of the group), Pola Lindenfeld, Marek Szwarc (Szwarz), Władysław (Chaim)

Weintraub (Wolf). Henryk Berlewi, who lived in Warsaw then, had close contacts with the group.

23 Ibid., 27–28. The difficulties of research into Jung Idysz are worth noting. There are few extant works by the artists, mostly graphic works on paper, and the few published reproductions or photographs that exist appear only in rare copies of publications. The paucity of original works discourages scholars from including the material in large exhibitions. At the monumental exhibition *Europe-Europe*, while there was some emphasis on the modern Jewish art of Central and Eastern Europe, the works of the Łódź group were hardly present. See: J. Malinowski, "Das judische Kunstleben in Ostmitteleuropa," in: *Europa, Europa: Das Jahrhundert der Avangarde in Mittel- und Osteuropa*, vol. 1, ed. R. Stanisławski and Ch. Brockhaus (Bonn: Kunst- und Ausstellungshalle der Bundesrepublik Deutschland, 1994), 228–38. Thanks to Malinowski's monograph (*Grupa Jung Idysz*) we now know more about the group. Several works— all that remained—were shown at the exhibition *Ekspresjonizm w sztuce polskiej* in Muzeum Narodowe, Wrocław, 1980. See *Ekpresjonizm w sztuce polskiej*.

24 J. Malinowski, *Grupa Jung Idysz*, 84–103. The reconstruction of views of the group is based on this fragment of the publication. Detailed references to sources can also be found in this section of Malinowski's monograph.

25 J. Malinowski, *Malarstwo i rzeźba żydów Polskich w XIX i XX wieku*, vol.1 (Warszawa: Wydawnictwo Naukowe PWN, 2000), 214.

26 Ibid., 216.

27 Ibid.

28 The biggest ethnic group after the Poles were the Ukrainians, then the Jews, who constituted ten percent of the entire population.

29 For the group, its history, ideology, and artistic production see J. Malinowski, *Sztuka i nowa wspólnota: Zrzeszenie artystów Bunt, 1917–1922* (Wrocław: Wiedza o Kulturze, 1990). My reconstruction of the group is based on this monograph, the only publication to date on *Bunt*.

30 Studies on this outstanding artist are very few. One of them is an MA thesis: J. Kubicki, *Stanisław Kubicki* (typescript) (Berlin 1986).

31 Piłsudski referred to a history of Poland when this country was a union between Poland and Lithuania, and many nations lived together in the kingdom of Poland. The Jagiellonian dynasty itself came from Lithuania. The first of them Władysław Jagiełło was a Lithuanian prince

32 Malinowski, *Sztuka i nowa wspólnota*, op. cit.

33 S. Kubicki, "Tamtym coś niecoś", in *Zdrój* 2 (1919): 34–36; reprinted in: *Krzyk i ekstaza. Antologia polskiego ekspresjonizmu*, ed. J. Ratajczak (Poznań: Wydawnictwo Poznańskie, 1987), 81–84.

34 A. Turowski, *Budowniczowie świata* (Kraków: Universitas, 2000).

35 This was noted for the first time by Jerzy Malinowski: J. Malinowski, *Grupa Jung Idysz*, op. cit., 108 nn. See also A. Turowski, *Budowniczowie świata*, op. cit.

36 The Congress of International Progressive Artists in Düsseldorf had scant publicity in Poland, as did most international events of the avant-garde. See Berlewi, "Międzynarodowa wystawa w Dusseldorfie," *Nasz Kurier* 209 (1922): 2.

37 J. Pollakówna, *Formiści* (Wrocław: Zakład Narodowy im. Ossolińskich, 1972), 127–28.

38 *Formiści*, ed. I. Jakimowicz (Warszawa: Muzeum Narodowe, 1989), 9 [English: 15].

39 *Formiści*, 6 [English: 12].

40 P. Piotrowski, op. cit., 45.

41 P. Leighten, "The White Peril and 'L'Art negre': Picasso, Primitivism and Anticolonialism," in *Art Bulletin* 72:4 (December 1990): 609–30.

42 J. Pollakówna, *Formiści*, 45.

43 H. Anders, *Rytm. W poszukiwaniu stylu narodowego* (Warszawa: Arkady, 1972), 127–28.

44 Contacts between both groups are analyzed in detail by Jerzy Malinowski in *Sztuka i nowa wspólnota*. See 23, 33, 86.

45 Ibid. 125.

46 J. Pollakówna, *Formiści*, 9.

47 See H. Anders, *Rytm*, 11.

48 W. Strzemiński, "Snobizm i modernizm," in W. Strzemiński, *Pisma*, ed. Z. Baranowicz (Wrocław: Zakład Narodowy im. Ossolińskich, 1975), 125–27.

49 M. Rogoyska, "Paryskie zwycięstwo sztuki polskiej w roku 1925," in *Z zagadnień plastyki polskiej, 1918–1939*, ed. J. Starzyński (Wrocław: Zakład Narodowy im. Ossolińskich, 1963).

50 A. Turowski, *Konstruktywizm polski: Próba rekonstrukcji nurtu (1921–1934)* (Wrocław: Zakład Narodowy im. Ossolińskich, 1981).

51 W. Strzemiński, "Sztuka nowoczesna w Polsce," in: W. Strzemiński, *Pisma*, op. cit., 205. Strzemiński's quotation dates from 1934. Earlier Strzemiński had ignored the Formists.

cracow

Berlin Poznań Warsaw

Dessau

 Łódź

Weimar Prague Cracow

 Vienna

 Budapest

Ljubljana Zagreb

 Belgrade Bucharest

the artist has to reach for more complex and "perverse" means to stimulate the obdurate viewer to experience the "strangeness of existence."

CRACOW

Tomasz Gryglewicz

More than in any other European country, Polish art at the beginning of the twentieth century was shaped by politics. Three powers—Russia, Prussia, and the Austrian Empire—had partitioned Poland and curtailed its independence (Cracow, in the province of Galicia, with its capital city Lwów, fell under Austrian rule). Art was obliged to perform patriotic functions, the best expression of which was perhaps the passionate historical painting of Jan Matejko, the head of Cracow's School of Fine Arts for many years. Matejko's successor as head, Julian Fałat, was appointed in 1895. A painter of genre scenes and landscapes, Fałat thoroughly modernized the school's curriculum and appointed artists of the younger generation as professors. The school became the Academy of Fine Arts in 1900. Sztuka [Art], founded in Cracow in 1897, had ties to the Vienna Secession. Artists in the group employed the styles of Symbolism and Impressionism.

Between 1905 and 1910 a crisis faced both the academy and Sztuka. Academy students went on strike, demanding reforms, and as a result, the head was replaced. Young artists, critical of the nineteenth-century naturalism that tainted the art of the older generation, founded in 1905 the Grupa Pięciu [Group of Five]. Rather than directly imitate nature, its members—Witold Wojtkiewicz, Leopold Gottlieb, Vlastimil Hofman, Mieczysław Jakimowicz, and Jan Rembowski—hoped to cultivate a new art combining Symbolism with a more Expressionist form.

The first timid manifestations of avant-garde tendencies appeared in Cracow's Exhibitions of the Independents, in 1911, 1912, and 1913. Shown alongside the works of recognized artists were those of the younger Tytus Czyżewski, Jacek Mierzejewski, and Eugeniusz Zak. The sculptors Andrzej and Zbigniew Pronaszko showed a project in a Cubo-Expressionist style for the altar of the Church of the Missionaries in Cracow. The young artists tended, more than their predecessors, toward tectonic compositions, using synthetic, geometricized forms adopted from Cézanne and other Postimpressionists.

Word of the new trends in art, particularly Cubism, also spread to Cracow. Many artists were exposed to Cubism directly when, after their education at the academy, they went to Paris for further studies. Some, like Mojżesz Kisling and Tadeusz Makowski, settled there; others such as Tytus Czyżewski, Leon Chwistek, and Stanisław Ignacy Witkiewicz (known as Witkacy, the son of naturalist painter and art theoretician Stanisław Witkiewicz) returned to Cracow and formed Poland's

p. 327:
Stanisław Ignacy Witkiewicz and Krystyna Glogowska seated next to her portrait, Zakopane, 1933

Above:
Andrzej and Zbigniew Pronaszko, 1915

Right:
Zbigniew Pronaszko, design for the altar of the Church of the Missionaries, Cracow, 1912

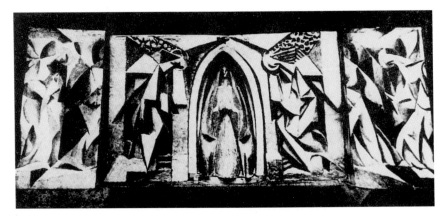

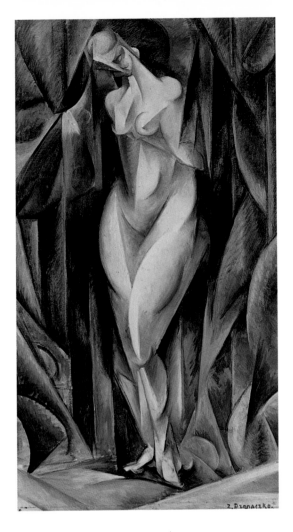

first avant-garde group, Formiści [Formists]. Initially the group was influenced by Postimpressionism. It was only Witkacy who, in addition to portraits inspired by Gauguin and innovative photographic experiments, produced a series of Expressionist "ugly drawings," as he called them, in the spirit of Alfred Kubin's grotesques.

The First World War was a turning point in Polish art, opening the way for avant-garde art, especially in Cracow. The unification of Poland into one independent state, with Warsaw as its capital, released art from its duty to preserve Poland's national culture. During the war, artists from Cracow and nearby Zakopane founded a group to represent the avant-garde. Organized on the initiative of brothers Zbigniew and Andrzej Pronaszko and Tytus Czyżewski, the First Exhibition of Polish Expressionists opened in the Palace of Art in Cracow on November 4, 1917. The artists exhibited under the Expressionist name

Above:
■ Zbigniew Pronaszko, *Nude*, 1917, oil on canvas

Right:
Tytus Czyżewski, *Multiplanar Picture*, 1918, relief painting

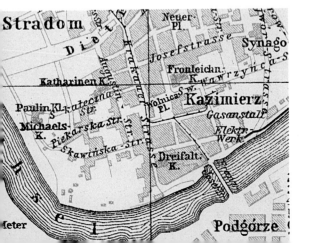

twice, and only in their third exhibition, in 1919, did they show their works as Formiści. The leading members of this nationwide group were Zbigniew and Andrzej Pronaszko, Czyżewski, Leon Chwistek, Witkacy, Jacek Mierzejewski, Jan Hrynkowski, Tymon Niesiołowski, Konrad Winkler, and the sculptor August Zamoyski.

The Formists had no doctrine, and each member of the group represented an individualized tendency toward a synthetic, distinct, and usually geometricized form over other painterly or sculptural means. Their work syncretized avant-garde trends taken from European art, above all from Cubism, Futurism, and Expressionism. The artists emphasized their formal differences but invoked their shared national traditions by drawing on Polish folklore. They frequently quoted romantic poet Adam Mickiewicz's pronouncements on art: "Art is not merely imitation… Art is not and cannot be anything else but an expression of vision."

The influence of Cubism can be seen in the paintings, sculptures, and theoretical views of Zbigniew Pronaszko. In his *Nude* of 1917, forms disintegrate into prismatic, geometric elements, and color is reduced to grays and gray-blues. His later Formist works show a higher degree of realism and, in spite of their generally Cubist form, a definite classicism.

Andrzej Pronaszko in his paintings, frequently on religious themes, began with a flat form and a strong outline reminiscent of stained glass (*Procession*, 1916; *Monk*, 1917). Later, influenced by Cubism, his paintings became more spatial (*The Flight to Egypt*, 1918–21). His works, including graphic works, are strongly expressive. Cubism, interpreted to some degree in an Expressionist way, can also be seen in the works of Tymon Niesiołowski, Jan Hrynkowski, and Konrad Winkler. Winkler, as well as incorporating elements of avant-garde painting, drew on folk painting on glass from the Podhale mountain region (*St. George*, 1920).

The painting of other leading Formists—Czyżewski, Chwistek, and Witkacy—is more complex and individual, not least because these artists were not only painters; Witkacy wrote plays, novels, and treatises

on aesthetics and philosophy; Czyżewski was a poet; and Chwistek a philosopher. At the first group exhibition in 1917, Czyżewski showed some of his experimental Multiplanar Pictures (1915–18), the radicalism of which caused some consternation. We know this work only from descriptions and poor photographs. Asymmetric in composition and irregular in form, they consisted of three-dimensional elements, mainly made of cardboard, that owed more to the spirit of Dada than Cubism. On the level of representation, they seem an odd, haphazard mixture of figurative and abstract forms juxtaposed in space as an assemblage.

The most Formist of Czyżewski's paintings, such as *Madonna* (c. 1920) or *Highland Robber* (1917–18), display like his poems a synthesis of the modern, especially Cubism, and the "primitive," in the sense of folk-art tradition. Primitivism also became part of the program of Polish Futurist poetry. From October 1919 Czyżewski, with Chwistek and Winkler, was editor of the periodical *Formiści*. At the end of that year he met two young poets, Bruno Jasieński and

Stanisław Młodożeniec, and together they founded the Futurist club Katarynka [Hurdy-Gurdy]. From then on contacts between Formists and Futurist poets became closer. They met in Cracow's coffeehouse Esplanada, where one of the rooms, called Gałka Muszkatułowa [The Nutmeg], was decorated with paintings described by contemporary art critics as Futurist. Painters participated in special evenings, the so-called poetry concerts. Like Futurist or Dadaist events, these poetry concerts were to a certain extent meant as provocations and often ended in brawls. Thanks to his participation in the Futurist movement (by such means as his contribution titled "Nuż w bżuhu" [Knife in the Stomach], and the scandalous 1921 group publication *The Futurists' Day*) Leon Chwistek did not obtain his assistant professorship at the Jagiellonian University in Cracow until 1928. Finding him lacking in the seriousness appropriate to a lecturer, the university held up his appointment. Chwistek, a doctor of philosophy (he studied in Cracow and Göttingen), had published strictly academic treatises in philosophy

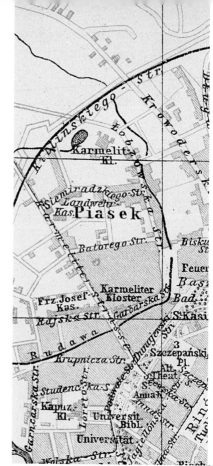

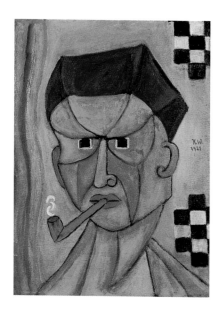

Above:
■ Konrad Winkler, *Portrait of Tytus Czyżewski*, 1921, oil on cardboard

Right:
■ Tytus Czyżewski, *Portrait of Stanisława Mróz*, 1918, gouache on paper

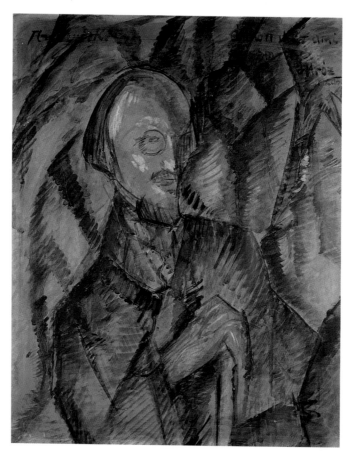

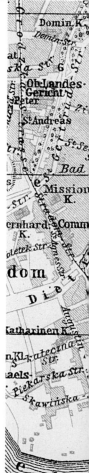

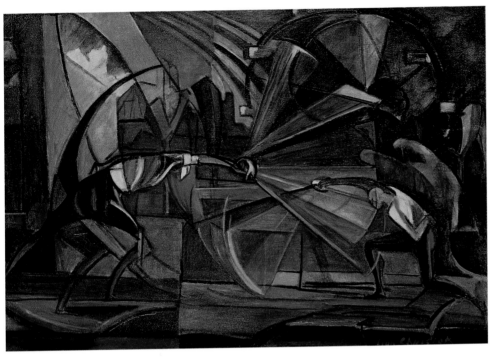

Left:
■ Leon Chwistek, *Fencing*, c. 1919, oil on cardboard

Below:
■ Leon Chwistek, *City*, c. 1919, oil on cardboard

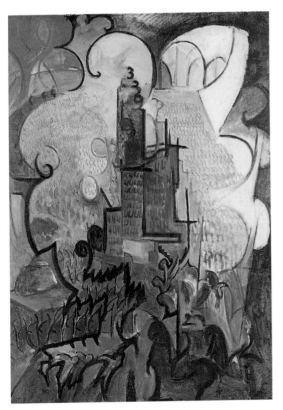

and logic. In his Formist years he was influenced mainly by Italian Futurism, both as regards formal means, above all simultaneity (e.g., *Fencing*, 1919), and in his choice of subject matter (e.g., the series *Cities*, c. 1919–20).

In 1918 Chwistek published a theoretical article, "Multiple Realities in Art," in which he identified Futurism with avant-garde art as a whole and linked it with the "reality of representations." This was one of four basic types of reality that he defined and correlated to a style. The others were the "reality of objects" (primitivism), "physical reality" (realism), and the "reality of impressions" (Impressionism).

Another key Formist treatise was Witkacy's *New Forms in Painting and Misunderstandings Arising from Them*. A friend of Chwistek's from their youth in Zakopane, Witkacy was his antagonist in philosophy. Witkacy held Chwistek's realism against him; for Witkacy, genuine art manifested itself only in "pure form," evoking "metaphysical sensations" in the spectator, which arose from the individual's experience of the

"strangeness of existence." In a contemporary, democratic, and mechanized society, Witkacy reasoned, as a result of inevitable revolutionary changes, "metaphysical sensations" disappear and with them also religion, philosophy, and genuine art and culture. Accordingly, the artist has to reach for more complex and "perverse" means to stimulate the obdurate viewer to experience the "strangeness of existence."

Witkacy based his theoretical and philosophical system partly on his experiences in Russia, where, as an officer in the White Guard during the First World War and the Revolution, he had become acquainted with Suprematism and other abstract art movements. Even though his treatise can be read as a justification of pure art, his work was not abstract. Compositions from his Formist period have a developed representational level (among others, *Creation of the World*, 1921–22; *The Temptation of St. Antony I*, 1916–21, and *II*, 1921–22; *Chopping the Forest (Battle)*, 1921–22). His paintings show a characteristic Expressionist deformation and antinaturalist form.

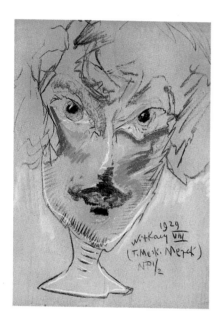

■ Stanisław Ignacy Witkiewicz, *Portrait of Nena Stachurska*, 1929, pastel on paper

The compositions consist of flat basic forms with strongly outlined dissonant groups of bright colors. Witkacy called the dynamic network of lines in his paintings "directional tensions."

Until 1922, when the group broke up, the Formists organized four exhibitions in Cracow and a few elsewhere—in Warsaw, Lwów, and Poznań. Zbigniew Pronaszko left the group to distance himself from Futurism and also because of his interest in color. His brother, Andrzej, joined the Constructivists and devoted himself more to stage sets than painting.

A similar process of moving away from the avant-garde in order to study color can be observed in the work of Czyżewski after stays in France (1922–29) and Spain (1929). Chwistek after his Formist period worked on his theory of "strephism," a means of pictorial stratification which he put into practice in his paintings. In 1930 he moved to Lwów to take up the chair of mathematical logic at Jan Kazimierz University. Witkacy announced in 1924 that he was ceasing any artistic activity (more or less at the same time as Marcel Duchamp) and thus, in his own views, breaking away from pure form in both painting and literature. He no longer painted compositions but, in a somewhat Dadaist strategy, set up a commercial "portrait firm" with its own set of rules and price list. Although Witkacy did not consider his very expressive portraits to be creative art, they are generally regarded as his highest achievement. Inspired by the hallucinogenic drugs he experimented with and wrote about, they are precursors of the avant-garde psychedelic art of the 1960s.

In the second half of the 1920s, the center of the artistic avant-garde moved from Cracow to Warsaw and, later, to Łódź, where groups of the Constructivist avant-garde emerged: Blok, Praesens, and a.r. In Cracow, the literary avant-garde community collected around the periodical *Zwrotnica* [Railway Switch], published by Tadeusz Peiper. This community included Kazimierz Podsadecki, Constructivist, abstract painter, photomontagist, and experimental filmmaker. It was not until 1931–33 that a strictly avant-garde group, the Grupa Krakowska, was founded in Cracow. Its members—including Sasza Blonder, Maria Jarema, Leopold Lewicki, Adam Marczyński, Stanisław Osostowicz, Jonasz Stern, and Henryk Wiciński—were active until the outbreak of the Second World War; they employed modernist forms to characterize their leftist ideological views.

Translated by Wanda Kemp-Welch

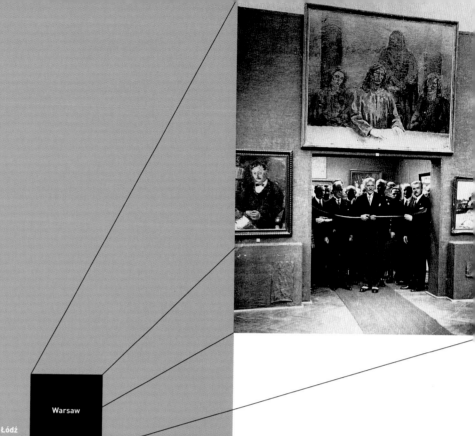

Berlin

Dessau

Weimar

Poznań

Łódź

Prague

Vienna

Budapest

Ljubljana Zagreb

Warsaw

Cracow

Belgrade Bucharest

warsaw

WARSAW

Dorota Folga-Januszewska

p. 333:
Opening of exhibition pavilions at the Institute of Art
Propaganda, December 1931

Warsaw in the nineteenth century was a place of meetings and exhibitions, but not a place of art collections. Clubs, discussion groups, and short-lived art societies determined the cultural atmosphere of the city. Successive wars and insurrections had destroyed artists' possessions and their studios, and art collections and archives survived only in small part. Awareness among Poles of their lost cultural heritage and lack of roots contributed to a subconscious disbelief in material permanence. In 1915 Eligiusz Niewiadomski, a painter and art critic, called for the establishment of a library of fine arts in Warsaw, saying: "As a matter of fact, Warsaw has nothing. Anyone wishing to see something must go at least…to Berlin!" Many Polish intellectuals shared this opinion, and despite the outbreak of the First World War, they began to lay the foundation for many new cultural institutions, including the National Museum in Warsaw.

Warsaw changed its status three times during the first three decades of the twentieth century. Until 1915 the city was subject to Russian administration; during the First World War it found itself under German occupation; and in 1918, after Poland regained its independence, it become the capital city of the Second Republic. The city's place in the cultural life of Central Europe has always been determined by its location at a crossroads. Warsaw rests at the intersection of a north-south axis, stretching from Lithuania and the Scandinavian countries to Cracow, Prague, and Vienna, and an east-west axis, running between Paris, Berlin, Moscow, and St. Petersburg. Especially in the period before the First World War, the comings and goings of other Europeans influenced the artistic life of the city.

Patriotic and liberationist tendencies were always strong—sometimes outright suicidal—in the Polish lands, yet Russian, German, and, understandably, French artistic and academic centers were close points of reference for Warsaw cultural life. Even while Poles were defending themselves against Russification and Germanization, they welcomed leading Russian and German artists, who stimulated and inspired the local art community,

and Warsaw became a stopover for many outstanding artists. When in 1913 the Warsaw Society for the Encouragement of Arts exhibited works by Leon Bakst, including the famous decorations for Diaghilev's *Scheherazade*, staged by the Ballets Russes in 1909 in Paris, Leon Schiller wrote in his catalogue introduction: "The aim of the exhibition of modern stage set painting is to overcome indifference, and to encourage a further artistic production, in the rhythm of the spirit of the nation and contemporaneity, by showing what has been achieved abroad and what has here begun to germinate."

The deep changes in scientific and artistic outlook that appeared at the beginning of the century could be seen simultaneously in many countries. The first signs were in science and philosophy. The fast pace of developments in the theoretical sciences—especially physics, astronomy, mathematics, and psychology—as well as new theories of space-time and resulting changes in the understanding of the universe transformed to a large extent art and artists' expectations. Warsaw was the native city of Marie Skłodowska-Curie, twice the winner of the Nobel Prize, who founded there in 1912 the Laboratory of Radiology of the Warsaw Society of Sciences. Between 1906 and 1914 Warsaw's daily papers reported a number of times on new theories in physics and changes in the theory of art under the influence of pure science. *Kurier Warszawski*, a source of popular knowledge about new discoveries, published reviews of exhibitions of French Cubists, Italian Futurists, German Expressionists, and Polish Formists.

The period between 1900 and 1914 was full of innovations in science and industry that drew artists, like a magnet, toward very difficult issues. Core attitudes were essentially transformed, with an openness toward and recognition of science before religion becoming prevalent. In January 1917 the Polish Art Club, based in the Polonia Hotel, was founded in Warsaw. Scientistic art criticism emerged, often practiced by the artists themselves. In Poland, this period of great intellectual ferment overlapped a complex political

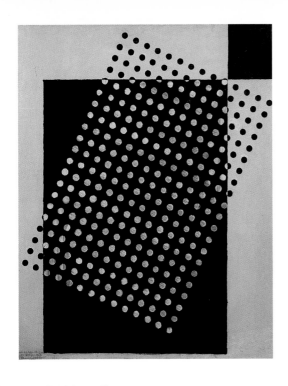

situation. Probably not until the first exhibition of the Formists, in 1919 at the Polish Art Club, did Warsaw artists advance a theory of pure art. The patriotic consciousness of the Polish intellectual elite, enslaved for almost 150 years under successive partitions of the country by Austria, Russia, and Prussia, was predominant. The profound destruction and material poverty suffered in the First World War, however, had the effect that Warsaw's cultural community became more open to change, and the city was said to be more modern than other Polish cultural centers. In the catalogue to the 1919 exhibition of the Polish Formists, Stanisław Ignacy Witkiewicz (known as Witkacy) wrote: "The aim of painting is not, and never has been, reproduction or even individual interpretation of the visible world...but the construction of forms on the plane, which

[together] constitute an unbreakable whole." This short summary of new artistic tendencies was formulated rather late. At the beginning of the century the Lithuanian Mikalojus Konstantinas Čiurlionis, now regarded as one of the first abstract painters, was being educated in Warsaw at the Conservatory and the Academy of Fine Arts. The author of an original theory of the abstract parallels between music and painting, he constructed nonobjective images of space-time using color and form. Čiurlionis was closely connected with the Warsaw community of painters from 1904 to 1906, but he left to go on to Prague, Dresden, Nuremberg, Munich, and Vienna. Perhaps he appeared too early in Warsaw; his extraordinary painting met with little response and failed to influence other artists.

The Warsaw art community was not static, though. A constant flow of people and ideas came and went, and sudden impulses passed away as soon as they arose. The first Polish state offices and cultural institutions were founded after 1918. The Formist exhibitions prepared the ground for the creation, in 1924, of the avant-garde group Blok. Recent newcomers Władysław Strzemiński, Katarzyna Kobro, and Henryk Berlewi together with Warsaw residents Mieczysław Szczuka, Teresa Żarnower, and Henryk Stażewski founded the group, and it seemed that Warsaw would become an important center of Constructivism. The first issue of the journal *Blok* appeared on March 8, 1924, a few days before the opening of their inaugural exhibition in the showroom of the automobile firm Lauren-Clement. The ideology of the group was a great step

Above:
■ Henryk Berlewi, *Mechanofaktur*, 1923, gouache

Below:
■ Katarzyna Kobro, *Space Composition 2*, 1928, painted steel

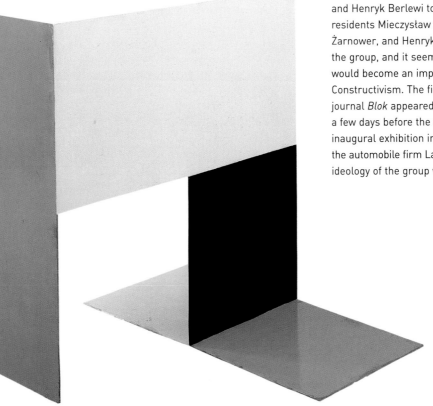

from the "pure form" described by Witkacy toward the issue of construction in the work of art.

The artists connected with Blok had international contacts. Berlewi circulated among Berlin, Warsaw, and Paris. His earliest *mechanofaktura* pieces were painted in Berlin in 1922–23 but published for the first time in Warsaw in 1924. Karol Hiller studied architecture in Warsaw until 1916, went to Kiev, and came back to Poland in 1921. Edging closer to Constructivism, he started experimenting with graphic techniques and photographic processes. Szczuka and Żarnower participated in exhibitions at Galerie Der Sturm in Berlin in 1923; Szczuka began his first experiments with abstract film, and Żarnower with experimental photography. From 1927 the Themersons, Franciszka and Stefan, started working on photomontage films. Except for their memoirs and works in the National Museum in Warsaw, their later artistic activity in France and England left no traces in Warsaw.

The 1920s was a period of mobilization for the forces of the Polish avant-garde. Among the venues available to them was the Exposition Internationale des Arts Décoratifs in Paris. The works of Stażewski, Jan Golus, Aleksander Rafałowski, and Żarnower qualified via competition for inclusion in this 1925 exposition. But increasingly the

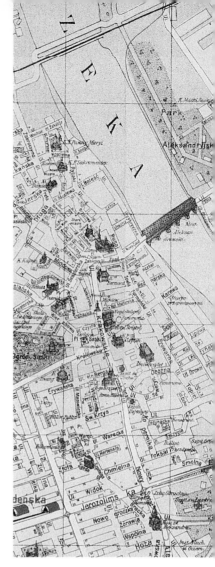

Below:
■ Władysław Strzemiński, cover design for *Praesens*, c. 1928, distemper and pencil on board

Below left:
Party for Kazimir Malevich on occasion of exhibition at Polonia Hotel, Warsaw, 1927

Below right:
■ Henryk Stażewski, cover design for *Praesens*, 1926 (vol. 1, no. 1)

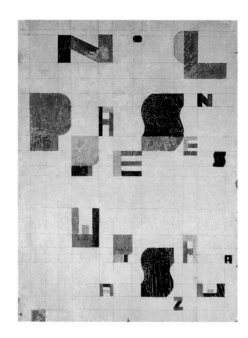

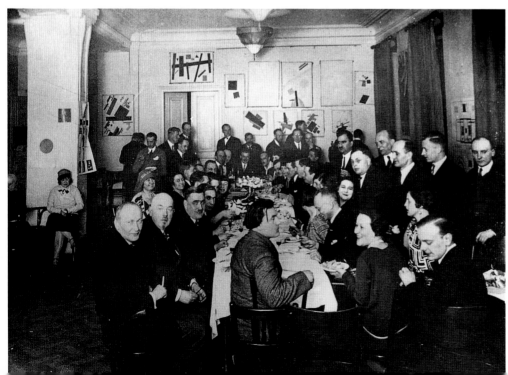

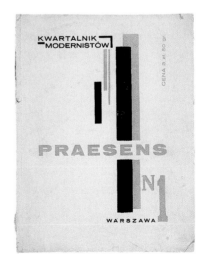

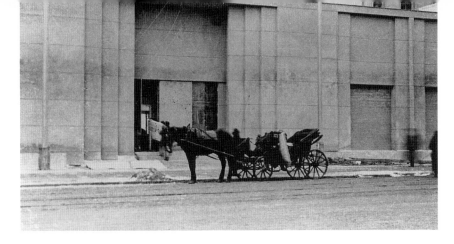

forces on the other side of the artistic barricade were getting stronger. From the beginning of the century certain tendencies in Polish art had referred to national and folk sources. The pavilion designed by the Society of Polish Applied Arts for the 1925 Paris exposition won a gold medal, a triumph that only created conflict within the Blok group. The breakup of the group and the founding, in 1926, of Praesens were very significant for Warsaw. One of the theoretical premises of Praesens was the realization of new architecture, and designs by Szymon Syrkus, Bohdan Lachert, and Helena Niemirowska (Syrkus) were a part of the new Warsaw built in the interwar period.

The network of contacts among Moscow, Kiev, Berlin, Vienna, and Paris continued to function. Thanks to it, Kazimir Malevich visited Poland between March 8 and 27, 1927. He presented a collection of his works in conjunction with a banquet in his honor at the Polonia Hotel, where he gave a talk on new art and his own. In the company of the Polish poet Tadeusz Peiper, Malevich went on to Berlin and then to the Bauhaus in Dessau. There Peiper introduced Malevich to Walter Gropius and László Moholy-Nagy. In fact, Peiper, who published the avant-garde journal *Zwrotnica* [Railroad Switch], was the link connecting many European art communities of the period.

Malevich's departure from Warsaw had, as history showed, the force of symbol. The late 1920s saw many avant-garde artists leaving the city. The a.r. group and its circle, a successor to Praesens, moved to Łódź; Berlewi and Hiller found themselves in Berlin and Paris. The time had

arrived for the work of art historians and critics. In 1926 construction began on a new building for the National Museum in Warsaw. The conception of the great building, designed by Tadeusz Tołwiński, was modern and functional. The idea of founding a museum of modern art, however, increasingly surfaced.

The first and only public and state institution to promote modern art in interwar Warsaw was the Institute of Art Propaganda, founded in 1930, which published the periodical *Nike*. Its eminent directors, Karol Stryjeński and Juliusz Starzyński, introduced what for the time was a very modern series of educational presentations of past and contemporary art. These shows reflected a nascent theory of modern art as an interpretation of art history. Władysław Strzemiński's theory of vision, which he was formulating in the 1920s, closed the period of struggle for an avant-garde interpretation of the past. The founding of the Institute of Art Propaganda and its collection redressed years of fruitless attempts to establish a repository for modern art in Warsaw. The holdings of the institute were transferred to the National Museum in Warsaw, thus creating the first museum collection of modern art in the city.

Translated by Wanda Kemp-Welch

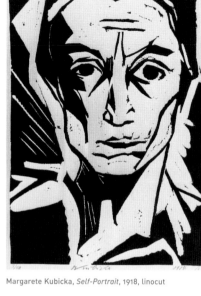

Margarete Kubicka, *Self-Portrait*, 1918, linocut

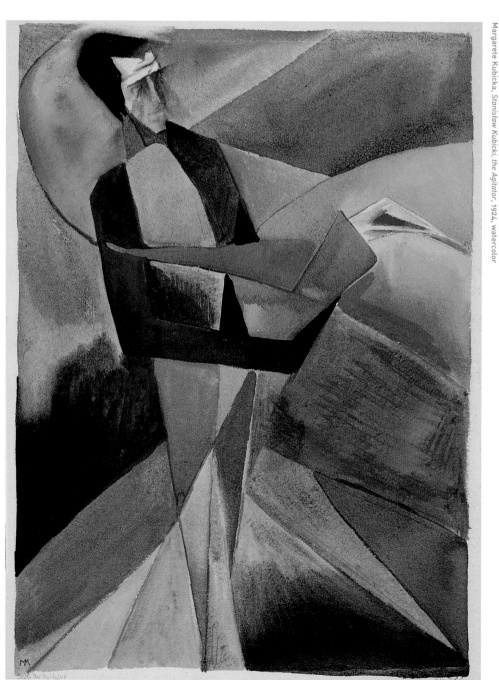

Margarete Kubicka, *Stanisław Kubicki, the Agitator*, 1924, watercolor

COLLABORATION AND COMPROMISE:
WOMEN ARTISTS IN POLISH-GERMAN AVANT-GARDE CIRCLES, 1910–1930

Monika Król

A traditional history of the development of modern art in Central Eastern Europe deals with the activities of associations and groups, but does not examine the artistic couple. This omission suggests that such couples may be considered a topic for gendered conversation, perhaps of interest solely to feminist art historians. But in fact, artistic couples constitute an example of a primary grouping that exists within and often prior to the structure of larger artists groups.[1]

Renée Riese Hubert in her pioneering 1994 book *Magnifying Mirrors: Women, Surrealism and Partnership* considers how partnership worked as a creative mechanism for many Western European artist couples; Toyen and Štyrský are the sole Central European example. Hubert's argument focuses mostly on Surrealist couples, because in her view Surrealism's eroticism and its desire to overcome the separation between art and life were what made Surrealist partnerships different, since these concerns supported working with a partner. Making a similar case with other avant-garde groups, Hubert observes that independent and talented women joined these groups because such affiliation "afforded them the best chance to make their mark as artists," and "could provide them with an identity and an authenticity that society continued to deny them."[2]

In the recent study *Liebe macht Kunst: Künstlerpaare im 20. Jahrhundert* [Love Makes Art: Artistic Couples in the Twentieth Century] the editor, Renate Berger, observes that in such partnerships the male artist is often seen as a genius, requiring the energies and assistance of a female, who generally falls into the role of mother, sister, wife, model, or patron. Berger underlines the fact that it is more difficult for women artists, especially the partners of male artists, to be equally recognized in the art world. Berger also includes only one Central Eastern European couple: Lucia and László Moholy-Nagy.[3]

The avant-garde couples that are the subjects of this study are Margarete and Stanisław Kubicki, the founders of the Polish group Bunt; Katarzyna Kobro and Władysław Strzemiński; and Teresa Żarnower and Mieczysław Szczuka, founders of Polish Constructivism. The meaning of their collaboration was different for each of the partners. In one case, what began as a creative partnership became a destructive battle later in life.

In most scholarly studies of the Central European avant-garde, the roles of Kubicka, Kobro, and Żarnower in art production have been overlooked.[4] Steven Mansbach's 1999 book *Modern Art in Eastern Europe: From the Baltic to the Balkans, ca. 1890–1939* is the first comprehensive summary and chronology of the Central European avant-garde published in English. Although Mansbach names Żarnower as Szczuka's collaborator and recognizes Kobro as Strzemiński's wife and partner, he does not address the role that these relationships may have played in their visual productions. Margarete Kubicka is unmentioned, despite her active participation with her husband in the Bunt group and the artistic events of the time.[5]

Margarete was German, and Stanisław a Pole from Großpolen, at the time a German province.[6] Stanisław was born in Ziegenhain near Kassel in 1889 and Margarete Schuster (Kubicka's maiden name) in Berlin in 1891. They met most likely in 1912 at the Königliche Kunstschule in Berlin. Just after the outbreak of the First World War, Kubicki entered the Prussian Army. The couple married in a civil ceremony (Kubicki did not believe in church weddings) on December 22, 1916, in Berlin.

The Kubickis complemented each other in many ways. She was more practical and supported the family; he was a free spirit and a thinker involved with various ideas and movements, including Buddhism, Communism, and anarchism. She kept him informed about Berlin's art scene during World

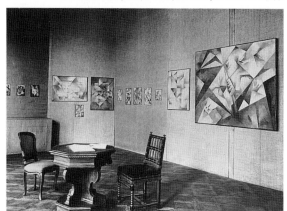

The Kubickis' gallery at the special non-juried exhibition, 1931

War I, when he was stationed in Silesia. Later, in Poznań, she came to visit him quite often and brought with her the German avant-garde periodical *Die Aktion*, which he then introduced to his Polish colleagues.

Their son, Karol Kubicki, states that his mother was more radical in her views, both artistically and politically, than his father, and that often she took the initiative, for instance introducing Kubicki to the painting style of the Munich Blaue Reiter group. Margarete supplied him with funds to live on during his time in Poznań, while supporting herself and their two children in Berlin as an art school teacher. As the main breadwinner for the family, she did not have time for the meetings in Berlin ateliers, and ultimately he became more informed about the latest art theories, which he shared with her at home in Berlin.[7]

Their contrasting styles can be seen in writings that appeared in a 1918 issue of *Die Aktion*. A statement by Kubicki stressed the political role of art, and two poems by Kubicka were epitaphs to the war. The first poem, "Leben" [Life], laments how fast the dead are forgotten, suggesting that no one is strong enough to live with the reminder of death's presence in the form of corpses. "Die Mutter" [The Mother], the second poem, attempts to capture a mother's feelings in losing a son to the war and ends with the question that Kubicka poses to "staggering women, without a leader: who will show us the way?"

Two years later they exhibited in the first Bunt exhibition, in Poznań. Its poster, designed by Stanisław, featured a reproduction of his linocut *The Tower of Babel*. The print, which shows a group of people gesticulating and screaming with the tower in the background, can be read as an allegory of the dominance of old master conservatism and the rebellion (*bunt* in Polish) of the young generation. Die Aktion gallery in Berlin also exhibited works by the two artists that year, and published an issue on Polish art that featured the reproduction of three woodcuts by Kubicki and two by Kubicka.

Kubicki's Cubist canvases and Kubicka's watercolors between 1918 and 1924 show parallel development and feature a similar use of volumes to contrast light and dark tones. According to Karol, Margarete thought of her art as a diaristic record of people she met and places she visited, but this became less the case as she developed stylistically from realism to a Cubo-Surrealist style.[8] The early period of her oeuvre is rich in portraits of her friends and her husband. In a rare linocut self-portrait the young Kubicka appears as a decisive woman. Her forehead shows two horizontal wrinkles, signifying a

340

thoughtful person facing life's troubles. Her wide-open eyes look straight out, almost as if she wants to penetrate the viewer's personality. Her face is surrounded by a thin white border, set against a black background. She had begun to paint subjects reflecting an abstract realm beyond the bounds of the rational world by 1922, two years before André Breton issued the first Surrealist manifesto.

Kubicki's 1918 *Self-Portrait*, also a linocut, shows his heavy head leaning on his hand. His face has a ghostly look as it emerges from the contrasting black. His eyes, covered with angular black shapes, are not visible at all. Kubicki's 1922

Cubist self-portrait is a culmination of his style. The artist constructs his face from basic cubic angles, which he then fills with further cubic shapes to represent his facial features. A vertical line splits the canvas into two uneven parts; the zigzag shape of his arm and hand supports one side of the face.

In general, Kubicka's lines are softer and rounder, with planes flowing into one another, while Kubicki's paintings are more linear and hard-edged. The Kubickis also used similar color schemes during this period, he in oils and she in watercolors. Both painted in warm tones, but she employed a larger range

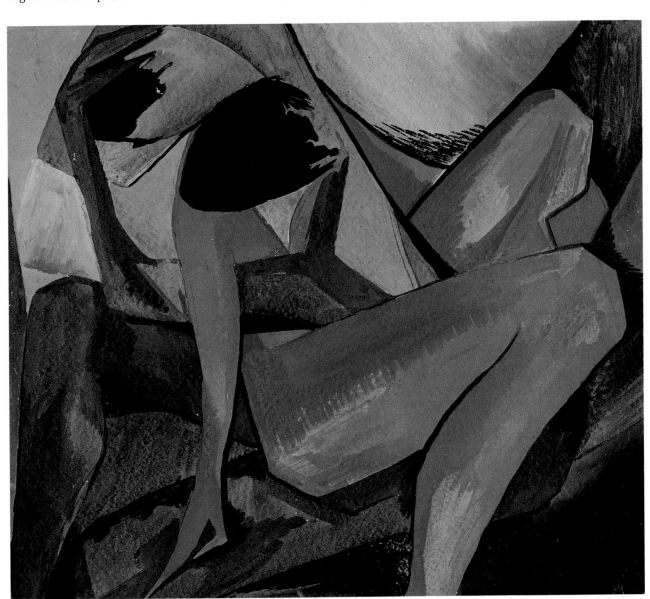

Margarete Kubicka, *L'Amour*, 1924, watercolor

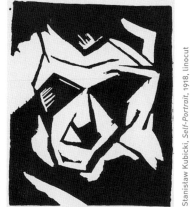

Stanisław Kubicki, *Self-Portrait*, 1922, oil on canvas

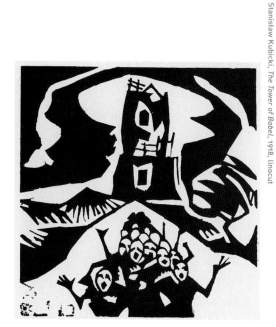

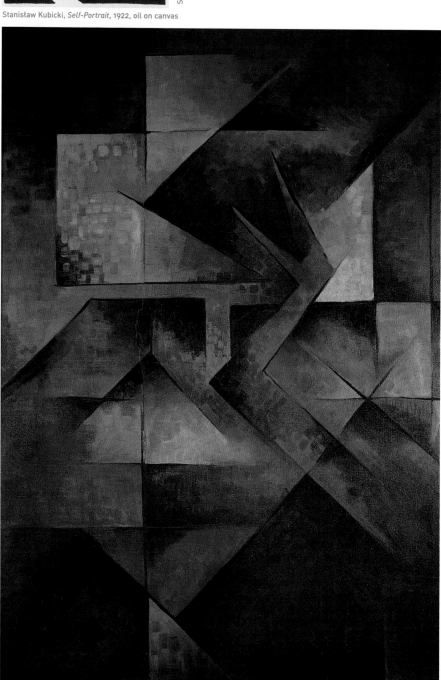

The Kubickis criticized the 1922 Düsseldorf international exhibition as representing a "selfish, partisan standpoint."

of shades. Kubicki's *Church Tower in Front of the Rising Sun*, an architectural abstraction of a cathedral, features planes of ocher that capture the reflection of the sun's first rays. Another painting, *Ecstasy III*, shows a Cubist figure with raised arms looking toward the sky. Yellow and brown predominate, while multiple diagonal lines cross in the middle, giving an impression of energy emanating from the composition's center.

Margarete was a member of Spartacus, a precursor to the German Communist Party, and in 1922 the couple were coauthors, with Otto Freundlich and Felix Gasbara, of the Commune's second manifesto. In it they proclaimed that their "task is to review the whole of the past. Not as an intellectual critique but through the lived experience of being otherwise." This meant not selling their art in galleries but making it for political and aesthetic reasons. Again, thanks to Margarete's hard work as a tutor and art school teacher, the family was able to survive. Margarete signed the Commune's manifesto as "Stanisławowa," following the Polish custom in which married women are given a nickname derived from their husband's first name. The Kubickis also criticized the 1922 Düsseldorf international exhibition and other participating groups as representing a "selfish, partisan standpoint" and not the "interests of the greater international community"; for this reason they did not take part in it.[9]

In November of that year they organized an exhibition in Berlin of revolutionary artists, and invited two colleagues from Bunt, Władysław Skotarek and Stefan Szmaj, to participate. This would be their last exhibition with members of the Bunt group. Kubicki then joined the Progressiven group from Cologne.

In 1924 Kubicka painted a series of emblematic watercolors devoted to her husband, with titles such as *Stanisław Kubicki and the Plants*, *Stanisław Kubicki and the Sciences*, *Stanisław Kubicki and the Occultist Powers*, *Stanisław Kubicki with Rocks and Insects*, *Stanisław Kubicki and the Animals*, and *L'Amour*. These are in a Cubo-Surrealist style, with an emphasis on color, and incorporate Cubistic shapes that resemble those in her husband's oil paintings. The strong angular portrait of her husband in *Stanisław Kubicki, the Agitator* is composed of multiple planes with lively colors emanating from his body. *L'Amour* is unique among the watercolors in portraying a couple. The orange color predominating is important symbolically in Buddhism, which was of great interest to Kubicki at the time. Though largely abstract, *L'Amour* can be seen as a tribute to the couple's relationship.

Kubicka's series was an homage to her husband, whom she called "a genius," as Eugenia Markowa recalls in *Le Choix*, a small book reprinted in the catalogue of the first major joint exhibition of their work, at the Berlinische Galerie in 1992. With its telling title, *Die Jahre der Krise* [Years of Crisis], the catalogue suggests that their life during these years was far from ideal.[10] The year 1920 was particularly difficult, as Peter Mantis points out, because Kubicki suffered from a depression that lasted until the end of the following year. Their friend Otto Krischer described Kubicki's emotional state as his response to the disillusionment of the years following World War I, which he overcame with the help of family and friends.[11]

The last big exhibition of his life was the *Sonderausstellung der Juryfreien* [Special Non-Juried Exhibition] in 1931. Due to Hitler's rise to power, Kubicki left Germany in 1934, choosing exile in Poland. Margarete and the children stayed in Berlin, in a house designed by Bruno Taut (where Karol Kubicki still lives). Kubicki lived first in Poznań and later in Warsaw. After a long surveillance because of his opposition to the Nazi regime, he was imprisoned and executed by the Gestapo in 1942.[12] According to Karol, Margarete, who lived to be 93, always referred to her husband as a genius and "a beautiful soul."[13]

The artistic exchange between Katarzyna Kobro and Władysław Strzemiński was fruitful at the outset but later proved to be destructive. Strzemiński was an officer in the czar's army at the start of World War I. A grenade explosion resulted in the amputation of his right leg and left forearm. From 1916 to 1918 he was a patient in a Moscow hospital, recovering from his injuries. Like many young women from well-to-do families, Kobro had volunteered to care for the war injured.

Their attraction was stimulated through their mutual interest in modern art. Their daughter, Nika Strzemińska, recalls in her book *Miłość, sztuka i nienawiść* [Love, Art, and Hatred] that Kobro told Strzemiński "she wanted to study sculpture and that she always found great pleasure in producing works of art… It was then that my father got interested in art."[14] Strzemińska also describes Kobro's willingness to give up her own creative time, and her tremendous physical and emotional strength in helping her handicapped husband on a daily basis.

Beginning in 1917 Kobro studied at the Moscow School of Architecture, Sculpture, and Painting. The following year, the school was opened to the avant-garde, according to reforms carried out after the October Revolution. In October 1918 Strzemiński began studying at the First Free Artistic Studio in Moscow; Kobro continued her studies at the Second Free Artistic Studio. In January 1919 Strzemiński first returned to his hometown in Minsk, due to the death of his father. In the fall of 1919 he moved to Smolensk (without graduating), where he cofounded a branch of the Unovis group with Malevich. In the summer of 1920 Kobro also moved to Smolensk. (Nearby in Witebsk were Kasimir Malevich, Marc Chagall, Wassily Kandinsky, and El Lissitzky). There she made sculpture, designed theater costumes and political posters, and lectured at the Smolensk School of Ceramic Art, where Strzemiński also taught. Together they supervised the Smolensk branch of Unovis until its closure in 1922.

In late 1921 they were married in a civil ceremony and shared a studio on a main street in Smolensk. Although they planned to settle permanently in Poland and become citizens, in the meantime Kobro lived with her relatives in Riga, returning to Smolensk for short visits. According to her daughter, she did not get along with her mother-in-law; in Riga, moreover, she could apply for Latvian citizenship, and consequently more easily for Polish citizenship.

Like many artists of the period they left Russia, due to lack of money as well as disappointment with the revolution. They were detained for a time by the police as a result of an illegal border crossing, since Kobro did not have a Polish visa. The following period was more difficult for Kobro because of her inability to speak Polish.

A recognized painter in Constructivist circles, Strzemiński published an enthusiastic review of Kobro's works in a 1922 issue of the magazine *Zwrotnica*: "The most talented from the young generation is a sculptress, Kobro. Her Suprematist sculptures have a European impact. Her work is a true step forward, attaining new and unachieved values; these works do not simply copy Malevich, but are a parallel development."[15]

In 1924 Kobro acquired Polish citizenship and began teaching at two industrial schools near Łódź. Strzemiński quickly made contacts with prominent artists in the Polish avant-garde, which included Henryk Stażewski, Teresa Żarnower, and Mieczysław Szczuka. In 1924 he cofounded the Blok group, which issued a journal of the same name; Kobro also joined the group. In 1926 they left Blok and cofounded Praesens, a group of artists and architects. Strzemiński and Szczuka had disagreements with the Blok group over a proposed modern art museum in Poland. In a February 1931 letter Strzemiński wrote: "I suggested to the members of the Blok that such a museum should be organized, but to no avail, because Szczuka was afraid of the technical and the painterly matters, of the painterly culture…"[16]

In 1928 Strzemiński published *Unism in Painting*, in which he asserted the formalistic view that a painting is a flat canvas covered with paint and bordered by a frame; the content, he maintained, should be optically unified. He achieved this by using varied color tones and through a roughness of texture that forced the eye to accept the illusion of the unified structure. This illusion can be understood, perhaps, to have a particular psychological importance to Strzemiński, who through his work was trying to reestablish the missing link between his injured physical self and the space which surrounded him: "Everything possesses the rules of the construction of its own organism. The organic principle of painting demands as high a unity as possible between the forms and the surface of the painting… The entire painting ought to function as one integrated surface."[17]

Kobro sought spatial wholeness in her art through different means. Janusz Zagrodzki, who has pioneered in the reconstruction of Kobro's lost work, explains that a fundamental element of her sculpture is the modular unit.[18] One of Kobro's extant abstract sculptures of 1924 incorporates her application of a unit of constant proportion. In 1925 Kobro revised her system and introduced a principle

"The organic principle of painting demands as high a unity as possible between the forms and the surface of the painting."

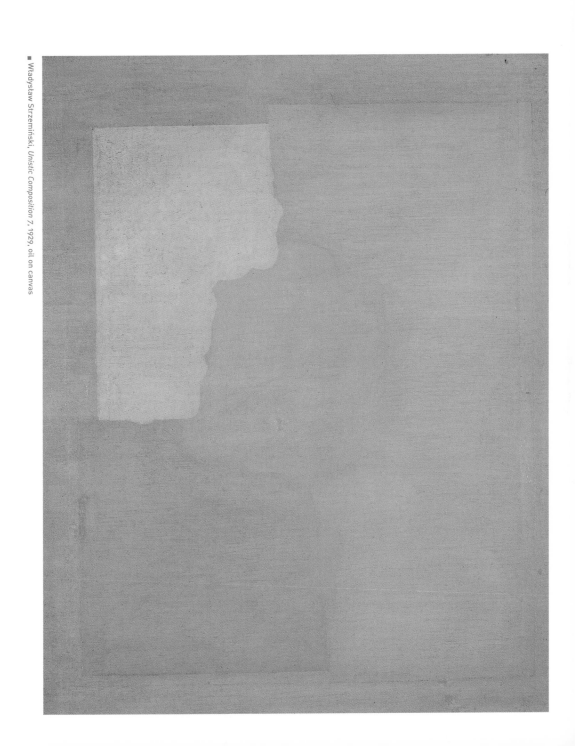

■ Władysław Strzemiński, *Unistic Composition 7*, 1929, oil on canvas

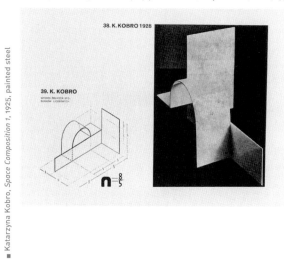

Władysvaw Strzemiński, comparison diagram in *Kompozycja Przestrzeni, Bibljoteki "a.r.," Łódź, 1931*

Władysvaw Strzemiński, comparison diagram in *Kompozycja Przestrzeni, Bibljoteki "a.r.," Łódź, 1931*

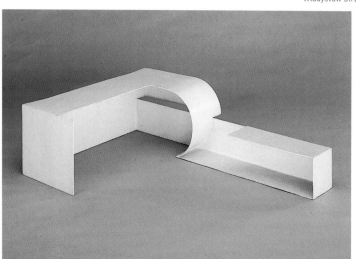

■ Katarzyna Kobro, *Space Composition 1*, 1925, painted steel

Katarzyna Kobro, comparison diagram in *Kompozycja Przestrzeni, Bibljoteki "a.r.," Łódź, 1931*

■ Katarzyna Kobro, *Space Composition 3*, 1928, painted steel

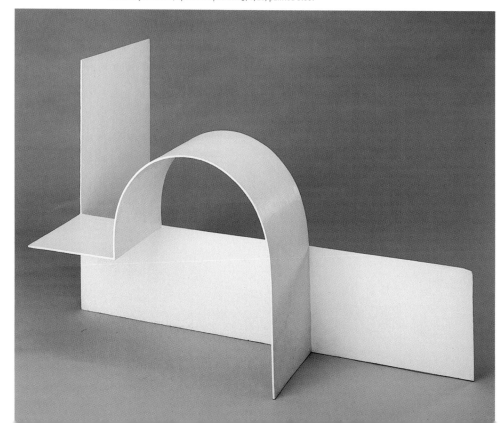

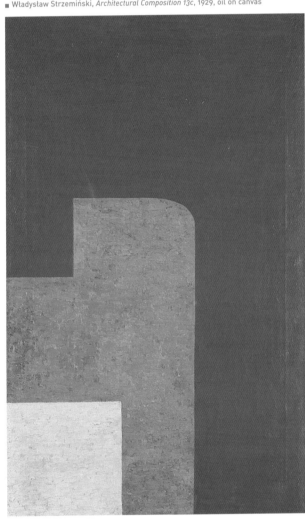

Władysław Strzemiński, *Architectural Composition 13c*, 1929, oil on canvas

of equal proportions that was applied to different lengths and surfaces.

Between 1925 and 1928, Kobro developed a specific mathematical formula that she used in constructing her sculptures. As she discarded the concept of isolated forms, her compositions began to merge with the surrounding space. Each piece was now made up of a few flat or curved rectangular planes joined at right angles along their edges. The planes appear to glide rhythmically, folding, doubling back, or stretching into elastic archways, as in her 1925 *Space Composition 1*.

Strzemiński began painting his own architectural compositions two years later, in 1927. The soft curve in *Architectural Composition 13c* resonates with Kobro's three soft curves in her 1925 composition.

In Kobro's spatial sculptures the relation between separate parts was most often close to an 8:5 ratio. Her formula employed an unequal division of a line or rectangle, so that the ratio of the smaller section to the larger is equivalent to that of the larger part to the whole. This ratio is derived from the classical proportions of the golden section.[19]

Kobro wrote in 1929 on the harmony of this "new form": "New sculpture should be the most condensed…part of the space. [Sculpture] achieves this because its form creates a rhythm of dimensions and divisions. The unity of that rhythm is based on its numerical calculations."[20]

Kobro's sculptures from this period are for the most part white, which lent them a totalizing spatial uniformity. In *Space Composition 3* of 1928, horizontal and vertical planes are united by a soft curve, which is subordinate to the harmony of the proportions. In her article "Functionalism" she postulates that comprehension of the nature of space and time results from an understanding of the everyday: "An understanding of the rules of relationship between the parts of

a sculpture shows that each form in the sculpture is also an organizational norm of the human psyche…"[21] According to Kobro, this concept would determine the composition of urban developments in the future, which would share in the simplicity and harmony of her sculptures.

The Functional Kindergarten (1932–34), the only architectural design by Kobro that has survived, was never implemented. Nevertheless, her innovative solution for sculptural forms had its resonance in modern architecture. She believed that "a sculpture should become an architectural problem, an experiment in organizing methods in arranging the space."[22] Unfortunately, her goal of transforming sculpture into architecture was confined to experimentation in her studio.

A 1931 book, *Kompozycja Przestrzeni. Obliczenia Rytmu Czasoprzestrzennego* [Space Composition: Space-Time Rhythm and Its Calculations], coauthored by Kobro and Strzemiński, described the mathematics of such open spatial compositions in terms of an 8:5 ratio. (The chronology of their art demonstrates that Kobro employed this ratio a year earlier than Strzemiński.) In the book they developed a theory of the organic character of sculpture, a fusion of Strzemiński's Unistic theory of painting and Kobro's ideas about sculpture's basis in human rhythms of movement: "A work of sculpture should make up a unity with the infinity of space. Any closure of a sculpture, any opposition between it and the space, strips it of the organic character of the uniformity of a spatial phenomenon by breaking off their natural connection and isolating the sculpture."[23] In a survey by the magazine *Europa* on modern sculpture Kobro stressed the importance of form and space: "Sculpture enters the space and the space enters the sculpture. The solid block is a lie against the real meaning of sculpture."[24] Art historian Ewa Franus justifiably calls the book "a shining example of cooperation, the culminating point of its authors' symmetrical union."[25]

Unfortunately, their collaborative endeavors did not last, and their relationship changed into a destructive competition. Strzemiński wrote in a letter to the type designer Jan Tschichold that it was impossible for him to do creative work after their daughter Nika was born, as she was ill and he did not have the space.[26] Consequently, their relationship worsened, putting additional strain on Kobro. Nika quotes from her mother's notes that Strzemiński did not want a child, and that his mother had warned Kobro never to have a child, but only to care for her husband.[27]

Nika Strzemińska describes a tragic argument between her parents in January 1945, during which Strzemiński accused Kobro of not caring enough for the family to secure wood for the fire. After this, Kobro destroyed her wooden sculptures of 1925–28; how many she destroyed is unknown. After World War II, the couple separated. Strzemiński took Kobro to court, attempting to deprive her of parental rights. He also wrote a denunciation when she was a candidate for a position as professor of sculpture at the Higher School of Art. Strzemiński "influenced the Ministry to deny her the offer."[28] Franus suggests that although Strzemiński was attempting to destroy Kobro as a person, he nonetheless respected her as an artist, since he included her sculptures in a 1948 exhibition at the Muzeum Sztuki in Łódź, in the "Neoplastic Room" that he created. However, because Kobro had given these spatial compositions to the museum in 1945,[29] it would have been difficult for Strzemiński not to include her.

Another example of constructive artistic exchange and emotional support is the collaboration of Mieczysław Szczuka and Teresa Żarnower. The artist Anatol Stern, a friend, commented: "These two people, besides their aesthetic ideas, shared a strong feeling that helped them to overcome obstacles in their fight for the truth in which they believed."[30] Szczuka credited Żarnower with the initiative to establish

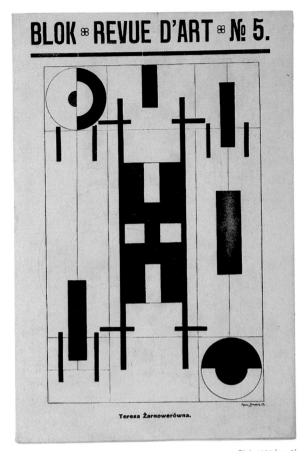

Teresa Żarnower, illustration for *Blok*, 1924 (no. 5)

Blok, 1924 (no. 5)

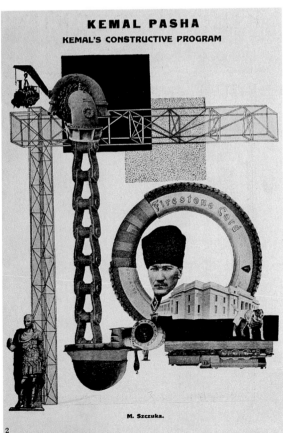

Dźwignia, 1927 (no. 5)

the Blok group and its magazine; she also provided it with financial support.[31]

Żarnower and Szczuka were both were from Warsaw; Żarnower was born in 1895 and Szczuka in 1898. Both graduated in 1920 from the Warsaw School of Fine Arts, and Szczuka had his first exhibition that same year. They often exhibited together: their names are listed in exhibitions in Vilnius in May of 1923, at the Sturm Gallery in Berlin the same year, in Bucharest in November of 1924, and at Warsaw's Polonia Artistic Club in 1924–25. In Berlin they exhibited twenty-two objects, including sculpture, drawings, and paintings.[32]

Most of their original works are lost, so the main information on the art of Szczuka and Żarnower is from *Blok* and from *Dźwignia* [Lever] magazine, which Szczuka edited until his death and which Żarnower continued. The layouts in these magazines are silent testimony to their close collaboration, as they are generally reproduced side by side or on consecutive pages. The first issue of *Blok* (1924) reproduces on the title page two untitled sculptures by Żarnower and two adjacent works by Szczuka: *Architektura* and an abstract composition. Other 1924–25 layouts in *Blok* demonstrate their collaboration on typography.

The cover of *Blok* 5 has an untitled composition by Żarnower on the front and a photomontage by Szczuka, entitled *Kemal Pasha: Kemal's Constructive Program*, overleaf. In the photomontage a schematic drawing of a construction crane on the left is amplified by a photograph of a chain parallel to the crane's mast. The image of the new Turkish leader Kemal Pasha is encircled by a Firestone tire; beneath his portrait is a modern building from Ankara. Next to the building is a photograph of a dog, as if to add a more domestic aspect to the collage. Beneath the building, an upside-down locomotive is situated. Żarnower's abstract composition corresponds formally with Szczuka's reality-based photomontage:

Blok, 1924 (no. 8–9)

the crane drawing is echoed by the vertical construction of
lines, and the Firestone tire and gear assembly synchronize
with Żarnower's circles.

In 1924, *Blok* 6/7 published the first Polish Constructivist
manifesto, "What is Constructivism?" Some attribute
this to Szczuka, but in fact it was signed as an editorial,
and Żarnower was on the editorial board. The manifesto's
fourteenth and last statement proposed that problems
of art are indivisible from social problems. Both Szczuka
and Żarnower continued their engagement in the leftist
political life of the young Polish state even after *Blok* ceased
to exist in 1926.

Also in *Blok* 6/7 was Szczuka's programmatic statement about
modern architecture, faced by a page of illustrations includ-
ing Willi Baumeister's *Raumgestaltung Mauerbild*, Strzemiński's
Flat Construction, an aerial photo, and an abstract decorative
composition by Żarnower, next to which was a photograph of
the Tatra Mountains. Szczuka's statement stressed the impor-
tance of the fusion of modern buildings with the surrounding
space: a building should not be perceived as a heavy structure,
rather it should be seen as a composition of different colors
and surfaces. Szczuka illustrated his architectural theory with
drawings published in later issues of *Blok*.

But Szczuka's later works in *Blok* are primarily photomontages.
He defined his pioneering work in this genre as a "poetic
visual plastic" [*poezoplatyka*] and thought of a photomontage
as a condensed poem, with stanzas corresponding to simul-
taneous images.[33] *Blok* 8/9 (1924) published one of his more
advanced photomontages in terms of its poetic compositional
structure. At the center a classical profile of a man is com-
bined with a statue of a woman and a modern high-rise
building. Above this structure a modern car rests on the back
of a hand. At the bottom of the photomontage a spool of film
unrolls, as if releasing these overlapping images. In a state-
ment beside the photomontage Szczuka links the two forms:
"Cinema is the multiplicity of happenings in one time /
Photomontage is multiplicity of occurrences." Below, *Blok*'s
editor placed one of Szczuka's interior designs. Żarnower's
abstract *Konstrukcja Filmowa* [Film Construction], with a motif
of uniform waves halted by rectangular geometric forms,
is situated on the right-hand page, opposite Szczuka's design
of a modern living space.

Above Żarnower's abstraction is another photograph of the
Tatra Mountains, juxtaposed to a photograph of a construc-
tion scene, with high-rise buildings in the background.
Szczuka's fascination with both mountains and high-rise
buildings allowed him to link them visually. The same issue

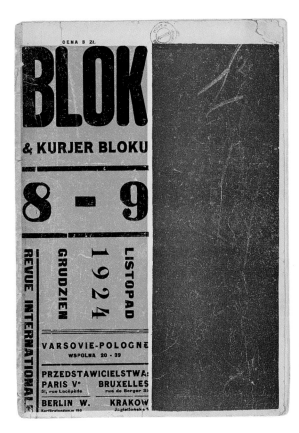

Blok, 1924 (no. 8–9)

of *Blok* reproduces Żarnower's and Szczuka's architectural constructions and reproductions of two architectural models, one by each of them. Their statement on the same page proposes the development of a flexible architectural system, which would allow additions at a later time.

Szczuka and Żarnower were the only artists in Poland who at that point in the 1920s used photomontage for political purposes.[34] Szczuka designed covers for political leaflets demanding the release of political prisoners. One of the leaflets is a photocollage documenting a political demonstration with the slogan: "We demand amnesty for all political prisoners." The simplicity expressed in the contrast of white paper with red typography and black background intensifies the demand. This cover is the first Polish photomontage poster and an example of the new politically engaged genre in Polish modern art.

Żarnower designed a poster for the Polish Communist Party in the 1928 election with the statement: "Vote for the unity of workers and peasants! 13" [Na jedność robotniczo chłopską głosuj! 13], which uses the same technique as Szczuka's amnesty poster. (Thirteen was the number of the "unity" statement in the party platform.) Żarnower was most likely the instigator of the couple's leftist political involvement, as she was a longtime member of the Polish Communist Party, while Szczuka grew up in a conservative family.[35] The bold red typography of her photocollage contrasts with the black-and-white images of dense crowds with raised arms. One man is singled out by enlargement; his hand, stretching toward the exclamation point, creates a structural division. On one side is the slogan, at which he is also looking; on the other is a factory, the visual sign of industrial modernity.

Their collaboration was truncated by Szczuka's tragic 1927 death in a snowstorm in the Tatra Mountains. Afterward, Żarnower abandoned her style of abstract composition and turned toward Szczuka's technique of photomontage. She continued the editing and graphic design of *Dźwignia* magazine. In 1929 she published Anatol Stern's poem *Europa*, illustrated with typocollage pages by Szczuka, and she designed the book's cover. He had finished the book design just before his last trip to the Tatra Mountains. Stern recalls in the introduction: "The man who had collaborated on the creation of 'Europe' did not live long enough to see the appearance of our work in its final form. An obscure presentiment had already guided his hand when, as he was finishing the cycle of collages which were to illustrate my poem, he put a black border round the last of his drawings, that of the Dead Peak,

Mieczysław Szczuka, "We demand amnesty for all political prisoners," 1926, photomontage

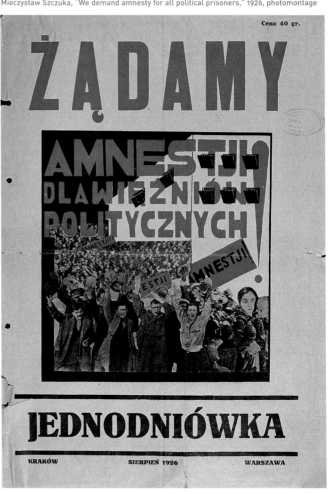

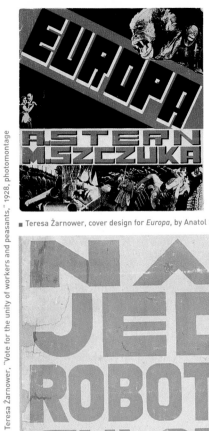

■ Teresa Żarnower, cover design for *Europa*, by Anatol Stern, 1929

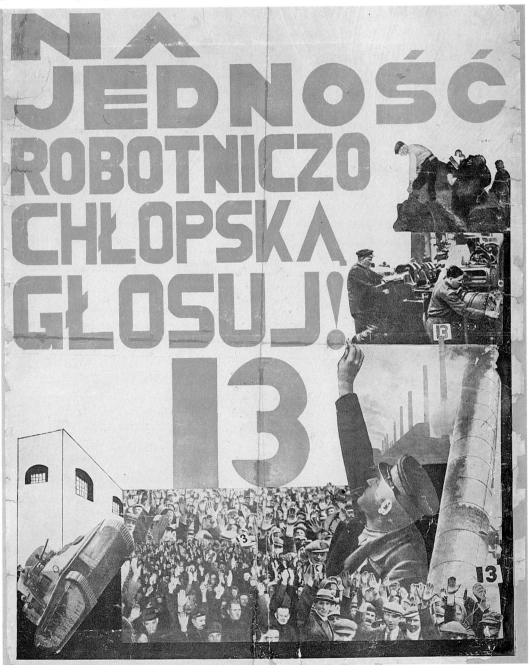

the witness of his first climbing triumphs in the Tatra mountains, and of his last descent from the rocks."[36]

Żarnower's heavy, posterlike cover design is unusual for a time when a simple design with small fonts and a light-colored background was more characteristic. Instead, she chose the colors that Szczuka had used in the layout of the book: white, red, and black. For the title she used black letters with white shading placed on an angled red banner, supported at the bottom by the creators' names in broad red letters with black shading. The page is divided into three spaces that feature different images. At the top the head of a growling gorilla overlooks the main title. An obscure dancing couple appears in the middle triangle between the diagonal title and the author's names. Below this, contrasting images of 1920s Europe are aligned. These show marching soldiers, a dead young man's face, and women dancers.

Stern describes Szczuka's visionary illustrations: "In his collage for 'Europe' he showed, as if in the luminous beam of a searchlight, the two faces of modern art: Chaplin, bursting into sardonic laughter before the European spectacle he contemplates, and Petrarch, crowned with laurel, among a thousand others, turning his back on the continent drowned in a sea of blood. Szczuka only saw the two poles; he abhorred the debauchery of nuances."[37] Two years after its publication, the book won a prize at an international exhibition of modern books in Paris, the final fruit of Szczuka and Żarnower's collaboration.

Because of her Jewish heritage, Żarnower emigrated from Poland in 1939, and died in New York in 1950. Andrzej Turowski claims she was so depressed that she committed suicide in New York,[38] while the late director of Muzeum Sztuki in Łódź stated that she died in a fire in her New York apartment.[39] Irena Lorentowicz, a colleague from the School of Fine Arts in Warsaw who knew the couple, wrote a memoir about Teresa Żarnower that gives yet another reason for her death: the shock of receiving a letter from her brother David, who had survived in Russia while she thought him already long dead. According to Lorentowicz, Żarnower was found dead in her apartment, seated at a table, with pen in hand and an unfinished letter in which she wrote: "My joy in knowing that you are alive will kill me."[40] David Żarnower died in 1965. In 1957 he had mentioned in correspondence with Stern that neither artist cared what happened to their art after it had been exhibited. Szczuka, more radical than Żarnower in this regard, was known to give away or even destroy his works. The works Żarnower left in Warsaw are most likely lost.[41]

The women in these collaborative couples played vital roles in the formation of larger avant-garde groups as well as in their periodicals: Kubicka introduced Kubicki to *Die Aktion* and was a cofounder of the Bunt group. Kobro was an active member of Blok and a.r. and, as the only representative from Warsaw, signed the "Manifeste Dimensioniste," printed in 1936 in Paris.[42] Żarnower was a cofounder of and coeditor in the *Blok* group.

The dynamics of couples allowed what neither member could have produced alone. Although each of the collaborations was different, I would like to point out that the women in these partnerships were expected to reach a compromise, as women, between their own careers and the support of their partners' careers. Although collaboration with their male partners was crucial in the art world's recognition of their talents, their devotion to family life and to their partner often meant a concession in their own career. But it is nonetheless fruitful, at the beginning of the twenty-first century, to examine and rethink the gender roles of artists in the early twentieth century, and to ponder the developments in female-male partnerships throughout the past century.

I would like to thank Ellen Fernandez Sacco for her many contributions, which reshaped this project in its numerous stages. My thanks go to Karol Kubicki, who generously shared stories and archival materials about his parents' life and work. I also wish to express my gratitude to Mirosław Borusiewicz, Janina Ładnowska, Zenobia Karnicka, Mirosława Motucka, and Jacek Ojrzyński from Muzeum Sztuki in Łódź, Maria Gołąb of the Muzeum Narodowe in Poznań, Ursula Prinz, Berlinische Galerie, Freya Mülhaupt, Dorota Folga-Januszewska of the Muzeum Narodowe in Warsaw, Joanna Sosnowska from the Institute of Art History at the Polish Academy of Arts and Sciences in Warsaw, and Beth Guynn at the Special Collections of the Getty Research Institute. Special thanks go to Bernard Kester. I am grateful to Radoslaw Sutnar for a consultation on the golden section. Finally, I would like to thank Thomas Frick, my editor at LACMA.

1 Sandor Kuthy, curator of exhibitions devoted to the couples Sonia and Robert Delaunay and Sophie Tauber and Hans Arp, has examined the theme of partnership in Western European art production. But until now the dynamics of Central Eastern European artistic couples have been little investigated.

2 Renée Riese Hubert, *Magnifying Mirrors* (Lincoln: University of Nebraska Press, 1994), 4, 10.

3 Renate Berger, ed. *Liebe macht Kunst: Künstlerpaare im 20 Jahrhundert* (Cologne/Weimar/Vienna: Böhlau, 2000).

4 In his book *Budowniczowie Świata* [Builders of the World] (Cracow: Universitas, 2000) Andrzej Turowski presents factual information about Kobro and Żarnower and comments on their art production, but Kubicka is not mentioned. Mariusz Tchorek, in "About Władysław Strzemiński," published in *Twórczość* 5 (1994), speculates about Kobro's influences on him while she was his nurse and about the meaning of the artist's body for his body of work. Ewa Franus has written a recent essay about Strzemiński and Kobro, not published in English to my knowledge, although Turowski quotes the Polish version ("Punkt nierównowagi w starym śnie o symetrii") in *Budowniczowie Świata*. Peter Mantis published the first article on Kubicka and Kubicki in the catalogue *Die Jahre der Krise* [Years of Crisis] (Berlin: Ruksaldruck, 1992), from the first major exhibition devoted to the artists, at the Berlinische Galerie in 1992. The Bunt group, active in Poznań between 1917 and 1922, is critically evaluated by Jerzy Malinowski in *Sztuka i Nowa Wspólnota. Zrzeszenie Artystów Bunt. 1917–1922* [Art and New Group Artists Association Bunt,

1917–1922] (Wrocław: Wiedza o Kulturze, 1991). The book's factual and chronological character hinders the articulation of the Kubickis' collaboration, but Margarete Kubicka is consistently acknowledged.

5 S. A. Mansbach, *Modern Art in Eastern Europe: From the Baltic to the Balkans, ca. 1890–1939* (Cambridge: Cambridge University Press, 1999), 121.

6 Kubicki's roots were clearly from Poznań. Since the Third Partition of Poland in 1795, Poznań was in a German province, Großpolen, until 1918 when the new Polish republic was proclaimed. The citizens of Großpolen were called Reichsdeutsche, since they belonged to the German Reich.

7 Karol Kubicki, interview by the author, Berlin, April 2001; and Kubicki's correspondence, Kubicki archive, Berlin. In a letter from December 10, 1925, Kubicki thanks Margarete Schuster (Schuster was Kubicka's maiden name) for money and issues of *Die Aktion*. Karol Kubicki commented that his mother had bought the earlier issues of *Die Aktion* and delivered them to Kubicki. He then deposited them with Jerzy Hulewicz, his later Bunt collaborator.

8 Karol Kubicki, interview by the author, Berlin, April 2001.

9 The manifesto was edited and published by Karol Kubicki, Berlin 1991.

10 *Die Jahre der Krise*, 29.

11 Otto Krischer, in *Die Jahre der Krise*, 17.

12 Letter to the author from Karol Kubicki, May 28, 2001. The Polish sources state that Kubicki was killed in Berlin, but his son denies this. Kubicki was brought back to Berlin for a surveillance confrontation with his wife; after both kept silent, thus protecting their friends in the Polish underground, he was taken back to Warsaw,

where he was killed in the winter of 1942.

13 Karol Kubicki, interview with the author, Berlin, April 2001.

14 Nika Strzemińska, *Miłość, Sztuka i Nienawiść* (Warsaw: Res Publica, 1991), 11; Nika Strzemińska, "Man and Artist," on the Donajski Gallery Web site: www.ddg.com.pl/strzeminski/manandart.html

15 *Zwrotnica*, no. 4 (1922): 113.

16 Letter to Julian Przyboś, February 1931, Archive, Muzeum Literatury, Warsaw.

17 Quoted in "Władysław Strzemiński," www.groveart.com

18 Janusz Zagrodzki, "Wewnątrz Przestrzeni" [Inside a Space], in *Katarzyna Kobro: 1898–1951*, exh. cat. (Łódź: Drukarnia Księży Werbistów, 1998), 73–82.

19 The golden section is discussed in the article "Architectural Proportion," *The Grove Dictionary of Art*, vol. 2, 345ff. The mathematician Luca Pacioli, a friend of Leonardo and Piero della Francesca, wrote a book called *Le divina proportione* (1509) in which he discussed the special properties of the golden section. It has been considered a mystical proportion with inherent aesthetic value and has been found in natural forms as well.

20 Katarzyna Kobro, "Rzeźba i Bryła" [Sculpture and Solid], in *Europa*, no. 2 (1929): 60.

21 In *Forma*, no. 4 (1936): 9–13.

22 "Rzeźba i Bryła," 60.

23 *Kompozycja Przestrzeni: Obliczenia Rytmu Czasoprzestrzennego* (Łódź: Drukarnia Mazurkiewicza, 1931), 49.

24 "Rzeźba i Bryła," 60.

25 Franus, unpublished article.

26 Letter to Jan Tschichold, April 28, 1939, Getty Research Institute.

27 Nika Strzemińska, *Miłość, Sztuka i Nienawiść*, 50.

28 Ibid., 67.

29 *Katarzyna Kobro: 1898–1951*, 59, 70.

30 My translation, from Anatol
 Stern and Mieczysław Berman,
 Mieczysław Szczuka (Warsaw:
 Wydawnictwa Artystyczne i
 Filmowe, 1965), 38.
31 Szczuka wrote in *Dźwignia*, no. 2/3
 (1927): "In 1924 Teresa Żarnower
 gives an initiative to unite in a
 group *Blok* and in March 1924—the
 first exhibition of the group and
 the first issue of the magazine
 with the same name take place."
32 Inventory letter from the Archive
 at the Art History Institute of
 the Polish Academy of Arts and
 Sciences in Warsaw. Żarnower
 and Szczuka signed a handwritten
 letter (February 12, 1923) request-
 ing permission to export seventy
 works of art. The permission was
 granted on March 24, 1923.
33 From Szczuka's 1924 statement
 in *Blok* 8/9 (my translation):
 Photomontage=the most con-
 densed poetry in form
 Photomontage=poetic visual
 plastic
 Photomontage gives the multi-
 plicity of multiple happenings
 in the universe
 Photomontage=objectivism of
 form
 Cinema is the multiplicity of
 happenings in one time
 Photomontage is multiplicity of
 occurrences
 Photomontage is multiple penetra-
 tion of two and three dimensions
 Photomontage=modern epos
34 *Mieczysław Szczuka*, 108.
35 Ibid., 80.
36 Stern, foreword to *Europa*, quoted
 in edition reproducing the 1929
 original's illustrations and typog-
 raphy (London: Gaberbocchus,
 1962), n.p.
37 Ibid.
38 Turowski, *Builders of the World*,
 218.
39 Ryszard Stanisławski, interview
 by the author, September 1999.
40 Lorentowicz in *Mieczysław
 Szczuka*, 148.
41 Stern, "Głód jednoznaczności," in
 Mieczysław Szczuka, 9.
42 Kobro, "Manifeste Dimensioniste,"
 in *Katarzyna Kobro*.

łódź

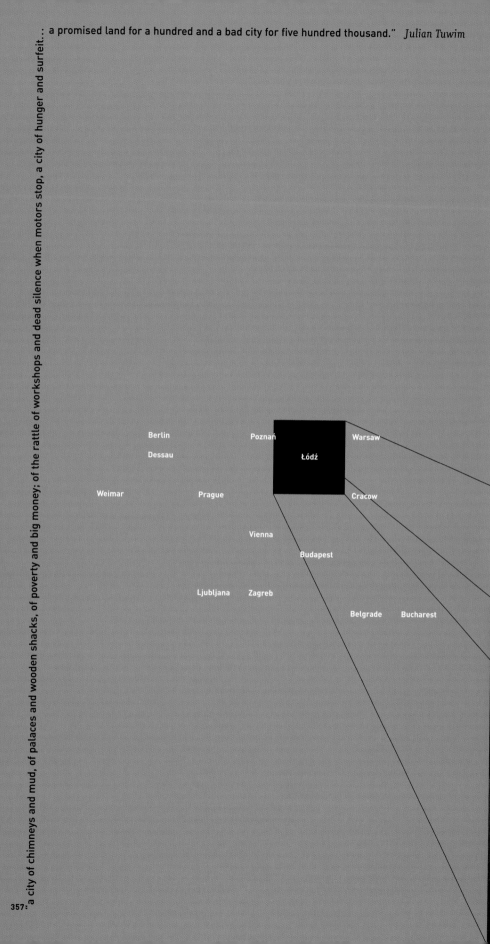

"... a city of chimneys and mud, of palaces and wooden shacks, of poverty and big money; of the rattle of workshops and dead silence when motors stop, a city of hunger and surfeit... a promised land for a hundred and a bad city for five hundred thousand." *Julian Tuwim*

Berlin

Dessau

Poznań

Warsaw

Łódź

Weimar

Prague

Cracow

Vienna

Budapest

Ljubljana Zagreb

Belgrade Bucharest

ŁÓDŹ

Jaromir Jedliński

The poet Julian Tuwim described early twentieth-century Łódź as "a city of chimneys and mud, of palaces and wooden shacks, of poverty and big money; of the rattle of workshops and dead silence when motors stop, a city of hunger and surfeit, of boredom and monotony…a promised land for a hundred and a bad city for five hundred thousand." Without a pronounced cultural or national identity, but wide open to diversity, this industrial town of contradictions and contrasts would become the crucible for modern art in its most radical forms. Karol Hiller, a painter and later an innovator in the field of noncamera photography, and Witold Wandurski, a poet and playwright, described the Łódź worker as a new type of man and citizen who would one day become the subject of the new art. Modern art, they wrote, reached out "to primitive sources and to folk art, since it is there that the principal elements of pure painting are most clearly discernible."

Working-class Łódź became a city of rebellion and a hotbed of social and artistic revolution. It was a hub of multicultural, creative expression—natural for a city with a multinational population—and fast became a center for functionalist theory and practice. Thanks mainly to the activities of Władysław Strzemiński, the city housed one of the first museums of avant-garde art in Europe. Founded on the basis of the International Collection of Modern Art assembled by the a.r. group, the Museum of Art opened to the public in 1931.

From the eighteenth century until the end of the First World War, Poland was divided between the empires of Prussia, Austria, and Russia. Łódź fell under Russian rule. Around 1910 its population—mostly immigrant and multinational—was approximately 500,000. The largest industrial center in Poland, Łódź resembled American manufacturing cities more than other Polish towns. As for its social composition, Łódź was a town of workers and the bourgeoisie. Even before the Bolshevik Revolution in Russia, Łódź had experienced the problems attendant to early capitalism, including exploitation of workers and lack of health and safety regulations. In those years the saying was: "Whoever does not have 100 rubles in Łódź is not human, whoever has them has ceased to be human." The city had its social activists, most noticeably in the field of theater; there was a popular and educational workers' theater, which began to demonstrate revolutionary tendencies. The poet Wandurski played a large role in this type of theater, as did Aleksander Zelwerowicz and, above all, Karol Adwentowicz.

At the end of the nineteenth and beginning of the twentieth century, industry in Łódź was integral to the economy of czarist Russia. Situated close to coal fields that provided ready fuel, the city produced textile products and sent them into the markets of the Far East and Siberia at a cheap rate. "The manufacturers of Łódź became the avant-garde of czarist imperialism," Strzemiński wrote. A railway line, the so-called cotton line, was built to connect energy sources, cotton fields, mills, and the markets, thereby lowering the cost of textile production still more. In the first decade of the twentieth century, market conditions favored the Łódź capitalists, and the number of new factories greatly increased. A massive influx of people came to the city in search of work. The mill owners were a mix of Germans, Jews, Russians, and Poles. The cruel effects of industrialization were described in a synthetic, visionary style in *The Promised Land* (1899) by Władysław Reymont, who was later awarded the Nobel Prize. A slump in prosperity followed Polish independence in

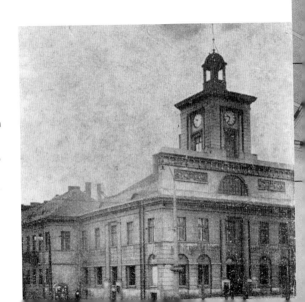

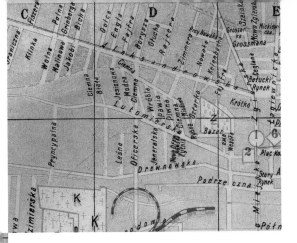

Right:
Jung Idysz, 1919

Below:
■ Jankiel Adler, *My Parents*, 1921, mixed media on wood

1918. The Eastern market ceased to exist, and in the West and South Łódź products could not compete with those of Western manufacturers, a situation aggravated by the world economic crisis of 1929–30. In 1927 socialists won seats to the Łódź city council. To a large extent it was they who later greatly contributed to the development of education and culture in the city. The socialists governed until 1933.

The Society of the Museum of Science and Art was founded in Łódź in 1910. Its role then was insignificant, but in 1923 it was taken over by the city. After the socialists came to power in 1927, steps were taken to institute a municipal art gallery. A Cracow historian and writer, Kazimierz Bartoszewicz, offered his art collection to the city in 1928, and a building on one of the main squares, formerly housing a city hall, was made available in 1930 for the new Museum of History and Art of J. and K. Bartoszewicz. Most significant for the assembly of a collection of the avant-garde, however, were the activities of the a.r. group in 1929, discussed below.

Generally, artistic life in the period that interests us here became more lively after the First World War. The Association of Artists and Supporters of the Fine Arts, founded in Łódź in 1918, organized two exhibitions that year, in spring and fall. Both exhibitions presented, for the first time, works by members of Jung Idysz [Young Yiddish], a group of artists from the newly enfranchised Jewish community who, in keeping with similar groups in other countries, sought to express their cultural identity. They chose artistic terms close to Expressionism, referring directly to the art of Marc Chagall. Jung Idysz was

undoubtedly the most interesting group of artists active in that period in Łódź. Jankiel Adler, the cofounder of the group, had been born near Łódź. As a young man he spent time in Germany, where he had contact with members of Das Junge Rheinland. In 1918 he arrived in Łódź. The poets and painters of Jung Idysz organized poetry evenings, theatrical productions, and art discussions in Yiddish; they also published an eponymous periodical. Other members included Marek Szwarc, Henryk Barciński, Ida Linderfeld, Ida Brauner, and Vincent Brauner as well as such writers and poets as Mojżesz Broderson, I. M. Neuman, and Icchak Kacenelson. The group's 1919 manifesto declared: "We seek the truth in our everyday life, in our mystical beliefs and in our symbolism— the so-called Futurism… We feel a great respect for traditionalism, for our wise men, for the Bible…but also for Futurism, for all time." Marek Szwarc recalled lively meetings infused with poetry, discussions, music, and dreams of a liberated Palestine at the house of painter Vincent Brauner. "Our first plans concerned the possibility of founding a legion for the liberation of Palestine," Szwarc said. Broderson started a cabaret theater, Ararat, while his wife organized a group of dancers and singers. *Jung Idysz* reproduced a rich program of graphic work, mostly linocut illustrations. Adler was the leader of this group of friends and artists; Szwarc recollected, "He told us about Rabbi Nachman and *cadyk* [Hasidic guru] Ba'al Shem Tov; he knew Martin Buber and was the first person to speak to us about Buddha. The holy figures of Hasidism often figured in his paintings."

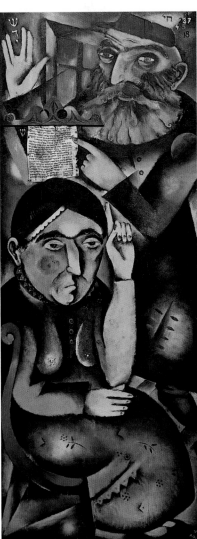

In 1920 Jung Idysz began to lose its impetus, although members still organized poetry evenings, sometimes in the Grand Hotel. In the same year Adler left for Germany; Szwarc traveled through Berlin to Paris; Lindenfeld studied in Berlin and Barciński in Dresden. Later Ida Brauner also left for Germany. The publication *Tel Awiw*, to which members of Jung Idysz had contributed, played a role in stimulating Jewish artistic circles, although these were gradually leaving Łódź and Poland. In December 1923 the International Exhibition of Young Art opened in Łódź after showing in Warsaw. Organized by Polish-Jewish communities, mainly from Berlin, it presented works by artists influenced by Expressionism; the venue was the stained-glass hall Casina. An annex to the exhibition featured artists working in Łódź in the Expressionist spirit as well as artists who were soon to become the leaders of the Polish Constructivist movement; some of them had participated in the Exhibition of New Art organized by Władysław Strzemiński in Vilnius in 1923 and would become the founders of Warsaw's Blok group in 1924. Constructivism was becoming the avant-garde of the avant-garde, although Adler still came to Poland and Łódź in the 1920s and 1930s and took part in local artistic activities. In the mid-1930s the Museum of Art in Łódź bought a few paintings by Adler for its permanent collection. Many of his works, such as *Two Rabbis* (1942) and *No Man's Land* (1943), are symbolic of the

Holocaust of the Jews of Łódź, who in the 1930s constituted one-third of the city's population.

The link between the Expressionist imagination and the Constructivist world can be found in the art of the Łódź artist Karol Hiller, who was active in the city from 1921 until his death at the hands of the Nazis, in December 1939. In 1923 he produced stage decorations for spectacles based on Schiller and Keller and mounted by pupils of the German gymnasium. He produced books and publications according to what Strzemiński called "functional printing," in which different sizes and fonts of type are combined with simple geometric lines and shapes. He also designed bookplates, and in 1928 took part in an international bookplate exhibition in Los Angeles. In his graphic art and painting Hiller created his own language, a poetic and lyrical brand of Constructivism. He also initiated what he called "heliography," a noncamera photogram technique. Hiller carried on a wide range of educational activities motivated by his wish to reveal, through the external beauty of Łódź, with its eclectic Art Nouveau and industrial faces, the collective soul of the city. He collaborated with the Workers' Stage theater, an amateur political group that promoted social solidarity and an affinity between the work of the artist and the industrial laborer. Authorities closed the Workers' Stage for reasons of "public safety and order," and Hiller, like many other artists who were moving progressively leftward, collaborated with the leftist review *Dźwignia* [Lever]. In the late 1920s he participated frequently in exhibitions with Strzemiński, the other principal leader of the new art in Łódź. Almost all Hiller's works are in the collection of the Museum of Art in Łódź.

Strzemiński and his wife, Katarzyna Kobro, played the most important role in the artistic life of the city, even though they did not move to Łódź until 1931. Successively associated from 1924 with the avant-garde groups Blok, Praesens, and a.r., Strzemiński and Kobro were schoolteachers in villages near Łódź. Strzemiński developed the most radical concepts of Polish avant-garde art: Unism, architectonism, and, in cooperation with Kobro, the idea of the

Below:
■ August Zamoyski, *They Are Two*, 1922, bronze (later cast)

Bottom:
Installation of the a.r. group, International Collection of Modern Art, Muzeum Sztuki, Łódź, 1932

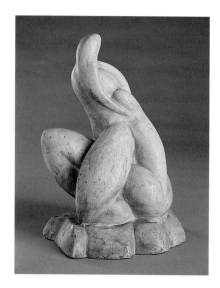

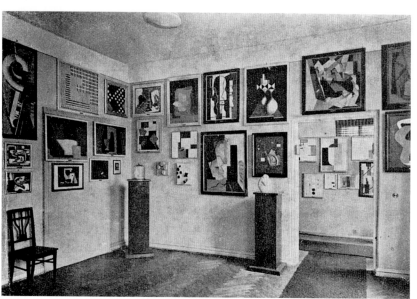

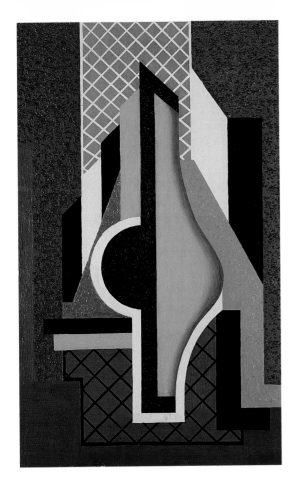

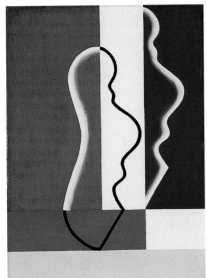

"composition of space" embodied in artistic practice. Strzemiński also was active in the field of typography, as an organizer of artistic life, and as an art critic and theorist. He was a link between Polish artists and the international avant-garde: it was Strzemiński who invited Kazimir Malevich to Warsaw and organized his exhibition there in 1927 for the Artistic Club at the Polonia Hotel, and as a representative of Praesens he co-organized the 1927 *Machine Age* exhibition in New York.

Most important to the cultural life of the city was Strzemiński's effort, through the a.r. group, to establish a permanent Constructivist exhibit, the International Collection of Modern Art. Strzemiński saw the possibility of establishing a museum of avant-garde art in alliance with the socialists in the city council, where his main ally was Przecław Smolik. Strzemiński had participated in the formulation of the revolutionary Russian avant-garde notion of museums of artistic culture that were meant to be collective and social in the truest sense. Several dozen artists of the international avant-garde offered more than one hundred works to the collection. Many of the works came from groups such as Abstraction-Creation and Cercle et Carré that were active in Paris; the Paris-based a.r. member and poet Jan Brzekowski helped secure donations. Strzemiński, on behalf of the group, deposited the works first in the Municipal Museum of History and Art of J. and K. Bartoszewicz. Abstract works formed the core of the collection. When it opened to the public in 1931 in the former Łódź city hall, it was one of the first public collections of avant-garde art in the world. The collection was to fulfill Strzemiński's postulate of "enriching visual consciousness and content." As Smolik stated in the catalogue, "The works in the collection were offered by their artists freely, with only one condition: that they should be housed in a suitable institution, with free access to all those interested in art...Thus the Łódź International Collection is, in the fullest sense, a collective, social act." Strzemiński and Kobro also offered almost their entire oeuvre as a gift to the Łódź museum, where, together with the greater part of the a.r. collection (twenty-nine works were lost in the Second World War), they are kept and exhibited today. It is impossible to overestimate Strzemiński's and Kobro's achievements and their efforts in organizing art in Łódź and Poland. Yve-Alain Bois addressed this in his "Strzemiński and Kobro: In Search of Motivation" (in *Painting as Model*, 1990): "Some works appear too early and make their comeback too late, their very precocity interfering—and continuing to interfere—with their reception... Władysław Strzemiński's and Katarzyna Kobro's texts and works from the 1920s and 30s belong to this category. They seem to have directly influenced the art and aesthetics of the 60s."

The art of the avant-garde and Jewish Expressionist art, which appeared in Łódź in the first decades of the twentieth century, the lessons of Strzemiński and Kobro, the material and moral foundations of the Museum of Art—these are still among the strongest signs of the paradoxical nature of Łódź, today once again a strongly capitalist city.

Translated by Wanda Kemp-Welch

Top left:
■ Maria Nicz-Borowiak, *Composition [Musical Theme]*, 1925, oil on wood

Top right:
■ Katarzyna Kobro, *Abstract Composition*, 1924–26, oil on glass

Above:
■ Maria Nicz-Borowiak, *Profiles*, c. 1930, oil on canvas

B

THE PHENOMENON OF BLURRING

Andrzej Turowski

An odor of boiled cabbage and stale beer rises over Central Europe, one can smell overripe watermelons. This land has a characteristic smell. The frontiers are blurred and irrational, only the sense of smell allows one to trace them with absolute certainty. *Josef Kroutvor*

The discovery of Central Europe by America reminds one of the discovery of America by Columbus. As in that case, people discovered here the part of the whole that they felt they lacked. Columbus's journey ushered in the modern era, and the fall of the Berlin Wall opened the gates to universal postmodernism and its multicultural nature. This was the beginning of the unity Europe had dreamed of. But let us leave this all-too-banal metaphor and this trivial philosophy of history, and note only the conviction, far older than the facts related here, that the emergence of Central Europe constitutes, in the eyes of the West, the recognition of the Other. Associated with the concept of the Other are, above all, boundaries—the clear division between that which is here and that which is there, that which belongs to Us and that which belongs to the Other. Otherness is an impassable state, in which there lies potential hostility, hatred, and exclusion as well as interest, hospitality, and friendship.

It is not surprising then that in the history of culture, the figure of the Other was associated with the conquistador and colonialist as well as the vagrant and traveler. The former, armed land-surveyors, measured out the land, drew up precise maps, and marked out sharp lines of division; the latter, mad dreamers, conquered frontiers without worrying about their location. They were in their element with changes of scenery, and the people they met were interesting interlocutors. Traveling was not an expedition for them, but free movement in multidimensional space. In this sense the Other is the unknown newcomer, the anonymous wanderer, arriving and then vanishing into the distance. The relationship is one of a meeting, whether unexpected or planned; it is also one of making acquaintance and coming together, or even

comradeship and fraternization. To put it another way, the relationship is the process of transforming the Other into one of Us. A sense of difference still remained from this process of acquainting oneself with the Other, and the modernist Other (given specific boundaries) was being transformed into the postmodernist Other (of undulating expanse).

If we write the history of the twentieth-century avant-garde from the perspective of a newcomer (Central Europe is a region of constant migration, immigration and emigration, of people arriving, departing, and moving around), then the cognitive horizon of our reflection will be determined by the issue of identity. "What is identity," writes the Algerian-born French philosopher Jacques Derrida (*Monolingualism of the Other*),

this concept, whose transparent identity is in itself a dogmatic and unspoken assumption in so many debates on monoculturalism and multiculturalism, nationality, citizenship, and affiliation in general? But before we say anything about the identity of the citizen, what might 'being oneself' [*ipseity*] be, is it the same thing? It does not come down to the abstract ability to say 'I,' because the former always precedes the latter. It may, in the first place, mean having the power of the 'I can,' which is earlier than the 'I' belonging to the chain in which the *pse* of the word *ipse* is inseparable from the power, domination, and sovereignties contained in *hospes* (I am referring to the semantic chain which is equally deeply inherent to 'hospitality' [*hospitalité*], as it is to 'hostility' [*hostilité*])...

In posing the old question of how to delineate the cultural boundaries of Central Europe and how, within its framework, to define the boundaries and limits of avant-garde art, I would like to focus my attention on three fundamental

issues. The first relates to the lives of artists, to their creative biographies as a basis for shaping the concept of cultural identity. The second is geography, a form of spatial differentiation within the whole complexity of the shuffling of historic, cultural, economic, political, philosophical, and ideological relations. The third issue encompasses the problems of historic and artistic processes, at the head of which are concepts associated with the emergence of stylistic trends, ideological attitudes, conceptions of history, and visions of the future, and with them the structure of the work of art, its integrity and fragmentation, its autonomy and disintegration.

Let us say to ourselves from the outset that the problem of the identity of Central European modernist artists is not a matter of abstract choice, resulting from the precedence of the subject being formed (logocentrality), but of the discursive coincidence preceding it, in which different histories have their beginnings while identity dissolves away. I am concerned, in the first place, with the difficulty of outlining the boundaries of Central Europe when speaking of the biographies of artists who for one reason or another found themselves within its geographical orbit. It is not accidental that in thinking of Central Europe, I begin my reflections not from the map or the landscape but from the people.

Kazimir Malevich, the founder of Suprematism, was born in a Polish family that had settled years before in Lithuania but resided at the end of the nineteenth century in Polesie, a region belonging ethnically to Belarus, though traditionally subject to Polish cultural influence. The artist's birthplace was the Ukrainian Kiev, part of the Russian Empire. Malevich's native tongue was Polish; he made his first acquaintances in Ukrainian, while he was educated, worked, and wrote his philosophical/artistic treatises in Russian (though with many words derived from Polish and Ukrainian). Having grown up in Central Europe, his cultural identity was formed in Russia, and as a fully formed artist he chose Europe as the territory for his universal identification.

Władysław Strzemiński was born in Minsk, in Belarus, was trained as an officer of the Russian Army, and worked as a Russian artist in Smolensk on the Western Front in the war against Poland. In 1922 he settled permanently in Poland, just as his whole family had previously done. For the first few years he communicated in Polish with difficulty, and many words derived from Russian can be found in his later Polish artistic treatises.

Katarzyna Kobro was the daughter of German emigrants who settled in Riga, Latvia, and was educated in Russian in Moscow. Together with Strzemiński she came to Poland, not knowing Polish but nevertheless soon cofounding the Polish avant-garde circle. János Máttis-Teutsch came from Braşov, in Transylvania, and was a member of the Hungarian and Romanian avant-garde. Serbian Ljubomir Micić was born in Croatia, first worked in Zagreb, and then in Belgrade. Vytautas Kairiūkštis was a Polish/Lithuanian artist. Gustav Klucis was Latvian/Russian. The Yiddish-speaking Jewish artists Chagall, Paliamov, Altman, Brauner, Adler, Lissitzky, Broderson, and Berlewi came from the Ukraine, Belarus, Lithuania, and Poland. These examples could be multiplied; nonetheless such multiculturalism has always been part of the life story of the Central European artist. One could say that the collective biography of Polish, Czech, and Hungarian artists would be similar. Hungarians born on the borderlands of Slovakia, Romania, and Austria recommenced their studies (which had been interrupted by the war) in Budapest. They were then conscripted into the Austrian army, became committed to the Communist revolution, and emigrated. The majority of them reached artistic maturity in Austrian Vienna or German Berlin. German was, alongside Hungarian, the language of their artistic expression.

Malevich, in his application for a visa for a trip to Paris that never came to fruition, gave Polish as his nationality; yet on a visit to Warsaw, in conversation with press reporters, he stressed his spiritual ties with Russian art. The huge cultural territories stretching westward from Moscow as far as Berlin, inextricably linked to his biography, were merely peripheral in his artistic experience. Witold Gombrowicz, after years spent in Argentina, sketched out his artistic testament in conversation with Dominique de Roux in France: "I was a Pole. I was in Poland. What is Poland? It is a country between East and West, where Europe is already starting to fade out, a country of transition, where East and West weaken one another. Consequently it is the country of the weakened form…" Jan Patočka, the Czech philosopher and coauthor of *Charter 77*, in the beginning of an essay on the existence of Czechs in European culture, noticed above all their marginalization. "The Czechs," he wrote, "are a small Central European nation, inhabiting the closed, formerly not easily accessible Czech Lands, and the adjoining open-transit country—Moravia. There were times when the rest of Europe took no notice of these countries, and there were also times when they were the center of attention because of the dramatic tension around them, which nevertheless calmed down and

was followed once again by silence, accompanied by a certain embarrassment..."

The awareness of one's own faults or those of others surrounded the biography of the Central European artist, a biography which is hard to typify as it is not based on the ethnocentric model of "cultural unity" and is full of the complexities of "weakened form." It was characterized by the undefined identity found in the myth of the Good Soldier Švejk and the personification of the Jewish dybbuk, and constructed in the messianic utopias of a Slavonic community and the ideologies of the Balkan Barbarogenius. On the negative side of this biographical uncertainty were all the forms of nationalistic fanaticism nesting easily in those places where national sovereignties appeared under threat or the regained independence manifested itself too emphatically. In all the examples related here, the peripheral nature of Central Europe existed as a problem of the parochialism of life, which was becoming the subject of expressive art, full of irony, absurdity, and the grotesque.

On top of this, which could be called the internal model of the irrationally experienced personality, there was another discourse taking up the challenge of rationalizing the experience of life in avant-garde art. The antipsychological disposition meant that biographies of these artists were inscribed into the framework of a formal order—expressed in art as tension—often quickly abandoned between attempts to base modern works of art on ethnographic tradition or national language and the strong tendency to universalize their own personality at least in the perspective of Europe as a whole, and more often in absolutist visions of the cosmos. There are many examples, so I will only mention on the one hand the Polish Formists, the Czech Cubo-Expressionists, the Ukrainian Cubo-Futurists, the Latvian Geometricists, and the Bulgarian Folklorists, and on the other hand call to mind Strzemiński's Unism, the *bildarchitektur* of Kassák and the Poetism of Štyrský, ideas unrestricted by space and time. In the models of artistic identity listed here, Central Europe did not exist, either as a place or as a problem. The boundaries of the new man were delineated below or above this cultural category, and all ties binding the life paths of artists on the borders of Europe to local tradition and lost life stories were considered to be conservative.

Central Europe looked rather different in émigré centers of modern art. Roaming around the world, Central European artists often found themselves in supranational configurations in the European capitals. It was they who formed the École de Paris, initiated Dadaism in Zurich, taught in the

The biography of the Central European artist ran counter to history, eluded place and chronology, covered many territories and occurred in different times. It was a disintegrated biography.

Bauhaus, and lived in Berlin and Paris. Not without difficulty joining the circles of the local artists, they were perceived as strangers, bringing with them a strange difference. This could be simply expression, sometimes the seeds of revolution, and more often universal utopia. Central Europe was written into their lives not as a geographical name but as the shared experience of the place left behind, whose boundaries, though concrete, had a mental character. These boundaries were stretched in their biographies, though they no longer created a distinct art dissolving amid general trends and poetics.

The biography of the Central European artist ran counter to history, eluded place and chronology, covered many territories and occurred in different times. It was a disintegrated biography.

The geopolitical problems of Central Europe are sufficiently well known not to have to rehearse the unresolved disputes concerning the historical, ethnic, and national boundaries of countries and the people inhabiting them. One can even identify the modernism of this part of Europe with the process of the map's formation, rather than with that of the landscape. These are not tectonic phenomena changing the historical landscape, this is not an eruption of social volcanoes, but rather, they are processes of retrenchment, the history of discord, in which the battle for the ownership of boundaries often took on a dangerous character. This is why, in speaking of Central Europe, I prefer to refer to the concept of topography, by which I understand the delineation and marking of places in a landscape, the route of roads and the positions of zones of buildings, and not geography, which is a description of the earth and its spatial differentiation.

However, we must first take stock of what we have in mind, whether from a geographical or topographical point of view, when speaking of Central Europe. Does it stretch from the Baltic to the Balkans and from the Dnieper and the Black Sea to the Adriatic, the Danube, the Elbe, and the Oder? Or maybe even further, to the North Sea and the Rhine? Or perhaps it occupies only the central part of this region, within the present territories of Poland, the Czech Republic, Slovakia, Hungary, Austria, Slovenia, and Croatia? Or perhaps less— only the countries on the Danube? Or perhaps Central Eastern Europe stretches in a wide strip from the northern boundaries of Poland, Belarus, the Ukraine, and Slovakia as far as Hungarian/Romanian Transylvania? Or perhaps, as Central Southern Europe, it has its center in the Balkans? Or as

Central Western Europe it stretches as far as Berlin? Or finally, does it remain nothing more than the historical legacy of the Habsburg monarchy unfurling between Vienna, Budapest, Prague, Cracow, and Lwów?

Each of the configurations of Central Europe outlined above has its political justification and particular place in history, and above all in the history of the Europeanization or Christianization of the world of that time. Since the nineteenth century, and especially since the beginning of the twentieth, the idea of a great European region has been either the result of unrealized ambitions to become great powers, or of self-defensive pacts of a federation, generally limited to the not particularly fortunate association of a few countries. There are many examples, including the German ideology of Mitteleuropa developed from 1915 onward, and the commonwealth of "independent" Western Russian republics propagated after the Bolshevik Revolution. There were also the existing international links, such as the union of the Slovaks and the Czechs (Czechoslovakia) liberating themselves from Hungarian domination, or, in its original intention, the alliance between the Serbs, Croatians, and Slovenians (Yugoslavia) in defense against Italy. If we add a few economic agreements such as the so-called Small Entente and the Baltic Entente, no other idea of supranational union has ever been realized here. Quite the contrary. The history of Central Europe, after the fall of the Austro-Hungarian Empire, the Russian Empire, and the Hohenzollerns, is a history of constant battles to rule over the largest possible territories by newly formed countries or those regaining their independence, whose struggles for self-determination, based on nineteenth-century ideals of distinct ethnic, linguistic, and cultural identities, were hardly ever respected in an aggressive policy of appropriation that rendered any thoughts of unity impossible. In other words: the modern political geography of Central Europe is the history of disintegration, canceling out the possibility of delineating a common regional boundary.

In terms of artistic geography, it is worth asking whether these processes, characteristic of the political plan and directed at gaining independence, are also sketched out on the cultural front. The reply, while affirmative, necessitates far-reaching differentiation. Above all it must be stressed that, as a subject of contemporary intellectual discussion, the concept of Central Europe as a cultural community has a relatively short history, which does not exceed the last few decades. Unity has been sought in Central European artists' specific aspirations to make artistic processes aesthetic and

autonomous; it has also been perceived in their excess of moodiness, nostalgic expression, and tendency to develop metaphysical narration. The parochialism and abstraction contained in such art, as well as its cosmopolitan and figural character, have both been stressed. Central Europe appeared still less frequently as an artistic utopia, having its precedents in visions of Slavic, Balkan, Baltic, and borderland unity, to name only the most characteristic examples. It will clearly be a truism, to which a great deal of attention has already been devoted, to state the close links between the artistic concepts of Central Europe and its historical, ethnic, territorial, religious, and linguistic differentiation.

To follow a slightly different track, I propose to take a look at the art of Central Europe through the topography of her towns. Understood in this sense, topography is above all political topography based on the citizen-oriented and essentially democratic construction of the Roman *civitas*, towns governed by their inhabitants, citizens (*civis*). It is precisely this tradition of Europeanization that, over the ages, not only Latinized the eastern borderlands of Western Europe, but laid the foundations for democratic civic order, within the framework of which the aforementioned otherness could be transformed into difference. This was not a simple process, and it is hard to say whether it will ever be completed. In other words: in Central European towns the sharp boundaries on the map marking national and political divisions dissolved in the coexistence of different nations, churches, and languages. Time and the historical processes associated with it were also broken down. It was hard to separate conservatism from modernism, and alongside the idea of progress, catastrophism was at work. Contradictions did not arise in binary oppositions; cutting across one another diagonally, they took on new meaning. And it is only on this basis, moving away from the geography of plains, rivers, and mountains, and above all of national ideologies, that the topographic, artistic labyrinth of streets, squares, houses, suburbs, ghettos, and enclaves will occupy us. We will be concerned with the relationship between place and distance as sources of nostalgia, obsession, and visions, and also of projects for the future, lofty plans, dreams of distant countries and travels overseas. It is here that we will rediscover Central European mythologies and utopias. Mythologies were generally nourished by familiarity and the emotionally experienced local day-to-day parochialism, while utopias took on the supraregional dimensions of an excessively rational universe.

From a vertical axis with international ports at its extremities, Gdańsk in the North and Trieste in the South, with Vienna positioned in the center, there extended a whole web of cities and country towns which, though they often changed their names in the course of history, nevertheless retained their multicultural character. Besides metropolitan cities such as Prague and Budapest, urban life was concentrated in Warsaw, Lublin, Zagreb, Cracow, Belgrade, Lwów, Łódź, Bratislava, and Brno, extending northward as far as Poznań, southward to Bucharest and Sarajevo, and northeast to Kiev, Vitebsk, Vilnius, and Riga. Between them, particularly on the Eastern borders, beginning with Lithuania and extending to the line of the lower Danube, were scattered many smaller towns, whose names sound like cultural stereotypes to the ears of the inhabitants of Central Europe: Pińsk, Drohobycz, Koszyce (Kassa, Košiče), Cluj (Kolozsvár), Nowy Sad (Ujvidék), Timiszara (Temesvár, Timișoara), Braszow (Brașov), Czerniowice (Černovcy)—the list is endless. What characterized the majority of these towns was their multilingual character, religious differentiation, national and cultural variety, and at the same time, the preservation of distinct Eastern and Northern traditions. In towns, both among the local population and that flowing in from as far away as West Germany, there was a large proportion of the population that possessed Yiddish language and culture, and Hassidic mysticism. I do not mean to say that there was an idyllic neighborly cooperation. On the contrary, tensions expressed the necessary or simple impossibility of the coexistence of increasingly entrenched enclaves in never-completed processes of assimilation.

When El Lissitzky stopped in Warsaw in 1921 on his way from Vitebsk to Berlin, during discussions on the fascinating problem of Suprematism taking place among the circle of Jewish artists Jung Idysz and the Polish creators of the future Blok, Berlewi and Szczuka, the question of how to rid the avant-garde's universal art of local, national, and religious tradition constantly imposed itself. In the West this question seemed already to have been answered once and for all by the radical stroke of the Italian Futurists, while in Central Europe it was floundering in the transgressive processes of the integration and Europeanization of contemporary art. This problem would be hypothetical if it were not for the urban context, which located it clearly amid the modernist aspirations of the bourgeoisie. It also gave a specific dimension to the vision in which the city, as a source of conflict, appeared both as an endless, towering construction and as the apocalyptic tragedy of the loss of

God. In all images of the city, the contemporary world seemed like a strange chaos.

The avant-garde discourse in Central Europe—and it was probably for this reason that it differed from Italian Futurism and Russian Constructivism—was born "on the ruins of the world," in the madness of civilization, in a dehumanized culture, in the times of the decline of Art. The atmosphere of self-destruction was widespread. In Karl Čapek's famous play *R.U.R.* the great physiologist Rossum, obsessed by a mania for functionalism, creates an artificial human-robot. Anthropomorphic machines quickly revolt against their human oppressors, proclaiming their victory over the human world. This catastrophic vision fascinated artists with its nihilism. "We are approaching the end with mathematical precision," wrote the Polish Futurist Bruno Jasieński:

Shortly machines will replace everything around us, life will revolve around machines. We are making our every move dependent on the machine. We are capitulating. We are giving ourselves up to an alien element. The girdle of steel nerves, which still maintains our hegemony, must snap at any moment. There remains battle or madness. For the time being, no one sees or understands this. We are blinded by our power. There is no way out. We have hemmed ourselves in on all sides. Anyway, this is already within us. You cannot live without the machine. Your forefathers perhaps still could. You no longer can. It is impossible to defend oneself. One has to wait. The poison is in us. We have poisoned ourselves with our own power. *Syphilis* of civilization.

In one of Janusz-Maria Brzeski's photomontages, in a somber landscape of factory buildings lit up by the light of explosions, amid burning objects and shattered machines, there lies the discarded body of the last man, approached by a robot striding like a sleepwalker and dressed in protective overalls, with his head covered by a helmet, a strange phantom of the future. "The din of houses collapsing," commented Brzeski. "Tons of bombs fall on the city. The proud skyscrapers crumble. In the city, which panted with play, joy and laughter—a horrible cemetery is born…"

Such images were not unlike the apocalyptic cityscapes of Ludwig Meidner (originally from Silesia), Serbian Ljubomir Micić's visions of the dying West, and Warsaw revolutionary Mieczysław Szczuka's collages of a perishing Europe. Revolutionary art, for it was thus that the Constructivist avant-garde wished to be called, inextricably linked the apocalyptic topos with the new reality. Rebirth would only be possible when the Apocalypse had been fulfilled. To build a new world it was necessary to completely destroy the old one. The motif of Christian theodicy, implanted in the traditional opposition between apocalypse and utopia, was an attempt to resolve the contradictions between God's omnipotence and the existence of evil, and the resulting fact that suffering and injuries cannot be left without compensation. The answer to the evil inflicted is its redemption by the realization of some great humanist cause. "Society must nurture a great Idea for which thousands and millions will be willing to give their lives; there must be a great cause, from which a great art shall be born!" So one could read in 1922 in the columns of the *Kultura Robotnicza* [Workers' Culture]: "This dream world can only come from the direction from which blows the breeze of the Great Idea of the Rebirth of the whole of mankind…"

Central European Constructivism was apocalyptic, and was unimaginable without a decadent mood. It was not accidental that, in the image of the city, the optimistic idea of utopia was breaking down. Languor was seen to be responsible for evil, although European civilization was actually the object of this utopia. From a historical perspective, this utopia revalidated the fin-de-siècle atmosphere that lived on in Central European cities at the time of the formation of modern urban organisms, turning its provincial atmosphere into nostalgic mythology or turning the revolt against the bourgeois society into a revolutionary cosmology. It should be added that the avant-garde was born in the prevailing city atmosphere of postwar confusion, crisis of consciousness, sense of alienation, the threat of modernity, and the uncertain future. If it was nihilistic, it did not refer to a specific political position, but easily and freely combined Expressionist pacifism and Dadaist anarchism with the Futurist and Constructivist ideology of civilization. It was on this ground that a specific form of pessimism, which is hard to express in an anti-utopian formula, was born.

The topography of art in Central Europe included the pulsating space of contracting and expanding boundaries measured by the variable amplitude of the experience of history and images. It was a topography of dispersal.

Comparative study in art history is fraught with dangers that lead to simplified judgments, all too often readily pointing to the particular or general relationships between works, artists, and movements. Notwithstanding the methodological difficulties resulting from the different ways of defining the objects and phenomena being confronted, comparative study is to this day dominated by the modernist vision of history as an organism, in which all events and their actors are

linked to one another by the principles of its genesis, whether functional or structural. Such a conception of history, dear to the artists of the avant-garde, proposes a certain entrenched model, with established questions and, at least in theory, ready answers.

It is not surprising then, that the issue of avant-garde art in Central Europe provokes methodological reflection concerning the nature and limits of contemporary comparative studies and art history itself. Firstly, with reference to what phenomena and from what historical/geographical perspective should we relate events in Central European art? Furthermore, what plane of comparison should we adopt: what works of art, trends, styles, ideologies, biographies, and the like can serve as comparable fields? More problems of this kind could be cited, but this is not the place for their detailed discussion. I would like to draw attention only to one of them, which seems to be the key problem in the discussion of artistic processes in Central Europe. I am referring to the breakdown of particular models of artistic development when considering the art of this region. In other words: the fundamental difficulty of delineating sharp boundaries for artistic processes in the perspective proposed by Western art history and art criticism.

A change in historical perspective is taking place in Central European art. The Western avant-garde's linear time is dispersed in space here, and loses its rigorous chronology and unified framework. The categories of otherness, locality, provinciality, and dependence, written into the art discourses of Central Europe and resulting from the experience of the discontinuity of historical time, effectively tear apart the order of Western historiographical narration based on a particular succession of facts. In Central Europe, an "other" history is being created, being, as it were, played out alongside "official" history, which, although coinciding with it at many points (thus introducing disorientation), is also dominated by spatial pluralism, whereas time all too often comes to a standstill. Great History in Central Europe is centered on the memory of martyrology and messianic vision, mythologizing the past and the future, in which tradition and utopia gain absolute value. Nevertheless, a modernity devoid of the dimension "before and after" takes a relativist view of all artistic processes and strips them of their pathos and logos, at the same time making them multidimensional and multi-directional.

Comparativists all too often fail to notice the result of all these facts in the field of artistic processes: imperfection, incompleteness, stopping halfway, or even extreme radicalism or judicious moderation—depending on one's point of view—but also the specific hybridization of artistic phenomena resolving itself into the blending and intercrossing of kinds, types, forms, styles, and concepts, and also a characteristic syncretism that allows seemingly contradictory poetics and views to come together to form a single whole.

Thus it is not without reason that in references to Central European art we find agglomerations of stylistic terms (used to define the processes known to western art history yet here heterogeneous phenomena) such as Secessionist Postimpressionism, Spiritual Fauvism, Baroque Cubism, Expressionist Futurism, and the like. Linked to this is the search for a distinct artistic terminology, particularly essential to the artists of the avant-garde, which allowed Central European artists to identify the art theory and artistic practice that were being created within their own history. The examples of Activism, Formism, Unism, Poetism, Artificialism, Integralism, Hipnism, Cosmism, and Zenitism were not the only ones. In the context of the stylistic ambivalence and the search for a logic of the development of form outlined here, one phenomenon that especially agitated historians of contemporary art was the emergence of abstract painting in the works of the Lithuanian artist Čiurlionis and the Czech Kupka, based on Symbolist theory, inside an imagination nourished by fantasy, parapsychology, and mysticism. It seems to run contrary to the general processes of modernity, tending in stages toward the elementarization and rationalization of art defining itself in terms of its nonobjective essence. Furthermore, it becomes apparent that in Central European art the key role played in modernism by the crisis of representation loses the formal justification it gains from the modernist model of artistic development. Let us take a look at some examples of the intersecting discourses.

In Polish Cubism, which called itself Formism, a primitive rhythm with roots in the folklore of the Podhale region (T. Czyżewski) was superimposed onto multiple-plane pictorial space. The post-Romantic ideology of Polish art found its reflection in Formism, and the declaration of a search for a timeless style led artists of this trend to colorist aesthetics based on the post-Cézanne ideal of "museum art" (Z. Pronaszko) or led others in the direction of the Polish version of Art Deco based on the concept of "national form" (W. Skoczylas). In effect, the reception of Cubism in Poland preceded reflection on Cézanne's conception of color. The direct connection between Polish Formism and

Constructivism, from which the latter was supposedly derived, is still more dubious. The relationship between these two currents pointed toward a rupture in continuity and a radical reorientation that occurred in the beginning of the 1920s, rather than to a straightforward continuation of artistic processes in the Polish avant-garde movement.

In Poland, Futurism and Dadaism—or perhaps better, Futuro-Dadaism, which had little in common with either Italian Futurism or the international Dadaism of the Cabaret Voltaire—operated in much the same way as Formist Cubism. Polish Futuro-Dadaism combined an interest in new artistic techniques and revolutionary social ideologies with protest against dehumanized technological culture. Its characteristically euphoric mood did not so much declare enthusiasm for progress as express conviction as to the decline of civilization. Futuro-Dadaism, developed primarily in literature and poetry, highlighted the absurdity of life and the grotesque nature of the world, finding continuity, well into the postwar years, in the multifaceted current of the radical avant-garde, where hopes for great change were inextricably linked to a catastrophic vision of a dying bourgeois Europe (M. Szczuka). This orientation, while it would seem completely unsuitable to the revolutionary and progressivist ideology highlighted by art history, was not foreign to Polish Constructivism. There was no room for Surrealist concerns in this model of art. If they occurred, then it was always indirectly, as an unwanted fragment of a work, as a reflection of a hidden part of a personality, as a regressive force threatening reason (W. Strzemiński). The Polish avant-garde lacked transgressive force. The tension between progress and catastrophe, which was felt the most strongly here, subordinated and added alternative attitudes to its own territory. There remained only Bruno Schulz, with his fascination for borderline, dubious, and problematic forms, such as "the ectoplasm of sleepwalkers, pseudomatter, the cataleptic emanation of the brain, which in certain cases spread out from the sleeper's mouth onto the whole table, filled the whole room, like a floating, rare tissue, an astral cake, on the borderline between body and soul" (*Cinnamon Shops*).

The situation in Czech Cubism was equally complex. On the one hand, particularly in its early phase, one could see in it, despite the protestations that were voiced, a clear echo of the atmosphere of Symbolism—strongly rooted in art in Prague around 1900—with its geometric form derived from Cubism. On the other hand, at a slightly later stage, poetically interpreted Expressionism with Cubist deformation took the place of mystical Symbolism (J. Zrzavý, J. Čapek). In painting, and

also in sculpture, Czech Cubo-Expressionism was characterized by a clear tendency to Baroque-type narration and intensified spirituality (O. Gutfreund, B. Kubišta, A. Procházka). In Cubist architecture and planning, unknown beyond the circle of Czech artists, alongside the striving for monumental solutions there was a tendency toward ornament, which broke with the tradition of the linearity of the Secession and introduced a new type of decorativeness, in which a vital role was played by blocks with broken surfaces and crystallike forms with sharp edges (J. Gočar, J. Chochol, V. Hofman, A. Procházka, P. Janák). Ornament conceived of in this way, hard to fit into the historical definition of the word, did not refer to the architectural details in which it found its direct expression, but transformed the whole structure of the building. It subordinated all spatial relations to itself and above all called into question the boundaries between internal and external forms. Structuralist thinking in Cubist architecture created strong foundations for Constructivist architecture and its theory, particularly important in the development of the Czech avant-garde of the 1920s.

As in Poland, in Czechoslovakia it is very difficult to accurately define the temporal and formal boundaries between Cubism, Dadaism, and Futurism. All three movements, equally often in combination with Expressionism, appeared concurrently and were linked with one another, and the noticeable differences between them resolved themselves into a different placement of accents in works, different roots in artistic categories, and different ways of functioning in cultural contexts. In Czechoslovakia, for example, attention to Dadaism of the kind originating directly from Tzara, Ribemont-Dessaignes, and Schwitters spread quickly to Constructivism, primarily because of the interest both tendencies declared they had in "the most modest art," in other words, melodramatic cinema, family photography, circus performance, and village fêtes, whose poetics both currents actualized in their works (J. Čapek). The technique of collage, so popular in Czechoslovakia, brought these apparently dissimilar positions even closer to one another. Czech Constructivism, having originated in architecture, drew to a large extent on local Cubism but was quick to throw rigorous rationalism aside in painting, in order that it might fully express itself in a Poeticism referring to Dadaism, in other words, in an art which, as Teige wrote, is "as delightful and accessible as sport, wine, and all sorts of tidbits." In Czech Constructivism, the place of the artistic utopia was taken by the modernist dream developed in fairytale imagery, in poetic paintings, and in collaged stories (K. Teige, J. Štyrský). Constructivism, conceived of in this way,

Style is not created by form but rather by its criticism in relation to fragments of works, ill-fitting expression, and formal waste.

guaranteed a continuity of imagination between Dadaism and Surrealism, which found its full expression only in Czechoslovakia. The Constructivist *objet poème* was smoothly superseded by the Surrealist *objet fantôme*. After the Dadaist adventure disclosed on the cinema screen and in the circus arena came the turn of the modernist journey to exotic countries to find its new expression in Surrealist poetics exploring the unknown depths of the libido (Toyen, J. Štyrský).

It would be difficult to trace Cubism in Hungarian art. Even though we may in the works of certain artists (J. Nemes Lampérth, L. Tihanyi) find some trace of an interest in geometric deformation, it quickly found its outlet in Expressionist subject matter (B. Uitz, G. Derkovitz). The context of the 1918 revolution meant that Hungarian Activism assumed the characteristics of politically committed art with a clear social dimension. This fact was a deciding factor in the almost natural process of the fusion of Expressionism and Constructivism, developed by artists emigrating after the fall of the Hungarian Soviet Republic. Constructivist art was evolving toward the introduction of architectural forms to abstract painting (L. Kassák). This enabled Hungarian Constructivists to stay in close touch with the teaching and the functionalist theory of the Bauhaus, as well as to put into practice, in the sphere of utopian projects for artistic and ethical synthesis, their ambition to unite abstract painting with socially useful art. The characteristic work of Moholy-Nagy appeared within the same current. At first he showed some interest in the Dadaist deconstruction of the picture and the dematerialization of form; in his later period, he interpreted Constructivism in the mechanomorphic categories of the era of advanced technology, within a naturalist and biological conception of the world. His neo-Romantic version of Constructivism could not have emerged without a strong Expressionist basis. Expressionist pantheism, which bound together in Activism the irreversible progress of natural history and the spiritualized figure of the victorious proletarian, was deeply implanted in the thinking of Hungarian modernists. This fact imposed obvious limitations on the range of ideas with which the Hungarian avant-garde was concerned, but nonetheless liberated a wealth of reflection, particularly regarding the broad connection of man to his technical and social environment. Perhaps one ought here to seek justification for the absence, in the circle of Hungarian avant-garde artists, of the psychoanalytical perspective of Surrealism, given that, at the same time, they took on the problems connected with the psychophysiological and existential condition of man in contemporary civilization.

In Romania it may have seemed that Dadaism would play a vital role, both because of the literary work of Urmuz (D. Demetrescu-Buzău), who was the precursor of the European literature of the absurd and above all an innovator in the language of literature, as well as on account of the direct participation of Romanian artists (T. Tzara, M. Iancu) in the international movement. But in the end Iancu, after his return to the country, rationalized Dadaism in architecture, while Constructivism, which was developing at the same time, was deeply indebted, particularly in painting, to the Expressionist conception of dynamic form and color contrast (J. Máttis-Teutsch, M. H. Maxy). The "picto-poetry"—the collage of abstract shapes and literary texts (I. Voronca)—that emerged on the basis of this movement defined the direction of the evolution of avant-garde art, pointing toward Romanian Surrealism while deeply rooted in Expressionist sources (V. Brauner, J. Herold, J. Perahim).

It is as hard to conceive of the Russian avant-garde without Ukrainian Cubo-Futurism (D. Burljuk, A. Bogomazov) as it is to conceive of Ukrainian abstract art (A. Ekster, V. Ermilov, K. Redko) without the experience of Russian Constructivism. Vilnius in Lithuania and Lwów in the Ukraine, which were then within the boundaries of Poland, were centers of these different currents. Polish Constructivism was born in Vilnius (V. Kairiúkštis, W. Strzemiński), and elements of Surrealism reached Lwów via Paris, featuring in the debate on Socialist Realism in the 1930s (M. Włodarski, O. Hahn). Latvian art, reluctant in relation to Russian Constructivism (with the exception of G. Klucis), clearly defined its position within figurative painting by using simplified and geometrized forms whose colors retained some elements of Fauvist expression and neo-Cubist decorativeness (O. Skulme, U. Skulme, R. Suta, N. Strunke, J. Liepiņš, A. Beļcova).

With the exception of the activity of the Slovenian artist Avgust Černigoj, Balkan Constructivism, with its slogans of connecting art and life, merges with the international community of avant-garde artists. Abstract art did not find any theoretical principles there, and Cubist-Purist stylization, which did not appear until the 1920s, led to classicizing figuration (S. Šumanović). Despite the fact that Zagreb Zenitism declared its affinity with Constructivism (Jo Klek), the ideology of the Balkan Barbarogenius expressed in the aggressive tone of Futurism was closer to the poetics of the Yugo-Dadaists, active at the same time. If a certain shift in focus took place in Belgrade, which had been the center of Zenitism since

1924, it was accompanied by criticism of Croatian Expressionism, which was identified with the destructive Latin culture of Europe. The remarkable popularity of the Russian avant-garde, whose postulates of Constructivist art organizing life were taken up in Serbia, contributed to this. The Bulgarian version of the Barbarogenius (G. Milev) had even less in common with the rationalist perspective of the avant-garde, being a combination of national mythology and folklore.

Artistic and stylistic processes in Central Europe lacked consistent continuity and identity. They referred to fragments of works, functioned in different discourses, and mixed up terms and concepts. It was a stylistics of indetermination.

The whole chronological, stylistic, and ideological approach as the historical basis for the history of contemporary art, both in the description of a work of art and in explaining artistic processes, requires flexibility and a critical attitude in relation to Central Europe. Exact dates and rigid boundaries of different currents must be abandoned. It is necessary to agree to a chronology which assumes that similar phenomena occur in different time periods; and historical continuity, if this expression can still be used, is found in interchanging discourses, which do not have to meet at all. Style is not created by form but rather by its criticism in relation to fragments of works, ill-fitting expression, and formal waste. As a result the stylistic discourse refers to flaws. Similarly, one has to realize that ideas do not once and for all integrate the creative subject—the artist—on the basis of some abstract identity of the work of art and life. The vision of the world always remains unfinished and takes on various configurations. The relationship between idea and form is not once and for all defined by shape and the meaning attributed to it; rather it is determined by the intellect conceptualizing life or art. This does not mean that the relationship does not exist. It is different at various points in time, different as to forms and different as to man. A feature of the ideological discourse is its aleatoric nature, and in this sense, the unpredictable relationship should be regarded as a critique of utopian reasoning, and at the same time as an intriguing subject of investigation for contemporary art history.

From the perspective of Central Europe, in examining subjects that have already been researched once, one has to reach for somewhat different sources, which have been little used before; one has to consider works that once remained in the background, and turn one's attention to problems that

were previously passed over in silence. In order to understand the situation better, I must make reference to the concept of *marginality* as the basis for critical reflection that subverts the integrity of artistic biographies, the homogeneity of avant-garde works, and the coherence of programs and currents. An example that illustrates this cognitive category is Witold Gombrowicz's account of how Bruno Schulz once assessed his works. "Bruno spoke, amongst other things," Gombrowicz recalls,

of the "level of subculture" in my novel, of its "set of minor forms." What did this mean? He was speaking of the way in which in *Ferdydurke* a kind of underworld emerges which is embarrassing and difficult to formulate, though it is not the world of instinct and the unconscious in the Freudian sense. It stems from the fact that in our relations with people we wish to be as cultured, superior, and mature as possible, and for this reason we employ mature language and say, for example, Beauty, Goodness, Truth. But in our intimate, private reality we feel inadequate, immature, so these proud ideals have their downfall within us, and we create for ourselves a private mythology, which is in principle also a culture, but a cheaper, worse culture, brought down to the level of our inadequacy. This world, said Bruno, is created from the leftovers from our official banquet: as though we were simultaneously at the table and under it.

The marginalized have a history in the manner of Gombrowicz, "simultaneously at the table and under it." The history of marginalized artists is, then, inextricably linked to the great history of art, though in marked contrast to it, and is characterized by lack of consequence, breaks in continuity, and breaking out of the system. The history of art, as developed by the avant-garde, omitted avant-garde margins. The history of art, written from the perspective of the marginalized, cannot omit the avant-garde.

Finally, let us ask to what degree the study of contemporary Central European art, this marginalized section of the "universal" avant-garde, changes not only our knowledge of contemporary art but also the very practice of art history. I want to stress that I am not concerned with quantitative revision here, with the addition of a few new facts to those already known, but rather with questioning the very principle on which art historians have based the history of art as we know it today. The answer will not be a simple one, but it is worth looking for.

It is all too evident that the introduction to general art history first of Eastern Europe (Russia), and somewhat later of Central Europe, new territories in the geography

of artistic life as subjects for study (which had begun in the early 1970s), disturbed accepted proportions and immediately called into question the well-known, dichotomous model dividing the artistic map of our continent into a radiating Western European center and peripheries dependent upon it. From this perspective it appeared, though not immediately, that the issue was not to reverse this order and recognize the dominance of the lively peripheries over the "degenerate" centers, but rather to call into question the epistemological paradigm that predetermines priorities in the order of places of artistic activity.

The new history of contemporary art that slowly emerged from these studies also adopted a different approach to history itself, and hence forced the critical rereading of historical material and the revision of the classification of sources in the field of visual art. As a result, the range of analytical, genealogical, and comparative studies has undergone deep transformation. But in order that these changes finally came about, it was necessary to bring to light what I would like to call the *discursive field* of contemporary art history, treating these studies as a necessary step allowing us to define the boundaries of the redefinition of concepts such as the system and its functioning, the whole and infinite fragmentation, continuity and accident, identity, homogeneity and variety, universalism and particularism, and finally—to remain with these few examples—the repetitions, similarities, and differences of phenomena and artistic processes.

The model of the history of contemporary art that emerges from the study of the peripheries tends naturally to turn to contexts and margins, to go beyond the canonical text of modernist or avant-garde geography and history, into sidespaces abandoned, shamefully concealed, or treated as reservations for "otherness." Of course what I have in mind is not the prudishness of those formations, but their ideology, within which, as Pierre Bourdieu has pointed out, the issue is always one of legitimizing one's own conception of art as a generally binding norm. But the norm is not binding on the margins, the system falls apart, the whole is lost in digressions, and ideology is reflected in a crooked mirror. The minority becomes the critical discourse of the text. The resulting studies of the margins of the avant-garde (the margins of the margin) in Central Europe are critical only so long as they succeed in clearly defining their position.

Le Four a la Perelle, 8 October 2000

Translated by Wanda Kemp-Welch

CHECKLIST AND ARTIST BIOGRAPHIES

The exhibition checklist reflects information available at the catalogue production deadline of October 15, 2001. The artist biographies were compiled by Peter Huk and Sara Cody. Illustrated checklist items are indicated by a ■. Illustration credits begin on page 436.

Jankiel Adler

1895–1949
painter

Born July 26, 1895, in Tuszyn, near Łódź. Began studies at the Künstgewerbeschule in Wuppertal, Germany (1913). Influenced by Das Junge Rheinland group in Düsseldorf (1918), helped form Jung Idysz group in Poland. Returned to Germany (1920). Helped organize the Düsseldorf Congress of International Progressive Artists (1922). Fled Germany (1933) for France (1933–35, 1937–40) and Poland (1935–37). Joined the Polish army (1940); moved to London (1943). Died April 25, 1949, near London.

My Parents, 1921
Mixed media on wood
53½ x 21¼ in. (136 x 54 cm)
Muzeum Sztuki, Łódź
■ P. 359

Alexander Archipenko
1887–1964
painter, sculptor, teacher

Vincenc Beneš
1883–1979
painter

Otti Berger
1898–1944
weaver, textile designer, teacher

Born May 30, 1887, in Kiev. Studied at the School of Art in Kiev (1902–5); moved to Moscow (1906), then Paris (1908). Opened art school (1912). Exhibited at Salon des Indépendents (1910), Salon d'Automne (1911–13), and the New York Armory Show (1913). Relocated to Cimiez, near Nice (1914–18). Traveled extensively; moved to Berlin (1921) then New York (1923); opened schools in New York City and Woodstock (1924). Moved to Los Angeles and opened school (1935). Died February 25, 1964, in New York.

Born January 22, 1883, in Velké Lišice, Bohemia. Studied at the Prague School of Decorative Arts (1902–4) and the Academy of Fine Arts in Prague (1904–7). Joined Osma, 1908. Participated in the twenty-ninth exhibition of the Mánes Association in 1909. Joined Skupina, 1911. Broke with Cubism in 1915. Rejoined the Mánes Association in 1917. After World War II continued painting mainly under the influence of Neoimpressionism. Died in Prague, March 27, 1979.

Born 1898 in Zmajavac. Studied at the Academy of Arts in Zagreb (1921–26) and the Bauhaus (1927–30). Worked as designer and consultant (1930–31), then taught at the Bauhaus (1931–32). Opened independent design studio in Berlin (1932–35) and worked for textile firms in Holland, Germany, and England until banned by Nazi regime. Moved to England (1937) but returned to Yugoslavia (1938); failed in attempt to emigrate to United States. Died at Auschwitz in 1944.

Woman with Hat, 1916
Wood, metal, papier-mâché, gauze, and oil paint
17⅝ x 14⅛ in. (44.8 x 36 cm)
Los Angeles County Museum of Art; purchased with funds provided by the Loula D. Lasker Estate and Merle Oberon
■ p. 237

Still Life with Clock, 1922
Lithograph
12 x 16 in. (30.5 x 40.6 cm)
Los Angeles County Museum of Art; purchased with funds provided by the Graphic Arts Council

Card Players, 1911
Oil on canvas
44⅛ x 34⅝ in. (112 x 88 cm)
Galerie výtvarného uměni, Ostrava
■ p. 15

Tram, No. 4, 1911
Oil on canvas
27 15/16 x 22⅝ in. (71 x 57.5 cm)
Národní Galerie, Prague
■ p. 290

Rug, circa 1929
Smyrna wool and hemp
49⅝ x 29⅛ in. (126 x 74 cm)
Bauhaus-Archiv Berlin
■ p. 225

Henryk Berlewi

1894–1967
painter, writer, designer

Aurél Bernáth

1895–1982
painter, writer

Born October 30, 1894, in Warsaw.
Attended the School of Art in Warsaw
(1904–9) then in Antwerp and at the
École des Beaux-Arts in Paris (1911–12).
Member of Jung Idysz (1921–22).
Exhibited at the Great Berlin Art
Exhibition and the Congress of
International Progressive Artists in
Düsseldorf (1922). Returned to Warsaw
and joined Blok (1924). Moved to Paris
(1928). Founded the Archives de l'Art
Abstrait de l'Avant-Garde International
(1960). Died August 2, 1967, in Paris.

Mechanofaktura, 1923
Gouache
21 5/16 x 17 in. (54.2 x 43.2 cm)
Collection Merrill C. Berman
■ p. 335

Mechanofaktura, 1924
Illustration in *Der Sturm*, vol. 15, no. 3
Periodical
Closed: 12 5/8 x 9 3/4 in. (32.1 x 24.8 cm)
Los Angeles County Museum of Art;
Robert Gore Rifkind Center for German
Expressionist Studies, purchased with
funds provided by Anna Bing Arnold,
Museum Associates Acquisition Fund,
and deaccession funds

Born November 13, 1895, in Marcali,
Hungary. Studied at Nagybánya (1915)
then in Budapest. Emigrated to Vienna
(1921) and then Berlin (1923). Returned
to Hungary in 1926 and joined the
Gresham Group. Taught at the Academy
of Fine Arts (1945–74). Exhibited at
Brussels International Exposition
(1958) and the Venice Biennale (1962).
Died March 13, 1982, in Budapest.

Cathedrals and Houses, 1922
From Graphic portfolio
Stencil, india ink, gouache, and gold
paint on paper
11 x 15 in. (27.9 x 38.1 cm)
Kieselbach Collection

Counts and Castles, 1922
From Graphic portfolio
Stencil, india ink, gouache, and gold
paint on paper
11 x 15 in. (27.9 x 38.1 cm)
Kieselbach Collection

Crossroad, 1922
From Graphic portfolio
Stencil, india ink, gouache, and gold
paint on paper
15 x 11 in. (38.1 x 27.9 cm)
Kieselbach Collection
■ p. 292

Peasants, 1922
From Graphic portfolio
Stencil, india ink, gouache, and gold
paint on paper
11 x 15 in. (27.9 x 38.1 cm)
Kieselbach Collection

Tumble and Scream, 1922
From Graphic portfolio
Stencil, india ink, gouache, and gold
paint on paper
11 x 15 in. (27.9 x 38.1 cm)
Kieselbach Collection

Villages, 1922
From Graphic portfolio
Stencil, india ink, gouache, and gold
paint on paper
11 x 15 in. (27.9 x 38.1 cm)
Kieselbach Collection

Irena Blühová
1904–1991
photographer, publisher, writer

Sándor Bortnyik
1893–1976
painter, printmaker, poster designer

Born March 2, 1904, in Povazsk-Bystrica, Slovakia. Worked as a bank clerk (1918–30) and pursued photography from 1922. Enrolled at Dessau Bauhaus (1931). Returned to Bratislava (1933) to work in politics and as publisher, bookseller, journalist, and photographer. Cofounded the Sociofoto group and agitprop theater group Dielna in Muhely. Lived underground (1941–45) as part of anti-Fascist resistance. Cofounded/directed the Pravda publishing house (1945–48), the Slovak Cooperative for Folk Arts and Crafts (1948–51) and the Slovakian Educational Library (1951–66). Died in 1991.

Experiments in Prof. Peterhans's Class,
1931–32 (later print)
From the Bauhaus Series
Photograph
15½ x 11⁷/₁₆ in. (39.5 x 29.7 cm)
Zuzana Blüh
■ p. 223

Siesta on a Balcony in Front of Canteen,
1932 (later print)
From the Bauhaus Series
Photograph
15⅛ x 11⅝ in. (38.5 x 29.5 cm)
Zuzana Blüh
■ p. 222

Born July 3, 1893, in Marosvasarhely (now Tirgu Mures, Romania). Moved to Budapest in 1910; began training in 1913. Early advocate of Activism and leading promoter of Ma. Emigrated to Vienna (1919). Published Bildarchitektur portfolio (1921). Exhibited at Der Sturm gallery in Berlin (1922). Returned to Hungary (1924). Founded the Green Donkey avant-garde theater and the Mubely Workshop (1928), modeled on the Bauhaus. Dean of the Budapest Academy of Fine Arts (1949–56). Died in Budapest, December 31, 1976.

Cover design for *Ma*, 1918
Vol. 3, no. 7 (July 15, 1918)
Linocut for periodical
4¾ x 5⁷/₁₆ in. (12.1 x 13.8 cm)
Los Angeles County Museum of Art;
Robert Gore Rifkind Center for German Expressionist Studies, gift of Robert Gore Rifkind
■ p. 54

Red Locomotive, 1918
Oil on paper
17⅜ x 13³/₁₆ in. (44 x 33.5 cm)
Magyar Nemzeti Muzeum
■ p. 55

Cover design for *Ma*, 1919
May 1, 1919 (Demonstration issue)
Periodical
11¼ x 9⅞ in. (28.6 x 25.1 cm)
M. Szarvasy Collection, New York

Picturearchitecture III, 1921
From the *Ma* Album
Color stencil print on paper
12 x 9½ in. (30.5 x 24 cm)
Janus Pannonius Múzeum, Pécs, Hungary
■ p. 159

Geometric Composition, 1922
Watercolor on paper
14³/₈ x 10 in. (36.4 x 25.5 cm)
Magyar Nemzeti Galéria
■ p. 167

Composition with Lamp, 1923
Oil on cardboard
21⁵/₈ x 17³/₄ in. (55 x 45 cm)
Kieselbach Galéria, Kieselbach Collection
■ p. 210

The New Adam, 1924
Oil on canvas
18⁷/₈ x 15 in. (48 x 38 cm)
Magyar Nemzeti Galéria
■ p. 212

The New Eve, 1924
Oil on canvas
19¹⁵/₁₆ x 15³/₈ in. (49 x 39 cm)
Magyar Nemzeti Galéria
■ p. 212

Cover design for *Ma*
Vol. 5, no. 3
Periodical
M. Szarvasy Collection, New York

Constantin Brâncuși

1876–1957
sculptor, painter, photographer

Victor Brauner

1903–1966
painter, sculptor, printmaker

Born February 19, 1876, in Hobita. Studied at the Craiova Arts and Crafts School (1894–97) and the Bucharest Academy of Arts (1898–1902). Moved to Paris (1904); attended École des Beaux-Arts (1905) and briefly assisted Auguste Rodin (1907). First solo show at Alfred Stieglitz's Gallery 291 in New York (1914). Associated with Dadaists in early 1920s, though never formally a member of any group. His only completed monumental work, the Tîrgu-Jiu complex, erected in Romania (1938). Retrospective held at the Guggenheim in New York (1955–56). Died March 16, 1957, in Paris.

Sleeping Muse, 1909–10 (cast circa 1920–29)
Bronze
7 x 11 x 8 in. (17.8 x 28 x 20.4 cm)
Frederick R. Weisman Art Foundation, Los Angeles, California
■ p. 250

Born June 15, 1903, in Piatra Neamt. Studied briefly at the School of Fine Arts in Bucharest (1921). Held first exhibit and cofounded 75 HP journal (1924); also contributed to *Unu* (1928–31). Moved to Paris (1930); joined Surrealist group (1932). Returned briefly to Romania (1935–36). Blinded in left eye (1938). Fled to the French Alps during German occupation (1940); returned to Paris (1945). Broke from the Surrealists (1948). Chosen to represent France for 1966 Venice Biennale. Died March 12, 1966, in Paris.

Construction (Ilarie Voronca and Victor Brauner, Bucharest), 1924
Photograph with ink
5 3/8 x 3 3/8 in. (13.7 x 8.7 cm)
Private collection
■ p. 251

Construction ("Punct"), 1924
Ink on paper
Private collection
■ p. 253

Portrait of Marcel Janco, 1924
Ink on paper
Private collection
■ p. 290

Illustration for *Punct*, 1924
Issue no. 1
Linocut for periodical
18 7/8 x 13 1/8 in. (48 x 33.3 cm)
Private collection
■ p. 300

Illustration for *Punct*, 1925
Issue no. 6–7
Linocut for periodical
12 3/4 x 9 1/2 in. (32.5 x 24 cm)
Private collection
■ p. 300

1902–1981
furniture designer, architect

1887–1945
painter, writer, printmaker

Born May 21, 1902, in Pécs. Studied briefly in Vienna before enrolling at the Bauhaus (1920). Worked briefly as architect in Paris (1924) before rejoining the Bauhaus (1925) to lead the carpentry workshop. Left to work for Walter Gropius (1928–31). Traveled extensively (1932–35); moved to England (1935), then joined Gropius at Harvard (1937). Designed UNESCO headquarters in Paris (1953–58) and the Whitney Museum of American Art in New York (1963–66). Died July 1, 1981, in New York.

Chair, 1922
Stained maple and wool
37 13/16 x 22 1/16 x 22 7/16 in. (96 x 56 x 57 cm)
Kunstsammlungen, Weimar
■ p. 214

Born March 23, 1887, in Hronov. Studied at Prague School of Decorative Arts (1904–10) and Académie Colarossi in Paris (1910–11). Cofounded Skupina in 1911 with his brother, writer Karel Čapek (1890–1938). Abandoned the group in 1912. Organized 1914 Modern Art exhibit at the Mánes Association premises. Joined the Tvrdošíjní in 1917. Pursued journalism, illustration, and theater design through the 1920s. Arrested by Nazis on September 1, 1939; imprisoned at Dachau. Died at Bergen-Belsen in 1945.

Drunkard, 1913
Oil on canvas
29 3/4 x 19 11/16 in. (75.5 x 50 cm)
Moravská Galerie, Brno
■ p. 47

Figure of a Woman, 1913
Oil on canvas
39 3/8 x 27 3/4 in. (100 x 70.5 cm)
Private collection

Head, 1913
Oil on canvas
18 1/8 x 14 9/16 in. (46 x 37 cm)
Private collection

Head, 1914–15
Oil on canvas
18 5/16 x 14 9/16 in. (46.5 x 37 cm)
Národní Galerie, Prague
■ p. 47

Signal, 1915
Ink and watercolor on paper
23 5/8 x 17 5/16 in. (60 x 44 cm)
Private collection, Prague
■ p. 95

Marie Čermínová (Toyen)

1902–1980
painter, illustrator, theorist

Avgust Černigoj

1898–1985
painter, designer

Born September 21, 1902, in Prague. Studied at the Prague School of Decorative Arts (1919–22). Met Jindřich Štyrský, husband and artistic collaborator, in 1922. Joined Devětsil (1923). Moved to Paris (1925). Presented Artificialist works and theoretical statements in Paris and Prague (1926–31). One of the leaders of Prague Surrealist group (1933). After Štyrský's death in 1942, remained leading proponent of the Prague Surrealist group. Died in Paris, November 9, 1980.

Geometric Composition, 1926
Oil on canvas
39 7/16 x 25 7/16 in. (100.2 x 64.7 cm)
Private collection
■ p. 101

Twilight in a Virgin Forest, 1929
Oil and tempera on canvas
44 7/8 x 35 in. (114 x 89 cm)
Collection of Martin and Olga Kotík, Prague
■ p. 126

Born in Trieste, Slovenia (now Italy), 1898. Educated in Italy and Germany; studied briefly at the Bauhaus (1924). Moved to Ljubljana and organized first Slovenian Constructivist exhibits (1924 and 1925). Under political pressure, forced to return to Trieste (1925). Founded the Trieste Constructivist group (1927). Contributed influential designs to *Tank* (1927–28). Died in 1985 in Lipica.

Charlie Chaplin, 1926
Collage
17 1/16 x 12 9/16 in. (42.3 x 31.9 cm)
Slovenski Gledališki Muzej
■ p. 60

Untitled, 1926
Collage
16 3/4 x 12 5/8 in. (42.5 x 32 cm)
Slovenski Gledališki Muzej
■ p. 285

Cover design for *Tank*, 1927
Issue no. 1 1/2
Periodical
9 3/4 x 6 3/4 in. (24.8 x 17.1 cm)
McCormick Library of Special Collections, Northwestern University Library
■ p. 287

Cover design for *Tank*, 1927
Issue no. 1 1/2–3
Periodical
Height: 10 1/4 in. (26 cm)
McCormick Library of Special Collections, Northwestern University Library
■ p. 287

Cover design for *Der Sturm*, circa 1928
Vol. 19, no. 9 (1928)
Linocut for periodical
2 7/8 x 3 1/4 in. (7.3 x 8.2 cm)
Los Angeles County Museum of Art; Robert Gore Rifkind Center for German Expressionist Studies, purchased with funds provided by Anna Bing Arnold, Museum Associates Acquisition Fund, and deaccession funds
■ p. 286

Leon Chwistek

1884–1944
mathematician, philosopher,
painter

Born June 13, 1884, in Cracow. Brief
artistic training in Cracow (1903–4),
Vienna (1910), and Paris (1913–14).
Studied philosophy at Jagiellonian
University in Cracow (until 1906) and
in Göttingen (1908–9). Taught mathe-
matical logic (from 1906) throughout
Poland, including Jagiellonian
University and Jan Kazimierz
University in Lwów. Began exhibiting
artwork in 1917. Along with Stanisław
Witkiewicz, became one of the leading
theorists of the Formists. Fled Lwów
(1941) for Tbilisi; later to Moscow. Died
August 20, 1944, in Barvish, near
Moscow.

Fencing, circa 1919
Oil on cardboard
27½ x 39⅜ in. (70 x 100 cm)
Muzeum Narodowe, Cracow
■ p. 331

City, circa 1919
Oil on cardboard
39¾ x 27½ in. (101 x 70 cm)
Muzeum Narodowe, Cracow
■ p. 331

Béla Czóbel

1883–1976
painter

Born September 4, 1883, in Budapest,
Hungary. Studied at Nagybánya (1902),
the Munich Academy of Art (1903) and
the Academie Julian in Paris (1904–5).
Returned to Nagybánya in 1906.
Cofounder of the Eight. Moved to the
Netherlands (1914) then Berlin (1919).
Lived in Paris (1925–39), then Budapest.
President of the Society of Painters
of Szentendre (1945). Taught at School
of Fine Arts in Budapest (1948–53).
Died January 29, 1976.

Boy with Ball, 1916
Oil on canvas
32¹¹⁄₁₆ x 24¹³⁄₁₆ in. (83 x 63 cm)
Pest Megyei Múzeumok Igazgatósága,
Ferenczy Múzeum, Szentendre,
Hungary
■ p. 36

Tytus Czyżewski

1880–1945
painter, poet, critic

Born December 28, 1880, in Przyszowa.
Studied at the Academy of Fine Arts
in Cracow (1902–7). Began exhibiting
in 1906. Cofounded the Formists (origi-
nally named the Polish Expressionist
Group) in 1917 and coedited *Formiści*.
Moved to Paris (1922). Exhibited at
the Salon des Independents and the
Salon de Tuileries; also the Semafor
Theater in Lwów (1925), the Modernists'
Salon in Warsaw (1928) and the
Contemporary National Art Exhibition
in Poznań (1929). Returned to Warsaw
(1930). Awarded the National Cultural
Fund prize (1938). Died May 6, 1945,
in Cracow.

Highland Robber, 1917–18
Gouache on paper
25⁵⁄₁₆ x 19 in. (64.3 x 48.3 cm)
Muzeum Narodowe, Warsaw
■ p. 316

Portrait of Stanisława Mróz, 1918
Gouache on paper
24⁹⁄₁₆ x 19½ in. (62.4 x 49.6 cm)
Muzeum Narodowe, Warsaw
■ p. 330

Born in Szilagysomlyo, Hungary, 1902. Studied at the Academy of Fine Arts and the Technical School of Budapest. Moved to Munich (1921); studied at Franz von Stuck Academy and exhibited at Glass Palace. Moved to the Hague (1923); worked with artists from iio, De Stijl, and the Dessau Bauhaus. Became a Dutch citizen in 1947, then emigrated to Lima, Peru, in 1949. Died in Peru, 1982.

Composition, 1927
Oil on canvas
18 7/8 x 15 in. (48 x 38 cm)
Berlinische Galerie, Landesmuseum für Moderne Kunst, Photographie und Architektur, Berlin

Born November 2, 1877, in Budapest, Hungary. Studied at Ferenc Szablya-Frischauf's private school, then in Nagybánya. Later studied with Matisse in Paris; met Sandor Galimberti and married him in 1911. Exhibited together at Salon d'Automne and Salon des Indépendants. Returned to Hungary (1914). Exhibited at the National Salon in Budapest and invited to the 1915 Panama-Pacific International Exposition in San Francisco. Died July 18, 1915, in Pécs; husband committed suicide two days later.

The Street, 1913
Oil on canvas
21 5/8 x 18 1/8 in. (55 x 46 cm)
Janus Pannonius Múzeum, Pécs, Hungary
■ p. 144

Born June 18, 1890, in Szentendre, Hungary, son of Károly Ferenczy (painter) and brother of Noémi Ferenczy (textile designer). Studied at Nagybánya (1907–10). Also studied in Florence, Munich, and Paris (1908–13). Emigrated to Vienna (1919). Lived in Berlin (1922–23) and Moscow (1932–35). Designed tomb for Egon Schiele (1928) and series of medals for political figures and artists throughout the 1930s. Returned to Budapest (1938). Taught at Budapest College of Fine Arts (1946–49). Awarded the Kossuth Prize (1948). Died June 2, 1967, in Budapest.

Portrait of Noémi Ferenczy, 1920
Bronze
Height: 14 3/16 in. (36 cm)
Magyar Nemzeti Galéria
■ p. 297

Emil Filla
1882–1953
painter, sculptor, printmaker, writer

Alfréd Forbát
1897–1972
architect, urban planner, teacher

Jaromír Funke
1896–1945
photographer, theorist

Born April 4, 1882, in Chropyně, Moravia. Began studies at Academy of Fine Arts in Prague (1903); won Academy's top prize (1904). Joined the Eight (1907). Participated at the twenty-ninth exhibition of the Mánes Association (1909). Split from the Eight to join Skupina (1911). Moved to the Netherlands (1914); returned to Prague (1920) and subsequently rejoined Mánes Association. Arrested by the Nazis on September 1, 1939; imprisoned at Buchenwald. Returned to Prague in 1945 and began teaching at the Academy for Applied Arts. Died October 6, 1953.

The Dance of Salome I, 1911
Oil on canvas
53 15/16 x 32 1/4 in. (137 x 82 cm)
Galerie Moderního Uměni v Hradci, Králové
■ p. 89

Head, circa 1912
Bronze
12 1/2 x 9 1/4 x 2 1/2 in. (31.8 x 23.4 x 6.4 cm)
Los Angeles County Museum of Art; gift of Marvin and Janet Fishman
■ p. 42

Born on March 31, 1897, in Pécs, Hungary. Began studies at the Hungarian Imperial Joseph Technical University (1914), then the Technische Hochschule in Munich (1918). Worked at the Weimar Bauhaus (1920–22) and exhibited at the 1923 Bauhaus exhibition. Settled in Berlin (1925). Active in 1929 CIAM Congress. Visited Moscow (1932–33). Returned to Pécs (1933–38). As a Jew, was forced to emigrate to Sweden in 1938, where he continued to design and teach. Died in Stockholm, May 23, 1972.

Abstract Composition, 1921
Colored chalk on paper
8 1/2 x 8 1/2 in. (21.7 x 21.7 cm)
Szépmûvészeti Múzeum, Budapest
■ p. 40

Born August 1, 1896, in Skutec. Turned to photography in 1922; originally studied medicine and law. Participated in the International Photographic Salons (1924–38) and Prague exhibitions of new photography (1930–31), social photography (1933), the avant-garde (1937), and the Mánes Association (1938). Taught at the School of Decorative Arts in Bratislava (1931–35) and the State Graphic School in Prague (1935–44). Died on March 22, 1945, in Prague.

After the Carnival, 1921
Photograph
11 1/4 x 9 in. (28.7 x 23 cm)
Artist's estate
■ p. 121

Composition, circa 1921
Photograph
8 1/2 x 11 3/8 in. (21.7 x 29 cm)
Artist's estate
■ p. 121

Composition: White Ball and Glass Cube, 1923
Photograph
9 5/16 x 11 3/8 in. (23.7 x 29 cm)
Artist's estate
■ p. 120

Abstract Photo, 1928–29
Bromide print
11 5/8 x 13 3/8 in. (29.5 x 33.9 cm)
Moravská Galerie, Brno

Abstraction
Photograph
4½ x 6 in. (11.4 x 15.2 cm)
The Marjorie and Leonard Vernon
Collection

Born May 31, 1883, in Kaposvar,
Hungary. From 1903 to 1907, studied
at Nagybánya, the Akademie der
Bildenden Künste in Munich, Simon
Hollósy's school in Técső, and the
Academie Julian in Paris. Exhibited
at the Salon d'Automne and the
Salon des Indépendents (1908–13) with
wife Valéria Dénés. Lived briefly in
Holland, then returned to Hungary
(1914). Exhibited together at Budapest's
National Salon and invited to 1915
Panama-Pacific International
Exposition (San Francisco). Committed
suicide July 20, 1915, following Dénés's
death.

Amsterdam, 1914
Oil on canvas
36¼ x 36⅜ in. (92 x 92.5 cm)
Janus Pannonius Múzeum, Pécs,
Hungary
■ p. 144

Born March 13, 1880, in Semín near
Pardubice. Studied at the Prague
School of Decorative Arts (1902–5).
Joined Mánes Association (1905) and
the Society of Architects (1908).
Cofounded Skupina (1911). Founded the
Prague Artistic Workshops with Pavel
Janák (1912). Taught at the Academy
of Fine Arts (1922–39). President of
Association of Architects (throughout
the 1920s) and the Czech Werkbund
(until 1924). Died September 10, 1945,
in Jičín.

Chair, 1915
From MuDr Deyl waiting-room set
Polished ash, leather
35⁷⁄₁₆ x 19¼ x 18½ in. (90 x 49 x 47 cm)
Umìleckoprùmyslové Muzeum, Prague
■ p. 44

Corridor Wall, 1915
From MuDr Deyl waiting-room set
Ash, mirror, and metal
74¹³⁄₁₆ x 59¹⁄₁₆ in. (190 x 150 cm)
Umìleckoprùmyslové Muzeum, Prague

Desk, 1915
From MuDr Deyl waiting-room set
Polished ash
43¼ x 54⅜ x 31½ in. (110 x 138 x 80 cm)
Umìleckoprùmyslové Muzeum, Prague
■ p. 44

Settee, 1915
From MuDr Deyl waiting-room set
Ash and leather
37¹³⁄₁₆ x 74¹³⁄₁₆ x 23⅝ in. (96 x 190 x
60 cm)
Umìleckoprùmyslové Muzeum, Prague
■ p. 14

Walter Gropius

1883–1969
architect, designer, theorist, teacher

Born May 18, 1883, in Berlin. Studied architecture in Munich and Berlin (1903–7) and worked for Peter Behrens (1908–10). Joined the Deutscher Werkbund and opened architecture office with Adolf Meyer (1911). Served on the Western Front during World War I. Joined and became director of Arbeitsrat für Kunst (1918). Appointed director of the Kunstgewerbeschule and the Hochschule in Saxony (1918); reorganized them into the Bauhaus at Weimar (1919) then Dessau (1925). Resigned as director and returned to private practice (1928). Emigrated to England (1934) and then the United States (1937). Taught at Harvard University (1937–52) and chaired the Department of Architecture. Founded the Architects Collaborative (1946). Died in Boston, July 5, 1969.

———————————

Working Model for the Monument to the March Dead, 1922 (reconstruction 1988)
Plaster
17⅞ x 30¾ in. (45.5 x 78 cm)
Kunstsammlungen, Weimar
■ p. 211

Otto Gutfreund

1889–1927
sculptor

Born August 3, 1889, in Dvůr Králové, Bohemia. Studied at the Professional School of Ceramics in Bechyně (1903–6), the School of Applied Arts in Prague (1906–9), and La Grande Chaumière in Paris (1909–11). Returned to Prague (1911) to develop Czech Cubo-Expressionism and join Skupina. Moved to Paris in 1914. Joined Foreign Legion and held as POW during World War I. Died in Prague, June 2, 1927.

———————————

Anxiety, 1911
Bronze
58¼ x 22½ x 19¹⁵⁄₁₆ in. (148 x 57.2 x 50.6 cm)
Národní Galerie, Prague
■ p. 88

Concert, 1912–13
Bronze
18⅛ x 18⅞ in. (46 x 48 cm)
Národní Galerie, Prague
■ p. 46

Cubist Bust, 1913
Bronze
Height: 23⅝ in. (60 cm)
Národní Galerie, Prague
■ p. 93

Viki, 1913 (cast 1960s)
Bronze
Height: 13 x 11 x 9 in. (33 x 27.9 x 22.8 cm)
HUC Skirball Cultural Center, Museum Collection, Gift of Reinhard and Selma Lesser
■ p. 302

Josef Matthias Hauer

1883–1959
composer, theorist

Born March 19, 1883, in Wiener Neustadt. Self-taught; active as a musician and conductor since his teens. Developed system of twelve-tone composition (even before Schoenberg) as part of a universal system related to color. Collaborated with Johannes Itten on work relating color and music (1919–20). Awarded the Prize of the City of Vienna in 1927 and 1954. In 1956 was awarded the Austrian State Prize. Died September 22, 1959, in Vienna.

———————————

Diagram of Twelve-Part Color Circle, 1919–20
Feather and collage on paper
13⅜ x 8¼ in. (34 x 21 cm)
Bogner Collection, Vienna

———————————

Josef Matthias Hauer and Emilie Vogelmayr

Interpretation of Melos, 1921
Watercolor over pencil on paper
7½ x 6½ in. (19 x 16.5 cm)
Bogner Collection, Vienna
■ p. 167

Vlastislav Hofman

1884–1964
designer, theorist

Ruth Hollós-Consemüller

1904–1993
photographer, graphic and textile
designer

Jaroslav Horejc

1886–1983
designer, sculptor

Born February 6, 1884, in Jičín. Studied
at the Czech Technical University
(1902–7). At different points was a
member of Artel, Skupina, the Mánes
Association, and the Tvrdošíjní; con-
tributed to the development of Czech
Cubism through theoretical treatises,
architectural projects, furniture
design, ceramics, and metalwork. Later
became leading stage designer in
Czechoslovakia in the 1930s. Died in
Prague, August 28, 1964.

Liqueur Service, 1911
Transparent glass, cut and frosted
Carafe height: 9½ in. (24 cm); glasses
height: 3¼ in. (8.4 cm)
Umìleckoprùmyslové Muzeum, Prague
■ p. 89

Coffee Set, 1913–14
Earthenware with white glaze and
black decoration
Various dimensions
Umìleckoprùmyslové Muzeum, Prague

Asymmetric Teacup and Saucer, circa 1918
Earthenware with ivory-colored glaze
Height: 2 in. (5.1 cm); diameter: 3⅜ in.
(8.6 cm)
Los Angeles County Museum of Art;
gift of Max Palevsky

Born in August 3, 1904, Lissa, Poland;
grew up in Bremen, Germany. Studied
at the Künstgewerbeschule in Bremen
(1921–24) then the Bauhaus (1924–28).
Work included decoration of the
Dessau Theater Cafe, samples of fabric
for industrial production, and photog-
raphy for the Bauhaus. Married Erich
Consemüller (1930) and moved to
Halle, then Cologne (1957). Died April
25, 1993, in Cologne.

Staircase Wit, 1927
Gelatin-silver print
2¼ x 3³/₁₆ in. (5.7 x 8.1 cm)
Bauhaus-Archiv Berlin

Born June 15, 1886, in Prague. Studied
at Prague School of Applied Arts
(1906–10). Joined Artel Cooperative
(1909), Mánes Association (1911), and
the Czech Werkbund (1914). Won Grand
Prix at the 1925 Paris Exposition for his
glasswork. Taught at Prague School of
Applied Arts (1918–48). Died March 1,
1983, in Prague.

Vase, 1911
Earthenware with black-and-white
glaze
Height: 8¼ in. (21 cm)
Umìleckoprùmyslové Muzeum, Prague

Jerzy Hulewicz

1886–1941
writer, printmaker

Born August 4, 1886, in Kościanski. Studied at Jagiellonian University and the Academy of Fine Arts in Cracow (1904–6), then Paris (1907–10) and Munich (1913). Joined the Wielkopolska Artists' Circle (1914). Cofounded Ostoja publishing house and began publishing *Zdrój* (1917). Cofounded the Bunt group and exhibited in Berlin, Poznań, Cracow, Lwów, and Warsaw (1918–20). Member of the Union of Polish Graphic Artists. Died July 1, 1941, in Warsaw.

Nude X, 1918
Linocut on paper
5$\frac{1}{2}$ x 2$\frac{15}{16}$ in. (14 x 7.5 cm)
Muzeum Narodowe, Warsaw
■ p. 309

Temptation of Christ, 1919
Linocut on paper
8$\frac{13}{16}$ x 6$\frac{1}{2}$ in. (22.3 x 16.6 cm)
Muzeum Narodowe, Warsaw
■ p. 320

Johannes Itten

1888–1967
painter, textile designer, teacher

Born November 11, 1888, in Sudern-Linden. Studied briefly at the École des Beaux-Arts in Geneva (1909) then with Adolf Holzel in Stuttgart (1913). First solo show at the Sturm Gallery in Berlin (1916). Moved to Vienna; established his own art school. Taught at the Bauhaus (1919–23), then broke with Gropius to set up arts community at Herrliberg. Established new school in Berlin (1926) then directed the Flachenkunstschule in Krefeld (1932–38). Returned to Switzerland via the Netherlands. Directed the Kunstgewerbeschule and Museum in Zurich (1938–54), the Textilfachschule in Zurich (1943–60), and the Museum Rietberg in Zurich (1952–55). Died in Zurich on May 25, 1967.

Landscape (View of the Viennese Atelier of Johannes Itten), 1916–17
Charcoal on paper
14 x 10$\frac{7}{8}$ in. (35.5 x 27.5 cm)
Bogner Collection, Vienna

Pavel Janák

1882–1956
architect, designer, theorist

Born March 12, 1882, in Prague. Studied at the Czech College of Technology (1899–1905) and the Academy of Fine Arts in Vienna (1906–7). Worked for Jan Kotera (1908–9). In 1908 cofounded the Artel cooperative and joined the Mánes Association. Cofounded Skupina (1911). Taught at Prague School of Decorative Arts starting in 1921. President of the Czech Werkbund (1924–42). Appointed to Hradcany Castle project, 1936. Died August 1, 1956, in Prague.

Coffee Set (partial), 1911
Earthenware with black-and-white glaze
Coffee pot height: 8$\frac{1}{4}$ in. (21 cm); creamer height: 6$\frac{1}{8}$ in. (15.5 cm); cup with saucer height: 2$\frac{5}{8}$ in. (6.7 cm); saucer diameter: 5$\frac{3}{4}$ in. (14.6 cm)
Umìleckoprùmyslové Muzeum, Prague
■ p. 44

Fruit Dish, 1911
Earthenware with ivory-colored glaze and black decoration
Height: 5$\frac{1}{8}$ in. (13 cm)
Umìleckoprùmyslové Muzeum, Prague

Large Concave Vase, 1911
Porcelain with black glaze and white decoration
Height: 12$\frac{3}{4}$ in. (32.5 cm)
Umìleckoprùmyslové Muzeum, Prague
■ p. 89

Marcel Janco

1895–1984
architect, painter, printmaker,
writer

Béla Kádár

1877–1956
painter

Large Convex Vase, 1911
Earthenware with black-and-white
glaze
Height: 12 5/8 in. (32 cm)
Umìleckoprùmyslové Muzeum, Prague
■ p. 89

Small Concave Vase, 1911
Earthenware with black-and-white
glaze
Height: 5 5/16 in. (13.5 cm)
Umìleckoprùmyslové Muzeum, Prague

Small Convex Vase, 1911
Earthenware with black-and-white
glaze
Height: 5 5/16 in. (13.5 cm)
Umìleckoprùmyslové Muzeum, Prague

Two Covered Boxes, 1911
Earthenware with white glaze and
blue decoration
Heights: 4 3/4 in. (12 cm); 3 1/8 in. (8 cm)
Umìleckoprùmyslové Muzeum, Prague
■ p. 299 (one illustrated)

Covered Box, reproduction of 1911
original
Earthenware with glaze and black
decoration
Height: 3 9/16 in. (9 cm)
Umìleckoprùmyslové Muzeum, Prague
■ p. 44

Born May 24, 1895, in Bucharest.
Studied with painter Iosef Iser
(1910–14). Cofounded *Simbolul* with
Tristan Tzara and Ion Vinea (1912).
Studied architecture at Zurich
Polytechnic (1915) and helped establish
Cabaret Voltaire (1916). Cofounded
the Neue Leben group in Basel (1918).
Traveled to Paris (1921); returned
to Bucharest (1922) and broke with
Dada. Copublished *Contimporanul* and
attended the Düsseldorf Congress
of International Progressive Artists
(1922). Emigrated to Israel (1941).
Founded New Horizons group (1948)
and the Ein Hod artists' colony (1953).
Died April 21, 1984, in Ein Hod.

Abstract Composition, 1926
Oil on canvas
13 3/8 x 19 1/4 in. (34 x 49 cm)
Private collection

Born June 14, 1877, in Budapest,
Hungary. Initially trained as a
machinist; turned to art in 1896.
Studied at the Academy of Fine
Arts in Budapest (1902). First solo
exhibition in 1918. Exhibited at
Der Sturm gallery in Berlin beginning
in 1923. Traveled to the United States
(1928–29). Confined to a Jewish ghetto
in Budapest during World War II,
where his eyesight began to fail. Died
January 21, 1956.

The Visit of Shepherds, circa 1925
Tempera on paper
23 1/2 x 34 5/8 in. (59.5 x 88 cm)
Private collection, Denver
■ p. 288

Mother with Child, late 1920s
Tempera on paper
39 3/8 x 35 5/16 in. (100 x 90 cm)
Janus Pannonius Múzeum, Pécs,
Hungary
■ p. 297

Born December 4, 1866, in Moscow.
Taught economy and law at Moscow
University (1893–96). Moved to
Munich (1896); attended private art
school, then the Munich Academy
(1900). Cofounded the Phalanx group
(1901), the Neue Künstlervereinigung
Munchen (1909), and the Blaue Reiter
(1911). Moved to Switzerland, then
Russia (1914). After 1917, lectured at
the Higher State Art and Technical
Studios (Vkhutemas) in Moscow and
cofounded the Institute of Artistic
Culture (Inkhuk). Returned to Germany
(1921) and taught at the Bauhaus
(1922–33). Moved to Paris (1933). Died
December 13, 1944, in Neuilly-sur-
Seine.

Orange, 1923
Color lithograph
16 x 15 in. (40.6 x 38.1 cm)
Los Angeles County Museum of Art,
Los Angeles County Fund
■ p. 207

*Postcard Announcement for the Bauhaus
Exhibition*, 1923
Color lithograph on cardboard
5 3/8 x 3 9/16 in. (13.7 x 9 cm)
Los Angeles County Museum of Art;
Robert Gore Rifkind Center for German
Expressionist Studies
■ p. 214

Born on March 21, 1887, in Érsekújvár,
Hungary. Apprenticed as a blacksmith
before turning to writing. Coordinated
efforts of the Activists (1913–15).
Founded the periodical *A Tett* in 1915;
banned on October 2, 1916. Launched
Ma within weeks; banned in July 1919.
Resumed publication in Vienna in
1920 and began producing visual art
(1921). Published *Keparchitektura* (1921)
and produced *Buch neuer Kunstler* with
László Moholy-Nagy (1922). Returned
to Hungary in 1926 and continued
writing, publishing, and painting.
Retrospective exhibit held in 1957.
Died in Budapest on July 22, 1967.

Noise, 1920
Collage and ink on paper
5 7/8 x 4 1/4 in. (14.8 x 10.7 cm)
Neues Museum—Staatliches Museum
für Kunst und Design, Nürnberg
■ p. 157

Dur, 1921
Bound portfolio (5 ink drawings, cover
collage with gold leaf and ink drawing)
13 3/4 x 10 1/4 in. (35 x 26 cm)
Library, Getty Research Institute,
Los Angeles
■ p. 153 (two illustrated)

Untitled ("Twenty"), 1921
Cut-and-pasted printed papers, ink,
and pencil on paper
7 7/8 x 6 1/4 (19.9 x 16 cm)
Museum of Modern Art, New York; the
Rikis Collection of McCrory Corporation
■ p. 156

Book of New Artists, 1922
Book (German edition)
12 1/8 x 9 1/4 in. (30.8 x 23.5 cm)
M. Szarvasy Collection, New York
■ p. 185

Book of New Artists, 1922
Book (Hungarian edition)
12 1/8 x 9 1/4 in. (30.8 x 23.5 cm)
M. Szarvasy Collection, New York

Picturearchitecture, 1922
Watercolor on paper
12 1/8 x 9 1/4 in. (30.8 x 23.5 cm)
László Nudelman Collection
■ p. 231

Cover design for *Der Sturm*, circa 1922
Vol. 13, no. 11 (1922)
Linoleum cut for periodical
7 1/16 x 5 11/16 in. (18 x 14.4 cm)
Los Angeles County Museum of Art;
Robert Gore Rifkind Center for German
Expressionist Studies, purchased with
funds provided by Anna Bing Arnold,
Museum Associates Acquisition Fund,
and deaccession funds
■ p. 111

Picturearchitecture V, circa 1924
Oil on cardboard
11 x 8 1/8 in. (28 x 20.5 cm)
Magyar Nemzeti Galéria
■ p. 158

Peter Keler
1898–1982
painter, designer, architect

Friedrich Kiesler
1890–1965
stage designer, architect

Born December 2, 1898, in Kiel, Hungary. Attended the School of Art in Kiel (1917–18) and the Weimar Bauhaus (1921–25). Cofounded the Kuri group (1922). Opened studio for the applied arts (1925). Graphic artist for textile and machinery industries in Dresden (1927–36). Architect and designer in Berlin (1937–43); work banned by Nazis in 1943. After World War II, taught at Hochschule fur Architektur und Bildende Künst in Weimar. Died in Weimar in 1982.

Peter Keler and Farkas Molnár

Mural for a Passageway, circa 1923
Color lithograph
8¼ x 9¹/₁₆ in. (21 x 23 cm)
Los Angeles County Museum of Art; Robert Gore Rifkind Center for German Expressionist Studies, purchased with funds provided by Anna Bing Arnold, Museum Associates Acquisition Fund, and deaccession funds
■ p. 216

Born September 22, 1890, in Vienna. Studied at the Academy of Fine Arts and at the Technical University in Vienna (1908–13). Started working with Adolf Loos (1920). Developed "Endless Theater" design (1924). Designed Austrian Pavilion for International Exposition in Paris (1925). Emigrated to New York (1926). Designs include the Eighth Street Playhouse (1929), the Film Guild Cinema (1930), the Universal Theater (1933), as well as installations for the Exposition of Surrealism in Paris (1947) and for Peggy Guggenheim's Art of This Century Gallery in New York (1957). Died in New York, December 27, 1965.

Cover design for *Catalogue of the International Exhibition of Theater Technology*, Vienna, 1924
Book
8⅞ x 12 in. (22.5 x 30.5 cm)
Bogner Collection, Vienna
■ p. 168

L-Type Display, 1924
Photograph
9⅞ x 7⅛ in. (25 x 18 cm)
Austrian Frederick and Lillian Kiesler Private Foundation

L-Type Display, 1924
Photograph
7½ x 5⅞ in. (19 x 15 cm)
Austrian Frederick and Lillian Kiesler Private Foundation

Display system, International Exhibition of Theater Technology, Vienna, 1924
Photograph
6¼ x 8¼ in. (16 x 21 cm)
Austrian Frederick and Lillian Kiesler Private Foundation
■ p. 168

City in Space, Paris, 1925
Hand-painted photograph mounted on paper
7⅝ x 9 in. (19.5 x 23 cm)
Bogner Collection, Vienna

City in Space, Paris, 1925
Photograph
10 x 8¼ in. (25.5 x 21 cm)
Bogner Collection, Vienna

Detail of the City in Space with a Stage Model of Alfred Roller, 1925
Photograph
9⅞ x 7⅛ in. (25 x 18 cm)
Austrian Frederick and Lillian Kiesler Private Foundation

L- and T-Type Display (reconstruction)
Construction
165⅜ x 165⅜ in. (4.2 x 4.2 m)
Bogner Collection, Vienna

Born December 23, 1889, in Miskolc, Hungary. Began early training in Kassa (now Košice, Slovakia); studied privately under Ferenc Szablya-Frischauf (1909) then in Paris at the Academie Julian (1911). Returned to Hungary and affiliated with Kassák's *Ma*. Collaborated with Jószef Nemes-Lampérth on poster design for the Hungarian Soviet Republic (1919). Formed New Association of Fine Artists (1924). From 1946, taught at Academy of Fine Arts in Budapest. Died December 16, 1975, in Budapest.

Woman with a Cup, 1916
Oil on canvas
26 x 21¼ in. (66 x 54 cm)
Janus Pannonius Múzeum, Pécs, Hungary
■ p. 142

Landscape, 1917
Oil on canvas
26 x 33¼ in. (66 x 85 cm)
Magyar Nemzeti Galéria
■ p. 145

Born January 26, 1898, in Moscow. Studied at the Moscow School of Painting, Sculpture and Architecture (1917) and State Free Art Workshops [Svomas] (1917–20). Moved to Smolensk (1920) and married Władysław Strzemiński (1921). Member of Unovis (1920–22). Moved to Vilnius and from 1924 belonged to Blok, Praesens, a.r., and the international Abstraction-Creation group; also wrote and edited for *Forma*. Moved to Belorussia in 1939; most of her work subsequently destroyed by Nazi regime. Returned to Poland after the war. Died February 26, 1951, in Łódź.

Abstract Composition, 1924–26
Oil on glass
9⁷⁄₁₆ x 12⅝ in. (24 x 32 cm)
Muzeum Sztuki, Łódź
■ p. 361

Abstract Sculpture 1, 1924
Glass, metal, and wood
28⅜ x 6⅞ x 6⅛ in. (72 x 17.5 x 15.5 cm)
Muzeum Sztuki, Łódź
■ p. 192

Space Composition 1, 1925
Painted steel
5½ x 21¹⁄₁₆ x 15⁹⁄₁₆ in. (14 x 53.5 x 39.5 cm)
Muzeum Sztuki, Łódź
■ p. 346

Space Composition 2, 1928
Painted steel
19¹¹⁄₁₆ x 19¹¹⁄₁₆ x 19¹¹⁄₁₆ in. (50 x 50 x 50 cm)
Muzeum Sztuki, Łódź
■ p. 335

Space Composition 3, 1928
Painted steel
15¾ x 25¼ x 15¾ in. (40 x 64 x 40 cm)
Muzeum Sztuki, Łódź
■ p. 346

Space Composition 4, 1929
Painted steel
15¾ x 25¼ x 15¾ in. (40 x 64 x 40 cm)
Muzeum Sztuki, Łódź
■ p. 18

Space Composition 5, 1929–30
Painted steel
9⅞ x 25³⁄₁₆ x 15¾ in. (25 x 64 x 40 cm)
Muzeum Sztuki, Łódź
■ p. 190

Jaromír Krejcar

1895–1949
architect

Margarete Kubicka

1891–1984
painter, printmaker

Stanisław Kubicki

1889–1942
painter, printmaker

Born July 25, 1895, in Hundsheim, Lower Austria. Studied at the Academy of Fine Arts in Prague (1917–21). Worked in Josef Gočár's studio (1921–23). Joined Devětsil (1921) and Association of Architects (1923). Designed USSR Pavilion for the Prague Trade Fair (1928). Joined Leva fronta in 1929 and Czechoslovak branch of CIAM in 1930. Worked in Moscow (1933–35). Designed Czechoslovak Pavilion at the 1937 World's Fair in Paris. Taught in Brno (1945–48) then London. Died in London on October 5, 1949.

Jaromír Krejcar, Bedřich Feuerstein, Josef Šíma, and Karel Teige

Cover design for *Život II*, 1922
Book
9¾ x 7⅜ x ½ in. (24.8 x 18.7 x 1.3 cm)
Zdenek Primus Collection, Prague
■ p. 110

Born 1891 in Berlin. Studied at the Imperial Academy of Art in Berlin (1911–13) and taught secondary school in Berlin (starting 1914). Cofounded the Bunt group in Poznań, Poland (1917–20). Cofounder (along with husband Stanisław Kubicki and others) the brief-lived Kommune group. Belonged to the Rheinische Progressiven until 1933. Discharged from teaching (1933) and refrained from producing art until after 1945. Died in Berlin in 1984.

Untitled (Two Figures), circa 1918
From *Die Aktion* 8, no. 21/22 (1918)
Woodcut
3¹⁄₁₆ x 4¼ in. (7.8 x 10.8 cm)
Los Angeles County Museum of Art; Robert Gore Rifkind Center for German Expressionist Studies, purchased with funds provided by Anna Bing Arnold, Museum Associates Acquisition Fund, and deaccession funds

Born November 7, 1889, in Ziegenhain near Kassel. Studied architecture at the Technische Hochschule in Berlin and at the Königliche Künsthochschule (1911–14). Stationed by military in Chelmsko (1916) then traveled to Poznań (1917). Cofounder of Bunt group, with whom he exhibited in Poznań and Berlin (1918); also exhibited with the Formists (1919–20). Contributed to *Zdrój* and *Die Aktion*; associated with revolutionary artists' groups in Germany. Killed by the Gestapo, 1942.

Uprising, circa 1918
From *Die Aktion* 8, no. 21/22 (1918)
Woodcut
4⁹⁄₁₆ x 6½ in. (11.6 x 16.5 cm)
Los Angeles County Museum of Art; Robert Gore Rifkind Center for German Expressionist Studies, purchased with funds provided by Anna Bing Arnold, Museum Associates Acquisition Fund, and deaccession funds
■ p. 48

Oarsman, circa 1918
From *Die Aktion* 8, no. 25/26 (1918)
Woodcut
3⅞ x 5¹³⁄₁₆ in. (9.9 x 14.8 cm)
Los Angeles County Museum of Art; Robert Gore Rifkind Center for German Expressionist Studies, purchased with funds provided by Anna Bing Arnold, Museum Associates Acquisition Fund, and deaccession funds
■ p. 320

Otakar Kubín

1883–1969
sculptor, painter, printmaker

Bohumil Kubišta

1884–1918
painter, printmaker, draftsman

Church Tower in Front of the Rising Sun,
1919
Oil on canvas
37 x 24 13/16 in. (94 x 63 cm)
Berlinische Galerie, Landesmuseum
für Moderne Kunst, Photographie
und Architektur, Berlin
■ p. 340

The Contrabassist, 1919
Linocut on paper
6 1/2 x 5 5/8 in. (16.5 x 14.3 cm)
Muzeum Narodowe, Warsaw
■ p. 310

Born October 22, 1883, in Boskovice,
Bohemia. Studied at the School of
Sculpture in Horice (1898–1900) and
the Academy of Plastic Arts in Prague
(1900–1904). Joined the Eight (1907).
Moved to Paris (1912), exhibited with
Der Sturm Gallery in Berlin (1913) and
in collective Der Sturm exhibits in
Germany and Holland (1916). Returned
to Czechoslovakia (1952), then to
France (1964). Died in Marseille, 1969.

Still Life with Box, 1912–13
Oil on canvas
25 1/4 x 31 1/2 in. (64 x 80 cm)
Galerie Výtvarného Uměni, Ostrava
■ p. 47

The Sun Worshiper, circa 1913
Oil on canvas
23 5/8 x 23 1/4 in. (60 x 59 cm)
Private collection, Germany
■ p. 4

Born August 21, 1884, in Vlčkovice,
Bohemia. Studied at the Prague School
of Decorative Arts (1903–4), the
Academy of Fine Arts (1904–5), and
the Reale Institute of Fine Arts in
Florence (1906). Returned to Prague
(1907) and cofounded the Eight.
Produced among the first works of
Czech Cubo-Expressionism (1910–15).
Promoted Picasso and Braque; associ-
ated with the Blaue Reiter, the Brücke,
and Herwarth Walden. Died November
27, 1918, in Prague.

Epileptic Woman, 1911
Oil on canvas
30 5/16 x 26 3/8 in. (77 x 67 cm)
Moravská galerie, Brno
■ p. 48

The Hypnotizer, 1912
Oil on canvas
23 7/8 x 22 7/8 in. (60.5 x 58 cm)
Galerie Výtvarného Uměni, Ostrava

El Lissitzky
1890–1941
architect, painter, printmaker, photographer, book designer, typographer, theorist

János Máttis-Teutsch
1884–1960
painter, printmaker, woodcarver, writer, sculptor, teacher

Born November 23, 1890, in Polshchinok. Studied at the Technische Hochschule in Darmstadt (1909–14). Began exhibiting in 1912. Returned to Moscow (1914). Graduated from Technological Institute of Riga (1915). Taught at Vitebsk Popular Art Institute and began first Proun work (1919). Taught at Higher State Art and Technical Studios [Vkhutemas] (1921). Moved to Berlin (1922). Participated in the First Russian Art Exhibition and the Düsseldorf Congress of International Progressive Artists (1922); copublished or contributed to multiple avant-garde journals. Treated for tuberculosis in Switzerland (1924–25); returned to Moscow. Designed Constructivist room at the Internationale Kunstausstellung in Dresden (1926); turned primarily to international exhibition design and political graphics. Died December 30, 1941, in Moscow.

Proun 17N, 1920
Pencil, india ink, gouache, watercolor
14 3/8 x 19 1/8 in. (36.5 x 48.5 cm)
Staatliche Galerie Moritzburg Halle, Landeskunstmuseum Sachsen-Anhalt
■ p. 36

Address Book, after 1921 (two examples)
Book
Closed: 5 x 5 3/4 in. (12.7 x 14.6 cm)
Library, Getty Research Institute, Los Angeles

Cover design for
Veshch/Gegenstand/Objet, 1922
Issue no. 3 (May, 1922)
Periodical
12 1/4 x 9 1/4 in. (31.1 x 23.5 cm)
Library, Getty Research Institute, Los Angeles
■ p. 177

Cover design for _Zenit_, 1922
Issue no. 17–18
Periodical
13 1/2 x 9 1/2 in. (34.3 x 24.1 cm)
Library, Getty Research Institute, Los Angeles
■ p. 258

Proun 3A [Proun 62], 1920–23
Oil on canvas
28 x 23 in. (71.1 x 58.4 cm)
Los Angeles County Museum of Art; purchased with funds provided by Mr. and Mrs. David E. Bright and The David E. Bright Bequest
■ p. 177

El Lissitzky and Hans Arp

Cover design for _The Isms of Art_ (1914–1924), 1925
Book
Height: 10 5/8 in. (27 cm)
Los Angeles County Museum of Art
■ p. 178

Born August 13, 1884, in Brasso, Transylvania (now Braşov, Romania). Studied at Budapest School of Craft and Design (1901–2), then in Munich (1902–5) and Paris (1906–8). Exhibited at Der Sturm gallery in Berlin starting in 1913. Joined the Activists (1917). Worked at the Weimar Bauhaus (1923). Starting in 1924, associated with Romanian avant-garde around the journals _Contimporanul_ and _Integral_. Spent summers at Nagybánya (1928–31). Died March 17, 1960, in Braşov.

Cover design for _Ma_, 1917
Vol. 2, no. 4 (February 18, 1917)
Linocut for periodical
5 9/16 x 5 1/8 in. (14.2 x 13 cm)
Los Angeles County Museum of Art; Robert Gore Rifkind Center for German Expressionist Studies, gift of Robert Gore Rifkind
■ p. 143

Dark Landscape with Trees, 1918
Oil on cardboard
23 5/8 x 27 1/8 in. (60 x 69 cm)
Janus Pannonius Múzeum, Pécs, Hungary
■ p. 22

Green-Yellow Landscape, circa 1918
Watercolor on paper
9 5/8 x 13 3/8 in. (24.5 x 33.9 cm)
Magyar Nemzeti Galéria
■ p. 145

M. H. (Max Herman) Maxy

1895–1971
painter, theater designer,
illustrator

Sensation, 1919
Oil on paper
10 ⅝ x 13 ¾ in. (27 x 35 cm)
Magyar Nemzeti Galéria
■ p. 38

Kiss: Composition with Two Figures, 1921
Painted wood
Height: 13 ⅜ in. (34 cm)
Szépmûvészeti Múzeum, Budapest
■ p. 243

Composition, 1923
Oil on board
39 ⅛ x 27 ⅛ in. (99.5 x 69 cm)
Dr. Gál Collection, Budapest
■ p. 292

Composition, circa 1923
Oil on board
13 ¾ x 10 ⅝ in. (35 x 27 cm)
Private collection
■ p. 253

Composition, circa 1923
Oil on board
13 ¹⁵⁄₁₆ x 11 ⅜ in. (35.4 x 28.8 cm)
Private collection

Composition, circa 1923
Oil on board
13 ¾ x 10 ⅜ in. (35 x 29 cm)
Private collection

Composition, 1924
Oil on paper
10 ½ x 8 ¼ in. (26.7 x 21 cm)
Private collection

Composition, circa 1924
Oil on board
14 ⅛ x 11 ⅜ in. (36 x 29 cm)
Private collection
■ p. 253

Untitled, 1924
Hand-colored linocut
12 ¼ x 8 ⅞ in. (31 x 22.5 cm)
M. Szarvasy Collection, New York

Untitled, 1924
Hand-colored linocut
12 ⅜ x 8 ⅞ in. (31.3 x 22.5 cm)
M. Szarvasy Collection, New York
■ p. 243

Untitled, 1924
Hand-colored linocut
12 ⅛ x 8 ¹⁵⁄₁₆ in. (30.8 x 22.7 cm)
M. Szarvasy Collection, New York

Untitled, 1924
Hand-colored linocut
13 ¾ x 8 ⅞ in. (35 x 22.5 cm)
M. Szarvasy Collection, New York
■ p. 243

Born October 26, 1895, in Braila.
Studied at the School of Fine Arts in
Bucharest (1913–15). First solo show
(1918). Moved to Berlin (1922); studied
with Arthur Segal and exhibited with
the Novembergruppe and at the Der
Sturm gallery. Returned to Romania;
organized international exhibitions
of Contimporanul (1924, 1930, 1935).
Cofounded the Academy of Modern
Decorative Arts (1924), published
Integral and founded the Group of
New Art (1924). Also active in theater
direction and design. Director of the
Museum of Art in Bucharest after
World War II. Died July 19, 1971, in
Bucharest.

———————————————

Vertical Construction, circa 1923
Oil on cardboard
27 ⅛ x 19 ⅛ in. (69 x 48.5 cm)
Muzeul National de Artă al României
■ p. 290

Nude with Idol, 1924
Oil on canvas
39 ¾ x 29 ¾ in. (101 x 75.5 cm)
Muzeul National de Artă al României
■ p. 302

Tristan Tzara, 1924
Oil on cardboard
25 ⅝ x 21 ¹⁄₁₆ in. (65 x 53.5 cm)
Muzeul National de Artă al României
■ p. 244

Candleholder, 1926
Metal
Height: 19 ⅝ in. (50 cm)
Private collection

Etel Mittag-Fodor

b. 1905
photographer, weaver

Lucia (Schulz) Moholy

1894–1989
photographer, writer, teacher

Decorated Box, 1926
Metal
Height: 3 15/16 in. (10 cm)
Private collection

Born December 28, 1905, in Zagreb.
Studied in Budapest and Vienna
(1925–28) and at the Bauhaus (1928–30),
where she met husband, architect
Gerhard Mittag. Began working as
freelance photographer and commercial artist (1930). Traveled to Soviet
Union and lectured at the Bauhaus
(1932). Fled Germany for Hungary
(1934), then Cape Town, South Africa
(1938). Concentrated on weaving
after 1962.

———————————————————

Albert Mentzel and Lotte Rothschild,
circa 1920
Gelatin-silver print mounted on album
card
8 7/8 x 7 in. (22.5 x 17.7 cm)
Bauhaus-Archiv Berlin
■ p. 223

Born January 18, 1894, in Karlin near
Prague. Studied at University of Prague
(1912). Worked as editor in Berlin (1915)
and lived at Worpswede artist colony
(1919). Met László Moholy-Nagy in
1920; married in 1921. Moholy-Nagy
appointed to the Weimar Bauhaus
(1923). Worked as photographer for
Bauhaus and studied in Leipzig
(1925–26). Couple moved to Berlin
(1928). Participated together in Film
und Foto Werkbund exhibition in
Stuttgart (1929); separated that same
year. Taught at Itten School in Berlin.
Moved to London (1933). Taught at the
London School of Printing and Graphic
Art and the Central School of Arts and
Crafts. Joined Royal Photographic
Society (1948). Moved to Switzerland
(1959). Died May 17, 1989, in Zurich.

———————————————————

*Bauhaus Buildings in Dessau (Balcony
of the Studio Building),* 1926
Photograph
6 5/8 x 5 1/8 in. (16.9 x 12.8 cm)
Bauhaus-Archiv Berlin
■ p. 17

*Bauhaus Buildings in Dessau (View from
the Vestibule Window),* 1926
Photograph
8 1/2 x 6 5/8 in. (21.7 x 16.7 cm)
Bauhaus-Archiv Berlin

Portrait of László Moholy-Nagy, 1926
Photograph
9 x 6 1/4 in. (23 x 15.9 cm)
Bauhaus-Archiv Berlin
■ p. 220

1895–1946
designer, sculptor, painter,
filmmaker, theorist, teacher

Born July 20, 1895, in Bácsborsod,
Hungary. Studied law in Budapest;
enlisted soldier during World War I.
Wounded and captured on Russian
Front; subsequently began drawing
in Odessa. Returned to Budapest and
joined Ma circle. Moved to Vienna
(1919) then Berlin. Began exhibiting at
Der Sturm gallery (1922). Collaborated
with Kassák on *Buch neuer Kunstler*.
Started teaching at Weimar Bauhaus
(1923); became director of metal
workshop and experimented in photo-
graphy, film, and design. Left the
Bauhaus (1928) with Walter Gropius
and others; returned to Berlin to pur-
sue commercial design work. Exhibited
with Abstraction-Creation group in
Paris (1932–36). Lived in Amsterdam
(1934), London (1935), then settled in
United States (1937). Director of the
New Bauhaus in Chicago; founded
the Institute of Design (1939). Died
November 24, 1946, in Chicago.

F in a Field, 1920
Gouache and collage
8 5/8 x 7 in. (22 x 17.7 cm)
Private collection, Berlin
(courtesy Kunsthandel Wolfgang
Werner Bremen/Berlin)
■ p. 155

Color Trellis, No. 1, 1922
Oil on canvas and board
29 1/8 x 22 in. (74 x 56 cm)
Private collection, Berlin
(courtesy Kunsthandel Wolfgang
Werner Bremen/Berlin)
■ p. 291

Cover design for *Zenit*, 1922
Issue no. 19–20 (December 1922)
Periodical
13 3/8 x 9 5/8 in. (34 x 24.5 cm)
M. Szarvasy Collection, New York
■ p. 266

Kinetic Constructive System, 1922
Watercolor, india ink, and collage
24 x 18 7/8 in. (61 x 48 cm)
Bauhaus-Archiv Berlin
■ p. 183

*Composition with Blue Circle Segment, Red
Cross, and Yellow Square*, 1922–23
Watercolor, glued onto black paper
17 x 14 1/4 in. (43.2 x 36.2 cm)
Private collection, Berlin (courtesy
Kunsthandel Wolfgang Werner
Bremen/Berlin)
■ p. 41

Composition (Circle Segment and Cross),
circa 1923
Linocut or woodcut on vellum
5 13/16 x 5 7/8 in. (14.8 x 15 cm)
Bauhaus-Archiv Berlin

Construction, 1923
Plate 1 of 6, Kestnermappe No. 6
Lithograph on paper
23 3/4 x 17 5/16 in. (60.3 x 43.9 cm)
San Francisco Museum of Modern Art

Construction, 1923
Plate 2 of 6, Kestnermappe No. 6
Lithograph on paper
23 11/16 x 17 1/2 in. (60.1 x 44.5 cm)
San Francisco Museum of Modern Art

Construction, 1923
Plate 3 of 6, Kestnermappe No. 6
Lithograph on paper
23 1/2 x 17 5/16 in. (59.7 x 43.9 cm)
San Francisco Museum of Modern Art

Construction, 1923
Plate 4 of 6, Kestnermappe No. 6
Lithograph on paper
23 1/2 x 17 5/16 in. (59.7 x 43.9 cm)
San Francisco Museum of Modern Art

Construction, 1923
Plate 5 of 6, Kestnermappe No. 6
Lithograph on paper
23 11/16 x 17 5/16 in. (60.1 x 43.9 cm)
San Francisco Museum of Modern Art

Construction, 1923
Plate 6 of 6, Kestnermappe No. 6
Lithograph on paper
23 5/8 x 17 5/16 in. (60 x 43.9 cm)
San Francisco Museum of Modern Art

*Postcard Announcement for the Bauhaus
Exhibition*, 1923
Color lithograph on cardboard
5 3/8 x 3 1/2 in. (13.7 x 8.8 cm)
Bauhaus-Archiv Berlin
■ p. 214

The Stage at the Bauhaus, 1924
Bauhaus Book No. 4
Book
9 3/8 x 7 5/16 in. (23.8 x 18.6 cm)
Los Angeles County Museum of Art

Lucia Moholy, 1924–25
Gelatin-silver print
3 1/8 x 1 13/16 in. (7.9 x 4.6 cm)
The J. Paul Getty Museum, Los Angeles
■ p. 220

The Broken Marriage, 1925
Gelatin-silver print of a photomontage
6½ x 4¾ in. (17.8 x 12.6 cm)
The J. Paul Getty Museum, Los Angeles
■ p. 221

Hand Photogram, circa 1925
Gelatin-silver print
9⅜ x 7 in. (23.9 x 17.8 cm)
Los Angeles County Museum of Art;
Ralph M. Parsons Fund
■ p. 187

Between Heaven and Earth (Look Before You Leap) I, circa 1926
Collage with photographs
25⁹/₁₆ x 19¹¹/₁₆ in. (65 x 50 cm)
Galerie Berinson, Berlin
■ p. 186

The City Lights, 1926 [?]
Photocollage and tempera on cardboard
24¼ x 19½ in. (61.5 x 49.5 cm)
Bauhaus-Archiv Berlin
■ frontispiece

Painting, Photography, Film (second revised edition), 1927
Book
Height: 9 in. (23 cm)
Los Angeles County Museum of Art

Light-Space Modulator, 1930
Gelatin-silver print
4⁵/₁₆ x 6½ in. (11 x 16.6 cm)
The J. Paul Getty Museum, Los Angeles
■ p. 221

Born June 21, 1897, in Pécs, Hungary. Initially studied at the College of Fine Arts and the Technical University in Budapest, then at Weimar Bauhaus (1921–25). Published in *Ma*. Composed the Kuri manifesto (1922). Developed "total theater" design with László Moholy-Nagy and Oskar Schlemmer, published 1925. Returned to Budapest in 1925 and resumed studies. Appointed delegate to the CIAM Congress (1928–38). Designed housing, villas, and churches until his death in Budapest on January 12, 1945.

───────────────

Grave Monument to the March Dead, Weimar, 1920–21
Lithograph
5⅜ x 8⅝ in. (13.7 x 22 cm)
Library, Getty Research Institute, Los Angeles
■ p. 211

Fiorentia, 1922
Sheet one from portfolio Italia 1921
Color lithograph
14⁹/₁₆ x 10⅛ in. (37 x 25.7 cm)
Magyar Nemzeti Galéria
■ p. 207

Untitled, 1922
Title page from portfolio Italia 1921
Lithograph
17⁵/₁₆ x 13⅜ in. (44 x 33.9 cm)
Magyar Nemzeti Galéria

Lovers in Front of House and Horn, 1923
Drypoint and etching
9¾ x 7¾ in. (24.8 x 19.7 cm)
Bauhaus-Archiv Berlin
■ p. 208

Postcard Announcement for the Bauhaus Exhibition, 1923
Color lithograph on cardboard
5½ x 3⅝ in. (14.1 x 9.1 cm)
Bauhaus-Archiv Berlin
■ p. 214

Otakar Mrkvička

1898–1957
painter, illustrator, designer,
critic

Born December 19, 1898, in Příbram.
Studied at the Academy of Fine Arts
in Prague, the Prague School of
Decorative Arts, and at the Academy
of Fine Arts in Munich (1919–25).
Joined Devětsil (1923) and cofounded
leftist satirical magazine *Thorn*.
Advocated Constructivism and collabo-
rated with Karel Teige. Exhibited book
illustrations at the Paris World's Fair
(1936). From the 1940s created set
designs, produced plays, and published
studies and criticism. Died November
20, 1957, in Prague.

––––––––––––––––––––––––––––

Cover design for *Samá Láska*,
by Jaroslav Seifert, 1923
Book
7 3/4 x 5 1/2 in. (19.7 x 13.9 cm)
Zdenek Primus Collection, Prague
■ p. 98

Fritzi Nechansky

1904–1993

Untitled, early 1920s
Charcoal on paper
17 1/2 x 12 3/8 in. (44.5 x 31.5 cm)
Bogner Collection, Vienna

Jószef Nemes Lampérth

1891–1924
painter, draftsman

Born September 13, 1891, in Budapest.
Began studies at the School of Applied
Arts (1909), then Nagybánya (1912).
Began exhibiting in 1910, but career
was limited by mental illness. Joined
the Activists and published in *Ma*.
Fought briefly in World War I.
Worked in the poster arts during the
Hungarian Soviet Republic and taught
at Proletarian Fine Arts Workshop.
Emigrated briefly to Berlin but
returned to Hungary, where he was
hospitalized. Died May 24, 1924, in
Satoraljaujhely near Miskolc.

––––––––––––––––––––––––––––

Still Life with Lamp, 1916
Oil on canvas
25 3/4 x 35 3/8 in. (65.5 x 90 cm)
Janus Pannonius Múzeum, Pécs,
Hungary
■ p. 145

Henrik Neugeboren (Henri Nouveau)

1901–1959
musician, painter, poet, designer

Maria Nicz-Borowiak

1896–1944
painter, designer

Gyula Pap

1899–1983
metalworker, lithographer, publisher, teacher

Born 1901 in Brasso, Transylvania (now Braşov, Romania). Began music studies in Budapest (1913) then in Berlin (1921) and Paris (1925–27). Began exploring abstract art around 1923. Returned to Berlin (1927); joined Dessau Bauhaus. Returned to Paris (1929). Developed "stereometric" designs corresponding to musical compositions. Held first one-man show in 1930. After 1945 participated regularly at the Salon des Réalités Nouvelles. Died 1959.

Composition, 1927–29
Colored paper on paper
8 1/8 x 5 7/8 in. (20.7 x 14.8 cm)
Szépmûvészeti Múzeum, Budapest
■ p. 225

Born on January 16, 1896, in Warsaw. Studied at the Academy of Fine Arts in Warsaw (1916–20). Early member of the Blok group (1924–26), then joined Praesens. Withdrew from art around 1930. Died September 14, 1944, in Warsaw.

Composition [Musical Theme], 1925
Oil on wood
19 11/16 x 12 9/16 (50 x 32 cm)
Muzeum Sztuki, Łódź
■ p. 361

Profiles, circa 1930
Oil on canvas
21 11/16 x 15 3/4 in. (55 x 40 cm)
Muzeum Narodowe, Poznań
■ p. 361

Born November 10, 1899, in Oroshaza, Hungary. Studied at the Royal and Imperial Grafische Lehr- und Versuchsanstalt in Vienna (1914–17). Soldier during World War I (1917–18). Moved to Budapest (1918) during the Hungarian Revolution. Emigrated to Berlin (1919), then joined the Weimar Bauhaus (1920–23). Taught at the Itten School in Berlin (1928–33), then returned to Budapest. Founded the Janos-Nagy-Balogh Painting School in Nagymaros (1947). Directed the Academy of Fine Arts in Budapest (1949–62). Died September 24, 1983, in Budapest.

Candleholder with Seven Arms, 1922
Brass
Height: 16 3/4 in. (42.5 cm)
Bauhaus-Archiv Berlin
■ p. 215

Tall Pitcher, 1923
Copper, brass, and silver
Height: 13 in. (33 cm)
Kunstsammlungen, Weimar
■ p. 215

László Péri

Born June 13, 1899, in Budapest. Began career as a stonemason; turned to visual arts in 1918 and joined the Ma group. After Hungarian revolution, lived briefly in Vienna and Paris before moving to Berlin. Exhibited at Der Sturm gallery in Berlin (1922); also published in *Der Sturm* (1922–28). Shifted to architecture and urban planning (1924); resumed painting (1930). Fled Nazi regime and moved to London (1933). Died January 19, 1967, in London.

Water between Houses (Space Construction I), 1920 (recast 1930s)
Painted cement
22 $7/16$ x 16 $1/2$ x 2 $3/8$ in. (57 x 42 x 6 cm)
Sammlung von Bergmann
■ p. 39

Space Construction 16, 1922–23
Tempera on shaped board
6 x 4 $3/8$ in. (15.2 x 11 cm)
Private collection, Bremen
(courtesy Kunsthandel Wolfgang Werner Bremen/Berlin)
■ p. 40

Space Construction 17, 1922–23
Tempera on shaped board
8 $1/2$ x 11 in. (21.5 x 28 cm)
Private collection, Bremen
(courtesy Kunsthandel Wolfgang Werner Bremen/Berlin)

Space Construction 20, 1922–23
Tempera on shaped board
9 $5/8$ x 11 in. (24.5 x 28 cm)
Private collection, Bremen
(courtesy Kunsthandel Wolfgang Werner Bremen/Berlin)
■ p. 291

Untitled, 1922–23
Plate 1 of Linoleumschnitte portfolio
Linocut on gray paper, glued down
6 $1/4$ x 8 $1/2$ in. (15.9 x 21.6 cm)
Private collection

Untitled, 1922–23
Plate 2 of Linoleumschnitte portfolio
Linocut on brown paper, glued down
5 $3/16$ x 6 $1/4$ in. (13.1 x 15.9 cm)
Private collection

Untitled, 1922–23
Plate 3 of Linoleumschnitte portfolio
Linocut on gray paper, glued down
3 $15/16$ x 7 $1/16$ in. (10 x 18 cm)
Private collection

Untitled, 1922–23
Plate 4 of Linoleumschnitte portfolio
Linocut on gray paper, glued down
5 x 7 $3/4$ in. (12.6 x 19.8 cm)
Private collection

Untitled, 1922–23
Plate 5 of Linoleumschnitte portfolio
Linocut on gray paper, glued down
6 $3/4$ x 8 $9/16$ in. (17.2 x 21.7 cm)
Private collection

Untitled, 1922–23
Plate 6 of Linoleumschnitte portfolio
Linocut on gray paper, glued down
6 $7/8$ x 8 $1/2$ in. (17.4 x 21.5 cm)
Private collection

Untitled, 1922–23
Plate 7 of Linoleumschnitte portfolio
Linocut on gray paper, glued down
8 $5/16$ x 11 $3/8$ in. (21.1 x 28.8 cm)
Private collection

Untitled, 1922–23
Plate 8 of Linoleumschnitte portfolio
Linocut on gray paper, glued down
8 $7/16$ x 11 $3/16$ in. (21.4 x 28.5 cm)
Private collection

Untitled, 1922–23
Plate 9 of Linoleumschnitte portfolio
Linocut on gray paper, glued down
8 $1/2$ x 8 $1/4$ in. (21.5 x 21 cm)
Private collection
■ p. 184

Untitled, 1922–23
Plate 10 of Linoleumschnitte portfolio
Linocut on gray paper, glued down
9 $11/16$ x 11 $1/4$ in.; 24.7 x 28.5 cm.
Private collection
■ p. 184

Design for Wall Forms for the Great Berlin Art Exhibition, 1923 (later signed "1924")
Tempera on lithograph
12 x 18 in. (30.5 x 45.8 cm)
Private collection
■ p. 184

Milita Petrascu 1892–1976
sculptor, illustrator

Pablo Picasso 1881–1973
painter, sculptor, draftsman,
printmaker, designer

Franz Pomassl 1903–1982
painter, designer

Born December 31, 1892, in Chisinau.
Studied in Paris under Constantin
Brâncuşi (1919–23). Participated in the
first international Contimporanul
exhibit (1924). Published in avant-
garde journals *Contimporanul*, *Punct*,
and *Unu*. Died on February 1, 1976,
in Bucharest.

———————————

Angel, date unknown
Wood, stone pedestal
35 ¼ x 5 ⅞ x 5 ⁵⁄₁₆ in. (89.5 x 15 x 13.5 cm)
Muzeul National de Artă al României
▪ p. 242

Born October 25, 1881, in Málaga.
Dominant figure of twentieth-century
art; extraordinarily influential in the
development of Central European
avant-garde movements. Educated by
father and at academies throughout
Spain. Moved to Barcelona (1895). Blue
Period (1901–4). Moved to Paris (1904).
After Rose Period (1904–6), turned to
primitivism and Cubism. Experimented
with neoclassicism and Surrealism
starting in mid-1920s. *Guernica* shown
at Spanish Pavilion of the Paris World
Exhibition (1937). Forty-year retrospec-
tive held at Museum of Modern Art,
New York (1939). Relocated to the south
of France (1948). Died April 8, 1973, in
Mougins.

———————————

Head of a Woman, 1909
Bronze
16 ⅛ x 9 ¼ x 9 ⅞ in. (41 x 23.5 x 25.1 cm)
Los Angeles County Museum of Art;
gift of Mr. and Mrs. Nathan Smooke in
memory of Joseph and Sarah Smooke
and Museum Purchase with funds pro-
vided by Mr. and Mrs. Jo Swerling,
Mrs. Harold M. English in memory
of Harold M. English, and Mr. James
Francis McHugh.
▪ p. 43

Born in 1903 in Vienna. Attended the
School of Arts and Crafts (1918–22).
Exhibited with the Association of
Applied Art (1934), the Hagenbund
(1935–37), and the Artists' House (1938).
Also worked with Otto Prutscher.
Participated in furniture design com-
petition at the Museum of Modern Art
in New York (1949). Died in Vienna,
1982.

———————————

Kometbar, 1926
Graphite on tracing paper
10 ⅝ x 13 ⅜ in. (27 x 34 cm)
Bogner Collection, Vienna

Three Chairs, 1928
Graphite on tracing paper
13 ⅜ x 15 ⅜ in. (34 x 39 cm)
Bogner Collection, Vienna
▪ p. 170

Untitled, late 1920s
Oil on plywood
8 ⅞ x 9 in. (22.5 x 23 cm)
Bogner Collection, Vienna

Miroslav Ponc

1902–1976
composer, painter

Born December 2, 1902, in Vysoké Mýto, Bohemia. Studied music at the Prague Conservatory (1920–22), the Stern Conservatory (1922), and the Berlin Academy of Music (1923). Involved with Der Sturm and joined Devětsil (1924). Exhibited at the Devětsil exhibition (1926) and in Berlin at the Der Sturm exhibition (1927). Conducted at the National Theater beginning in 1942. Created numerous orchestral compositions and over 600 scores for theater, radio, and film. Died on April 1, 1976, in Prague.

Chromatic Turbine in Eighth-Tones, circa 1925
Ink and watercolor on paper
20½ x 59½ in. (52 x 151 cm)
Galerie Hlavního Města, Prague
■ p. 204

Antonín Procházka

1882–1945
painter, designer

Born June 5, 1882, in Vážany u Vyškova. Studied law in Prague (1901–2), the School of Decorative Arts (1902–4), and the Academy of Fine Arts (1904–6). Joined the Eight (1907), then Skupina (1911). Gradually turned from Cubism toward primitivist classicism. Died in Brno, June 9, 1945.

Concert, 1912
Oil on canvas
23⅝ x 15¾ in. (60 x 40 cm)
Galerie výtvarného uměni, Ostrava
■ p. 201

Still Life with Bottle, 1913
Oil on plywood
18⅛ x 12⅝ in. (46 x 32 cm)
Galerie výtvarného uměni, Ostrava

Zbigniew Pronaszko

1885–1958
painter, sculptor, theater designer, teacher

Born May 27, 1885, in Derpeczyn, Podolia. Studied at the Academy of Fine Arts in Cracow (1906–11). First exhibit in Cracow (1907). Lived in Zakopane (1914–17). Exhibited with the Formists in Cracow, Lwów, Warsaw, Poznań, and Paris (1917–22). Codirector of the Free School of Fine Arts in Zakopane (1919); also taught at the University of Stefan Batory in Vilnius (1923–25), the Free School of Painting in Cracow (starting in 1925), and the Academy of Fine Arts in Cracow (starting in 1945). Died February 8, 1958, in Cracow.

Nude, 1917
Oil on canvas
44⅛ x 25⅝ in. (112.1 x 65.1 cm)
Muzeum Narodowe, Cracow
■ p. 329

Ivan Puni (Jean Pougny)
1892–1956
painter, illustrator, designer

Leopold Wolfgang Rochowanski
1885–1961
journalist, editor, playwright

Jaroslav Rössler
1902–1990
photographer

Born February 22, 1892, in Kouokkala, Finland (now Repino, Russia). Educated in St. Petersburg; visited Italy and France (1909–12) and studied in Paris at the Académie Julian. Exhibited with the Union of Youth group in St. Petersburg (1911–14). Exhibited at Salon des Indépendants in Paris (1914). Taught at art school at Vitebsk (1919). Moved to Berlin; exhibited at Der Sturm gallery (1921) and later with the Novembergruppe. Moved to Paris (1924). Died December 28, 1956, in Paris.

Exhibition Announcement—Der Sturm, 1921
Pen, ink, and pasted paper on paper
4⅛ x 3½ in. (10.5 x 8.9 cm)
Museum of Modern Art, New York; Katherine S. Dreier Bequest
■ p. 202

Born August 3, 1885, in Zuckmantel (now Zlaté Hory, Czech Republic). Studied at University of Vienna (1907–16). Edited multiple Austrian and foreign publications, cofounded Der Bücherkasten theater, directed Thyrsos publishing house (1924–25), and planned performances and exhibitions (including 1928 exhibition of modern Austrian art in Prague). Began writing plays in 1928. Banned from working by Nazi regime (1938). Directed Agathon publishing house (1946–48). Died September 3, 1961, in Vienna.

Untitled, early 1920s
Black crayon on thin linen paper
5½ x 3⅝ in. (14 x 9.3 cm)
Bogner Collection, Vienna

Born May 25, 1902, in Smilov. Trained at František Drtikol's studio (1917). Best-known photographer in Devětsil. Published in avant-garde magazines *Stavba*, *ReD*, *Pásmo*, *Disk*, and *Pestry tyden* and worked for avant-garde Liberated Theater. Lived in Paris (1925–26, 1927–35), then opened own studio on the outskirts of Prague (1935). Lived largely in seclusion until 1950s; continued with photographic experiments through 1960s. Died January 5, 1990, in Prague.

Abstraction, 1923
Photograph
8¼ x 8⅜ in. (21 x 21.3 cm)
The Marjorie and Leonard Vernon Collection
■ p. 119

Abstraction (PJ), 1929
Photograph
11⅜ x 9⅜ in. (28.9 x 23.9 cm)
The Marjorie and Leonard Vernon Collection
■ p. 119

János Schadl
1892–1944
painter

Hugo Scheiber
1873–1950
painter, draftsman

Kurt Schwitters
1887–1948
painter, designer, sculptor, writer

Born 1892, in Keszthely, Hungary. Studied art in Budapest and at Nagybánya. Published drawings in *Ma* and participated in exhibitions through Lajos Kassák's Activist group. Withdrew to the countryside in the 1920s to paint more naturalistically. Died in 1944.

Houses and Aurél Bernáth, 1919
Oil on canvas
37⅜ x 29½ in. (95 x 75 cm)
Janus Pannonius Múzeum, Pécs, Hungary
▪ p. 143

Born September 29, 1873, in Budapest. Spent childhood in Vienna. Originally a sign painter; studied at Budapest School of Applied Arts (1898–1900). Returned to Vienna (1921); held exhibits in Budapest (1923), Berlin and London (1924), New York and La Paz (1926), and Vienna (1930). Member of the Hungarian New Artists group and exhibited with the Futurists at the Mostra Nazionale d'Arte Futurista in Rome (1933). Died in Budapest, March 7, 1950.

Amusement Park, 1920s
Oil on cardboard
26³⁄₁₆ x 39⅜ in. (66.5 x 100 cm)
Magyar Nemzeti Gáleria
▪ p. 294

Born June 20, 1887, in Hanover. Studied at the School of Decorative Arts in Hanover (1908) and in Dresden and Berlin (1909–14). Served in the military (1917). Associated with Der Sturm in Berlin and attended the Technische Hochschule in Hanover (1918). Created first Merz picture (1919). Associated with Berlin and Zurich Dadaists (1920). Published 24 issues of *Merz* (1923–32). Created first Merzbau environment and opened design agency (1924). Participated in Cercle et Carre exhibit (1930) and joined the Abstraction-Creation group (1932). Banned by Nazis and fled to Norway (1937) then England (1940). Died January 8, 1948, in Kendal, England.

Lithograph 4, 1923
From Merz 3 portfolio
Lithograph on blue paper
22 x 17½ in. (56 x 44.5 cm)
Los Angeles County Museum of Art; Graphic Arts Council Fund
▪ p. 241

Arthur Segal

1875–1944
painter, printmaker, teacher

Josef Šíma

1891–1971
painter, illustrator

Władysław Skotarek

1894–1970
printmaker

Born July 13, 1875, in Iasi. Moved to Berlin (1890). Studied at the Academy in Berlin, the Academy in Munich, and the Académie Julian in Paris (1892–98). Cofounded the Neue Secession group in Berlin (1910) and associated with Der Sturm (1911–14). Relocated to Switzerland and associated with Dadaists (1914–20). Returned to Berlin (1920); joined the Novembergruppe and opened painting school. Emigrated to Mallorca, Spain (1933), then London (1936). Opened painting school at Oxford. Died June 23, 1944, in London.

Human Life, 1921
Oil on board
30 5/16 x 37 3/4 in. (77 x 96 cm)
Private collection
■ p. 36

Born March 19, 1891, in Jaroměř, Bohemia. Studied at the School of Decorative Arts in Prague (1910–11) and the Academy of Fine Arts in Prague (1911–14, 1917–18). Briefly joined Skupina (1911–12). Moved to Paris (1921). Exhibited with the Tvrdošíjní (1921) and joined Devětsil (1923). Cofounded Le Grand Jeu in Paris (1927). Exhibited at the Aventinum Garret in Prague (1928). Participated in 1932 Surrealist Exhibition sponsored by the Mánes Association in Prague. Died in Paris on July 24, 1971.

Hot-Air Balloon, 1926
Oil on canvas
25 3/8 x 20 7/8 in. (64.5 x 53 cm)
Národní Galerie, Prague
■ p. 104

Europa, 1927
Oil on canvas
31 1/2 x 25 5/8 in. (80 x 65 cm)
Moravská galerie, Brno
■ p. 129

Born May 6, 1894, in Wojnowice. Trained at the Polichrom stained-glass and mural painting workshop in Poznań (1913–17). Joined Bunt group and exhibited in Poznań and Berlin in 1918. Also exhibited with the Formists in Warsaw (1920) and the Society of Fine Artists in Poznań (1921 and 1931). Retired from art after 1931 and worked as a bank clerk. Died November 29, 1970, in Poznań.

Embrace, 1918
Linocut on paper
5 5/8 x 3 1/4 in. (14.3 x 8.3 cm)
Muzeum Narodowe, Warsaw
■ p. 311

The Panic, 1919
Linocut on paper
6 11/16 x 8 7/8 in. (16.9 x 22.5 cm)
Muzeum Narodowe, Warsaw
■ p. 311

Václav Špála
1885–1946
printmaker, painter

Lotte Stam-Beese
1903–1988
architect, urban planner

Henryk Stażewski
1894–1988
painter, designer, theorist

Born August 2, 1885, in Žlutice, Bohemia. Studied privately and at the Academy of Fine Arts in Prague (1903–9). Cofounded Skupina (1911); left with Josef Čapek (1912) to join Mánes Association. Exhibited with Tvrdošíjní (starting 1917). After the 1920s turned from Cubo-Expressionism toward realism and still lifes. President of Mánes Association (1936). Died May 12, 1946, in Prague.

Brick Factory, 1912
Oil on canvas
19 1/4 x 23 5/8 in. (49 x 60 cm)
Státní Galerie, Zlín
■ p. 15

Bathing, 1913
Oil on cardboard
24 x 19 7/8 in. (61 x 50.5 cm)
Národní Galerie, Prague
■ p. 95

Landscape, circa 1918
From _Die schöne Rarität_ 2 no. 8 (1918)
Woodcut
5 1/2 x 4 5/16 in. (14 x 10.9 cm)
Los Angeles County Museum of Art; Robert Gore Rifkind Center for German Expressionist Studies, purchased with funds provided by Anna Bing Arnold, Museum Associates Acquisition Fund, and deaccession funds

Born January 28, 1903, in Reisicht, Silesia. Studied at the Bauhaus (1926–28). Worked in Czechoslovakia (1929) and then the Soviet Union (1930–34), where she met Dutch architect Mart Stam. Moved to Amsterdam and married (1935). Served as architect for the development of the city of Rotterdam (1946–68) and taught at the Amsterdam Academy of Building and Town Planning. Died on November 18, 1988, in Krimpen, Netherlands.

Katt Both, 1927–29
Gelatin-silver print
3 1/2 x 4 1/2 in. (8.9 x 11.4 cm)
Los Angeles County Museum of Art; Ralph M. Parsons Fund
■ p. 223

Born January 9, 1894, in Warsaw. Studied at the School of Fine Arts in Warsaw (1913–19). Exhibited with Formists and future Polish Constructivists (1921–23); also closely associated with Cercle et Carré and Abstraction-Creation groups in Paris. Joined Blok (1924), Praesens (1926), and a.r. (1929). Helped organize the International Collection of Modern Art in Łódź and cofounded the Circle of Graphic Advertising Artists (1933). During World War II nearly all of his work was destroyed. Resumed painting after 1945. Retrospective held in 1955. Died June 10, 1988, in Warsaw.

Cover design for _Praesens_, 1926
Vol. 1, no. 1
Periodical
12 x 9 1/2 in. (30.5 x 24.1 cm)
Library, Getty Research Institute, Los Angeles
■ p. 336

Composition, 1930
Oil on canvas
28 3/4 x 21 1/4 in. (73 x 54 cm)
Muzeum Sztuki, Łódź
■ p. 8

Cover design for _Blok_, 1924
Vol. 1, no. 1
Periodical
24 x 18 in. (61 x 45.7 cm)
Library, Getty Research Institute, Los Angeles

Henrik Stefán

1896–1971

sculptor, printmaker

Władysław Strzemiński

1893–1952

painter, theorist, typographer

Born in 1896 in Mariakemend, Hungary. Studied in Pécs. Due to ethnic diversity of the Baranya region, identified himself variously as a Hungarian, German, and Serb. Joined Pécs Artists' Circle, then studied at the Weimar Bauhaus (1921–22) and the Dessau Bauhaus (1925). Returned to Hungary (1928). Died in Budapest, 1971.

Monte Venere, 1921
Lithograph with watercolor
13 3/16 x 9 1/2 in. (33.5 x 24.2 cm)
Ernst Gallery, Budapest
■ p. 207

Born November 21, 1893, in Minsk, Belorussia. Studied engineering in Moscow; drafted into Czarist army during World War I and seriously wounded. Studied art after 1917 in Moscow, Vkhutemas, and Inkhuk. Taught in Smolensk (1920–21) and worked with Unovis (1920–22). Married Katarzyna Kobro (1921) and moved to Vilnius (1922). Published in *Żwrotnica* (1922) and began developing theory of Unism. Joined Blok (1924), Praesens (1926), and cofounded a.r. (1929). Published *Unism in Painting* (1928) and copublished (with Kobro) *Composition of Space* (1931). Initiated Collection of Modern Art in Łódź (1931). Member of the Abstraction-Creation group (1932–36). Cofounded the State Higher School for Applied Art (1945) but dismissed by Stalinist regime in 1950. Died December 26, 1952, in Łódź.

Cubism—Tensions of the Material Structure, 1919
Oil and mixed media on canvas
8 7/8 x 6 7/8 in. (22.5 x 17.5 cm)
Muzeum Narodowe, Warsaw
■ p. 52

Cover design for *Six Hours! Six Hours!*, by Tadeusz Peiper, 1925
Book
8 5/8 x 6 7/8 in. (22 x 17.5 cm)
Muzeum Sztuki, Łódź
■ p. 300

Architectural Composition 6b, 1928
Oil on canvas
37 3/4 x 23 5/8 in. (96 x 60 cm)
Muzeum Sztuki, Łódź
■ p. 191

Cover design for *Praesens*, circa 1928
Distemper and pencil on board
11 3/4 x 8 5/8 in. (30 x 22 cm)
Collection of Alexander Kaplen
■ p. 336

Unism in Painting, 1928
Book (reprint)
9 1/16 x 5 15/16 in. (23 x 15 cm)
Muzeum Sztuki, Łódź

Architectural Composition 13c, 1929
Oil on canvas
37 3/4 x 23 5/8 in. (96 x 60 cm)
Muzeum Sztuki, Łódź
■ p. 347

Unistic Composition 7, 1929
Oil on canvas
77 x 63 in. (195.6 x 160 cm)
Muzeum Sztuki, Łódź
■ p. 345

Illustration for *Blok*, 1924
Issue no. 5 ("Split Rectangle—Analytic Work")
Periodical
9 1/2 x 13 in. (24.1 x 33 cm)
Library, Getty Research Institute, Los Angeles

Jindřich Štyrský

1899–1942
painter, graphic artist,
photographer, publisher, theorist

Born August 1, 1899, in Cermna, Bohemia. Studied at the Prague Academy of Fine Arts (1920–23). Joined Devětsil (1923); along with wife and collaborator Marie Čermínová (Toyen), was a leading proponent of Poetism as an alternative to Constructivism and Dadaism. Moved to Paris (1925); began to develop Artificialism. Published *Erotic Revue* (1930–33) and founded Edition 69 (1932), a series including de Sade's *Justine* and work by poet Vítězslav Nezval. Cofounded Surrealist group in Prague with Nezval and Toyen. Illegally published (with Jindřich Heisler) fierce condemnation of Hitler (1941). Died March 21, 1942, in Prague.

White Star Line, 1923
Collage
8½ x 11¼ in. (21.5 x 28.5 cm)
Collection Merrill C. Berman
■ p. 63

Cover design for *Pantomime*,
by Vítězslav Nezval, 1924
Book
8½ x 5½ in. (21.6 x 14 cm)
Library, Getty Research Institute,
Los Angeles
■ p. 62

Sleepwalking Elvira, 1926
Oil on canvas
28¾ x 45 11/16 in. (73 x 116 cm)
Státní Galerie, Zlín
■ p. 127

Deluge, 1927
Oil with sand on canvas
43 5/16 x 21 5/8 in. (110 x 55 cm)
Moravská Galerie, Brno
■ p. 129

Jindřich Štyrský and Marie Čermínová (Toyen)

Cover design for *False Matrimony*,
by Vítězslav Nezval, 1925
Book
Height: 7⅞ in. (20 cm)
McCormick Library of Special
Collections, Northwestern University
Library
■ p. 101

How I Found Livingston, 1925
Collage
15¾ x 11¾ in. (40 x 30 cm)
Private collection, Prague
■ p. 99

Cover design for *The Smaller Rose Garden*,
by Vítězslav Nezval, 1926
Book
7 5/8 x 5 3/8 in. (19.5 x 13.7 cm)
McCormick Library of Special
Collections, Northwestern University
Library
■ p. 126

Born October 19, 1898, in Warsaw. Studied at the School of Fine Arts in Warsaw (1915–20). Showed with partner Teresa Żarnower at the Exhibition of New Art in Vilnius in Berlin at Der Sturm gallery (1923). Cofounded Blok (1924) and coedited group's journal until its dissolution (1926). Helped organize the International Exhibition of Architecture in Warsaw (1926). With Żarnower, was first in Poland to use photomontage in political graphic design. Participated in the Exhibition of New Architecture in Moscow (1927). Began publishing Communist journal *Dźwignia* in 1927. Died August 13, 1927, in the Tatra Mountains.

Self-Portrait with Palette, 1920
Oil on canvas
53 x 24 in. (134.5 x 91 cm)
Muzeum Narodowe, Warsaw
■ p. 301

Abstract Composition, 1924
Ink on paper
11 x 7 5/8 in. (27.9 x 19.5 cm)
Private collection
■ p. 233

Fumes above the City, circa 1926
Photographs and black ink on paper
15¾ x 12 3/16 in. (40 x 31 cm)
Muzeum Sztuki, Łódź
■ p. 53

Cover design for *Blok*, 1924
Issue no. 6–7
Periodical
13½ x 10 in. (34.3 x 25.4 cm)
Library, Getty Research Institute,
Los Angeles
■ p. 189

Mieczysław Szczuka and Teresa Żarnower

Cover design for *Blok*, 1924
Issue no. 2 (April 1924)
Periodical
13¾ x 10 in. (34.9 x 25.4 cm)
Library, Getty Research Institute,
Los Angeles

Cover design for *Blok*, 1924
Issue no. 5
Periodical
9⅜ x 6¼ in. (23.9 x 15.9 cm)
Library, Getty Research Institute,
Los Angeles
■ p. 349

Cover design for *Blok*, 1926
Vol. 3, no. 11 (March 1926)
Periodical
14 x 10 in. (35.6 x 25.4 cm)
Library, Getty Research Institute,
Los Angeles

Born December 13, 1900, in Prague.
Initially inspired by Tvrdošíjní, but
eventually denounced them. Visited
Paris (1923); became primary spokes-
man of Devětsil (1924–25). Published
First Manifesto of Poetism (1924), preced-
ing Breton's *First Surrealist Manifesto*.
Joined Surrealist group in Prague
(1935). Moved (1947) to Paris (with
Toyen and Jindřich Heisler) to join
André Breton's Surrealist group.
Died in Prague on October 1, 1951.

Cover design for *Devětsil Revolutionary
Almanac*, ed. Karel Teige and Jaroslav
Seifert, 1922
Book
9⁹⁄₁₆ x 6⁵⁄₁₆ in. (24.3 x 16 cm)
Library, Getty Research Institute,
Los Angeles
■ p. 85

Travel Postcard, 1923
Collage with halftone, letterpress,
tempera, and ink
12¹³⁄₁₆ x 10¹⁄₁₆ in. (32.5 x 25.5 cm)
Galerie Hlavního Města, Prague
■ p. 61

The Departure for Cythera, 1923–24
Collage with halftone, watercolor, ink,
and graphite
10½ x 8¾ in. (26.7 x 22.2 cm)
Galerie Hlavního Města, Prague
■ p. 62

Cover design for *Pásmo*, 1924
Periodical
18⅞ x 12¼ in. (48 x 31 cm)
Library, Getty Research Institute,
Los Angeles

Design for *Abeceda*, by Vítězslav Nezval,
1926
Book (photographs by Karel Paspa;
choreography by Milča Mayerová)
11¹³⁄₁₆ x 9³⁄₁₆ in. (30 x 23.3 cm)
Library, Getty Research Institute,
Los Angeles

Cover design for *ReD*, 1927
Vol. 1, no. 1
Periodical
9 1/8 x 7³⁄₁₆ (23.2 x 18.3 cm)
Zdenek Primus Collection, Prague
■ p. 118

Cover design for *ReD*, 1927
Vol. 1, no. 2 (November 1927)
Periodical
9³⁄₁₆ x 7¼ in. (23.3 x 18.4 cm)
Zdenek Primus Collection, Prague
■ p. 115

Cover design for *ReD*, 1927
Vol. 1, no. 3
Periodical
9³⁄₁₆ x 7¼ in. (23.3 x 18.4 cm)
Zdenek Primus Collection, Prague
■ p. 86

Frontispiece and title page for
With the Ship that Brings Tea and Coffee,
by Konstantin Biebl, 1928
Book
Open: 7½ x 10¾ in. (19 x 27.4 cm)
Umìleckoprùmyslové Muzeum, Prague
■ p. 194

Cover design for *ReD*, 1929
Vol. 2, no. 8 (April 1929; "foto film foto")
Periodical
9¼ x 7⅛ in. (23.5 x 18.1 cm)
Zdenek Primus Collection, Prague

Cover design for *ReD*, 1930
Vol. 3, no. 5 ("Bauhaus")
Periodical
9¼ x 7⅛ in. (23.4 x 18.2 cm)
McCormick Library of Special
Collections, Northwestern University
Library

Karel Teige and Jaromír Krejcar

Cover design for *North—South—
West—East*, 1923
Periodical
7¼ x 5¼ in. (18.5 cm x 13.3 cm)
Karel Srp
■ p. 230

Karel Teige and Otakar Mrkvička

Cover design for *Trust D.E.*, by Ilya
Ehrenburg, 1927
Book
7¾ x 5½ in. (19.7 x 13.9 cm)
Library, Getty Research Institute,
Los Angeles
■ p. 102

Born October 19, 1885, in Budapest.
Attended Budapest School of Applied
Arts (1904–5). Relocated to Nagybánya
(1907–10). Participated in first
exhibition of Mienk [Hungarian
Impressionists and Naturalists] at
Budapest's National Salon (1908).
Cofounder of the Eight. Member
of the Union of Freethinkers (later
the Galileo Circle). Exhibited at the
1915 Panama-Pacific International
Exposition in San Francisco. Moved
to Paris (1920) after the fall of the
Hungarian Soviet Republic. Joined
the Abstraction-Creation group (1933).
Died on June 11, 1938, in Paris.

Self-Portrait, 1912
Oil on canvas
22¹⁄₁₆ x 17¾ in. (56 x 45 cm)
Magyar Nemzeti Galéria
■ p. 144

Portrait of Lajos Kassák, 1918
Oil on canvas
34⅛ x 27½ (86.6 x 70 cm)
Magyar Nemzeti Galéria
■ p. 143

Working-Class Family, 1921
Oil on canvas
46 x 35⅜ in. (116.7 x 90 cm)
Magyar Nemzeti Galéria
■ p. 203

*Man Standing at the Window (Self-Portrait,
Berlin Schöneberg)*, 1922
Oil on canvas
55¼ x 41¾ in. (140.2 x 106 cm)
Magyar Nemzeti Galéria
■ p. 203

Portrait of Poet Branko Poljanco, 1925
Red and black crayon on paper
20¹³⁄₁₆ x 14⁹⁄₁₆ in. (52.8 x 37 cm)
Magyar Nemzeti Galéria

Portrait of Tristan Tzara, 1926
Oil on canvas
40⅛ x 28¾ in. (102 x 73 cm)
Magyar Nemzeti Galéria
■ p. 250

Béla Uitz
1887–1972
painter, printmaker, draftsman, writer

Otto Erich Wagner
1895–1979
painter, teacher

Andor Weininger
1899–1986
painter, theater designer, musician, choreographer

Born March 8, 1887, in Temes-Mehala, near Timisoara, Romania. Attended the Academy of Fine Arts in Budapest (1908–13); first exhibition, 1914. Won gold medal at Panama-Pacific International Exposition in San Francisco (1915). Member of Activists; contributed to *A Tett* and *Ma*. Cofounded (with Robert Berény) the Proletarian Artists Workshop (1919). Briefly imprisoned after failure of revolution; moved to Vienna. Launched *Egyseg* (Unity) in 1922. Lived in Paris (1924–26), then the USSR until 1970. Died January 26, 1972, in Budapest.

———————————

Woman in White Dress, 1918
Oil on cardboard
40 x 23 7/8 in. (101.5 x 60.5 cm)
Magyar Nemzeti Galéria
■ p. 57

Analysis VIII, 1922
Linocut on paper
8 x 12 1/8 in. (20.2 x 30.7 cm)
Magyar Nemzeti Galéria
■ p. 160

Analysis XXIV, 1922
Linocut on paper
12 11/16 x 7 7/8 in. (32.2 x 20 cm)
Magyar Nemzeti Galéria
■ p. 180

Analysis on Purple Base, 1922
Oil on canvas
62 3/16 x 55 1/2 in. (158 x 141 cm)
Magyar Nemzeti Galéria
■ p. 167

Born September 10, 1895, in Klepacov-Blansco. Served in World War I. Attended Teacher's College (1919–23) and the School of Arts and Crafts (1922–24). Began teaching at School of Arts and Crafts (1924 onward). Participated in International Exposition in Paris (1925); also worked as commercial artist. Punitive army transfer to Yugoslavia (1944–45). Joined Vienna Secession (1949). Died February 2, 1979, in Vienna.

———————————

Composition, 1924
Gouache
9 5/8 x 8 3/8 in. (24.6 x 21.2 cm)
Bogner Collection, Vienna
■ p. 169

Born February 12, 1899, in Karams. Studied in Pécs, Budapest, and Munich (1917–21). Enrolled at the Bauhaus (1921). Formed the Bauhaus jazz ensemble. Moved to Berlin (1928). Spent time in Paris, then emigrated to the Netherlands (1938), where he joined the Creatic group. Moved to Toronto (1951) then New York (1958). Died March 6, 1986, in New York.

———————————

De Stijl–Composition II, 1922
Gouache and graphite on paper
9 7/8 x 9 7/8 in. (25 x 25 cm)
Harvard University Art Museums, Busch-Reisinger Museum
■ p. 209

"Abstract Revue" of Moving Surfaces (Mechanical Theater), 1926–28
Graphite, watercolor, and black ink on card
7 1/8 x 9 3/8 in. (18.1 x 23.9 cm)
Harvard University Art Museums, Busch-Reisinger Museum
■ p. 225

Konrad Winkler

1882–1962
painter, writer

Stanisław Ignacy Witkiewicz (Witkacy)

1885–1939
writer, painter, photographer, theorist

Born January 20, 1882, in Warsaw. Studied at the Jan Kazimierz University in Lwów, the School of Fine Arts in Cracow, and in Paris. Exhibited with the Formists in Cracow, Warsaw, and Poznań (1919–21) and began coediting *Formiści* (1921). Attempted to reorganize the Formists (1927). Exhibited with the Praesens group (1929). Died January 16, 1962, in Cracow.

The Switch, circa 1920
Oil on glass
12 5/8 x 9 7/8 in. (32 x 25 cm)
Muzeum Sztuki, Łódź

Portrait of Tytus Czyżewski, 1921
Oil on cardboard
19 7/8 x 15 1/2 in. (50.5 x 39.5 cm)
Muzeum Narodowe, Cracow
■ p. 330

Born February 24, 1885, in Warsaw (son of painter, critic, architect Stanisław Witkiewicz). Received informal artistic training from childhood at home in Zakopane; first exhibition, 1901. Formally trained at the Academy of Fine Arts (1904–10). Accompanied anthropologist Bronisław Malinowski to Australia (1914), then went to Russia to become an officer in the Czarist army. Returned to Zakopane (1918); became (with Leon Chwistek) one of the leading theorists of the Formists. Exhibited in Cracow, Warsaw, Poznań, Lwów, and Paris (1919–29). Also wrote treatises, plays, and novels. Committed suicide on September 17, 1939, in Jeziory.

Jadwiga Janczewska, Zakopane, 1912
Gelatin-silver print
5 1/4 x 5 1/16 in. (13.3 x 12.8 cm)
Gilman Paper Company Collection
■ p. 50

Astronomic Composition, 1918
Pastel on paper
18 5/16 x 23 13/16 in. (46.5 x 60.5 cm)
Muzeum Literatury im. A Mickiewicza, Warsaw
■ p. 322

General Confusion, 1920
Oil on canvas
39 3/8 x 35 7/8 in. (100 x 91 cm)
Muzeum Narodowe, Cracow
■ p. 48

Portrait of Eugenia Wojnicz, 1924
Pastel on paper
24 13/16 x 18 1/8 in. (63 x 46 cm)
Muzeum Literatury im. A Mickiewicza, Warsaw
■ p. 322

Portrait of Nena Stachurska, 1929
Pastel on paper
26 x 19 5/8 in. (66 x 50 cm)
Muzeum Literatury im. A Mickiewicza, Warsaw
■ p. 332

August Zamoyski

1893–1970
sculptor

Teresa Żarnower

1895–1950
designer, sculptor

Born June 28, 1893, in Jablon, near
Lublin. Initially studied economy and
philosophy, then sculpture in Berlin
(1916–18). Moved to Zakopane (1918).
Contributor to *Zdrój* and member of
Bunt and the Formists. Exhibited in
Poznań, Berlin, Cracow, Warsaw, and
Lwów (1918–24). Moved to France (1923);
lived and taught in Rio de Janeiro
(1940–55) and visited New York during
the 1940s. Returned to France (1955).
Died June 28, 1970, in Saint-Clar de
Riviere, near Toulouse.

Born in 1895 in Warsaw. Studied at
the School of Fine Arts in Warsaw
(1915–20) and began collaborating
with Mieczysław Szczuka. Displayed
together at the Exhibition of New Art
in Vilnius and Der Sturm gallery in
Berlin (1923), then cofounded Blok
(1924). After Szczuka's death (1927),
assumed publication of his journal
Dzwignia. Produced graphic arts for
Polish Communist Party until emigrat-
ing to New York. Died in New York,
1950.

Cover design for *Europa*, by Anatol
Stern, 1929
Book
11 5/8 x 10 7/8 in. (29.5 x 27.5 cm)
Galerie Berinson, Berlin
■ p. 353

They Are Two, 1922 (recast)
Bronze cast
Height: 12 5/8 in. (32 cm)
Muzeum Sztuki, Łódź
■ p. 360

Illustration for *Blok*, 1924
Issue no. 6–7 (pages 14–15)
Periodical
Closed: 13 1/2 x 10 in. (34.3 x 25.4 cm)
Library, Getty Research Institute,
Los Angeles
■ p. 350

Theater projects for *Blok*, 1925
Issue no. 10
Periodical
Closed: 13 3/4 x 10 in. (34.9 x 25.4 cm)
Library, Getty Research Institute,
Los Angeles

Cover design for *Dźwignia*, 1927
Issue no. 5
Periodical
9 5/8 x 6 11/16 in. (24.5 x 17 cm)
Muzeum Sztuki, Łódź
■ p. 349

Born in 1906 in Prague. Studied at
the Industrial School of Construction
in Prague (1923–27) and the Bauhaus
(1929–31). Returned to Prague; became
a member of the architectural division
of Leva fronta and the Union of
Socialist Architects (1933). Worked in
France (1934–35). After his return to
Czechoslovakia he worked in Pnetluky.

Design for a Bauhaus Poster, 1930
Paper collage
16 5/8 x 15 3/4 in. (42 x 40 cm)
Národní technické muzeum, Prague;
Architectural Archive
■ p. 221

A Futuristák és Expressionisták, exhibition
catalogue, Nemzeti Szalon, 1913
Book
M. Szarvasy Collection, New York

Ma, 1918
Vol. 3, no. 12 (December 18)
Periodical (with insert catalogue
of Sándor Galimberti and Valeria
Dénés exhibition)
12 1/4 x 9 1/4 in. (31.1 x 23.5 cm)
M. Szarvasy Collection, New York

Sturm postcard (Rudolf Blümner), 1922
From Herwarth Walden to János
Máttis-Teutsch (Dec. 12, 1922)
M. Szarvasy Collection, New York

Zwrotnica, 1922
No. 1
Periodical
8 5/8 x 12 in. (22 x 30.5 cm)
Library, Getty Research Institute,
Los Angeles
■ p. 233

Zwrotnica, 1923
No. 5
Periodical
8 5/8 x 12 in. (22 x 30.5 cm)
Library, Getty Research Institute,
Los Angeles
■ p. 337

Blok, 1924
No. 3–4 (June)
Periodical
9 7/8 x 13 3/4 in. (25.1 x 34.9 cm)
Library, Getty Research Institute,
Los Angeles

ReD: Review of the Union for Modern Culture
Devětsil, 1927–31
Periodical, edited by Karel Teige, 29
issues
Each: 9 1/4 x 7 1/8 in. (23.4 x 18.2 cm)
Mary and Roy Cullen

Bauhaus, 1928
Vol. 2, no. 2–3
Periodical
Library, Getty Research Institute,
Los Angeles
■ p. 219

Bauhaus, 1929
Vol. 3, no. 1 (January)
Periodical
Library, Getty Research Institute,
Los Angeles

Postcard
From Kassák (Vienna) to Tihanyi
(Berlin)
M. Szarvasy Collection, New York

Sturm postcard (Severini, *Pan Pan*)
M. Szarvasy Collection, New York

Sturm postcard (Severini, *Die Modistin*)
M. Szarvasy Collection, New York

Sturm postcard (Luigi Russolo, *Zug
in voller Fahrt*)
M. Szarvasy Collection, New York

SELECTED BIBLIOGRAPHY

Note

This selection is largely restricted to monographic studies, with most emphasis given to movements and artists outside of Germany. Artist monographs are included, but without any intention of being exhaustive. For further research the reader is directed to the extensive bibliographies in the following, current through 1994: S. A. Mansbach, *Modern Art in Eastern Europe: From the Baltic to the Balkans, ca. 1890–1939* (Cambridge and New York: Cambridge University Press, 1999), and Stanislawski, Ryszard, and Christoph Brockhaus, eds. *Europa, Europa: das Jahrhundert der Avantgarde in Mittel- und Osteuropa*. Exh. cat. 4 vols. (Bonn: Stiftung Kunst und Kultur des Landes Nordrhein-Westfalen; Kunst- und Ausstellungshalle der Bundesrepublik Deutschland, 1994), vol. 4.

Aderca, Felix. *Mărturia unei generaţii*. Bucharest: Editura Naţională Ciornei, 1929.

Jankel Adler, 1895–1949. Exh. cat. Düsseldorf, Städtische Kunstahalle. Cologne: DuMont Buchverlag, 1985.

Aleksić, Dragan. *Dada Tank*. Ed. Gojko Tešic. Belgrade: Nolit, 1978.

Alexandrescu, Sorin. *Romanian Art from Modernism to Postmodernism in Figurative Art*. Exh. cat. Amstelveen: Cobra Museum for Modern Art, 1998.

Anna, Susanne, ed. *Das Bauhaus im Osten: Slowakische und Tschechische Avantgarde 1928–1939*. Stuttgart: Hatje, 1997.

Antonowa, Irina and Jörn Merkert, eds. *Berlin Moskva 1900–1950*. Exh. cat. Munich: Prestel-Verlag, 1995.

Apke, Bernd, et al. *Okkultismus und Avantgarde: von Munch bis Mondrian, 1900–1915*. Ostfildern: Edition Tertium, 1995.

Alexander Archipenko: The Creative Process: Drawings, Reliefs, and Related Sculpture. Exh. cat. New York: Rachel Adler Gallery, 1993.

[Archipenko] Karshan, Donald H. *Archipenko: The Sculpture and Graphic Art, Including a Print Catalogue Raisonné*. Tübingen: Wasmuth, 1974.

[Archipenko] Karshan, Donald H., ed. Archipenko: *International Visionary*. Washington, D.C.: Smithsonian Institution Press, 1969.

[Archipenko] Michaelsen, Katherine Jánszky and Nehama Guralnik. *Alexander Archipenko: A Centennial Tribute*. Washington, D.C.: National Gallery of Art, 1986.

Art Around 1900 in Central Europe. Cracow: International Cultural Centre, 1999.

L'Art comme utopie. Exh. cat. Le Havre: La Maison de la culture du Havre, 1979.

El Arte de la vanguardia en Checoslovaquia, 1918–1938/The Art of the Avant-garde in Czechoslovakia, 1918–1938. Exh. cat. Valencia: IVAM Centre Julio González, 1993.

The Art of Nagybánya: Centennial Exhibition in Commemoration of the Artists' Colony in Nagybánya. Exh. cat. Budapest: Hungarian National Gallery, 1996.

Arts and Architecture between Avant-Garde and Modernism, 1920–1930. Proceedings of the International Symposium, Bucharest, 1993.

Avant-Garde Polonaise 1918–1939: Urbanisme Architecture. Brussels: Editions des Archives d'Architecture Moderne, 1981.

Avantgarde: progressive ungarische Kunst des 20. Jahrhunderts. Munich: Galerie Heseler, 1975.

Bajkay, Éva R. *Klassiker der Avantgarde: die ungarischen Konstruktivisten*. Innsbruck: Galerie im Taxispalais, 1983.

——. *A Magyar grafika külföldö: Németország/Ungarische Graphik im Ausland: Deutschland 1919–1933*. Budapest: Magyar Nemzeti Galéria, 1989.

Balotă, Nicolae: *Urmuz*. Cluj: Editura Dacia, 1970.

Bann, Stephen, ed. *The Tradition of Constructivism*. New York: Viking, 1974.

Baranowicz, Zofia. *Polska awangarda artystyczna, 1918–1939*. Warsaw: Wydawnictwa Artystyczne i Filmowe, 1975.

Bartha, Miklos von, and Carl Laszlo, eds. *Der Sturm: die ungarischen Künstler am Sturm, Berlin 1913–1932*. Basel: Edition Galerie von Bartha, 1983.

Baum, Peter. *Ungarn: Avantgarde im 20. Jahrehundert*. Exh. cat. Linz: Neue Galerie Der Stadt Linz, 1998.

Behring, Eva, ed. *Texte der Rumänischen Avantgarde 1907–1947*. Leipzig: Verlag Philipp Reclam, 1988.

[Beneš] Matějček, Antonín. *Vincenc Beneš*. Prague: Melantrich, 1937.

[Beneš] Štech, V[áclav] V[ilém], and Luboš Hlaváček. *Vincenc Beneš*. Prague: Nakladatelství československých výtvarných umělců, 1967.

Berend, Ivan T. *Decades of Crisis: Central and Eastern Europe before World War II*. Berkeley: University of California Press, 1998.

[Bílek] Díla, Vybor. *František Bílek*. Prague: Galerie hlavního města Prahy, 1986.

Birgus, Vladimír, ed. *Tschechische Avantgarde-Fotografie 1918–1948*. Exh. cat. Stuttgart: Arnoldsche, 1999.

Blaga, Lucian. *Ferestre colorate*. Arad: Editura Librăriei Diocezane, 1925.

Eve Blau and Monika Platzer, eds. *Shaping the Great City: Modern Architectue in Central Europe, 1890–1937*. Munich and New York: Prestel, 1999.

Blum, Helena. *Zbigniew Pronaszko*. Warsaw: Krajowa Agencja Wydawnicza, 1983.

Bogdan, Radu. *Die Avantgarde Bewegung in Rumanien und ihr Verhaltnis zur Weltkunst*. Brno: Ars, 1969.

Botar, Oliver A. I., ed. *Tibor Pólya and the Group of Seven: Hungarian Art in Toronto Collections, 1900–1949*. Toronto: Justina M. Barnicke Gallery, Hart House, University of Toronto, 1989.

Bowlt, John E., and Nicoletta Misler. *Twentieth-Century Russian and East European Painting*. London: Zwemmer, 1993.

[Brâncuși] Bach, Friedrich Teja, Margit Rowell, Ann Temkin. *Constantin Brancusi, 1876–1957*. Exh. cat. Philadelphia Museum of Art. Cambridge: The MIT Press, 1995.

[Brâncuși] ———. *Brâncuși în România*. Bucharest: Editura All, 1998.

[Brâncuși] Georgescu-Gorjan, Ștefan. *Constantin Brâncuși: Templul Din Indor*. Editura Eminescu, 1996.

Victor Brauner. Exh. cat. Muzeul de artă din Oradea. Catalog afiș de H. Clonaru, 1976.

[Brauner] Pavel, Amelia. *Victor Brauner*. Bucharest: Editura Arc 2000, 1999.

Brubaker, Rogers. *Nationalism Reframed: Nationhood and the National Question in the New Europe*. Cambridge and New York: Cambridge University Press, 1996.

Brühl, Georg. *Herwarth Walden und "Der Sturm"*. Cologne: DuMont Buchverlag, 1983.

Brus-Malinowska, Barbara, and Jerzy Malinowski. *Kisling: i jego przyjaciele and His Friends*. Warsaw: Muzeum Narodowe w Warszawie, 1996.

Budapest 1869–1914: Modernité hongroise et peinture européenne. Exh. cat. Dijon: Musée des Beaux-Arts de Dijon, 1995.

Bydžovská, Lenka, and Karel Srp, eds. *Český Surrealismus 1929–1953*. Exh. cat. Prague: Galerie hlavního města Prahy, 1996.

Bydžovská, Lenka, Vojtěch Lahoda, and Karel Srp, eds. *Czech art 1900–1990 from the Collections at the Prague City Gallery, House of the Golden Ring*. Exh. cat. Prague: The Prague City Gallery, 1998.

[Čapek] Kotalík, Jiří, Jaroslav Slavík, and Jiří Opelík, eds. *Josef Čapek: 1887–1945: Obrazy a kresby*. Exh. cat. Prague: Národní galerie, 1979.

[Čapek] Opelík, Jiří. *Josef Čapek*. Prague: Melantrich, 1980.

[Čapek] Pečinková, Pavla. *Josef Čapek*. Prague: Svoboda, 1995.

[Čapek] Pečírka, Jaromír. *Josef Čapek*. Prague: Státní nakladatelství krásné literatury, hudby a umění, 1961.

[Čapek] Slavík, Jaroslav and Jiří Opelík. *Josef Čapek*. Prague: Torst, 1996.

[Čapek] Sonnberger, Gerwald, ed. *Josef Čapek: 1887–1945*. Exh. cat. Český Krumlov: Egon Schiele Centrum; Passau: Museum Moderner Kunst; Bochum: Museum Bochum, 1996.

[Čapek, Karel] Spielmann, Peter. *Karel Čapek Fotografie*. Exh. cat. Museum Bochum. Heidelberg: Brausdruck, 1990.

Cârneci, Magda, ed. *Bucharest in the 20s–40s between Avant-Garde and Modernism*. Exh. cat. Bucharest: Simetria, 1994.

Cavanaugh, Jan. *Out Looking In: Early Modern Polish Art, 1890–1918*. Berkeley: University of California Press, 2000.

Čechische Bestrebungen um ein modernes Interieur [Gočár; Janák; Kysela]. Intro. V. V. Štech. Trans. Otto Pick. Prague: Pražské umělecké dílny, 1915.

[Černigoj] Krecic, Peter. *August Černigoj: Srecko Kosovel in konstruktivizem*. Exh. cat. Sežana: Mala galerija, 1984.

České a slovenské umění 20. století. Karlovy Vary: Galerie umění Karlovy Vary, 1981.

České umění 1900–1990 ze sbírek Galerie hlavního města Prahy dům U zlatého prstenu. Prague: Galerie hlavního města Prahy, [n.d.].

Charazińskiej, Elżbiety, and Łukaska Kossowskiego. *Koniec Wieku: Sztuka polskiego modernizmu 1890–1914*. Warsaw: Muzeum Narodowe w Warszawie, 1996.

Chrzanowska-Pieńkos, Jolanta, et al. *Art from Poland 1945–1996*. Warsaw: Galeria Sztuki Współczesnej Zachęta, 1997.

[Chwistek] Estreicher, Karol. *Leon Chwistek. Biografia artysty (1884–1944)*. Cracow: Państwowe Wydawnictwo Naukowe, 1971.

[Chwistek] Kostyrko, Teresa. *Leona Chwistka filozofia sztuki*. Warsaw: Instytut Kultury, 1995.

Čiurlionis, Mikalojus Konstantinas. *Mikalojus Konstantinas Čiurlionis: Paintings, Sketches, Thoughts*. Kaunas: Valstybinis M. K. Čiurlionis dail esmuziejus; Vilnius: Leidykla Fodio; Rome: Editalia, 1997.

Congdon, Lee. *Exile and Social Thought: Hungarian Intellectuals in Germany and Austria, 1919–1933*. Princeton: Princeton University Press, 1991.

Cubist Art from Czechoslovakia. London: The Arts Council of Great Britain, 1967.

Cubist Prague, 1909–1925: A Guidebook. Prague: Central Europe Gallery and Publishing House in collaboration with ODEON Publishers, 1995.

Czartoryska, Urszula, ed. *Les chefs-d'oeuvre de la photographie polonaise, 1912–1948, de la collection du Muzeum Sztuki de Łódź/ Masterpieces of Polish Photographiy, 1912–1948, from the Collection of the Muzeum Sztuki in Łódź*, Paris: Institut Polonais, 1992/Łódź: Muzeum Sztuki, 1992.

Czech Functionalism: 1918–1938. London: Architectural Association, 1987.

Czech Modern Art 1900–1960: The National Gallery in Prague. Exh. cat. Prague: National Gallery, 1996.

Czech Modernism 1900–1945. Exh. cat. Houston: Museum of Fine Arts, 1989.

Czekalski, Stanisław. *Awangarda i mit racjonalizacji. Fotomontaż polski okresu dwudziestolecia międzywojennego*. Poznań: Poznańskie Towarzystwo Naukowe, 2000.

[Czyżewski] Pollakówna, Joanna. *Tytus Czyżewski*. Warsaw: Ruch, 1971.

[Czyżewski] Stopczyk, Stanisław. *Tytus Czyżewski*. Warsaw: Krajowa Agencja Wydawnicza, 1984.

Dabrowski, Magdalena. *Contrasts of Form: Geometric Abstract Art 1910–1980*. New York: Museum of Modern Art, 1985.

Dankl, Günther, and Raoul Schrott, eds. *DADAutriche, 1907–1970*. Innsbruck: Haymon-Verlag, 1993.

Dautrey, Charles, and Jean-Claude Guerlain, eds. *L'Activisme hongrois*. Montrouge: Goutal-Darly, 1979.

De Stijl 1 and 2, 1917–1920. Amsterdam: Athenaeum, Bert Bakker, Den Haag and Polak & Van Gennep, 1968.

Die Deutsche Werkbund-Ausstellung Cöln 1914. Cologne: Kölnischer Kunstverein, 1984.

Donat, Branimir. *Antologija dadaisticke poezije*. Novi Sad: Bratstvo i jedinstvo, 1985.

Dufek, Antonín, ed. *Czechoslovakian Photography: Jaromír Funke, Jaroslav Rössler*. Exh. cat. London: The Photographers' Gallery; Brno: Moravian Gallery, 1985.

Éri, Gyöngyi. *A Golden Age: Art and Society in Hungary, 1896–1914*. London: Corvina/ Barbican Art Gallery; Miami: Center for the Fine Arts, 1989.

Expressionism and Czech Art 1907–1927: Fine art, architecture, applied art, set design. Prague: National Gallery, The Institute of Art History, The Museum of Decorative Arts, 1992.

Expressionismus a české umění: 1905–1927. Exh. cat. Prague: National Gallery, 1994.

Expressionistische Tendenzen in der polnischen Graphik. Exh. cat. Braunschweig: Herzog Anton Ulrich-Museum Braunschweig, 1979.

Fabre, Gladys, and Ryszard Stanislawski. *Paris Arte Abstracto Arte Concreto: Cercle et Carré 1930.* Valencia: Institut Valencià d'Art Modern, 1990.

Figura: w rzeźbie polskiej XIX I XX wieku. Warsaw: Galeria Sztuki Współczesnej Zachęta, 1999.

Filla, Emil. *Otázky a úvahy.* Prague: Spolek výtvarných umělců Mánes, 1930.

[Filla] *Tschechischer Kubismus: Emil Filla und Zeitgenossen.* Exh. cat. Passau: Museum Moderner Kunst Passau, 1991.

[Filla] Venera, František, ed. *Emil Filla.* Brno: Václav Jelínek a František Venera, 1936.

[Filla] Lahoda, Vojtěch, ed. *Svět Emila Filly.* Exh. cat. Prague: Galerie hlavního města Prahy, 1987.

Finkeldey, Bernd, et al., eds. *Konstruktivistische Internationale Schöpferische Arbeitsgemeinschaft 1922–1927: Utopien für eine europäische Kultur.* Stuttgart: G. Hatje, 1992.

The First Russian Show: A Commemoration of the Van Diemen Exhibition, Berlin 1922. Exh. cat. London: Annely Juda Fine Art, 1983.

Flaker, Aleksandar. *Poetika osporavanja. Avangarda i književna ljevica,* Zagreb: Biblioteka Suvremena misao, Školska knjiga, 1982.

Föhl, Thomas, et al. *The Bauhaus Museum (The Kunstsammlungen in Weimar).* Berlin: Dt. Kunstverlag, 1996.

Foltyn, Ladislav. *Solwakische Architektur und die tschechische Avantgarde 1918–1939.* Dresden: Verlag der Kunst, 1991.

Frontiere d'Avanguardia: Gli anni del futurismo nella Venezia Giulia/Avant-garde Borders: Futurist Years in Venezia Giulia. Exh. cat. Gorízia: Musei Provinciali, Palazzo Attems, 1985.

Jaromír Funke. Fotografie. Úvodní studie Ludvík Souček. Prague: Odeon, 1970.

Jaromír Funke. Cologne: Rudolf Kicken Galerie, 1984.

Jaromír Funke: Fotograf und Theoretiker der modernen tschechoslowakischen Fotografie. Intro. Daniela Mrázková and Vladimír Remeš. Leipzig: Fotokinoverlag, 1986.

Jaromir Funke (1896–1945): Průkopník Fotografické Avantgardy. Brno: Moravska galerie v Brně, 1996.

[Funke] Dufek, A., ed. *Jaromír Funke.* Exh. cat. Brno: Dům umění města Brna, 1979.

[Funke] Linhart, Lubomír. *Jaromír Funke.* Prague: Státní nakladatelství krásné literatury, hudby a umění, 1960.

Gassen, Richard W. and Bernhard Holeczek. *Die Neue Wirklichkeit: Abstraction als Weltentwurf.* Exh. cat. Ludwigshafen am Main: Wilhelm-Hack-Museum Ludwigshafen, 1994.

Gassner, Hubertus, ed. *WechselWirkungen: ungarische Avantgarde in der Weimarer Republik.* Marburg: Jonas Verlag, 1986.

Gervereau, Laurent, and Yves Tomic, eds. *De l'Unification à l'Eclatement: L'espace yougoslave, Un siècle d'Histoire/From Unification to Dispersion: Yugoslav Space, One Century of History.* Paris: Musée d'Histoire contemporaine—BDIC, Les Invalides, 1998.

Giżycki, Marcin. *Awangarda wobec kina. Film w kręgu polskiej awangardy artystycznej dwudziestolecia międzywojennego.* Warsaw: Wydawnictwo Małe, 1996.

Goldscheider, Irena. *Czechoslovak Prints from 1900 to 1970.* London: British Museum Publications, 1986.

Gresty, Hilary, and Jeremy Lewison, eds. *Constructivism in Poland, 1923 to 1936.* Kettle's Yard Gallery in association with Muzeum Sztuki, Łódź. Cambridge: The Gallery, [1984?].

Gryglewicz, Tomasz. *Malarstwo Europy Środkowej, 1900–1914: Tendencje modernistyczne I wczesnoawangardowe* Cracow: Nakladem Uniwersytetu Jagiellonskiego, 1992.

Gutfreund, Otto. *Zázemí tvorby. Paměti, korespondence, dokumenty.* Ed. Jiří Šetlík. Praha: Odeon, 1989.

Gutfreund, Oto, 1889–1927. Exh. cat. Kunsthalle Nürnberg. Nürnberg: Kunsthalle, 1970.

[Gutfreund] Císařovský, Josef. *Oto Gutfreund*. Prague: Státní nakladatelství krásné literatury a umění, 1962.

[Gutfreund] Kramář, Vincenc, et al., eds. *Gutfreund: 1887–1927: Plastiky, kresby*. Prague: Spolek výtvarných umělců Mánes, 1927.

[Gutfreund] Šetlík, Jiří, and Václav Erben, eds. *Otto Gutfreund*. Exh. cat. Prague: Národní galerie, 1995.

Hanák, Péter. *The Garden and the Workshop: Essays on the Cultural History of Vienna and Budapest*. Princeton: Princeton University Press, 1998.

Hárs, Éva. *Modern Magyar Képtár, Pécs*. Budapest: Corvina, 1981.

———, and Ferenc Romváry. *Die moderne ungarische Galerie Pécs*. Budapest: Corvina Kiadó, 1982.

Herwarth Walden und der Sturm: Konstruktivisten, Abstrakte: eine Auswahl. Exh. cat. Cologne: Galerie Stolz, 1987.

Herwarth Walden und Der Sturm: Artists and Publications. Exh. cat. [New York]: La Boetie, [1981].

Hofacker, Marion von, ed. *G: Material zur elementaren Gestaltung*. Reprint, München: Kern Verlag, 1986.

[Hofman] *Tvůrce české scény Vlastislav Hofman – životní dílo*. Exh. cat. Prague: Umělecká beseda, 1948.

[Hofman] Hlaváček, Luboš, ed. *Vlastislav Hofman: 50 let výtvarné tvorby*. Exh. cat. Prague: Svaz československých výtvarných umělců, 1960.

Honisch, Dieter, and Ursula Prinz, eds. *Tendenzen der Zwanziger Jahre: 15. Europäische Kunstausstellung Berlin*. Exh. cat. Berlin: Dietrich Reimer Verlag, 1977.

Hošková, Simeona, ed. *Kubistická Praha: 1909–1925, Průvodce/Cubist Prague: 1909–1925, A Guidebook*. Prague: Středo-evropská galerie a nakladatelství, 1995.

Howard, Jeremy. *Art Nouveau: International and National Styles in Europe*. Manchester and New York: Manchester University Press, 1996.

Hungarian Art: The Twentieth-Century Avant-Garde. Exh. cat. Bloomington: Indiana University Art Museum, 1972.

The Hungarian Avant-Garde: The Eight and the Activists. Exh. cat. London: The Arts Council of Great Britain, 1980.

Hungarian Constructivism 1918–1936. Exh. cat. Tokyo: The Watari Museum of Contemporary Art, 1994.

Ilk, Michael. *Brancusi, Tzara, und die rumänische Avantgarde*. [Bochum]: Museum Bochum and Kunsthal Rotterdam, [1997].

Jakimowicz, Irena, *Witkacy, Chwistek, Strzemiński. Myśli i obrazy*, Warsaw: Arkady, 1978.

———. *Formiści*. Warsaw: Muzeum Narodowe w Warszawie, 1989.

Janecek, Gerald and Toshiharu Omuka, eds. *The Eastern Dada Orbit: Russia, Georgia, Unkaine, Central Europe and Japan. From Crisis and the Arts: The History of Dada* series, ed. Stephen C. Foster, vol. 4. New York: G. K. Hall, 1998.

[Janák] Benešová, Marie. *Pavel Janák*. Prague: Nakladatelství českoskovenských výtvarných umělců, 1959.

[Janák] Herbenová, Olga, and Jiří Šetlík, eds. *Pavel Janák: Vybrané stati autorovy a příspěvky ze semináře ke stému výročí architektova narození*. Prague: Uměleckoprůmyslové muzeum, 1985.

[Janák] Herbenová, Olga, and Vladimír Šlapeta, eds. *Pavel Janák: 1882–1956: Architektur und Kunstgewerbe*. Exh. cat. Prague: Kunstgewerbe Museum; Wien: Technische Universität, 1984.

[Janco] *Marcel Iancu Centenary 1895–1995*. Exh. cat. Ed. Simetria şi Meridiane. Bucharest, 1996.

[Janco] Seiwert, Harry. *Marcel Janco*. Frankfurt am Main: Verlag Peter Lang, 1993.

[Janco] Şerban, Geo. *Marcel Iancu. Întâlnire la Ein Hod*, in Secolul 20. Bucharest, 1979.

[Jarema] Ilkos, Barbara. *Maria Jarema 1908–1958*. Wrocław: Muzeum Narodowe we Wrocławiu, 1998.

Jaroslava Hatláková, Jindřich Hatlák. Exh. cat. Brno: The Moravian Gallery, 1991.

Jevtović, Jevta, ed. *Zenit i avangarda 20ih godina / Zenit and the Avant-Garde of the Twenties*. Exh. cat. Beograd: Narodni muzej, 1983.

Jovanov, Jasna. *Demistifikacija apokrifa. Dadaizam na jugoslovenskim prostorima 1920–1922*. Novi Sad: Apostrof, 1999.

[Kádár] *Béla Kádár 1877–1956: Retrospective Exhibition: A Leading Expressionist in the Twenties of "Der Sturm" in Berlin*. Exh. cat. [New York]: Paul Kovesdy, 1985.

Kállai, Ernst. *Neue Malerie in Ungarn*. Leipzig: Klinkhardt & Biermann, 1925.

———. *Ernst Kállai: Schriften in deutscher Sprache, 1920–1925*. Budapest: Argumentum, 1999.

Kändler, Klaus, Helga Karolewski, and Ilse Siebert, eds. *Berliner Begegnungen: Ausländische Künstler in Berlin 1918 bis 1933: Aufsätze–Bilder–Dokumente*. Berlin: Dietz Verlag, 1987.

Kassák, Lajos. *MA, Kassák*. Basel: Editions Panderma Carl Laszlo, 1968.

Kassák 1887–1967 (Arion 16). Budapest: Corvina, 1988.

Lajos Kassák: Lasst Uns Leben in Unserer Zeit: Gedichte Bilder Und Schriften Zur Kunst. Budapest: Corvina, 1989.

Lajos Kassák: Retrospective Exhibition. Exh. cat. New York: Matignon Gallery, 1984.

Lajos Kassák y la vanguardia húngara. Exh. cat. Valencia: IVAM Institut Valencia d'Art Modern, 1999.

[Kassák] Csaplár, Ferenc. *Kassák Lajos Az Európai Anantgárd mozgalmakban 1916–1928*. Budapest: Kassák Múzeum És Archívum, 1994.

Kassák, Ludwig, and László Moholy-Nagy. *Buch neuer Künstler*. Vienna: Ma, 1922. Reprint, Budapest: Corvina Verlag/Magyar Helikon, 1977.

Katalog Wystawy Nowej Sztuki. Łódź: Muzeum Sztuki, Łódź, 1993.

Kersting, Hannelore, Bernd Vogelsang, and Helmut Grosse, eds. *Raumkonzepte: Konstruktivistische Tendenzen in Bühnen- und Bildkunst 1910–1930*. Exh. cat. Frankfurt am Main: Städtische Galerie im Städelschen Kunstinstitut, [n.d.].

[Kertèsz] Kincses, Károly, et al. *A Kertèsz: 1984–1994*. Budapest: Museé hongrois de la Photographie–Editions Pelikán, 1994.

Kincses, Károly. *Photographers: Made in Hungary*. Milan: Actes Sud/Motta, 1998.

Kish, John, ed. *The Hungarian Avant-Garde 1914–1933*. Storrs, Conn.: William Benton Museum of Art, University of Connecticut, 1987.

Kłak, Tadeusz, *Czasopisma awangardy*, vol. 1: 1919–1931, vol. 2: 1931–1939. Wrocław, Warsaw, Cracow, Gdańsk: Zakład Narodowy im. Ossolińskich, 1978.

[Klien] Neuburger, Susanne. *Erika Giovanna Klien 1900–1957*. Exh. cat. Vienna: Museum moderner Kunst, 1987.

Knoll, Hans, Ed. *Die zweite Öffentlichkeit: Kunst in Ungarn im 20. Jahrhundert*. Dresden: Verlag der Kunst, 1999.

[Kobro] Jedliński, Jaromir, ed. *Katarzyna Kobro, 1898–1951*. Exh. cat. Mönchengladbach: Städtisches Museum Abteiberg; Cologne: Edition Wienand, 1991.

[Kobro] Ładnowska, Janina, and Zenobia Karnicka, eds. *Katarzyna Kobro, 1898–1951. W setną rocznicę urodzin*. Exh. cat. Łódź: Muzeum Sztuki, 1998. English ed. *Katarzyna Kobro, 1898–1951*. Exh. cat. Leeds: Henry Moore Institute, 1999.

[Kobro] Zagrodzki, Janusz. *Katarzyna Kobro i kompozycja przestrzeni*, Warsaw: Państwowe Wydawnictwo Naukowe, 1984.

Kolekcja: sztuki XX w., w Muzeum Sztuki w Łodzi. Exh. cat. Warsaw: Galeria Zachęta, 1991.

Konstantinovic, Rade. *Bice i jezik u iskustvu srpskih pesnika dvadesetog veka*. Belgrade: Nolit, 1983.

Jan Konůpek (1883–1950) Zeichnungen und Graphik. Exh. cat. Bochum: Museum Bochum, 1980.

Jan Konůpek (1883–1950) Puotník K Nekonečnu. Prague: Galerie hlavního města, 1998.

Körner, Éva. *Die ungarische Kunst zwischen den beiden Weltkriegen*. Dresden: Verlag der Kunst, VEB, 1974.

Koščević, Želimir. *Tendencije avangarde u hrvatskoj modernoj umjetnosti 1919–1941*. Exh. cat. Zagreb: Galerija suvremene umjetnosti, 1982.

Kowalska, Bożena. *Polska Awangarda Malarska: Szanse i mity 1945–1980*. Warsaw: Państwowe Wydawnictwo Naukowe, 1988.

[Kramář] Olga Urhová and Vojtěch Lahoda. *Vincenc Kramář: From Old Masters to Picasso.* Exh. cat. Prague: National Gallery, 2000.

Edward Krasiński 3/1996. Exh. cat. Kunsthalle Basel. Basel: Schwabe Verlag, 1996.

Krecic, Peter. *Slovenski konstruktivizem in njegovi evropski okviri.* Maribor: Založba Obzorja, 1989.

Krimmel, Bernd, ed. *Tschechische Kunst 1878–1914: auf dem Weg in die Modern.* Exh. cat. 2 vols. Darmstadt: Mathildenhöhe, 1984.

———. *Tschechische Kunst der 20er + 30er Jahre: Avantgarde und Tradition.* Exh. cat. Darmstadt: Mathildenhöhe, 1988.

Krzysztofowicz-Kozakowska, Stefania. *Polish art nouveau.* Cracow: Kluszczyński, 1999.

Kubicki, Juliane. *Stanisław Kubicki* (typescript). Berlin, 1986.

[Kubicki] *Die Jahre der Krise: Margarete Kubicka und Stanisław Kubicki 1918–1922.* Berlin: Berlinische Galerie Museum für Moderne Kunst, Photographie und Architektur, 1992.

Kubišta, Bohumil. *Předpoklady slohu: Úvahy – Kritiky – Polemiky: Soubor statí z let 1909–1914.* Ed. František Kubišta. Prague: O. Girgal, 1947.

Kubišta, Bohumil. *Korespondence a úvahy.* Ed. František Čeřovský a František Kubišta. Prague: Státní nakladatelství krásné literatury, hudby a umění, 1960.

[Kubišta] *Bohumil Kubišta 1884–1918.* Exh. cat. Prague: Národní Galerie, 1993.

[Kubišta] Kubišta, František. *Bohumil Kubišta.* Brno: František Kubišta: Prague: S. V. U. Mánes, 1940.

[Kubišta] Nešlehová, Mahulena. *Bohumil Kubišta.* 2nd ed. Prague: Národní galerie; Odeon, 1993.

Kunst im Klassenkampf: Arbeitstagung zur prolitarische-revolutionären Kunst. Berlin: Verband Bildender Künstler der DDR, 1979.

Die Kunst Osteuropas im 20. Jahrhundert in öffentlichen Sammlungen der Bundesrepublik Deutschland und Berlins (West). Exh. cat. Bochum: Museum Bochum, 1980.

[Kupka] *František Kupka.* Exh. cat. Tokyo: ADAGP; Paris: SPDA, 1994.

[Kupka] *Zwei Wegbereiter der Moderne: Frantikšek Kupka: aus der Sammlung Jan und Meda Mladek / Two Pioneers of Modern Art: Frantikšek Kupka: from the Jan und Meda Mladek Collection.* Exh. cat. Prague: České muzeum výtvarných umění, 1997.

Ładnowska, Janina, ed. *W 70 rocznicę Wystawy Nowej Sztuki, Wilno 1923/The 70th Anniversary of the New Art Exhibition, Vilnius 1923.* Exh. cat. Łódź: Muzeum Sztuki, 1993.

Lahoda, Vojtěch. *Česky kubismus.* Prague: Brana, 1996.

———, et al., eds. *Dějiny českého výtvarného umění: 1890/1938. Vol. 4/2: Umění první republiky: 1918–1938.* Prague: Academia, 1998.

Lamač, Miroslav. *Die Bildende Kunst Der Tschechoslowakei.* Prague: Orbis, 1958.

———. *Osma a Skupina výtvarných umělců (1907–1917).* Prague: Odeon, 1988.

———. *Cubisme Tchèque.* Exh. cat. Paris: Flammarion, 1992.

Lang, Lothar. *Konstruktivismus und Buchkunst.* Leipzig: Edition Leipzig, 1990.

Larvová, Hana, ed. *Umělecké sdružení Sursum 1910–1912.* Prague: Galerie hlavního města Prahy, Památník národního písemnictví v Praze, 1996.

A László Károly-Gyűjtemény: Részletek egy bázeli műgyűjteményből / Die Carl-Laszlo-Sammlung: Teil einer Kunstsammlung aus Basel. Exh. cat. Budapest: Budapesti Történeti Múzeum Fővárosi Képtár, 1996.

Lawniczakowa, Agnieska. *Fin de Siècle in Polen. Poolse schilderkunst, 1890–1918, uit de collectie vanhet National Museum Poznań.* Zwolle: Waanders, [1996].

———, ed. *The Naked Soul: Polish Fin-de-Siècle Paintings from the National Museum, Poznań.* Exh. cat. Raleigh: North Carolina Museum of Art, 1993.

A Legacy Envisioned: A Century of Modern Art to Celebrate Hungary's 110 years, 1896–1996. Exh. cat. Washington, D.C.: The World Bank, 1996.

Lesnikowski, Wojciech. *East European Modernism: Architecture in Czechoslovakia, Hungary and Poland Between the Wars, 1919–1939.* New York: Rizzoli, 1996.

Liskar, Elisabeth, ed. *Der Zugang zum Kunstwerk: Schatzkammer, Salon, Ausstellung, "Museum".* Wien: Hermann Böhlaus, 1986.

Lissitzky, El. *El Lissitzky, 1890–1941*. Exh. cat. Cambridge: Harvard University Art Museums, Busch-Reisinger Museum, 1987.

[Lissitzky] Nobis, Norbert, et al. *El Lissitzky 1890–1941: Retrospektive*. Exh. cat. Hannover: Sprengel Museum; Frankfurt am Main: Ullstein, 1988.

[Lissitzky] Tupitsyn, Margarita. *El Lissitzky: Jenseits der Abstraktion: Fotografie, Design, Kooperation*. München: Schirmer/ Mosel, 1999.

Lukacs, John. *Budapest 1900: A Historical Portrait of a City and Its Culture*. New York: Grove, 1988.

Łukaszewicz, Piotr. *Zrzeszenie artystów plastyków "Artes", 1929–1935*, Wrocław, Warsaw, Cracow, Gdańsk: Zakład Narodowy im. Ossolińskich, 1975.

———, and Jerzy Malinowski, eds. *Ekspresjonizm w sztuce polskiej*. Exh. cat. Wrocław: Muzeum Narodowe, 1980.

Ma: aktivista folyóirat. Reprint, Budapest: Akadémiai Kiadó, n.d.

Machedon, Luminiţa, and Ernie Scoffham. *Romanian Modernism: The Architecture of Bucharest, 1920–1940*. Cambridge: MIT Press, 1999.

Macková, Olga. *Art tchèque du XXe siècle: choix d'œuves illustrant quelques aspects de son évolution*. Geneva: Musée Rath, 1970.

Madžarska Avangarda Osmorica i Aktivisti. Osijek: Galerija Likovnih Unjetnosti, 1982.

A Magyar grafika külföldön: BÉCS 1919–1933. Gyula: Kner Nyomda, 1982.

Malinowski, Jerzy. *Grupa "Jung Idysz" i żydowskie środowisko "nowej sztuki" w Polsce, 1918–1923*. Warsaw: Polska Adademia Nauk, Instytut Sztuki, 1987.

———. *Sztuka i nowa wspólnota: Zrzesenie Artystów Bunt 1917–1922*. Wrocław: Wiedza o Kulturze, 1991.

———. *Malarstwo i rzeźba Żydów polskich w XIX i XX wieku*. Warsaw: Wydawnictwo Naukowe PWN, 2000.

Mansbach, Steven A., ed. *Standing in the Tempest: Painters of the Hungarian Avant-garde, 1908–1930*. Exh. cat. Santa Barbara: Santa Barbara Museum of Art, 1991.

———. *Modern Art in Eastern Europe: From the Baltic to the Balkans, ca. 1890–1939*. Cambridge and New York: Cambridge University Press, 1999.

Margolius, Ivan. *Cubism in Architecture and the Applied Arts: Bohemia and France 1910–1914*. Newton Abbot, Devon and North Pomfret, Vermont: David & Charles, 1979.

Masák, Miroslav, Rostislav Švácha, and Jindřich Vybiral. *The Trade Fair Palace in Prague*. Prague: Narodni Galerie v Praze, 1995.

Mattis-Teutsch, Hans. *Ideologia artei*. Bucharest: Kriterion, 1975.

[Mattis-Teutsch]. Bajkay, Éva, et. al., *Mattis Teutsch and Der Blaue Reiter*. Exh. cat. Hungarian National Gallery, Budapest: MissionArt Gallery, 2001.

[Mattis-Teutsch]. Banner, Zoltan. *Mattis-Teutsch*. Editura Meridiane, 1970.

[Mattis-Teutsch]. Deac, Mircea. *Mattis-Teutsch şi realismul constructiv*. Cluj: Editura Dacia, 1985.

Maxy, Liana. *Nucleul magic*. Ramat Gan (Israel): Integral, 1986.

M. H. Maxy. Exh. cat. Bucharest: Dalles, 1965.

M. H. Maxy. Exh. cat. Bucharest: Muzeul de artă al R. S. România, 1974.

[Maxy] Oprea, Petre. *M. H. Maxy*. Bucharest: Meridiane, 1984.

Meisterwerke Der Ungarischen Moderne: Ausstellung der haputstädtischen Gemäldegalerie (Ungarn) im Schloss Plankenwarth bei Graz. Exh. cat. 1989.

Mészáros, Julia, et. al. *Közép-Európai Avantgárd Rajz- és Grafika: 1907–1938 / Central European Avant-Garde Drawing and Graphic Art: 1907–1938*. Exh. cat. Városi Művészeti Múzeum Képtára, Győr, 2001.

Meyer, Raimund, ed. *Dada Global*. Zurich: Limmat Verlag, 1994.

[Michăilescu] Oprea, Petre. *Corneliu Michăilescu*. Bucharest: Meridiane, 1982.

Mierau, Fritz, ed. *Russen in Berlin: Literatur, Malerei, Theater, Film 1918–1933*. 2nd ed. Leipzig: Verlag Philipp Reclam, 1987.

Mincu, Marin. *Avangarda literară românească*. Bucharest: Minerva, 1983.

Modern Művészet Új Szerzemények a Grafikai Gyűjteményében. Exh. cat. Szépművészeti Múzeum. Budapest: The Museum of Fine Arts, 1993.

Moeller, Magdalena M., ed. *Die abstrakten Hannover: Internationale Avantgarde 1927–1935.* Exh. cat. Hannover: Sprengel Museum, 1987.

Moholy-Nagy, László. *László Moholy-Nagy.* [Stuttgart]: Verlag Gerd Hatje, 1991.

In Focus László Moholy-Nagy: Photographs from The J. Paul Getty Museum. Malibu: The J. Paul Getty Museum, 1995.

László Moholy-Nagy: From Budapest to Berlin 1914–1923. Exh. cat. Newark: The University Gallery, University of Delaware, 1995.

[Moholy-Nagy] David, Catherine, et al. *László Moholy-Nagy.* Exh. cat. Musée Cantini Marseille. Marseille: Musées de Marseille, 1991.

[Moholy-Nagy] Passuth, Krisztina. *Moholy-Nagy.* London: Thames and Hudson, 1985.

László Moholy-Nagy, László Peri: Zwei Künstler der ungarischen Avantgarde in Berlin 1920–1925. Exh. cat. Bremen: Graphisches Kabinett; Kunsthandel Wolfgang Werner KG, [1987].

Moravánszky, Ákos. *Competing Visions: Aesthetic Invention and Social Imagination In Central European Architecture, 1867–1918.* Cambridge: The MIT Press, 1998.

[Mucha]. Arwas, Victor, et al. *Alphonse Mucha: The Spirit of Art Nouveau.* Alexandria, CA: Art Services International, 1998.

Müller, Lars, ed. *Vešč objet gegenstand.* Reprint, Baden: Verlag Lars Müller, 1994.

František Muzika (1900–1974): obrazy, kresby, scénické návrhy, knižní grafika. Exh. cat. Prague: Národní Galerie, 1981.

[Nacht-Samborski] Gołąb, Maria. *Artur Nacht-Samborski 1898–1974.* Poznań: Muzeum Narodowe w Poznaniu, 1999.

Nakov, Andrei B. *Abstrait/concret: art non-objectif russe et polonais.* Paris: Transédition, 1981.

Nebeský, Václav. *L'art moderne tchécoslovaque (1905–1933).* Paris: F. Alcan, 1937.

Nerdinger, Winfried. *Rudolf Belling und die Kunstströmungen in Berlin 1918–1923: mit einem Katalog der plastischen Werke.* Berlin: Deutscher Verlag für Kunstwissenschaft, 1981.

Nezval, Vítězslav. *Abeceda: Taneční komposice: Milča Mayerová Praha 1926.* Prague: Torst, 1993.

Nyolcak És Aktivisták. Exh. cat. [Budapest]: Magyar Nemzeti Galéria, Janus Pannonius Múzeum, 1981.

Olschowsky, Heinrich. *Der Mensch in den Dingen: Programmtexte und Gedichte der Krakauer Avantgarde.* Leipzig: Verlag Philipp Reclam, 1986.

Padrta, Jiří, ed. *Osma a Skupina výtvarných umělců. Teorie, kritika, polemika.* Prague: Odeon, 1992.

Pană, Sașa. *Antologia literatura română de avangardă.* Bucharest: Editura pentru literatură, 1969.

———. *Născut în '02.* Bucharest: Minerva, 1973.

Paris-Prague 1906–1930. Exh. cat. Paris: Musée National d'Art Moderne, 1966.

Paryż i artyści polscy, Wokół E.-A. Bourdelle'a 1900–1918. Exh. cat. Warsaw: Muzeum Narodowe w Warsawie, 1997.

Passuth, Krisztina. *A Nyoclak Festészete.* Budapest: Corvina, 1967.

———. *Magyar művészek az európai avantgarde-ban : a kubizmustól a konstruktivizmusig 1919–1925.* Budapest: Corvina, 1974.

———. *Les avant-gardes de l'Europe centrale 1907–1927.* Paris: Flammarion, 1988.

———. *Avantgarde Kapcsolatok: Prágától Bukarestig, 1907–1930.* Budapest: Balassi Kiadó, 1998.

———, and Julia Szabó, eds. *L'Art in Hongrie 1905–1930: art et révolution.* Exh. cat. Saint-Étienne: Musée d'art et d'industrie, 1980.

Pavel, Amelia. *Pictura românească interbelică.* Bucharest; Meridiane, 1996.

[Pešánek] Zemánek, Jiří. *Zdeněk Pešánek, 1896–1965.* Exh. cat. Prague: Národní galerie ve spolupráci s Gema art, 1997. With English summaries.

Pirovano, Carlo, ed. *Budapest 1890–1919: l'anima e le forme.* Exh. cat. Milano: Gruppo Editoriale Electa, 1981.

Polish Constructivism 1923–1936 from the Muzeum Sztuki, Łodź. Exh. cat. Washington, D.C.: The Board of Governors of the Federal Reserve System and the National Bank of Poland, 1993.

Polish Painting of the Turn of the Nineteenth and Twentieth Centuries from the Collection of the National Museum of Poznań. Poznań: National Museum of Poznań, 1993.

Pollakówna, Joanna. *Formiści.* Wrocław, Warsaw, Cracow, Gdańsk: Zakład Narodowy im. Ossolińskich, 1972.

——. *Malarstwo polskie między wojnami, 1918–1939,* Warsaw: Auriga, 1982.

Polnische Malerei und Graphik in den Jahren 1918–1939. Rostock: Kunsthalle Rostock, 1978.

Polské Malířství: Přelomu 19. A 20. Století, ze sbírek polských muzeí. Prague: Šternberský Palác Kvéten Červen, 1984.

Pomajzlová, Alena, Dana Mikulejská, and Juliana Boublíková, eds. *Expresionismus a České umění.* Exh. cat. Prague: Národní galerie, 1994.

[Ponc] Jaromír Paclt. *Miroslav Ponc. Neznámá kapitola z dějin meziválečné umělecké avantgardy.* Prague: Supraphon, 1990.

Pop, Ion. *Dada Rumanien, in Tendenzen der Zwanziger Jahre.* Exh. cat. Berlin: Dietrich Reimer Verlag, 1977.

——. *Avangarda în literatura română.* Bucharest: Minerva, 1990.

Porębski, Mieczysław. *Interregnum. Studia z historii sztuki polskiej XIX i XX wieku,* Warsaw: Państwowe Wydawnictwo Naukowe, 1974.

Praesens N1: Kwartalnik Modernistów, Warszawa. Łódź: Muzeum Sztuki w Łodzi, 1994.

Prague 1900–1938: capitale secrète des avant-gardes. Exh. cat. Dijon: Musée des Beaux-Arts; Paris: Diffusion Seuil, 1997.

Prague Art Nouveau: Métamorphoses d'un style. Exh. cat. Brussels: Palais des Beaux-Arts. Gent: Snoeck-Ducaju & Zoon, 1998.

Prahl, Roman, and Lenka Bydžovská. *Freie Richtungen Die Zeitschrift der Prager Secession und Moderne.* Prague: Verlag Torst, 1993.

Presences polonaises. L'art vivant autour du museé. Exh. cat. Paris: Centre Georges Pompidou, 1983.

Primus, Zdenek, ed. *Tschechische Avantgarde 1922–1940: Reflexe europäischer Kunst und Fotographie in der Buchgestaltung.* Hamburg: Kunstverein in Hamburg, 1990.

Prinz, Ursula, and Eberhard Roters, eds. *Berlin Konstruktiv.* Exh. cat. Berlin: Berlinische Galerie, 1981.

Iwan Puni, 1892–1956. Exh. cat. Musée d'art moderne de la ville de Paris. Berlin: Berlinische Galerie; Stuttgart: Hatje, 1993.

[Puni] Roters, Eberhard, and Hubertus Gassner. *Iwan Puni: synthetischer Musiker.* Berlin: Berlinische Galerie, 1992.

Quattrocchi, Luca. *La Sécession à Prague.* Paris: Gallimard, 1992.

Rathke, Ewald. *Konstruktive Malerei 1915–1930.* Hanau: Peters, 1967.

Rochard, Patricia, ed. *Csárdás im Quadrat: Ungarische Avantgarde (1919–1930) und traditionelle Baurenkultur.* Exh. cat. Mainz: Boehringer Ingelheim/Internationale Tage; Verlag Hermann Schmidt, 1995.

[Rössler] Birgus, Vladimír, ed. *Jaroslav Rössler.* Prague: Torst, 2001.

[Rössler] Birgus, Vladimír, Jan Mlčoch, Karel Srp, eds. *Jaroslav Rössler: Fotografie, koláže, kresby/Photographs, Collages, Drawings.* Exh. cat. Prague: Uměleckoprůmyslové muzeum, 2001.

[Rössler] Fárová, Anna, ed. *Jaroslav Rössler.* Exh. cat. Brno: Dům umění města Brna, 1975.

Roters, Eberhard, ed. *Avantgarde Osteuropa 1910–1930.* Exh. cat. Berlin: Deutsche Gesellschaft für Bildende Kunst, 1967.

Rousová, Hana. *Lücken in der Geschichte 1890–1938: polemischer Geist Mitteleuropas Deutsche, Juden, Tschechen.* Exh. cat. Prague: Galerie hlavního města Prahy, 1994.

——, ed. *Deviace Kubismu v Čechách/ Deviationen des Kubismus in Böhmen.* Exh. cat. Cheb: Staatsgalerie der Bildenen Künste in Cheb, 1995.

Rubinger, Krystyna, ed. *Die 20er Jahre in Osteuropa/The 1920s in Eastern Europe.* Exh. cat. Cologne: Galerie Gmurzynska, 1975.

Russische und ungarische Avantgarde 1913–1925: Graphik von Malewitsch, El Lissitzky, Rodtschenko, Popowa, Rosanowa, Krutschonich, Moholy-Nagy, Péri und anderen aus dem Cabinet des estampes du Musée d'art et d'histoire, Genève. Exh. cat. Basel: Kunstmuseum Basel, 1996.

Rylska, Irena, *Katalog Zbiorów Gabinetu Grafiki Tom I: Grafika polska w latach 1901–1939.* Wrocław: Muzeum narodowe we Wrocławiu, 1983.

Rypson, Piotr. *Der Raum der Worte: Polnische Avantgarde und Künstlerbücher 1919–1990.* Exh. cat. Wolfenbüttel: Herzog August Bibliothek, 1991.

Sayer, Derek. *The Coasts of Bohemia: A Czech History.* Princeton: Princeton University Press, 1998.

Scheffran, Barbara. *Prager Jugendstil.* Dortmund: Edition Braus, 1992.

Schilling, Jürgen. *Wille zur Form: Ungegenständliche Kunst 1910–1938 in Österreich, Polen, Tschechoslowakei und Ungarn.* Exh. cat. Vienna: Hochschule für Angewandte Kunst, 1993.

Schmitt, Evmarie. *Abstrake Dada-Kunst: Versuch einer Begriffserklärung und Untersuchung der Beziehungen zur künstlerischen Avantgarde.* Münster: Lit, 1992.

Sedlářová, Jitka, ed. *Stálá expozice ceského umění 20. století / Permanent Exhibition of 20th Century Czech Art.* Brno: Moravská galerie, 1994.

[Segal] Herzogenrath, Wulf, and Pavel Liska. *Arthur Segal, 1875–1944.* Berlin: Argon, 1987.

[Seissel] Buzancic, Vlado. *Josip Seissel.* Bol: Umjetnicka galerija "Deškovic," 1989.

[Seissel] Susovski, Marijan. *Josip Seissel. Donacija Silvane Seissel.* Zagreb: Muzej suvremene umjetnosti, 1997.

Šima. Exh. cat. Paris: Musée d'Art Moderne de la Ville de Paris, 1992.

[Šíma] Pagé, Suzanne, et al., eds. *Šima: Le Grand Jeu.* Exh. cat. Paris: Musée d'Art Moderne de la Ville de Paris, 1992.

[Šíma] Šmejkal, František. *Josef Šíma.* Prague: Odeon, 1988.

Šlachta, Štefan. *Moderne Archietektur in der Slowakei 20-er und 30-er Jahre.* [Bratislava]: Architektenverein der Slowakei, 1991.

[Šlenwiński] Jaworska, Władysława. *Władysław Šlenwiński.* Warsaw: Władysława Jaworska and Krajowa Agenjca Wydawnicza, 1991.

Smith, Anthony D. *Nationalism and Modernism.* London and New York: Routledge, 1998.

Solomon Callimachi, Dida. *Amintirile domnişoarei Iulia.* Bucharest: Cartea Românească, 1976.

[Špála] Kotalík, Jiří. *Václav Špála.* Prague: Odeon, 1972.

[Špála] Matějček, Antonín. *Václav Špála.* Prague: Melantrich, 1935.

Spector, Scott. *Prague Territories: National Conflict and Cultural Innovation in Franz Kafka's Fin de Siècle.* Berkeley: University of California Press, 2000.

Spielmann, Peter, ed. *Osteuropäische Avantgarde aus der Sammlung des Museum Bochum und privaten Sammlungen.* Exh. cat. Bochum: Museum Bochum, 1988.

Stanislawski, Ryszard, and Christoph Brockhaus, eds. *Europa, Europa: das Jahrhundert der Avantgarde in Mittel- und Osteuropa.* Exh. cat. 4 vols. Bonn: Stiftung Kunst und Kultur des Landes Nordrhein-Westfalen; Kunst- und Ausstellungshalle der Bundesrepublik Deutschland, 1994.

——, and Agnieszka Lulińska, eds. *a.r. Internationale Sammlung Moderner Kunst Muzeum Sztuki, Łódź.* Rolandseck: Stiftung Hans Arp–Sophie Taeuber-Arp; Stiftung Bahnhof Rolandseck, 1989.

——, et. al., eds. *Constructivism in Poland 1923–1936: BLOK, Praesens, a.r.* Exh. cat. Łódź: Muzeum Sztuki, 1973.

Staniszewski, Mary Anne. *The Power of Display: A History of Exhibition Installations at the Museum of Modern Art.* Cambridge: Massachusetts Institute of Technology, 1998.

Stationen der Moderne. Exh. cat. Berlin: Berlinsche Galerie und Nicolaische Verlagsbuchhandlung Beuermann, 1988.

Stażewski, Henryk. *Henryk Stażewski: reliéfy z let 1967–69.* Exh. cat. Prague: Národní galerie, 1970.

[Stażewski] Kowałska, Bożena. *Henryk Stażewski.* Warsaw: Arkady, 1985.

[Stażewski] Ładnowska, Janina, and Zenobia Karnicka, eds. *Henryk Stażewski, 1894–1988. W setną rocznicę urodzin.* Exh. cat. Łódź: Muzeum Sztuki, 1994.

Steneberg, Eberhard. *Russische Kunst Berlin 1919–1932.* Berlin: Deutsche Gesellschaft für Bildende Kunst, 1969.

Stopczyk, Stanisław. *Ekspresjonizm*. Warsaw: Krajowa Agencja Wydawnicza, 1987.

Strzemiński, Władysław. *Unizm w malarstwie*. Warsaw: Bibljoteka "Praesens," 1994.

Strzemiński, 1893–1952. Materials of the conference organized by the Muzeum Sztuki in Łódź with the Władysław Strzemiński Fine Arts Academy. Łódź, November 26–27, 1993. Łódź: The Muzeum Sztuki Library, 1995.

[Strzemiński] Ładnowska, Janina, and Zenobia Karnicka, eds. *Władysław Strzemiński, 1893–1952*. W setną rocznicę urodzin. Exh. cat. Łódź: Muzeum Sztuki, 1993.

[Strzemiński] Sommer, Achim, and Volker Adolphs, eds. *Władysław Strzemiński, 1893–1952*. Kunstmuseum Bonn. Cologne: Weinand, 1994.

[Strzemiński] Turowski, Andrzej. *Władysław Strzemiński*. Exh. cat. Düsseldorf: Städtische Kunsthalle, 1980.

Strzemiński, Władysław, and Katarzyna Kobro. *L'espace Uniste: Écrits du Constructivisme Polonais*. Lausanne: L'Age d'Homme, 1977.

Strzemiński, Władysław. *Unizm w malarstwie / Unism in Painting*. Reprint, Łódź: Muzeum Sztuki, 1994.

Štyrský, Jindřich. *Každý z nás stopuje svoji ropuchu: Texty 1923–40*. Ed. Karel Srp za spolupráce Lenky Bydžovské. Prague: Thyrsus, 1996.

Štyrský a Toyen. Úvodní slovo napsal Vítězslav Nezval, doslov Karel Teige. Básně Vítězslava Nezvala. Prague: Fr. Borový, 1938.

Štyrský a Toyen 1921–1945. Exh. cat. Brno: Moravská Galerie, 1966.

[Štyrský/Toyen] Bydžovská, Lenka, and Karel Srp, eds. *Štyrský–Toyen: Artificialismus: 1926–1931*. Exh. cat. Pardubice: Východočeská galerie; Karlovy Vary: Galerie umění; Praha: Středočeská galerie, 1992.

[Štyrský/Toyen] Linhartová, Věra, and František Šmejkal, eds. *Štyrský a Toyen: 1921–1945*. Exh. cat. Brno: Moravská galerie, 1966.

Subotic, Irina. *Het tijdschrift Zenit en de verschijning van het konstructivisme: Joegoslavisch Konstructivisme 1921–1981/Die Zeitschrift Zenit und die erscheinung des Konstruktivismus, Jugoslawischer Konstruktivismus 1921–1981*. Exh. cat. Utrecht: Hedendaagse kunst, 1983; Rattingen: Stadtmuseum, 1984.

——. *Zenit i jego krag 1921–1926*. Exh. cat: Konstruktywism w Jugoslawii, Muzeum Sztuki v Lodzi/Muzeum Narodowe v Krakowe, September–October 1986 (= A Zenit ès kore. Az avantgard jugoszlaviaban. A Zenit-kor 1921–1926, Magyar Nemzeti Galeria, Budapest, December 1986–January 1987).

——. *Likovni krog revije Zenit (1921–1926)*. Ljubljana: Znanstveni inštitut Filozofske fakultete, 1995.

[Sudek] Farova, Anna. *Josef Sudek: Poet of Prague A Photographer's Life*. New York: Aperture, 1990.

Sugar, Peter F. and Ivo J. Lederer, eds. *Nationalism in Eastern Europe*. Seattle: University of Washington Press, 1969.

Šuvakovic, Miško. *Scene jezika. Uloga teksta u likovnim umetnostima. Fragmentarne istorije 1900–1920*. Exh. cat. Belgrade: ULUS, 1989.

Švácha, Rostislav. *The Architecture of New Prague 1895–1945*. Cambridge: The MIT Press, 1995.

——, ed. *Devětsil: the Czech Avant-garde of the 1920s and 30s*. Exh. cat. Oxford: Museum of Modern Art; London: Design Museum, 1990.

Svestka, Jiři, ed. *1909–1925 Kubismus in Prag: Malerei, Skulptur, Kunstgewerbe, Architektur*. Exh. cat. Düsseldorf: Der Kunstverein für die Rheinlande und Westfalen; Stuttgart: G. Hatje, 1991.

Szabadi, Judit. *Jugendstil in Ungarn: Malerei, Graphik, Plastik*. Budapest: Corvina, 1982.

——. *Art Nouveau in Hungary: Painting, Sculpture and the Graphic Arts*. Budapest: Corvina, 1989.

Szabó, Júlia. *A Magyar aktivizmus muvészete, 1915–1927*. Budapest: Corvina, [1981].

[Szczuka] Stern, Anatol, and Mieczysław Berman, eds. *Mieczysław Szczuka*, Warsaw: Wydawnictwo Artystyczne i Filmowe, 1965.

Wacław Szpakowski (1883–1973): The Infinity of the Line. Exh. cat. Warsaw: Muzeum Narodowe w Warszawie, 1992.

Sztuka dwudziestolecia międzywojennego. Materiały Sesji Stowarzyszenia Historyków Sztuki, Warszawa, październik 1980. Warsaw: Państwowe Wydawnictwo Naukowe, 1982.

Sztuka lat trzydziestych. Materiały Sesji Stowarzyszenia Historyków Sztuki, Niedzica, kwiecień 1988. Warsaw: Stowarzyszenie Historyków Sztuki, 1991.

Tank. Reprint. Ljubljana: Mladinska knjiga, 1987.

Tank! Slovenska Zgodovinska Avantgarda. Exh. cat. Ljubljana: Moderna galerija, 1998.

[Tatlin] Subotic, Irina. *Vladimir Tatlin. Leben, Werk, Wirkung, Ein internationales Symposium.* Cologne: DuMont Verlag, 1993.

Teige, Karel. *Modern Architecture in Czechoslovakia and Other Writings.* Los Angeles: Getty Research Institute, 2000.

——. *Výbor z díla I. Svět stavby a básně. Studie z dvacátých let.* Ed. Jiří Brabec, et al. Prague: Československý spisovatel, 1966.

——. *Výbor z díla II. Zápasy o smysl moderní tvorby. Studie z třicátých let.* Ed. Jiří Brabec, et al. Prague: Československý spisovatel, 1969.

——. *Výbor z díla III. Osvobozování života a poezie. Studie ze čtyřicátých let.* Ed. Jiří Brabec, et al. Prague: Aurora; Československý spisovatel, 1994.

Karel Teige: Surrealistické koláže, 1935–1951: ze sbirek Památnike národního pisemnictvi v Praz. Prague: Edice Detail, 1994.

[Teige] Cisarová, Hana, and Manuela Castagnara Codeluppi, eds. *Karel Teige: Architecture and Poetry.* Bologna: Cipia, 1993.

[Teige] Codeluppi, Manuela Castagnara, ed. *Karel Teige: Architettura, Poesia: Praga 1900–1951.* Exh. cat. Milano: Electa, 1996.

[Teige] Dluhosch, Eric, and Rostislav Švácha, eds. *Karel Teige 1900–1951: L'Enfant Terrible of the Czech Modernist Avant-Garde.* Cambridge.: MIT Press, 1999.

[Teige] Srp, Karel, ed. *Karel Teige 1950–1951.* Exh. cat. Prague: Galerie hlavního města Prahy, 1994.

Tešic, Gojko, ed. *Zli volšebnici. Polemike i pamfleti.* Beograd–Novi Sad: Slovo ljubve-Beogradska knjiga-Matica srpska, 1983.

——. *Antologija srpske avangardne pripovetke.* Novi Sad: Bratstvo i jedinstvo, 1990.

——. *Srpska avangarda u polemickom kontekstu (dvadesete godine).* Belgrade-Novi Sad: Institut za književnost i umetnost–Matica srpska, 1991.

——. *Antologija pesništva srpske avangarde (1902–1934).* Novi Sad: Svetovi, 1993.

[Toyen] Bischof, Rita, ed. *Toyen: Das malerische Werk.* Frankfurt am Main: Neue Kritik, 1987.

[Toyen] Breton, André, Jindrich Heisler, and Benjamin Péret. *Toyen.* Paris: Édition Sokolova, 1953.

Toman, Jindřich. *The Magic of a Common Language: Jakobson, Mathesius, Trubetzkoy, and the Prague Linguistic Circle.* Cambridge: The MIT Press, 1995.

[Tomljenović] Koščević, Želimir. *Ivana (Koka) Tomljenović: Bauhaus–Dessau 1929–1930.* Exh. cat. Zagreb: Galerije grada Zagreba, studio galerije suvremene umjetnosti, 1983.

[Toyen] Holten, Ragnar von. *Toyen: En surrealistisk visionär.* Köping: Lindfors förlag, 1984.

[Toyen] Srp, Karel. *Toyen.* Trans. Karolina Vočadlo. Prague: Argo; City Gallery Prague, 2000.

Treca decenija. Konstruktivno slikarstvo. Exh. cat. Belgrade: Muzej savremene umetnosti, 1967.

Treptow, Kurt W. *A History of Romania.* New York: East European Monographs; Iaşi: The Center for Romanian Studies, 1996.

Turowski, Andrzej. *Konstruktywizm polski. Próba rekonstrukcji nurtu (1921–1934).* Wrocław, Warsaw, Cracow, Gdańsk, Lódź: Zakład Narodowy im. Ossolińskich, 1984.

——. *Existe-t-il un art de l'Europe de l'Est?: utopie & idéologie.* Paris: Editions de la Villete, 1986.

——. *Awangardowe marginesy.* Warsaw: Instytut Kultury, 1998.

——. *Budowniczowie świata. Z dziejów radykalnego modernizmu w sztuce polskiej.* Cracow: Universitas, 2000.

Tutnjevic, Siniša, and Vidosava Golubovic, eds. *Srpska avangarda u periodici/Serbian Avant-garde in Periodicals*. Novi Sad and Belgrade: Matica srpska; Institut za knjizevnost i umetnost, 1996.

Tvrdošíjní. Exh. cat. Ed. Karel Srp. Prague: Galerie hlavního města Prahy, 1986.

Tvrdošíjní a hosté. 2. část. Užité umiění. Malba, kresba. Exh. cat. Ed. Karel Srp. Prague: Galerie hlavního města Prahy, 1987.

Tvrdošíjní: z.část a hosté. Exh. cat. Prague: Galerie hlavního města Prahy, 1997.

Twentieth-Century Hungarian Art: Paintings, Sculpture and Graphic Works. Exh. cat. London: The Arts Council of Great Britain, 1967.

Two Centuries of Hungarian Painters 1820–1970: A Catalogue of the Nicolas M. Salgó Collection. Washington, D.C.: The American University Press, 1991.

Uchalová, Eva. *Czech Fashion 1918–1919: Elegance of the Czechoslovak First Republic*. Prague: Olympia, and the Museum of Decorative Arts in Prague, 1996.

[Uitz] Bajkay, Éva R. *Uitz Béla*. Budapest: Gondolat Könyvkiadó, 1974.

El Ultraísmo y las artes plásticas. Exh. cat. Valencia: Instituto Valenciano de Arte Moderno, 1996.

Unerwartete Begegnung: Lettische Avantgarde 1910–1935: Der Beitrag Lettlands zur Kunst der Europäischen Moderne. Exh. cat. Neuen Gesellschaft für Bildende Kunst. Köln: Druck- & Verlagshaus Wiennand, 1990.

[Váchal] Ajvaz, Michal, et al. *Josef Váchal*. Prague: Argestea, 1994.

Marina Vanci-Perahim. *Le Concept de modernisme et d'avant-garde dans l'art roumain entre les deux guerres*. Thèse de doctorat, Ecole Pratique des Hautes Etudes, Paris, 1972.

Vegesack, Alexander von, ed. *Tschechischer Kubismus: Architektur und Design 1910–1925*. Exh. cat. Weil am Rhein: Vitra Design Museum, 1991.

———. *Czech Cubism: Architecture, Furniture, and Decorative Arts 1910–1925*. Exh. cat. Princeton: Princeton Architectural Press, 1992.

Vergangene Zukunft: Tschechische Moderne 1890 bis 1918. Exh. cat. Stuttgart: G. Hatje, 1993.

Versuch einer Rekonstruktion: Internationale Ausstellung Revolutionärer Künstler 1922 in Berlin. Berlin: Neuer Berliner Kunstverein, 1975.

Vianu, Tudor. *Fragmente moderne*. Bucharest: Cultura Națională, 1925

Vision and Unity: Stremiński 1893–1952 and 9 contemporary Polish artists/Strzemiński, 1893–1952, en 9 hedendaagse Poolse kunstenaars. Exh. cat. Łodź: Museum Sztuki; Apeldoorn: Van Reekum Museum, 1989.

Voices of Freedom: Polish Women Artists and the Avant-Garde. Washington, D.C.: National Museum of Women in the Arts, 1991.

Völgyes, Iván, ed. *Hungary in Revolution, 1918–19: Nine Essays*. Lincoln: University of Nebraska Press, 1971.

Vrecko, Janez, and Srecko Kosovel. *Slovenska zgodovinska avantgaarda in zenitizem*. Maribor: Znamenja, Založba Obzorja, 1986.

[Wauer] Laszlo, Carl. *William Wauer*. Basel: Editions Panderma, 1979.

Andor Weininger: von Bauhaus zur Konzeptuellen Kunst. Stuttgart: Edition Cantz, 1990.

Wiese, Stephan von, ed. *Ungarische konstruktive Kunst*. Exh. cat. Düsseldorf: Kunstmuseum Düsseldorf, 1979.

[Witkiewicz] Benedyktowicz, Zbigniew, ed. *Malinowsky, Witkacy: fotografia*. Exh. cat. Special issue of: "Konteksty: polska, sztuka, ludowa: antropologia, kultury, etnografia, sztuka." Warsaw: Polska Akademia Nauk, Instytut Sztuki, 2000.

[Witkiewicz] Franczak, Ewa, and Stefan Okołowicz, eds. *Przeciw nicości: Fotografie Stanisława Ignacego Witkiewicza/Against Nothingness: Stanisław Ignacy Witkiewicz's Photography*. Cracow: Wydawnictwo Literackie, 1986.

[Witkiewicz] Harten, Jürgen, and Ryszard Stanisławski, eds., *Hommage a Stanisław Ignacy Witkiewicz* Exh. cat. Düsseldorf: Städtische Kunsthalle, 1980.

[Witkiewicz] Immisch, T.O., et. al. *Witkacy: Metaphysische Portraits*. Exh. cat. Fotomuseum im Münchner Stadtmuseum. Leipzig: Connewitzer Verlagsbuchhandlung, 1997.

[Witkiewicz] Jakimowicz, Irena. *Witkacy Maralz*. Warsaw: Wydawnictwa Artystyczne I Filmowe, 1985.

[Witkiewicz] ——, Przy Współpracy, and Anny Żakiewicz. *Stanisław Ignacy Witkiewicz 1885–1939*. Exh. cat. Warsaw: Muzeum Narodowe w Warszawie, 1990.

[Witkiewicz] Micińska, Anna. *Stanisław Ignacy Witkiewicz. Życie i Twórczość*, Warsaw: Interpress, [1992].

[Witkiewicz] Piotrowski, Piotr. Metafizyka obrazu. *O teorii sztuki i postawie artystycznej Stanisława Ignacego Witkiewicza*. Poznań: Uniwersytet im. Adama Mickiewicza, 1985.

[Witkiewicz] ——. *Stanisław Ignacy Witkiewicz*. Warsaw: Krajowa Agencja Wydawnicza, 1989.

Witkiewicz, Stanisław Ignacy. *The Witkiewicz Reader*, Daniel Gerould, ed. and trans. Evanston: Northwestern University Press, 1992.

[Witkiewicz] Sztaba, Wojciech. *Gra ze sztuką. O twórczości Stanisława Ignacego Witkiewicza*, Cracow: Wydawnictwo Literackie, 1982.

[Witkiewicz] Zgodzińska-Wojciechowska, Beata, and Anna Żakiewicz, eds. *Witkacy. Kolekcja dzieł Stanisława Ignacego Witkiewicza w Muzeum Pomorza Środkowego w Słupsku*. Warsaw: Auriga, 1996.

Wittlich, Petr. *Prague: fin de siècle*. Paris: Flammarion, 1992.

Wojciechowski, Aleksander. *Polskie Życie Artystyczne w Lactach 1915–1939*. [Wrocław]: Instytut Sztuki Polskiej Akademii Nauk, 1974.

Zagrodzki, Janusz. *The Gallery of 20th-Century Polish Art (1949 guide)*. Warsaw: The National Museum in Warsaw, 1995.

——, ed. *Jan Maria Brzeski/Kazimierz Podsadecki. Z pogranicza plastyki i filmu*. Exh. cat. Łódź: Muzeum Sztuki, 1981.

[Zamoyski] Kossakowska-Szanajca, Zofia, ed. *August Zamoyski, 1893–1970: Wystawa monograficzna w stulecie urodzin artysty*. Warsaw: Muzeum Narodowe, 1993.

Zemina, Jaromír. *An Exhibition of Painting and Sculpture by Czech and French Artists at the Tate Gallery*. Exh. cat. London: Arts Council of Great Britain, 1967.

ACKNOWLEDGMENTS

This exhibition and its catalogue have become an embodiment of the international exchange and transformation that is its subject, for it is the fruition of the contributions of an ever-widening community of individuals and institutions.

This expansive process could not have been undertaken without the enthusiastic support of the Museum's director and president, Andrea L. Rich and former director Graham W. J. Beal. I am grateful to them both and to the museum's board of trustees under the direction of Walter L Weisman for their sustained support of this complex project.

The realization of this project is greatly indebted to the Art Museum Council, the National Endowment for the Arts, and the National Endowment for the Humanities for their generous sponsorship. Additional support came from the Austrian Federal Ministry for Foreign Affairs. I am grateful to Austrian Consul General Peter Launsky-Tieffenthal and Deputy Consul General Bita Rasoulian-Mahmoudi for their enthusiastic efforts in securing this funding. Mary and Roy Cullen and H. Kirk Brown III and Jill Wiltse not only lent wonderful works, but also provided support for the publications accompanying this exhibition.

As an endeavor of international exchange, *Central European Avant-Gardes* benefited greatly from an extraordinary level of support from the diplomatic community. In the spirit of the new European unity represented by our Honorary Committee (listed on page 5), the ministries, embassies, and consulates of our lender countries showed their generosity in innumerable ways by helping us make contacts and reach a wider audience. Among those to whom we are indebted are Coriolan Babeti of the Romanian Cultural Center New York; Kate Delany of the American Embassy in Warsaw; Petra Erler of the European Commission; Zdenka Gabalova, Consul General of the Czech Republic; Ivana Hlavsová of the Foreign Ministry of the Czech Republic, Pavel Jirásek of the Ministry of Culture of the Czech Republic, Monika Kalista of the Austrian Ministry of Foreign Affairs, Krysztof W. Kasprzyk, Consul General of the Republic of Poland, and former Deputy Consul General Pavel Potoroczyn; Szabolcs Kerék-Bárczy, Consul General of the Republic of Hungary; Erzsebet Szentpeteri-Koczian of the Hungarian Ministry for Cultural Heritage; Hans-Jurgen Wendler, Consul General and Joseph Beck, Deputy Consul General, the Consulate General of the Federal Republic of Germany; and Rafał Wiśniewski, Joanna Kozińska-Frybes, and Eliżbieta Jogałła of Polish Ministry of Foreign Affairs.

The genesis of this project came unexpectedly some seven years ago when, during a side trip to Prague, I found myself in Josef Gočar's splendid and freshly restored "House of the Black Madonna," overwhelmed by the Czech Cubist masterpieces that surrounded me in its first installation. I was able to return to for earnest research thanks to the Alexander von Humboldt Foundation, which provided a stipend for a residency during 1996–97 at the Kunsthistorisches Institut of the Freie Universität in Berlin, where Thomas W. Gaehtgens was a most cordial host. From this base I was able to travel throughout Central Europe visiting museums and archives. In 1998, as a Wolfsonian–Florida International University Fellow, I conducted specialized research on the wealth of related materials in the Wolfsonian Collection and library. During the summer and autumn of 1998 I was able to research the essential collections at the Muzeum Sztuki in Łódź as a result of LACMA's participation in the International Partnerships Among Museums Program of the American Association of Museums, with funding from the Bureau of Educational and Cultural Affairs of the United States Information Agency and the Samuel H. Kress Foundation. This program also allowed Muzeum Sztuki Curator, Maria Morzuch, to spend time in Los Angeles, advising on various aspects of the exhibition. The project benefited immensely

from a grant from the Trust for Mutual Understanding providing invaluable support for the travel and research of an Advisory Committee for the initial planning of the exhibition. Consisting of Kristina Passuth, Piotr Piotrowski, and Karel Srp, this committee advised and contributed to every phase of this project and its publications, and I am deeply indebted to them.

Monika Król, who joined the project in 1998, very ably assisted me in these planning meetings and became involved in virtually all aspects of researching and implementing the project, and I am grateful to her for her enthusiasm and creativity. To her I am especially indebted for the organization of the Honorary Committee.

The Center for European and Russian Studies at UCLA under the direction of Ivan T. Berend allowed this core committee to be expanded for a two-day planning colloquium in which many of the authors of the present catalogue participated: Jaroslav Andel (independent curator, New York), Éva Forgács (visiting professor, Art Center College of Design, Pasadena and UCLA), Maria Anna Harley (professor and director of the Polish Music Reference Center, USC), Michael Henry Heim (professor and chair, Slavic Languages, UCLA), Christina Lodder (professor of Art History, University of St. Andrews), Steven Mansbach (University of Maryland at College Park), Nancy Perloff (curator, Getty Research Institute), Derek Sayer (professor of Sociology, University of Alberta), and Mary Anne Staniszewski (professor, Art History, Rennselaer Polytechnic Institute), and Andrzej Turowski (University of Bourgogne in Dijon). We are especially grateful to Peter Hahn and the Bauhaus-Archiv, and Ruediger Zill of the Einstein Forum for facilitating our meetings in Berlin, as well as to Krisztina Passuth for making her private library in Budapest available to the group. We are indebted to Christoph Vitali and Hubertus Gaßner of Haus der Kunst for not only facilitating a meeting there, but also for hosting this exhibition in Munich. We thank Joachim Sartorius and Gereon Sievernich of the Berliner Festspiele for their energetic reception of this this project in Berlin.

As this project evolved through international meetings, discussions, and correspondence, our team expanded to include the authors of the present volume, each of whom has uniquely enriched the enterprise. An outgrowth of this exchange was the anthology occasioned by this exhibition, *Between Worlds: A Sourcebook of the Central European Avant-Gardes, 1910–1930*. Éva Forgács served as coeditor with me to shape the rich collection of texts amassed by Krisztina Passuth, Piotr Piotrowski, Karel Srp, Irina Subotić, Ioana Vlasiu and made consistent by Michael Heim's mastery of many of the languages involved. I am grateful to them, and to the authors of the present volume for creating a stimulating and productive esprit de corps that has added immensely to the value of the project and sense of satisfaction in participating in it.

For their help in researching and mounting this exhibition we would like to thank the following: Pierre Apraxine and Maria Umali, Gilman Paper Company Collection; Anna Baranowa of the Jagiellonian University in Cracow; Thomas Crow, Charles Salas, Wim De Witt, and Beth Guynn at the Getty Research Institute for the History of Art and Humanities; Marianne Gergely, Gyorgy Horvath, Éva Bajkay-Rosch, and Bakos Katalín of the Hungarian National Gallery in Budapest; László Beke and Krisztina Jerger at the Műcsarnok in Budapest; Mgr. Peter Beránek of the Gallery of Fine Arts in Ostrava; Mechtchild Borries-Knopp at the Villa Aurora in Berlin and Joachim Bernauer of the Villa Aurora in Los Angeles; Mirosław Borusiewicz, Jacek Ojrzyński, Krzysztof Jurecki, Zenobia Karnicka, Janina Ładnowska, Mirosława Motucka, Maria Morzuch, and Anna Saciuk-Gąsowska, Muzeum Sztuki (Art Museum) in Łódź; Kaliopi Chamonikola, Jitka Sedlářova, and Antonín Dufek

at the Moravian Gallery in Brno; Ferenc Csaplár at the Lajos Kassák Múseum in Budapest; Penelope Curtis, Henry Moore Institute in Leeds; Elena S. Danielson, Hoover Institution Archives at Stanford University; Renate Eikelmann, Bavarian National Museum in Munich; Jaroslav Fatka and Olga Malá at the Gallery of the City of Prague; Dr. Jiří Vykoukal, State Gallery of Fine Arts in Chleba, Czech Republic; Peter Fitz, Kiscelli Museum in Budapest; Edelbert Köb and Katalin Neray, Museum of Modern Art, Ludwig Foundation in Vienna and Budapest; Harald Krejci, Friedrich and Lillian Kiesler Foundation in Vienna; Dorota Folga-Januszewska and Anna Żakiewicz at the National Museum in Warsaw; Gary Garrels, the Museum of Modern Art; Barbara Gilbert at the Skirball Cultural Center in Los Angeles; Zofia Gołubiew and Stefania Krzysztofowicz-Kozakowska at the National Museum in Cracow; Mieczysław Jaroszewicz, and Beata Zgodzińska-Wojciechowska, Muzeum Pomorza Srodkowego in Słupsk; Peter Hahn, Klaus Weber, Sabine Hartmann and Elke Eckert at the Bauhaus-Archiv in Berlin; József Sárkány, Zoltán Huzàr, Orsolya Kovaćs, and Gyorgy Várkonyi at the Janus Pannonius Museum in Pécs; István Ihász at the Hungarian National Museum; Lázlo Jurecskó of Mission Art in Budapest; Ewa Kirsch, San Bernardino University Art Museum; Milan Knizak, Tomáš Vlček, Tomas Pospiszyl, and Jana Wittlichova at the National Gallery in Prague; Helena Koenigsmarková, Iva Janáková, Josef Kroudvor, and Katerina Dostalová at the Museum of Decorative Arts in Prague; Lukasz Kossowski and Janusz Odrowąż-Pieniażek of the Muzeum Literatury in Warsaw; Vojtěch Lahoda, Institute for Art History in Prague; Russell Maylone, Special Collections, Northwestern University Libraries; Jörn Merkert, Ursula Prinz, and Eva Züchner, Berlinische Galerie; Billie Milam-Weisman, Frederick R. Weisman Foundation; Stanislaw Mossakowski, Institute of Art in Warsaw; Miklos Mojzer, Szépmûvészeti Múzeum (Museum of Fine Arts); Weston Naef and Mikka Gee-Conway,

J. Paul Getty Museum; Peter Nisbet, Busch Reisinger Museum, Harvard University; Anda Rottenberg and Agnieszka Morawinska, Zachęta Gallery of Contemporary Art in Warsaw; Tomas Rybicka, Gallery of Modern Art in Hradec Králové; Angela Schneider, National Gallery in Berlin; Katja Schneider, Staatliche Galerie Moritzburg Halle, Landeskunstmuseum Sachsen-Anhalt; Peter Klaus Schuster, Staalitche Museen in Berlin; Ludvik Ševecek, State Gallery of Fine Arts in Zline; Michael Siebenbrodt and the Bauhaus Museum, Kunstsammlungen
in Weimar; Gary Smith at the American Academy in Berlin; Joanna Sosnowska, Institute of Art History at the Polish Academy of Sciences in Warsaw; Peter Spielmann at the Bochum Museum; Wojciech Suchocki and Maria Gołąb at the National Museum in Poznań; Júlia Szabó, Valeria Majoros and Gabor Patzia at the Research Institute of Art History in Budapest; Ivo Svetina at the Slovenian Theatre Museum in Ljubjana; Roxana Theodorescu and Mariana Vida at the National Museum of Art of Romania; Gyula Viga, Pest Megyei Múzeumok Igazgatósága, Ferenczy Múzeum in Szentendre; and Vít Vlnas at the Archives of the National Gallery in Prague.

Among the many individuals whose advice has added to this project, I would like to thank Rachel Adler, Jaroslav Andel, Marek Bartelik, Miklos von Bartha, Hendrik Berinson, Merrill C. Berman, Tamara Bissell, Zuzana Blüh, Gertraud and Dieter Bogner, Oliver Botar, Adam Boxer, Magda Carneci, Elizabeth Clegg, John Czaplicka, Stanislaw Czekalski, Eric Dluhosch, Nicolas Éber, Sabina Eckmann, Frantisek Frejci, Gilles Gheerbrant, Krystyna Gmurzynska, Wulf Herzogenrath, Thomas Hines, Keith Holz, Connie Homburg, Michael Ilk, Tamás and Anita Kieselbach, Henry Klein, Ryszard Kluszczynski, Paul Kovesdy, Karol Kubicki, Mojmir Kyselka, Milena B. Lamerova, Raimund Meyer, Medea Mladek, Hattula Moholy-Nagy, Levente Nagy, Petr Nedoma,

Ewa Frańczak and Stefan Okołowicz, Lenke Pap-Haulisch, Zdenek Primus, Olivier Renaud-Clement, Lutz Riester, Milton and Ingrid Rose, Hana Rousová, the late Ryszard Stanisławski, Rostislav Švácha, Jiri Svestka, Michael Szarvasy, Jindřich Toman, Joan Weinstein, Michael R. Weintraub, Wolfgang Werner, and Steve Yates.

The research and implementation of this project was a collaborative endeavor involving loans form many departments and advice from many individuals at the Los Angeles County Museum of Art. Many curatorial colleagues, including Stephanie Barron, Carol Eliel, Kevin Salatino, Robert Sobieszek, Lynn Zelevansky, and deputy director for curatorial affairs Nancy Thomas, offered advice and support. At the Robert Gore Rifkind Center for German Expressionist Studies collections librarian Susan Trauger attended to innumerable research requests while associate registrar Christine Vigiletti managed the immense complexities of loans, budgets, and shipping logistics. Our curatorial administrator Claudia Ramos energetically and efficiently managed masses of correspondence, database information, and innumerable details related to exhibition preparations. To her and her predecessors Sarah Sherman and Krishanti Wahla we are very grateful.

The initial research for the project was greatly advanced by the diligent research work and engaging dialoguing of Isabel Wünsche, research fellow at the Rifkind Center during 1995–96. Kristina Bradeanu also provided help with our research on Romania, while museum service council volunteer Martha Nelson translated Hungarian materials indefatigably over several years. Her colleague Maria Steinberg made certain that our correspondence with German institutions was conveyed with the greatest refinement. Deborah Barlow Smedstad and the staff of the Mr. and Mrs. Allen C. Balch Research Library helped find many sources, while program specialist Anne Diederich facilitated countless interlibrary loans. In the last stages of the project, Amy Walsh undertook the important task of researching and documenting the provenance of works of art included in the exhibition.

The design of this publication, at once innovative and sensitively inspired by the revolutions in book design seen in the exhibition, was created by Scott Taylor. Katherine Go helped implement this design and gracefully complemented it with her graphic components for the exhibition installation. The clarity and consistency of the diverse texts in this volume is due to Thomas Frick and his fellow editors Elizabeth Durst, Suzanne Kotz, and Sara Cody. We are indebted to Sara Cody and to Peter Huk for their research and production of the biographies in this volume. Karen Knapp coordinated the book's production, and Dianne Woo provided very thorough proofreading. Supervising photographer Peter Brenner and staff photographer Steve Oliver supplied photographic material, while Sonja Cendak obtained material from institutions far and wide. Cheryle Robertson, Julie Rosenberg and Giselle Arteaga-Johnson researched and secured copyright permissions. The scope with which this volume addresses so complex a subject is indebted to the vision and energy of Garrett White, former director of publications, and to the imaginative intelligence, resourcefulness, and diligence of his successor, managing editor Stephanie Emerson, who adeptly guided the volume through every phase its production. We are grateful to Roger Conover of MIT Press for his continual enthusiasm from the inception of this book.

The presentation and touring of this exhibition presented many complex challenges that were deftly managed by the exhibition programs department, headed by assistant director Irene Martin. Programs coordinator Christine Lazzaretto handled a myriad of details, while financial analyst Beverly Sabo helped us achieve a greater return while remaining within our budget. Assistant director

of collections management Renee Montgomery and registrar Ted Greenberg helped untangle the complexities of loan negotiations.

Art Owens, assistant vice president, operations and facility planning managed the construction of an exhibition space embodying the interchangeability of center and periphery cogently designed by Bernard Kester. We were kept on schedule for this complex endeavor by Bill Stahl, manager of construction, and his adept staff. Dale Daniel and the department of art preparation and installation installed the exhibition with great skill and care. Audiovisual expertise was provided by Elvin Whitesides and his staff.

The numerous artworks of various media—many of the national treasures from our lender countries—were given the greatest care throughout the exhibition by our accomplished team of conservators under the direction of Victoria Blyth Hill, director of conservation. Don Menveg, furniture; Sabrina Carli, John Hirx, and Maureen Russell, objects; Joe Fronek and Virginia Rasmussen, paintings; and Margot Healey and Chail Norton, paper, made sure each object was suitable and safely displayed.

The educational component was very ably organized by Elizabeth Caffry Frankel and her colleagues Karen Satzman and Margaret Pezalla-Granlund in the Education Department under the leadership of Jane Burrell. We are grateful to Karl Koehn, Juliet Koss, Juliana Maxim, and Holly Raynard for their lectures for the related art history class conducted by Monika Król. Gabriel Gössel provided invaluable Czech jazz and classical recordings for the installation. Ute Kirchhelle, director of the Los Angeles Goethe Institute, provided us with expertise for the gallery film program. Ian Birnie, director of LACMA's film department, organized a related film series.

Tom Jacobson, director of development and his successor, acting director Connie Morgan, oversaw our productive relations with donors and granting agencies. The intricate details of our proposals were ably managed and budgets skillfully crafted by director of grants Stephanie Dyas and associate director of grants Karen Benson. Keith McKeown and his team in communications and marketing including Kristen Schmidt, Bo Smith, Anne Welsbacher, and designer Sean Fay conveyed the intent and scope of our project to the public.

Los Angeles is itself incomparably diverse and hence a fitting locale for the exhibition's theme of exchange and transformation. I would like to thank Susan Annett, with whom I share a fascination for the cultural variety in Los Angeles, for her encouragement and support.

Timothy O. Benson
Curator, Robert Gore Rifkind Center for German Expressionist Studies
Los Angeles County Museum of Art

LENDERS TO THE EXHIBITION

Bauhaus-Archiv, Berlin

Berlinische Galerie, Museum für Moderne Kunst, Photographie und Architektur, Berlin

Busch-Reisinger Museum, Cambridge

Galerie Berinson, Berlin

Galerie Hlavního Města Prahy (Gallery of the City of Prague), Prague

Galerie Moderního Uměni v Hradci Králové, Hradec Králové

Galerie Výtvarného Uměni v Ostravě (Gallery of Fine Arts, Ostrava), Ostrava

The Getty Research Institute for the History of Art and Humanities, Los Angeles

Gilman Paper Company Collection, New York

J. Paul Getty Museum, Los Angeles

Janus Pannonius Múzeum, Pécs

Kieselbach Galéria, Budapest

Österreiche Friedrich und Lillian Kiesler-Privatstiftlung (Austrian Frederick and Lillian Kiesler Private Foundation), Vienna

Kunstsammlungen zu Weimar, Schlossmuseum, Bauhaus-Museum, Weimar

Los Angeles County Museum of Art

Magyar Nemzeti Galéria (Hungarian National Gallery), Budapest

Magyar Nemzeti Muzeum, Budapest

Moravská galerie Brno (Moravian Gallery, Brno), Brno

The Museum of Modern Art, New York

Muzeul National de Artă al României (National Museum of Art of Romania), Bucharest

Muzeum Literatury im. A Mickiewicza, Warsaw

Muzeum Narodowe w Cracow (National Museum), Kraków

Muzeum Narodowe w Poznan (National Museum), Poznań

Muzeum Narodowe w Warsaw (National Museum), Warsaw

Muzeum Sztuki w Lodzi (Art Museum), Łódź

Národni Galerie v Praze (National Gallery, Prague), Prague

Národni Technické Muzeum (National Museum of Technology), Prague

Neues Museum Staatliches Museum für Kunst und Design in Nürnberg, Nürnberg

Northwestern University Libraries, Evanston

Pest Megyei Múzeumok Igazgatósága, Ferenczy Múzeum, Szentendre

San Francisco Museum of Modern Art

Skirball Cultural Center, Los Angeles

Slovenski Gledališki Muzej (Slovenian Theatre Museum), Ljubljana

Staatliche Galerie Moritzburg Halle, Landeskunstmuseum Sachsen-Anhalt, Halle

Státni Galerie ve Zline (State Gallery of Fine Arts), Zlin

Szépmûvészeti Múzeum (Museum of Fine Arts), Budapest

Umìleckoprùmyslové Muzeum (Museum of Decorative Arts), Prague

Frederick R. Weisman Foundation, Los Angeles

PRIVATE LENDERS

Bergmann Collection, Düsseldorf

The Merrill C. Berman Collection, Scarsdale

Zuzana Blüh, London

Dieter and Gertraud Bogner, Vienna

H. Kirk Brown III, Denver

Mary and Roy Cullen, Houston

Dr. Gál Collection, Budapest

Prof. Dr. Wulf Herzogenrath, Bremen

Lászlo Kiss Horváth, Budapest

Alexander N. Kaplen, New York

Martin and Olga Kotík, Prague

László Nudelmann, Budapest

Claudia Oetker, Frankfurt

Zdenek Primus, Riegrova

Miloslava Rupešová Collection, Prague

Dr. Jaroslav Slavík, Prague

Karel Srp, Prague

Michael Szarvasy, New York

The Marjorie and Leonard Vernon Collection, Los Angeles

Wolfgang Werner Collection, Bremen

and several collectors who wish to remain anonymous

ILLUSTRATION CREDITS

2; 183 left; 340 top: photos © Markus Hawlik, Berlin

8 top; 51 right; 53 right; 112; 346 top right, middle right; 349 bottom left; 350; 351; 357; 358; 359 bottom right; 360 bottom left; 361 top right, top left: Muzeum Sztuki w Łodźi, photos by Piotr Tomczyk

8 bottom; 18; 53 left; 190; 191; 192; 300 middle left; 334 bottom right; 345; 346 middle left, bottom; 347; 349 top right; 359 bottom right: photos by Piotr Tomczyk

12 top; 142 bottom left: Budapest Történeti Muzeum, photos by Tihanyi-Bakos Fotostudio

13 bottom right; 243 top: M. Szarvasy Collection, New York, photos © Wilfried Petzi

13 top: National Technical Museum, Prague / Architectural Archive

13 bottom left: Magyar Nemzeti Muzeum

14 bottom; 98; 120; 121; 194 bottom: photos by Miloslav Šebek

15 top: Galerie Jiri Svestka

17; 160 bottom; 177 right, top left; 220 top; 258 middle left: © 2002 Artists Rights Society (ARS), New York / VG Bild-Kunst, Bonn

24; 142 middle left; 144 top, bottom; 145 bottom: photos by Fuzi Fotó, Pécs, Hungary

34; 173: Netherlands Architecture Institute, Rotterdam/collection Van Eesteren-Fluck en Van Lohuizen-Foundation, The Hague, photos by Retina

36 top left: © 2002 Artists Rights Society (ARS), New York / VG Bild-Kunst, Bonn, photo by K.E. Goltz, Halle, Germany

36 top right: © 2002 Artists Rights Society (ARS), New York / HUNGART, Budapest, photo by Fotó Gajzágó Jolán, Szentendre, Hungary

37: Staatsgalerie Stuttgart—Graphische Sammlung, © 2002 Artists Rights Society (ARS), New York / VG Bild-Kunst, Bonn

38 top; 143 top left; 144 bottom right; 145 middle; 158; 203 middle right, middle left; 250 bottom right; 297 right: photos by Tibor Mester

38 bottom: Van Abbemuseum, Eindhoven Holland

39: © 2002 Artists Rights Society (ARS), New York / HUNGART, Budapest, photo © Walter Klein

40 left: © 2002 Artists Rights Society (ARS), New York / HUNGART, Budapest, photo by Józsa Dénes

40 right; 41 top; 54; 55; 180 top; 184 top, middle, bottom right; 185 top left; 207 bottom right; 208 middle left; 210 bottom right; 211 bottom right; 214 bottom left; 288 middle left; 290 top left; 291 bottom: © 2002 Artists Rights Society (ARS), New York / HUNGART, Budapest

42 top; 111 bottom; 143 top right; 187; 216; 223 bottom right; 286 middle right: photos © 2002 Museum Associates/LACMA

42 bottom: Kunsthalle der Stadt Bielefeld, © 2002 Artists Rights Society (ARS), New York / VG Bild-Kunst, Bonn, photo by von Uslar Foto-Design

43 middle: © 2002 Estate of Pablo Picasso/ Artists Rights Society (ARS), New York, photo © 2002 Museum Associates/LACMA

44 top right; 89 bottom middle: photos by Gabriel Urbánek

45 middle; 205; 250; 316 right; 359 top right: Los Angeles County Museum of Art, The Robert Gore Rifkind Center for German Expressionist Studies, purchased with funds provided by Anna Bing Arnold, Museum Associates Acquisition Fund, and deaccession funds, photos © 2002 Museum Associates/LACMA

47 bottom right; 129 right: photos by Michaela Dvoráková

48 right; 329 top left; 330 bottom left; 331: photos by Marek Studnicki

48 bottom left: photo by Irena Armutidisová

51 top; 350; 351: Muzeum Sztuki w Lodzi

52 bottom left; 301; 309 top left; 310; 311; 316 left; 320; 330 bottom right: photos by Teresa Zóltowska-Huszcza, Zaklad Fotografii Muzealnej

52 top; 263; 264 bottom; 349 bottom left: Library, Getty Research Institute, Los Angeles

56; 169 middle left: Magyar Nemzeti Muzeum, © 2002 Artists Rights Society (ARS), New York / HUNGART, Budapest, photos by Zsuzsa Berényi

57; 167 bottom; 212; 294 bottom: © 2002 Artists Rights Society (ARS), New York / HUNGART, Budapest, photos by Tibor Mester

202 middle right: © 2002 Artists Rights Society (ARS), New York / ADAGP, Paris, photo © 2002 The Museum of Modern Art, New York

202 top right: Berlinische Galerie, Landesmuseum für Moderne Kunst, Photographie und Architektur, Berlin, © 2002 Artists Rights Society (ARS), New York / ADAGP, Paris

204 top: photo by Hana Hamplová

204 bottom: Van Abbemuseum Eindhoven Holland, © 2002 Artists Rights Society (ARS), New York / VG Bild-Kunst, Bonn

207 top left; 250 top: © 2002 Artists Rights Society (ARS), New York / ADAGP, Paris, photos © 2002 Museum Associates/LACMA

206; 208 right: © 2002 The Oskar Schlemmer Family Estate and Archive and The Oskar Schlemmer Theatre Estate/ Bühnen Archive, I-28824 Oggebbio (Italy)

209 bottom right: courtesy The Weininger Foundation, photo © President and Fellows of Harvard College, Harvard University, Katya Kallsen

209 top right: Ulmer Museum

210 top right: Szépmuvészeti Múzeum, Budapest, © 2002 Artists Rights Society (ARS), New York / HUNGART, Budapest

211 middle: photo © Stefan and Eberhard Renno

214 top left; 241 bottom; 251 middle right; 290 top left; 300 top, middle right: © 2002 Artists Rights Society (ARS), New York / ADAGP, Paris

214 bottom right: The Museum of Modern Art, New York. Phyllis B. Lambert Fund, photo © 2002 The Museum of Modern Art, New York

215 bottom left: © 2002 Artists Rights Society (ARS), New York / HUNGART, Budapest, photo by G. Lepkowski

215 bottom right: © 2002 Artists Rights Society (ARS), New York / HUNGART, Budapest, photo by Drepler

215 top: Bauhaus-Archiv Berlin

217; 224 top left: © Zuzana Blüh, photo by Judit Karasz

218 bottom: Musée national d'art moderne/ Centre de création industrielle, Centre Georges Pompidou, Paris, photo © Bauhaus Archiv Berlin

219 top left: Bauhaus-Archiv Berlin, © 2002 Artists Rights Society (ARS), New York / VG Bild-Kunst, Bonn

220 middle; 221 top right, bottom right: photos by Ellen Rosenbery

220 bottom: Bauhaus-Archiv Berlin, © 2002 Artists Rights Society (ARS), New York / VG Bild-Kunst, Bonn, photo by Gunter Lepkowski

222; 223 top left: © Zuzana Blüh

225 top right: photo © President and Fellows of Harvard College, Harvard University, Allan Macintyre

225 bottom right: © 2002 Artists Rights Society (ARS), New York / HUNGART, Budapest, photo by András Rázsó

225 middle left: photo by Fred Kraus

227; 236 top left and right; 237 top and bottom right; 261; 264 top; 265; 266; 268; 269; 270 right: National Museum, Belgrade

229 top: Archives Flammarian

230 top; 252 top; 300 bottom right: courtesy of Krisztina Passuth, photo by Zsuzsa Berényi

234: Polska Akademia Nauk, Instytut Sztuki, photo # 17.588 PL

235: Kunsthal Rotterdam, courtesy The Estate of Marcel Janco

237 middle right: © 2002 Estate of Alexander Archipenko / Artists Rights Society (ARS), New York, photo © 2002 Museum Associates/LACMA

237 middle left: Museum of Contemporary Art, Belgrade, photo by Vladimir Popovic

243 bottom right: photo by Józsa Dénes

243 bottom left: M. Szarvasy Collection, New York

247: Library of the Romanian Academy

248 middle left; 249 bottom left: Collection of the Foundation Artexpo, Bucharest, Romania

251 top; 254: Vladimir Pana Collection

253 top right: Private Collection, © 2002 Artists Rights Society (ARS), New York / ADAGP, Paris

255; 256 bottom left; 257 top left: © Muzej Grada Zagreb, photos by Miljenko Gregl

259 right: Muzej Suvremene Umjetnosti, Zagreb, photo © The Museum of Contemporary Art, Zagreb, Boris Cvjetanoviæ

279, 280 bottom: photos courtesy of Miško Šuvakovic

282 bottom right: Museum of Applied Arts, Belgrade, photo by Nikola Vuco

282 middle left: Museum of Contemporary Art, Belgrade

283: courtesy of Dr. Peter Krecic, Architectural Museum of Ljubljana, Slovenia, photo by Lavrencic Mario

284 bottom right; 287 bottom: courtesy of Dr. Peter Krecic, Architectural Museum of Ljubljana, Slovenia

294 top: The Museum of Modern Art, New York. Gift of Philip Johnson, © 2002 The Oskar Schlemmer Family Estate and Archive and The Oskar Schlemmer Theatre Estate/Bühnen Archive, I-28824 Oggebbio (Italy), photo © 2002 The Museum of Modern Art, New York

298: Museum of Decorative Applied Art, Latvia, © 2002 Artists Rights Society (ARS), New York/ AKKA-LAA, Riga

302 right: photo by Susan Einstein

307; 309 bottom right: Polska Akademia Nauk, Instytut Sztuki, photos by Witalis Wolng

309 middle right: Biblioteka Narodowa

312: Muzeum Narodowe w Poznaniu (National Museum)

318; 322 left: National Museum in Warsaw, photos by Teresa Zóltowska-Huszcza, Zaklad Fotografii Muzealnej

325: Wydawnictwo Arkady

327: courtesy of Tomasz Gryglewicz, photo by Jozef Glogowski

328: photo © Zaklad Narodowy im. Ossolinskick, Andrezej Niedzwiecki

336 middle: photo courtesy of Ubu Gallery, New York

336 bottom left: Polska Akademia Nauk, Instytut Sztuki, negative no. 33.441 PL

333; 337 top right: courtesy of Dorota Folga-Januszewska

338 bottom left; 342 bottom right: Private Collection, photos © R. Friedrich

352; 253 bottom: Muzeum Niepodleglosci (Museum of Independence)

353 top: photo by Friedhelm Hoffman, Berlin

361 bottom left: photo by Adam Cieslawski

INDEX